together had a wonderful time
meet Picasso if our friends ever
States in the fall. There I met this Nigerian student, an
Egyptian film producer and assorted other people. Ralph's
work is very interesting and he seems to love it. He is a
United States Information Service officer and translates
and publishes books in Cairo along with planning the
U.S. library and publishing U.S. propaganda evaluating
Egyptian propaganda. He, like a few other people at the
Embassy work under press pressure, they all formed what
they call the hard core which is strictly american, with
every friday for dinner and Saturday for get-togethers
just to blow off steam. They begin with a toast to American,
colonialism and Imperialism the 3 thing the Egyptian
government is pursuing 24 hrs a day in the newspaper
and on the radio. Cairo itself is fantastic and the Bazzar
is marvelous. I was even involved in a little intrigue, just
myself. I exchanged money on the black market, just
quite innocently and then to the husband of a friend of the
phillips who is trying to get out of Egypt. It seems
first of all its almost impossible to get a visa to get out of
Egypt and secondly one can only take out a very small
specified amount of money in Egyptian currency. One
cannot buy American dollars legally anywhere, so
people who want to leave, buy gold and american dollars
in the black market and smuggle them out of the country.
Its really a police state with even my little ole
letters being opened + censored before I got them. Still
really floored me, but the newspapers are even worse.
Its pretending the fiction they publish as news.
Anyway I had a few uneasy moments when I was
leaving alexandria because my money declaration
which I filled out quite honestly when you leave, didn't
and where you have to show what you had done with the money, what
jive at all with what I had. done with the money showed anyway
I had left and what my letter of credit and told them
fuss told me to conceal the letter of credit and that the reason I had
I had sent it back to the bank and officially was fixing. I
I only exchanged $50 which was true in a pinch.
was living with friends, which too true in a pinch.
Anyway it was all unnecessary (I hid the letter of credit
in mybra) since I managed (thanks to a Greek businessman
I met on the plane from Cairo to alexandria who had a
partour pass) not to show the money declaration at
all. Anyway I never ate so much in my whole life,

I ALWAYS KNEW

A gift to
Delores "Dee"
Jackson
from her daughter
Dawn Eileen Jackson
10/28/2022

I ALWAYS KNEW

A MEMOIR

Barbara Chase-Riboud

PUBLISHED BY PRINCETON UNIVERSITY PRESS

PRINCETON AND OXFORD

IN ASSOCIATION WITH

THE PULITZER ARTS FOUNDATION

Requests for permission to reproduce material from this work
should be sent to permissions@press.princeton.edu
Published by Princeton University Press, 41 William Street,
Princeton, New Jersey 08540
In the United Kingdom: Princeton University Press,
99 Banbury Road, Oxford OX2 6JX

press.princeton.edu

Jacket image: Author's portrait. Photograph © Estate of
Jeanloup Sieff

Jacket design: Shiraz Abdullahi Gallab

ISBN 9780691234274
ISBN (e-book) 9780691238067

British Library Cataloging-in-Publication Data is available

Design and composition by Julie Allred, BW&A Books, Inc.

This book has been composed in Adobe Text Pro
and Rebrand Display

Printed on acid-free paper. ∞

Printed in the United States of America

10 9 8 7 6 5 4 3 2 1

To Vivian Mae, Queen Lizzie, Agnes & Anna

CONTENTS

PREFACE

magine that someone says to you, you can have one last conversation with your adored deceased mother. You can tell her anything, repeat everything that has happened to you in the past thirty years by reliving these memories through corresponding with her. There is only one restriction: she can listen but cannot converse, nor express any opinions except with silence. This is what happened to me on November 4th, 2008, when on the eve of the U.S. presidential election I read 600 letters I had written to my mother over a period of 30 years for the first time since writing them. I had found them 17 years earlier at her death, stacked in a small blue metal box I discovered in her clothes closet as I was going through her possessions.

Surprised and overwhelmed, I didn't read them at the time but simply closed the lid of the box, locked it, and put it back on the shelf and later in a safety-deposit box. It was not until sixteen years later, eight years into the century, that I asked a graduate student to photocopy, transcribe, and correlate by date those fragile, onion-skin, red white and pale blue airmail pages I had sent from Paris. The student wrote me a letter when he had finished, telling me how much he had enjoyed reading these letters and how he wished he had had a mother like mine.

"I laughed a lot," he said, "I cried a little too! You were so lucky to have her." Impressed, I filed the photocopies and the transcript in three large loose-leaf binders, vowing to read them myself soon. Those faded, pale pages sealed within themselves, filled to each corner and in all the margins with my own familiar scrawl, seemed ominously like Pandora's Box.

I Always Knew is the result of that encounter with my own letters and my own life from 1957 to 1991. I saved none of her responses, yet her voice is as clear as a running spring and my monologue as fresh as the days I wrote to her. So this is not autobiography, nor biography, nor memoir, nor fiction but a strange hybrid mixture of disparate and even contradictory narratives out of which portraits of the two of us emerge, separate yet united and indivisible. It was somehow like finding the gravestone of a very young woman. I wonder even today how my life would have changed if I had read them then rather than now.

These letters are about travel, about adventure, about humor and love but they are above all about identity. About becoming and still being left intact. Neither

victim nor hero but *The Thing I Am*. Somebody. Somebody who would become an artist—one of the most difficult ways of becoming someone because one's actions are left singular and solitary in a universe one has no power over but that one is always imagining. Did I always know? My title was suggested by the master of historical novels Gore Vidal in an old video where he claimed it was a perfect title for a book, especially a book like this one whose whole purpose is to discover *why* I always knew.

It begins with my mother embarking a teenage girl, me, on a French liner *Le Flandre*, bound for France, and ends with that same mother leaving the daughter still standing but alone. It is a book about perfection, about striving, about ambition and youth, about years when one's purpose in life was to learn everything you could learn, understand everything you can understand, do everything you can do: travel, read, study literature, art, and philosophy, absorbing it all in order to figure out who you are and who you might become. To try out smart-aleckness and arrogance, downright silliness and naïveté, wild ambition and all kinds of delusions, to discover love and sex and all their terrific and terrible implications including disappointment and betrayal, loss as well as power and glory. Who you are in the eyes of Mothers and who you are in the eyes of a loved one and in your own eyes. All this while standing on a ledge, overhanging an abyss trying to find pride and identity, in a careless and indifferent world, obedient to your upbringing and confident that you will see it through. Always, at least in my case, expecting the best, not the worst.

As a child, success came easily to me. I loved to learn. I loved academic work. I loved the music lessons and the ballet lessons and the art classes at the Philadelphia Museum, ready to adore anything that was beautiful to stare at. My favorite painting as a child: the blood red Degas painting of ballerinas I discovered on the walls of the Philadelphia Museum of Art. I loved my parents, my grandparents, my teachers, and of course the family dog whose name was Beauty, what else? I loved praise, I loved parties, jokes, and laughter.

Not only was I not willing to settle for anything less than the best, I was also not willing to exhibit less than perfection to the world or anybody in my entourage.

"Making things look easy," my grandmother would say, "is a matter of politeness. Letting people know you are carrying a heavy burden is a third-world attitude toward life."

But she also amended that a bit by saying, "Pride goeth before a fall," just in case I got a little too uppity. Her third admonishment was simple, direct, and effective. "Don't get mad. Get even."

Many editors wanted to change these letters into autobiography with editorial commentary and, as they put it, "framing," which for me would have been like trying to fit a square peg into a round hole—impossible and false. The letters, unexcerpted and intact, stand alone, like a string of short stories as witness to a time and

many places. Their value is in this immediacy. Rather than edit them, I separated them chronologically and within those sections inserted brief essays rather than an editorial, although sometimes it is both—like the opinion page of a newspaper. At times, the essay has something to do with the letters or my life or hers and sometimes not. In order to explain the various names that pop up in the narrative, I have annotated a sentence or two in a footnote and included a list at the back of the book. I have inserted longer notes of identification as each section unfolds. Mostly the characters are explained sooner or later in the letters themselves. Of the 600 letters I discovered, I culled 300 and left them intact.

As the new twenty-first-century art of blogging has illustrated, one doesn't have to know or have the blogger explain in order to listen and respond to what they say and do. By dawn the following day, November 5th, 2008, I had finished reading the letters I had turned to for some incomprehensible and mysterious bromide for my anxiety, just as the final election results came in announcing that Barack Obama would be the 44th president of the United States of America.

As the age changed with the breaking dawn, I wondered if I had anything to do with the cool, passionate, contradictory, egotistical, greedy, selfish, smart, intense creature that grew before my very eyes. Was I anywhere related to this crazy, ambitious, tempestuous, imperial, but funny pilgrim—spoiled yet fearless little girl? Who was this cruel, headstrong, generous, optimistic, dreamy wayward young woman? But one thing I did know, I was my mother's daughter—I had deserted her by never returning home again, but home was not where I was even now. In safekeeping these letters from Paris, I realized my mother had forgiven me even that and had made this a home away from home for me.

These are not literary letters. There is no pretension, no intellectual one-upmanship, no byplay or clever turns of language, not even any real gossip, yet I could date my poems and novels from them. They were not artist's letters either, with all that angst and ambition and self-invention and self-importance, full of influences, strategy, and the machinations of the art world. Yet I could find the cornerstone of major changes and directions taken later by my sculpture. Neither were they like entries one would make in the privacy of a diary basically talking to oneself for others to listen, nor the self-indulgent hindsight of a memoir, although I realized that some missing letters I remembered writing had been purged by her because of indiscretion, indecorum, and likely sin. But what *was* there was breathtaking authenticity, the uncensored, unfiltered urgency, timeliness, and single-mindedness of love letters in which the sender in her naked desire doesn't care what the recipient expects or wants but is concerned only with her own devouring need—this was my mother, after all, Mom, Mummy, Ma, Mother, *Maman*, Madame, Ma'am—and as in all love letters, one is more interested in one's own love than that of the beloved. And that goes for Mother-love as well.

Still it was as if she were there with me, listening in silence—forever attentive

to my wholesale dreams and name-brand adventures. The letters to my surprise had taken on a life unto themselves in which the two protagonists, one invisible and silent, took on a whole world of feelings. I realized what kind of mother I had had. Her persona like some omnipresent, voiceless goddess listened to the chattering prayers of her worshippers without response or comment, accepting all out of unconditional love.

I ALWAYS KNEW

"Jerry"

obstructive

Central Apnea = (whole body -
 heart related)
&
structural

mask w/o magnet = 4 hrs.

TO Read chip:
Dec. 28, - Wed. AM 10 am

S taring at the photograph of my mother and me, standing on the deck of the French Line *pacquet* boat *Le Flandre* about to set sail for Le Havre with me on board, I am struck at how little most children know of their parents' private lives, ignorance that usually lasts their whole lives. My mother stands beside me in the black-and-white photograph, beautiful, elegant, alluring, and just divorced from my father. My grandmother had died three years earlier at fifty-seven, and the moral constraints she exercised upon her son broke down with the closing of her eyes and he left his wife of nineteen years for his long-time mistress. In a time period of twenty months, my mother, Vivian Mae, had lost her mother-in-law, her husband, and now me.

I am standing next to her, a tall, gawky teenager not even twenty-one—the legal adult age at the time—who owed her life to her grandpop who had once saved it and who was still alive and in whose house we lived. At four years old, I had been struck by polio meningitis, equivalent to a death sentence for a young child in the 1940s. My grandfather had run with me in his arms the one or two city blocks it took to arrive at the Philadelphia Children's Hospital, the most famous hospital for children in America, so close to our home that it was faster to run than wait for an ambulance to answer an emergency call. As we arrived at the top of the wide marble steps of the building, a nurse blocked his way, explaining that the hospital had no Colored ward and so could not accept a Colored infant, dying or not, since they had no beds for Negro infants. My grandfather pushed her aside and raced into the emergency room, which was full of young interns.

"She," he protested, "is not a Colored infant. She is Barbara Dewayne Chase, my granddaughter, and she doesn't need a bed, she needs to be placed in an iron lung or she's dead! And if she doesn't get what she needs to stay alive, I will demolish this hospital brick by brick."

Alarmed, a young intern rushed forward and took me in his arms, ignoring the protests of the nurse. The emergency doctors admitted me to the hospital and saved my life. And indeed, I spent the next months of my existence in an iron lung—which is how I learned what the term meant and developed a phobia for tight bedcovers. My grandpop, who was an independent building contractor,

knew a thing or two about demolition and had helped build the Philadelphia sub-urban housing development of Levittown, which in the 1940s he could neither live in nor buy.

Growing up in the 1940s and 1950s during the Eisenhower years, it never occurred to me that there were "Americans," all White, and then there were "others." It also never occurred to me that my mother was an immigrant—a foreigner and a non-American, being a British Canadian. It was only now that she was divorced that she had requested American citizenship and thus lost her status as an alien in an alien land.

Yet she had generously given permission for me to travel to an "alien" land, Italy, on a John Hay Whitney fellowship for a year at the American Academy in Rome, sacrificing her own need for me just as three years previous I had renounced my scholarship to Wellesley College for Philadelphia's Tyler School of Art at Temple University in order to remain near her.

My parents' marriage had been a shotgun teenage one orchestrated by my grandmother, Elizabeth, the matriarch of our family, between her son and the convent-bred, Catholic "foreigner," my mother. I had been produced when my mother was sixteen and my father seventeen, neither old enough to drink, drive, or vote. All three of us were raised by my grandmother, but especially me, disciplined and polished by dance professors, piano professors, art professors, my mother's girl scouts, Jack and Jill, concerts at the Philadelphia Academy of Music, Saturday art classes at the Philadelphia Museum, swimming lessons at the YWCA, a child prodigy and freak of nature, best-dressed, white-gloved, highly popular Black dream girl. The big issue at the time was the viability of the "race" for "equality" and the key was education. Were we "ready"? Was it "possible"? Did it have to do with morality or politics? "Colored" people were barely acknowledged on the limpid White surface of America. They were called that (the National Association for the Advancement of Colored People) and they called themselves that and nobody called them "beautiful."

America was rising as the ultimate world power. Dwight D. Eisenhower had been reelected, James Watson, Francis Crick, Maurice Wilkins, and a woman named Rosalind Franklin had discovered the structure of DNA. Rosa Parks had sat in the front of the bus in Montgomery, Alabama, and refused to move, igniting a bus boycott and Martin Luther King's protest march. I was leaving to explore the world outside just as the United States was looking inward and exploring its own apartheid, which would leave it never the same again. I had no idea at the time that what was named the Civil Rights Movement was heading toward a summit point in the world that would render it unique. And I would experience it from an altogether different vantage point—a Yankee in Western Europe, a "foreigner in a foreign land, and finally an American in Paris." Philadelphia's Grace Kelly married European Prince Rainier, Marilyn Monroe married Jewish intellectual Arthur Miller, Jacqueline Bouvier married John F. Kennedy, James Bald-

win published *The Fire Next Time*, Kenneth Galbraith wrote *The Affluent Society*. In Europe, I would meet them all in time.

From that moment on the *Flandre*, my mother and I began a correspondence that lasted thirty years, through a sojourn abroad, graduate school at Yale University, several wedding engagements, marriage to a Frenchman much older than I, two children, a divorce, a second marriage to another European, fame, success and a million miles of travel from one end of the earth to the other.

While I was climbing the pyramids in Egypt, 1,000 paratroopers and 10,000 National Guards were protecting five Colored students who integrated Little Rock Central High School. The median family income was $5,087 and a Colored family's average was half that. Alaska and Hawaii became the 49th and 50th states of the Union. It cost 4 cents to send a one-ounce letter and 15 cents to send it to Europe by airmail, which would carry my words, thoughts, and dreams back to Philadelphia on tissue thin pale blue double-folded onion-skin paper framed in red, white, and blue stripes to my mother's eyes. As many pages as there were miles between us from that day.

September 27, 1957
Le Flandre, The French Line

Darling Mother,

I hope you and Grandpop are fine. The ship has photographs taken at the pier as we left and there is one photo in which I can see everyone when you were standing on the steps waving good-bye. I'll send you one. (The food on the ship is really magnificent and we have a very funny steward who pops into our cabin at all kinds of weird times.) Shirley and I get along very well of course and the trip has been very smooth, except for Wednesday night when I felt a little uncomfortable. The people are pleasant but on the whole rather dull. There are about 80 Fulbright students on board ship, most of them all-American kids, you know.

I have met some interesting people…a Haitian gentleman and his daughter. He is going into diplomatic service in the French Islands. I met a French girl, Nicole, who is returning to Paris from a year in the States and she is wonderful. Shirley met her in New York. I also met a very funny French doctor and a very nice, shy nuclear physicist who reminded me of Arnold. So of course I immediately fell in love with HIM.

Last night we stood out on the deck for a while watching the moon and then very romantically, he said well it's my bedtime!

[…] Great! He was talking about how he could go do rocket research if the fact that he wore glasses would not keep him off the first rocket to the moon. He is so sweet. Oh last night also I danced in the lounge with some boy from Ohio. The orchestra is not too good, but they were playing something that could be made

into a Cha cha cha so we danced (he's Colored) all night practically. We ended up putting on a floorshow because no one else dared to dance with us on the floor.

Getting back to the food. I have never gotten up for breakfast, but lunch and dinner consist of about six or seven courses. A typical meal: hors d'oeuvres which today was a cold fish, some kind of salad, and salami, then entrée which was kidney stew and spaghetti, then main course was pork, mashed potatoes, and greens, then cheese (two kinds), then fruit, then dessert which is a pastry at lunch and ice cream at dinner, then coffee or tea. At dinner there's another course too added in and of course soup. So we waddle up from the lunch or dinner table and usually have to take a nap before we can do anything. We usually don't do anything anyway.

All the French waiters think I'm very pretty and that I don't look American at all. They keep spouting this French to me, which I don't understand at all, so I just smile sweetly.

People are swimming in the pool on deck so you can imagine how warm it is. I met this one little girl yesterday who was just the prettiest thing. She was going to England and then to Italy. I guess she was about seven years old. So I drew a picture of her and she drew one of me. But I was sitting with our other cabin mate, who is a theology student. And the little girl wanted to know why I was so tan. So the theology student sitting there with me started with this stuff "God made her that way" etc.... So the little girl said "I know God made her that way but *why* is she so tan?" So she said "well some people are red and some yellow"... So at that moment I stepped in because the little girl was looking at the red deck chairs we were sitting in. So I told her that people were not red or yellow but as she traveled around the world with her mother and father, she would see that people have different complexions, some are tan and some are brown and so on... It was very cute. But I get so tired of this red, yellow, and black stuff. So I told her no one was red, that red was the color of the deck chair and no one had skin that color.

Nothing else very interesting has happened on the ship so far. Everyone is sleeping later and getting drunker earlier because they are bored. Tonight is a gala affair where everyone is supposed to get all dressed up in evening clothes.

Oh yes, you can forward my mail until about Oct. 15 to me c/o Miss Shirley Abbott

> Fondation des Etats-Unis
> Cité Universitaire
> 15 Boulevard Jordan
> Paris, 14e, France

We will dock in Plymouth England Monday morning and no one is quite sure when we get to Le Havre. But it will be around Monday night or Tuesday morning.

I don't know how anybody can go on a sea voyage to think. I've been in a stupor for five days now. You do nothing but sleep and eat; the ship is like an incubator. It keeps you warm, feeds you, and rocks you to sleep at night. It's terrible. You end up not even having energy enough to read. I have been writing Harold the Christmas letter since Tuesday. I'll finish it Sunday night so it can be posted in England along with yours. Please tell Bernice that this letter is for her too. If I have to write four or five of these letters all saying the same thing I'll go out of my mind.

I will write as soon as I get to Paris. I love you and I miss you terribly. And how old is Mr. Gary Cooper the second?

Love,
Barbara

P.S.—Please send me the letter I received from the American Academy in Rome as soon as possible…I have to write them from Paris. If it isn't too much money send the booklet also—

October 4, 1957

Darling Mother,

I hope you are well and don't miss me too much. How is Grandpop? It seems months and months since I've seen you both. That boat ride seemed to last forever. Did you get my first letter? I haven't had a letter from a soul yet so tell everyone to start writing. You might as well send them on to Rome c/o American Academy Via Angelo Masuria # 5, Rome 28, Italy, or c/o American Express, Rome.

Mother, will you please call Harold's mother and find out what's wrong with him or if he is in the city? I am really frantic: I've wired him 3 times and gotten no answer. If he won't answer me will you please wire me or get Harold's mother to wire me c/o American Express Rome (send a night letter, it's cheaper). I just can't spend any more money wiring him. It's just impossible.

Paris is just magnificent. I've never seen anything like it. If Rome or Florence are more beautiful I can't imagine how. The weather thank goodness is good. Cold but sunny. Of course no French establishment of any kind turns the heat on before October 15, so it's usually warmer outside than in. Just my luck to come at the worst time in the world to get hotel rooms. There's an automobile show, a motorcycle convention, and a hairdressers' convention all in town this week. I couldn't stay at the Cité because of the Fulbright so I had to come back in town. Right now I'm at a very nice hotel on the Rue Tronchet, right in the center of town near all the museums and monuments. But I only have it until Sunday unless someone moves out or cancels, so I have several people I contacted in

Paris looking around for me. Yesterday I looked up one friend of Paul Keene's who was very nice. I'm to spend this Sunday with them. She is married and has a little boy. I'm having dinner tonight with another friend of Paul Keene's, Joyce La Page, so I'll have one French meal before I leave. I am leaving Paris Friday the 11th either by train or by plane, I haven't decided. Paris is very expensive so I just can't stay any longer. I hope I can get to see all I want to by then. If I fly—and I will if I can ship my luggage cheaply—I will be in Rome Friday evening. Oh yes, next Wednesday I'm going to the Ballet de Paris and day before yesterday evening I went to the Paris Opera House, which is just down the street from my hotel, to see the Royal Opera Ballet Company. It was very exciting. One thing they did was really great. The Opera House itself is unbelievable. It's very old and ornate with huge marble stairways and chandeliers and red velvet seats, and big, big high-ceiling rooms with heavy brocaded drapes. It's about 14 times as elegant as the Academy of Music and three times as large. There's a great dome in the middle and all kinds of murals painted on the ceiling and walls. The guards wear these ornate ribbed and decorated uniforms in blue and scarlet with their rouge and white gloves and epaulets on their shoulders. Paris is just so marvelous. I can't begin to tell you about the narrow winding streets that suddenly open out into a magnificent square or plaza where there are four or five great monuments and the tops of several ancient, historical buildings looming in the distance or seen at the end of a Boulevard or Avenue. But the traffic is just unbelievable. You must just close your eyes and walk across the street. There are no lights, no stop signs, no go signs, no traffic lights, no nothing but a charming traffic police man who in the most haphazard way "directs" the traffic by his own particular rules. Most of the intersections are circles as in Washington with 3, 4, or 5 streets all converging and these little toy cars, scooting this way and that, not to mention the scooters, buses, and bicycles. I have seen Notre Dame Cathedral, the Arch of Triumph, and walked by many of the famous Palaces. Today Shirley and I are going to the Louvre, where the largest collection of European masterpieces is. I've also been to UNESCO to look up the friend of Paul Keene's. I have seen very few Africans—some of the men are so handsome, but many of them do not speak English. There are loads of them at the Cité Univérsitaire. But the Cité is so far out and is so much like a college dormitory that I'm glad I didn't stay there. Shirley hates it.

Oh yes, I have to tell you about the rest of the voyage. Mostly it was dull, but there was a Gala Captain's Party the Saturday night before we docked in Le Havre. It was great! Lasted practically all night. Everyone was so depressed being cooped up on that boat so long they were absolutely mad—you know with paper hats etc., etc. Remember the handsome married man I told you about? Well, I finally danced with and talked to him. He works for Life Magazine and has a six month leave of absence to write in Europe. His wife is a would-be painter. He was about as tall as Harold, blond, blue eyes, and very athletic looking. He had

asked me to dance and then we got caught up in this silly dancing game they were playing called statues. You know when the music stops the dancers have to stop dead still—if you move you're eliminated from the dance floor. We almost won! Finally I started talking to this boy from Morgan State. By this time we were both wondering what in the world we were doing on this boat. So he bought me about 4 scotches (I had been drinking champagne and we both got crocked). I was speaking perfect French by the end of the evening, and he was speaking perfect Italian.

The ride from Le Havre to Paris was great. It had rained in the morning, but had cleared up and the sun was shining. We went through all this lovely green countryside with its quaint houses, patches of planted field and gardens, flower gardens. At one point it was just too much. A big rainbow broke across this perfectly lovely post-Courbet landscape with the cows, fields, etc., etc.

If you don't write every day, it's so hard to remember everything you want to say. Well, I'll write again day after tomorrow, by then I can remember the rest. No interesting men yet. I'm not homesick, but Harold is driving me out of my mind. Of course I miss you terribly and wish you were here. Also the language difficulty is terrible, but other than that everything is fine. I'll be glad to get to Rome, though, and get settled. Last night both Shirley and I were really blue. She like an idiot had left this guy Ken—30 years old, a vice-president, rich, apartment on Central Park West, wants to marry her and I assume fairly good-looking. So we were both contemplating buying plane tickets on the next plane back to New York. But we figured we'd never live it down so we gave up the plan (smile).

Good-bye, I must get out of this room; it's such a lovely day—Love to all.

> Your daughter,
> Barbara

P.S.—Write on airmail paper like this and send all letters airmail or they'll never get here.

October 8, 1957

Darling Mother:

Received your letter yesterday. I hope you and Grandpop are well. I'm glad you don't miss me so much. I suppose someone else is taking up all your time. I'm now at the Cité—living here that is. I'll be here until Friday when I'll fly to Rome 10:00. It takes about three hours. I'm going Air France. Will be in Rome in the early afternoon. It takes about 24 hours by train and I just didn't want to go through that. It's quite expensive to fly, however. Everything is about twice what I expected it to be. The cost of living in Paris is unbelievable. It's only 3% below the cost of living in New York and the salaries aren't half as much. Had

wonderful times Saturday and Sunday. Had dinner with a French family Saturday, the family of a friend of Shirley's. Sunday I spent the day with some friends of Paul Keene's. They have the most fabulous studio—not modern or anything but so Greenwich Village–like, old and sort of medieval and romantic. With tall windows. Like many of the places in Paris there is nothing but an old, narrow alleyway with shabby doorways, then when you walk through the doorway you're in a courtyard with perhaps eight ateliers all facing onto it. This is how their house was.

I also met some of their neighbors. There's a French sculptor, an Italian sculptor, a Swiss painter, and a very famous French photographer for *Life Magazine*, Pierre Boulat (see if you can find the issue of *Life* in which there is a photographic essay called "A Frenchman Looks at American Women").

Tomorrow I'm going to the Ballet de Paris with Shirley. I'm also going to get my hair done tomorrow. Oh, about flying to Rome—it's costing me $60.00. Thursday I hope to have a rip-roaring time with this guy I met on the boat—fancy restaurant and café later since it will be my last night.

I met two medical students a couple of days ago (both Colored) who have been fixing everyone up (all the sick Americans, that is) with medicine. They were telling me that of all the Americans that have enrolled at the University of Paris in the last 10 years only three have graduated, and those three were Colored. There are now two guys going into their 5th year, a girl intern, one of the boys I met who is a sophomore and the other just starting, all Colored. They had me dying laughing about the African boys. There are a great many at the University and some of them are so damned good-looking your eyes pop out. Many of them don't speak English and most of them come from Morocco.

Anyway, they usually date French girls but they make it a point of honor to date and if possible "make" every blond, southern, American girl that walks into the University. Their motto is "Send six home pregnant by Christmas"!

Other than having a cold I'm alright, but I think the Italians eat a lot better than the French. Oh, I have a long list of things to send me when you send over the shirts. First of all, try and keep the clothes from looking new in case they open the package for duty. Sometimes they do and sometimes they don't. If you send records put them in old jackets as well as their own jackets, etc.

1. The shirts
2. Jacket to crepe dress
3. Helena Rubinstein skin dew lotion
4. Pressed face powder # 8
5. My L.P. Records (I think Pat has my "My Fair Lady" album)
6. If you can, some new ones. Ask Harold to get some for me
 I'd like—"Concorde" by Modern Jazz Quartet, Prestige Label
 "Latin Escapade"—George Shearing, Capital Label
7. My flat blue shoes (I've worn out practically every pair of shoes I brought)

8. Transformer for American electrical appliances called a "Voltage Adapter"—tell them it's for Italian voltage. They are made by the "United Transformer Corp." New York City, NY, U.S.A.

Send it to American Academy, I'll be there at least until the 21st of October. It seems just ages since I left home or even since I've been on the *Flandre*. Sometimes I feel like time is going quite quickly and other times it seems like months and months instead of days. Did you know there is 5 hours difference in our time? It's now about 11:00 here but in Philadelphia it is just 6 pm—dinner time. I'll let you know how my hair turns out and how much it cost me. I got the name and address of this hairdresser from a girl I came over with on the *Flandre*.

The French women certainly haven't impressed me as far as dressing is concerned. Most of them look like peasants or south-Philly sisters that buy their dresses at Robinson's and Lerner's. Yet one can see the quality or cut of a coat or suit but when they put it on—something happens. They either have on the wrong shoes, or color, or scarf, or bag or something. Speaking of bags, I could just go out of my mind the French handbags are so beautiful. They use suede a lot in their handbags—and what shapes—those soft folded clutches—just beautiful.

Most of them are very expensive—not in comparison with what you'd pay in the States for a good bag, but in comparison with European prices.

What about this Russian satellite? I didn't know anything about it until it had circled the globe for about three days. America must be hysterical. You can't tell much from the European editions of the *Herald Tribune* (which is the only U.S. paper we can get over here). Most of the French seem rather pleased. They really believe in this balance of power idea and they are just as afraid of the U.S. as they are of Russia.

Mother please tell my Aunt Bernice and my Aunt Helen that these letters are for them too. It's so hard to write three or four newsy letters. Oh yes, I was approached verbally by my first Frenchman a couple of days ago. Very interesting. French men aren't moving me at all—but those Moroccan men! Wow!

> Love, Goodnight, and Kisses,
> Barbara

P.S.—Mother please start writing on airmail paper like this—and using airmail envelopes. You'll spend a fortune in stamps. Tell everyone to write to me.

P.P.S.—Please add to list—aspirin which you can't get here without a prescription.

Just got out of the hairdresser's. You should see my hair. It looks like something out of *Vogue*—all black and shiny. They were very nice, but very expensive. I got there at 10:00. It is now 12:30. I think he must have combed it for a half hour anyway—it looks so professional I'm afraid to touch it!

October 15, 1957

To my utterly sweet Mother:

Finally in Rome. Of course I have just received your two letters. They were wonderful. I laughed and laughed about those lines "Darling I'm not scolding, but don't get in the habit of drinking too much…" I had a rip-roaring time that night. Jack, the boy from Morgan, is very sweet and if you think that is terrible wait until I tell you about my last day in Paris (smile). Really mother I am not going anywhere near the dogs, let alone to them. I also have no intention of coming home. I am lonely at times but not in the least depressed. I have received one wire and one letter from Harold. He felt, as I do now, all my hysteria was just breaking ties from home, being in a strange country and being lonely. So much happens in such a short space of time, I can never remember where or what day I left off in my last letter and writing everything in quadruple for you, Paula, Shirley, and Harold, not to mention Paris, Pat, Eleanor, and Izzy, is giving me corns on my fingers! Let's see, I must have written you the Tuesday before I flew to Rome. Well, that Wednesday Shirley and I went to the Ballet de Paris, which was slightly disappointing after seeing them in the States with Roland Petit (remember "Carmen"). The dancers however were wonderful so it sort of balanced out. Before the Ballet the Ambassador had a party for the Fulbrights which I crashed. It was great! Champagne flowed like water and all kinds of goodies (I don't think anyone had eaten dinner). There was also an exhibition of I think a Fulbright's paintings which were so bad it was pathetic. The party was held in a very ritzy hotel, beautiful ballroom with crystal chandeliers, etc. I must have drunk about five glasses of champagne. (Mother, please don't faint!) I was happy, happy, happy—surrounded by hundreds of people! Thursday night I went out with this boy from Morgan. Pat Moore and her husband had given Shirley and me the name and address of a great restaurant and of another café, so we went there. The restaurant was called in English the "Peacock Queen" and it was rather expensive, 400 francs for the both of us. But the food was heavenly. I have never, ever eaten a meal to compare with it. It is served in about 7 courses and (please, Mother, control yourself) a different wine is served with each course and an aperitif before dinner! So you have about eight glasses each on your table before the meal. One waiter serves the food, and another serves the wine. Then a brandy, a red wine with the hors d'oeuvres, a white wine with the fish, a dry red with the meat, a white dry wine with the salad, then I lost count. Everyone in the restaurant starts out very dignified, the conversation is low. By dessert, which they serve with champagne of course, the men are laughing a little louder, everyone is flushed and red (except us), the girls' eyes are a little brighter.

They could probably charge you 400,000 francs by that time, you're having such a good time, it doesn't matter—then we went to a café called l'Abbaye. It is

run and owned by a White guy and a Colored guy (is he ever beautiful) who sing folk songs. They are just great. Both are quite handsome. The White fellow is very tall and thin with a sort of line-y face, the Negro is quite tall but real muscular, looks a little like Henry! The place is quite small and dark, lit only by candles. You couldn't squeeze more than thirty people in it. They sing classic folk songs, spirituals, French love songs, etc., in a very vibrant dynamic way. Especially the Colored fellow. He makes most American songs look like pale choir hymns. He used very dramatic gestures à la Belafonte and he is as good, I think. Both wear tight black pants with white shirts open at the neck. At the end of the evening they take requests from the audience and as they sing them they put out a candle until there's just one more song and the room is completely dark except for one candle. Then they sing a calypso song called "Time Man to Go Home" and they roll down their sleeves, button their collars, put on their ties and jackets and put out the last candle. Great, huh? They are very popular in Europe, they make records, and play in the movies. If they expanded they could make a fortune, but it's so nice the way it is.

Friday at 10:15 I flew to Rome. It only took three hours and was wonderful. They served lunch on the plane, the day was clear and sunny except for big fluffy white clouds. You could see the change as one left France and entered Italy. We flew down the coastline so that you could see all the microscopic-looking coastal and fishing towns with little boats. When we landed in Rome, the effect was startling. Everything in Paris is this sort of filtered gray light. In Rome everything is golden. It is still so warm here women are wearing summer sleeveless dresses. Everything is still lush and green. The Italian men are as I expected—verbal but harmless enough. This friend of Paul Keene's I looked up really had some funny stories to tell about Italian men and his wife while they were in Italy. Well, they do stare (it isn't considered rude as it is in the States) and whistle and call and follow you down the streets and honk their horns, but they rarely really frighten or annoy you. They act as if they have X-ray eyes or something, walk around like Marcello Mastroianni with their dark glasses and cigarette holders. I really think the older men are much more fascinating than the young ones. I've been in Rome and in downtown Rome for 4 days and I have yet to see another Negro African or otherwise, so you can imagine the effect. Let's put it this way: I'm never alone. I always have 10,000 eyes to keep me company and when I sit down always about 3 or 4 Italian men surround me. Once in a park, they even started serenading me! But all in all they are quite helpful. Sometimes I have to resist the urge to make horrible faces. The problem now is to get a studio. I won't have to worry about it for a few days yet, because I'm going to Florence to visit Natalie. I eat at the Academy, although they had gotten me a place in a pension not too far away until the 18th when I'll be living there. The Academy itself is unbelievable. It's just outside of Rome, in a very quiet residential section of huge villas and gardens. First there's a big iron gate with a gatekeeper and a small court or

garden in front. Then there are big marble steps leading through the façade of the building which is a series of big arched windows into the most beautiful inside court with big poplar trees, gardens and a romantic-looking fountain in the middle. We usually eat lunch on the sort of porch-like extension from the building which surrounds the courtyard. Most of the rooms look out onto the courtyard and the studios are great—so big. I wish I could stay here and then I don't. It would be great for work but it's so isolated and so American. I met a very nice sculptor-painter named Jack Zajac who is fairly well known the first night purely by chance. Later I discovered Lionni had written and told him to look me up. He (Lionni) had bought some drawings from Jack and it's sort of tentative that he do a *Fortune* assignment. Jack is married; his wife is going to have a baby. I like his work very much. It is very exciting. There is another sculptor here whom I admire very much. These people are no hacks. Most of us are serious professionals who are good and who have already made a mark in the art world. Yesterday I stayed downtown all day, indulged myself in a real American lunch at a restaurant that caters to Americans—cheeseburger, ice tea (with ice! First ice I've had in 3 weeks) and ice cream and cake. It was great. I must do it again sometime and it was cheaper than all the Italian lunches I've had except at the Academy. I haven't found anything in Rome or Paris that is really cheap yet. The shoes are beautiful and believe me you'll get a handbag for Christmas...but they are not cheap. Of course you'd pay much more for them in the States, but they average around 10 or 11 dollars. Housing here as in Paris is ridiculously high. I don't see how the average Roman lives in Rome. Yesterday I went to a gallery in town and met the sculptor who was having the show there (Puccinelli), a fairly well-known West Coast artist, and he said Florence, he found, is not cheaper. The one studio he knew about was the one Natalie had rented about a month ago. So he showed me the artist section of Rome, where all the studios are, and helped me find a place called the Artist Center. They couldn't help me either as far as a studio is concerned but I did find Katherine Dunham's school. I think I'll go over there tomorrow morning and see if I can find a Philadelphia-dancer from Marion's who is supposed to be there. I really want to take some pictures, but I haven't bought a camera yet. Words won't describe most of the places I've seen like the Colosseum at dusk so I won't even try. I hope to buy one in Florence while I'm there. Today I'm going to try to get in touch with a Fulbright sculptor here who has a studio in town. Also trying to get in touch with several of Paul Keene's friends, one of whom writes for Italian movies I haven't been able to contact at all. The other lives out of Rome so I'm going to write him today. I haven't had any time to start studying my Italian. The weather has been so wonderful I've been trying to see as much of the city as I can. My Italian is not bad, but pretty primary. I can ask for things and usually get them. But when I say something and I get back this flow of Italian, I can't understand it of course. The pension where I'll be staying until the 17th when I leave for Florence is very

nice—big room with breakfast in my room and flowers, etc. But it's also very expensive—2,000 lire per night. I'm doing fairly well though. I'm sure I won't spend any more than $100.00 this month which means I'll have $300.00 to spend next month. I still haven't made up my mind about the Vespa. Gee, I'm so behind on my letter writing it's not even funny. It doesn't seem possible that in a few days I will have been away for a month. Yet the boat ride seems years and years ago. Even Paris is beginning to seem like it happened a long time ago. I received a letter from Natalie while I was in Paris. She is much happier now, doesn't want to come home in the least. I haven't written Paula or Pat about Paris yet. I think I will today if my hand holds out. I'm going to start writing carbon copies or writing one letter and telling the person to forward it to the next person. But send me Frances's address, also, Helen's, Bernice's, Jerry's and whomever else you can think of so I can at least send them postcards. I'm sending one to Frances c/o cousin Elizabeth because I can't remember her address. Oh yes, I did have a cold in Paris, but so did every other American. It's practically gone now and it was just an ordinary old cold. I didn't even do anything for it—just let it run its course. But the day I received your first letter which stated among other things "take care of yourself, don't catch cold and don't let yourself get stopped up," I was hacking away constipated as a jailbird.

You take care of yourself and don't work too hard. Don't get spoiled by these novels you're getting as letters. They'll probably get shorter (smile). I'll write Daddy soon. In the meantime you'll just have to read him my letters or forward them or something. The people at the Academy have been very kind, and as soon as I can make some contact with someone with means of transportation I'll be in business. It's very difficult for a girl to go out after dusk in Rome by herself. Italian women just don't go out. The further south you get, the earlier they get inside for the night.

Last night I went to see a Jeff Chandler movie in Italian. If you think that isn't funny. The dubbing was very good, though; it sounded just like Jeff Chandler only speaking Italian. The movie was a western and lousy and made things even worse. The Italians loved it. I haven't been to St. Peter's yet. I might go tomorrow since I'll be in town or wait until I get back from Florence. By November it should begin to rain so I'd like to get settled by then. It's so hard to plan a day here. You end up doing about half of what you plan to. The stores are closed from 1 to 4 in the afternoon and that's that. Sometimes it's more like 2 to 5. For me, the whole day is shot. The Italians eat and sleep from 1 to 4 and then the shops open up again until about 9 o'clock at night. Last night I ate in a very nice little Italian restaurant. I ate early around 7:30 so the place was practically empty. I had a nice long talk with the owner about this and that. He wanted to know all about me etc. Rome is really beautiful. I don't know which I really like best, Rome or Paris, although Paris has the edge now. I like the pace in Paris, it's very much like N.Y. but it would be impossible for me to live there.

Shirley has already started her campaign to be transferred from Grenoble to Paris. Grenoble is a university town equivalent to living at Penn State in Pennsylvania rather than Philadelphia.

Well, I haven't run out, but my hand has. I'll write again in a few days. Miss you and love you. Wished Sunday night I was sitting home looking at Steve Allen rather than what I was doing, whatever it was. But I'm awfully glad I came. Just these 3 weeks were worth all the trouble and to think it's almost free. It's really wonderful. Looking forward to seeing Natalie but I'm sure I'm having much less trouble than she. She was really miserable.

Love,
Barbara

P.S.—"Bella" which means beautiful one is what I hear all day and I can't say it isn't swell.

P.P.S.—You can fly, Mother. It's not dangerous and you might get sick on the boat—the sea is very rough in winter.

October 20, 1957

Darling Mother:

Here with Natalie in Florence. Very well. We were so happy to see each other. You'll probably get this letter before the one I wrote previous to this since I don't think I had enough postage on it. It was all in answer to your two letters I got when I arrived at the Academy. Florence is very beautiful. I might live here most of the year. I found a wonderful apartment—studio not to be occupied until December. It has two large rooms, bath (no bathtub yet), kitchen, terrace, fireplace, and very interesting furniture. It has great possibilities. I had already pictured it next spring when you and my new daddy (smile) come over. Natalie's place is very nice too. Also very convenient. It's owned by a handsome Italian count and his mother with whom Natalie promptly fell in love (the guy, not his mother). I have just finished writing Paris and Paula. I asked Paris how his car was and what bitch he had riding around in it. Opened Paula's letter with "Dear Paula: As I sit here admiring my Lucrezia Borgia arsenic-filled ring, having just finished my hare soup, I had just mentioned to Natalie as she prepared to serve the roasted sparrows that Italy hasn't changed us a bit." The hare soup is a long joke, too complicated to explain. The Lucrezia Borgia ring is something I bought on a shopping spree here along with gloves and cotton stockings. It's this crazy, big chunky ring with a pink stone in it. The stone part opens and there's a little compartment. It's called a Borgia ring because it's the kind they used to carry around poison in. The story of the roasted sparrows is this: some friends of Joan

and Dick's that we looked up took Natalie and me to this little restaurant way out in the country. And the Italian guy that was with us ordered among other things roasted sparrows. I couldn't eat them, they looked like grasshoppers to me.

Please don't worry about me, I'm fine. And please don't worry about me "worrying about Harold." I don't. As a matter of fact, all I've been thinking about is Paris since I got to Florence. Oh yes, go to the Pyramid opening and tell me all about it. Send me a catalogue too. I hope to do some work when I get back to the Academy even though I don't think I'll have a studio there. I'll stay there until the other studio here can be moved into.

I'm getting tired of Italian men. All this staring and shouting and following you down the street can get wearying after a while. Don't worry though they're perfectly harmless. Once in a park they even started to serenade me. I think I've made a big hit in Italy. The policemen stop traffic for me. I haven't seen another Negro woman since I got here! I still have a few friends of Paul Keene's to look up when I get back to Rome. I'll also write White—that's a good idea about the records. I'm going to write Pat tonight also and Daddy if my hand holds out. Have met some very good, kind people here. Like the guy that told me about this studio in Florence. Rome I think is impossible. It's too expensive and studios are very hard to find. Natalie is turning into a very good cook and she swears so will I. Well I came up with something today. Tuna fish and tomato sauce for spaghetti. You'll have to be sending me cookbooks after a while. Oh yes, I forgot to tell you, the studio is on the seventh floor. Oh well, I always wanted a walk-up penthouse.

I'll write soon. Give my love to Grandpop and tell him I miss him. Tell him, also, to be good and not to shake up the ladies too much. Wish I could see the new front all painted—anything with the hole in the ceiling?

My love to Helen and Bernice. If I ever get organized, I'll write them. Be good.

<div style="text-align:center">

Love and Kisses,
Barbara

</div>

October 28, 1957

Darling Mother,

Back at the Academy. It is still warm and sunny here, although the days are shorter. Left Natalie's Wednesday morning by train and got into Rome Wednesday afternoon. The train ride was fun. You know, 8 people to a compartment. They were all Italian of course (I was traveling 2nd class) and when I said I was an "artista" the connotation was not artist but actress, and they thought I was a movie star. That was fun. They were arguing about whether I was African or not. They couldn't get over my hair (which is holding up beautifully and which I wear in sort of casual ringlets around ears, etc., and two big dips in the front, <u>casually</u> swirled

around in the back with little curls falling down my neck etc.). Very effective, it really looks great and that Helena Rubinstein stuff makes it so soft! I was a real sensation at the Academy too. The new fellows (meaning holders of fellowships, not guys) returned to the Academy from a trip just as I was getting back. Some pretty cute guys, but nothing to the one I've got lined up. He's <u>fantastic</u>! I just finished writing Natalie about it. Do I have a crush? He actually has given me a weak bladder. His name is Erik and he's an architect from Cornell on the second year of his prix de Rome prize. As his name implies, he's Swedish, his parents came over in the 20s. Well, if you can imagine a blond, blue-eyed Harold, he's it. He's really a giant, about 6'4", very blond wavy hair, blond eyebrows, eyelashes, fair skin but sort of outdoorsy looking, crinkly eyes, wonderful smile. His eyes turn sort of blue violet at night. He is really unbelievably handsome, sort of Greek type features, or rather, typically Nordic. Well, it all started the night I shared my "dolce" (means dessert) with him at dinner. Eva and I (Eva is the Italian wife of one of the painters) were talking about material and dresses, etc. You would really go wild here in Rome. The fabric shops are fabulous. Huge stores with nothing but bolts and bolts of cloth. That's what you can send me for a Christmas present, because I have a lead on a dressmaker here in Rome. Anyway, Erik offered to drive me in town one day, if I wanted to pick up some material. He likes to shop for material and things because his mother sews. So, we got to talking and I mentioned I really needed a means of transportation and was thinking about a used car—had given up the idea of a scooter. He said he'd look out for me. Next day at lunch he mentioned the deal of a Volkswagen for $100. We talked and finally he asked me to go for a drive with him. Of course I did. He has a beautiful new Volkswagen with the top that rolls back and it was a beautiful day. So we drove around Rome and finally out into the country to this villa called Villa d'Este which is famous for its beautiful fountains and gardens. Of course, the walks were very slippery, so I held on tight. Can you imagine the contrast between him and me! Then he asked me to dinner, so we went back to the Academy to change. Well, he had taken care of his needs very gracefully (as European men have a way of doing) at the Villa (it's a pleasure spot and they have the usual men's urinals). I didn't have to go then but when we got to the Academy I was dying and we stopped first for coffee. I just did make it. Today I had my picture taken by some Italian photographer, a friend of Eve's, and Erik treated me so coolly at lunch just as if we hadn't spent the whole day together. Oh yes, we went to a wonderful restaurant in Rome last night, drove around to all the fountains that are lighted at night—How romantic can you be?

So tonight at dinner we finally got together again. We played billiards, had coffee at a little coffee shop nearby and I finally got him up to the graphics studio where I'm working on some etchings (ha ha). But you know, after the cold shoulder this afternoon, I really decided to launch a campaign. Give him the old Barbara one-two. He's really very sweet, though, and I'm sure quite unconscious of all the uproar he's stirring up. But it would make a great *Love Is a Many*

Splendored Thing–like story huh Mom? Don't worry, I'm just fooling. But he is really something. When we walk down the street together—wow!

Oh yes, forget about the thing for the recording machine, I'll get it here. Tell me more about this call you got from the United News Service and tell me also about the Pyramid Club show. I haven't gotten Helen's letter yet. I'm slowly getting out the cards to various people. The Academy had a trip down to the South of Italy—Naples, Salerno, etc. on which I wish I had gone, but then I might not have met Erik. I'm taking Italian lessons from this Eva girl who is Florentine. She's very good. There's also another Negro sculptor here named John Rodin, whom I met. Still very friendly with this friend of Leo Lionni. I wrote Whitney about records and a camera so I expect to hear from him in a few weeks. Still looking forward to my boxes. Hope my letters are amusing. It's really amazing I'm not at all homesick. I wish you were here instead of wishing I were home. Did Natalie's mother call you? Have you heard anything from the Galleries? I haven't sold anything, have I? I'm sorry about work, but we'll find a way. (I just read over this letter and that etching bit is very funny.)

Well, I guess that's all for tonight. So many things happen in a day. It's hard to remember anything. It seems like a week's events are crammed into one day here. I'm really getting spoiled at the Academy, all this service, meals served old-style by servants, finger foods, the works—I intend to look up a couple of Paul Keene's friends too, which might be interesting. Well, I have to go to the bathroom again it's the 6th time today. Oh, that Erik—

<div style="text-align:center">

Love and kisses, sleep well,
Your devoted daughter

</div>

Kiss Grandpop for me—more of the saga of Erik and Barbara to follow—I might just end up in India someplace.

November 5, 1957

Darling Mother,

Your letter sounded as if you haven't been getting mine. I'm going to start numbering them. I wrote Paris while I was in Florence, also Pat and Daddy and I haven't heard from any of them (Natalie said she would mail the letters as I boarded the train for Rome...I wonder). It's very strange, especially Pat and Paris. Call Pat and see if she got my letter, also Daddy. I'm quite fine and regular (smile). I had trouble with my foot (really from too much walking) and finally went to the doctors, who said I had an irritated tendon. He gave me two X-ray treatments and it's much better, although it's costing me a fortune. The hospital I went to was Salvador Mundi, an international hospital where all the rich Americans go. As for the box, I hope you sent it airmail or else I won't get it for two months.

Well, you alien you, when are you being deported? (smile) I really don't think it's anything to worry about. But you know how excited this stupid government can get over unimportant things. Eisenhower and this satellite thing really look flat-footed and stupid in the European papers. It's really pathetic. Also, you did not tell me about Patsy and John whatever it is. I won't be near to Natalie in my studio, but Florence is a very small city, so I won't be far away either. My rent is 25,000 lire or about 40 dollars a month (I told you all this). The studio is very nicely furnished with linen supplied. I did find out that there's really no Dunham School in Rome. I'm working on a series of etchings now which I will have printed up in a few days. Night before last had dinner with a friend of Paul Keene's (it turned out that he didn't remember him at all) but anyway he was charming and quite nice. He lives with a girl (Italian) who translates from Italian to English for Random House Publishing Co. in New York. He's very, very smart and very well known in Italy. As a matter of fact, he is the best known translator in Italy and does all the major works. He also does scripts for the movies. So all in all it was a pleasant day. I met an Englishman who's married to a Jamaican, who are friends of theirs, and also a Guggenheim (not a fellow, a member of the family) named Barbara who sounds like a real character. The girl also works for a magazine and thinks I might be able to illustrate a story for them. I told them I wanted to do some advertising design. Of course they said stay in Rome, but I don't know. As I said, rents are high and one doesn't get much for the price. But he's really in the "in" group and by the end of the month I might not want to leave. He and the girl were supposed to have dinner here at the Academy with me Saturday, but Ben has to return immediately to the States (he's been here 9 years) because of an illness of his mother. So Diana and I will have dinner and then we're invited to some friend's house that I don't know. Ben, by the way, is from Boston, his father's a lawyer. He (Ben) went to Fisk University. I just missed having my picture in an Italian magazine. Ben had taken this photographer for some magazine doing an article on foreign artists living in Rome around to all the artists he knows at the Academy about 10 days ago when I was in Florence. But he says they're already doing things like that, especially on Negroes, so I'll probably have my face plastered in a few magazines tomorrow. The director of the Academy is giving a reception for someone or other so all the Academy is invited. My darling architect took off right after my last letter for northern Italy and Switzerland and hasn't returned as of yet. So my romance is on ice for the present. I've decided Ben can surely get me a nice rich Italian anyway although I sort of like Americans. I'm going to wash my hair today at long last. It was rainy for a few days but it has cleared up in the last couple and is sunny again. I saw the *Prince and the Showgirl* at the English-speaking movies in town and ran into Ralph Ellison (the Negro writer I told you about at the Academy). He was leaving for the States in a few days, had lectured in the Far East, India, and Japan. Later, from Ben I found out how famous he is. He wrote *The Invisible Man*, a very

literate, very good bestseller a couple of years ago. Ben knows all kinds of famous writers like William Gardner Smith (*The Last of the Congress*) and Richard Wright. He worked on a Paris newspaper for a while and lived in Paris for quite a spell. I wrote a letter to Daddy (I always called him Whitey) before I received the one you got, so I'm expecting to hear from him soon also. Got a letter from Izzy, who will be in Europe in April or May. He's now in Fort Benning, Georgia. How's that for fate? Haven't heard from Harold lately but have gotten all of 2 letters from him. While in Florence Natalie and I decided it was all over with Harold and me, but I don't know. Certainly, he can't give me many of the things I think I want out of life, most of them bordering on the materialistic and social, but one can't live by love alone. I miss the movies and my nightly ice cream (I eat pastry here instead) but don't miss the vision at all. Glad to hear about the stockings, I can use them. I'm finally going to get my trunk today or tomorrow. I don't know what's happening to my mail. I still haven't gotten Helen's letters yet. Oh yes, also call Paula and see if she got my letters. She should have gotten two which had the right postage on them. Give my love to everyone and kiss Grandpop for me. I'll let you know when I crash the movies—

> Love you always (even if you're not a citizen yet)
> Barbara

P.S.—I always say, you let those foreigners in, they take all the good jobs, their daughters win all the scholarships and fellowships—disgraceful.

P.P.S.—God, I could stay in Europe for years if I wanted to: people at the Academy seem to think I might have a chance for an American Academy fellowship. It's possible to get the Whitney renewed, there's the Fulbright and if I meet the right people, the possibility of earning a living in advertising art. It seems once you win a fellowship, this sort of thing can go on perpetually. Don't worry yet though. I'm not even remotely thinking of staying more than a year.

Saturday, November 17th, 1957

Darling Mother,

I delayed writing you because I wanted to do something that I wanted to tell you about, but I've forgotten what it was. Anyway, I did it and it was great. Then I forget where I left off in my last letter so I don't know how far back to start. Today, Sunday, I went to what is called the flea market (they also have one in Paris) where you can buy anything from an 18th century candlestick holder to a jigsaw. It's sort of like 8th Street only more varied and exciting. Colored beach umbrellas, bolts of cloth, antique furniture, clothes, jewelry, weird things, sculpture, Etruscan pots, coins, some things really collectors' items. It's really one big game because you have to bargain down the price of everything, for instance I bought

a jade ceramic necklace and the man wanted 2,000 lire. I offered him 1,000. Then he started telling me about his sick wife and 14 children, so I start to walk away. He calls me back, asks me what I'll give him and I say 1,000—1,500 he says. I walk away again—1,200 he says. I look at the brooch again, 1,000 I say. He snatches the necklace back, gives me a dirty look, and finally as I'm turning to leave he sells me the necklace. Great, but exhausting. Think of doing your Christmas shopping like that. I went with Erik, around 9:00. It opens at about 5:30 in the morning and the bargain hunters get there at that time. This afternoon I phoned Diana and found out I had missed a great party by going with Erik Thursday. So I'm going with her to see a friend this evening.

Yesterday, I went to a place called Bomarzo with Erik and a friend of his. It's a little medieval town about 30 miles outside of Rome where there's a villa with crazy sculpture carved right out of the rock foundation. It was fun, but not worth missing a phone call I received from some Italian man—I don't know who, he didn't leave his name, but I suspect it was this director of a Roman magazine called *Roto* whom I met a few days ago at Diana's. Anyway the telephone operator thought I had gone out of town for the weekend, so he won't call again until Monday I guess. I'm really getting travel fever. If Erik and Alan don't stop talking about Egypt and Erik says once more "Why don't you come along" or "Come with me to the Kasbah and we'll sail up the Nile together," I'll be off. I just finished talking to another guy, a mural painter who has also been in Egypt, and it really sounds fabulous. Early this afternoon I had a coffee at a bar near here (bars here are more like coffee or snack bars, although they serve liquor also) with Eva, the Italian girl. Well it was a pleasant way to kill a few hours because two Italian boys (as usual) tried to pick us up (not in the same connotation it would be in the U.S., it's more of a national pastime). They were quite good-looking, dark glasses, slick red convertible. First, they decided who was to have which: the blond or the brown one. Then they followed us first to the dressmakers, then to the wine shop, then to another bar, then we took a walk through the park. All the time Eva was really enjoying herself (so was I), we would talk to them now and then, they invited us out, etc., etc., finally we all said goodbye very amicably.

Let's see, where was I? Oh yes, last night went to an American movie with Erik and Alan. Eva told me today everyone thinks we (Erik and I) make a very handsome couple, but she thinks his head is too small. I think his head is <u>perfect</u> but I am getting a little bored with the whole thing and unless something happens fast…like us going to Egypt together—(don't worry Mom, he's perfectly harmless). Anyway, as usual we kicked up quite a stir in aristocratic Rome. Friday, I worked on some waxes for bronze I'm trying to get done to cast. Thursday, I went for a drive in the afternoon with Erik stopping to take photographs for slides. He'll be an instructor at Cornell next year, so he's doing a lot of photography. The weather here is really wonderful, bright, sunny, and one can wear a heavy dress or wool suit without a coat. I also wrote Natalie about

the apartment in Florence (I don't know what's up with it) and as I was waiting (I told her this in the letter) I was being serenaded by mandolin music floating across the courtyard from Erik's room. Romantic, huh. I also told her about the housewarming party I went to last Saturday. I had Diana, her mother, and an architect friend of hers over for dinner and I had asked Erik and this Negro couple here on a fellowship from Chicago Institute to have a drink in this mural painter's studio before dinner and then afterwards we went to this housewarming party which was nothing great but I felt like Marjorie Morningstar with this architect friend of Diana's. He's successful, but cynical, unmarried, around 40, you know, feeling defeated about his life, etc., and here I am, embarking on my great European adventure, young, etc. So, we have this little scene as he is taking me home about his life and what I want out of being here and out of life in general and the fact that he's grown up hoping for these things but when one sees something fresh, young, and beautiful (that's me) it's only human to grab it. The dialogue was fantastic, straight out of *Love in the Afternoon* or something. I got my etchings back from the printers Monday and they are going to be in a show at the Academy this Tuesday. I don't know how I managed that but I did as usual. Just when I think I'm really getting bored with Erik, he ignores me for a couple of days and renews my interest. He's been busy getting ready for this trip through Egypt, the Near East, India, China, and Japan and finally the States and home via San Francisco, so he's been running around getting visas and stuff. I also did these illustrations for this magazine in the beginning of the week. The thing still isn't settled yet, but I think they will be used finally. I finally got a letter from Paris, his first letter had gotten lost or something. He's still on the hook. I got a letter from Paula saying she's glad I didn't marry Harold yet, to be selective and not to leave Izzy out of the sweepstakes. I also got a letter (2nd) from Izzy. He'll definitely be here in the spring and intends to buy a Jaguar. I also got a very sweet letter from Daddy and he promised to write again soon. Wanted to know what I wanted for Christmas and said there is a business recession and a few other things. I wrote the Whitney Foundation about the articles; also intend to tell Daddy I want money for Christmas. My foot is fine and I can't buy shoes here. I have to have them made, so if you want to send a pair—if they are closed-toed get a 9 ½ AAA. Did you ever get the dress out of Snellenburg's? It was such a nice dress…I guess you never did. I have been meeting the best-looking men over here. Met an English writer (married) who was a cross between William Holden and Judd. Wow! I have a chance to sublet his apartment for 2 months if I don't go to Egypt or to Florence (smile). Still haven't heard from El or Pat. I have to write Shirley too since she's supposed to spend Christmas vacation with me. I'm glad everything is straightened out with your status with the U.S. government, you alien you. That's great! Haven't heard from Harold in 2 weeks. I wish I could afford to buy the baby presents. They have the most exquisite baby clothes here, but very expensive.

Friday night I somehow got involved with babysitting for a very nice couple who are at the Academy. I did quite well too. They had me dying laughing about the time they were flat broke and Irma, the wife, sold a painting to Rod Steiger, not knowing who he was (you know the torn-shirt actor) and thinking the check would bounce and then by accident going to see *On the Waterfront*. They also decided to find a boyfriend for me (they don't know I like Erik who is a very good friend of theirs). I think I'll let it slip that I do and see what happens. Erik's the kind you have to sort of hit over the head. It's terrible. Still haven't gotten the package yet, but still hoping. You and Pat coming over together sounds wonderful. Spring isn't very far off you know. Pat might be able to leave school a little bit early.

It is now Monday morning. I intend to take it easy today and write some letters. Last night Diana and I visited a wonderful old professor friend of hers, along with another poet and her sister. He was great, about 67 or 8, very dynamic, completely deaf but read lips beautifully. We talked about everything from Shelly to Michelangelo. Tonight I'm going to the Fulbright Reception for the American Fellows in Rome. The drinks should be good as they were in Paris and I can meet tons of Americans who are in Rome. If you and Pat can really arrange to come, I'll save all of my traveling in Italy and Greece until you get here. We could rent an automobile along with Natalie if she's still here or if I can save enough money buy one (or have Paris send his Cadillac over) (smile).

Oh yes, the king of Sweden is at the Academy. Last night I raced down the steps right by him and didn't even give him a good look! I was wondering why everyone turned around and looked at me. Oh well it's been so many years since we played tennis together I had forgotten what he looked like. I hope to get my student card soon; it will save me a lot of money in museum fees. Give my love to Bernice and Helen and kiss Grandpop for me. I'm going to write to him today, so you'll probably get letters at the same time. I eat so much! It must be the change in climate or something. Yesterday I ate a breakfast of 2 eggs, 4 slices of toast, 2 cups of coffee, fruit, then around 11 went out with Eva, had another cup of coffee and a coffee cake on our way back from the dressmaker. We had a brandy at a bar in which I bought 4 little cakes and some chocolates. We got back to the Academy in time for lunch which was pasta (huge bowls of spaghetti or some kind of stuffed noodles), steak, French fried potatoes, spinach, and ice cream. Around 4 o'clock I ate 3 of the 4 cakes and all of the chocolates. At 5 I went downstairs and had tea, at 7 I had a martini with Diana and the professor, and at 10 we ate a dinner (I was starved by that time) of spaghetti cooked with egg and bacon, veal cooked with slices of ham, lots of bread (the brown bread is very good here), beer and fruit. And I haven't gained a pound. Really amazing. I think I'll be elegant tonight. I bought a three-quarter length sleeve low neck jersey top in the shopping near here and I'll wear my black brocade shirt and coat with the collar. I burned a hole with a cigarette in my coat at the movies Sunday,

but it's very near the seam and right at the bottom of the coat so (don't faint) it can be easily repaired and doesn't really show. I'm really getting more and more excited about this Egypt thing, I just might go. Of course my funds are limited 200 dollars a month, really isn't very much in a place like Rome or for traveling so I would have to budget rather strictly. It sounds fascinating doesn't it? Will write soon, sorry for the slight delay,

<div style="text-align:center">

Your loving daughter,
Barbara
</div>

P.S.—See you in the spring! Izzy can take us around in his Jaguar by that time! Oh yes, found out who the phone call was from. An Italian architect I met, Florentine, fantastically charming. He's looking for an apartment for me in Rome.

November 21, 1957

Darling Grandpop:

Just a note to let you know I'm fine and very happy in Europe. My foot is fine, but I can't buy shoes here—my feet are too long and too narrow, so I'll have to have them made. How are the puzzles coming along? Remember you have to win enough money to come over here next spring. I have a whole line of countesses, Borghese princesses (they're all over 50) all lined up for you. Rome is really beautiful and it sort of grows on you. The days are getting shorter, but it's still not cold enough on most days for a winter coat.

I got a letter from Daddy which really surprised me, and I hear we have nice new shiny storm windows now. How are all your girlfriends? Is Sarah speaking yet? I sent her a card. I hope she got it alright. Why don't you ask her? I suppose mother has told you all about Erik and his trip and Egypt. I just might be sailing up the Nile, who knows? I'm looking around in Rome for a place to work since I'm having difficulty with my studio in Florence. But it's worth waiting for, so I'll have to be patient. I'll have turkey for Thanksgiving Thursday. The American Academy gives a big cocktail party and turkey dinner which sounds wonderful. I just got a letter from my friend Shirley in France, who has slight troubles: she thinks she's fallen in love with a Muslim Pakistani physicist named Shameem. There should be some kind of vaccination against falling in love with handsome strangers for all American girls leaving for Europe. Natalie's in love with her landlord! Oh well it's great fun anyway. Take care of yourself and keep me posted on *Edge of Night*. I can barely sleep at night wondering what happened. I told Mom, I really miss my ice cream every night, also I can't seem to go to sleep at night right away without the late, late show blaring in my ears (smile). I've really been meeting some fabulous people lately, the author of *Lust for Life*, the King of Sweden (he was here at the Academy for a few days and for one of them, I, being

in a great hurry, raced right by him and a bunch of startled people without giving him even as much as a second glance) so I really didn't meet him until dinner.

Well, write soon, even if you have to do it on one of your 2-cent postcards. All my love and prayers.

<div align="right">Your loving granddaughter</div>

November 25, 1957

Darling Mother,

This is going to be one of those two-day letters. I hope it is good since Shirley is coming here for the Christmas holidays and I won't be able to move to Florence until the end of January. The girl in the studio in Florence was working on a large group of sculptures which has since fallen over and broken into a million pieces…so she's staying until she repairs it. The gods just want me to remain in Rome, that's all, because these things just don't happen: Not that I mind at all. Rome is wonderful and I'm having a very good time—not much work but wow! Thanksgiving there's another cocktail party given by the Academy. I think I'll wear my black sheath (the black and red one) since I've never worn it in Rome. Among other crazy things, I got a call from an Italian photographer who had through an agency gotten the assignment from *Ebony* to take photos of me… in black-and-white and color no less. So, yesterday and the day before I spent posing in front of "Forum de Roma" and another modern building which I don't know the name of. It was great fun. Day before yesterday was cloudy and a little cool, but yesterday and today (if you can imagine it) I played tennis! It is still too warm during the day for anything except a fairly heavy suit. I'm really going in for this tennis bit. The Academy has a court and I really like the game very much. Oh yes, enclosed are three negatives we didn't send. These are the worst so you can imagine how good the photos we sent were. This photographer is very good…he's done covers for *Life, Time, Look,* etc. Well, I hope he can add *Ebony* to his list. The material is good, it just depends on what they do with it. I also had lunch with him and his wife yesterday, very nice. Anyway I wish you would get some prints made and send me a copy of each. Go to some place good like Berry + Hower on North 7th Street (the address is in one of the small drawers in the white chest) and it shouldn't cost too much. Be sure to show them to Harold and so on. I'm going to write to him tonight and tell him about it. You really can't see my hair style in these photos, but you can get the general idea, very casual (it only takes me 15 minutes to comb it) with curls trailing down my neck. Did I tell you (I always forget where I left off) I went to a cocktail party last Monday for the Fulbright and 1. Met an architect that makes Erik look like a washed-out calf but I've only seen him twice, 2. Met a weird 12-tone composer (very left wing) who fell madly in love with me and started writing microscopic love letters to me (he's

extremely near sighted, and 3. Met an Italian painter named Mimmo Rotella who is a very nice man. He's looking around for a studio for me and I met him in town last week and we ended up at his apartment madly playing bongo drums. He has quite a collection from all over the world. He has a great record collection too and is supposed to get my transformer for me.

Every time I think I'm getting over Erik, he does something sweet like giving me a flower in the midst of a lecture on Roman history at the Forum. Egypt still looks mighty good (smile). As I said, Shirley is coming here for the Christmas holidays. If you think I'm bad with Erik, you should read her letters. It seems she's fallen in love with a Moslem nuclear physicist named Shameem who's from Pakistan of all places! Can't you just picture it? Shirley and her Moslem boyfriend and me and my Swedish. Unfortunately she's bored to death in Grenoble and I think this is one escape. I also intend to take some bronzes to the foundry to be cast next week. So at least I'll have that much work accomplished. I've forgotten if I told you about the housewarming party I went to where I felt like "Marjorie Morningstar." If I did, it's too long to repeat and if I didn't, I'll tell you in my next letter. I got a letter from Joan a few days ago. She seems to be worried about Paula. Man trouble as usual. I wish she were here, this place is crawling with good-looking American architects with futures. I'm really afraid I'm being very much spoiled as far as men are concerned. I'm being thrown in with the cream of the crop and my standards are unfortunately getting higher and higher.

Also keep sending candy—I like to get it, and it's very expensive here. Give my love as always to Grandpop. I still haven't heard anything from Pat. Did I say I wasn't gaining weight? All my shirts I can just barely fasten and my belts! It's a real struggle to get them even in the first hole. It's time for a diet.

Sunday December 8, 1957

Darling Mother:

Things here are hectic but exciting as usual. I spent most of the week apartment hunting in Rome. I've forgotten where my last letter left off but anyway, I have to move out of the Academy because they need the rooms for other commitments and the girl in Florence with the studio I wanted had an accident with her sculpture and has to repair it so she doesn't know when she'll be leaving. Anyway, night before last when I was so depressed by apartment hunting and being so disorganized and was ready to take off for Munich the next morning with Erik and Alan, first the apartment came through (I still haven't signed the lease) and second the photographer called and said *Ebony* wanted a photo for the cover. Isn't that fantastic! So for the last couple of days we've been shooting. Last night I was quite discouraged because we hadn't gotten what we wanted. Something was wrong with every photo. It seems I have to look pretty, arty, colorful, and feminine all in the

same photo. So the photographer was trying to cheer me up by saying he always had trouble photographing women, the only woman he didn't have trouble with was Sophia Loren! Well that did it. Today we went out again and I really think we took some good shots. Drawing crowds as usual. I'm hoping this apartment will get settled tomorrow and I can move in. It's in a modern building, ground floor, 2 rooms, kitchen and bath and garden. The rent is fairly cheap (for Rome) about 48.00 dollars a month but everything is extra: heat, electricity, gas, telephone. So it is going to run me about 65.00 dollars a month. But it's the best I can do, the rents here are out of this world and I'm tired of looking. Also if I can swing a deal to continue to eat here, food will cost me only about 30.00 dollars a month. I have to wait until the director comes back from Spain because the secretary has taken a dislike to me so I can steer clear of her. She could have helped me a lot this last week. Fortunately I had others to do it for me. I wrote Daddy for money because the deposit I spent on this apartment is taking all my allowance for this month, so I'm sure he'll send it "*subito*" (that means fast).

Also getting over my crush on Erik, I think. But anyway, remember the architect I told you I met at the Fulbright party that made Erik look like a washed-out calf? Well, I've been dating him. Wow! What a sweet guy. Tall (not quite as tall as Erik) with brown curly hair and blue eyes. A real doll! We've been out several times and like each other a lot. You know stopping in the apartment for a brandy after spending the evening listening to jazz, dancing out on the terrace to radio music—all very innocent, mother. Just romantic as heck, that's all. I haven't heard from Harold in a month. I get letters regularly from Izzy and Paris. Also haven't heard from Pat, but sent off her Christmas present anyway. If anyone wants to know what I want for Christmas—sweaters, pants (slacks), stockings (although they are cheap here), towels, sheets, pillowcases, oil paints, and brushes—they're very expensive here, perfume, woolen gloves, etc., etc. Money is what I could use most right now. The rent is easy. Shirley is still coming to Rome for Christmas. I hope I have a place for her to stay. How're Bernice and Helen? I hope they get their Christmas presents in time. I haven't written anyone in a week or so. It's so different when you're in a state of confusion. This is really one 2-month period in my life I'll never forget. It seems I've crammed 5 years of living into it and although time seems to be going quite quickly, I'm amazed that it's only December and not April. As soon as I get settled I'm going to write the Whitney Foundation and find out what my chances are of getting more money really. I have three small things at the foundry now which are going to cost me 150.00 dollars. But I might as well live it up. This only happens once in a lifetime, although this perpetual fellowship thing can go on for years and years. The more you have the more you get or something. I haven't heard from Natalie lately, but I suppose she's making out all right. I'm getting very confused letters from Shirley. It seems she's fallen in love or did I tell you? Some Moslem at the University—talk about me! I read the *New York Times* (about 3 weeks late) sometimes and it looks

like there're some good motion pictures in the States. That's one thing I miss or do I? Went to see *Around the World in 80 Days* with Jordan (the new architect crush) in Italian, but I still enjoyed it (maybe it was the company). I wrote Daddy about all my adventures and mentioned that you really don't expect these fantastic romantic things that you joke about happening in Europe to really happen—and they are! It's fantastic—tall handsome young men chasing after you, sleek sports cars, photos on covers of magazines, elegant cocktail parties, etc., etc. Boy, am I having the time of my life. Even this utter confusion has its charm. The prospects of fixing up the apartment, even if I don't have much money, are great. It's a charming place and I had to get a place with you in mind for this spring, etc. So I think I'm going to be happy with it. The landlord has a daughter the same age as me who has improved my Italian immensely. I'll write again in a few days. Kiss Grandpop for me.

<div align="center">Barbara</div>

December 20, 1957

Darling Mother:

Just received your letter dated December 15. I'm so sorry I didn't write sooner. I always forget the last time I write and what I wrote. What a memory! Did I really sound that worried about money? Anyway, everything is fine now. It must have been one of those days. I did write Daddy for money, which I received last night—75.00 dollars. Wasn't that sweet! And I did need it, but there was really nothing to worry about, it was just the initial expense of the apartment, which if I haven't already written, I do have, and it's lovely. I even have some furniture— a wardrobe, chair, stove, marble top from my landlady, a bed from Ben and Bernarda, records and a painting from an Italian painter-friend of mine, 2 chairs which I paid 2.00 dollars apiece for, an architectural drawing table which I paid 3.00 dollars for, 2 antique candlestick holders (very fashionable) which I paid 1.50 dollars for, a poster which I got free, and pillows, bed cover for the bed, etc., etc., which cost the most. I'll send you a photo as soon as I can. Believe it or not, it's really elegant. Right now I'm trying to find another bed for poor Shirley to sleep in when she comes. We just might take a short trip to Florence to see Natalie and maybe Switzerland. I met a wonderful Swiss girl-photographer a few days ago who invited me to visit her. Shirley should arrive Saturday or Sunday. This week has just been one long party. Everyone at the Academy gives Christmas cocktail parties the week before Christmas and it's mad! Mad! Let's see, Monday it was Bob Buchanan, an architect, Wednesday, it was George and Pat Conley (he's also an architect), yesterday I had dinner with this Italian painter whose picture I have at a wonderful restaurant complete with candlelight and mandolin players. I also met a very glamorous Polish fashion designer there. I had

a wonderful time—this guy is going to Sicily for the Christmas holidays, but he'll be back for New Year's. He's great to know because he knows every other artist in Rome practically, including the movie directors, I didn't tell you I was going to crack the movies? Tonight another cocktail party—Jim Gerret—a real doll of an architect and afterwards dinner with Ben and Bernarda and this smooth Italian guy (also an architect—Daddy wanted to know where I picked them all up from). Saturday there's a party at someone's studio in the Greenwich Village of Rome which is called Via Margutta.

Oh yes, I didn't tell you about this other Italian architect I met. Wow! What a layout he has—fabulous apartment in Via Margutta—real weird color combinations so tasteful it hurts. He invited me and this Swiss photographer to have lunch with him, he cooks divinely. Speaking of cooking, I can't get into any of my clothes. You know the jacket to the new black dress? Well, I can't get it buttoned around my waist, all my straight skirts are too tight in the hips, all my long-sleeve dresses are too tight in the sleeves—even my bosom is getting bigger! I don't know what I'm going to do. It's terrible! My appetite is so big, I just can't stop eating. Coffee and cake at 6 o'clock and a huge dinner complete with lasagna at 8! Sunday Shirley will be here and we'll go to Rosati's, this professor friend of Ben and Bernarda's, Sunday evening. Monday I invited Erik and Alan here for cocktails. Tuesday and Wednesday have no plans, but I'm sure something will come up. Thursday I'm having my housewarming party from 6 to 8:30 so the people won't drink so much and Friday Shirley and I will probably take off. Oh yes, Wednesday there's the big dance at the Academy and a party for the children of the servants.

Also my illustration will be published in *Rotosei* next week and I'll be paid the week after so if I'm a little short the end of the month, Shirley can loan me some money. But I must have written you about the cover. I am supposed to be on the cover of *Ebony*, you know. Haven't heard when, but this Italian guy took millions of pictures of which he rejected about 25—those I have. Jordan took off for Sicily a few days ago—darn it! I wanted to show him off to Shirley. He loaned me his transformer (don't laugh), it's for the phonograph machine and I borrowed some jazz records from Mimmo (Italian artist) so I'm all set for my party. I still haven't made the invitations yet. I still don't understand why you have to be naturalized. You married an American citizen—that automatically makes you a citizen whether you're divorced or not. But really don't worry about sending me any money. I'm fine and if I really need money you know Daddy will give it to me and there are tons of people here that I can borrow money from if I run short at the end of the month. You have enough to do without worrying about me. If you could see this apartment—you'd die laughing at the starving young sculptor bit. It looks more like a well-heeled Madison Avenue fashion designer. You know how I can stretch money when I have to. I haven't as yet received any Christmas boxes. I hope they get here before Christmas, I could use the shoes

terribly. I've eaten through all of mine. Have you and Grandpop received your Christmas presents yet? I also sent Bernice, Helen, Pat, and Paula. I forgot Jerry so would you buy her something imported from Italy and tell her it's from me and was in your box? I also sent Harold's and his mother and father's, but I don't think they'll get them in time for Christmas. I hope he at least sends me a card. Of course I sent Daddy's present so I'm all squared away here. It's still so mild here it's rather hard to get into the Christmas spirit except that downtown Rome is worse than New York City at Christmas with the crowds, the things here are so beautiful—the clothes, shoes, gloves—so damn elegant and expensive. Really the Italian women in downtown Rome make one feel like a bum! Oh yes, I promise not to forget your birthday. I wish I could send you a count or something, but he might get squashed in shipping. Anyway as Erik keeps telling me, Venice is the place for princes, etc. So I'm off this spring—Shirley and I, prince hunting. Oh yes, Erik and Alan were very sweet about helping me move. Alan went to the flea market with me Sunday to help me get my furniture home and all three of us finally went out to dinner. I still haven't heard from Pat! What's with her? And Paris! He sent me of all things for Christmas a photograph of himself! Well, that's the end of Paris. I at least expected a nice cashmere sweater! Why should I look at Paris all year when I can look at Erik, Alan, Jim, Bob, Sandro, Mimmo, Mario, Silvo, and Jordan. Oh as soon as you can, get those photos taken for me please. I really have a number of contacts through Mimmo for shows, one woman in Paris and several galleries in Rome. The only thing that worries me is I can't seem to get out of the Volkswagen class into the Rolls Royce, Jaguar, Mercedes-Benz class. All the American boys have Volkswagens and all the Italians have these rickety old cars that I don't even want to be seen in. Well, give me another month and we'll see what happens.

Merry Christmas, darling. How I wish I could fly home just for the day! Or better still you could come here. Welcome the New Year in with a bang.

<div style="text-align:center">

Love,
Barbara

</div>

1958

On New Year's Eve, I found myself on a Greek freighter, *The Adrianne*, out of the port of Brindisi, headed for Alexandra, Egypt, all because my architectural colleagues at the Academy dared me to put my money where my mouth was by sailing to Egypt at the height of the Suez Canal crisis for the love of Egyptian sculpture, and without my mother's knowledge. An American sculptor and his Egyptian wife invited me to liberate myself from my sedentary academic life and rarified atmosphere to plunge into a Middle Eastern adventure. I hardly knew a Roman, I lived high above the city near the Vatican in the Janicula Hills in a country where 65 percent of all the art in the world resided, the honey pot of Western civilization. But what did I know about the rest of the Mediterranean? North Africa? Tunisia, Algeria, Morocco, Egypt? Their lecture enraptured me. What indeed did I know about non-European art?

I had booked third class on the departing ship, but the captain took one look at me and put me in first class with my friends. The same friends who, once we had arrived, left me stranded on the quay alone, alien, and unchaperoned in a Muslim country as they walked away with an Egyptian Army colonel come to fetch them without a backward glance. I had 100 U.S. dollars and the name of not a single living soul in Egypt. The wharf was full of bodies, merchandise, food vendors, the sound of Greek and Arabic, sailors, stevedores, military men, veiled women, goat carts, livestock, Coptic priests, snake charmers, and one little wide-eyed, sunglassed girl from Philadelphia.

For the first time, I heard the Muslim's call to worship wash over the city rebounding from one minaret to the other riding on the wings of flocks of gliding swallows. The temperature was 40 degrees plus centigrade. I walked up to the policeman directing traffic, my porter with my baggage following me. The man in blue with the white gloves looked me up and down. "Hilton," he said. "Hilton," he told the porter, who piled my one bag into a taxi. I was delivered to the Hilton Hotel, the most famous American hotel in Alexandria. I found myself in the lobby trying to explain myself to a gentleman who looked like Peter Lorre and spoke English like a native. He turned out to be the Middle East president-director of Coca-Cola. What, he asked, was a lone American girl doing wandering around the Middle East without guide or chaperone in the midst of the Suez Canal War?

Didn't I know that I could end up kidnapped in some potentate's harem? Or didn't I have the sense of a bee? Where, he scolded, was my mother?

After lunch, he escorted me to the railway station and bought me a ticket to Cairo. "You go straight to the YWCA," he admonished, "then register yourself with the American Embassy. I will call and let them know you are arriving." He tipped his Panama hat, gave me his card and I never saw him again. When I arrived at the Cairo train station, I took a cab directly to the embassy, where to my great surprise I really was expected. The cultural attaché turned out to be "Colored," and after the now-familiar lecture on the Middle East, harems, kidnapping, and pirates took place, he took me home and introduced me to his wife and two daughters, who explained to me once more what a harem was. I replied that I knew what a harem was. "Does your mother know where you are?" asked the wife. I replied no and please not to tell her because she would kill me.

"This is a Muslim country," the wife explained, "Single women and girls do not travel alone, do not drive, do not go unveiled—and do not even shop without their *Ama.*" The family became my surrogate family for the rest of the three months I remained in Egypt and the Sudan. I didn't dare tell my mother where I was, and the attaché mailed a letter to her from the embassy in the diplomatic pouch. They had a colleague who was on home leave, and they installed me in his beautiful flat in the middle of the Nile where my duties were to feed the goldfish. They found an Egyptian student from Brown University to act as a guide and escort. But I traveled alone to the Upper Nile by boat, deserted train, and emptied English hotels. I had confronted Islam and Arab culture long before the American movement called Black Muslims arrived in New York and Philadelphia.

I not only grew up that winter under the burning Egyptian sun, in the Sahara, among the pyramids, the temples of Luxor and Karnak, the sphinxes of Khartoum and Aswan, but I made many of the most important decisions of my life and career and where they would take me. The cool breath of the Valley of the King's tombs told me I had been born to make architecture and sculpture. Moreover, it seemed according to a soothsayer who couldn't understand why I couldn't speak Arabic that I also could put words together. Architecture became my religion and although "writers operate through words," I knew in the words of Pomponius Gauricus that "sculptors operate through deeds." My deed had been to venture into a war zone for the love of sculpture. There had been no rationale for my impetuousness. I was not particularly courageous or brave nor was I timorous or cautionary—like most Americans I was simply ignorant of other nations, other cultures, much less a young woman's place in a Muslim country. I had learned about Egypt up until now from books and movies and a Baedeker's guide from 1930. The guidebook was my handmaiden to customs, religions and rituals, the veil, the harem, female circumcision, the Koran, the Sahara with its nomad tribes and its ladies who didn't speak Arabic or wear a veil and who called me "Sir" while painting exquisite designs on my hands in henna. There were no cell phones, no

laptops, no Internet. I didn't possess a camera. And I didn't write to my mother. Egypt had a profound impact not only on my profession but on my soul and spirit. There had been no serious ramifications—I was not kidnapped, sold into slavery or the harem, murdered by desert tribes, captured by pirates. I had sensed no real danger of life or limb but on the contrary the real danger was in changing my mind about a multitude of preconceptions, prejudices, born of provincialism and fear of the "other." It was as if I had been the satellite Explorer that the United States had just launched or the Hubble telescope. The stars shone as bright over the Sahara as they did over the Schuylkill River; I had grown a rocket on my back and I would never stop traveling. It was like a blessing or a curse: the need to define, explore, and encounter those I had never dreamed existed. This was the first but not the last time geography would devastate me.

I returned to the Academy via Istanbul, Athens, and Delphi. Standing on the steps of the Greek temple there with its overview of what was then considered the navel of the known world, I realized that after Egypt, Greek sculpture resembled a wedding cake. And after Hagia Sophia, Notre Dame de Paris was a letdown. Istanbul was the first place I could afford to buy art books and where I finally stayed in a Hilton Hotel. The Arab-Israeli war had changed the geopolitics of the Middle East and oil had changed its mentality. The age of Middle East oil had begun.

A few days after returning to the Academy from Athens and Delphi, I attended an after-dinner film projection one evening. As I prepared to sit next to Ralph Ellison, who was in residence, he said, "Don't sit next to me. People will think we're having an affair." It was one of the cruelest and most asinine remarks ever addressed to me in life. If I was "Colored" and not a maid, which I obviously was not, then I had to be a jezebel. Shocked and shaken, I finally sat next to a visiting American designer from New Orleans, who turned out to do graphics for shopping malls and who was a graduate of Yale University's Design and Architecture school. It was a formal affair of dinner jackets and evening dresses, and this female graphic designer of shopping malls, Jane Doggett, was one of the few women architectural professionals in America. We became friends during her time at the Academy and I told her the story of my life so far: How I had been rescued from death by my grandfather when I had been stricken by polio meningitis at age three or four. How he had run with me to the Children's Hospital of Philadelphia only a few blocks away only to be barred at the entrance by a nurse who declared that there were no beds for Negro children, and how my grandfather had declared that he would tear down the hospital with his wrecking ball if I was not admitted and how a young White intern had taken me in his arms and saved my life. In my mind's eye, I always saw that immense children's ward of tiny steel "iron lungs" lined up like a football field of tiny coffins. It was that experience, I told her, that had resulted in my phobia against tight covers and not being able to move. The result being that my mother would never tuck me in but made pajamas

with mittens and socks and a hood so that I could sleep outside the covers. One night, my Aunt Rose was babysitting and insisted upon keeping the window open and tucking me in. Until after the third attempt of my kicking off the covers and admonishing her that my mother doesn't cover me up, I finally punched her in the nose, at which point my nickname became "Miss My Mother Doesn't Cover Me Up" and the tale a family legend.

I told her how I had planned to go to Wellesley or Vassar with my scholarship to any seven-sister school of my choosing but because of my mother's divorce from my father, I had decided to stay at home with her and entered Philadelphia's Tyler School of Fine Arts in Elkins Park instead, to be near her, a British immigrant who had not even been a naturalized American until her divorce from my father. Many secrets were exchanged between us.

And one afternoon at tea, which was an English affair at the Academy, she said to me, "I don't think you should have gone to Wellesley. I think you should go to Yale, my Alma Mater." The next thing I knew, I received an invitation to attend the Yale School of Architecture and Design on a full-paid fellowship for two years. She had already left for the States when I received the letter with its amazing offer, which I accepted with joy. It made me the first Black female to graduate from Yale's School of Design and Architecture two years later. That same year, Jane asked me to design a waterworks and fountain for a shopping center she was designing for Wheaton Plaza as a commission near Washington, DC, in Silver Spring, Maryland. My first public work.

March 7, 1958

Darling Mother,

I'm now in Athens on my way to Istanbul Monday night. I'm at the American School of Classical Studies here, which is a poor man's American Academy. I arrived here last Saturday, the 1st, from Alexandria. I had a wonderful, wonderful time in Egypt plus the usual adventures everything from having tea with the manager of Coca-Cola and the son-in-law of the Greek president in Alexandria to riding across the desert sands with an Egyptian archaeologist to living for a month in a borrowed penthouse apartment, complete with terrace, view of the pyramids and houseboy! Ho-hum life is so monotonous. Anyway as far as our plans are concerned I'm still expecting you in June. I'll be back in Rome about March 15th where I'll stay at least until June. As far as coming home is concerned I might be able to come home the end of June with you. It depends on whether I get an extension from the Whitney Foundation if this job with Hoffman in Switzerland works out and if I get admitted to Yale in the fall. My other dates are the beginning of August, the middle of September, or the end of November. I still don't have a camera, but I received a letter from Izzy who will be in Europe in

April and I'm going to get him to get me a fairly good one through the P.X. As it is now I can't even afford a cheap camera, let alone the film for it because I'm using all my money for traveling.

As I mentioned, I met some wonderful people in Egypt and had a real ball. Most of them were from the American Embassy and one Colored couple Ralph and Jean Phillips in U.S.I.S. really smothered me with kindness. Another friend of theirs, Russ Edmondson, who is a consulate officer at the American Embassy, is the one who let me use his fabulous apartment while he was in Port Said. Also on board was one Egyptian archaeologist who really showed me all over Cairo and will be at Brown University this September and one darling Swiss photographer, Rene Burri, whom I met in Luxor, dated in Cairo between his assignments of flying back and forth to Damascus. He works for a New York–Paris syndicate of photographers called Magnum, is very successful and is a friend of Picasso's. I met him in Luxor in upper Egypt and he and I and another Swiss boy sailed across the Nile to the Valley of the Kings together. He was on assignment, but I think he took more pictures of me than anything else. Anyway we came back to Cairo together, had a wonderful time. He's promised to take me to meet Picasso if our plans coincide. He'll also be in the States in the fall. Then I met this Nigerian student, an Egyptian film producer, and assorted other people. Ralph's work is very interesting and he seems to love it. He is a United States Information Service Officer and translates and publishes books in Cairo along with running the U.S. library and publishing U.S. propaganda evaluating Egyptian propaganda. He, like a few other people at the Embassy, work under such pressure, they all formed what they call the "hard core" which is strictly American, meets every Friday for dinner, and Saturday for get-togethers just to blow off steam. They begin with a toast to American colonialism and Imperialism, the two things the Egyptian government is denouncing 24 hours a day in the newspapers and on the radio. Cairo itself is fantastic and the "bazaar" is marvelous. I was even involved in a little contraband myself. I exchanged dollars on the black market, just a few quite safe and then to the husband of a friend of the Phillips who is trying to get out of Egypt. It seems first of all it's almost impossible to get a visa to get out of Egypt and then one can only take out a very small specified amount of money in Egyptian currency. One cannot buy American dollars legally anywhere, so people who want to leave buy gold and American dollars on the black market and smuggle them out of the country. It is really a police state with even my little ole letters being opened and censored before I get them. That really floored me, but the newspapers are even worse. It's amazing the fiction they publish in the news! Anyway, I had a few uneasy moments when I was leaving Alexandria because my money declaration which I filled out quite honestly when I entered and which you have to show when you leave, didn't jive at all with what I had done with the money, what I had left and what my letter of credit showed. Anyway, Russ told me to conceal the letter of credit and tell them I had sent it back to the bank

and tell them that the reason I had only exchanged $50 officially was because I was living with friends, which was true in a sense. Anyway, it was all unnecessary (I hid the letters of credit in my bra) since I managed (thanks to a Greek businessman I met on the plane from Cairo to Alexandria who had a diplomatic pass) not to show the money declaration at all. Anyway, I never ate so much in my whole life, I'm as fat as a pig (20 pounds more than in October) and nothing fits. I had all my skirts taken out in Cairo, am going on a strict diet (which I've started now as Greek food is terrible) when I get back to Rome. Right now, it seems quite dubious if I'll ever be a size 11 or 12 again. This I've had a few crying spells about, I still don't look fat, but I want my Audrey Hepburn figure back. It's just that you don't realize how much more you eat here (and I had a lot less nervous tension) than at home. Besides I read somewhere 20 is the time to start watching your weight. Ralph nicknamed me "Hips" and insisted it wasn't fat, just "natural" development. The attitudes I found in Egypt were strange indeed. First of all, most Egyptians are the most uninformed, misinformed people I've ever met because of this police state situation. They all give you this stuff about "all being the same color" but they have no concept of the American Negro. They think all dark-skinned Americans are Indians and like most mixed races (they all look like crazy mixed-up American Negroes ranging from white to dark brown with varying degrees of Negro features just like our folks in the States), they are extremely color conscious and also are typically prejudiced against the Negro who is not Muslim. There are so many new American cars, I thought I was on the Pennsylvania Turnpike coming into Cairo on the bus from Alexandria. The city itself is quite modern in many sections, has suburbs that look like any American city suburb, and of course, practically everyone speaks English because of the British occupation. I really went all out buying things at the Souk. I went with the wife of an Egyptian, so I got good prices. I bought a canal paddle, a Sudanese pipe, an ivory and pearl inlaid box, a necklace, a miniature Egyptian bronze of Isis, a scarab and a few other odds and ends.

Now, about my clothes. I'm going to try and send you some money the beginning of April to buy some material because I just don't have any summer clothes at all and I thought maybe you could run up a few light sheaths and send them airmail as soon as possible or maybe, you could buy me one of those knitted sheaths or something. You know what I like. The trouble is my measurements which are surely different from what they were when I left. This is very approximate but as of now, hips 42, waist 26, midriff 34, bust 34, upper arm 12, lower arm (3/4 sleeves) neck 14: Don't faint, by the end of the month I should have my hips back to 38, my waist 24, and my midriff 32 at least or else I'm going to shoot myself. Enclosed are Vogue 9415 (in a lightweight check gabardine with a white collar, black buttons). I also like the double-breasted one. And of course there's the old paisley shirtwaist dress with roll-up sleeves. Also maybe you can get me an all-in-one corset (bra & girdle for 38 hips) as they are frightfully expensive

here. I'll see how much money I can send. I'd also like a pair of colored stockings (a maroon tinge, they have them in Turners for the dress the Italian dressmaker is making), those you can send in a letter or something. Don't send a box because it will take too long to get here. Also there's the airlines "go now and pay later." The thing with flying is you can stop off at so many places along the way, you really save money. On a ticket from Philadelphia to Rome you could stop off at Paris, Genoa, Milan, Venice, Florence, probably London. It would save a lot of train fare, etc. Well, I'll send you a card from Istanbul and I'll write again soon. Give my love to Grandpop and many kisses.

Love,
"Fatso"

Rome, March [no date], 1958

Mother!

You know you wouldn't have let me go if I had told you! You would have had a heart attack and then been on that plane in a minute. Besides there was no time. It happened on a dare by a couple at the Academy on New Year's Eve. I barely had time to race up the stairs, pack my bag and jump on the train for Brindisi! I thought I was traveling with them until the wife threw a fit of jealousy for no reason and they dumped me on the Quay in Alexandria! What was I to do? I suppose I could have gotten back on the boat and returned to Italy but having come so far and to Egypt! I couldn't turn back and besides what would they have thought if I had come back to the Academy with my tail between my legs—there were all these macho men architects edging me on...Remember when I was a little girl at the beach and while the other kids were building sandcastles I built myself a pyramid!

Well, I wasn't broke. I had my American Express card and the head of Coca-Cola was a nice man—he offered to buy me a train ticket to Cairo and he told me to go straight to the YWCA when I got there! Instead when I got to Cairo, I went straight to the American Embassy and the cultural attaché who was Colored and spoke the most beautiful Arabic took me home to his wife. I wasn't alone one minute. They took me in, found me a place to stay, introduced me to a Brown University graduate student and we were off, dashing across the Sahara on horseback every day. I finally gazed up at the pyramids I had dreamed of ever since I was a little girl in Atlantic City!!!

I do admit that taking a train up the Nile to Luxor and Karnak was a little dangerous. The trains were empty—but they ran on time and the big English Hotels were deserted...I guessed I could have been kidnapped like my Coca-Cola man said—and ended up in a harem—but I think that is a little bit exaggerated—I had an American passport after all. The end of the trip I met this Magnum (a famous

photo agency) photographer Rene and another Swiss photographer. We had this huge fight in the middle of the desert over the last felucca to cross to the left bank of the Valley of the Kings and then we just broke down laughing: three idiots caught in an international crisis arguing over a rickety water-logged boat that cost two cents! Rene showed me Cairo and convinced me since I had come this far I might as well go to Turkey and Greece on the way back to Italy. I would have stayed longer but I needed to get back to work but I was determined to see Santa Sophia before I die so...and then I figured I might as well see Athens as well especially since all the sea captains always gave me a first-class cabin without paying... I wrote you that letter from Delphi...the top of the world for the Greeks—the summit of the architecture of the Western World! But I found it to be nothing compared with the temples of Karnak for example—I didn't take any photos not having a camera, but I finished some drawings when I got back to Cairo.

I am now safe and sound at the Academy and my friend Jane says it looks good for Yale. I wrote to the Whitney people for a loan...we'll see. At least I got a hero's welcome from the Academy guys—

Your contrite and loving Daughter

P.S. Mom I'd do it again if I had the chance—even though my knees are now shaking. Don't tell daddy anything but you can tell Grandpop—I bought him a Turkish pipe and lots of art books in Istanbul.

Rome, March 20, 1958

Darling Mother,

Am finally back in Rome. Flew in from Istanbul day before yesterday and am trying to get settled again. Had a ball in Istanbul complete with black market money, fabulous art books, Turkish reporters, the Istanbul Hilton Hotel, and a cute Swiss banker! I'm really ready to settle down now (ha ha). I got back in town to discover two of my favorite men, Silvo and Jim (both architects), had been deathly ill while I was away. Of course they blamed my sudden departure for their lack of good health. Anyway everything is fine here except that I'm having trouble with one of my ovaries. I went to the doctor in Egypt, but wasn't there long enough for him to do anything. So I'm going to a doctor here next week and I'll let you know how serious it is, although I don't think it's very. It's probably because I've been changing climates and altitudes so much in the last two months. My job in Switzerland came through, but the dates I can work there are not convenient, so I'm working on your plane trip. Let me know exactly when you're coming. I'm still waiting to hear from the Whitney Foundation about my extension. If I don't get it, I'll have to come home the beginning of August or thereabout, so if you came over later in the summer we might be able to come home together, but if I don't find out

by the end of this month, go ahead with your plans otherwise you'll be too late. I hope Grandpop is well and everyone else at the old homestead. Getting back to Istanbul, I encountered a Spanish barber my first day in Istanbul and managed to change my American dollars (which I had smuggled into the country) on the black market at twice the official rate. This enabled me to stay at the fantastically plush Istanbul Hilton which is the absolute end in hotels, kidney-shaped swimming pool and all! Wow! The Hilton, by the way, at the official rate, is $30 per day including nothing. Then, the second day I was walking through the lobby and suddenly I'm surrounded by Turkish photographers wanting to know who I am and what I'm doing in Istanbul. I finally ended up being escorted around to the monuments by a photographer taking pictures all the time. Anyway, when I got back to Rome, I was notified the day after I arrived that I had a long-distance phone call from Istanbul! Well it turned out to be the Swiss banker who naturally will be in Rome. Jim got a big kick out of that. I really couldn't imagine who it was. So now I'm being teased to death about my long-distance phone call since the gatekeeper had everyone in the Academy looking for me. Also my photograph came out the end of February and I'm sending you the magazine separately as it will take a while to get there. It came out very well and the reproduction (color) is excellent. I must also write Daddy, all he's been getting from me for the last two months are postcards. I wrote Harold about Erik. I don't know whether I should have or not but he wanted to know. I haven't heard from him since although I'm expecting a letter from him in a couple of days. Also Mrs. Haskins' box or somebody's box arrived. I haven't gone down to the post office to get it yet. The two dresses I was having made have turned out quite well, one is a dark red sack with long sleeves (tight), a V-neckline with a bow at the end. The other (the gold material you sent) I had a sheath and jacket made. The sheath is a wrap around, sleeveless with a plunging neckline. It fastens in the front with two bows one at the waist and one at the knee and where it laps at the hemline, is cut round so that there is a split in the front. Very nice, but no one can compare with you when it comes to making a dress. At the suggestion of someone at the Academy, I have also written to Yale University about admission next September on a fellow scholarship and am waiting to hear from them. I have almost decided if I do get the extension I'm going to use it to go to Yale instead of staying in Europe. This I haven't told the Whitney Foundation yet, I'm waiting to hear from Yale. I'm glad you had a nice birthday and have changed to an easier job. As I told you in my last letter, I'm not eating these days trying to get my shape back. I wouldn't go back home now if I could, no one would recognize me—although people say it looks good, I don't agree—but sexy wow! Speaking of sex, how's old Bernice and her opposite Helen? Hope they're fine. Poor Shirley didn't get her transfer to Paris so she's disconsolate. So am I, because I wanted to visit her in Paris sometime this spring. Also haven't heard from Natalie in quite a while. I've quit writing my girlfriends about my adventures. They're just too unbelievable, except for Shirley

who has been in Rome and knows these things happen. Also getting letters from all my friends in Paris wanting to come to Rome for the Easter Holiday, but I intend to be working quite hard by then, so I'm afraid they're either going to be angry or disappointed. I don't suppose anything's been heard about *Ebony* and after all that trouble too! That's why I love Colored people. As I mentioned in my last letter, I will try and send you some money toward the dresses at the beginning of the month. God, you really put so much wear and tear on clothes when you're traveling with a very limited amount. My navy blue suit is just about on its last leg (especially when dry cleaning is not good). My gray box jacket suit, I gave away. It was just too small all over. Well, guess that's about all for now. Take care of yourself and Grandpop. No more adventures for a while, I hope. Sometimes I don't even believe myself, the things that happen to me. The time has gone so quickly I'll have to start to make plans to come home, if I expect to get space. I've been living so high off the hog; I haven't saved a thing so I'll have to use August's allowance to pay my fare home. As soon as I hear from Yale and the Whitney Foundation, I'll write my final plans.

Love and Kisses,
Your daughter

March 22, 1958

Darling Mother:

I've just received your two letters—was very excited about the *Ebony* cover. By all means send a couple of copies, everyone at the Academy is dying to see it. I've been having inquiries for the last three months. I'm also very curious and am not sure when or if it will be on the newsstands in Rome. So I'll be sitting on pins and needles until it gets here. I'm fine, but am going to the doctors on Monday. The job in Switzerland has come through for part of the summer or did I tell you? Anyway, I'm waiting to hear from Whitney and Yale. At any rate I will be home by September. I suppose cousin Elizabeth is having a ball in Baltimore with the cover. I can just imagine. Everyone's leaving Rome about the beginning of April for travel here and there so I would have so many distractions to keep me from working. I might try some modeling here in Rome if I have a chance. I'll try to send cards to everyone I've missed, etc. Also, the $430 price for Pan American is one way or round trip? If that's one way, I don't see how we can manage it with any fare coming back. Ship is much cheaper—$430 would be round trip. Also I may have to go to Switzerland in June and July instead of July and August because of Hofmann's vacation, but then you could come in August instead of June. I suppose everything depends on what I hear from the Whitney Foundation. The fashion show sounds like fun. Think you should be in it. I was happy to hear about the Bells, speaking of babies, Joan and Dick are having one too. Well

I just wrote to tell you to be sure and send the *Ebony* (as soon as you can). I'd like to send one to the Phillips in Egypt too.

<div align="center">

Love,
Barbara

</div>

P.S.—Kiss Grandpop for me and tell him his famous granddaughter will be home in a few months. Also don't worry, I'll take good care of myself.

May 15, 1958

Darling Mother:

I received both your letters and sorry I took so long to answer them, but as usual things are ever popping. Everything from fan mail from Switzerland (with enclosed presents, no less) to a new romance. I'm going out with a penniless but beautiful Italian count (he doesn't use his title), who is a painter and is a fairly well-known set designer! He's worked in Rome and Paris and in the old Vic in London, speaks English with an English accent and of course also German, French, and Italian. He's really quite delightful and charming and quite hand-some. Besides it's quite exciting because being in the theater world, he knows everyone connected with it, and the sort of aristocratic café society that goes with it. I drove up to Spoleto with him (in a beautiful Alfa Romeo), where they are having a big festival like the ones in Antwerp and Vienna and so on with Menotti's operas, Butler ballets, art exhibitions (I may exhibit but it's not certain) and so on, beginning June 5th with all sorts of big names. So since Domenico is designing one of the sets for one of John Butler's ballets, I went up with him and met Menotti, John Butler, Carmen de Lavallade, who is very sweet, I found out her anniversary (Geoffrey Holder) and my birthday are on the same day, so it was all very interesting. Domenico also has a summer villa in Spoleto (he's also taking a house in Spain this summer), so it was all very nice. He also tells the most dev-astating stories about people like Barbara Hutton, who's marrying or has married a friend of his, and Lady Diana Cooper and Philip Douglas (aircraft), and Peggy Guggenheim. Besides, we really enjoy each other's company, he's young (26) but will be completely gray I think by the time he's thirty, which with his face will make him the end as the dashing Italian. His mother is also very sweet, you'd like her. His grandmother, Marquisa, I've never met, but I hear she's a terror. I've also been working so hard, July and August are the times all the museums and gallery owners come through Rome, so I'm really undecided about Switzerland, although it does have its advantages. Yesterday I received a fan letter from a Swiss medical student with the loveliest piece enclosed you want to see. It was a very sweet letter which had been waiting for me for ages at the American Embassy where they had been trying to locate me. The only reason I got it at all was that

three American boys from Germany (Colored) having seen my picture (in *Ebony*) spent all day trying to locate me in Rome and finally did and since they had been to the American Embassy about me found out I had mail waiting for me. They were very cute but I had a date that night (French architect) so I didn't go out with them. They were on their way back to the States. I haven't heard from Izzy at all, so don't know where he is. I'm going to write *Mademoiselle* and may have a chance to do some fashion reporting (drawing the new designs at the openings) for a friend of Domenico's who writes for fashion magazines. Actually Domenico knows the owners of all the big fashion houses here and if I could just get thin enough I could have all the modeling I want! Oh heck, the trouble is I'm not fat enough to make me really frightened so I have no will power. I am what you would term well-stacked at the moment. Shirley is all set for next year, is sailing July 4th on the *Ile-de-France*, going to Columbia U. next year for which they are giving her 1800 dollars. She will be through Rome again I think and a friend of hers is photographing the festival at Spoleto. I wrote Pat, but haven't heard any more from her about when she's coming over, etc. Also heard from Barbara Bell and she sent me the most adorable picture of the baby you went to see. Of course I know that telling you not to feel too badly about Forrest doesn't do much good or any for that matter. Especially from a person who has never really had a serious disappointment in life, but anyway I just wish all this good fortune wasn't so lopsided or I wish I could sell a piece of sculpture and we would be in business. The president of the New York–Rome Foundation came over to the studio to see my work and liked it very much. She's sending a photographer over in a few days to take some photographs. She also mentioned that Peggy Guggenheim (who collects art by the roomful) might like my large pieces. If something fantastic like that were to happen, it would really be great. How's Grandpop? What's he doing now that he doesn't have the puzzles anymore? Kiss him for me. I'll write again soon.

Your loving daughter (la contessa)

May 28, 1958

Darling Mother,

Don't know what's wrong with everybody. I haven't received a letter in weeks! Did you get my last one and did you write? I think my mail is being held up somewhere. Dominique wrote me two letters from Spoleto which I never got and I received an invitation to a buffet dinner, two or three days late—very strange. Anyway, how are you? What are you doing and so on...I've been busy working on stuff for an exhibition in Spoleto. Did I tell you? The Spoleto thing should be very interesting—loads of famous people all of whom Dominique knows. Also a Grand Ball June 14 at a very beautiful villa there with everyone from Elsa Maxwell

to Ben Shahn. The gallery which is the Obelisco Gallery in Rome (which is my gallery now—they have ten drawings of mine and will have sculpture as soon as it's back from the foundry) is very beautiful and so is Spoleto. Fantastic, I think I told you in my last letter. So I'm trying to get together some kind of gown for this grand ball. I also went with Michel who is a young (handsome) architect there and felt (and looked) like a princess. At least I had the setting for it. I wore my white evening shirt. It was just too elegant. I told you about the N.Y.–Rome Foundation, didn't I? The president saw my work, liked it very much and sent a photographer yesterday to take photos of any sculpture—This is very good as this foundation is connected with the most important people in the art world. I had dinner last night with Calder, you know, the very famous sculptor who makes the mobiles, his grandfather did the statue of William Penn. He was very funny. He's like a great big bear. I also wrote to *Mademoiselle Magazine*. Did I tell you about the fan letter from Switzerland? I've completely forgotten when and what I wrote you. Anyway, in your next letter you can tell me the titles of the things I haven't told yet. Shirley will be back in Italy soon along with a friend of ours who is photographing the Festival. She usually works for very big magazines like *Life*, so maybe I'll get some publicity. My work is going very well—amazingly well as a matter of fact. I have about seven small bronzes, 2 completed direct plasters, one huge about 4 feet, 4 more on the way, and two more waxes. Plus tons of drawings which I mentioned this gallery took, I think I can swing a show there in September before leaving. It's the best gallery in Rome, but small in size. I'll be staying with Carmen when I go up to the festival. I think I told you that their anniversary is the same day as my birthday. Oh, I'm also losing weight—almost down to my natural size except for my hips and my face—which is as round as anything. Well, not really round, but I've certainly lost my hungry look! Did I tell you Shirley's all set at Columbia for next year? I'm going to try to make reservations tomorrow. The problem is the money for the down payment. I've got to sell something quick! I still haven't heard from Izzy—I don't know where he is. Did I tell you about the boys from Germany who saw the *Ebony* cover? Right now I'm making wallpaper designs of all things— for a customer of Dominique's who buys them for $150 each. If I can just sell a few I'll be set. As usual money is the problem at the moment, frames, bronzes for the show, transportation for the big statue all cost a fortune. Why is it the Chases always live beyond their means? Oh yes, had my first real ride on a Vespa a few nights ago. I went out with an Argentine architect who will be in the States in September. It was great. The Italian girls are very dignified. They sit side-saddle and hold on to the driver's waist with one arm—very romantic. Well, I'll close and wait to hear from you what I haven't told you in the latest escapades of B.C.

Love,
Your one and only daughter

Kiss Grandpop for me. Will send picture taken on set soon.

Summer [no date], 1958

Darling Mother:

Please forgive me for not writing for so long, but I've been very busy and trying to make up my mind about several things. I hope I didn't worry you. How are you and Grandpop? Harold wrote that he stopped by to see you. Also received a letter from Daddy a few days ago. I'm well. Went to the doctors and had everything cleared up so I should be perfect in about 30 days. The reason I have been so busy is I've had my hand in so many pies trying to make money. I'm running myself ragged (I love it you know). Well, your daughter has gone from cover girl to starlet (smile), am working (it's very hard work, you have to get up early) in an Italian film, have been for about 3 days as a sexy slave girl in Technicolor and costume. It's fun. I like all the attention makeup, etc. There are two other American films, the Goya film with Ava Gardner, and *Ben-Hur* with Carlotta Hilton, that I'm going to try to get into. The pay is fabulous. The American films pay about $50 a day and the Italian about $20–$25. I'm also seeing about some modeling (I'm getting my weight back to normal). You should have seen me yesterday, much with the cheesecake on the set with two gorgeous Italian actors. One shot with me lounging on one of those things the ancient noblewomen were carried around on by slaves surrounded by these two "Roman soldiers." Then one with one sitting between the two of them on their arms make like a seat and being hoisted up into the air. For some reason everyone thinks I'm fantastically beautiful. Movie people are certainly used to seeing good-looking girls. I guess it's the color that gets 'em. Anyway, I met the Negro actor that won the prize as the "Best Actor" at the Cannes festival last year for a Yugoslavian film I remember reading about in an issue of *Ebony* or somewhere. He was working on a French film on the same lot. I am now waiting for a nice rich producer (who buys sculpture) to come along. Anyway I had some more photos taken today by a Florentine guy who had taken some a few months ago. Oh yes, one was published in a German magazine. I hope I can get a copy. Talk about being international. But I do intend to have a show in September before coming home. Also I'm very nebulous about Switzerland. I don't know quite what to do. If I go in July and all August, I surely won't be able to have the show in September, but it would probably help me to get a job when I get back to the States. Did you ever get the magazine I sent? I've done another illustration for that magazine which will be out next week. Rome is practically empty. Everyone is away or going away on trips. It's great for working and I am getting quite a lot done, I was going around for a while with a lovely painter Dominique. God, how beautiful he is, but I'm really not very interested in anyone at the moment. There's a French actor in this film this Colored guy is in who's a doll, but he's leaving in a few days. Shirley's in Spain, I got a card from her about a week or so ago. She also went to Tangiers. I got a long letter from Harold

a few days ago (with money). He has an apartment now with a friend of his, but is still in difficulty with jobs. Goldie is better and why didn't you tell me Harold had an ulcer. That's terrible! I'm going to try and get some cards written but honestly I've been so busy and so broke (I couldn't have bought stamps if I had had the time). When you have the time, could you sort of gather up all the photos of me you can find (the good ones)...aw, never mind. I just got some etchings back from the printers, which turned out very nice. I have a gallery interested in selling them. Also I've got myself a maid. She'll only cost about $10 a month, and I'm working so hard and so used to having a maid at the Academy until this apartment looks like a pig pen, so I just had to. You know, I'm not the neatest person in the world anyway (smile). How's Grandpop. I hope he's well and still doing his puzzles, kiss him for me. The weather here has been awful up to now. It is just beginning to turn nice. The Romans just couldn't understand April at all. I guess it was bad everywhere. Oh yes, there is this Argentine architect (ho hum) who is very nice. If I ever get back any of the photos that were taken on the movie lot, I'll send them to you. Most of them are for one film magazine or another (Italy has millions of them) but I don't know which ones. Anyway, the production is pretty good—a quarter of a million dollars ain't hay, especially in Italy. It's so funny everybody is exactly as one imagines. The script boy looks just like the stereotype script boy, crew cut, tight black pants, small and thin and sort of falling apart. The director is exactly the prototype of a typical Italian movie director, dark glasses, walking stick which he hangs on for attention, tan and all. It's fantastic. The hairdressers look just like hairdressers, the costume women are all fat and motherly, the assistant director is exactly as nervous as he should be, the producer (also complete with dark glasses and cigarette holder) could find a job anywhere playing the role of a movie producer. The leading male actor is always combing his wavy locks, etc. The casting director is as lecherous as he should be. So hum, what next, I wonder. I may just give up sculpture for the theater. After all, I can't go around breaking my fingernails doing sculpture if I'm a starlet now, can? Speaking of starlets I went to a party a few nights ago and met the oldest starlet in history. She looked forty if she was a day. I wore my dress I designed out of the gold material you sent. It's sensational except that I can't sit down in it. It has a split up the front—a little miscalculation in the design. Oh well, it's a great stand-up dress. I met these two English-Jamaican girls (not at the party, before) who are sisters. Real characters, but they do have lovely English accents, but you know how even Indians are anyway and Jamaicans are worse. One is married to an English publisher and the other is living with an Irish poet. I also met a terrific American writer, a friend of Ben and Bernarda's and got a terrible crush on him, but alas he considers me but a child. Then I read his book which isn't so good, but I still have the crush I think and he's not my type at all. The last letter I got from Erik he was leaving Nairobi on his way to Bombay. Lost my sunglasses, dammit, and have to invest in another pair. I guess that's all the news. Say hello to Bernice

and Helen and Jean for me. And don't worry if I marry for money, it will be a heck of a lot and I haven't met anybody that rich yet.

Your loving daughter,
Barbara

P.S.—Take good care of yourself. I wish I could really land a windfall and send you the money to come over. I'll do my best, though. I'll write *Mademoiselle* as soon as I can. Yale is definitely out, it's too late and I got another copy of the cover from the Whitney Foundation. Also could you send the manuscript of that story I wrote about the African boy called "The Happy Time"? It's somewhere in my chest of drawers with the rest of the papers. Also when is Daddy's birthday?

Monday, June 9th, 1958

Darling Mother:

Received your letter a few days ago. Have been so busy, I can't see straight! I'm sorry about Mother's Day, but they don't celebrate Mother's Day here, darling. It would be so ridiculous since mama is the center of the universe in Italy anyway. So I didn't even know the date of Mother's Day really. Please forgive me, I might have a nice belated Mother's Day present for you in a few days. I hope so anyway. Please don't worry about sending me money. I'll always make out and day before yesterday I signed a contract with MGM to be in *Ben-Hur* at $48 a day. I don't know how many days but anyway I hope I can make enough to cover bills this month. I'm sorry already that I did it although it is quite exciting and fun because I was supposed to finish the works. Today, rushed back from Spoleto, last night leaving things undone that should have been done and not. I probably won't work until Tuesday. Spoleto was fantastic as far as publicity goes. I think my picture was taken by every Italian magazine there is. I went to the very elegant and fashionable opening of the festival with Dominique and ended up being the sensation of the evening, getting in the Italian newsreels (as Dominique and I walked into the open house, also when I arrived at the station in Spoleto). Enclosed is the brochure and a clipping from *El Tempo*. Of course everybody who was anybody was there. All the magazines (*Vogue, Harpers, Life, Time, Fortune*). Festival is quite a thing. I wore the dress I had made out of the gold material, long white gloves, and as you can see in the picture, a tiara. Also met Ben Shahn and Calder and Agnes Moorehead and millions of counts and princes and princesses, until they were coming out of my ears. Also there was a girl there from *Ebony*. Moreover I met the assistant director on a movie they are filming at Cinecittà and he asked me to be in his movie! I'm part of Ben-Hur's household. You should see the contract—it's a mile long you'd think I was going to play Ben-Hur or something. But anyway it means I'll be in Rome all summer I think. The big art exhibition

opened last night in Spoleto, but I didn't get a chance to see it. I know there's one very good female sculptor that I know. I'm glad in a way and sorry in a way, sorry because the show is getting nationwide publicity (*Life, Time*) in the States and glad because I don't know my stuff would have stood up against such competition. So anyway I won't worry about it. Have a dozen pieces of sculpture and a drawing by now, I think because I had to leave last night before finding out definitely. I hope I don't have to miss Dominique's opening tomorrow night (I told you he was designing a ballet for the John Butler Company there). I'll die if I can't see its opening night. Really, between getting ready for this exhibition, shipping and packing and running back and forth and Dominique's ballet and the movie I've really been out of my mind. I'll write again soon. Kiss Grandpop for me.

Love,
Barefoot Contessa (I told you Dominique was a count)

June 27, 1958

Darling Mother,

Hope you and Grandpop are well. I've been just sort of getting out of Spoleto and working in *Ben-Hur*. The costume was great, I had a headdress that covered my whole head except for my face and hung down to my shoulders. I looked like an Egyptian. It was fun—met Charlton Heston and Billy Wilder and Hedda Hopper was on the set one day and greeted me like a long-lost friend. I don't know who she thought I was. Anyway my birthday turned out to be very nice. I had my hair done (I had had a permanent about a week ago which really turned out nice. They use a cold wave to straighten your hair and then the works, wash set and dry and combed), you should see it blowing in the breeze and of course to set it I just wet my hair thoroughly. Ha, thought you'd never see the day. I can't wait to go swimming without a bathing cap, and come out with this straight stringy hair! It's just too much. I had it cut a little in a very nice curly bouffant, everyone complains I cut off all that long beautiful hair. I also had two headbands made with points in the front, one gold and one shell to match my rhinestone one which was such a sensation. Everyone agrees it's a very pretty cut and with the bands I look like the queen of Sheba. Then I went out to the movie studio to get my check. I was with Jane Doggett, and Shirley who is on her way to Moscow to cover an architectural convention for *Architectural Record*. She's quite a girl, one of New Orleans' best families, rich as anything. Went to Yale and is quite successful as a graphic designer and photographer in New York. Anyway we ran into the set decorator of *Ben-Hur*. I don't know if I told you about him. He's really charming. Italian from Milan but extremely blond and tall with the same sort of Park Avenue charm as Dominique (Dominique is still in Spoleto. No I'm not in love with him, wish I

were). Anyway Lorenzo the set decorator who among many other assets has a white MG sports car, promised to take me out to celebrate. So I ended up having a very wonderful dinner with champagne. He was so sweet, he even arranged a little cake with candles for me and riding around town in a white MG like the wind with my hair blowing wildly. If he hadn't had to be on the set the next day, we just might have ended up in Venice! Anyway, here I go again—there's really a chemical reaction. But something is missing—as in Dominique. They just aren't masculine enough. It's very difficult when you don't really know what it is—sometimes in architecture—Michel has it I think, law or something like that, but in the arts, no matter how sexy there always seems to be something missing. I told you I got a check from Daddy. I paid more bills and bought a bathing suit (white). Oh yes, I finally saw myself in the newsreels and heard about all kinds of photos in various magazines but I just didn't have time to go hunting them down. One in *Rotosei* I'm going to try to locate of Dominique and me. All the papers had a fit about Carmen and I'm afraid they rather confused the two of us, we do look amazingly alike in photographs. Did I tell you about selling a sculpture to Ben Shahn? That was very nice. I still don't know about when I'm coming home. It all depends on this show, if I have it or now and when: If I don't I'll probably be home in August. What I want to do is write a couple of letters to New York and see if I can't cook something up for when I get back. I need a list of addresses which is somewhere in my papers or maybe your desk because it was with the *Mademoiselle* things and the Prix de Rome application. It's a list of magazines and employment agencies in New York (*Vogue*, *Charm*, etc.) and I especially need the address of this particular employment agency. I'm going to write to them and ask them to start looking around for something for me for September. If you can find it, could you send it to me right away? If I don't have a show here, or even if I do, I still want to get a show in New York around November. I have this one huge piece of sculpture which has to be cast and which is going to cost about $500 to cast and lord knows how much to get home, so I'm having all sorts of problems. After I get worked out, then I can let you know about your belated Mother's Day present. If nothing else, I'm going to try some modeling this summer if I can lose enough weight. I did hear from my Italian teacher, he wrote me a very nice letter which I haven't answered yet. Oh yes, in case I don't get to write Patsy tell her I'm sorry for not writing, that it will be damned hot in Rome and bring very light but dark clothes, that I hope her party turned out well (the locket sounds lovely) that I had no idea where the posters were anyway and that I'll be expecting her I hope all the gang is well, etc. I haven't heard anything from Harold or from Izzy lately—I don't know where Izzy is even. I met a girl I went to school with who is here with her husband who does films for NBC who told me Natalie had come home in April. Both Natalie and Paula are absolutely green over my year and will probably never speak to me again unless I come home destitute and can't find

a job. Really I would have thought of Natalie but not of Paula. I'm afraid I must have overdid the letters or something. Anyway, Shirley warned me. She just doesn't write her best friend in the States! I mean, really, Shirley spent a month in Spain, Algiers, and the French Riviera! Oh well, that's life. When I just think about what I have to do to get out of Europe I go into an epileptic fit—all the stuff I have, packing took Shirley 8 days. Can you imagine how long it's going to take me? Reservations, shipping…I'll go out of my mind—really. What I'd love to do is just leave everything and hop on a plane and by some miracle everything would be there when I got there. I can see how people just stay in Europe. It's a heck of a lot easier than packing up and coming home. I've just about gotten myself organized from Spoleto and now I have to go through the whole thing all over again. Anyway, if I ever manage to organize myself enough to get home, Jane had some good ideas. This architectural graphics is great and new, also she thinks she might be able to get me a commission this year and she thinks Yale is a good idea—so do I on a fellowship. She never could have made it without her Yale contacts. I just wish I had thought about Yale sooner for this year—it would have made things so simple—Well, I'm getting nervous just thinking about what I have to do so I'll close now. My Italian doctor turned out to be great—everything is all cleared up. He finally broke down and gave me some pills to help me lose weight. I don't think they do much of anything, but they shut me up. Well, with incredible luck I've managed to live beyond my means for 9 months and still come out even. I finished paying my bills at the Academy with my movie money and am now free and clear except for 40,000 lire yearly payment to the portiere which I will pay next month. I won't have to worry about packing either since I've worn out all my winter clothes and don't have any summer ones. Take good care of yourself. Be home soon.

<div align="right">Love,
Your daughter</div>

July 8, 1958

Darling Mother:

I hope this finds you well. I enjoyed your letter, but I'm not really worried about packing and stuff—just lazy. Jane, a friend of Shirley and mine from New York is here with me now. Well, right now she is in Milan, but she was staying with me and is on her way to Russia for an architectural convention. Michel, the French architect, will be there too. He wrote me the sweetest letter from Paris. We had a fight just before he left and I took off for Spoleto and didn't see him again—wish I had. Well, if I fly home, he wants me to stop once in Paris which I'd like to do. Dominique is having all kinds of family trouble at the moment. His sister who is

married to the Italian representative to the U.N. has left her husband and come back to Italy which is really a major disaster in an Italian family—an annulment costs about $17,000 for one thing and is still rather a scandal. I've been seeing this set designer with the white MG. Went to a fabulous cocktail party at Frances McCann's a few nights ago. Wow! What an apartment. It's on par with Helena Rubinstein's. I took Jane (who is also very rich New Orleans—her father builds highways) along, we had a great time. I also received a card from Pat. I'm applying to Yale after all for this year as Jane who is one of the few female graduates from Yale insists there is still a possibility. She and everybody are writing letters. I've also written Leo Lionni and Brad Thompson at *Mademoiselle*. I'll just wait and see. The chances of financial help are also slim because it is so late. But if I get accepted something might turn up. Jane wants to buy a big piece of sculpture of mine when she gets back to the States. My short, happy movie career is over and I've just finished an illustration. I'm going to see about some modeling tomorrow. As far as Yale is concerned, you will have to send:

1. The enclosed letter, which is a copy of the letter I wrote to the head of the design department;
2. A Tyler catalogue which describes the courses—there're several in my room;
3. My high school and college transcripts;
4. A money order for $10;
5. A note explaining that my application blank has been sent directly to Mr. EISENMAN along with the original of the letter enclosed for special consideration.

Send all this to:

CALLISTA V. CLANCY, REGISTRAR
DEPARTMENT OF DESIGN
SCHOOL OF ARCHITECTURE AND DESIGN
YALE UNIVERSITY
NEW HAVEN, CONNECTICUT

I have just talked to the travel agent about passage home, and I think I'm going to try and fly Rome to Pittsburgh with stopovers at Paris and London or get the *Queen Frederica* out of Naples 31 of August if there's a chance of more movie work or modeling to tide me over and of course if Yale comes through. Everything is quite confused now because money I thought I would get here, I won't get until I get back to the States. There is a possibility of a show in Milan but not until October. So I'd have to let you know as soon as my plans are definite. Really it would be a lot simpler just to stay. I can understand now why people just never go home—Kiss Grandpop for me. And I was kidding about Paula. If I got letters

like she did from me I guess I'd be mad too. I wrote her a very funny card back, suggested by Shirley.

Your loving daughter,

P.S.—Just called some friends of mine with whom I hadn't spoken for ages. They said they kept up with me in the newspapers—not only did they put me in places I was, but in places I've never been in my life, like Milan! But then one must keep the press happy (smile). See if you can't start a fund for the preservation of the institution of Barbara Chase or are there enough people who want me back in the USA.

July 25, 1958

Darling Mother,

All kinds of news, of course, good and bad. The main news being I need about $150 to get home. I went to Cinecittà yesterday, made a fast $20 for a costume fitting and will work next week. I just hope I work about 4 days and I'll be set. There is a dancing part but I don't know if I can stay long enough to do it or if I should. Dominique seems to think it's quite undignified and rather frivolous of me as a sculptress to be dancing across the screen in a skimpy costume and he's probably right although his attitude is definitely European. Anyway, this call from Cinecittà came the same day I found out I was selected for the Carnegie show in New York, which is just about one of the most important art shows in the U.S. It also travels all over the States. The Gallery said I was the first artist they've chosen in Europe and it's definitely an honor as only established artists ever get in. I also got a letter from Snellenburg's saying they were sure I could come back there and we could agree on salary so I wrote them my salary range was $4,500 to $5,000 a year—double! Phila. seems quite set. But I have a feeling Yale will come through. Also Dominique will be in New York in October to do some panels for an apartment of a friend of his. I have been trying to convince him to stay in New York for the winter (he probably will) but he claims he'll get all involved with being a playboy and won't paint (which is also right). Anyway he's decided that if he were going to get married, I would be ideal but since the very thought of marriage terrifies him with the thought of ruining somebody's life, he prefers to go from flower to flower. Sound familiar? I told him the men who make the best husbands always say that. It's the ones who pledge undying devotion that you have to look out for. Anyway, the same day I found out about the show, I went out with an atomic scientist I had been dying to go out with for months. The evening turned out to be deadly (I suppose most scientists are dull company) and besides my pocketbook got taken out of the car with glasses, keys,

makeup, and a little money, besides having my little leather clutch bag inside my big patent leather envelope! So I have to get new glasses. I would be ahead on the money I got from Cinecittà if it weren't for that. Oh also good news, I found a couple to sublet my studio, so I hope to get all that settled by next week. The plan is to ship my trunk and crates home COD by Bollinger by slow freight so that by the time they get there I'll have money enough to pay for them. I plan to fly from Rome to Paris on the 12th of August, stay in Paris a few days in order to see Michel (the architect) who will be back from Moscow on the 10th. I will probably stay at the Cité in Paris where I stayed before and where there is this composer I told you about that I met in Spoleto. I'm going to write to him to try and reserve me a room. Also I'll probably meet Izzy in Paris as he had planned to take his leave on the 15th of August and come to Rome. But I wrote and told him I'd be in Paris. I don't remember what I wrote in that letter, but I received a letter this morning which to say the least thinks I'm coming to Paris only to see him. Anyway, I'll probably leave Paris (unless I go south with Michel) about the 15th or 16th so I'll be home the same day as a matter of fact. Isn't that marvelous? Jane and I really figured it is the cheapest way to do it. Besides, the fact that I'd never get a boat now for August or even September. I made my reservations yesterday. I was really out of my mind as to where I was going to get the rest of my plane fare. But I think it will work out alright now. If not, I'll have to write Daddy as I won't get the rest of my money from Ben Shahn until I get back to the States.

Enclosed are some photographs of me which appeared in several Italian magazines this week. Dominique says I look like Buddha and he's right. This was how fat I was when I got back from Egypt. It was taken on the set of the crazy Italian film. Note expressions of leading man and "Warrior"—typical of male Italian expressions which is vaguely like viewing the 8th wonder of the world. Met a very cute man for you from Philadelphia who has lived in Europe for about ten years. He looks to be about 41 or 42, bald as an eagle, very nice. Wish I could ship him home to you COD, via Bollinger. Well, I'll be leaving Rome at a good time—nobody is in Rome after August 10th anyway. Pat arrived on the 20th—Jane left for Moscow on the 20th so I didn't even have a breathing spell. Jane is a doll. I really love her. Talking to Pat, I realized how much I have changed in the last year. Being away from a person for so long really gives you a chance to look at them objectively when you see them again. Not that Pat is really dull or provincial, but things I never noticed before like her laugh and her pettiness as far as people are concerned and her lack of style, and when she started talking about this 43-year-old man in Detroit who owns the local Colored newspaper and a carwash garage, I thought I would die. I don't know, it's not so much a matter of personality as of attitude, but it seems so small and limited to me. Anyway I'm afraid she's a little disappointed in her trip. But what could she expect with

15 other schoolteachers from Virginia (who are also complaining). For one thing Europe is extremely expensive and the tourist just gets it left and right besides the fact that traveling in a pack like that you can expect nothing except what's written on the itinerary. I wish I had written Pat ahead of time and really explained this to her. Anyway, I think she had a rather nice time here. She had two free days, so we went to the beach with some nice Italian boys and then to a cocktail party (unfortunately not one of the elegant ones) and finally out to dinner with one of the boys. I had a date which I had to keep with Dominique as he had just come back to town after getting over a temper tantrum (it really wasn't that simple, but he had overworked himself in Spoleto and had decided that the only thing I was interested in was my sculpture, etc., etc.). So we met again the next day and went out that evening with Mimmo Rotella and some other Italian boys. So she's now in Paris where I gave her the name of this composer there and the two medical students I met there (remember). I think she flies home on the 1st of August. Meanwhile I haven't heard from Yale yet which may be a good sign. I must write to Jane in Moscow and tell her what happened with Carnegie as she has so much enthusiasm for my work. She took very beautiful photographs for me and wants to buy a very large piece I have when she gets back to the States and gets paid for this job. She, of course, is having a ball. After Moscow, Finland, and finally a date with a Dutchman and his yacht in Copenhagen. She won't be home until September I guess. Well, I guess that's about it. Home on about the 16th. I'll cable you flying all the way. I might stop off at New York if I have to go to Yale or something. If I do, I'll write cousin Margaret and you can meet me there since you're not working. It's terrible about Elenora. I wasn't really surprised because it's been coming on for quite a time. I'm just very, very sorry. She is still the only really good friend I have except Paula and Shirley, although Jane and I have gotten to be very close. Kiss Grandpop for me. Tell Daddy I'll write soon if you talk to him. Pat's plane had engine trouble in Boston and guess who she called while she stopped over and in guess what did guess who come racing out to the airport to see her? I haven't heard from Harold in months. He doesn't know it or of course he does, he's certainly more elegant in his silence than Izzy or Paris with their love-sick letters.

<div style="text-align:center">

Love,

Your daughter

</div>

P.S.—Dominique also added that he was sure I'd marry just exactly who I want to as I'm a very determined girl.

August 4, 1958

Darling Mother,

Maybe when I get back home, things may be a little brighter. Maybe some of my luck will rub off on you somehow. But I think maybe things do call for a complete change away from that house away from Phila. Maybe. My plans are still not set. I finally had to write Daddy for money as through some mistake Cinecittà thought I had already left (I had told them the 12th) and didn't call me for the 2 or 3 days I had counted on. I have reservations for the 12th. I don't know if I will stop in Paris or not. I promised Izzy, but I don't know if I'll have the money and I don't think he has much. So I'm liable to be home on the 13th. If I wrote to Margaret, maybe we could stay in New York for a few days. I have some contacts I should make and maybe just make a few interviews for jobs in New York just in case something good turns up and we could see a show or something nice. Got a long letter from Harold today too. He sounds much better. Last night I went out with my two favorite architects from the American Academy, Jan and Bob. I had them over for drinks, then we drove outside Rome to a place called Villa d'Este which has a magnificent park or garden of fantastic fountains, huge elaborate thing, which are illuminated on Sunday nights. Afterwards we ate at a wonderful restaurant with a waterfall view and built in the midst of an old Roman temple with columns all around really wonderful, one of the best times I've had in Rome. Night before last Jim and I went out with an old school chum from Tyler and her husband who makes films for NBC (documentaries, etc.) who are living here now and really had a wonderful time.

That lousy picture I sent you was only the beginning. It seems some columnist (clipping enclosed) wrote an article on me in one of the Italian newspapers and he must be the Charlie Knickerbocker of Italy. Translated the article is as follows: The name of her column is "Speaking of Rome" and my part is called the "Ebony Statue." Quote: The most beautiful Negro in Rome is undoubtedly the stupendous tall sculptured Barbara Chase to whom as soon as he had seen her in the local Obelisco gallery, producer Zimbalist offered a bit part in "Ben Hur." Barbara Chase is not only a beautiful girl, refined and impeccably dressed. She is a sculptress and painter of first rank. Barbara Chase lives at the American Academy in Giancolo and explains gracefully that before coming to Rome she (lived) posing as a model for the cover of the American Negro magazine "Ebony." Perhaps it is also because of this that her Roman friends call her "The Ebony Venus."

I mean really. It's a product of his imagination from beginning to end but it does make good copy. Anyway, since then two of the biggest magazines in Italy have taken photos for picture stories and within the next month I'm supposed to

be on the cover of *Rotosei,* the magazine I did the illustrations for! I'm really quite a celebrity. All kinds of rumors good and bad. I mention to someone I'm going to Milan, the next day it's in the papers. Enclosed is another clipping. I was at both parties both with Dominique. I also may have a chance to go to the Venice Film Festival if this television guy I know gets me a job as "translator" or something. I told him I'd never seen Venice so he said he'd see what he could do about a job. If I did go I wouldn't be home until the end of the month as it starts on the 22nd. That's it for the news love, but keep tuned in. It's getting fast and furious. I got rid of my apartment and have to get out by the 12th. Haven't heard from Yale yet. I'm glad you sent those clippings, they were really very valuable information that was a nice note from Leo Lionni. Anyway darling cheer up, maybe things will break when I get back. I've always thought a little shop or something with the right contacts and maybe a partner would be the perfect thing. I'll write again soon. My love always and kisses to Grandpop.

<div align="center">—Barbara</div>

1959

Returning to the United States after more than a year of freedom, adventure, and liberty in Europe was the leitmotif of my return to Yale University. The university itself had no Black students at all, the graduate school a sprinkling of females and only three of them Black when I entered the MFA program. There were two other Black females in the class of 1960 graduate school—one woman in the law school and Joyce Cook, who was the first Black editor of the *Yale Review of Metaphysics* and the first woman to be named as a teaching assistant and of course the first PhD in philosophy at Yale. We became close friends for many years. Both Joyce and I lived off-campus. I had two roommates, neither at Yale, one from Texas who was a nursing student and one from Philadelphia who was hiding a secret pregnancy, in our little house on Park Street—a kind of little family: I was father, the girl from Texas was mother, and our pregnant ward was baby. I took care of the repairs, rent, bills, electricity, and shopping. The Texan cleaned and cooked, augmenting our lack of the money with burlap sacks of pecans sent by her parents when we were out of cash at the end of the month.

Of course, my letters to my mother ceased. We used the telephone and week-end train trips from New Haven and Philadelphia to New York, where I had learned from someone that the Plaza Hotel rented their maids' rooms out at 10 dollars a night to White students. It reminded me of the Barbizon Hotel and my guest editor days at *Mademoiselle*. So we phoned, we visited, and I never wrote those two years. I led an independent life from the school and from my mother. That September, with a full fellowship and a loan, I would be the first woman of color to integrate the Design and Architecture School at Yale to complete a master's degree.

I studied under Paul Rand and Herbert Matter, audited Josef Albers' courses in the architecture department with Paul Rudolph, even took a course in Chinese art under Vincent Scully. New Haven was the most southern town in the North, and the war between the Townies and the Yalies had been going on for centuries. For me, fresh from Europe, it was like being dropped onto another planet. My "culture shock" was shared by my Nebraskan friend who had spent her Fulbright year in Chile. We were homesick for adults, sophistication, and continental-style intellectualism. We would take the train on Friday, rent a maid's room at the

Plaza, and haunt Greenwich Village or take my mother to exhibitions on Saturday when she arrived. At a time when fraternizing with the faculty was not politically incorrect, I was discovered by an English architect named James Frazer Stirling, who was a visiting professor in the Architecture School and who followed me around school for weeks until he finally asked me in his alluring British accent who I was and what I was doing at Yale.

"Who are you? What are you doing here?"

"I live here."

"Are you the one they call Miss Chase?" he said to me.

"I'm the one."

"Don't you have a first name?"

"Barbara. Barbara Dewayne."

"Baar-bra," he repeated slowly. "Baar-bra," he said with a tinged Scot-British accent.

His laugh was surprisingly youthful, almost girlish like the Beatles, and a hank of fair hair shot up and fell over one eye. The electricity in this small exchange was startling. We had both decided that this was a historic moment. I felt as if I were standing on the quay in Alexandria. Did this man have a plan, I wondered. I decided to audit Professor Stirling's class, and not to my surprise I was the only girl present. He promptly fell in love, and asked me to marry him and come live in London. As I was convinced this was fate, I promised to do this as soon as I graduated.

Unbeknown to either of us, but for some odd reason not to my mother, there existed at that time miscegenation laws against interracial marriage in twenty-four of the fifty states of the United States. Only Connecticut, New Hampshire, New York, New Jersey, Vermont, Wisconsin, Minnesota, Alaska, Hawaii, and the District of Columbia had never enacted Black laws. In 1957, Hannah Arendt wrote,

> Even political rights, like the right to vote and nearly all other rights enu-
> merated in the Constitution are secondary to the inalienable human rights
> to life, Liberty and the pursuit of happiness proclaimed in the Declaration
> of Independence and to this category the right to home and marriage un-
> questionably belongs.

But in 1958, a Gallup poll showed that 96 percent of White Americans disapproved of interracial marriage. So did my mother. If I married him, she informed me, I would be a felon in twenty-four different states in the United States where it was forbidden to mix the races. When I told my Englishman this, he laughed in my face. He didn't believe a word of it. I admit I felt a little foolish. Maybe my mother had made it up to keep me at home, I thought. I had never been to the South, had never experienced that raw primal prejudice that corrodes pride in ways I could not even imagine. Still, I thought, this is *against the law*. But like Stirling, I didn't really believe it. Times were changing, the first rumblings of a

movement that would change apartheid in the United States was already under way. Young people not only of the South but the de facto North were organizing, preaching, demonstrating, and marching. Echoes had begun to infiltrate even the elite and the upper strata of the Eastern Anglo establishment. Suddenly, my degree was in danger.

This was my second year, and the administration decided that my thesis project, which was an 18-foot, aluminum fountain for the Wheaton Plaza Shopping Center in Washington, DC, and which included not only its fabrication (at a New Haven airplane factory) but the entire design of the reflecting pool, the waterworks, the engineering and blueprints, was not acceptable. It had been commissioned by my Rome Academy friend, Jane Doggett, the lone woman graduate who had decided I should go to Yale. According to the administration, my project had not been executed under faculty supervision (I had not asked permission) and was therefore invalid. I was shocked that an actual architectural project that had already been installed in the Wheaton Plaza Mall had been rejected when there were theses of cigarette cases and matchbox covers that had been accepted. I was wondering how I was going to explain this to my mother, when word came that without exception, the entire faculty of visiting critics and professors had declared that if I didn't graduate, no one would graduate. They would refuse to grade anyone. The committee acceded, but I was still obliged to provide a second thesis—in three weeks. I accomplished this by producing, printing, and binding a book of engravings based on Rimbaud's *A Season in Hell*, with an essay by the French writer and critic Henri Peyre, then a professor at Yale. The only copy disappeared from Yale's archives shortly afterward. It is still missing.

I did not make an appearance at the graduation ceremonies much to my mother's despair and regretted it much later. Instead, I took the first plane out to London to join Stirling.

From there, I followed the echoes of the coming storm in the British press filled with the cries of African independence and dismantlement of colonial rule and the empire. I soon became versed in this new development—the Civil Rights War that was destined to become the Third American Revolution. I became for my British friends their expert witness and formidable guide—that is, until I turned into a runaway bride.

1960

London was the prettiest of European cities: rain-washed stone, flocks of swallows, greenery, monuments, and rushing, somberly dressed people whose arms seemed to grow into wrapped black umbrellas. There would be a settled gray haze and then without notice, like a capricious cover girl, glorious sunshine would appear from nowhere filling the streets with color and pedestrians would go drunk with it as if they were at a wedding celebration. They would laugh, drink, sing, pontificate, make love, eat fish and chips, feed the pigeons, go shooting, or riding or hunting, or shopping because the sun was shining.

Everyone had a cottage in the country, prince or pauper, where they would gather every weekend, and the exuberant tree-filled parks and squares and circles and crescents of London that were the heart of carefully constructed five-story townhouses built mostly in the Adams style would remain deserted and empty until Monday morning, wasting the best of London. Hyde Park was a marvel, Hampstead Heath glorious, Regent's Park where I lived, incredibly elegant just the way I wanted it to be. I settled down to Stirling's practice, his windowless house project, his erudite and noisy Oxford and Cambridge friends, several sculptors among them, Lynn Chadwick, Reg Butler, and Eduardo Paolozzi. Our friends were also rowdy colleagues, and weekends we spent in damp but beautiful houses set in exquisite green landscapes.

My mother had warned me: never fall in love with someone who is not in his own country, a stranger, which was exactly what I had done. And she had added never fall in love outside your own country. A rule I had broken. But Stirling was happy, excited, optimistic, the office was beginning to get work, advanced by a clutch of young architects whose names are now household words. We socialized greatly, shocking some, enchanting others, and outraging a third group who thought we both were crazy. These were the West Indians.

Since we were always away from London on the weekends, during the week I looked for a flat, raced from museum to museum, from office to home, and finally found a sculpture studio, adding to the confusion. One couple became our best friends whose partnership as architects we both admired. Then there was the magic of the actors, the theater, and the ballet of London. It was the heyday of

"Swinging London," the mini skirt, Portobello Road, antiques, English silver that Stirling made a fetish of, and the execrable never-ending rain...

There was something opaque about Londoners, something as impregnable as their raincoats except for the high English color that insisted on giving them away with flush and blush as I called it. So I always knew what English people thought no matter how timid or imperious or unemotional they appeared. What I loved most was British wit. I swooned over their British accents, their repartee and *bon mots*, especially the actors like Alan Bates, his wife Vicki, and eventually their twins. Stirling, being on the taciturn side most of the time, made an exception for a good joke for which he exploded with laughter at anything even remotely funny, the sillier the better, destroying his serious demeanor. Anything resembling a party he adored. We wrote, slept, and ate architecture although he discreetly made it understood that I was a sculptor and no matter how hard I tried, I would never be an architect—a matter of temperament, biology, and mathematics, he reiterated. I believed him. I realized that his reputation as the most daring and original post-modernist "bad boy" architect in London was well deserved. The few commissions that he and his partner managed to build were worshipped by other architects, his lectures and appearances and articles drew crowds of admirers. After a summer of inevitable shock, I settled into several happy friendships and began to take myself seriously as a sculptor, falling in with several critics and professors at the Royal College of Art, looking for ways to resolve what I had decided was a major obstacle: the legs and base of my sculptural configurations. Without those two distracting elements, they would no longer have a "human" dimension and reference. They would join pure abstraction yet keep their spirituality. I would never, I knew, be able to build a house like that. It was agreed. I would never be his equal. He was the Gargantua architect, the one and only.

Stirling fretted constantly about commissions and especially one: a house designed without windows for a private client. He was torn between principle and pleasing the client. I knew I couldn't help him. His own overwhelming intellect as well as his intransigence were proving to be too much for me, a young formless American, to handle. One day I gazed out the window of our apartment. It was stone cold and raining, with heavy-laden clouds that promised hail and snow. There under my nose were two Englishmen in tennis whites playing a round of tennis on a clay court as calm as can be as if they were bathed in sunlight. Suddenly, they were bathed in sunlight. Either I was crazy or this country is crazy I thought. If I stay here, I'll be just as crazy as they are...I'll turn into an impeccable Brit—like mom...

August 27th, 1960

Dearest Mother:

Have arrived safely and am in the process of settling in a flat not far from Stirling's studio. All is well—although a little strange and I haven't really come down to earth yet. London is charming—especially the section we live in. I will let you know a mailing address in a few days.

 We plan to leave for Southern France as soon as Stirling can get away.

 Take care of yourself. I love you.
 Barbara

August 29th, 1960, London

Dearest Mother,

My new address is 12 Kent Terrace, Regents Park NW1, or you can write me there or in care of James at the address I gave to you. At the moment, things are rather difficult, but I expect they will straighten out eventually. The flat we had hoped to have in September won't be available until November and space is probably the hardest item to find in London. Since both his apartment and mine are too small for two people, this is quite a problem. We have postponed going to Europe until the end of this month because of work and I am at the moment looking for a studio, which is hard to find and expensive. London weather is fantastic, changing about 30 times a day and <u>never</u> passing without raining at least twice. The first day I arrived was perfect—sun shining (although occasionally cloudy) so we did all the romantic things we could think of and all the <u>very English</u> things— Stirling has a sleek new black sports car in which we drove around London seeing all the tourist sights, had tea in a very elegant chateau and garden of some duke, walked along Thames, had beer in a picturesque little pub overlooking the river and watched the swans and the sailboats on the river with London Tower in the background. London itself is very charming and very elegant (the places we've been) also very sordid and overcrowded (places we haven't been). The food which has a reputation for being bad seemed quite wonderful until we ate at James' Club yesterday where they served real English food (we had been eating in Italian, Indian, and expensive English and Continental restaurants). The idea of living year-round in London leaves me rather cold at the moment, but maybe it will grow on me unless I turn out to be one of those people who are greatly affected by the weather (as Americans are prone to be, it seems). Anyway, I will let you know how all progresses. It is very easy and cheap to go to Paris for weekends, etc., which I may do sometimes this month. I have a new raincoat (which I really needed) and my hair is usually as straight as can be. I haven't started to write to people yet but will get around to it eventually. So far, things have been very

exciting and loving etc., but I am slowly realizing that a great many things are going to have to be worked out if anything permanent is going to come about. I know that part of my time has to be spent in the U.S. of course if James continues at Yale, part of his time also would be spent there. Also London is dreadfully expensive to live well in—rent and food especially to say nothing of clothes. The only thing that is cheap here is labor—services and servants. I think it is even more expensive than New York or Paris and certainly more than Rome.

Have you heard anything from Mr. Eisenman about the plates of the book? Also any other mail? If you get around to sending coat and skirt etc. either address is alright. Also try to find out the name of the editor of the Pittsburgh Courier in Phila. I must write to him for some material I left with him. How are things in old Philadelphia? All the houses in Regents Park look like the ones on Rittenhouse Square—really lovely. The park across the way is more like Central Park though—very big and very green. The front of the houses all have columns and floor to ceiling windows and are cream colored with huge black doors and shiny brass knockers. These English people are crazy. It's like a bad day in November and there are two fools playing tennis in the court across the way.

Can you imagine, at another dinner party the other night, one of Stirling's best friends comes up to me and says, "Barbara, looking like you look, I don't understand why you bother to do anything at all—especially architecture . . ." ha ha ha—the nerve! He wouldn't have dared if Stirling had been there. He would have gotten a punch in the nose. I told him what he could do with his silly testosterone joke! He thought he was being funny. It wasn't funny. Kiss Grandpop for me.

 Love,
 Barbara

London, September 2

Yesterday, September 2, it finally stopped raining long enough for me to get a good look around. Regents Park and the houses around it are fantastically elegant. I will send you photos as soon as I can. The houses are like the very prettiest parts of Phila. And are called terraces, all built by the same architect. They all overlook a magnificent park, very large which also contains a zoo along with various lakes, etc. I don't know really if I can bear the weather here. Stirling says that in the winter—the winter!!! one doesn't see the sun from one week to the next. Today however was a good day with sun <u>almost</u> all day long. Last night a party, rather informal and the night before, the theater—a new play which turned out to be very good. As I was saying about these very elegant houses on the outside, they are cold as hell and with antiquated plumbing on the inside due to the fact that they are considered historical monuments and the architecture can't be altered. A typically English attitude. I am beginning to discover how much the climate has to do with national character. Stirling went away this afternoon on a

site trip and will be back tomorrow evening. Tuesday we are invited out to dinner also Thursday and we are going away to friends (a sculptor) in the country over the weekend. Kiss Grandpop for me.

<div style="text-align: center">

Love,
Barbara

</div>

September 14, 1960

Dear Mother,

I received your letter yesterday and was very happy to hear from you. I am fine and still trying to get both feet back on the ground. I have acquired, since I wrote to you, a wonderful studio…free. A gift or rather a loan from a woman I met through the editor of *Ebony Magazine*. She owns a lovely old Georgian house about five blocks from here and the studio is in the garden. Since it was already a sculptor's studio, it is quite perfect. I can have it until December or January, by which time I will have done enough work for a show which I am hoping can be planned for the Hanover Gallery here. There are several things I would like you to do: First. Look in my files for the negatives to the enclosed contact sheet. I must have forgotten them. They should be around somewhere. If you do find them, could you send them to me as soon as possible? Secondly, there is a book in my room called *Mountolive*, it has a green cover. Could you wrap it up and send it (it doesn't have to be airmail) to Miss Jo Stuckey c/o Mr. and Mrs. Ted Henderick, 18, Old Park Ave. London. S.W. 12, with a note saying that I forgot to mail it to her before I left. I have written the New Haven Telephone Company telling them that they have applied the wrong payment to the wrong bill. It is quite confusing, but shouldn't be, since it was marked quite plainly on the check. I am hoping to get an advance on either the show at Bertha Schaefer or the one here (if I get it) to clear up all the rest of my bills. I should know by the end of the month just what is going on. If I can't work anything out, I'll have to see what can be worked out with Stirling. The weather is still quite good here although it is getting cold. This studio is tremendous luck as getting space in London is almost impossible. That is why we are so worried about this apartment. If it falls through at the last moment looking for another place might take months and months. I am going to try to get to Paris in the next four weeks or after just for a few days. Also would you please send my desert boots if it isn't too late? We have just been going around seeing a lot of people, dinners and things. I've really been meeting the English. The weather has gotten much better; as a matter of fact it is quite fine at the moment. I have a standing invitation to Mexico which I may take up on some time this winter or spring depending on what happens. The main thing is to get some money at the moment. At any rate that's all the news. Still pub hopping and being very social. Most of James' friends are probably on the order of the people you meet with Marie. As a matter of fact, she would adore him. As

far as Stirling and I are concerned, it is still quite up in the air. Things never seem to be black or white in this country and now that it is getting down to a matter of practicalities, I am getting much more uncertain about what I should do. I know it will take a lot of love to keep me happy in London, but I usually try to rush things, so I will just wait and see what happens. At last I am getting rested after Yale and (according to James) gaining back the weight I lost. I had lunch with one of Stirling's architect friends today (he is out of the city, up North about a job) who taught me more about the English in general and Stirling in particular than anyone else in one long afternoon.

The enclosed clipping is an idea for a winter suit. Who could you get to knit a collar and hat? Also one can get good English wool as cheaply in U.S. as here and more variety believe it or not. There is a pattern for the collar and hat (Vogue) enclosed. Kiss Grandpop for me.

--

October 3, 1960, London

Dear Mother,

Received your last letter this morning. About the pictures, it would be best if this woman arranged to borrow them from the Little Gallery since they are already framed, etc. Call, or have her call Mrs. Rosenfield, Little Gallery, 252 South Sixteenth Street, Ki-5-7562. They can have any ones they want. I would choose: print called "Seascape," the two "Torso" prints, drawing called "Warrior" and drawing called "Bull." They can also have large colored drawing at home. No sculpture. Everything here is fine except for money. I am still waiting to hear from New York Gallery. The book that is supposed to come out here is being published on October 31st. I had lunch with the author Cedric Dover a few days ago and am going to have lunch with him again Wednesday with editor of *Studio Magazine* (Studio Books is the publisher of The book). They may do an article in the magazine on me—Also, I may be on English television!! The book is rather well turned out—lot of it is historical. It will come out in U.S. same time as here, about the end of next month. I have seen the American edition. It costs $10.00. It is also it seems coming out in such places as New York Graphic Society, France, Italy, India, and Japan. Although I don't quite agree with the approach, I couldn't have afforded not to be in it I think. There is only one other contemporary sculptor, a friend of mine, Richard Hunt from Chicago. I met him two years ago in Rome. Wednesday besides having lunch with these people I am going to opening at the Hanover Gallery to meet Cesar, a French sculptor. By the end of the week, I should be in either Italy or Spain. Haven't decided yet. Oh yes, you must tell Frances that the woman who gave me this studio was married to the vice-president of the Encyclopedia Britannica. He lives in Chicago and is in charge of all international sales—so if she wants an inside track.... He used to be the vice-president of Schweppes Tonic Water. Anyway, she isn't married to

him anymore. How did that ever turn out anyway? Well, I am trying to get some important letters off. Will write again soon.

Love,
Barbara

P.S.—Saw a picture called *Jazz on a Summer's Day*. Harold was in it. It was about the Newport Jazz Festival. You couldn't see his face because he always had a camera in front of it. But he is clearly recognizable.

London, October 31, 1960

Dear Mother,

I received your letter this morning and the box a few days ago. I expected slacks? Also tan desert boots. I wrote to the YWCA asking them if you couldn't receive award for me. I thought you would enjoy it. I have been busy socially lately. I met the cultural attaché at the American Embassy yesterday and am going to a cocktail party there Wednesday before they move into their new building, which was designed by an American architect, Eero Saarinen. James has to interview him the end of this week for a magazine article. The attaché is trying to get me some money to do a show here. I also got a letter from the woman at the Main Line Gallery about the Jewish YWCA thing, which is on March 12th, and the print club book. I will know in a week or so about it she said that you have had a marvelous Indian summer—the weather here is usual—horrible. You are busy, aren't you. I hope they sell some of the pictures at the tea. The drawing for New York is rolled up in back of the attic. It is all big black spots something like this [drawing]...It has to be framed with glass, etc. James is running into much difficulty with his work—as a result we are on not too good terms—we haven't broken but I'm having reservations about a great many things. Architects probably have the hardest time here than anywhere else if they are attempting modern architecture and don't have money of their own or family. At the moment I am waiting to hear from a gallery in New York and also I may get a commission from London Arts Council if I'm here long enough. I still have my studio and am simply waiting to find out how things are going to shape up. As soon as I know I will let you know. But at the moment funds are low on all counts. Maybe you'll meet somebody at all these shindigs you are going to because of me—wouldn't that be nice. Meanwhile let me know what is happening on home front—I am meeting all kinds of interesting people and contacts—am going to dinner with author of *Rabbit Run* tomorrow and West Indian painter and party for another painter on Tuesday. I'll write again soon—

Love,
B

64

Paris, October 31st, 1960

Dearest Mother,

Am in Paris for holiday visiting friends (from Yale). Everyone is arriving either here or London from NY. One can't escape. James is coming over in about two weeks. Work is very bad at the moment and the apartment still dubious. Meanwhile I may sell sculpture, do some modeling, work in graphic design. Met millionaire "action" painter in London and am seeing him here. He is interested in buying *Adam-Eve* but nothing definite yet. He has two Rolls Royces and a Mercedes Benz. Pity I can't drive. Have been royally wined and dined, etc. Am looking up old friends and meeting famous people. I will write as soon as any plans are definite.

<div align="center">

Love,
Barbara

</div>

November 19th, 1960
c/o Mr. E. Taubkin

Dearest Mother,

I received your last letter also money order, also telegram in Paris where I have been for past two weeks. Please don't worry about paying any more money. I am doing some art direction for *New York Times International* and have made in past four days $750.00. So . . . I will be sending you money soon. Also I will pay my bills from here. *The Times* wants to make this a permanent thing and plans to pay me in New York in dollars deposited in my account so that I can draw on it anywhere I am. Also as the work comes in spats, I don't have to be in Paris all the time. At the moment I am finishing up some designs and setting up their office. I then plan to go back to London the end of the month and probably, unless something comes up, stay until Christmas. I got good, good news from Stirling, who is as usual working very hard. As I mentioned we had a huge crisis with work about two weeks ago. James' biggest (and most important) building looked like it was going to fall through. As I explained before, it's not the client (in this case a university) who has the last word on a building in England but something called a planning committee which is made up of local boobs who know nothing about architecture and hate modern architecture. (It seems strange after the U.S. that there are places who won't accept modern building.) At any rate, if this had happened, James would have had to close the office (the job is 1 ½ million dollars) and since he has huge loan at the bank, might really have been in serious trouble. He was so upset about this; there was no point

in my being around as I couldn't seem to get him out of his depression. At any rate he wrote that they got the building through (although he is over budget) so I guess I can go home...except that now the panic is the university wants to start building in December, which is almost an impossible starting date. So I might as well stay till the end of the month and see if I can solidify this fabulous job. Office in Paris—flat in London. That's the life. I received a letter from Mei Lou, my Chinese friend, it seems two of our best friends are coming to London to work (one of them was her boyfriend, the bastard) so the London scene is being invaded by Madison Avenue. Already two top rate guys are here making fantastic salaries doing graphics. It seems the English think Americans can do no wrong as far as advertising goes. The terrible thing about Mei Lou is that she didn't even bother applying for the same job because she didn't want to leave the bastard that's coming here!!! I am taking pictures of Paris when I get a chance, but I always forget to get them developed. So I have one roll, which I shall put in the shop tomorrow. You may even get some pictures of Egypt if Rene ever comes back to Paris. He has negatives at his office here of crazy shots taken in Paris. I am also expecting back this week my millionaire action painter who has been in Spain for the past 14 days and who has promised to buy a piece of sculpture from me (the piece in Rome). If that comes through, wow!! I am also trying to get a show here in Paris. I have a place to work, it's just a matter of getting money to cast things, etc. Latest encounter was with a German ski instructor who looks like an ad in full color to get any woman anywhere to take up skiing. For four months of the year, he's in Paris, for four months in the Alps, and for four months on the Riviera teaching water skiing!!! It's really a crime when they get that good-looking. They really lose all sex appeal. It's like going out with a walking ad!! Also my boss, Mr. Taubkin, is very nice, very sad—Before I forget, please send immediately again the name of the man at the *Tribune*. I must get a script (the exhibit on American Negro) from him right away. There is a chance that it might be produced either here in Paris or in Cairo. I have a contact with an architect here who does exhibits and he is interested. Better still, call him and pick it up yourself if you can, I don't trust him to do it. And if he's lost it, I'll die. There's no other copy in the world!!! Please, don't worry. I'm fine. As you well know, I usually land on my feet. I am being published in three or four magazines in February. One is out, a Swiss magazine. Also, now that the work strain is over or will be for a while, both James and I will be more relaxed. Especially if this new apartment comes through. I am sending you a beautiful Christmas present from James and I. I have to wait until next week to find out if I can afford it. Say hello to everyone and kiss Grandpop. I just haven't had time to send any cards. Oh yes, I must tell you how I got this job. I spent the first few days with friends from Yale in Versailles, which is just outside of Paris. I was met at the plane by the action painter Georges Mathieu I mentioned (he is on the board of directors

of the United States Line), who after showing me around Paris for a few days, left for Spain unexpectedly. I then moved to Paris (my friends had other friends coming) and met at an opening the sculptor Tinguely who made the self-destroying machine at the Museum of Modern Art. I went to see him the next day, and met another painter all of the same new school called "New Realists." They are supposed to be the avant-garde of Paris. But they all (I proceeded to find out) take themselves very seriously except for Tinguely who is the only one who is any good. At any rate, through this other painter (Swiss-Hungarian) I met another of the group called Yves Klein. The next day I was walking down Rue St. Honoré on my way to deliver a note to Rene at Magnum office and I saw Klein taking down an exhibition of his in a gallery. I stopped, went in, got my picture taken for *Paris Match* when three men from the *NYT* wandered in. One of these was Mr. Taubkin. We started to talk as soon as he found out I was American. Oh, by the way, by this time, I had borrowed $40.00 from my friends and had lost my return ticket to London, so he said he'd like to see my sculpture some time. He also was complaining about graphic design in Paris and how he couldn't find anyone to do it, etc., etc. So I volunteered and he gave me some ads to do. And that was that. I still don't know how it will finally work out—certainly I won't make $700.00 per week—but they have the money and my prices are still cheaper than New York prices. So you can write me here, or in London. Don't worry about paying Jenny off. I will do that. Just worry about yourself and keeping well and cheerful and your daughter who is going to be rich (I hope). Please don't forget about *Tribune* man. This is a real opportunity to get this exhibit done and a neat profit. Especially if I can do it in Cairo (which is where I got the idea in the first place). The American government there has so many Egyptian pounds (they can't take them out of country) they are using them for toilet paper just begging someone to help them spend them. I would also have help—from my friends at USIS, although they are now in Beirut. I must write to them. I haven't written to *Mademoiselle*. I will do that when I get back to London. But first of all, I would like to make about $400 or $500 more from this job—quick so that I am completely in the clear as bills go except for Yale.

Write to me soon and send this letter to Daddy or call him as I won't have time to write probably until the end of the month.

Take care of yourself.

Love,
Your daughter

P.S. Among my books is a little gray box filled with colored paper—could you send this special delivery air mail to NY Times building c/o Mr. Taubkin.

November 29th, 1960

Dearest Mother:

I received checks, etc. Thank you. You must not worry about me—I am fine—and I might add, pleased to be in Paris. I was very upset when I phoned Harold. Not because of James (who is coming over this week. His work is much better now and crisis is over) but some things in my life seemed to be getting out of hand. As you know, I lead a fantastic and fabulous life which sometimes gets to the point where I don't believe it myself. I was very nervous about the painter I told you about. Not sooner than I had "imagined" or wished that he would buy a sculpture from me or take an interest in me than lo and behold frantic telephone calls from him, cars meeting me at the airport, etc. For one wild moment, it was really too much. Fortunately he took off for Spain a few days later and I have since got my balance back. Meanwhile acquiring this fantastic job, which I could never get in America with office, consultant status—it's fabulous if I can solidify my position. As I told you, they are paying me in dollars. Dollars are much better to have as everything one buys is 20% off in dollars. Okay on that score, I am now looking for studio and *carte de séjour*. Rene Burri (photographer from Egypt) is back in Paris and has decided to stay. He is leaving for Germany next week fortunately as James is coming over here. Of course the language difficulty is terrific and I must study very hard. Now that all the strain or at least some of it is off James, we may be able to continue our plans—so I can only wait and see. I also got a check from Bertha Schaefer in the mail, with a very nice letter. Did Daddy get that drawing to her? Sunday I spent a wonderful day with Rene in the country at a friend's castle (yes complete with peasants in the valley). It's a beautiful *château*; the friend is Rene's boss, the head of Magnum Photos. The house has so many rooms one can't count them (all heated) white walls, dark Bermuda wood, red tile floors— really fantastic. We had long lunch, longer tea, and then everyone put on boots and went for a walk in the woods. The outside of the house and the surrounding houses are the same as they were 500 years ago. The chapel, which is attached to the house, still serves the people in the valley who come up every Sunday. Last night we had dinner in a small Spanish restaurant—fooled around doing silly things, went for a walk along the Seine. Today we had lunch with Le Corbusier, the great architect. Rene is to do some photographs for him in India. Meanwhile, I am meeting all kinds of interesting people (of course). I have sent off checks for all bills except money owed to Daddy and Yale. The reason I didn't let you know what I was doing is that I don't know myself from day to day. When I called Harold it was 3 weeks ago. Anything can and did happen in three weeks. The weather here has been magnificent. It is now getting cold. I have a new coat and dress to match (winter coat). I am also trying to find time to take some pictures. I finally got Rene to print up some pictures he took of me in Egypt two years ago—so I

will send them—just to prove I was there. I also have a roll of London pictures if I ever get them developed. I am still working on trying to sell that big piece of sculpture—two people in mind, but nothing yet. Tomorrow I shall try to find time to acquire some shoes, a bag, and a dress since I am now an executive; I am hard up for clothes. Ruined my red suit and have to have it dyed black. Enclosed also check. Could you do that suit I sent you from London? Don't worry about collar and hat, I can buy them here. Give Grandpop my love and everybody. Tell them I'm sorry about the wedding but then again, it may come off in the end anyway. I will write again soon.

> Your runaway bride,
> Barbara

1961

My letters from Paris made it clear at least to my mother that I had become a runaway bride without realizing it, crisscrossing the English Channel like a seagull in flight. My Paris address was now 235 Rue Faubourg St. Honoré… I spent every weekend in London, returning to my Paris flat and the *New York Times* office on Sunday night. Or Stirling would take the plane from London, and we would spend our time-consuming French gourmand meals, drinking French wine, and devouring medieval architecture. He would return to London, and I would remain in Paris, which began to enchant me more and more. I found myself humming the old Josephine Baker song "J'ai Deux Amours," I have two loves, my country and Paris, and being more and more reluctant to return to London.

John F. Kennedy was now the elected president. The Bay of Pigs had occurred. The Berlin Wall had been erected, the Peace Corps had been established, and Audrey Hepburn had conquered the Western world. When the film *Paris Blues* with Paul Newman, Sidney Poitier, and Joanne Woodward opened in Paris, my old Swiss friend from the Valley of the Kings Rene Burri showed up and invited me to the opening premiere. It was just after midnight when we stopped at Magnum's office just up the street from my flat and encountered another Magnum photographer who was working late, hunched over a light table in silence, to whom Rene did not introduce me. A week later, I visited the Magnum office looking for a Henri Cartier-Bresson photograph for the *New York Times*. The same photographer was there. This time he introduced himself. His name was Marc Eugene Riboud, and he was a member of Magnum like Rene Burri, his best friend. He sent the gloves I had forgotten on the light table back to me by messenger saying he was catching a plane that night to the Congo Republic but that he would call me from the airport when he arrived back in Paris. The day he chose to arrive was the day of the surprise coup d'état against President de Gaulle by the French army that failed. We managed to have dinner anyway. When he brought me home, I realized I had locked myself out of my apartment by forgetting my keys inside. This was Paris. There was no hope that my landlady would open the door after nine P.M., and I could hear the phone ringing behind the door; Stirling worried about the coup, trying desperately to reach me.

The thoughtful Frenchman escorted me to the only 24-hour post office in Paris so that I could call London, and then offered his apartment for the night. Since the alternative was to book a hotel, which I couldn't afford, I accepted and spent the night in the apartment of a total stranger while the mysterious Mr. Riboud slept on the couch in the living room, only to encounter his sister Françoise who had keys to the flat the next morning as she let herself in. She exclaimed how happy she was that her brother had finally found "someone" at last. We never told her that we had met only 12 hours before.

I had the impression that I had walked into a Hollywood movie being filmed without a script and without an ending. What did the director have in mind since there was no writer? I had a fiancé in London, where I intended to live happily ever after in the cold and damp. I loved Stirling, I told myself. I believed in fate but it's not something you bet your life on—or did you? Marc also had a plan—to make up for lost time. He had never had time between planes to have a real girl-friend. He was in a hurry. A determined whirlwind courtship ensued by plane, Alfa Romeo, motorboat, scooter, and helicopter, which Marc later described as snatching me from Lord Wellington or Napoleon's revenge. Stirling's staid and British style didn't stand a chance against the flamboyant Latino of Riboud. Marc also had an advantage he couldn't have dreamed of. Sheila and I both had vowed while at Yale to marry Magnum photographers before we were twenty-five. There followed a series of incidents worthy of a boulevard comedy: mistaken identities, locked doors, missed planes, overheard conversations, nosy maids, operatic tantrums, midnight music, and finally an ultimatum from both men. In a tearful long-distance phone call to London in April, with Marc holding the telephone to my ear, I finally revealed my treason to Stirling. By Christmas, I was to my great surprise married to a Frenchman for good…

We married at Sheila's ranch near Acapulco, in a village called Talcapulco to be exact, on Christmas Day 1961. The ceremony took place in a magnificent Spanish baroque cathedral as large as the actual village of 200 souls, both of us for the first time. The entire village attended the wedding. I borrowed a bridesmaid's dress from Sheila's brother's wedding that was white, a lace mantilla from my mother, a sapphire-and-diamond brooch from my late mother-in-law and walked to the altar barefooted carrying a bouquet of red poinsettias. I am the only bride whose wedding pictures never include the groom, who was of course busily taking pictures.

On our marriage day in 1961, interracial marriage was still a felony punishable by fine and imprisonment in twenty-four states in the United States, including the entire South, and states like Oregon, Oklahoma, Indiana, Kansas, and Wisconsin. In principle, we could have been arrested in more than half the territory of the United States. When once I laughingly pointed this out to my new husband, he too thought I was joking. He didn't believe me then, and I don't think he ever

believed me. But my mother took one look at my handsome Frenchman with the gorgeous accent and the lavish blue eyes and changed her tune. She promptly fell madly in love with him at first sight. Fine, prison, or death.

The beginning of our marriage was an exercise in perpetual motion, together and apart as we crisscrossed the globe in millions of miles from Siberia to Algeria, from Katmandu to Scotland, from St. Petersburg to Petra. We heard what the world thought about the United States repeated by Brown people, Asian people, Africans, and East Europeans, background noise to any discussion about America. My mother and I continued to write. The letters would cease when we found each other in the flesh either in Paris or Philadelphia or New York, and sometimes places like Spain or the south of France. And they merged with other names and places in North Africa, Asia, Eastern Europe, from Denmark to Cambodia, from Tibet to the Congo, from India to China. A tiny Parisian studio in the Latin Quarter near the Sorbonne was home. Like students, we moved like the coming times, with the speed of light from continent to continent by car, boat, plane, and train.

Yuri Gagarin made the first orbital flight, Kennedy announced that the United States would land a man on the moon and return him safely, and Student Nonviolent Coordinating Committee (SNCC) workers were jailed in Mississippi for attempted to integrate a Greyhound bus station. The United States launched its first manned space satellite, and Alan Shepard became the first American man in space. Chubby Checker introduced the Twist. Yet the bitter struggle, the famous names, the legislation, and Southern police brutality that were all in the headlines were never very far away: the Civil Rights Acts of 1957 or 1960 or 1964, Little Rock, the sit-ins. The formation of the SNCC, the Freedom rides in Birmingham and Montgomery, Bull Conner and his firehoses, the National Guard at the University of Alabama.

Reading James Baldwin's 1963 book *The Fire Next Time* from afar was like standing on the platform of an iceberg slowly moving out to sea—the bulk of it still under the ocean, and what was visible was slowly sinking. All my assumptions and ideas, prejudices and theories about America were melting. They sank to the bottom. I didn't really know my country at all. But I knew it had all become part of my mother's life first-hand, this battle to the finish, this mother of all civil nonviolent (except that it was not) resistance. And Marc and I had done our part as well and were still jailable and felons for another six years until the landmark Supreme Court ruling of 1967: *Loving v. Commonwealth of Virginia.*

January 3, 1961

Dearest Mother,

Received your last letter yesterday with statement. Happy New Year. I spent New Year's and Christmas in England with Stirling. I left here on the 21st and came back on the 3rd. Christmas Eve we spent visiting friends and ended up at a couple's house that had children (3) and the father was setting up a huge train set. So we spent the rest of the night (James, another architect, and the father who is an engineer) playing with the trains of course. James wouldn't let anybody else work the controls and finally they all got into such a fight (which threatened to wake up the children) the wife and I had to work our "turns" so that everybody could play. New Year's we went to a big party in London.

I have achieved the "impossible" in Paris, a studio-flat right in the center of Paris, a very fashionable address, one of those two-story balcony deals with ceiling to floor windows on one side. I can work in it, I share the kitchen with the landlady, a countess. I have private bathroom. I plan to move in Wednesday. It is furnished, of course. I think I will keep it at least until April. The address is 235 Rue du Faubourg St. Honoré, Paris, Paris 8. I have a friend coming over on the 23rd to cover the Fashion Houses who may stay with me. A recruiter from Yale is in town, and one of James's friends is arriving today also. James is supposed to come over the end of the month.

Nothing more that I can think of. I have written Daddy once, but received no reply. I will write to him again. I will write also to the Phillips. Give a kiss to Grandpop and say hello to Sarah. Also give my best to Pat.

[no date] 1961

Dear Mother,

James and I are still writing to each other, but when it comes right down to it, such a big age difference, 15 years, can or cannot make a lot of difference and in this case, it does. James is just too old to believe in the kind of love I chose to believe in and in England he is too engrossed in his work...married I would say to architecture. It is only outside of England that he really comes alive and after all England is where we would have to live. And although I was looking for a "brilliant man" for myself, if it doesn't work on the inside, no matter how good it looks, it doesn't work at all.

Will write again soon.

<div style="text-align:right">

Love—your runaway bride,
Barbara

</div>

May 5, 1961

Dearest Mother,

Please forgive my long delay. Did you get my letter from Moscow? It was mailed by a friend of mine there for May-Day celebrations...no, I didn't go completely off my rocker. He is back now, full with stories...and Gagarin. We had a caviar (he brought back 20 cans) and champagne party the night he returned. The *New York Times* is fine and hectic as usual. I am sorry about Paula. I meant and meant to write always waiting for something or other until the letter I had to write got so long, the whole chore seemed to require at least a week. But I will write her soon. As for yourself, how are you? It doesn't seem possible that it has been eight or nine months since I have seen you. It really seems weeks away. I don't know if that is good or bad, but so many things happened so fast, I just haven't had the time or inclination to sit down and evaluate all of them. The fashion show sounded nice. Also glad you saw Harold. Yes, I do write to him. I must write Daddy also. I was in London this weekend and saw Mei Lou. Do you remember the Chinese friend from Yale. I went to see a concert by Thelonious Monk and Art Blakey Jazz Messengers and discovered I know one of the musicians... Bobby Timmons. I went to school with him...Stanton and Bartlett. He was so surprised to see me! I went backstage after the concert and met everyone. He says he is coming back to Europe in a few years to live. He comes here every year on concert. It was really funny because for the first time here was someone whom I actually hadn't seen in twelve or ten years! He plays the piano and is very good, one of the top jazz pianists if you haven't already heard of him. Went to lots of parties in London and everyone wanted to know about the crisis in Paris. I didn't know anything about it until it was practically over. A friend called me from Berlin the same night to say he had heard it over the radio, etc., but the next day things were the same and calm in Paris. The French seemed to be more disgusted than anything else. Everyone is tired of the Algerian War, which has been going on for eight years and is the last death rattle of the French Empire and a lost cause to say the least. So, I'm sorry to say, I have no exciting stories about the siege that never took place. Stirling called me the next day in case I wanted to come back to London, but all the foreign press seemed to exaggerate a little bit I think. But French crises seem to follow me or vice versa. Last time it was Suez.

I still have made no definite plans for the near future, I know I must soon, but I'm putting it off and interesting things are still happening to me as usual. As usual, it is...a friend who calls me from Berlin, from Moscow, from Brussels, etc., etc. Very nice and I like him. He is a photographer for Magnum, an international news agency, and travels all over the world. When I met him the first time, he was on his way to the Congo. He is working with other Magnum photographers on a book about President Kennedy which will be out in a few weeks called the *First*

Hundred Days. If you have this week's *Life* magazine, shot when he was in India two years ago! He is also doing a book on Crete, we hope, with text by Laurence Durrell, which would be great. He speaks English as he had an English governess when he was small. He is thirty-eight, a bachelor, has eight brothers and sisters, 24 nieces and nephews, eight godchildren and has been in every country in the world. His brothers range from very very very very rich to fair and middling. His mother and father are dead. He has one sister-in-law who is Indian, another who is Chinese...a very international family. He is related by marriage (Indian sister-in-law) to the Indian poet Tagore (see same issue of *Life*) and de Gaulle (see *Time, Newsweek, Life,* etc., etc.). His family is originally from Lyons, in the southern part of France, where his oldest brother (who bottles all the mineral water in France) lives. By profession he is an engineer, went to the University of Lyons. One day he decided he wanted to take pictures so he walked off his job in his uncle's factory, went to India to learn English, became a protégé of Henri Cartier-Bresson, who is probably the most famous photojournalist in the world, and finally joined Magnum (where Bresson is also). Oh yes, this month *Vogue* too has a picture of his on Dakar. Yes, name: Marc Riboud pronounced Ri-Boo.

I haven't received suit yet. But am looking forward to same. Did you send it airmail? My address is 235 Rue du Faubourg St. Honoré, Paris 8e France. But mail can still be sent to the *New York Times.* I guess this is really all the news, Paris is lovely and springy. I am well and confused...my usual state. James is fine and working hard.

Goodbye. I'll write again soon...from some other exotic place.

XXXXXXXXXXXXX
B

May 26, 1961

Dearest Mother—

Don't say "This Marc" like that. He may be the only son-in-law you'll get. It is both Marc and I who invite you to Paris and it was Marc who gave me your Mother's Day telephone call. He is in love with me and wants to marry me. And I love him. So—

Happy news is coming. I would live in Paris, make annual trips to New York and South America, travel around the world with him to places like Tokyo, Calcutta, Ghana, Istanbul, Manila, Singapore, Hong Kong, Moscow, etc., etc., etc., and do sculpture (in Paris) and have babies (anywhere). James is part of the past. Reread carefully my last letter. Marc is a very special brand of man— a rather rare and exotic type whose personal and professional life happens to fit and flow into my personal professional aspirations about life. I think we can be very happy. I delayed in telling you because I didn't want to disappoint you in the

end—in other words, I wanted to be reasonably sure. Marc has a rare sensibility and an understanding and sympathy with me that is unparalleled in my life. He is gentle and kind, the gentleness and kindness which spring naturally from good breeding. He has described his father as a "grand bourgeois" which from what he has told me describes very well a man of means (he was head of a large private bank) who used his means in the cause of spiritual and intellectual sensibility for his children and for himself. He had great libraries as well as great houses and a close-knit family. He was certainly not a liberal by any means, but he was at least an enlightened conservative—as well as a Catholic. Marc has told only his closest friends. Henri Cartier-Bresson, a famous photographer, and his sister Françoise. I have told no one except Sheila—who arrived in Paris a few days ago, for one day passing through to New York. She was the one person I really wanted to talk to and it was fabulous luck that she turned up when she did. I now have a tutor in French and am really attacking it in earnest. You may do as you like as far as coming—July or September, but I will talk to Marc once more about it. I foresee no difficulty (or at least no serious difficulty with Marc's family—except on Catholicism, which of course is our problem, not theirs, and concerns not so much us but our children). There is one problem at the moment, which concerns Marc's older brother Jean who is very very very rich and is the one with the Indian wife. I will have to see for myself, but any rate it seems she has come between the very close relationship of Jean and Marc. And since she is loath to part with anything—a problem will arise when an agreement has to be reached between Marc and Jean concerning his father's library. Marc's mother died in 1957 and in her will stated that the library which consists of thousands of books (one of the best in France) was to be divided between Jean and Marc. Marc of course never bothered since he had no permanent place to put them and since then Jean has brought out the rest of the children's interest in the big family chateau (remember the picture of the house I sent to you) where the library is. He now uses it as a country house. Jean's wife is not going to want to part with half that library—and this is the only thing Marc and I really want—and I want it more than Marc. So it is going to be a problem. It is not so much between Jean and his wife and us, but how it will look to the rest of the family. The big break in this family came when Jean, the favorite, married his wife—a non-French, non-Catholic, non-European, non-White, non-French-speaking girl—Nothing, but nothing will ever parallel that. It was only Marc and Françoise who helped Jean through, and Jean's wife has never forgotten this. So whatever Marc and I do will really be of little consequence in that way although there is still an amazing closeness between various brothers and sisters. But although I have no expectations of being very close to Jean's wife, I should be grateful to her at least for marrying into the family! At any rate—we have to buy a house before we start worrying about books. Please don't be too shocked by all this. Life is strange and wonderful and one must take it as one finds it. Marc has been to New York

many times and comes at least once a year for a board of directors meeting of Magnum, the photo agency for which he works and is vice president. He usually spends a month or more and we will probably extend it even longer now. He also usually spends some time in the East: China or India or Japan and the rest of the time in Europe. His latest trip to Africa was in the Congo—get a book called *The First Hundred Days*, Kennedy Administration, by Simon & Schuster, out May 15th. He wrote and photographed the section on the Congo. You can get the book anywhere. There is also a nice photo of him in China—as if you don't have enough pictures. Please, please don't mention this to anyone yet. It will probably be an accomplished fact before most people know. But my only extravagance will probably be the lavish marriage announcement that is the French custom to send out. I must write to Daddy very soon. And I will write to you again in the next few days about when to come—June is Crete, Greece—but after that, anything is possible.

<div style="text-align:center">

Love Always,
Your daughter
Barbara

</div>

And kiss Grandpop. And mother, don't worry. Grandpop must know how lucky he is to have you and I am sure he will always want to see that you are taken care of. Also it is a lot less complicated to come than you think. You need 1) Apartment: Go to the Customs House at 8th + Chestnut—the passport bureau. They will give you all information. It takes about 2–3 weeks. You need your birth certificate and for you your marriage certificate which makes you an American citizen. 2) A health certificate for small pox vaccination—you get this from Customs House and take it to Dr. Ramsey (Give him my love) and he will give you two shots, a new vaccination and fill it out. 3) A ticket—That's all—By jet it takes 7 hours or 6, but with the difference in time you arrive a few hours after you leave N.Y.

P.P.S.—Plans are always changing—Changing. Enclosed is clipping from April *Vogue*. Tomorrow I am going with Marc south on a one-day photo shoot. Then we are going to "La Carelle" (the chateau of Marc's family) overnight and Sunday to see Françoise, Marc's sister. I hope the weather is good. I'll take pictures maybe. You know trying to get a photographer to take a picture is like trying to get a certain builder I know to fix a screen door—I am sending a package of postcards from my last trip south (a much shorter one). How is Bernice? Is she married? I must close now and go to sleep. I have to get up very early tomorrow morning.

<div style="text-align:center">

XXXX
B

</div>

I will talk to Marc Sunday and write to you Monday or Tuesday.

June 14th, 1961

Dearest Mother—(got your cable)

I haven't yet received your letter—but enclosed is ticket money—Actually I thought you were coming on 15th instead of first. The first two weeks you will miss Marc completely as he has to be in Greece but we should catch up with him around the fifteenth. At any rate—when I receive your letter—I will know better how to make my own plans. I am going out of Paris for two weeks but I will get your letter in a few days—the terrible thing is that our plans are constantly changing from one day to the next—a few days ago, we were with friends who have been planning a trip to Moscow for months. Marc actually opened his baby blue eyes and "You mean people actually plan trips?" So we are very used to going off to South America in two days' notice. Flying to New York for a week and coming back and it is difficult to get normal perspective on things. But that's Marc's job so . . . At any rate, things are pretty much at the moment as I explained in letter. I can't wait to see you—Is everything alright with passport etc.?

<div style="text-align:center">

XXXX

B

</div>

Dear Mrs. Chase,

I am so anxious to see you, and also so moved . . . I love Barbara more and more, she makes me happier than I have ever been—come soon and I will show you some parts of France in Paris.

<div style="text-align:right">

With my affectionate regards,

Marc

</div>

P.S.—Marc is the only person I know except you who tells me when I'm having one of my "light days" or vice versa!!

P.P.S.—Did you ever get my letter from Moscow?

July 31, 1961

Dearest Mother—

Am in Pyrenees—climbing mountains and spying on Spain! Marc is very well and sends his love. This trip is real vacation for a change. We have been here for a week—But tomorrow we move on across the Pyrenees—in one week we should be at opposite end at the sea—and story will be finished. Marc then has to return to Paris for one week then to Normandy to cover a movie called *The Longest Day*. Depending on what can be done on flat, I may go with him (most

probably) or stay. Did you see the outside of the house? There is a lot to do—we are now looking for an architect. I hope we can move in by November before we come to U.S.A. Trip to Mexico is definitely on. I think it will probably be the end of November around Thanksgiving, I hope. I still have many letters to write to various people—all overdue. I was so sorry your farewell to Paris (or rather ours to you!) was so unspectacular (just two people going down in an elevator). But I hope everything went alright and you got off sanely and safely. You must write of all your adventures after you returned to Philadelphia. What everyone did and said—and of course, your party. We may stop at Marc's brother's (oldest—not Jean) villa in the Alps before returning to Paris—if I can just do something with my hair. Did you manage to get Marie on the plane finally safely back to her husband? Both Marc and I apologize again for not being able to stay in Paris until the end of your visit. Did everything in the flat work alright—and you left the keys in the mailbox? How is Grandpop? Give him a big kiss for me. Write soon—and plan to go to Mexico around Thanksgiving!!? Do you think I could ask my father to come? Will write more of this (that is if more doesn't change his mind!). At any rate, my best to Marie to Helen to Bernice to Pat—to Janet, etc., etc. Write soon—and take care of yourself. Don't forget to go see Dr. Ramsey. Did you get a nice knitted dress? Did you manage to get to any of the fashion houses?

P.S.—SOS package received!

[MARC'S HANDWRITING]

I am taking over the pen…but Barbara writes so much better than I do… Our departure from Paris was so hectic. I have the impression I hardly told you goodbye…I wish I could have done more for you during your stay and you probably have an awful impression of me…seeing me always between two doors or two planes or two cameras!…I love Barbara more and more and your visit has given more reality to our love. It will not be very long before I see you again in the States (returning your visit…as a polite Frenchman!).

It was also so wonderful to know Marie…I am sure you are never bored with her!

My very affectionate love,
Marc

--

October 12, 1961

Cherie Maman—

Please forgive the long delay in writing—but—things have been so hectic! How are you? I finally heard from Paul and from Joyce. Joyce is getting married in December—I hope I can get to the U.S. in time—it will probably be around Christmas. So that was wonderful news, but she won't tell me to whom! The house will,

I hope, be settled this week and work begun on the redecoration, etc. We leave for Italy for three weeks around the 15th I hope. The important thing is that the date of wedding is set for December 1st—in Mexico. We will be passing through New York around the 26th or 27th of November. I wrote Daddy this in case he would like to meet Marc before we go to Mexico. Marc is supposed to do a book on Africa in February—so we may both go. Friday we are going to a party at Pierre Cardin for one of his models Hiroko (a Japanese girl and friend of Marc's) who is getting married. So I'm very excited—a chance to be your very elegant-est in Paris and have ordered a black suit which I hope turns out well with a black chiffon blouse which looks like a dress when you have on just the skirt and the blouse, low in the back with long sleeves—the suit is very simple, straight jacket with my famous mink collar—and Marc has given me the most magnificent diamond brooch which belonged to his mother, which I will wear of course and which will make the dress. I had to compromise and get a suit since to get a dress would mean to get a coat too as I have no winter coat. But several weeks ago, in order to go and spend the weekend with Marc's brother in his villa in Switzerland I got a Pierre Cardin suit (unfortunately too sporty to wear to this party) which is beautiful. For the last few weeks I have done nothing but visit various chateaus and villas belonging to the Riboud family. "La Carelle" which is really unbelievable, but which was nothing according to Marc in comparison with the mansion they had outside of Lyon while his father was living. You will see it sometime. I really can't describe it. But Marc has some beautiful things from his mother (besides the jewels). 5 Louis XI chairs (worth as antiques about $500.00 apiece), silver and dishes, Persian tiles from his grandfather, Chinese objets d'art, etc., etc. Even a mink-lining, which we can't find and I had visions of a fabulous coat—but anyway so beautiful. The trouble is—(oh yes a beautiful huge Persian rug) that putting things like this in your house, you can't suddenly put something from Sears & Roebucks!!—A problem. But I think the house will be really beautiful especially when we fix up the garden. We are going to see an architect tomorrow—Michel—remember the French architect Michel from the Medici French Academy in Rome? We received a nice letter from Marie which of course we haven't had time to answer yet, but which I sent to Marc in Africa. Marc, dear Marc is fine, very busy as usual, his Africa trip was a success—all family knows about wedding, etc., so everything is fine. And how is Bernice and Helen? Give them my love. We plan to send out announcements after wedding around the beginning of December—by both you and Marc's family. I think it is simpler. I will order them either in Paris or on my way through New York to Mexico. Françoise, Marc's sister is so sweet and is helping me a great deal—so we will probably think of a way to do it. For Paris also it has to be announced in the papers too. Of course Marc's family, which is huge, is abuzz with the news. I met the last sister a few days ago at a "family dinner." So I promise to write again very soon. Marc is in a new book that I will send you. I am

also looking in earnest for a place to work—along with 4,000 other things mainly trying to keep Marc happy—

<div align="center">

Love X X X X X

B

</div>

P.S.—Also practicing my signature:

Madame Barbara Riboud

P.S.—<u>Very important</u>—please send my birth certificate or legal copy right away!!! I need it for wedding

[no date] 1961

Dearest Mother—

Really I don't want you to get upset about the money we are spending—1) we can always get it back. I said we spent $50,000 but we can sell it for $60,000 tomorrow—2) We had no choice—for newcomers in Paris—there are no rents except very high ones and since we had the capital it seems silly to rent for $200 which is money down the drain (That's what our old flat would have cost to rent!) and after all we can't expect to sell two rooms for $18,000 and buy 5 or 6 with a garden and not spend double the money. At any rate we will probably sell it soon anyway. I am trying to figure out a way to dabble in real estate in America—we could own an apartment house for the price of this house—and I intend to look into it probably in the fall. As for the tonnage of ships—it is their size in tons and it denotes size only. The bigger the ship usually the more stable it is on the water (not affected by waves, wind, storms, etc.). But some of the smaller ships (who have two classes not three) like the *Flandre* on which I came over the first time are very pleasant. But I suggest a French boat because of the food and service. I don't know if the *Flandre* is still running (I think it has been replaced) but you can ask. It's a wonderful ship if not, try the *France* it is the last word even in third class. Usually the smaller ships are slower by one or two days—but any ship on the high seas these days is quite safe. But I would be disappointed not to see you on the *France*. It seems like such a wonderful ship. The name of the bank is Schlumberger and it is really an investment company. I will have to look through Marc's papers to find the name of his advisor—but I will send it to you in next letter. Hope Grandpop is well—and wearing his raincoat. Don't you ever give up?? I was very confused at the let-down in your last letter about house—thought it was practically decided. What made you change your mind? What does Bernice say? How is she anyway? Give her a big kiss for me...I just finished writing Marc in Abidjan on the Ivory Coast. I promise to write again soon.

<div align="center">

Love,

B

</div>

November 23, 1961

Dearest Mother—

Back in Paris again for 1 week. Your letter was waiting for me. We are very busy as usual, but very well. We plan to be in New York for about a week (address unknown at the moment) so we can discuss trip. Sheila will be so disappointed if you don't come. She is really counting on it, intends to write you herself to invite you. We have postponed for a week and half the wedding because of plans of Sheila. Her brother is getting married the same time in Chicago and she has to attend (also be in wedding) which is going to be very big with the mother and father of John Kennedy in attendance. So we won't marry probably until the 21st and spend Christmas holidays in Mexico with Sheila. So this gives you more time and is closer to Christmas. Daddy said he couldn't come, but would see me in New York. Don't worry about things to wear—it's a ranch—nobody will see you. Just a dress for the wedding which after all there wouldn't be anyone except me, Marc, Sheila, her baby and her husband, and sister of Marc. Françoise can't come because of her work so we are very disappointed. I am now looking for a card among other things with not much time. Oh another thing, can you find my certificate of baptism (I am Anglican, no?) somewhere and either send it, or keep it until I see you? I need it for the wedding if we have a religious ceremony. We plan to have announcements printed in Mexico and will probably send them from there—so start getting your list ready. I am going to wear I think my white cape dress that you made with a white lace jacket over it. Also you have a month to get your tooth fixed!! Really you should have had it done ages ago!! Maybe Marie can fix you up with an appointment. Surely he can do something temporary. Also I hope you have been going to Doctor Ramsey. I wrote him about my marriage, inviting him if he cared to come. Say hello to everyone for me and kiss Grandpop, I'm bringing him two bottles of genuine French brandy when I come. And . . . what would you like for Christmas? Let me know.

[MARC'S HANDWRITING]

Dear Mother,

How are you?
 I am happier than ever!
 Can't believe that before two weeks we will be in New York and see you.

My fondest love,
Marc

(above left) 1. Solomon Chase, author's great-grandfather, 1880s.

(above right) 2. Anna Johnson, author's great-grandmother, 1940s.

3. Elizabeth Chase-Saunders (Queen Lizzie), author's grandmother, September 1916.

4. "Colored Troops—Famous Colored Regiment Arrives Home on the *France*," 1919. James Edward Saunders (Grandpop), author's grandfather, was part of this regiment.

5. Charles Edward Chase, author's father, 1940s.

6. Barbara Dewayne's childhood residence at 415 S. 16th Street, Philadelphia, 2021.

7. Vivian Mae Chase, author's mother, 1940s.

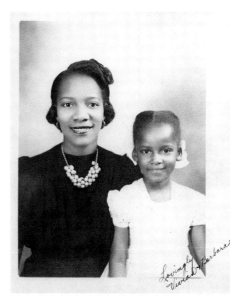

(left) 8. Three generations: Agnes (author's grandmother), Vivian Mae (author's mother), Anna (author's great-grandmother), and Barbara Dewayne as a child, 1940s.

(right) 9. Barbara Dewayne with mother, mid-1940s.

10. Author with parents, Tyler graduation, 1950s.

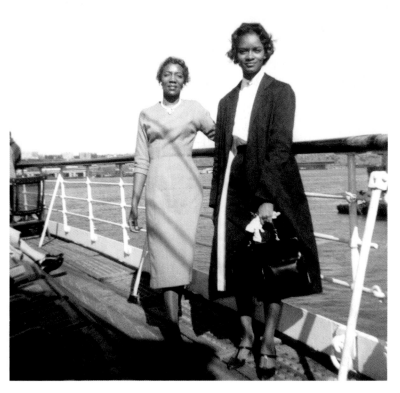

11. Author and mother, send-off
to Europe, *Le Flandre*, 1957.

12. Author with co-editors
of *Mademoiselle Magazine*
(The "Millies"), 1956.

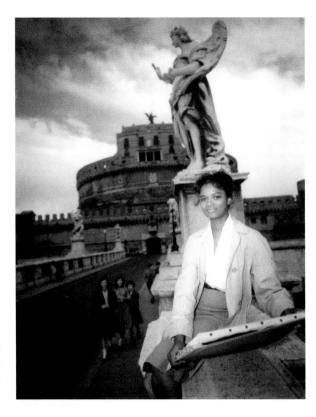

13. Author at the American Academy in Rome, 1957.

14. Author at the American Academy in Rome, 1958.

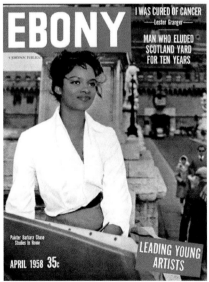

15. Author on *Ebony* cover, April issue, 1958.

16. *Adam & Eve*, bone sculpture, 1958.

17. Sir James Stirling, 1960s.

18. Jane Davis Doggett in her studio, 1970s.

(left) 19. Author in Egypt, 1958.

(right) 20. Author in Karnak, Egypt, 1958.

21. Wheaton Plaza Fountain, author's first public commission, Maryland, 1960.

22. <u>Barbara Chase/Marc Riboud wedding</u>, Acapulco, Mexico, December 25, <u>1961</u>.

23. Marc Riboud, Magnum photographer (author's first husband), 1963.

24. Antoine Riboud, author's brother-in-law, 1974.

25. Author dancing with James Baldwin, Spain, 1962.

26. Portrait of Han Suyin by Ida Kar, 1958.

27. Author visiting Salvador Dalí at his home in Figueres, Spain, 1963.

28. Author with Russian dissidents, 1964.

29. Pablo Picasso and his dogs, Antibes, France, early 1960s.

30. Author and husband Marc Riboud, Peking, 1965.

31. Author in China, 1965.

32. Author in Beijing, Manifestation against Vietnam, 1965.

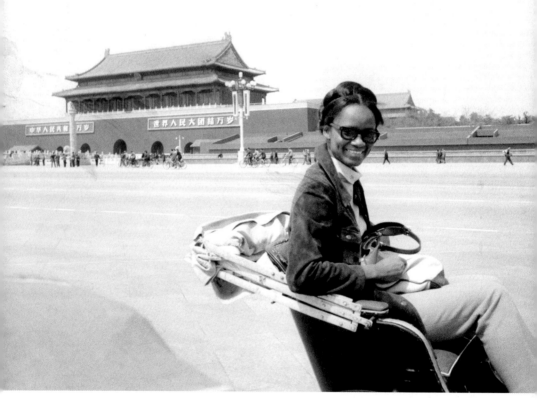

33. Author in Beijing, May 1965.

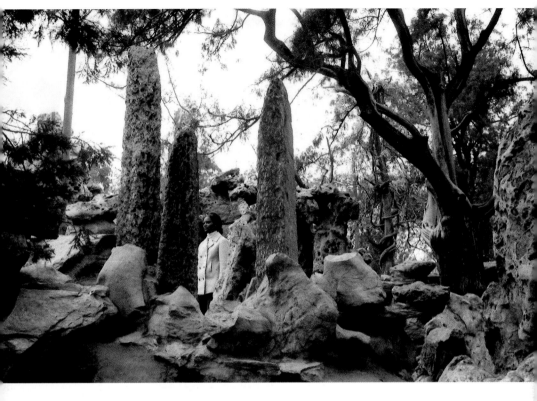

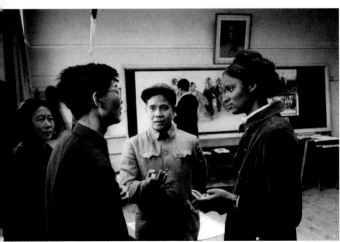

34. Author in gardens of the Forbidden City, Beijing, 1965.

35. Author in Fine Art School discussing abstract socialist art with school director and an interpreter, China, 1965.

36. Author at the May Day banquet at People's Palace with 3,500 guests, Zhou Enlai, Liu Chao-Shi presiding, China, 1965.

37. Author at May Day banquet, Peking, 1965.

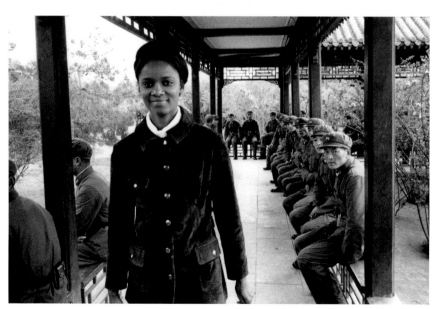

38. Author at the Peking Summer Palace, 1965.

39. Author, Marc, David, Alexei, 1970.

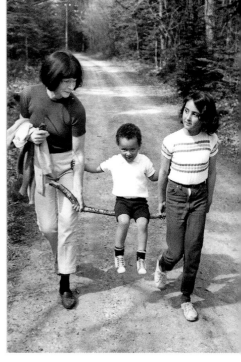

40. Sergio Tosi with Lucio Fontana, 1965–66.

41. Françoise, David, and Caterina, 1968–69.

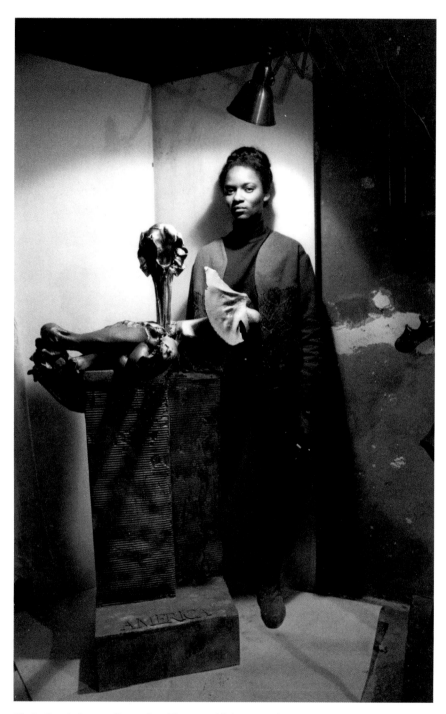

42. Author in her atelier at Rue Blomet with bone sculpture *America*, 1968.

December 28, 1961

Dear Grandpop,

Mexico is fine...sunny and warm. I am sitting beside the pool taking it all in.
Marc and Mom and I have been so lazy the past few days, we haven't moved.
I hope you got my cable. I sent one to Daddy too. The wedding was beautiful.
I hope all the pictures we took came out. The civil ceremony was at the ranch
on Saturday the 23rd with lawyers, judges, etc., in fact the whole courthouse of
Taxco plus the wives. On Christmas day at high noon in the cathedral of Aca-
pulco in a grand Spanish baroque cathedral set in the smallest town you've ever
seen was the religious ceremony—Catholic combined with the Christmas Mass
for the whole town. It was beautiful and I won't say any more until you see the
photographs. Sheila was wonderful and still is and she has a wonderful baby.
Everything went off so well and so simply even I was amazed. So Mom and me
are having a good rest preparation for hectic New York on the 4th. One thing we
must do right away is order the announcements from Bailey Banks and Biddle.
Enclosed is the form, Mom is going to pick a nice expensive-looking engraved
roman type. It could be that. But the paper must be double or triple weight rag
folded twice in an eggshell or ivory. The card inside should not be in script but
in roman letters, maybe something shaded. Also I wish you would order for me
some calling cards (sample also enclosed). It should take about two weeks or
even less. We all spent a very quiet time on the ranch just making Christmas for
Sheila's baby. Marc sends a hug and me too.

<p style="text-align:center">Bobby xxxxxxxxxxxxx</p>

1962

I n a little over a year out of Yale University, I had run away from one European
marriage only to embrace a second, propelled into the then exclusive club of
international reportage and photographic journalism. There were two revolu-
tions going on: the public one, Civil Rights, and the private one, the world accord-
ing to Chase hyphenated Riboud. There was no tourism where we went. There
were Brown people, exploitation, oppression, and often war or rebellion. People
got jailed, people got killed, children starved. I took another look at the world and
the United States with new eyes. There were still the great magazines: *Life*, *Look*,
Epoch, *Esquire*, *Newsweek*, *Time*, *National Geographic*. They printed the photo-
graphs Marc took, which filled up my passports both American and French with
visas and entry stamps from all over the world. Marc's mentor Cartier-Bresson
called at 7 every morning to make sure we were awake. He once asked me when I
got up in the morning. "When you call," I told him gently.

At the same time, I was inducted into the chaos of my childhood dream of
having brothers and sisters: a mammoth haut bourgeois French family of almost
a dozen sister- and brother-in-laws, twenty-two nephews and nieces, innumera-
ble aunts, cousins, and uncles. As an only child of only children, I reveled in this
intricate network of interlocking dynasties whose tentacles in banking, petrol,
and food had spread worldwide by the middle of the twentieth century. I could
sink or swim: the Frachons, the Schlumbergers, the Neuflizes, the Boisons, the
Seydoux, the Gaumonts, the Monniers, the de Menils, the Ribouds, the clans
went on and on. The connections spread from Lyon to New York, to Texas (Jean
and Krishna lived in Paris because Jean refused to consider living with Krishna
in Houston), from Houston to Paris, from Arizona to London to Hong Kong
to Saudi Arabia. My mother had long given up trying to temper my passion for
another country or the exotic worlds I passed through, including my bewilder-
ing French family. She was happy for me yet tentative. Were they taking her place
while she was so far away?

According to my mother, Marc had metamorphosed from an introspec-
tive, shy provincial into a glamorous celebrity and I had metamorphosed from
an accidental trophy wife into an assured multidisciplined global trotting intel-
lectual still searching for answers. For her, it was less miracle than mystery as

to where she had inherited us both from. She would shake her head slowly, her dark brown curls bobbing and repeat one of her mantras about wondering where we came from.... Yet, it had been my grandmother who had set us both on the road to eccentricity; her British way and my American way both insisted on making difficult things look easy. She made her own life look serene when in fact, I knew it was a hard row to hoe. There was Grandpop, old and fragile, the divorce that despite her youth was the tragedy of her life, there was the loneliness without Queen Lizzie, and there was the loneliness without me. We had always been close, more like sisters, and now when there should have been a time of freedom and dating after her divorce, she settled on girlfriends and surrogate daughters. I began to insist that she should move out of the house and find an independent apartment or house, which she promised to think about but never did. She also never explored her Canadian roots or made any effort to find relations outside of a small circle of a few eligible men. My father remarried a woman who looked so much like my grandmother she could have been her daughter or her double. I wondered if this was the answer to the enigma of my father. His betrayal had cost my young mother her health. His new wife, who could also go places her dark husband could not, had four sisters all unmarried and worked as an executive for the Philadelphia Red Cross Blood Bank certainly without ever revealing her true color.

Meanwhile, the Riboud family took my mother to their hearts, and her amazement at this huge family as crazy as any Brits she had ever known kept her constantly with news, events, births but always 3,000 miles away. Vivian Mae realized finally that I was never coming home. The world was my home and would stay that way. I myself was absolutely mesmerized and seduced by these human and family interactions even to writing little notes to my in-laws trying to sooth feuds and arguments that as in all grand families had festered for years. For me, it was an exercise in psychology, diplomacy, and seduction. As far as I was concerned, there could be no family feuds. It didn't rhyme with my vision of familial happiness. What did it matter if one brother had gotten a larger piece of chocolate cake than another forty years ago? Why should Sylvie and Michèle complain about each other's sons—the doctors—over something that had happened ten years ago? What were those mysterious rules that governed siblings? The political drama of Françoise winning the mayor's municipal elections of the village by one vote over her brother's candidacy, which had been a family tradition for centuries, raised the specter of a great nineteenth-century family saga by Thomas Mann or Gustave Flaubert.

My favorite brother-in-law was Antoine, an extroverted business genius who became famous for having conducted the first hostile takeover of a publicly traded company in France—a shocking operation that was "not done" in European family business circles. One of my numerous sisters-in-law was Krishna Roy, an Indian Brahmin from New Delhi, a little darker than I, raised as a Christian, educated at

Wellesley on a scholarship and a niece of Rabindranath Tagore, the Indian Nobel Prize laureate in literature. She and her husband Jean were the ones who had taken over the family seat of La Carelle in the hills of wine-growing Beaujolais south of Lyon before my time.

Marc took me there for the first time to show me where he had grown up. It was a vast, 300 hectares or so, domain of farms, timber forests, vineyards, and a nineteenth-century chateau of uncountable rooms and enough clean linen according to his mother's records to last a year. Every spring, the family of parents and seven brothers and sisters would move from their winter apartment in Lyon to an intermediary mansion just outside the city, and during the months of July and August, again to La Carelle, their country house in the hills of wine growing. Marc hadn't told me anything about his family, as a matter of fact; except for Cartier-Bresson and Françoise, I didn't know anything about his background before we were married. He took me up to the crest of a hill where I could see the pine forests and the farms and the chateau and said, "Everything as far as the eye can see is all Riboud...." I smiled up at him and then I let out a guffaw that echoed across the gorgeous hills and valleys then returned to us, rejoining my husband's giggle.

I was reminded of the first trip we had taken together to cover a concert of Pablo Casals, at the Prado in Spain for *Life Magazine*. The maid in our hotel came up to Marc one day beaming, "Oh, I know who you are," she said excitedly peering to the right and the left like a spy. "You're Peter Townsend! But don't worry, I won't tell a soul," she said squeezing my arm. "Your secret is safe with me...."

"Your secret is safe with me?" I laughed as she slid by with a shy smile.

"I wonder," I said to Marc, "Who she thought I was? Princess Margaret?"

"We were supposed to be incognito," smiled Marc, his eyes crinkling.

I gazed up at my good-looking Frenchman. What did it mean to be French? What did it mean to be American? What did it mean to be a hyphenated American? And what did it mean to be this kind of American—an American of color in Europe? I had realized since being in Europe that perception was everything. The reality behind it didn't count for much. People like people everywhere believed what they wanted to believe and saw what they wanted to see whether it corresponded to the facts or not. In 1961, the French looked at me and saw either an African princess or Josephine Baker's daughter. I could never be perceived as an architect. I knew my husband intimately, who he was, what he did, how he thought, his shape, his height, his tastes and dislikes, his capacities, his family, his fears, his ambitions but did I really, I wondered? Was my assurance about Marc any truer than the maid's conviction about his being Peter Townsend? Given the circumstances, I wondered what luck I would have convincing her that I was really not Leontyne Price...and what made this family so sure I was so uncompromisingly American—"La petite Americaine"—the French called me—a fact of which my own compatriots were not at all sure. I was very young. I had been born in the United States. But most of America would have difficulty cataloguing me as "typ-

ical American" for only one reason, the color of my skin. I was an American who was beginning to feel French, who had a French passport (besides my American one), who was bilingual, multiracial, and who joined the long line of immigrant artists Americans insisted on calling "expatriates"—a word I detested, because it meant either you loved your country and never left it or you left it because you detested it. There didn't seem to be any compromise, no hope of self-definition. I was now and forever *la petite Americaine*; I bowed my head.

It was a mystifying experience if ever I had one, walking back toward La Carelle. We cut through Krishna's zoo, filled with uncaged peacocks that screamed at us in their high-pitched voices as we made our way hand in hand through the thick forest. A few weeks back, "uncle" Maurice Schlumberger had given a garden party for 10,000 people at his house in Haut Bois near Marnes La Coquette. He had chosen that date because it was the most favorable date for his rhododendrons.... I smiled at the memory of the biggest party I had ever attended even in Venice.... Life was certainly full of surprises I mused, looking down at my tall rubber boots as a farmer passed and doffed his hat.

Change was surely my middle name, I thought. First the brothers' wide knowledge of the world, their assured place in it, their passion for what they did and indeed their world excellence in what they produced had given me new standards. Marc, like Albers, had become as much an instructor of the world and the worldly as a husband and instructor in "color studies" at Yale. There was quietness under his volatile French charm that somehow reminded me of Grandpop. The difference in age gave him a kind of gravitas like that of my grandmother—a natural authority and his experience of the real world, while it educated me in international cynicism and political *savoir faire*, also served as a shield of safety from which I could forage into aesthetic and intellectual forests I would never have ventured to explore on my own.

Near the end of the year, I took my first trip to Russia, and as a result got my first look at Eastern Europe and the Berlin Wall. The sight was chilling. It was twilight, and searchlights already roamed the thick, desolate, brick, concrete, and barbed-wire wall, at times catching small animals in their glare: moles, squirrels, and rabbits, and even a fawn. On either side lay a no-man's land of ragged empty space, the wilderness in the mire of American machine guns on one side and East German machine guns on the other. A rabbit got caught in the searchlight, pink eyes glowing, and an East German guard shot it dead—probably for stew, while the American army guards shouted that the rabbit was in the American zone.

East Germany was wretched, but I didn't care anymore for Moscow, which was dark, dirty, and gloomy. The floor concierge in our mammoth hotel was sinister and prison-guard-like. I was sure there were hidden microphones everywhere. I hid the list of Soviet dissidents—poets, abstract painters, writers—we were to contact and photograph whose names couldn't even be spoken aloud, including a great female poet Anna Akhmatova I longed to meet.

There were also Africans at the Patrice Lumumba University in Moscow. The Russians loathed them except when they worshipped them as Soviets, revolutionaries, and anti-colonials, explained one engineering student we talked to who sniffed at the "superstitious Russians." He had been traveling in winter on the Trans-Siberian Railroad with his pregnant wife when she went into labor and the train had to stop at a small village in the middle of nowhere. As African infants are often born light-skinned and darken only after two or three weeks, the villagers thought the pale-skinned newborn was a miracle and brought gifts to the clinic like a procession of wise men from as far away as Kief. As the couple left within the week, the villagers continue to worship the miracle. After having a good laugh at the expense of the Russians, the wife added, "If we had stayed much longer, they would surely have kidnapped the baby and eaten him."

I wondered if I could tell my mother the baby Jesus story in a police state censored letter. I decided not to. Depressed, I consoled myself with Iranian caviar for breakfast, lunch, and dinner.

January 23, 1962

We are getting all our furniture from La Carelle the beginning of July and foresee a big fight with my brother-in-law, Jean, over the books. I spent a very nice weekend in the country with some new friends of mine. A *Vogue* photographer and his wife and a journalist and a psychiatrist who is quite enamored of me—claims I'm a witch. His specialty is the study of mystical manifestations like spells, possession of the devil, hallucinations, voices, voodoo, etc. He is quite fascinating and funny—being Italian. So now I have my own private hand-kissing psychiatrist "on call." So between Marie-Anne Poniatowska and Franco and Sheila I'm beginning to have quite a collection of "witches." He has promised to do my horoscope for me too, which should be interesting. I was so sorry to hear about Mrs. Parker. I think what you said about finding me "quite an unusual daughter for you to give birth to" was quite sweet. What do you mean!!! Goodness I'm not *really* a witch. Marc, I am happy to say, is in wonderful spirits—still nervous, but you know that's the way he is, but healthy and strong and in love and ready to conquer the world. And so am I...I have found a maid who comes every day and is much better than the other one (smile) and we just finished the new bathroom in the old flat Rue Monge, just as we're moving...We took out the wall between the toilet and the shower and made one big room put in a bathtub and a new washbasin with a counter and a "bidet" you know, the thing you wash your "feet" in and painted everything white. It is very pretty. I have to do a lot of reading over the weekend since the story we have to do Monday in London is on Bertrand Russell, the philosopher who is against the atomic bomb and makes all these sit-down strikes in London—and I've never read a book of his!! Which is rather

embarrassing. I wish Joyce were here. How is Elizabeth and all my cousins? Maybe you can take Marc to visit them in July—without me it might be fun… He can learn the Madison, which is just now reaching Paris and is the new rage. I'll let you know exactly when he is coming, after all it's almost as good as me!!! Or maybe even better. I'm still having trouble keeping my hair decent. I have lost my hairdresser (he went to the Opera!!) and the only other place I know of is Caritas' which is very expensive. The wife of the president of the Ivory Coast (did you see *Time Magazine*) goes there but it costs a fortune. I bought a beautiful orange dress and jacket original (model size) from Nina Ricci (which I haven't shown to Marc yet as it is being altered) but it is beautiful and so well made. All the fashion houses (like you went last year too dear) have sales of models clothes twice a year. And this is when I buy all my clothes. Clothes are so expensive in Paris it's horrible. There is no equivalent to Blooms or Lord + Taylor where you can get good things at reasonable prices or even Wannamaker's. Everything is either very cheap or very expensive but you know this very well. But I discovered like everything else in France you have to know where to go. No news from Daddy at all. I guess things are all right. Marc's family are all ok except for one little nephew who caught his finger in the door and almost severed it. We are still waiting to know if he will lose it or not. I close for now. Weather is better but still not perfect. Jean told me it was very hot in New York so it must be the same in Philadelphia. And don't worry no matter what or how you do what you do in life people are going to stick their noses in where they don't belong. It's amazing no matter how much I tend to mind my own business people always want to do it for you.

Love XXXXX
B

February 9, 1962

Dear Mother,

I have arrived here in good shape after New York etc., etc. Nothing has happened on the house which is, to say the least, very discouraging. Marc is set to leave for Africa next week which also doesn't help my spirits very much. I am set to plunge into French without much confidence at the moment that I will ever come out speaking the language. I got by with no overweight but only because the man at the airlines was so nice. I am including the list of people for the announcements in U.S.A. and have still to speak to Marc about announcements here. The weather is warm but gray and it seems I have so many things to do but no energy to do them with. We also saw the architect yesterday which was not very cheerful either. Marc had cleaned and changed around the whole flat when I came back.

What a surprise! I was so glad to see him—he looked very well taken care of. He seemed glad to see me. I haven't called or seen anyone yet, but I realize I can't hold off much longer. We must have dinner with some in-laws this weekend and I will probably go to Lyon for a few days when Marc leaves for Africa (he is supposed to leave next week).

<div align="center">

Love always, be good

B

</div>

P.S. Marc says he received your letter and was very touched and happy to hear from you.

February 15, 1962

Dearest Mother,

Thank you so much for the Valentine card. Marc loved it, and please forgive us for the long silence, but we have moved and it was such a mess on top of which Marc had a big job to do, on top of which nothing was finished, etc., etc. So we are just now seeing our way clear and Marc's preparing a trip back to Africa the beginning of March. So it was pretty hectic plus things weren't going too well altogether. But Marc was so pleased and happy to see you looking so well and dressed so well. Of course we expect you here this summer any time after April will be all right. Make your reservations by all means and by all means go by boat and if you can, get a French boat. I hope you have done it already. I am working hard on a possible commission to do on a fountain (bigger than the one in Washington) in South of France for a big wool manufacturer. The decorator is a friend of Domenico's and works a great deal for the Rothschilds. So this may be a big opportunity. I must say Domenico does turn up at the right moments. Also I heard from the girl who is going to Africa with Marc as his assistant (paid by the publisher of the book) that another friend of mine, the Irish poet I met in Rome, is coming to Paris. It seems she has met me in Rome and knows several good friends of mine there. So there, it is a small world. I hope Grandpop is better. As for your plan (either of them) I generally approve and so does Marc—although I think what should be planned is something that will bring you income a little later on and not just a place to live. Grandpop is surely going to leave his house to you after all these years and this turned into two apartments plus a house of your own with one plus a little for me would be enough for spending money and the normal monthly bills. This is what I have in mind, but it will take a few years yet. But if you feel you really would like a place to be by yourself, take up the offer of Dad—it is a compromise but until you can have a place of your own it would do and since it is right around the corner you wouldn't be disturbing Grandpop's needs at all. I know it is very difficult and I suppose you should talk to Daddy about it too. I got a letter from him yesterday. Most important of all I have found

a small atelier on Rue Blomet, number 48 in the Montparnasse district. It is very close to the new house and therefore very convenient. Still problems with the house, which moves like a slow-motion nightmare hell. That's life. Neither Marc nor I in the best of spirits, but it is because we both need to work.

I promise to write this evening more than a short note—but I want to get this off as soon as possible. You'll be bombarded in a few days. You know us—it's either feast or famine. I laughed and laughed at the article on the dancer Frances Jimenez. 23 my foot!! She's 29 if she's a day—and I should <u>know</u>.

<div style="text-align:center">

Love X X X X X

Marc and Barbara

</div>

April 12, 1962

Dearest Mummy,

Please forgive the long delay—received your cable yesterday—Marc just returned Sunday morning—looking very well, healthy, tan, happy. He is very well. I have been involved with the problems of the house—and so on—a little depressed mostly because Marc wasn't here. But now I am fine. The house is all settled and work has begun. We added a new room plus the three on the 2nd floor so it is now a very workable size. It will be very expensive as I have discovered—but very beautiful in the end. So I am really obsessed with everything concerning the house, glass, tiles, furniture, drapes. The present from "the girls" sounds wonderful—but I haven't received it yet. They really shouldn't have—something so expensive! I hope I can get it through customs without too much duty!!! Poor Grandpop—why is he still in the hospital? What is wrong? What can I do??—So far away. I miss you. Sheila flew (literally and figuratively) into Paris yesterday. I am always so happy to see her. She said she received a wonderful letter from you. She is very well, traveling, the baby is in Chicago with her parents and she will probably stay in Europe for four or five months. So we had dinner together last night and today we all went to an exhibit of Mexican sculpture and art which is in Paris now. Tomorrow will have lunch and gossip for two hours. She looks beautiful. Since she arrived in New York shortly after I left and knows all the same people, she can tell me everybody's reactions and comments on my visit, etc., etc. Everyone is trying to find out just WHO I married and just HOW rich… (impressed with my diamonds and Chanel suit). I will really get an earful tomorrow. Well, the 29th Marc and I leave for Majorca (Spain) for a week to cover a convention of writers (all the most famous writers—Gould, Durrell, Moravia… will all be there—I am very excited) where they give the grand prize for the year. Majorca will be wonderful, beach and warm and sunny and the affair elegant. So this is my reward after Africa!! Marc shot some good stories—two for *Saturday Evening Post* and one for the *London Sunday Times* (Antony Armstrong-Jones,

Earl of Snowdon...). He is now busy editing. But really he came back with his little head full of racists' propaganda. It must have been hilarious for him, listening to all these White farmers complain, etc., etc., knowing to whom he was married. He said that if he had told any of them the color of his wife, 1) they would never in a million years have believed him and 2) they would probably have shot him on the spot. I don't know what we will do, if anything for Easter, since we are going away the week after. Spring hasn't come yet to Paris. It is still cold, gray, and rainy. But I hope during the next week, the weather will break and the sun will come out. Another friend of mine (really a friend of Harley's... remember the architect I had the crush on at Yale—NO not Stirling...before that), well, he introduced me to a friend of his, a Colored girl (very pretty) married to an Austrian-Jew. She came to Paris a few weeks ago complete with the most adorable six-month-old baby...and we have had lunch and dinner. I started to borrow the baby to take to the airport to meet Marc when he returned, but considering how delicate he is, he would have probably fainted dead away and what would I have done with him in the middle of the airport? Anyway, she is coming to dinner tonight with the baby. But what courage...to travel and work (she is a singer) with a small baby...in hotels, etc., without a nurse or anyone. Anyway her husband is due to arrive from the U.S. next week. But what a beautiful baby, really a dream. Well, if Marc ever stays home long enough...Other than worrying about the house, white-washing the atelier and taking French driving lessons, I haven't done anything. Claude and his wife Jacqueline (designer & architect) were very nice to me while Marc was gone, they have moved into a huge very nice flat on the Ile St. Louis. I haven't heard at all from Shirley or Paula and Pat, I wish you would call her, I sent a little thing for the baby and I haven't received any acknowledgment and I would love to know if she has received it. It was a little smock—so sweet—all embroidered. I hope she got it, but it has been months since I sent it. Also is Felmar still coming to Paris this summer? Unfortunately, the house is going to take ages...six months!!! We will be lucky to move in September and it will probably be November!! Not like the good old U.S.A. And speaking of houses—no letter from Daddy. Is he alright do you know? I'm glad he got the pictures we sent. Everyone thought they were so wonderful. Mummy, you must forgive me for not writing, I really have no excuse. One gets involved in one's own little problems (this time the house—I was really upset when I found out how much it was going to cost) and time goes by and on and on. I promise it will never happen again. I will let you know as soon as the present arrives, it will probably be quite a while if it has been shipped by boat, but I think I should write the thank-you notes when I receive it so I can be specific. Again, it was so nice of the girls to do this...really. The final plans of the house make it much larger than before. Of course there is still the problem of my studio—no leads so far and everything is so expensive. But I keep trying. I bought one everyday suit for spring but I don't intend to buy anything else. I'll wait until the Pierre Cardin sale

this summer!!! Also we are making a special place for your present—glass shelves beside the fireplace. Well, c'est tout, as they say in French. And how are your French lessons going, by the way? I expect to be getting letter soon... I'm glad that Helen is now doing your hair—the French way I hope?? Give her my love. Also Bernice and all the "girls." I love you. So does Marc. So does Sheila. So do we all. Be brave and be good as always. I wish I could see you.

<div align="center">

Love,

B and Marc

</div>

P.S. Buy a new hat!!! No, never mind... I'll send you one. There are some beautiful ones at Printemps.

June 18, 1962

Dearest Mummy,

Received your last letter and was so happy to hear from you. The package with the present has finally arrived. I must go tomorrow to pick it up and I will write the notes right away. Everything here is fine. Marc just got back. We should be off to Moscow in a week or so—but I will be here on the 29th when you come. I will meet you at the airport. I have decided to start doing my hair myself. It is still my biggest problem and Marc is so funny—the house is moving very slowly, but I really can't complain I feel about ready to get back in the swing of things—I've been having such a lovely vacation-honeymoon. Many plans for the next five years including a little one or two and another house. Marc gets more and more wonderful every day. Went to a wild garden party a few weeks ago and met some of his more distant relatives—aunts, uncles, cousins, what a crowd—the word "Lyon-nesque" in French is the same as Boston-ish in English. Nothing else new, trying to get a wardrobe together for summer. Haven't heard from anyone. One thing I asked you a long time ago was to find out if Pat got the little dress I sent the baby. It was months and months ago, and no word from her. Finally saw the *Ebony*—where do they get their information? I will write. It's very amusing since the editor of *Ebony* in New York is a friend of Marc's (they met in Africa, shared the same room) who of course doesn't know we are married—it will be a big surprise. Maybe he'll get shot by the other side! I can't believe I've been married really six months already. Amazing isn't it? Well, will write again soon. Marc sends his love always and of course we are planning for you to come to see us next year when the house is all finished. The fun part of choosing furniture, linen, silverware, rugs and stuff is about to begin now that the horrible part is almost over.

<div align="center">

XXXX

B

</div>

July 23rd, 1962

Dearest Mother:

I hope you are well. Marc is out of Paris as usual but he is very well and sends his love.

We have very happy and beautiful news (no, not a baby) but Marc and I have talked it over and have decided to buy a little house for you in Philadelphia (if you want to stay in Philadelphia) or anywhere else either to live in or to rent so that you will have a place of your own. I was very upset that you were thinking of leaving home and renting a place on your own as I know very well that when Grandpop dies he will leave you his house—after all the years of taking care of him, he has no other choice morally. At any rate, this does not concern us happily at the moment. Grandpop is going to live to be 100. The exciting thing is that we can really do something if we just have a little imagination (and money) and try to find something. I, of course, was thinking of Society Hill because Marie's daughter had told me that she had been thinking of buying a little house (on other side of Broad Street) of three or four rooms for I think 6 or 7 thousand dollars. This would be possible. It would be a good investment as real estate prices are bound to go up and also if you wanted to make a little shop or some-thing, it would be a good business address. What does that doctor say about your continuing sewing if you didn't have another job and if you could find someone (a little girl from Sak's or someplace) to help you later on . . . ?

Maybe with this new medicine you would be able to do it—it sounds so wonderful. Talk to Dr. Ramsay about it. It would be wonderful to make what you've always wanted: a little shop of custom-made clothes, very snob with a good address where you could have a small flat above and rent the flat or just keep it to stay in from time to time. It would make us so happy to be able to do this for you—because it is because of you that we are so happy—that I exist at all for Marc and that I was able to find Marc in the first place. So you deserve everything we can give you. Remember what Marc wrote in your *First Hundred Days* book. He really feels this way and we have just made some unexpected money on the stock market, Marc's work is going well and he was so upset that you were so unhappy—we really had to figure out some way to help you. Don't you think it is wonderful of Marc?

Well now, there are lots of things to do—First of all I want you to get hold of Dick Watson (Joan's husband). Call Paula if you have to because they have moved from German town to Society Hill, but maybe you can just find him in the telephone book. He would have an address downtown. He is very much involved in the redevelopment program in Philadelphia and knows exactly what is going to be developed and what isn't before it is public knowledge and he may

be able to help you especially since he has bought a house there himself (of course three years ago was just the right time to buy). Tell him what we have in mind and see if it is still possible to find something cheap. I am sure also that we will have a problem of housing discrimination—but then we have little ole Marc. We may not be able to show our brown faces. But Marc can probably do it through his bank in New York or through Magnum New York so this is no problem. Tell this also to Dick. Also go to see Brown Real Estate and find out what's up on the fringes of Society Hill (get approximate locations from Dick but it is roughly between 30th and 18th Streets and Race and South. He just may have something that Dick thinks may have possibilities in five or six years. I am going to write Dick who's now in Geneva about this little house he was interested in and where it was exactly. Also call Marie. Tell her what we have in mind (I know she is so involved in her own neighborhood) but there are two things: one this would be my second choice for location of a house and two—if you do decide to start a little shop or something Marie may be interested if she is tired of working for her dentist. My third choice is maybe something in West or SW Phila which would be bigger maybe with a little garden where you would really be quiet and very pleasantly located. This is absolutely up to you, but in terms of investment, it offers the least opportunities. If after seven or eight years you want to move to a quiet neighborhood something in center city would bring twice the price it is now if this redevelopment continues. But I would certainly look into price and sections to find out exactly what is possible. I think if you have something of your own even if you don't live in it, it will change your attitude toward Grandpop and living at home. I know it's the feeling of helplessness and dependence that is frustrating—well, the only thing that cures that is money. It would be very difficult to leave Grandpop, but not impossible even if you stayed one or two days at his place and the rest at your own. Or even came once a day. I know Grandpop doesn't ever show it, but he needs you and he loves you. Grandpop is old and he has to have somebody to take care of him. If you like, talk the whole thing over with Daddy. Certainly he would be involved in the work on the house and he might have some ideas. But as far as buying something near Grandpop, I don't think it is worth it and besides it's depressing.

Marc is arriving August first in New York so he will call you as soon after he arrives as he can and you two will talk about it. Try and get some information ahead of time and try to arrange that Marc meet Dick. I wish I could come. Maybe it would be worthwhile to come to help you because Marc is going to be very busy, but August is vacation time so I don't know how much we could accomplish at any rate. You will have to do a lot yourself and probably it will be January before we can get anything settled—you may not be able to see everything yourself—this we will have to find out about ahead of time. But try and get a hold of Dick and also Harold will help you—he has a car and can take

you around. I know he would do it for you. Tell Dick that Marc and I are looking around for a little property to invest in for you on the fringes of Society Hill in a section that is slated to go up not down and does he have any ideas or a good agent or a good contact. The best would be to find something with an agent. The most exciting thing for me is the idea of a little shop for you where even if you didn't make much money, you would be quiet and comfortable and chic and could do what you like—and of course with a house and a shop a man automatically follows in this day and age. In six years you may not only be a grandmother (I hope) but also a bride!!! But I feel so helpless sitting on this side of the ocean not being able to help you. But you have lots of friends (who used to be friends of mine) to help you. Talk to Needleman and to your bank. Talk to Daddy and to the several Negro real estate operations in the neighborhood, talk to Marie, Joan, and Paula, talk to Dr. Ramsey (kiss him for me) about your health and about my idea of a little dressmaking salon made-to-order shop. If he thinks it would be too much or not—Sometimes things that would be too much are easy when you are happy. You would certainly have to have someone to help you.

Well this is my news for today. Marc will call you in about two weeks and give you a big kiss for me. Please write back special delivery to

> c/o Françoise Riboud
> La Bergerie
> Ouroux
> France

I am leaving Friday for the country to visit her and am meeting Marc there coming from Geneva. Be well and try to be happy. Think about your little house...til I see you.

> XXXXXX
> Your loving daughter

--

August 19th, 1962

Marc and I are in the country for a while until the end of the month, very well. Marc is home safe from New York. Please don't worry, as I guessed Marc felt he didn't really have a chance to speak with you while he was in Philadelphia. He said you were always with Marie and afterwards Daddy came down and he didn't think he should bring up the subject. You know how shy Marc is and he seemed to think this was a very personal matter and he was rather embarrassed to speak of it in front of others. So, I suggest you keep looking and in January we will have more time and privacy to go over it together. I would never have written you if I hadn't meant every word I said, and you know Marc well enough to know that he would never have allowed me to write to you otherwise.

Everything takes time and everything will be arranged. Especially with Marie and Felix, Marc had no idea that you had spoken to them about our project there was a slight confusion. Anyway, I promise you everything will turn out. I hope you are keeping well and making plans. The country is beautiful and Marc is getting a good rest. When you come next year you will come with us—see enclosed—one is La Carelle, the other is Françoise's house. Give a kiss to Grand-pop. Write soon. Bernice gave me your letter to read. You can't imagine how restful and quiet it is here. We should be leaving for Moscow in September. Marc kisses you and says not to worry!!! Françoise is in Spain for the month. And we have a friend visiting us and a cook to take care of us—

XXXXX

September 5th, 1962

Dearest Mother:

I am glad to hear you are alright. I reviewed your last letter also the one sent to Marc at the office. He thought you were crazy—"Why didn't she ask you for money if she needed it?—and why five dollars, why not eight or seven?" Needless to say the reason you sent $5 never occurred to him. I thought you were crazy too. We don't expect to receive any money back. We were just happy that it happened to be there when you needed it. Besides, we can't cash it anyway—so forget about it.

Sorry to hear Grandpop is not well. I intend to write to him soon—and Aunt Rose. Call Joan Watson [...] and see if you can find Paula's telephone number and then call Paula. I am worried about her. Neither I nor Shirley, nor Betty has heard from her. Joan's address is 255 Meehan Ave. Marc is still in Tanganyika. He will be home around the 15th. The house is at a standstill at the moment. We are waiting for the agents to come back from vacation, etc. I have some rough plans. But finally we have decided to have a big house outside of Paris. But close enough for weekends—something with real character and something that would be an anchor for us as a family. Since we both live like gypsies most of the time. The trouble with the house (present) is that still I don't have a studio. But perhaps we will work something out. Give my best to Alma and a kiss for me. Mei Lou and her husband were here for the weekend. I saw them along with my boss at NYT for dinner. She's fat and very cute. Next weekend I'm going to visit Marc's sister in La Carelle for three or four days. I have had dinner with Claude several times since Marc left. Jacqueline, his wife, is in Saint Tropez. They both went to Russia in August for the opening of the French exhibition there. Jacqueline designed one of the pavilions. We want her to help us with the house. I am still, after all this, not quite decided about it. I don't know if we should spend more and get more (including a workspace for me)—or not. I have no idea how much money

Marc has—. He also has stocks and bonds, some French, but mostly American. He is on the other hand, more cautious than daring in using his money to the fullest advantage. And tends not to invest it—he has neither the time nor the inclination to look after it. I received a very nice letter from Marie thanking Marc and me for her trip. She said that she hadn't seen you, but that she would very soon. I also received a letter from Shirley. She may be able to come to Paris; there may be a job at Magnum in a few months. There is a great deal of difficulty at the moment. but I hope in the long run, everything turns out alright—everything falls on Marc's shoulders as vice-president. I hope nothing happens to Magnum as Marc would be lost without it.

I wish I could do more for you now—like send money, but at the moment things are very disorganized. Afterwards, I'm sure that I can—Marc is very generous and we spend a lot of money—But I hope soon to be making some money of my own—I still owe about $900 which I haven't told Marc I owe—$300 to Daddy, $300 to a personal friend, and a long-term loan from Yale of $300. Marc paid my foundry bill of $500, transportation of sculpture of $150, and a bill at Yale for $200, so the rest I'll have to do myself. But the only way to do it is to work day and night.

It is hard for me to know what to say. I have always felt guilty about keeping you and Daddy together for so long when you should have been apart when you were younger and had more strength to start again. It would have been just as hard for Daddy to begin again if he hadn't had a readymade situation to fall into—and it would have been much easier for you if you hadn't had a readymade situation (i.e., Grandpop and that wretched house!) to fall into. Now it is a very difficult situation—Grandpop is old and sick and needs someone to take care of him. But he's not as helpless as all that. Maybe if you left, he would find a way— Miss Ella or someone else, but one never knows for sure if this would be the case. But it is not too late. It is never too late if one has courage. I don't think anything good can ever happen to you in that house. I hate it myself and I always have. I have always regretted not making an issue out of it when I was young because I could have forced us to move—I know that and everything would have been different. But that was the main reason I couldn't live at home. It wasn't you; it was the house and all the unhappiness it stood for. I think probably Grandpop will leave you the house—if he doesn't he just should!! After all you have done for him. I know you can't do anything in this world without money—you wouldn't get much selling the house. But with what I could give you, you would be able to buy another house with a shop in some other city—Baltimore maybe. But of course Grandpop will probably live for a long time—and you are still a young woman. Give me a little time and I think we will be able to work something out. At any rate, don't give up—and don't expect to find solutions on TV!!! I could name you 20 women I know personally—some younger, some much younger and some older (Marc's sister for one) with the same problem—it is the problem of

money basically (some have it and some don't) it is not the problem of laziness.
Write soon. I love you. Kiss Grandpop for me—

 Barbara

Marc sends his love always—

October 18, 1962

Dearest Mother,

Please write and tell me how you are doing. And please it is urgent you send
details about this house you mentioned—is it still available—and the terms. I have
spoken to Marc about it and he is interested. We are ready to start things mov-
ing if it looks like a reasonable deal. When I think about the difference in prices
here and there, my goodness. I must also write to Daddy as I haven't lately and
I don't seem to have anyone's address like Helen or Bernice and I know I must
write to them—so please send again their address. I know I had them for the
thank-you note for the silver but I can't find it. Marc read all your letters because
I think he should know everything. He loves you so much, my goodness he cried
more than I did!! I must admit I was terribly shocked—just coming back from
Russia and finding all these letters. But I hope that Grandpop is better and out
of the hospital. Marc's trip to Cuba is still up in the air. He is planning to go with
a friend K. S. Karol here—and if we do something about this house you found.
I won't be able to come with him—but we are still planning a trip for you this
summer here. The house is moving a little bit better. But you know how costs
mount and mount. We hope to be in by Christmas. I am also writing Dr. Ramsey
now especially to thank him for taking such good care of you. Please write special
delivery or wire about house. We await your reply and remain always your loving
son and daughter.

 Barbara + Marc

P.S. Just spent a wonderful weekend at "La Carelle" (did I tell you) visiting Marc's
sister Françoise who runs a children's home on one of the farms attached to the
estate which she started during the war. It is really as beautiful as it looks in the
picture—and is really a whole valley with about ten farms. It must have been a
wonderful place to grow up in, beautiful landscape—Marc got very excited being
back. Jean and his wife who use the big house as summer house only come in
July–August and to imagine one person who bought out the rest of the family
owning all that land—besides since I had never seen a cow or a lamb etc. etc.
close up—it was really fun. Marc thinks I'm terribly ignorant (I thought strawber-
ries grew on bushes!!!) according to my complete ignorance of the ins and outs of
farm animals he doubts if I even know where babies come from—(I do). Anyway

they (Françoise and Marc) are determined to educate me. French is coming very slowly because I am having difficulty concentrating and finding enough time to study. But I have high hopes—I have Jan. 1963 as deadline and I just hope some big surge of energy inspires me to make it by then since Marc is under the impression that I am intelligent. You should learn a few words yourself—

Love,
B

P.S. I will get your letter tomorrow—It is being sent from Paris.

October 25, 1962

Dearest Mother,

Things have been hectic since we came back...reason for the delay in writing. Everything is going wrong with the house, but other than that, Marc is in good form and I am tired but in good fighting spirits. Sheila is divorced and has just lost a baby (the second which was born prematurely). Very sad. She is in such a mess and is all alone in Mexico with Itaka. I am tempted to come see both of my little family to make sure that everything is all right. It seems that there are hard times ahead for all, but I hate to see the two people I love most apart from Marc in difficulty especially health wise...a thing which as you well know terrifies me. But Sheila has a huge fight on her hands with her former husband who wants complete control of Itaka. I haven't written Dr. Ramsey for lack of time, but I will send a note off today for sure. Please send more information on this duplex you found and price in a separate letter so that I can discuss it with Marc. It sounds good. I hope Grandpop is well. I haven't heard from Joyce* since her last letter to me and mine to her. So I don't know where she is or if she is divorced or not. Françoise is very well and is coming this week to Paris. I will be happy to see her. I don't know how long she will stay, but at any rate she plans to move to Paris in the near future which will be very nice. But since she has no profession, it will be very difficult for her to find a job. As a matter of fact, I don't know what she could do. Something like working in a Fashion House, but these jobs are few and it requires knowledge of society in Paris and so on that Françoise doesn't have, living in the country. Ideally she should teach, but she has no certificate and no degree in teaching. It is very difficult since it was never expected that she would work in the first place and so she is completely unprepared although extremely intelligent. I caught a terrible cold in Moscow, which didn't leave until I got back to Paris, and for the first few days, I felt miserable. And then getting your letters all at once didn't help. But I was happy to speak to you over the telephone and you sounded in such good spirits. How did it work out, this week back at work? I am so disgusted with the architect, the house, and all this nonsense that is

becoming a joke, I only hope that we can get out of it by Christmas (certainly not before) and we will be able to move in. We will see. Meanwhile, remember that Marc and I love you better than anything and after all as long as we are on our feet (and Marc and I are always on our feet) that you have nothing really to worry about...except that we do not live in the USA, at least not most of the time. This makes us very sad, but once we have a house in the country, maybe you would like to live, at least part of the time, in France. But you would have to learn how to speak French? N'est-ce pas? I will write again soon. Again time is very pressing. Moscow was very interesting, but I wouldn't want to live there. I am glad I went once because of course I want to do everything at least once. Everyone here in Europe was very surprised and happy at the outcome of the Cuba thing. We were sure when Kennedy announced his blockade that there would be war or at least such a crisis...a blockade of Berlin, etc., etc. Europeans can't get very excited about little Cuba and big USA and most Europeans have to live with communism they see no reason why the Americans can't too. Except that they are spoiled beyond all description and want only what they want. Regardless of what the US papers print, Cuba is better off and is happier now than they were before...at least the poor people. For the rich...well they have all left anyway so it's a country of people who have never had anything and if now they can learn how to write and read, well that is more than they had before even if they are just as poor, and they are.

Love and Kisses from Marc.

<div align="center">Your loving daughter,</div>

<div align="center">B</div>

*Joyce Cook, editor of the *Yale Philosophical Review* at Yale University, an Oxford fellow.

November 12, 1962

Dearest Mother,

I am so happy to hear from you. Keep writing. We are settled in Paris for a while now, so it is easier to write more often. I am going to send pictures from Russia as soon as I have some printed. Marc and I think of you all the time and wish you were with us. I hope Grandpop is holding his own—I feel so sorry about the television. I know how it can get on your nerves, I remember when I was home it drove me crazy—and you must rest and be calm—I don't know. Isn't there a thing you can attach to the telephone with earphones which would be perfect for Grandpop? Daddy could be doing something and Grandpop must realize that he must help you—or he should be made to realize it. I absolutely authorize it—you must get an attachment for the television. They have them in all the hospitals. Marc and I are still discussing what would be best for the house, but I think we

should do this in person or at least you and Marc if I don't come this year—so meanwhile we send a little money so that if you need anything you will be able right away to have it and not worry about not being able to reach us or something. What I want most for you is a source of income—that is why perhaps a small apartment house even if you don't live there—might be a good thing. A rent every month of a certain amount is always a comfortable feeling. I think we should plan something along this line. Of course I realize there are taxes—as for the rest, it is paid of course by the tenants. But upkeep certainly is also an element to be considered, but maybe something could be arranged with Daddy—after all to all extents and purposes he should be paying you alimony. He is a very lucky man—

Well, the Cuba crisis seems to be fading into the background much to everyone's relief. Here in France, too, are elections in a week or so for parliament. So there is lots of activity. Biggest news here was trial of a couple accused of killing their five-day-old daughter malformed as a result of this drug thing (no arms). Surprisingly enough in a Catholic country, they and the doctor involved were acquitted completely—but the doctor in question also had the blow of having his own sister-in-law give birth to exactly the same kind of malformed baby as a result of this same drug.

It seems that politics is becoming a millionaire's club—Romney, Scranton, Rockefeller, Kennedy—a poor man just doesn't have a chance these days. It is true that America is becoming more and more anti-revolutionary and anti-democratic—but as long as Americans feel such awe and envy for wealth and power, men like Scranton have a tremendous glamour over any other person no matter how well qualified or intelligent—the symbol of success: money dazzles everyone in America even if it is inherited. But it is a little frightening when one thinks about it.

I am sending you a Russian hat for your Goddaughter. I hope she doesn't think it too "square." I don't know—I still think in terms of European children who are still children—she will probably hate it.

Anyway, I kiss you goodnight. I love you.

As always,
Barbara

P.S. I hope you don't think that we are being casual about the check enclosed. We discussed and spoke very carefully on it and what we could do. It is so difficult when we are so far away but we wanted to do something—even not being able to see you—or at least until we see you so that you feel secure and not alone and not protected as long as you have Marc and I you will always be protected. That's what we are here for. I only wish that we could be together which is so much more important than anything else. But in spirit we are together always—

The daughter who loves you

1963

My own country was in the mire and throes of an undeclared Vietnam War inherited from the French Indochinese War; the French had been defeated. Many Americans saw it as a crucible as cruel and unyielding as the Civil Rights Movement with which it collided. "Bring our boys home!" "No Vietnamese ever called me nigger." The two movements merged into one youthful peace movement. In the Black community evolving to left were the Black Muslims, creeping up alongside the Black Panther movement and the Black Power movement. The Indochinese colonial war had obsessed and divided the French for a decade, not only politically but also morally—as it would eventually in the United States—within families and generations. French intellectuals warned Americans, but they didn't care to learn from history, just repeat it.

Marc had made several trips to war zones, and on one of his last trips, he had turned to me and said, "Find us a house with a garden in Paris." This was an almost impossible feat—much like in New York City—but of course I didn't know this. When I found a typical Parisian atelier on Rue Vaugirard at the end of a tree-lined impasse with a garden that had three trees, I could hardly believe my luck. Almost the same day, I found my first sculpture atelier on Rue Blomet, and then to top it off, visiting friends in the Loire Valley, I discovered an eighteenth-century, three-building farmhouse ruin near the chateau of Chaumont and the Royal Park of Montrichard with a lake and magnificent 200-year-old trees, called *La Chenillère* because of its oak and elm trees, which became our country house.

When I filed by the embalmed body of Lenin in its glass sarcophagus in Red Square, I thought of Egypt and Lenin embalmed pharaoh-style wrapped in linen and buried in painted casket after painted casket like the Russian dolls sold in the market to tourists.

But the Russians had other ways of separating foreigners from their money. Marc and I left Moscow together—I was heading home and Marc to Prague, his plane leaving a bit earlier than mine. We passed through customs at the same time, then I waved him off on his flight and prepared to board my own, except I was turned back by the Russian police, my luggage returned to be reinspected, and I was found to have more export duty to pay—except that Marc had taken all the traveler's checks and cash with him. Terrified at the thought of spending the

night in a Russian jail for smuggling, I must have been a forlorn sight, as gray and furry as that Berlin rabbit shot for dinner. There were no more flights to Paris. "Well," I asked, "where can I go?"

"To Amsterdam," was the answer.

I had my watch. A stainless-steel Jaeger-LeCoultre. "I'll take it. Will this be sufficient to change my ticket?" I smiled my sweetest, most engaging smile and lifted my eyes to the custom inspector's. My ticket was changed. My baggage reappeared. Marc was still in midair. Cell phones didn't exist. Neither did pay phones. And I didn't have a dime to my name anyway. I took my plane to Amsterdam via Warsaw and a 12-hour layover without calling anyone until I was safely in the Netherlands. Meanwhile, I had thrown Le Bourget airport into a panic when I failed to debark from the Moscow–Paris flight. My name was on the passenger list. An American had disappeared...on a plane from Moscow, into thin air...

A tearful Françoise had called her brothers in New York, Marc in Prague had already called the French Embassy in Moscow, who already had the KGB looking all over the airport and Moscow for me. A diplomatic incident was officially in the works by the time I descended from the plane after a sleepless night on a bench in the Amsterdam airport.

March 19, 1963

Dearest Mother,

So happy to have your last letter. You sound fine. I like that crazy chair and my goodness 134 pounds! That's really wonderful. Marc is gone off to the jungle—have a cable and that's about all. He will be out of communication with everybody for two weeks—with some crazy tribe called the Barraro. He likes all that jazz—but he doesn't think I would get along very well with the savages, and he is right. I am moping around trying to finish the house without success. I am really fed up with it. But I really must before Marc comes back and start on something else. I'm not in a very good mood but I guess I'll snap out of it—probably let down after 15 months of marriage. I feel like an old lady, etc., etc. and spring really hasn't broken yet. I'm thinking of taking a holiday in Venice with a friend after Easter and probably meeting Marc in Greece on his way back from Africa on an island called Corfu—but I am spending so much money I hesitate even to go to London for the weekend. Maybe I'll go to the country if it gets a little warmer the next week or so. How is Helen and Bernice—and Grandpop? I met an old friend of mine from NY the other day quite by accident—she is working for an advertising firm here in Paris—was in London for a while. I finally have Mei Lou's address from her (remember the cute Chinese) and will write to her. Also did you write to Joyce? Please do—write on the letter please forward...she will probably get it. I also got a letter from her old roommate in Yale who is in

London and to whom I must write also. And remember my handsome architect in Rome—not the French one, or the Italian one, but the American one—Erik Svenson—got a letter from him. He has been in South America fooling around and is getting married to a German girl in a few months. Still staying around Boston I think. It was great to hear from him. Also I saw the mother of another architect friend of mine—she is Diana Vreeland, the fashion editor of *Vogue* magazine and she was here for the collections. What a card! But I really like her. We were both at a film premiere of some friends of ours, William Klein and his wife who work for *Vogue*. He does the whole Paris fashions issue in March. Did you get *Show Magazine* with Marc's cover? Please do—Also I have a beautiful baby grand piano, which arrives sometime next week—but no music. I am looking forward to it. Well that's all the news for the moment. I'll write again soon.

Love,
Barbara

[no date] 1963

Dearest Mommy,

Please forgive the long delay—but we have been traveling and it seems not a minute to spare. I hope you got all the cards and I hope all goes well with the house. Our house is coming along very well except that Marc keeps writing people before it is finished!!! Sheila is here—and of course I am so happy to have her—it looks like she is staying a long time this time—her divorce and everything is final, but now she is having trouble with the other guy. Anyway everything will work out all right, I suppose. Marc is very well and happy. He brought back a monkey from Africa supposedly for his nephew but we have had it for a month. It is so cute and gets into all kinds of trouble (see clipping). Its first day in Paris it got loose in the gardens and went four courtyards down to another garden and there it stayed refusing to come down. The people went all over the neighborhood looking for the owner. Finally they found me (I had forgotten I even had a monkey) and when I arrived there were the police, the fire engines with the long ladders and about 100 people!!! All shouting, giving orders, etc. You know how excited French people can get!!! Finally they decided the best thing to do was to call this little monkey by name—Agamemnon—of all things (not that he even knew he had a name). And there I was—it was really very funny calling this ridiculous name—finally he came down—but he took his own good time about it. Finally the journalists and photographers came—so you know the rest. It was in all the papers—we have the most famous monkey in Paris—not only that, but we took him with us to this Prix Formentor, a literary prize—very snob and elegant and he was the hit of the conference. At any rate this weekend he goes to

Lyon I think to the nephew. We will miss him probably. So nothing else new—
I have not started to work yet—but there are several projects coming up—a com-
petition for a fountain for Temple University which I have written to Boss about
and an exhibition here maybe—and a book for the Phila Print Club. Also no other
little "projects." Marc doesn't stand still long enough. This summer there is a
wonderful trip coming up we hope to Israel, Spain, Morocco, Corfu, and maybe
even Tahiti! Anyway that's in the books for this summer. Marc is in Rome for the
moment doing a story on Communist leader in Italy—then he is off to Algeria. He
had a very good trip in Africa and did some really beautiful things. We will send
you some prints. Got also a letter from Pat—it seems she has been sick on and off
for the past year with high blood-pressure or something. And pictures of the baby
who is adorable. I haven't gotten any new clothes lately—didn't even go to the
fashion openings. How is Grandpop? And Helen? And Bernice? It has been a hor-
rible spring here—it is still not warm and three or four days ago it was freezing.
We still have the heat turned on and everything. I should get my driving license
in two weeks or so—if I pass. So that should be interesting. Haven't heard from
anyone in States. Did you get in touch with Joyce? What did you do for Easter? It
is wonderful about Jimmy graduating. Maybe after all it was the girl who really
gave the last push. And he seems happy? I must say Marc seems delighted with
his life at this moment and me too except for my own work. Well, I'll write again
soon—I kiss you and Grandpop.

<div align="center">

X X X X

B

</div>

May 19th, 1963

Dearest Mother,

I hope you have been getting my cards...Genoa and Majorca. We had a won-
derful time in Majorca. Met James Baldwin, Henry Miller, Moravia, etc., etc.
Baldwin does a wild Twist. He was late for the conference because he had to
have dinner at the White House. Marc got some good pictures. The weather was
wonderful warm sunny and the beach was great. As I mentioned, the hotel where
everyone stayed was very plush and elegant with lots of parties every night so I
can't say we worked very hard. But next week, we are going to Czechoslovakia
to cover a jazz festival (incidentally Ray Charles is here) then to Moscow where
Marc is going to work for a month and a half on several stories but I am going
to return to Paris in 8 or 10 days. But it is very exciting. I am looking forward to
being in Russia and seeing what is going on. It will be wild for caviar (breakfast)
and I'm going to buy your mother's day present there (a fur hat) no surprise. And
it seems strange because I'm going to speak to you before you get this letter. We'll
miss you in Russia. We had a big argument about when to call you...for French

mother's day or American mother's day—so this is a compromise. Marc is well, healthy, happy and me too. The house goes very slowly. Also I have met a wonderful girl with whom I will probably be great friends—Princess Poniatowska—a real princess, not one of these Johnny-come-lately Napoleonic ones. Really a wonderful person—also a sculptor. I met her through Sheila who met her in Mexico where she was making a show. Strangely enough, Marc, when he was in the States in 1957, making a tour from Alaska to Mexico (short trip), stayed at her parents' house in California—again small world. But she is very, very nice, very aristocratic, very alive—she lives on her own away from her family. I haven't seen the *Ebony* this month, it's not out here, but I never got any papers to fill out from Whitney—so it is all a great puzzle as to where they got their information and if they managed to get that information (from whatever source) why they couldn't manage to get the right information. Any pictures?? How is Grandpop? Got a letter from Daddy asking for more pictures (we can't find the negatives). Tomorrow we are going to a huge garden party (10,000 people) given by one of the great families in France, friend of Marc's father and the boss of Jean, Marc's brother. It should be amusing, lots of interesting people, very high society, etc. I am wearing my white suit as it is still very cold in Paris. The spring, if you can call it that, has been absolutely horrible and it still isn't warm!!! I bought a pair of Chanel shoes to go with the suit, but Marc doesn't like them so I have to take them back. Is Felmar still coming this summer? I sent Harold a postcard about skiing. We promise to write you from Moscow, but don't get confused with the stamps like you did the last time and think it's surely Turkey!!! Françoise is coming up from Lyon for the party. Also went to the opening of Marlene Dietrich which was marvelous. Learning French—no babies yet…Marc kisses you and me too…

<div align="center">

Love,

B

</div>

June 1, 1963

Dear Mother,

The package finally arrived, so I am sending off thank you notes today. We had to pay duty, but anyhow the gift is lovely. They really shouldn't have done it. We were really so pleased with it. The Russian trip has been postponed until September and Marc is going off to Algeria next week instead. Something that I am not too happy about, but he assures me that it is not dangerous what he plans to do, but for any Frenchman in Algeria especially a journalist, it is not too safe. But he hasn't been on an adventure for a long time so I guess he is getting restless. I think I have found a studio if the details can be worked out, which is very good news for me. It is very close to the house and so is very convenient. I finally saw the picture in *Ebony*, or did I write you that in my last letter? How is Grandpop?

Is he all finished now with the hospital? Did you ask Pat about the little blouse I sent? It seems strange that she never answered. We have found the negatives of the wedding which were lost for a while. One thing I would like for you to do for me right away is...to send me the exact time of my birth down to the minute if you can. I have gotten mixed up and interested in, for the 100th time astrology and really intend to have my chart made which I never did. Anyway, she has convinced me that I should have it done and she knows all kinds of astrologers etc. in Paris. She herself does the cards and it seems very well. I think it's fascinating. She is going to teach me how to do them if I want. I told her that although I thought I had the intuition for it, I was much too selfish to be able to transfer myself so completely to other people's problems, but maybe it would be interesting to try. How would you like to end up with a witch for a daughter!!! Anyway, could you do it right away? Now that I have decided to do it, I can't wait. Maybe you could send a cable? I think this month, I hope, will be quiet for me, at least and that I can concentrate on my French which is improving but not as fast as it could. I think all this month, I will be in Paris. The beginning of July, we are going to Marienbad to do a story. Remember the motion picture? It must be playing now in Philadelphia. Go to see it, you won't understand it, nobody did, but it is interesting and full of Chanel clothes. But don't take Bernice for heaven's sake. The weather here has been absolutely terrible. I have never seen anything like it. It is like November, cold, rainy, windy, cloudy, and for weeks and weeks. We haven't had one really warm day yet...and the heat is still turned on in June! I hear you are having a heat wave there. Also a little panic...on the stock market. I guess we lost a few thousands on paper ourselves, although the company that takes care of Marc's stocks is so smart they probably made money. As a matter of fact I think it was one of the companies that stopped the trend by buying instead of selling. The whole thing was so silly considering the state of the US economy and the people who lost were the very small stock owners. Anyway, I think it is over now and quite normal. The house is going so slowly I could scream. And we hope to move in September, but I doubt it now. At any rate, I intend to concentrate on my French for the next few months during the summer come hell or high water since it would really make it much easier for Marc if I could really take care of everything myself. Well I guess that's all. Please please don't forget about the date-time. I will write again soon. I guess your fur hat will have to wait until September. Marc sends all his love.

XXXX

B

[no date] 1963

Dearest Mother,

So happy to receive your last letter and learn about the house—it's really wonderful. I'm so happy. Let me know if there's anything special you want—I will send you something nice from here. Is it all settled now? Marc is also delighted. There was a chance that we would go to New York this June—but so far we have no word—if not maybe in September or October. When are you taking your vacation? Can't you wait until the end of the summer so by then we will know if we are coming or not? Marc had a sudden and terrible attack of something (maybe a stone, but the doctor didn't find one) in the kidney which had him in agony for about 12 hours, two days ago. I finally took him to the hospital where he stayed two days—but it passed like that. I think and hope it was a result of this last African trip—where he traveled a great deal by car and had very rationed water supply—so a kind of deposit formed by dehydration took place in the kidney. But it is really a terrible pain—worse than giving birth according to doctors and since Marc can't stand much pain anyway—it was terrible. But he is back home now and well as ever—as if nothing had happened (except he says he feels sore in all his muscles as if he had done some kind of exercise or skiing or something). He is now working on this African book and is planning a trip to Italy and this Club Mediterranean story also which will take us to Israel, Spain, Morocco, Greece, Tangiers, and maybe Tahiti I hope.

 I did see the James Baldwin article in *Time* and also the story on the Black Muslims in *Life* by Gordon Parks. It is quite a *cause célèbre* here—much like the Urban Revolution with all the intellectuals very interested in what is going on etc. What do Felmar and Marie have to say about it? I would be interested to know. And what about you? And Grandpop? I feel really out of the mainstream of the problem and my reaction is almost that of a foreigner and not an American citizen-Negro. Everyone seems to be much more militant and even the upperclass Negroes are getting down off their high horses and realizing that in reality they are no better off than the least of their brothers—a good thing too. But it is quite true that there has never been a crisis like this since the Civil War. The photos photographed and printed here about Birmingham were really shocking more than anything else—Kennedy really has his hands full and if he doesn't come through—wow!! What for instance do the people in the neighborhood think? Are there any Black Muslims? Of course the central idea of race supremacy in reverse is crazy—and silly—yet how much it would appeal to certain people I'm really interested in knowing what is going on. We spent last weekend at La Carelle visiting Françoise. She asked about you. She is well and so is her little girl—La Carelle is as beautiful as ever. I would love to have a house near there. Marc is all excited about learning how to fly and buying a plane—I don't know how long it is going

to last—but the idea is to be able to make small trips by plane and also to have a country house near an airport that we could reach quickly by plane—well, we'll see. He travels fast enough as it is without that. Anyway I think we are going to buy a new car—an Alfa Romeo sports car in Italy next month. I took my driver's test yesterday and failed!!!

I couldn't park—so I have to wait three weeks until I can take it again. Oh well—Marc wasn't the least surprised—but I did very well—except for the parking even though it was the day after Marc's attack and he was in the hospital. I am still trying to arrange my own work and workplace. I must write the Little Gallery also about the book which I am trying to get published by the Print Club. If not I may print it myself—here privately. I got a letter from Daddy—he seems to be well and as always working hard—and how is Grandpop? Sitting here in the garden I have such an impulse to call you on the telephone as a matter of fact. I think I will. I am trying to figure out what time it is in Philadelphia. It is such a long time since I have seen you. We really must arrange something soon—Well, just got the phone call I put through!!! How wonderful to hear your voice. You sounded very well—and so did Grandpop. I just wish you both could be here. The weather is finally nice—not too hot. Marc's brother Jean and his wife were in Florida this spring for vacation—so you see it is now very chic for rich Europeans to go to America for a vacation. We are going to London the end of this week for a day to photograph Elizabeth Taylor—the only reason I'm going is to meet Richard Burton! But this is just about the only safe time to go to London and not find rain. Rome was very nice this time. I bought two more candlesticks like the gold ones that you have and made lamps out of them. Also my old boss from the *New York Times* is coming on vacation next week so I will see him. I thought Shirley was coming this spring, but so far she hasn't shown up. How is Felmar—what is she doing. This summer, again today I am reading articles in the *New York Times* about racial tension in America. It is really reaching the boiling point. What is weird is that the one Negro magazine *Ebony* doesn't reflect this at all—what are the Negro papers saying, send me a *Tribune* and an *Afro-American* and what's the name of the third one? Read two books by James Baldwin—*Nobody Knows My Name* and *The Fire Next Time*...I'll write again soon.

<div align="right">

Love Love Love,
Barbara & Marc

</div>

Milan, July 11, 1963

Dearest Mother,

Please forgive the long silence, but it has been hectic since Marc came back and left again. We are now in Milan on our way back to Paris, after having traveled in Italy (Rome, etc., Sicily). Thank you so much for the clippings. Actually I

realize now that it was well covered by the press here and by the *New York Times International*. What I really wanted was the Colored newspapers. I am so happy about the house. The settlement is still the 11th of July. I must send you a beautiful housewarming present. What would you like? I would love to come back to the States for a few weeks in the fall so maybe I can bring it. How is Grandpop? And Jerry? Also thank you for the book too. It was quite interesting. I saw Leo Lionni over the weekend. He now lives in Italy near Genoa. It was very pleasant. He retired from *Fortune* magazine and is painting. Marc is working hard on two books and two big assignments which will keep him busy all summer. We return to Paris around the 15th and leave again for Spain and Morocco the 20th. We come back the 5th and leave for Greece and Italy the 17th. I can hardly wait to see the house. If I come this fall may I stay there? Our house is coming along okay— Marc is very happy.

Well...if it isn't a false alarm you better start preparing to be a grand-maman to a little brown-skinned blond curly haired gray-eyed bebe!!! But I really must wait another two or three weeks to be sure—so keep your fingers crossed. Meanwhile Marc is moving around like a chicken with no head and all I can think about is all the American food I'd like to eat and can't: Chocolate nut sundae; butter pecan ice cream; hot corn on the cob; potato salad and fried chicken; cornbread; hot biscuits all buttered with jam and honey; pancakes with butter and hot log cabin maple syrup and little sausages and fried egg; baked sweet potatoes and sweet potato pudding; rice pudding with big fat raisins; eggnog ice cream; kidney stew over hot waffles; chocolate layer cake; a real cheeseburger with Kraft cheese; potato salad and hot dogs!!!; deviled eggs; a real Italian submarine sandwich from around the corner from you; hominy grits with gravy and butter; chicken salad; maple walnut ice cream; Philadelphia Scrapple; baked ham and pineapple; coconut custard pie; sweet potato pie; apple pie; hot cinnamon buns; popcorn with melted butter; crab cakes wow!!!

I could go on and on so the only solution is to come back to the States and let everybody cook for me!! Anyway the first thing I'm going to do when I get back to Paris is to head for the P.X.!!! Somehow I have the feeling this isn't a false alarm.

<div align="center">

XXXX
Barbara

</div>

Summer 1963

Dearest Mother,

I got your last letter this morning. So glad you saw Elizabeth and that she and all the family are alright. Also the house looks so nice too. I read about the riot in Philadelphia in the *Times*, but I'm afraid one must be prepared for a lot worse

to come before things get better. By the March on Washington, we Negroes have shown a remarkable unity (remember we used to say they could never get together like Jewish people…well they have!). And the opposition can certainly see their strength and determination. This scares and frustrates them because they see also their ultimate defeat. When people see defeat coming it makes them mad, frustrated and desperate. The result is nastiness, violence and brutality to the last degree. Now, everyone is so aware of the problem, there is no escaping it anywhere. People resent this. They resent having to think about something that never concerned them before, which really concerned only us. Already in the South, violence and brutality have increased and the segregationists are digging in for a long hard fight. They can no longer either ignore the problem, or pretend that Negroes are happy or pretend that they can't change it or anything else. There are no shadowy corners left for people to hide. You are either for or against. In America the Negroes will just begin to see how nasty and wicked people can get when they are pushed to the extremes of a decision. And if this Civil Rights Bill doesn't pass, the Negroes have no choice then to be just as nasty back. It is going to be Hell. The March was also on French television. I'm hoping they will rerun it again. But *Time Magazine* had a very moving article about it and there was also a demonstration in Paris (with James Baldwin, Hazel Scott, William Marshall, Art Sims, James Jones and others—including yours truly). About 400 people in all. Also all the French papers had articles on it. Marc and I were so impressed and moved, especially Marc by Alice's letter that Marc gave it to the biggest weekly in France, *L'Express*, who published it this week and a friend of ours showed a copy of it to *The Times* in London who also used part of it. I hope Alice will be pleased. Her views will be read by about a quarter of a million French and English people. Mostly they were impressed because it was the first personal touch they had with the real American Negro. The intellectuals like Baldwin are fine for defining our views and the basic moral and intellectual principles, but what they really wanted to know was how the ordinary Blacks felt and feel. And this I think she did and I did—I only regret that neither of the letters were signed but please send me her address as the *L'Express* would like to know where to send the check. Also Magnum may distribute it in other European countries especially Italy where we will make sure she gets a credit line. The headline in the French paper says "Letter to a Black (Negro) sister." It goes on to explain that "For a European, the problem of the 'Negro' has often only political or intellectual significance. If they are touched by passion, it is through a news item in the United States. Here is a human terminology: simple and poignant, the letter of an American Negro telling the reasons for her struggle to a friend living in France who herself is an American Negro married to a Frenchman."

Then it reproduces most of the letter. The big title says: "Enough, I cry!" I will try to get another *New Statesman* for you, but I think you can find it easily

in Philadelphia maybe even the *L'Express*. The *New Statesman* is much more intellectual and precise about it also the lead article is very good and so is the cartoon. I am enclosing a note to Alice to be forwarded to her. The letter passed around so much, the envelope with her address on it got lost and now I don't have it.

Well, I am very well. I have chosen a doctor tentatively but I may change although he is very nice, I don't know if I will have the baby in the American Hospital because they don't let you take care of it yourself. At any rate, it looks like Marc is going to China in March of next year, just after the birth of the baby. The plan is for me to leave Paris as soon as I can after the birth of the baby, if all is normal, and to stay for a while with Sheila in Mexico in her new ranch until I get my strength back. We thought of this rather than my coming home right away because of the weather and the fact that I can find an Indian nurse for the baby very easily and cheaply in Mexico and can then bring her with me back to the United States where I would join Marc for several months visiting you in Philadelphia. This gives us lots of time with the baby. And I would go back to Paris in the late summer. I think it is a good plan if it is alright with Sheila. Of course you and Daddy would see the baby before Mexico as I would stop off in New York, but since it will be still cold and rainy, Mexico might be better for both of us, as I'm not looking forward to a horrible winter in Paris (weather-wise, that is). Marc will probably stay three months in China. He should have by October a contract to do a book on China for Doubleday with a friend of ours, Karol. So, if I stayed March, April, May in Mexico, met Marc there on his way back from China (via Tokyo and California) and came to Philadelphia for June, July, and August while Marc finished the editing of the book, it would be perfect and you would have more time and the baby would be more fun. They don't really get to be fun until after three months when they can do something except sleep and eat. What do you think? At any rate, I don't think it is a good idea for me to stay alone in Paris trying to cope with the house and a new baby and a French nurse and being without Marc all at the same time as well as trying to get my own strength back. Sheila should turn up here in February just in time for the birth as she has an exhibition in Zurich around that time, so I won't be all alone. Also Françoise and my other sisters-in-law will be here, but it would be nice if you could be here too. I just hope whatever comes out has the right number, size, and shape of everything it is supposed to have and I will be happy…and of course two dimples!!! A malformed child is something I really don't think I could get over to the point of continuing life normally. And you know how Marc is about perfection. Well, I guess all expectant mothers fear exactly the same thing. Well there are twenty-two perfect, healthy Riboud children so far in this world. Let's keep our fingers crossed.

How is Bernice and is Helen finally speaking to you? Trip to New York in October is still up in the air, but I think I can manage it. Marc needs some time

away from Paris to arrange some things and finish two books he is working on. Well, write soon and let me know what you think.

<div style="text-align:center">

Love,

XXXX

Barbara

</div>

July '63

Dear Mother,

I am feeling very well, but lazy and sleepy all the time by 10 o'clock I am finished for the evening. So as far as we can figure the arrival will be around the beginning of March. The only little cousin (out of 22) that will be near in age is a little girl now one year old, daughter of one of Marc's sisters, Sylvie. Then there's Sheila's little girl, 4 years old. At any rate, I'm sure some will turn up. Marc also called Daddy to tell him. He seemed really delighted. Maybe at last he'll have a light-skin good-haired baby! Well, we'll see what happens. Meanwhile, I have quite a suntan. Nothing to do in Morocco or Spain—no shade, I was happy at least that Marc would take you to see *Cleopatra*, but I suppose he really didn't have time. He's always hiring or firing somebody between Paris and New York. I got a long and very impressive letter from Alice in Cambridge. Marc was very moved. The only thing was she explained the race situation (between the papers and James Baldwin last year, I am pretty well-informed) as if I was a nice French matron wondering what in the world was going on in the U.S.! Anyway, it was very nice of her to write such a long impassioned letter. Also I am so happy Marc had photos for you although not to a real advantage for the house and as you can see, it is not finished. Anyway we will bring other shots with us when we come. Just think, by then I'll be five months pregnant what about that! So you'd better think up some good things to feed me and don't forget the gumdrops—lots of them...if only I could have one of Mrs. Haskins' layer cakes she used to send to Italy! Marc and I hope to give (or have given) a big party while we are in New York—we are really obliged to do something this time. We have so many people we have to see. I haven't quite decided which is the best to do. Also if there are any maternity clothes sales going on... Thank goodness it is in the winter—be all over by spring!

August 6th

Well this letter is being continued in Paris where the weather is just awful at the moment. Worse than London! Marc told me about your hectic visit and your letter was waiting for us when we arrived. I am so happy the little house is turning out so well—I'm sure even Grandpop is pleased, you really mustn't have

a bad conscience about Grandpop. Think of what you have done for him all these years—I think you have been very patient and more than a loving and faithful daughter. Now it is more equal—and I think really everybody should be happier. After all Daddy doesn't have any children nor family so it is hardly difficult for him to help—Jerry too. As for people—they will talk whatever you do so really—as long as you are comfortable and out of the rain you should not care—I don't know if really you should show those pictures of the house around—So really if you start to show around pictures...they'd start asking you for a loan! It is practically sure that we will be in U.S. around October. I will be so happy to see you! I don't know how long we will stay but for I suppose at least a month, Marc is (as you could see) working hard. We have two weeks coming up in Corfu and Sicily and work on this book of voyage. But more than anything, he is trying to get into China where the Big Story is this year. Of course he has been in China once in 57–58 and he has some hopes of returning although the Chinese are very strict. So I just wrote a friend I can see myself having our baby in the Chinese People's Workers Union Clinic in Peking!! Well, it would be rather original for us to have a little Chinese baby!!! Woo Ming Riboud or Flower Petal Riboud...But it is a mad rush with about ten other famous photographers all trying to go—the Americans are automatically excluded—but any Europeans technically can go if they can get a visa, so we will see. Just now I am looking for a baby-arriving doctor (not Chinese) I must say my sisters-in-law with their 22 children should know of somebody, but now is vacation time in Paris, it is absolutely deserted—not a restaurant nor a doctor but Sheila had a good doctor when she was here four years ago pregnant so I am going to call him I guess. Sheila, by the way, is fine, back in Mexico—probably here in February March just in time for the event. I am about to write to her the news, also Shirley, etc.

What do you have as furniture in living room? Didn't you have two chairs given to you? And a television?

August 1963

Dearest Mother,

Marc told me what a hectic time he gave you—I'm sorry it wasn't longer and that he couldn't see the house. Anyway we hope to be back in October for a while. Oh yes before I forget—you must absolutely send me some gumdrops Lofts or Woolworth's I don't care—but for weeks that's all I've been dreaming of!!! That cable I sent from Morocco was really in desperation. Unfortunately it came too late to be very useful. Anyway thanks for the Jewish pickles! We are in beautiful Spain for a week—until Sunday—then back to Paris for two weeks. After that a question mark as we are supposed to go for two more weeks to Greece and Italy, but it may change because of business. I suppose Grandpop is happy to be going to be

a great-Grandpop. I sent him a card from Morocco. I forgot your letter with the new address but next time I'll remember it. How is Bernice? Does she have her apartment settled too? Do you two eat together? It will be so funny coming back to Philadelphia and not going home. Marc told me how everything has worked out for Grandpop. I am so happy. It sounds like a fair solution not too tiring on anyone and it gives you lots of free time. We will wait until we come in the fall to buy you a housewarming present. But you do have your television set? The house is working out very well—I have a Madame Rosiere who is wonderful who comes every day all day until 7 and makes lunch and dinner etc. But now we have to figure out something for the baby. I got a long letter from Sheila who is taking a house in Taxco with her little girl and her nanny. I am about to write to Sheila about the baby. She will be here (Europe) just in time for a show. It seems that her romance didn't work out and she is staying in Taxco for the moment. Last time I heard she was going to marry a Mexican. Called Jesus—Anyway, she is going to be in and out. She has taken a new house in Taxco which is probably very nice. I would love to see her this winter when she comes, but it all depends on Marc. If he is so dead set on going to China and if he really succeeds in going any time soon, I will stay in the U.S. until he comes back. I hardly think I would risk a trip to China in my state although Christ they have more babies there than any place else! Françoise is well and so is her daughter. They are both in Copenhagen for August. The school is closed for the year and she is still planning to come to Paris to live one of these days. Jean and Krishna are at La Carelle and our little monkey is in the mountains with his new family becoming very snob with his silver chains and hand knitted sweaters.

Well, give Grandpop a big kiss for me. Ask him if he received my card from Morocco. Write soon—

<div style="text-align:center">

Love always,
Barbara

</div>

August 24, 1963

Dearest Mother—

So happy to have your last letter. Everybody here is fine—Baby is chugging along. I am spending a few days with friends in the country while Marc is in Sicily. I could have gone, but I couldn't face that heat and sun. But I must say here the weather couldn't be worse. It is really terrible and has been all summer—rain and clouds, wind and cold. It is incredible for this time of year and very depressing. So I can't say I don't wish for a little heat and sun. I suppose Philadelphia is having its usual heat wave. We still plan to go to Corfu in September and to New York in October. So if all goes as planned I will see you soon. I am glad you saw Marc and that the house is working out well. I hope by now you have stopped

feeling guilty about this change which is the best thing that could have happened. Marc thinks you look very well. I am so looking forward to seeing you. I am feeling well, but tired all the time. Did Grandpop get my card? So far, I haven't heard directly from Daddy but I did write to him and Marc called him when he was in New York. He seemed really pleased and excited. Well, maybe this one will be light enough for him. We have thought of names already—at least I have—Sabina (pronounced SA-BEAN) if it is a girl and Mathieu (pronounced MAT-TOO) if it's a boy—means Matthew. Marc thinks Sabina is too chic, but I like it and it is very French and not common. Mathieu is a compromise since I wanted Marc as a name and Big Marc didn't. I haven't heard from anyone from Philadelphia for ages, but wonder of wonders, just by accident I met an old Tyler school friend, a girl, living here in Paris since 2 ½ years and married to a Frenchman since the same time Marc and I have been married. It was quite a surprise. I passed her on the street—she was sitting in a café with her husband near the one you and Marc like so well and she recognized me. You met her once—she danced with me in that *Oklahoma* production at Tyler—remember? She is a wonderful girl and I am so happy. Her husband is a journalist. And she is working as Art Director in an advertising agency here—and had been working for *Vogue* for a while.

Well, I don't know when we will get our new car—It is in Milan and we were supposed to get it this week, but plans have changed again. It is a dark blue Alfa Romeo Julia Sprint—very pretty. I drive now all the time and quite well. At least I haven't run over anything yet. Well, I promise to write again soon. Kiss everybody for me.

<div align="center">

XXX

Barbara and Marc

</div>

September 14th, 1963

Dearest Mother,

I hope everything is well with you. It seems a long time since I have heard from you—but we did get the air travelers card back. Thank you!! Can you imagine getting it back? Marc had no idea where he had lost it.

Went to London last week for the opening of a photo exhibition and we saw the first part (we had to catch a plane) of <u>Langston Hughes' *Black Nativity*, a gospel play.</u> It was corny and great. You know how gospel singers can really move you—it was something Williams—an imposing lady and her singers plus a male chorus and two dancers. It is about to tour Europe now, but was in New York last winter. It was also in Spoleto this June. That's all, haven't seen anything else except movies. How is Grandpop? Give him a kiss for me. The house is moving slowly. I sent Daddy some photos, but I forgot which ones of the wedding he wanted. Give me news about the houses. Have you been looking? Anything

interesting? I enclosed a letter for Felmar. Is she back yet or has she stayed in Europe? If so where? I haven't heard from her. Everyone here is shocked over the latest things in Cuba. The U.S. it seems is acting like they are in the 19th instead of the 20th century—although I can see and understand what a difficult situation they are in. With their "alliance for freedom" program in South America they cannot afford to have Cuba exporting revolution and sabotage into South America. But as usual, they are too late and too little, instead of finishing it last year when the public opinion in Europe was on its side. Well, what does Marie think about it?

P.S. I see my friend Tamara from Tyler all the time in Paris. Do you remember her at all? She danced with me in that glorious production of *Oklahoma* I did at Tyler and she has red hair!! She is now 30 pounds thinner and looks very chic—wonderful in fact. There's nothing like a French husband to bring out the best in one I always say!! I promise to write again soon—I love you and I miss you. I'm doing my best to get to the States this month. Keep your fingers crossed...

<div align="center">

XXXX
B

</div>

October 7, 1963

Dearest Mother,

Well, here we are in Moscow. Very excited, but have caught cold in the past days. Marc is working very well and things seem finally to be moving after a very slow start. Moscow is provincial, not very beautiful except for the Kremlin. But last week we went to the ballet as Stravinsky was visiting here and Khrushchev showed up! Which was an added bonus. The New York City Ballet is opening tomorrow here and I plan to go. We are staying in an unbelievable hotel called the Lenin Gradskya which looks like a cathedral! It is really something. The place where one gets the elevator is shaped and decorated like an altar. All this in the time of Stalin (1955) too!! And all the walls are marble. The ceiling is bronze and there are red carpets (naturally) everywhere. The dining room is even more fantastic with enormous bronze chandeliers and a dance orchestra that sounds like they just stepped out of a 1930 Hollywood movie!! Plus all these Russian peasants and I do mean peasants with rubber boots and kerchiefs sitting in this grand dining hall eating with their fingers. What puts me in seventh heaven is caviar is so cheap here I can have it for breakfast! Which is more than I can say for anything else since the food is pretty lousy and getting toast for breakfast is like trying to invade North Korea. How is Grandpop? And how are you? Did you get my card from Moscow yet? I will be back in Paris around the fifteenth. Has Felmar gotten home yet? Domenico showed up in Paris a few weeks ago just

before I left, separated from his wife and doing a mural for the Rothschild's!! Also Harley passed through and Marc and I had dinner with him before Marc left. Marc wants very much to go to Cuba in January. My plans are indefinite but I may come too for a while. Françoise is well and sends her best to you. Moscow is not cold and the weather for the past week has been very good. But it is a poor city—and country. While they land men on the moon, women are standing in line trying to find fruit and eggs. A green salad in Moscow is practically non-existent (I haven't had one in three weeks) as are most vegetables (none in three weeks and we are staying at a luxury hotel) and flowers. The buildings are crumbling, even the new ones which aren't even two years old. They won't stand until they are ten and already look like slums. Plus that people still live in shacks, or in commercial apartments: i.e., an old six-room apartment where they have placed six families each to one room, all sharing the one kitchen and toilet and if there is one, bathroom. Even those who have apartments, they are so small each adult is entitled to 89 square feet of living space or a room of 9' × 9'—no couple even with children has more than two rooms. The foreigners of course live very differently and there are lots of Africans. There is even a Patrice Lumumba Friendship University. But all the Russians think I am Cuban. Sometimes I say no sometimes I say "si." There are no Western newspapers or magazines here at all except the *Daily Worker* which is communist. I therefore found out about the Patterson-Liston fight from a boy from Ghana whom I met while trying to find a drugstore! I found out about the new cosmonaut from the ABC correspondent here a day later. But the Russian people are very nice, very warm if a little on the "heavy-gray" side. They are, as a matter of fact, very much Americans were say, at the turn of the century and I think they will continue to become more and more like America. It is only natural. Meanwhile they struggle on while their government puts on a big front for the world. Nevertheless soon or later they will catch up, even now the atmosphere is changing and people are demanding more consumer goods. Ah yes—and Mississippi—I heard about that from a French correspondent here—and the Russian newspapers. So strange to be reading about Mississippi standing in the middle of Red Square...I finally got hold of a copy of the *New York Times* and was really shocked out of my wits. Since then I have read *Time Magazine* and have been filled in on the details. Practically every European I spoke to was deeply shocked, especially in France where one correspondent got killed and of course in Moscow, the Russians were making the most of it...of course *The Times* had a point when they said they couldn't understand why anyone would want to go to Ole' Mississippi in the first place, but it is obvious someone had to sooner or later. A friend of ours in Paris just interviewed Roy Wilkinson of the NAACP and wrote a very good article on the situation. Some of his statistics were appalling: i.e., one which said if the whole of Manhattan (including I guess Central Park) was inhabited with the same density as some parts of Harlem, 180 million people, i.e., the total population of the U.S.

would be living in Manhattan. He also made me wonder really if the gap between Negroes and Whites economically was closing. He seems to think not: of all the unemployed in the U.S. two out of three are Negroes although Negroes make up only 11% of the population. Also their gross income is still only 40% of that of the White population. And about the same (percentage) as it was 50 years ago. Well anyway, don't worry, I'm not going communist—socialism is not for me—

I can't think of anything more boring.

<div align="center">

Love,
Barbara and Marc

</div>

I'll write again soon—kiss everybody.

Hospital Pitié, Paris, November 23, 1963

I was in the hospital at Françoise's side when I heard the news. I started sobbing, I didn't know what to do. Françoise thought it was the baby and I couldn't explain to her that it was the president. I was so upset she thought I was about to lose the baby. I was holding my stomach and bawling like the little one inside. I threw up and then she really got scared. It seemed to me the world as we knew it had stopped. Françoise had just had a terrible car accident and had smashed her hip to pieces. There she was wired up and immobile trying to comfort me, her sister who refused all comfort. It was not foreigners or Cubans who did this... they were Americans USA Americans sure... Texans and southerners... We were both crying afterwards, lost. God help the USA. I kiss you.

<div align="center">

—B

</div>

December 8, 1963

Dear Mother,

I hope things are going well, Marc will be in New York the 4th or 5th of January. We have sold the flat so we must move by the 31st of January at latest—so I don't think I will be able to go with him. He is also thinking about going to Cuba after Christmas, but just for a few days for January 1st. So—I am busy trying to get things moving on the house. It is so incredibly slow—you have no idea. I was so happy to receive your last letter which sounded so optimistic. I wish so much I could see you and speak with you in person. I spoke with Françoise over the telephone today. We will be in Paris, I think. Probably we will have a quick dinner with friends of ours, and Marc will leave the day after for America. How is Marie? Marc often asks about her. Do you ever see her? Did you ever get the little things we sent? The hat and spoon from Russia and the rest? Marc has picture story

in *SHOW Magazine* this month, on Marienbad. We went Christmas shopping today. We bought a beautiful bag for Françoise because we owe her a nice gift from this summer when we stayed with her at La Carelle. And we bought a little toy piano for her little girl—so sweet. I remember mine so well. And we bought toys for several of Marc's numerous godchildren. We are hoping also to send out Christmas cards—a drawing—if we ever get around to having it printed. And did you get the earphones for Grandpop? I was really serious about that. And please write. We love to hear from you. I got a letter from Dr. Ramsey, saying not to worry that you were much better than you thought. Boy—what an optimist. But from what he says, it will be very difficult for you to sew for long periods at the sewing machine unless you have your feet up—this of course is not impossible with a knee-operated machine—even to getting a special attachment. Wait, I am trying it now and it's very easy—try it with the machine, because this seems to be the main thing—lots of rest and keeping your feet elevated. How is the message working out—and what about swimming? You used to love it so—and it would be perfect exercise. I close now with a big kiss.

<div align="center">

XXXX
Barbara + Marc

</div>

Monday night, December 1963

Dearest Mother:

I just talked to Françoise who told me she had received a letter from you—she was so happy—she is much better than we imagined and came through very well the operation. The doctors were amazed—sort of how they always are with you. But by living in the country and so on, she was in very good shape and withstood the shock of the accident and the operation. Fortunately two of her three brothers were in Paris at the time and so could take care of everything. But please write to Françoise again, she will surely answer your letter. As for me, I arrived safely in Paris. There was someone to see me on the plane so it was not so bad, but I arrived in Paris tired and am now feeling the tiredness. I am going to the doctors tomorrow or Wednesday for a check-up. Marc was amazed to see my tummy—he can't keep his hands off. Well, the murder of Kennedy in Dallas really was a shock here. I had no idea I would react so emotionally, but to see such vitality and such life-force so brutally destroyed was really a shaking experience—Everyone is terribly depressed. It seems just now to have settled in over the initial shock. I had planned a party for Thanksgiving which I have called off. I am just too tired. The weather here is really winter which doesn't help much either, but the house looked very nice and neat. Also Françoise has found what seems to be an ideal nurse. It is still not sure, but she was with two of my sisters-in-law at one time or another and they were very pleased. She

is French about 35 now and very experienced. The only thing is, she has been working lately for some Countess or somebody so I don't know if she wants to change her social standing—not to mention her comfort so much. But we will see what happens. We have written to her and are awaiting a reply. Other than that, nothing is new. I will be glad to have that problem off my mind. Marc came home day before yesterday in good shape—thinner and is now trying to catch up on things. No plans to leave Paris any time soon. Jeannine + Bill are expected back today, but they may have stayed for the funeral in the U.S. and so on. Everyone in Paris thinks that the new development of the murderer, Oswald: the shooting all put up to keep Oswald from spilling who really was behind the plot to assassinate Kennedy. We all suspect it was the radical right and the racists who were really behind this and Oswald is just a front because everyone can yell communists!! It is all too sad to be true, true it just isn't that way—and the shooting of Oswald!! The police didn't even try to stop the guy. It is really incredible. Well at any rate, it doesn't change the death of Kennedy, but it certainly would greatly change the reaction of the country—maybe that's why everyone is covering up. But Bobby Kennedy has such a sense of vengeance I doubt if he is going to swallow this story by the Dallas police. I think we are in for the most shocking scandal of the century. Kennedy isn't going to stop until he has gotten to the bottom of it—Marc sends his love and he misses you. He says he is sorry for all the telephones and that he is happy to be home. Me too. Let's hope too that Bobby Kennedy finds out what Blacks already know about Southern police and Southern "justice"— all my love from the Riboud clan and my love to everybody—Bernice...

XXXX B

Please please call the Little Gallery and find out what is happening to prints I left there. They were supposed to call me in New York and didn't. Re-telephone if necessary and worry them until they get them back and either send them or at least deliver them to you. There are also several drawings. I want everything out of that Gallery.

December 31, 1963

Dearest Mother,

Please forgive the long delay in writing, but everything is well, Marc is well, I am fine, just ten pounds heavier that's all. I can't tell you how much we loved your Christmas present and Françoise too. She has probably written to you by now. She recently had some very bad luck with her leg. During the reeducation at this center where she is, she injured one of her muscles doing the exercises, and you know how painful that can be. It will make everything much longer, because now, of course she can't do anything because of the pain. It is really terrible. Marc and I

spent Christmas with her at the hospital as there are no other brothers and sisters around and we spent Christmas Eve quietly with Jeannine and Bill although we went out later to a party. But I made all myself a beautiful tunic in Indian silk, a sort of rust color with the slits and long sleeves! Can you imagine...all hand-sewed because nobody I know has a sewing machine? It really turned out very nice, not at all "home-made" looking. So, I am discovering all kinds of hidden talents like furniture finishing...But then so are you. Your last letter describing the apartment sounded great. I am so happy you are happy with it. I am sure it looks very nice. Did you get your Christmas present? Not much, but I thought you would like them. They are so pretty and to serve people on your trays, I thought they would be perfect. Do you have your high-fi yet? It also sounds very nice. All the families here in Paris are gone for the holidays...Either skiing or on a trip. Jean and Krishna are in India with their little boy. Paris will be very quiet until about the 5th of January when the people start coming back from vacation. I am trying to get things organized for the baby before it gets too late. To finish the room and finish the dining room downstairs and to finish our bedroom also. I am also trying to get a studio organized so that after the baby is born, I can go back to work in the spring. Well, I'll think about that tomorrow. Already the house seems much too small. It really is if you count Madame Rosier and a nurse for the baby, Marc and me. So I must really be organized and also find a place for myself to work. I am sending a few, but not many Christmas cards this year mostly for business. Everything is really slowing down because of the baby, so my letters will get pretty boring I guess until the end. It looks like everything is going to be very normal. We have now gotten down to three or four names: Sebastien, David, or Manuel if it is a boy, Sabina, Raphael if it is a girl. Charles for the middle name or Elaine (Marc's mother) Vivian for a girl. Yes, there is a divine christening dress that comes from the family that Françoise has. Just unbelievable in all its splendor. Of course it is so fragile, it is all lace covered with pearls with all kinds of little dresses and slips in lace that go underneath. Even the little shirts are of lace. Well, give my best to Bernice and Franklin. I will write another one of my motherly letters soon. Marc sends you a big kiss and a hug and best hopes for a wonderful New Year...and me too.

<div align="center">

I love you grandma...
XXXB

</div>

1964

Anyone who was an adult in the United States on November 22, 1963, remembers where they were and what they were doing when the assassination of John F. Kennedy took place. Like 9/11, 11/22 marked an entire generation. For those of us who were young adults, sudden violent televised mass death was new—the coverage of the war in Vietnam only a fraction of the coverage we now endure on Iraq and Afghanistan. Shock, grief, disbelief, terror became a reality for America in the most personal way. I had been at the hospital bedside of Françoise, who had suffered a terrible automobile accident. Marc called from Cuba, where he had been photographing Fidel Castro, who complained to him that the CIA would certainly blame it on him. Then he had called my mother, who was as shocked to receive a phone call from Havana as she was over the murder. Jean called from New York to describe the shock, trepidation, and disarray among Americans. The city's life, just as on September 11th, 2001, had been destroyed as if a giant foot had stepped on the anthill of Manhattan, whose very heart stopped beating: cars and buses stalled as passengers descended to find out what had happened, horns wailing, people wandering around looking for a television in a shop or bar to watch, grown men crying, television commentators weeping—no one had iPhones or Facebook or YouTube or Twitter in those days, so chagrin and grief spread more slowly. The conviction that nothing would ever be the same again, that even America was no longer safe, was the same emotional reaction. Kennedy had embodied by his beauty, intelligence, and charisma the seeming impregnability of all the American qualities we wanted to embrace, whether we were Black or White or Latino. The magic of the name—the famous Camelot—seemed to us a talisman against evil, hurt, and failure. The image of Jacqueline Kennedy on her knees trying to catch a part of her husband's brain, the blood-stained pink skirt evoked unimaginable rage and a kind of deception—failure had won, and a Southerner from Texas who Kennedy despised was now president. There was no one that day who could imagine that by the end of the year, that same Lyndon B. Johnson would have signed into law the 1964 Civil Rights Bill outlawing America's apartheid—legal segregation in the South.

On February 23, a little Riboud had come into the world, adding his presence to his 22 cousins. What to name somebody like him? If he was going to be bira-

cial, binational, and bilingual, we thought his name shouldn't be a handicap to his universality. David was a great name in all languages, we decided. We were part, we felt, of a revolution sweeping the world as people defied ancient taboos to form new kinds of relationships from various cultural, religious, and racial backgrounds. Like all couples, they loved each other. Like all couples, they produced children they felt protective of. For want of a better name, they were called mixed couples. In Paris no one could have cared less. No question or eyebrow was raised at the hospital. But from Oklahoma to Virginia, we were outlaws. I looked down at this tiny human being and wondered who was he? Who were we? The enlightened before our time? The elite avant-garde? Hardy pioneers? Social revolutionaries? Politically incorrect misfits? Or just plain lunatics from the Latin *lunaticus*, moonstruck.

My mother was delighted beyond words. She had finally become the grandmother she had always dreamed of becoming but not exactly as she had expected. She was separated from David by 3,000 miles and a foreign language. She wouldn't be able to play the role of Queen Lizzie as had my indomitable grandmother who had had such a role in my life. She who used to say, "Making things look easy is a matter of politeness. Looking like you are carrying a heavy burden is a third-world attitude towards life." Something I would have to share with David one day.

My son increased the family chaos by adding one more life to the anarchic quiltwork of a huge extended family. My mother and I, both only children, marveled at this advancing horde of relatives as wild and wooly as Queen Lizzie's bingo and pinochle parties. I added my grandmother Elizabeth as well as my mother into this vast family network augmented by a large and chaotic panorama of "independents" like "Uncle Maurice," who had thrown a garden party for 10,000 guests at his vast house near Marnes La Coquette to celebrate his rhododendron plants' blooming, or "Tante Inez," who papered her kitchen walls with her parking tickets until they threw her in jail for a few hours, or Krishna, who had taken over the family seat in the Beaujolais wine country and had built herself a private zoo complete with white peacocks, Indian baboons, and a water snake or two.

We returned to Françoise's farm at *La Carelle*, and its domain of farms, timber forests, vineyards and its uncountable rooms, which in Marc's mother's time before World War II had been run by a staff that resembled a class graduation photograph—some with rifles slung over their shoulders. Every spring up until 1939, Françoise told me, the family of parents and seven children would move from their winter apartment in Lyon to *La Carelle*, which became their home during the war. Who was the real Riboud? The scraggy, absent-minded photographer I had married or the "*leopard*"?

Sunday, January 19, 1964

Dearest Mother:

Happy Happy Birthday—Marc sends his most tender good wishes and love. Marc
keeps promising to take a picture of me sideways, but he never gets around to
it. Anyway it is not so spectacular. I miss you—miss you and wish that you were
here—but I am very well except for spells of depression which come and go. Marc
has been in Paris these past weeks and will probably remain until after March.
I have everything ready for the baby—all the little shirts and socks and diapers
and under shirts and smocks to go over. I finally got around to getting a dining
room table as I am trying to get everything organized before the baby comes
and I have ordered the draperies. I hope Marc's gift will finish off the hi-fi so you
can concentrate on records!! We think of you so much and love you so much.
Françoise is much better and so is her morale, she should be on her feet in a few
weeks + hobbling around on crutches. You know the complication...she got
jaundice from the blood transfusion she had 7 months ago during the operation!!!
Really she has luck like yours! This put her back in the American Hospital again
after leaving for a re-education center to learn how to walk again. Well, I guess
that's all the news I have—just six more weeks to go—the doctor moved it up a
week because it was really fallen. Last week there were two days I could hardly
walk, the head was pushing down on my pelvis...I felt like Françoise! I must
write Daddy too. I want him to send me some grass seed for the poor lawn which
is naked as a newborn baby—if I have to look at that all spring!! Have to fill in at
the last moment, okay?? Marc and I give you a big kiss and hug and again happy
birthday—

<div align="center">

XXXXXXX

B Marc and "3/4" or "8/9"

</div>

January 23, 1964

The greatest news, I leave until last, Jeannine and Bill have adopted a baby three
days ago!! It happened really like something out of the blue through a Rothschild
connection, who has a clinic here in Paris. Anyway, Jeannine had spoken over
the years to this friend of hers about adopting a baby, but neither she nor Bill
had really done anything serious about it. But out of the blue, the friend called
saying that they had a wonderful baby for adoption and would she and Bill like
to come see it. They said yes and they went without telling anyone. Finally, they
didn't like the baby offered, but it was in a big big nursery of 80 children and in
the corner was this little baby that Bill just went mad over (and who looks like
him) but they had no idea if he was for adoption or not. So they called the next

day to tell the director that they didn't think they would take the baby offered but that there was another little baby which they described in which they were interested and the director said that just by chance he had the papers of that baby on his desk and if they wanted him (a boy, 8 months) they could have him. They said immediately yes they wanted him, they came with the lawyer that afternoon, and the next day Jeannine took him home! She you see, she is a mother before me!! He is very sweet and looks just like Jeannine and Bill. Jeannine's mother swears he looks just like she did when she was a baby! So they are very excited and happy and we are new mothers together! Think of that—Also there is another friend from Yale here expecting a baby in May—so it's really a club!! I am planning when you can come to see all the babies!! Françoise is very well and sends her love, I have seen a lot of her lately because she has been staying with Marc's brother, Jean, around the corner. She is walking with a cane and a little limp— that's all—that's what the best doctors can do for you. She is very lucky—she has to change her car to automatic gear shift. She doesn't have to change her foot back and forth. Anyway, Françoise is connected with vacations and trips because there is a chance—just a chance at the moment that the aunt of Marc is going to let Françoise use her villa in the south of France in June. She keeps saying she is going to do it, but to pin her down is another matter. Anyway if she does... Françoise and I are going to install ourselves in style there for a month and that is when you must come to see the baby and be with it. It would be so wonderful if it works out—the villa I understand is really fantastic with gardens and pine trees and view over the Mediterranean etc. But it sounds too good to be true. Anyway, if that doesn't work out then we will spend the end of July beginning of August at La Carelle. The estate of Marc's parents (which now belongs to Jean) where Françoise lives also is a very nice house. This is also a very beautiful place which I begin to like more and more. Then you can see the chateau where Marc spent his childhood and grew up. The people are wonderful and if Françoise decides to move to Paris or Lyon we will probably keep her house there as a summer place for us because there is a difference when there are roots and history to a house. I can see with the son of Jean who is an only child how much La Carelle means to him even though it is far from Paris. He has his dogs and pets, everyone around knows him. He invites his friends for the school vacations. So either one plan or the other, as soon as I know I will let you know.

> We love you—X X X X X X
> Marc—me, and baby

March 4, 1964

Dear Grandma,

Hope everything is well with you. I am very well and home from the hospital. My nurse arrived and is very nice—everyone has been very nice. The house looked so good to me, I'm just taking it easy. I went out yesterday and had tea with Jeannine. We talked about, what else, our babies! She is very well. Her son's name is Peter. Bill just got back from making a film on Clay and Liston. What a farce that was! Unfortunately he didn't bet on Clay or he would have made a fortune.

As for the insurance, I'm not sure. It is an expensive insurance for what it is and I'm afraid they wouldn't issue it to you under your conditions, but I'm going to think about it for another few days. At any rate, you know that if you got sick that Marc and I would take care of you and the house payments. This is without question and I have told you several times. For the maximum payment of 720 dollars you are paying each year 92 dollars. That's what it comes down to if you analyze it. It is doubtful if any sickness is going to last for six months... even a serious accident like Françoise's is finished nowadays in three months so you are paying 92 dollars for even less. You have Blue Cross Blue Shield? I really don't think it is worth it plus with the difficulty of the examination, there may be all kinds of conditions. However, I realize that you would feel better having some kind of income in case of sickness, that is why I am thinking in terms of an income-producing property, if I can swing it. There are all kinds of complications but I hope I can manage in the near future. Just be a little patient. It may take two years or so before I can actually do it. Meanwhile, trust Marc and me. Nothing is going to happen to your house!

I sent some pictures of David to Grandpop. I know he'll like them. Wasn't I right? He does look like Grandma! I got the card from Pat at the store. Tell her thank you for me. Tell Bernice that in French David is pronounced Daaa-vide with the accent on the "vide."...

> Love and kisses, kisses
> Barbara, Marc and Daaaa-vide

March 19

Dearest Mother:

Just received today the sheets and the diaper liners. Thank you!! The sheets are very sweet—I already wrote to Pat and Mrs. Graham. How are you?? Everything here is back to normal: Marc is leaving tonight for the south of France to do an advertising job—back before Easter. The baby will be christened after Easter, probably the 19th of April. He is doing fine—growing and gaining weight. He is

very sweet—beginning to see a little and his dimples are beginning to show. He is very strong—amazingly so and all boy already—I have the feeling he is going to be quite a handful. He is terribly spoiled—his room is nothing but a jungle of toys and presents. His aunts keep rushing over with things like blue hand-embroidered batiste shirts because ordinary shirts are too rough for his tender skin…My boss from the NYT gave him some lace shoes from Brussels!!! I'm just waiting for the silk sheets to arrive…!!! Anyway more pictures—(in the bath) are on the way—if Marc ever gets them out of the lab. A few French Catholics wanted to know why we named him David—a Jewish name—I wonder how they manage to forget that Jesus Christ was a Jew for Christ's sake and that most Christian names are Jewish…Anyway Marc told them he had converted and that I was a Black Muslim…from now on we spell our name with an X (i.e., Riboux)—it is pronounced exactly the same in French anyway. Glad Grandpop got his pictures. Hope he was happy with them. I haven't heard anything from Daddy since the telegram. I am working in the garden trying to get it finished for spring and make it nice for David. I am also trying to arrange something with Françoise about the house at La Carelle. I would love for David to have the experience of grow-ing up there and spending his summers in a place where he has some roots and connections—it is beautiful country and everybody around would know him and become part of his existence. I know it is really an important part of Chris-tophe's life (he is the son of Jean and Krishna). Thank you for getting in touch with Dorothy Grafly—wow—when they make a competition, they really make a competition. This one is not for me—too expensive to enter with a commission like that. One would need such a presentation I would have to hire an architect and engineer to do the drawings, someone to build model etc., etc., etc. Oh well, I wrote for the prospectus just for the hell of it—

Write soon.

Love and kisses,
Barbara and David

Easter, Paris, 1964

Dearest Maman:

David has his rabbit for Easter and he sends you a big kiss and thank you. He is so adorable now—getting fatter and fatter every day he weighs 8½ pounds already and has lots of hair: it is straight black and we part it on the side. He really now looks like a little boy and not a baby!! The reason you have not received the new pictures is because Marc forgot to have them developed. But in a few days you will have them, I promise. I sent Grandpop a cable for his birthday from David, "Happy birthday great-grandpop—David." I think he will enjoy that. Not a word from Daddy. I think he is insulted. I had to tell him to stop sending (not to stop

sending—but a different way of sending) all these electrical gadgets he sends. It is so sweet, but it was costing us a fortune in duty taxes and we can't even use them on our voltage. Anyway I must write a nice letter for Easter. Marc just returned from the south of France from doing an assignment; It went very well so he is in good spirits—and he brought back the most marvelous presents for me—pottery and beads and 2 lengths of hand-printed silk and one of hand-woven white wool with a border which will make wonderful summer dresses. Very elegant. I have found through Jeannine at long last a great dressmaker (i.e., as good as you are) wonderful for cutting and details. She is an old Russian lady who used to work for one of the big fashion houses and boy oh boy can she every cut and copy!! She is copying my Chanel suit for me in navy blue. It is going to be wonderful. And she is making also a dress in Indian silk that my sister-in-law Krishna brought back for me from India, also a black silk dinner suit out of some material I showed you when I was in the States last time. And speaking of that, I didn't by any chance leave a tan checkered long sleeve shirt with the initials BR in brown there? Did I? I can't find it anywhere and I am really upset. I'm afraid it is lost. Anyway I am very happy with all my new clothes. You can imagine how happy I am to be thin again. I feel like a new woman!! And to be able to wear pretty things again...
what a pleasure. I think that is the greatest thing about being pregnant. It makes you appreciate your shape when it finally comes back!! I hope your Easter cocktail party turned out well. Your outfit sounded very nice. When I come this summer (if you don't come here) I will bring you some material. I went to a great party night before last. Marc hadn't arrived back so I went with Sheila's new boyfriend (who was in Zurich, Sheila, that is—smile), who cuts almost as handsome a figure as Marc! I wore a black backless dress by Pierre Cardin—not exactly backless, but with bars of black crepe over a low-cut back (that people love to put their fingers into!!). But at the party was the wildest looking girl I have ever seen: She is French-Canadian from Montreal and looks to be about ¼ Negro or maybe ½. But the color of David, this golden honey color with straight black hair and great eyes. Anyway she had on an outfit of leopard skin—skin-tight leopard skin pants, black boots, a leopard skin vest, black sweater. She looked just great. She is here promoting a film she made. I'm sure she will have a grand success. The funny thing is she looked just like me except for her color and her nose which is much prettier. One woman—who knows me well—spent ten minutes talking to me thinking I was the other girl (of course there were only two of us at the party). She spoke French as her first language and English with a very heavy French accent. She was charming...

Sheila arrived for her show in Zurich and spent two days in passing in Paris. So she saw David and we had a long talk. She thought David was beautiful. Her little girl is due to arrive next week. She (Sheila) is moving out of Mexico to somewhere in Europe. She hasn't decided where yet maybe Greece or Spain. Françoise is closing down her school in La Carelle and probably we will make a

country house out of it (it is a beautiful house) for Françoise and her daughter, Marc, David and me. This we are going to discuss with Françoise when she comes for the Christening. She is Godmother for David. The Christening is set for the 26th in the afternoon with a kind of cocktail afterwards. There will be about thirty-five people when you count all the children so it is going to be rather a mad-house. The poor grass!! I just hope it is good weather so all the children can be outside. I am just going to have punch, champagne and little sandwiches. To make a real lunch for 35 people!! That's why I am having it in the afternoon and not in the morning. Anyway, I suppose it will turn out alright. The priest Pere Pigue is a real character. He has long been a friend, advisor and priest of the family, but he doesn't sound or act much like a priest. He is very funny and jolly and tells the most off-color stories I've ever heard. Anyway, I like him. Next Saturday I have to take David to be circumcised. I completely forgot at the hospital and of course in France they don't do it automatically. Marc screamed at first, but I finally convinced him. It's terrible though when you really have to decide then it really becomes an issue and not something you don't even think about. I am very excited about the house of Françoise that we may share as a country house. It is a beautiful farmhouse situated in very beautiful wine-country. It is, of course, on part of the estate of La Carelle, the property of the parents of Marc. It is important to Marc as he spent all his childhood there and it will mean a lot to David I think plus the fact that it is so pleasant in itself. He can have all his pets and things there, spend his summers there with the sense that his father, his grandfather, and his great-great grandfather also spent their summers there. I am looking forward to your seeing it either this summer or next when we will have had a chance to make it really a house. It doesn't need much, just a few touches—all the basic things are there. I thought I had a postcard of it but I don't. Maybe I sent you one before. Marc had wanted something further south (this is 5 hours south of Paris) for the weather, but I prefer this rather than just plopping down somewhere for no reason at all in the midst of strangers. As you can see, I am becoming very "root" conscious all of a sudden; but I think children need this more than anything else. Well, I'm going to close now. David sends you all his love and so do we—I promise to write soon.

> Love, XXXXX
> Barbara

April 2, 1964

Dearest Mother:

Please cheer up—your last letter made me so sad … you will be seeing your little David again soon. And he is growing so well, so strong and so pretty. Enclosed are some contact prints of the Christening. Real photos are on the way. You really

can see the dress on these—On photo A in left-hand corner is Krishna, next to her going right is Nicole, the oldest step-daughter of Sylvie, a sister-in-law, and then you, the old sculptor who lives next door, then the nurse holding the baby and the priest. In photo B—You and Françoise are on far right. Remember, it was such a beautiful day. On the way also is a little present from David to you + Bernice + Grandpop. I was very worried not to have heard from you in such a long time— I was ready to call today when I received your letter. I hope your visit cheered you up. I still plan the trip at the end of June, but if you can have more than two weeks' vacation it would be wonderful. Maybe we could make other plans—let me know exactly when your vacation will be…As I mentioned, Marc has to be in New York around the 6th of July—I planned to come before but after all I may come with him at the same time. There was a possibility of coming in May, but I don't think I can swing it—I have an invitation to the opening of the new wing of the Museum of Modern Art in New York and I would adore to go, but I don't think I can change my plans to such a degree. Anyway, don't be sad—you have a beautiful grandson whom you will see all the time, who loves you and a son and daughter who love you more and more and who will take care of you.

My atelier is coming along well—it is almost finished. Also thinking about the project although now that I have the details I am less enthusiastic. It is very limited in design and in what is possible to design. Anyway we will see what is possible to do…I am in midst of writing my partner in Philadelphia.

Well, I will send you real photos soon. You can't really see the dress on these which are contacts. Say hello to Bernice for me and all the gang. Give one of the photos to Miss Bertie. And please cheer up. We will be seeing each other soon. Françoise sends her love, she spent the week here with me and we had so much fun. I hope she moves to Paris. She is now looking for a flat.

<div align="center">

Love XXXX
Barbara, David and Marc

</div>

P.S.—His little thing is all healed!!! And is it pretty—

April 16, 1964

Dearest Mother—

Marc just called me from Milan—all happy. He will be back at the end of the week. Day before yesterday we went to see Josephine Baker here in Paris and guess who was with her—my friend from Spoleto Carmen de Lavallade, the ballerina who is married to Geoffrey Holder. They were both dancing during the changes of Josephine's wardrobe. I was so happy to see them. They have their little boy here also. I am going to give a dinner party for them next week. The show is really terrific. Josephine's well worth seeing—and the

costumes—fabulous—but I was most happy to see Carmen and Geoffrey—will tell you more when I see them again. How is Bernice? Give her my love. I sent her also a box from David. The candies inside are called Dragées and are traditional at weddings and Christenings and confirmations. I find them so pretty—and they are good luck besides. I also sent Daddy one and Grandpop. I hope Grandpop is alright now. He is a sturdy old thing. Tell him to hold on, David is on his way. He'll give him a new lease on life!!!

Kiss Miss Bertre and everyone for me—

Love
XXXX
B

July 30, 1964

Dearest Mother,

So happy to get your letter. We have just been looking at the pictures of you and David. They will be on their way soon. As soon as we can get enlargements. We have also taken some of him in his swing—so sweet. And he loves it. He is very well. The doctor is on vacation, so he won't have a check-up until next week. But he eats well and no more gas... He is on four meals a day now with his cereal at night before he goes to bed and he sleeps through the night from 8 pm to 8 am—

Marc is well, busy working as usual. He is doing a story for *Ladies Home Journal* on *Harper's Bazaar* and how they cover the Fashion openings. Also I spoke to James Baldwin. We will probably have dinner with him over the weekend. Oh before I forget write Françoise for the present. Send it here as she will probably stop by on her way to her vacation. She so likes to hear from you. We are supposed to be going to a very elegant dinner party given by *Vogue* tomorrow night—so I am happy I bought that dress at Saks—

So tomorrow I must spend half my day in the hairdresser's etc., etc. And I must find a dinner jacket for Marc. Sheila is still here and fooling around. She sends her love. I got a letter today from Alice with a baby card in it. She is so nice. There is a very telling paragraph about Goldwater too. She says it should happen to a dog!!

I am getting lots of rest and I have to stay in and mind David. Of course Mme Rosier is here. The garden looks wonderful and so does the house. The photographer is supposed to come next week to photograph the house. I am still debating whether to paint the hallway dark gray or not.

David sends you a big kiss. He is so happy to get back to cool Paris. Although there was a heat wave here too.

XXXX
B

August 31st, 1964

Dearest Mother,

I will get to work on the plans—I'll have many things to do. Last weekend we went to our country house—a farm or rather a vision of a farm which we are going to do over little by little. Finally, it will be quite beautiful. It is a beautiful setting: in wheat fields and pastureland with cows and horses on the edge of a very beautiful forest. It is quite big, lots of buildings, stables, etc., but the thing that really made us buy it were the trees, about 200 of them, many 2 or 3 centuries old. It is something money can't buy and makes the kind of park that only a chateau would have. So we are both very excited about the prospect. We have a friend who lives nearby who is going to supervise the work for us—otherwise it would not be possible. It is two hours from Paris going south, very near to Jeannine's. I am full of all kinds of plans, etc. But the idea of the farm is like the description of the one enclosed... For David it will be wonderful to have all that space, horses, the forest, hunting. What is there now... the buildings exist more or less and the trees... everything else has to be done—electricity, windows, doors, partitions, all interiors, roof on the studio and a new roof on most of the house. The pond exists. There are many more buildings some of which we are going to tear down completely... Marc will be back on the 6th or 7th and we plan to go down for several days to make the plans with our friend. The mayor of the village has promised to build a road (there is no real road for the moment to the house and we have a farmer there this week clearing the underbrush).

Françoise came through Paris yesterday and I told her about it. She was very excited. And of course Jeannine is delighted. Jeannine is the one who discovered it in the first place. So really we have her to thank. I can't tell you how beautiful the countryside is. It is really what they call the "Sweet France" in the heart of the chateau country. But our landscape really resembles a kind of 18th century English landscape painting—flat, beautiful light dotted here and there with huge oak trees. The name of the farm is La Chenillère which was probably La Chênière which means "The Oaks" or the place where the oaks are. But through the years in dropping the accent it has become "the place where the caterpillars are," so we are going to put back the accent!! I hate caterpillars—I will tell you about the sale in another letter. It is a hilarious story. Of course I wasn't there. Everybody thought anyone so exotic looking was sure to scam this rich French peasant, so I have the story second-hand.

I can't tell you how beautiful David is these days—and big and fat... The girl turned out to be very good with him except... she is pregnant. I can't keep her more than a couple of months!! What luck—and this is her third!! Me and my

ideas about unwed mothers!! Well Mme. Rosier told me that old French saying "Where there are two, there will be three!!..."

<div style="text-align: right">

Love X X X X X
X from David
B

</div>

P.S.—He is almost sitting up alone.

September 6, 1964

Dearest Mother:

Here is telephone bill. I am so happy you liked the pictures. I don't think you look old, but very thin. It is just a matter of gaining weight. Marc will be back from Portugal tomorrow or tonight and we will leave for Jeannine and Bill's place in the country Thursday. We have a new nurse, Ann Marie who will probably be alright although she is terribly slow... and Marc can't stand that. The other one was so quick—well, we shall see. She is very sweet and patient with the baby. David is more beautiful every day. Strong and healthy. The gas pains stopped as soon as he got back to Paris!!!

Well it is not the end of the world for the photos, but Marc is sure I didn't bring them back with me to France. Therefore they must be in Philadelphia. Look again and make sure they are not at the house.

The plan for the sewing shop sounds good: but you would need more than $500.00. Another thing: what about this little store next door? If you could use that as a shop and dressing rooms and to receive people, the basement could be the workroom. I would work on this plan even if it is a lot more ambitious. It is better to ask for too much and get not quite that than to ask for not enough and to get even less.

Before I can make the plans for you, I need to know the dimensions of the basement. Send me a drawing like this then get in touch with the real estate agent about the little shop and try to find out how big it is—also price etc. Get very specific information and send it to me. What would be nice would be a workshop in basement—linoleum floor, paneled walls, something simple. I could make very professional plans and presentation. Also for the little shop—since you say it is quite small, there would just be room for a desk, chairs (gold painted like in the fashion houses) two armchairs a little dressing cubicle with mirror, stool—the store window could be done in French Provencal with a little glass chandelier and one French Provencal chair over which you could display a dress or suit.

I received a note from Beryle Hastie (Judge Hastie's wife) saying that her daughter will be in Paris on the 29th of August for two months on her way to

Switzerland to school. So that we will see her and show her around a little bit. She is with a friend—Paris is absolutely empty. Everyone leaves during August. All factories, most shops, all industry is closed down the month of August. I don't know where everyone goes, but they all go somewhere...Françoise passed through a few days ago on her way to the seashore. We had a wonderful dinner with friends last night. One a South American composer who came back home and played the piano until 2 o'clock in the morning. It was great. The combination of a Russian dinner with lots of vodka and music and a home concert of Brahms, Schubert, Beethoven, Bach, and Debussy really hit the spot...I can't think of anything more luxurious than having one's own private concert except having one's own private movies like the night I had James Baldwin here for dinner.

So write me quick the measurements of cellar and also of little shop, and I will start on drawings. David misses you. He is almost sitting up weighs 14½ pounds.

<div align="center">

XXXX—Marc too...

B

</div>

August–September 1964

Dearest Mother—

Please excuse the long delay—but both Marc and I have been so busy...terrible. Everything here is fine. David is wonderful. I am doing several projects which I hope will bring in a little money. So I am really hoping I can send you the money for the workshop before Christmas. I should know next week. Of course it would be much better like this. I don't like the idea of your borrowing money—I will speak to Marc about it if the projects (with the *New York Times*) don't come through...We will work something out—

I hope you got the card announcing Marc's show. It was a big success. Everyone is very happy. I have enclosed the biography the museum wrote for the show. There is a woman here from Prague who is doing a book on Marc and his work. So I have been working with her, sorting photographs and finding articles on Marc, etc. Also I have been trying to work a little myself—the deadline is near. I am glad to have this exhibition off my hands and also the book finished. Marc is in the south of France—he will be back tonight—We are invited to a ball and dinner given by Pierre Cardin and Jeanne Moreau. I'm happy I bought that dress at Saks!! Otherwise it would be impossible a long dress is very expensive in Paris. Now to get Marc into a dinner jacket. I intend to look beautiful!! It is Wednesday the 30th of September at his town house.

Shirley got married last month. I enclose the announcement that just arrived...just like mine! No word from Joyce.

We may be going to London for a month or so for work—if the China visa doesn't come through or is late—if it does, I am invited to Hong Kong to wait for Marc, and I just may go…

David is sitting up very well…getting fatter and fatter. He will soon be in a playpen. I can't keep him in his little bed any longer—still the problem with Ann Marie, the nurse, but I'll think about that tomorrow…Madame Rosier made David the sweetest white wool knit sweater with a little collar. He looks so adorable in it. He is practically all the time dressed in white, he looks so divine in white.

Tomorrow I am having a few friends in for drinks for the woman who is doing the book on Marc who is staying here. Very nice. Friday, we will have dinner with Jeannine and Bill just back from the country, and for the weekend, "La." I hope. So, I must work tonight. I send you a big big kiss—You'd better start thinking about boat reservations for next summer—

<div align="center">
XXXXX

B
</div>

30th September 1964

Dearest Mother,

Thank you for the photo. It is lovely. Marc was absolutely fascinated with the story—and just two days ago, he had a friend who called him from Montreal… I was so sorry to hear that Grandpop is back in the hospital. I am sending him a card by the same mail and another little picture of David. My goodness, it does seem you had a busy week—I am sorry. Everything here is fine, but everyone overworked. Marc's China material is going very well, I am sending issue of *Match* also by this mail. Look on 19th October and the book deal it seems will be closed next Wednesday in London. As for me, I am working hard at the studio. I got an invitation to exhibit and the <u>first World Festival of Negro Art in Dakar (Africa) in April.</u> An invitation by the United States Committee. I have already sent photos and will probably get a reply by next week. They said they had been looking for me for months and finally got my married name from Phila Museum.

David and Maria are fine. Finally great friends again. Tomorrow we go to a reception at the Chinese Embassy. Yes Lucy Jumbor did come by and left the wonderful little dog for David. Although I wasn't here (probably working) she didn't call first to let me know that she was coming. Anyway, the dog's name is Mac. I hope that is American enough for you!

I will let you know how all the projects turn out, but as far as actual work, it goes very well for both Marc and me—selling it for me is another matter. In about six months there will be that question. Marc's China is sold everywhere—London, Italy, France, Germany, USA—so he is very pleased. The weather here

is still awful although we had one beautiful week. We managed to spend one day in the country and it was magnificent. The house is coming along very nicely. We are so lucky to have this friend there.

Well, that's all for now. I've collected some more stamps for you. A big kiss from David... and me... and Marc.

<div style="text-align:center">XXXX
B</div>

P.S.—Please pay television off...

[MARC WRITES]

Dear Mother, we think so often of you. David is funnier and funnier—and so healthy. He weighs as much (nearly) as his cousin who is 3 years old! We are so proud of him.

<div style="text-align:center">I kiss you.
Marc</div>

October 1964

Dearest Mother:

This is cheer you up paper... I'm sorry about long delay but I have really been busy. The card was to say I was too busy to write. Enclosed is latest on Pierre Cardin Ball. I told you we were invited and went. I wore my white dress and coat. I looked very nice—but was handily outclassed by the Dior's, Balenciaga's, Cardin's, etc., etc. It was the ball of the season so far and it was great. We got home at 4 in the morning. Marc looked so handsome in his dinner jacket. The ball was in Cardin's private house, a mansion on the banks of the Seine near Place de Concorde. There was first a showing of models from his collection, then a sit-down dinner (superb) for 200–250 people at small (8–10) tables. A fabulous dinner beginning with salmon and champagne then a veal and rice dish with raisins (red wine, '57 Bordeaux) then salad, cheese and a peach melba for dessert. Then the tables were cleared away and the 2 orchestras (one South American, one yeah-yeah) began.

Everybody was there—the vicomtesse de Ribes, all 3 Rothschild brothers and their wives, Elsa Martinelli, Françoise Sagan, Rubirosa and his wife—all kinds of princesses and princes, dukes, and duchesses. The women were the most beautiful in Paris or in the world if you like being at the same time the richest. The jewels were out of this world. There were at least 20 bodyguards just for the jewels. There was one poor princess of I don't know what name at our table who really looked like she needed two men to lift her to her feet she had on so many jewels. It turned out she was Belgian and all those diamonds and rubies

came from the Belgian Congo! She had a necklace of diamonds and rubies which looked like it weighed a ton—with earrings to match, a bracelet to match and a brooch to match the bracelet and a diamond ring of at least 20 carats. It was really disgusting. Thank goodness she was old and ugly which couldn't be said for many. There were some people from New York and London who had flown over just for the party and Dionne Warwick was the attraction. She was here doing a show at the Olympia and Cardin asked her to perform for the party. She was great she sang "A House Is Not a Home" and "Don't Make Me Over" and "Anyone Who Had a Heart." The people loved her... So, I enclose pictures of me from before the ball and pictures of the ball in one of the French magazines. Cardin's house (I had been there before for a wedding) is magnificent. He has a big salon d'été (French Summer Room). I guess you would call it about the size of a small ballroom all done in mirrors and black marble with giant rubber tree plants which overlooks the river. So that from the street below one can see the entire room since it is all glass. Of course there was always a group of people outside watching. Anyway it was a great evening. Some people even thought I was the prettiest thing there—but those dresses...

David, little David is growing and growing and growing. He is still as sweet and good-natured as ever—always laughing. He weighs more than 20 pounds!! But he is not fat. He is all rosy and golden and looks more and more like Marc. He is out of his bed—on the floor now and sitting up by himself practically all the time if he is not asleep—He sings and talks all day. My God, how good-natured can you get?? He is also very affectionate.

Marc is in good spirits these days—dashing around in his Alfa Romeo. It looks like he may get to China after great difficulties and delays over the visa. The show in Chicago was a big success and the book on him should be finished soon.

The house in the country is fine—all signed and everything and we even have a road!! The municipal government (we know the mayor of our village) built the road just to the property and just by luck, we made a trip there that day and had them make our road going from the main road to the court while they were there. We were so excited they made such a beautiful curved road! Anyway you will see it all this summer—but don't expect a house. It is a ruin—abandoned for years and years and everything has to be done. But the place is so beautiful and now at the beginning of fall with the trees turning, it is divine... I'm still hoping I can make my grand salon this year, but is going to be too expensive—next year or the year after because I really want to do it up right. My dream room. I am copying the floor from the chateau of the Rothschilds (who copied it from the Italians!). But can you imagine a living room 30 feet by 50 feet long!!! And our friend we have helping us is wonderful—but it is the work of a lifetime. I want to make an avenue of trees leading to the woods and another on the road leading to the house—it only takes 20 years for them to grow!!! But I can just imagine little David with his pony there—

I should be doing some work for *NY Times* soon so your check will be forthcoming I promise. Also I haven't forgotten your coat. I hope someone next week can take it to New York with them. It will be mailed from there.

I am working very hard. Haven't heard from anyone. Sheila is here in Paris. Jeannine is fine, so is Françoise.

> I kiss you—
> XXXX
> B and David

December 21, 1964

Dearest Mother:

I was so happy to get your letter. By now I hope you have our Christmas present…David can hardly wait to see you. Don't be too sad. We miss you as much as you miss us. I am making a small tree for David all silver and I have bought him a rocking horse, a transistor radio which plays "Ten Little Indians," a telephone, a spinning top and some lollipops. He got a beautiful gift from Magnum a kind of demountable wooden toy train all lacquered in different colors. Our two receptions (one for Jeannine and Bill Klein, and one for Magnum) went very well the house was beautiful and the party very chic with a serving butler and all, ladies in long dresses, about seventy people. Everybody (including the waiter) had a ball stayed until four. All the women were dying to dance with Geoffrey Holder who was there but I danced with him the most. The party was to celebrate the first prize Bill Klein won for a short subject documentary on Cassius Clay at a film festival here. I had a sit-down candlelight dinner for twelve served by this famous waiter who by the end of the evening was serving drinks on his knees practically!! Then people came after dinner around 10:30 to drink and dance. All my in-laws (except Jean and Krishna) were there also. I had on a long black skirt and a sheer black top (chiffon) with ¾ sleeves. I looked very nice. Jeannine had on a long black dinner suit, very lovely. Tamara from Tyler was at the dinner as well as Norbert Ben Said (our new family doctor, terribly handsome as well as being personal friends), the Nabokovs (he is the nephew of the writer Nabokov), Bob Fabian, an American painter, and Sophie, Marc's blond and beautiful traveling companion in Africa. Madame Rosier cooked and I made the dessert: apple pie— it was delicious. We had salmon and champagne to start.

Now for David, as you can see from photo, he is standing up, he also has a little cart like a kind of slab with wheels on it that he can maneuver very well. So he really gets around. First it was by pushing backwards. Now he can go forwards and sideways (that's pretty funny). Actually what this thing looks like is a kind of metal hoop skirt and any day now he is just going to pick up the whole thing and

start walking. He is very strong and will probably walk very early. He also loves to rock by and forth—that's the reason for the rocking horse. And he has two teeth you can barely see. He is the sweetest funniest baby ever. We never stop laughing at him. Marc now is completely wild. When he is home he does nothing but play with David. It is just in the last two or three weeks that this has started but it is just now that David has really started to respond as a human being and not an infant. He already wears size two years clothes so I don't know what I'm going to do with him when he is four! He is invited to a Christmas party Christmas day. The Kleins are giving a children's party for Peter. Actually he is too young to go but I'm going to bring him anyway in his little contraption. He'll get along alright. I bought him today a pair of Italian knit short pants and a sweet white long-sleeve blouse with ruffles at the wrists. With his long white stockings and yellow Mary Jane shoes he will look absolutely adorable. He is really so pretty. Between you and Marc this summer I don't know what I'm going to do. And the nurse is just as bad. She spoils him terribly.

Don't worry that your package hasn't arrived yet, even if it arrives after Christmas, David will love his presents. Anyway it's not good for him to get a lot of things at the same time. Nevertheless, I wonder what has become of it—?

Work has started on the country house and I'm dying to go see it. Maybe we will go this weekend. I'm already planning my gardens—all white flowers except for roses and lilies—besides that, white jasmine, magnolias, daisies, lavender, maybe some white tulips and cherry trees. A whole walkway lined with them plus all kinds of vegetables. Turn a city girl loose in the country and she goes completely wild—Marc thinks I'm crazy. But wait until you see my garden in full bloom!!!!

Also enclosed a clipping from a Danish magazine on the Cardin ball... who is that handsome man sitting beside me? My husband!—to the right Pierre Cardin—to the left a princess I forget which one, but I think she is in the other magazine I sent you—

We went to the "salon" of the Paris director of *Harper's Bazaar* last week too on our rounds of Christmas parties. She is a wonderful woman, very old and very famous in Paris. She knows and has known everybody who is anybody in Paris since the 20s. Everyone loves her. She wanted especially a photo Marc had taken of her during the time of the collections so that she could give it to her dear friends Elizabeth and Richard (Burton, that is)...

Can you imagine I'm going to be a great-aunt!!! I already made my 23-year-old nephew stop calling me "Aunt Barbara," but now I have another 22-year-old niece (the step-daughter of Marc's youngest sister), the one who was married last June and "knew all about birth control" is, of course pregnant and that makes me...oh well, I'd rather not think about it—the only funny thing is that it also makes David an uncle!!

David will be writing to you soon and you can begin to collect all his drawings. I haven't tried him out yet with a crayon, but I'm sure he will love it, if he doesn't eat it first—

All our love and kisses this Christmas and here's to next spring and a wonderful visit with David Riboud—

XXXXX

B

December 25, 1964

I can't believe that Christmas is here again. Our third wedding anniversary. Can you imagine that?! We are still working on plans for the new house. But it will go very slowly.

Did I tell you that Shirley got married? A friend of hers passing through PARIS says she is very well. I wrote her a note for the wedding, but haven't sent a gift yet.

No news really—I'll write again soon.

Love
XXXX
Barbara and David and Marc

1965

I was just getting back to work after David's birth when another of my earthquake trips loomed on the horizon. Marc called from Beijing (then Peking) to inform me that I had an invitation to visit the People's Republic of China.

He called on the 21st of April, from Tiananmen Square, his Indo-French accented voice conveying his excitement through the phone's static.

"I've just photographed Chairman Mao and Zhou Enlai, the Prime Minister, and you've just been invited to China! Listen to this..."

I heard a low rumbling like the ocean and a coarse sound like the rain on a tin roof. "Tiananmen Square is filled with half-a-million Chinese getting ready for May Day!" he exclaimed. Holding my breath, I listened to the rise and fall of a sound like a huge heartbeat. "It's the chance of a lifetime, Bar-ba-ra," he chanted. "But," I protested, "Americans are not allowed to visit China...China is closed..."

"You can use your French passport...they will accept you as a gesture of friendship toward the American people. I will be on the tarmac at the foot of the plane to meet you!"

"My mother will kill me..."

"No buts. You can't turn down an invitation like this! You'll be the only American in China—the first one since Mao's revolution!" he explained.

The static and Marc's enthusiastic voice cracking with electricity over the 6,000 miles that separated us made it seem as if I were listening to the voice of an alien from outer space. This was the moon. China was another planet. My son, David, was little more than a year old. Was he crazy?

"But the baby," I stuttered.

"Bring him! There are lots and lots of babies in China...Millions and millions of them. And don't bring any skirts or high-heeled shoes. Only trousers. The only thing women here wear...There's no second chance, *Cherie*...it is now or never. Your visa is at the Chinese consulate in Paris. The next Air France plane leaves next Tuesday. Be on it. Love you."

"But..."

The phone went dead. I sat by it stunned, staring at the little black-on-white numbers on the face of the rotary dial. This was not yet the digital age. What could I possibly do in the People's Republic of China, I mused? Could I leave David?

Take him with me? This was not the first time I had packed my bags on the spur of the moment and grabbed a plane, ship, or train for an exotic, outrageous destination. But now I was a mother, China was hostile, dangerous, typhoid-ridden, filthy, filled with exotic diseases, including communism. My mother really would kill me, I thought. Which is just what I had said to myself when I embarked on my first Egyptian voyage. Which I thought wryly meant I was already on my way...

I took down *The Pelican History of Art: The Art and Architecture of China*, and began to read.

"The Chinese possessed the longest continuous history of any of the peoples of the world," I read, "Five thousand years before the excavations at An-Yong, the earliest known sculpture of certain date was the rather crude, but forceful group of animals and carved soldiers at the tomb of a Han general who died in 117 B.C..."

I stirred David's vegetable soup and read on...I studied the poor-quality black-and-white illustrations of porcelain, silk, bronze, marble, the sculpture, the Paravans, the lacquers, the scroll paintings, the gardens, the Buddha's, the calligraphy...this was what China had been. What was it like now, after the destructive violence of World War II, the long Civil War, years of famine and natural disasters, and finally a communist revolution, I wondered? I knew I wanted to find out first-hand. Gently I laid the book down, open, on its face, and picked up the telephone.

I called Françoise. "Marc wants me to join him in Peking," I told Françoise, as if announcing the end of the world.

"How wonderful," she said immediately, "You must go! It's a fantastic opportunity...Don't worry about David. I'll take care of David. He adores me. What else could be stopping you?" she asked as I explained my hesitations.

"Americans are forbidden to travel in China. We don't have diplomatic relations."

"You mean that the U.S. doesn't have diplomatic relations with a quarter of the people on this planet?"

"Yes. I know. It's incredible."

"And with a quarter of the art on this planet as well..."

"To be sure..." I laughed.

"Your father-in-law made a trip around the world in the 30s and spent several months in Shanghai...I think I have his journal somewhere...I must look for it," she explained. "You must read it before you leave...Marc never did."

"I'm leaving in six days...I can take it with me."

"You and Marc are the family's explorers of the world. You've got to go..." Françoise said eagerly.

"Well, I'd better go out and find something I can wear," I said. "Pants and a jacket. Marc says no skirts, no high heels, no dresses."

"Barbara, they make clothes in a day in Peking—it's only their art that takes five millennia…"

Yes, their art, I thought. Even Mao's regime would come and go, but the Lung Mên Buddhist caves were eternal…and I would see them before I died.

And so began a love affair that would last through 40 years. The trip I had decided to embark on would take me to the far-flung corners of Inner Mongolia's steppes and Tibet's mountains; the wood and marble Forbidden City of Beijing and the bustling wharves of Shanghai; I would be moved to tears, paralyzed by fright, delighted by unexpected pleasures and sights, entranced by mysterious and overwhelming beauty, puzzled by exotic trivia, fascinated by Buddhist theology, Chinese philosophy, and Mao's little red book. But most of all I would be mesmerized by five millennia of Chinese art, which would shimmer and gleam in my unconscious and which I would eventually use subversively to shape my own art. I was about to enter a new old world, a slumbering universe about to awake, shuddering into the second half of the twentieth century with a violence that had shaken and terrified the world. I, thanks to chance, would enter that world, not belonging, and yet not entirely an alien, even feeling at times at home. I determined to take it all in without prejudice, to open to every nuance, to refuse no integration, accept no form of discrimination or preconceived ideas—China was now, after all, thanks to Prime Minister Zhou Enlai's invitation, an open book to me.

In May, I joined Marc in the People's Republic of China invited by the Chinese government, which made me the first American to visit China since Mao's Revolution. Using my French passport, I took the Air France direct flight that left from Paris, stopped in Moscow, and passed over the North Pole to Beijing without passing through Hong Kong as Marc and K. S. Karol, the journalist traveling with him, had done. I had even concocted myself a Chinese uniform: a dark green suede military jacket with khaki work pants and a Mao working man's cap.

When the plane landed, Marc and Karol were both standing there on the tarmac at the foot of the stairs in front of an official limousine flying the French flag, with enormous bouquets of fresh flowers—a Chinese welcome surrounded by smiling translators, guides, commissars and chauffeurs, a whole welcoming committee.

It was the beginning of another transforming voyage not at all like the Egyptian adventure but more like the rediscovery of an old friend. I had studied Chinese art under Vincent Scully at Yale. I had hesitated long and hard about going. I had hated Moscow—what could be different under still another communist regime? Françoise argued I would be silly to decline and I would regret it all my life if I did. I waited until the last moment to tell my mother, who didn't approve. I was leaving little David with his aunt for at least 7 weeks. I was once again entering a war zone—the Vietnam War had escalated with 150,000 new troops being deployed. And besides that war zone, there was the war zone in the United States.

Malcolm X was assassinated, sparking riots in the ghettos, unifying the radical left with the nonviolent wing of Martin Luther King who had delivered his "I Have a Dream" speech at the Washington Monument. He was jailed in Birmingham. Four Black schoolgirls were killed in a bomb explosion in the same city. The Watts section of Los Angeles exploded in riots that killed 34 people and left 1,032 injured and 3,952 in jail. Friends were arriving from the United States talking about being political refugees and young men were fleeing to Canada to escape the draft.

I would soon find myself standing in a 100,000-seat stadium in Beijing surrounded by a thundering chanting army of wind-swept red flags and Mao-capped demonstrators all brandishing the Chairman's little red book and shouting "Down with American Imperialism" anti-war slogans. By the time I left Shanghai, on my way to India, the seeds of the Cultural Revolution had begun to sprout in the universities around the country and Red Brigades had begun to turn on their teachers, parents, and relatives, provoking one of the most brutal upheavals of society in history, filling reeducation camps and gulags and killing millions.

January 1965

Dearest Mother,

I was so happy to get your letter. We were getting a bit worried the mail was so slow. Finally, your Christmas stocking arrived miracle! It is so pretty it will be perfect for next year. I have put it away for David. The things were all adorable, David especially needs things to chew on, he has three teeth now. Did you get the following letter with the picture of David standing up? One is for Grandpop. David is so fat I don't know when he is going to walk. It is not that he is fat as you can see from the pictures, but he is so heavy he weighs at least 22 or 23 pounds. He says Maman and on occasion pap and "gateaux" which means cookie. Well finally Marc got his visa for China!!! For one month with the hopes of an extension. I may even go myself if he stays longer!! But more of that later. He is going to leave here the 21st of January, but he is going to pass by New York for a few days for a meeting. So you will see your darling Marc!! You may have to come to New York because I doubt if he will have time to come to Philadelphia. Anyway from New York he will fly via San Francisco Honolulu on to Hong Kong and in Hong Kong he will meet Karol, his friend and the writer who will travel with him. From Hong Kong they will take a slow train to China!!! Actually we have very good friends in Hong Kong with a beautiful flat so it would not be impossible for me to go there, stay or a few days and then join Marc somewhere. But first I have to get the visa, then permission from the State Department. I have already applied for a French passport. It would be fantastically exciting and this is possibly the last chance I'll have in the near future to see China. But nothing

is definite. We are going to the Chinese Embassy on the 15th for dinner. It seems they have great Chinese food!! (smile) So I am looking forward to that. We spent a very quiet Christmas and New Years, Marc has been working so hard trying to get everything ready for his trip—I think I told you about the Christmas Party Jeannine gave for Peter. David was adorable with the other children. He wore a white tucked shirt with ruffles at the sleeves (long sleeves) with pale blue piping and little pale slippers (You can see in enclosed picture with tree). Marc gave me books and I gave him sweaters and a love letter. David got tons of toys from everywhere—the US, Switzerland, England, Italy, etc., etc. Most of them I have put away for later.

The plans of the house are really marching along—Not much will be finished by summer, but at least we may be able to live there if we can get one part in shape. Then we can visit all the castles in the area and take walks and play with David and plant flowers!! Marc is like me, I think he is getting a real mania for building houses. Anyway that's all sculptors do or think about—building things every time they get an atelier, they want a bigger one!

Write soon.

> Love,
> Barbara

January 1965 (Sunday afternoon)

Dearest Mother,

I think the beginning of June would be good. But I think you should arrange to go one or the other way by boat. It is such a wonderful crossing (only a French ship) great food and sunshine. It is just what you need. Maybe on the way back since you would be so impatient to see David you wouldn't relax properly. Yes— I think that's it—to fly over and sail back—but if you think the reverse would be better, then do that. At least think about it.

I am still waiting for my first letter from Peking. It should arrive tomorrow. Everything here is fine. David is in good shape. He has two teeth and can eat anything and now he is beginning to crawl a little. I am working away and on all kinds of diets and dance classes to get myself in shape for spring. I am going tomorrow by train to the country to see the house just for the day. I will probably come back Monday night or at latest Tuesday morning. I can hardly wait. Last night Geoffrey Holder and his wife Carmen had a going away party. Carmen is going back to New York to do a ballet at Lincoln Center. It was a nice party. All dancers and crazy people.

Write soon.

> Love love love and a bientôt!
> Barbara and David

January–February 1965

Dearest Mother:

I was so happy to receive your letter and your news from Marc. Forgive me for
the belated birthday greetings, but I hope Marc did the honors. Did he look too
tired? Usually, New York wears him out. But the meetings seemed to go very well
this time. He called me from New York the day before he saw you and he was in
very good spirits. I hope the visit with him wasn't too hectic (as usual).

David, lovely David is well and growing. Waiting for Grandma to arrive. My
goodness I wouldn't worry about making yourself understood to David!! What
do you think he is going to say Mother??!! Except for ma ma and da dad and Ma
ma and giglegoogoo . . . I think it is the same in all languages! But I am looking
forward to your seeing the house in the country, even though it will be a mess.
We can work together in the garden and doing curtains and things. Now, the
roof is being repaired and the buildings which have to be demolished are being
torn down. I have everything planned right down to the towels! (brown with
white initials)—all the rooms are planned and the garden. So don't be shocked
when you see this old wreck in my mind's eye. I always see it perfectly finished
with everybody sitting on the terrace! I have been working the last few days in
the studio. Sheila is making a trip back to the States in a week or so. I asked her
to get me a Warner's sketch thing you know, the transparent one. I saw a picture
of it in the American *Vogue*. It looked beautiful. Now, by the way, is the time of
the collections. Bill is fantastically busy working all night photographing the
dresses for *Vogue* (he sleeps all day) so Jeannine and I go to the movies! I spoke
with Françoise over the phone yesterday. She is very well and coming to Paris
in two weeks. I will be so happy to see her. I must call her today anyway. I am
trying to get a French passport which is a hell of a lot more complicated than it
sounds. The last thing was, I needed the birth certificate of my father-in-law!! So
I have to find out from Françoise where I can find it. My brother-in-law Antoine
has just become president of the company he has been directing for the past
years. It is really a feather in his cap!! Marc will probably become president of
Magnum and Jean (the other brother) of Schlumberger (oil) so we will have three
company presidents in the family. Another brother-in-law, the husband of Marc's
youngest sister Sylvie went with the French delegation to Churchill's funeral. He
was in the RAF during the war, after France had been defeated. He was married
first to an English girl, and then to Sylvie whom he met in South America of all
places . . . Anyway, he was going to walk in the funeral procession and so on. It is
funny you spoke about David's old nurse (he has a Spanish one now very good)
not only does she get paid but there is a system in French where you get a prize
every time you have a baby!! People make a fortune that's why taxes are so high.
You get the first part of the prize when you declare you are pregnant. The second

part at 6 months and the rest after successful delivery!! Actually everybody who has a child married or not gets paid by the State. This is to encourage population increase. I forget how much it is about $15 or $20 for each child. It gets really interesting when like Marc's sister, you have 6!! $120 or $130 a month is not bad—married. And Sylvie collects too. There is not this feeling of snobbishness after all this is a socialist state at least somebody in the family should get some money back. I have to pay social security much higher than in the States for Madame Rosier and the nurse, so now Marc is at the social security so we get back part of medical expenses (Medicare is part of the French government program for years). It is hardly worth the effort there are so many papers to fill out. And they keep sending them back with another paper attached. In a few weeks they won't even be able to send it through the mail.

I have just changed my hairstyle. Today is my "beauty day." I spent all last night and this morning working. You know how I can get myself in a mess—well I was. Anyway I gave myself bangs like I used to have at Tyler remember?? It looks very nice. I have a huge chignon in the back rather elaborate with big loops and thin bangs. I am going to send a picture to Marc. He has never seen me in bangs. Anyway I feel better. Jeannine has bangs these days too. Very nice. But Marc is going to be surprised. You know all the pants now have bell bottoms like the sailor pants—well I found a place in the "flea market" which is like 8th street used to be only 15 times larger with antiques paintings, furniture, clothes, costumes, everything that has real sailor pants and I bought a pair for $4.00. And had them fitted by my dressmaker. They are great. They look beautiful I think I've started a fad—all my friends are now rushing to the flea market to buy sailor pants. I'm going to buy some white ones for the summer. I'm hoping Marc will bring back some silk from China. He should have something made for himself too in Hong Kong. The tailors there are supposed to be fantastic. I wish Marc cared a little bit more. He can be so good-looking when he wants to be but he just trails around in that trench coat and whatever he happened to leave on the bedroom floor the night before. Oh well. I suppose only the handsome and rich can afford to look like such a bum!!

> Love—David sends a huge kiss and hug and lots of spit bubbles—
> XXXX
> B

Thursday, February 25, 1965

Dearest mother,

David got your wonderful cards and presents. He is so sweet now and can almost walk. Marc sent him a wonderful Chinese painting of two bears for his birthday. Everything is going quite well here. Bill, Jeannine and I were very upset over the

death of Malcolm X. Jeannine and Bill knew him well and admired him. And now the vendetta with the Black Muslims and the followers of Malcolm X—is really not funny...So much violence going on in the US I read a review in *Time* magazine where they discovered about 1/5 of the cowboys in the West were Negroes...Say just watch Sidney Poitier run...Poor White Americans don't have anything left after all this integration. The Negro comedians sure have a good time with that one. The book is called *The Negro Cowboys*—written by two historians from Harvard. If you hear any good jokes about it let me know...I am enclosing an envelope addressed to Marc in case you would like to write to him— He seems to be having a whale of a time. David's birthday party was wonderful. Tamara and her husband and Vicky and her boyfriend and me—Maria, the nurse, made a Spanish dish called Paella, a kind of rice with seafood in it and we drank champagne and I had a cake for David with one candle. I'll write again soon.

<div align="center">

Love,

B

</div>

P.S.—So I will consider the beginning of June—the date set for your arrival...

Paris [no date], 1965

Dearest Mother,

I am happy everything is OK. David is growing every day and learning new steps (dance) with Maria. I am working hard so please excuse short letter. We will send you all the things on China as they come out. I just hope they don't all get changed because of this China-India ultimatum. It was fascinating about my having a great-great aunt in Wilmington. She must be 100! But there were lots of holes in your story. For instance who did your great-grandfather marry? Was he married when he got to Canada? Did he come with family or did he marry there? And Aunt Wayne was the daughter but who was she married to? How come your mother came out so light? Was she married to somebody called Johnson, an American from Cleveland? If so, why did he come to Toronto and what did he do? And your mother, was she married to this medical student? If not, is that why she ran away to America? Where does this jazz musician you used to tell me about come in? If your grandmother's married name was Johnson why did they name street Ward's Lane? That was the name of your great grandfather no?...

 A Scot? From where? And now I understand why great-great grandma was in Montreal just after the Revolution. They were exiled as Black Loyalists way before the underground railroad! 1779! But who was Ward? What did he do and where did he come from? And the Johnsons?

 I would still like to know about the store. For my own information and future reference if you can find out anything. I'm glad you got your television.

How much did it cost? I still have some things to get for David for fall and winter coat—so that begins. From the way it looks like I'll be working this winter, I won't need any clothes at all. I am going to dye my Nina Ricci fur (Marc never was never crazy about the color) burgundy and that is that and I will finally have my fur coat.

I kiss you and David and Marc send big kisses too.

XXXXX B

P.S. Can you tell me again what hour I was born?

March 8, 1965

Dearest Mother,

My big news is that I have decided to join Marc in China. Françoise will take David and Maria for a month and I will leave about the middle of April and we will come back together the end of May. I am French as of Saturday afternoon so I can have a French passport. Marc will ask for the visa in Peking. On the way back we will stop in Hong Kong, Cambodia (in the Prince's Palace!) and in New Delhi (with the British ambassador). I am trying to borrow a villa in the south of France that belongs to Marc's aunt for a few weeks in June to rest up from the trip with David and then back to Paris. If I can have it, it would be wonderful for us all to be together there. But if not we will come directly back to Paris and probably spend some time in the country near the house in a hotel. It is true that you are horribly underpaid at that job, but that they do look out for you. Maybe you can talk them into June too! But still all of July and August will give you a lot of time with David.

Sheila is back in Paris after having been in New York. She is going to get married again to this Spanish painter this time in Morocco!!! Must rush now. I'll write again in a few days.

Love from David

XXXX
B

March 26, 1965

Dear Mother,

Please forgive me for not writing these past days, but I have been waiting to hear from Marc about our trip. He has had his interview and is now on a tour. He won't be back in Peking until the 10th of April and wants me to arrive around that time. With this date in mind, I don't know if I will be back in Paris by the

eighth of June. I am supposed to fly to Peking via Moscow. Stay in Peking, make a tour of Mongolia and Manchuria with Marc and his friend Karol. Then return via Shanghai, Canton, Hong Kong, Cambodia, Nepal and India. Quite a trip. All this should take about a month and a half, but the date of departure is the thing which even now may change. Marc is very excited about this trip and thinks it may be the most important trip of his career. For this reason, I can't rush him or ask him to change his plans and schedule. Now, either we will pay the extra money for the ticket and you come on the 21st as you had thought. You can very easily come on the 8th. We would be back very soon and Sheila is in Paris and could meet you, take care of you in Paris for a few days and if we were not back, put you on the train for Lyon. You could stay with Françoise and David and Maria in the country. Françoise will be delighted to have you and you would see and be with David and see the ancestral home of your son-in-law. The choice is very much up to you and either way will be wonderful. If you would rather be here in France with David we would be back at the latest on the 15th. Or you can come on the 15th and we will pay the difference.

I'm sorry that you have to change your plans slightly but it seems that it's unavoidable. This is why I haven't written you before because I wanted to make sure that I could give you some kind of date that is more or less definite. Marc sends his love from Peking and I am beginning to get very excited about this trip.

David is fine as usual. He has another tooth on top and he is almost walking. As a matter of fact he will walk in a few weeks.

Spring is here in Paris and everything is turning green. I am replanting the lawn and putting in some extra rose bushes. I am working very hard in my studio and work seems to be going very well. I am going to London with Sheila for the opening of her show on the 11th of April and before that I am going to take a drive down to see how the house is coming along. Please say hello to everybody there for me. How are your French lessons coming along? I'm sure that David will be able to understand you perfectly, especially since he speaks only Spanish. I am very happy with Maria and don't know what I would do without her. Jeannine and Bill are fine. All of Marc's family are fine, except for Krishna. Give a kiss to Bernice for me. David had his polio shot and has a slight head-cold, but he is his usual bouncy self. Tamara broke her foot skiing and her husband wasn't very good in that emergency, in fact he was down-right lousy. I spent the day with her yesterday and we baked gingerbread. Marc has been sending marvelous things to David from China and he has bought some wonderful things for us like a 17th century scroll and a fur coat for David and I keep getting posters from Peking in the mail.

Marc told me to tell you that he received your letter and was very happy and surprised to hear from you. The Chinese, it seems open letters from America. I am full of things like typhoid and typhus and cholera, as I have had all my shots for the trip. I also have my visa and now I am getting together my wardrobe which will consist mostly of pants for China and a few light-weight dresses for the

rest of the trip as it will be very hot. It will be wonderful in Nepal, where Marc has lots of friends. But the rest of the trip will be made in tropical climate, just before the monsoon and it will be fantastically hot.

Well, I guess that's all. Please let me know what you decide about the trip and remember either solution is all right with us. I want to let Françoise know so let me know as soon as possible. I'm sorry to ask you to change your plans but it's unavoidable because of Marc's trip. I can hardly wait to see you and David too. I think of you all the time—

<div style="text-align:center">

Love XXXX

Barbara and David

</div>

[TELEGRAM]

March 28, 1965

Everyone fine was waiting word Marc date departure to ok your plans letter follows with new plans don't worry looking forward to wonderful summer love

<div style="text-align:center">

Barbara

</div>

April 6, 1965

Dearest Mother,

So happy to get your last letter. Everything is all right on this end. Françoise and Sheila will be expecting you on the 9th in Paris and we will be back not later than the 15th. So you will have a few days in the country alone with David! You will have a wonderful few days with him and Françoise and just the fact that you will finally become friends makes me very happy. You can take David for walks in his private zoo!

I am fantastically busy these days with the house in the country and getting ready for the trip and working on new sculpture. I am supposed to go to London Sunday for the opening of a show of Sheila's, but only for the day. I will come right back, I will try to see a play and the museum. I spent the weekend in the country at the house. God, it is so beautiful. We are having a wonderful spring and everything is already in bloom and green. Of course the site is a wreck, but at least now one can see how it is going to be when it is finished.

Can you bring me one of those Warner Stockings (I'll pay you when you get here) and two big tubes of vaginal cream for my diaphragm? You know that it is illegal to have one in France!!! Anyway, I can't get the cream unless I go to Switzerland or London and if I don't go next weekend to London for some reason, I'll be out of luck. I also got a letter from Mildred Greenberg who is coming this spring (I won't be here) but she says your telephone is turned off. Why didn't

you write? You know really that I would not let you stay without a telephone!!! Besides the inconvenience, it is dangerous for somebody alone, even with Bernice upstairs. And let her go find out where Nepal is. I get lots of letters from Marc. He is in good spirits and working hard and having fun with his friend Karol. David gets more and more beautiful every day. His nurse is devoted to him. He is about to walk. I just hope he does before I leave! Already the garden in Paris is nice. What about yours? What have you planned lately? Absolutely no word from Daddy since Christmas. I have no idea if he plans to come over or not. How is Grandpop? I hope he is alright. I wish so much that he could see David. He has his first high-top shoes in navy blue! Well, since everything is settled like this, I can expect to see you in two months meeting us at the train station in Lyon.

All my love—and David too!

Easter Sunday, 1965

Dearest Mother,

Everything is under control and fixed for you to arrive on the 9th of June. We may be back as early as the 10th or 11th, but anyway Françoise is expecting you and a friend of mine, Vicky, will meet you at the airport on the 9th. I will give you her address and telephone number. This is probably the last letter I will have a chance to write before I leave although I will try and write and end of next week and certainly when I arrive in China, but via Hong Kong so it will take a long time to reach you. You can't write me directly so you can write to Hong Kong at some friends who will forward the letters. Just put "Please forward in different envelope." The address in Hong Kong is c/o

> Brian Brake
> A9 Repulse Bay Towers
> Repulse Bay
> Hong Kong

Now, Vicky knows you are coming, but I suggest you write to her time, number and name of flight just to be sure. You will love her and she will see that you get on the train for Françoise's when you like. She will also have the keys to the house. You can probably see Tamara too with her in Paris before leaving for Françoise's. I have all the rights to my diary (of China), but it will be easy to sell when I come back. I am hoping at least to earn my plane ticket! And a lot more I hope. *Look* is interested and also the *Ladies Home Journal*. So we will see. You should call Daddy before you leave to see if he has anything to send to David also to know if he is coming this summer or fall or not. And don't worry about your hair. You remember there are very good hairdressers for you here for your hair. I do mine mostly myself except for a special hairstyle if I am going someplace

special. The texture and quality of my hair has completely changed since I have been living in France. It must be the food. All Americans complain about the same thing. People who normally have straight hair suddenly have wavy hair. So you can imagine, I can't keep my hair straight anymore or rather it takes a great effort and doesn't last. You remember I could go for months with completely straight hair. Well here it is more like two days…

It is Easter Sunday. I bought a beautiful egg for David with his name on it. A little egg-house with a little bird inside made out of pressed almonds! I am spending the day writing all the letters I must get off before I leave and filing all the mail and getting my addresses together. I am really getting very excited now. I leave Saturday at noon and arrive in Peking Sunday at noon. Françoise is coming to get David Friday and will stay to get me off on the plane. My goodness, I just realized that Daddy doesn't even know I'm leaving for China! Well, I will write him a note this afternoon. Or maybe I'd better write him from Hong Kong. Anyway I am off on my great adventure. It is and there are really so many beautiful things to see. This time I am really going to take lots of pictures! Not like Egypt. Well, I will write you a long letter from Hong Kong. I kiss you and I will see you in six weeks!

XXX
Barbara and David

Peking, May 2, 1965

Well, my first meal in China was really something to write home about, so that is just what I am doing. I am getting so used to the Chinese meals, a thirteen-course dinner doesn't even seem unusual to me anymore. My first meal in Peking consisted of a first course of paper-thin slices of liver, tongue, veal, beef and fish; pickled lettuce hearts, string beans, mixed salad, bite-sized pieces of octopus, eel, lobster, giant and baby shrimps, stewed shark fins!!! Cucumber rinds and Chinese mushrooms pickled and one-hundred-year-old eggs! (they are very good) Then there was a soup (several soups are served during the course of the meal to clean the palate) then giant shrimps in sweet and sour sauce, lacquered chicken, roast duck, omelet, lobster, a soup again, fried sparrows, bamboo shoots, another soup and finally a dessert of cooked cut-up apples in hot caramel which one dips in cold water to cool the caramel and make it crispy on the outside. Finally one is served hot plain rice which one is not supposed to eat because then it would mean that you were still hungry!! Then one is given hot perfumed towels to wash the hands and face and green tea with rose petals in it. And these Chinese meals have gone ever onward and upward. We went to a banquet for Zhou Enlai to celebrate May Day and it was a sit-down banquet for five thousand people in which they served thirty dishes! I have wonderful stories of Marc in China with his friend Karol. They are becoming a legend in their own time in

China. I am making a fantastic collection of Chinese seals which are very beautiful. We have done so many things and seen so many people that I really can't believe it. I get letters from Françoise about David in the country. He is very well and happy. I see so many children in China and so many little Davids. You know David looks slightly Chinese anyway. Marc always says the mixture of the two races makes the third one—it is only normal! Chinese children are wonderful and beautiful. We will show you many photographs.

<div align="right">

We love you...
B

</div>

Peking, May 5, 1965

Dearest Mother,

This letter will be mailed to you from Paris, but we are really and truly here in China. It is fascinating. It is the trip of our lives. So much to tell you when we see you so soon. I am making a wonderful collection of Chinese seals, one of which you see at the top of the letter. Of the many wonderful things in Peking (and there are many) the Forbidden City is the most beautiful. It used to be the living quarters of the Emperor of China just until 1912. It is now a museum. But is huge. You cannot imagine how big. Bigger than twenty French chateaux! It is the most beautiful and perfect architectural complex now existing in the world and I have seen it with my own eyes. We have been very well received here and have met a lot of interesting people. And the most fantastic food you can imagine. You remember Han Suyin, the friend of Marc's who wrote *Love Is a Many Splendored Thing*, which was made into the movie. Well, I quote from another book of hers about China her impression of the Forbidden City...

> ...Red walled, tiled along the marble terraces with their marble balustrades, carved with dragon and phoenix—thousands of tons of white marble carried by elephants a thousand miles across China from the quarries of the Burma border. That tells the magnificence of the emperors five hundred years ago! Blood and sweat built the Imperial City—forced labor and taxes ground from the poor. Many young moderns of my race see in it only a monument to tyranny.
>
> Yes... but stand in the sunlight silent before its vast dignity. All is proportioned with such just and balanced sureness: the still courtyards, level as water the ground plan pure and true with the compass and the sun, East, South, West, North; the mounting terraces, foundation to majestic pavilions with their red walls—a red more burning and golden than scarlet—with their tall arched doorways and their golden roofs sweeping downward in curves of sheer power. It is the imagination of China! By oppression and tyranny, the blocks of marble were laid, the roof beams hewn: Yes. But the essential design—the inev-

itable, exact proportions, the soul-releasing magnitude—this is the outgrowth of all China. It dwarfs the individual man: it is the oppression of a nation: no emperor could have been worthy of the setting. No one architect could have conceived these stately dimensions and this splendor of strong, simple color. This stability, this centered peace, this harmony with earth and sky—this is the final statement in concrete beauty of the Chinese philosophy of life.

—Han Suyin, 1942

Peking, May 12, 1965

Dearest Mother,

Standing in the huge Tiananmen Square, flanked by the monstrous People's Hall and the Historical Museum, one faces the Tiananmen Gate; entrance to the "Violet City." The narrow moat which surrounds the walls is spanned by a marble bridge of excellent proportions. The crowds are already passing through the red-arched door—soldiers in their unpressed khaki cotton black cloth shoes and fresh round faces—workers in blue tunics—the girls with knee length braids, old men and women, usually with a grandchild or two in their old-fashioned black tunics. Only the children are dressed in bright flowered jackets, quilted, Chinese style, but they usually have western-style overalls, open in the back. Hundreds of children are escorted everyday through the red gates. Inevitably, there is a group of soldiers having their picture taken in uniform. Day after day I returned to the Forbidden City and its museums and the scene never varied. I got into the habit of traveling the whole length of the wall surrounding the city in order to enter by the north gates. The north gate is called the "Gate of Godly Prowess." Between this gate and the Gate of "Earthly Tranquility" is an exquisite small park. Each square foot of it is landscaped, almost choreographed with the refinement and meticulousness of a Sung painting: the stone and wood pavilions, the small marble stages for the theater, the stone and rock gardens, the ponds and small lakes. There are ancient trees married one to the other to form natural arches, held up by intricate trellis work, marble bases, bent back ancient lilac and wisteria trees, stone couches and stools placed under flowering almond trees evoking Ku Kai-chih's 4th century painting *Nymph of the Lo River*. Courtyards and gardens where Tai Lake stones sit . . . like Henry Moore (etc.) or are set like creatures in stone landscapes entwined with ancient hump-back lilac (etc.).

To the right and the left of these parks are the smaller gardens and courtyards of the emperor's family and concubines, wives and servants, scholars, as well as the office of the emperor during the Ch'ing dynasty when it was called the Hall of Cultivation.

Peking, May 18th

Dear Mother,

It is already summer in Peking. Last night we went for drinks to the house of the British Rutgers correspondent here. We arrived and we went up on the terrace. We had a delicious cold drink called "ancient coin," a kind of Chinese sparkling champagne made from specially cultivated grapes. The terrace of their house at 11 Nan Chihtze Street, a small street just off the moat of the Forbidden City, has one of the unique views in the world. We stood in the heavy silence of the late May evening and looked out. We could see beyond the placid moat and the graceful young trees that line its banks, to the red clay walls of the City itself. Above the walls, against the hard blue sky, the tiled roofs of the palaces caught the last sunlight and threw it back as if the sun was only a reflection of their own color. Beyond stood the Western hills, a deeper, porcelain blue, and to the North, Coal Hill with its Bell and Drum towers used to call the officials of the Imperial City to work every morning and to bed every night. Along the mall of the moat, solitary figures in proletariat blue passed the Western Gate with its brass-studded red door.

Of the fifty or so palaces, pavilions and gates enclosed within the City, perhaps twenty roofs are visible above the walls; Golden roofs of stunning harmony, and grace. In my old 1913 Carl Crow guide book there is a quotation from the writings of Marco Polo which seven centuries later still captures the dream of these roofs:

> "Know that it is the greatest palace ever...
>
> "The roof is very high: the walls of the palace and the divisions between the rooms are all covered with gold and silver. There are also all sorts of painted dragons, beasts and birds, horseman and scenes and other marvels painted on them. And the ceilings are also made and painted in nothing but gold and silver.
>
> "The hall is so long and so vast that ten thousand people can be seated and dine within. And there are so many rooms that it is a marvel to see. In short, this palace is so big, so beautiful, so rich that no man could have commanded, in the whole world, a finer one. The tiles of the roofs are red, yellow, green, blue and the other colors. And they are varnished so well and cleverly and skillfully that they are resplendent like crystal. And know that these roofs are so strong and so solidly made that they will last forever...."

I remembered also that there was something more unique in our view than even Marco Polo suggests. Up until 1912, no building in Peking was allowed to be taller than the walls of the Forbidden City or to overlook the palaces. And no ordinary Chinese could set foot within the walls on the pain of death.

The sky is streaked now, and small sparrows maneuver in the failing light

like kite birds. The lights come on along the mall and what had been a summer breeze becomes the cold wind off the Gobi desert, cause of the sudden Peking dust storms. Directly below us are the tiny courtyards of the surrounding house: lights are being turned on, dinners are being made, and domestic noises come up through the dusk. Here and there a child lingers outside, savoring the last daylight before bedtime. Finally, as the wind became stronger, we went down, like the children, resisting until the very last and final darkness made it possible to see the outlines of the golden roofs in front of us.

Peking, May 21, 1965

I can't believe I have been in Peking for three weeks. Time is passing as in a dream. I have taken one wonderful trip to the South, while Marc and Karol were in the Northeast. It reminded me so much of my trip by train to the Upper Nile in Egypt. I begin to smile at the comparisons. I was all alone with no interpreter. It was a train ride overnight. The train was wonderful. Chinese trains are wonderful, very clean, since they scrub them at every station (as well as play patriotic music as they pull out of the station). They are all of wood and each compartment is like the inside of a little Chinese lacquered box with Russian trimmings! There is a little table with a frilly lamp on it, handmade and embroidered sheets and tablecloths, thermos bottles of hot water for tea any time of the day or night (what a dream for tea lovers!) altogether lovely. I stopped first at the Lung Men Caves which consist of thousands of Buddhist sculptures placed in varying sized caves during the centuries when it was the capital of China. There are figures that range in size from a few inches to over thirty meters high. It is shocking to see the vandalism of the American and English archeologists and missionaries in this sublime place. Practically all the medium-size Buddhas (about 50%) have their heads cut off and these heads are resting in museums and drawing rooms over the length and breadth of America and England. But the biggest and most beautiful ones have survived thanks to the primitive methods of transportation of the beginning of the century. Sometimes they make big point of this in the museums, with big signs saying this and that are in America, stolen by the "Yankee Imperialists" with the photos to prove it. The caves date from the 5th, 6th, and 7th centuries. I spent the morning there and took the train again in the afternoon for Sian. The countryside between Sian and Lung Men is some of the most beautiful in China. Terraced and with few trees the landscape is manicured into the most divine sculptured plains and forms divided by canals and rock walls, natural gorges and small rivers. And everywhere green wheat, green wheat climbing the steep ridges, up to the railroad tracks, on every inch of flat land. The landscape gets much more rugged and mountainous toward Sian. There are vast gorges and ridges as in Chinese paintings, small mountains and canyons and on every terrace sculpted out of the mountains, the thatch of green wheat laid like a

velvet drapery, descending and climbing, hugging every ridge and gorge, sucking in its breath to cling to the steep mountains. It is then that one knows how poor is China and how precious every stalk of wheat. And it has been like that since always. The same peasants clinging to their steep fields plowing and hoping and dying. I got this same feeling in Egypt watching the rich bend of farmland that borders the Nile speed away. It still is like going back in time. And one is speeding back in time. I arrived at Sian, ancient capital of the Tang Dynasty and except for the city itself, it is the 6th century, nothing has changed. I stayed in Sian at an incredible place called the People's Hotel which has 2,000 beds in it, was built for the Russians who are no longer there and I had the whole hotel to myself! I burst into laughter since this happened to me also in Egypt. Those big Victorian Hotels on the Upper Nile normally filled with sweating Englishmen had these enormous hotels all to myself!!! At any rate, the next day I spent in a trance at the museum in Sian. The things they have found since 1950 is incredible. Over 60,000 objects just in and near Sian. The museum itself is an old Buddhist Temple with beautiful gardens. It is beautifully installed. It is also the place where the famous Tang Horses are (except for the two—there are six all together—the two are in the museum in Philadelphia!). They asked me if I had seen them, how they were installed, etc. I assured the director that I had seen them and that they were very well taken care of...Everyone was very kind. I had a long interview with the head of the museum (who looked like the head gardener) and had a wonderful interpreter, a girl. They are very proud of a prehistoric village they have excavated in the past few years, supposed to be 5,000 years old. And they have built a fantastic glass museum over the excavations to protect the site, very elaborate, and have reconstructed part of the village and so on. The only trouble is that twenty meters away, one can see exactly the same sun-baked clay house with its clay roof and central fireplace with a very much alive peasant living in it!!

May 22, 1965

Maman,

The day after I returned from Sian, I went for the second time to the Forbidden City. My first visit had been with Marc, my second day in Peking, and I wanted to make sure I wasn't imagining the impact of my first visit. Standing in Tiananmen Square, looking north, I faced the yellow capped walls of the violet city. Outside, the moat which surrounds the walls is spanned by several marvelous bridges. The city is a public park since 1950 and several of its palaces, museums. Admission is about one-fourth of a cent and every day the Chinese stream through the red-arched "gate of heavenly peace" towards the wall's entrance: apple-cheeked boy-soldiers in unpressed khaki and cloth shoes strolling hand in hand; workers in faded blue with the same blue caps that are affected by the intellectuals; peasants

in dusty black-and-white head bandanas; old men and women usually with a grandchild or two, two women hobbling on the bound feet of another era, another world, their tiny black shoes on non-existent feet below wide black pants bound at the bottom; fresh round-faced students in white shirts and blue pants, boys and girls alike; girl sweepers in white surgical masks and knee-length pigtails; and everywhere, children, dressed either in Chinese-style bright flowered quilted jackets or in western-style overalls…all streaming through the red gates. The scene never varies except when there is a mass demonstration and Tiananmen is filled with half a million Chinese. In front of the south entrance are the grandstands used for these great holidays when Mao Tsé-Tung and the leaders of China appear.

Palaces and pavilions with names that are both ridiculous, touching and delicious: "The Gate of Supreme Harmony, The Palace of Supreme Harmony, The Palace of Exalted Harmony, The Gate of Prosperous Harmony, The Palace of Perfect Peace, The Palace of Glorious Literature, The Palace Where One Honors the Masters, The Palace of Intellectual Honors, The Palace of Unity and Harmony, The Palace of Dazzling Clarity, The Palace of Fruitful Power, The Palace of Terrestrial Tranquility, The Palace of Purity in Affection, The Palace of the View to the South, The Palace of Eternal Happiness, The Palace of Delices, of Quietude in Old Age, The Palace Where One Gives Thanks for a Son, The Palace of the Culture of Character, The Palace of Eternal Springtime, The Palace of Supreme Elegance, The Palace of Complete Happiness, of Cloudless Heaven, of Bringing Forth Blessings. There is the Palace of the Certitude of Happiness, The Gate of Earthly Tranquility, The Gate of Beautiful Views, The Palace of Vigor in Old Age, The Pavilion of Melodious Noises, The Hall of Mental Cultivation, the tower where one discovers the truth, The Pavilion of Rain and Flowers, The Pavilion of the Most Pure Perfumes and finally The Wells of the Most Precious Concubine, Pearl." Altogether sixty-one Palaces, Gates, Pavilions and gardens covering 15 acres.

We leave for Inner Mongolia tomorrow. It will really be the Wild West all over again. I will write from there.

As ever,

P.S. My seal means Riboud (Li bou) which means *600 meters of cloth* in Chinese.

Later same day…

We will be back in Paris at least by the 15th of June. We will leave Peking on the 28th or 29th. Don't worry if you don't hear from us. We are very well and happy and excited. I am writing a journal and trying to help Marc a little. We have learned much on the political situation here. We are bringing back some beautiful things: I have my collection of seals, and we have also some jade and some paintings and drawings and other things. You will be very happy. We are leaving tomorrow for Inner Mongolia for four or five days. It will be really wild. We both kiss you. We love you…B

1966

My mother had begun to understand the French while I had begun to understand America. Standing outside its confines, viewing it with external and judgmental eyes, detesting and loving it, criticizing it yet defending it against the French took me to a new level of comprehension and political thought.

I had always considered myself apolitical, my role as an artist coming before my role as an activist. Art beyond borders and beyond race was what I did best and achieving world excellence was my way of fighting oppression and racism. I had to either join politically or go on fighting in my solitary individualistic way. I was a lousy public speaker, a bad organizer, tentative and shy with people, unable to simplify my thoughts down to the kind of reasoning that roused people to action. Where did I fit in the panorama of this third revolution? I didn't believe in propaganda art and rage was not my thing. I stood on the thinking sidelines, engaged without a method to express it. The United States I realized was not the navel of the world. There were billions of people who saw it not as the Promised Land but as the last White colonial power, taking the place of the French, the British, and the Russian empires. After five or six years of trying to explain America to French intellectuals, I had come to new conclusions myself: the racial crisis in the United States was more than just a matter of segregation and civil rights; it was a psycho-drama that went back to the genesis of the nation and its very foundations. Racism had been built into the system not only by law but by blood. It was the apartheid system exercised by the White majority against the minority, not the White minority against the majority. But the use of power, force, and coercion was just as violent and the results just as fatal. The big difference was that America had a conscience. I watched the spectacle of bombs and beatings and murders, fire-hoses and dogs, and the insane red-hot and selfless courage of children—children in danger, children in scholastic and psychological bondage—and thought it had finally come to a fight to the finish. America could not survive as itself half-slave and half-free. The Constitution could not either, against lawless contempt and manipulation. The United States couldn't fight two wars—they would lose them both. The French had warned the United States against both Indochina, which they had lost, and racism, which they had practiced against their colonial Arab population. They also warned of the wearing down of moral principles manifest

in the methods of controlling an oppressed population—the costs on the psyche of the oppressor. The moral cost of torture. But the Americans didn't or couldn't listen. The third revolution took on a new dimension when Stokely Carmichael gave his first speech in Mississippi using the new slogan "Black Power."

I had been married now for almost four years, and in that time my mother had built and engineered a life for herself of daughters, suitors, girlfriends, taking care of Grandpop and selling clothes at Bonwit Teller department store. Her letters and visits were always full of news and gossip. She was always busy. She never complained nor ever described her health in any way. Physically, she remained amazingly young; in her forties, she could have passed for a college student.

This is what she had been now for several years without revealing it to anyone. She had enrolled in adult classes at Temple University and had now completed her courses and had received her diploma in histology. With qualifications that left me breathless with wonder, she began working at the Temple University Cancer Center in North Philadelphia—an independent woman. My father was stunned. He had never considered the possibility that my mother could achieve a professional level of competence in medicine. His own professional career had ended when he had been rejected from the University of Pennsylvania Architectural School because of his race.

At the same time, I had had my first one-person exhibit in Paris, where I showed rather surrealistic sculptures in bone (retrieved from a taxidermist) and plaster with bronzes I had learned to cast in Rome with a technique that later became my signature sculptures, impossible to fabricate outside Italian foundries.

The exhibit was a success—dealers and collectors came. Reviews appeared in the French press. Cartier-Bresson complained that I was late for my own opening and that that was a matter of courtesy, sounding like my grandmother. Salvador Dalí came, Georges Mathieu came, the drawing curator of the Louvre came. I sold out the drawings and made a contract for an exhibit in New York.

In the midst of this triumph, Grandpop died. For my mother as well as myself, it was a sea change despite our independent lives. His silent presence had been the link between me and my departed grandmother. My mother had lived with him and taken care of him since her divorce. We mourned him and Queen Lizzie at the same time. It had been a family joke that his stupefaction at having won my grandmother's hand as her second husband had rendered him so speechless, he hadn't said another word since.

To our surprise, Grandpop was eligible to be buried with military honors in a military cemetery at the expense of the U.S. government. He had never talked about his service as a soldier in World War I or his tour in France in the trenches of the Marne as a U.S. military volunteer or the attack of mustard gas that had disabled him and given him his terrible cough. But all had been duly recorded by the Veteran's Administration. The triangular folded American flag was given to my mother. My ears rang with the gun salute.

It was only then that I learned he had not returned home to the United States for almost a whole year after the war, remaining in France, doing what? Why? How? Whatever his reasons, when he did return after the Spanish Flu had ravaged the world, he had married the widow of one of his comrades in arms, Solomon Chase, and Elizabeth Chase became Mrs. James Saunders. ʔ

There was still another sea change to come. Father, or rather stepfather, and son. My mother discovered that my grandfather's will had left his house not to his loyal and faithful daughter-in-law who had sacrificed her own private life to take care of him all these years, but to his adored stepson, my father. When I confronted my father with the injustice of this surprising news, he refused to transfer the deed of his stepfather's house to my mother, citing his "other obligations," despite the fact that his new wife owned the house he lived in and my mother found herself homeless.

We bought another house for my mother near the university, which she shared with a girlfriend and which had a separate flat she could rent out. Not until my mother intervened a decade later did I repair the canyon created between my father and me over what I considered a betrayal of the woman who had cared for and nursed both my grandmother and Grandpop.

"Think," Vivian Mae had implored me, "how terrible you would feel if your father disappeared without your ever speaking to him again..."

January 1966

Dearest Mother,

So sorry for the long delay, but as usual we have been working day and night. I'm glad the *Look Magazine* was such a big success. We are sending you *Match* (French) and *Epoca* (Italian) where big stories have also appeared. The book seems to be going along alright and Marc has made a fortune from sales. Other than work, everything here is quiet. David is big and bad as ever. He talks much more now. He has a little cold for the moment, but it doesn't seem to bother him as much as it bothers Maria. The house in the country is coming along fine. We spent four days last week just at the end of Indian summer. It was divine, all golden. It is really beautiful country. Marc was very happy and very relaxed although we managed to do a million things. We decided to place an alley of pear trees in back of the stables. We visited the former owners of the farm who live in the village. Very rich peasants very sweet who were just dying to meet "Madame Riboud." We spent the afternoon talking with them in their kitchen drinking the best white wine I have ever tasted (Montrichard 1947) and eating cookies. René in the meantime had come to Paris. We just missed him, but we saw the contractor, the notary, the farmer who has to cut some trees and clear the property. We saw our white horse that roams around in the pasture in front. It

was so warm, one could eat lunch outside. We came back to Paris just as the cold weather broke.

The exhibition in Dakar is all set on the American side, but there is a much more interesting possibility to exhibit on the French side. I'll let you know more later if it works out. Anyway, that is what I am working on at the moment. The street is really getting filled up. Marc has decided David makes too much noise too near to his studio so he wants to build a room for him on top of our room in the attic. I am having nothing to say, it is his project, but at any rate, it will give David a playroom and Maria a room to herself. My horoscope lady claims that I will have another baby in 2 years—so watch out! She turned out to be great and David it seems is going to be extraordinary (as if he wasn't already)—but according to her, writer, actor, dancer, director, composer, musician all in one a kind of combination of Laurence Olivier, Leonard Bernstein, and Balanchine all rolled into one! Françoise is fine, but we miss her. We haven't seen her in ages and ages. Sheila also is fine, but I see her rarely. Vicky and Jean are finally together again forever. Jeannine and Bill are fine and working hard. Bill is beginning to film his full-length movie called *Maggie Magoo* about a fashion model. So they are really frantic with casting costumes, sets, actors and all the works. Peter is fine except he fell a week ago and broke open his head…this after his broken arm. I have a sculpture to do for my brother-in-law Antoine for his garden in his summer house at Lake Annecy. I also have to go soon to Verona for casting all the things I am about to finish. I hear that Ben Shahn will soon be in town. I hope to see him this time around. Marc is probably going to have an exhibit in London this spring of photographs from China.

Anyway I am dying to earn some money of my own: for you and so I can spend it all on the house in the country: a beautiful huge reception room and a tennis court and an Italian garden and a new big studio. So there goes the next ten years. Anyway, we are very happy with the house. I think it is lovely. Did you find out about the little store near you? I am really determined that you have a fashion shop of your own. What's going on in the store except Christmas? I am going to buy David a little car for Christmas. He is so wild about "autos." He has a little pale blue winter coat, fitted very sweet and a kind of knitted hood for his head. I am going to get him a pair of fur-lined blue suede boots to go with his coat today. How is Doris? Has she had her baby yet? And Grandpop. I am sending a magazine for him too—I haven't heard from Daddy since last Christmas, but I guess he is alright. I write to him every now and then. What did he say about his present from China? I guess he saw the *Look* magazine. Last night we had a few friends for drinks and I wore a great "at home" dress. Marc's brought me a length of white cashmere wool from Kashmir India. With white and gold embroidery, very discreet along one side. Very beautiful. So I made a long dress, sleeveless, very straight with high slits on each side and a high rolled collar. The embroidery runs down one side of the dress and also the collar. It is really stunning and very

sexy according to my husband. I still have this little Russian dressmaker who is very good (not as good as you are) but she really did a good job this time. Also I have a fur coat finally after all these years. It sure is warm. I got a white turtle-neck dress to go under it which looks very nice. Marc is his usual sloppy (not really but very casual) self. I can't get him to care about what he puts on although people still tell me he is much better now than he used to be.

It is already one week later and I still haven't mailed this!! Meanwhile, everyone is fine. David had a little cold but he is fine now. Marc working hard as usual and me too. I have some vague hopes of a week in Tunisia with another photographer from Magnum who lives in Hong Kong. Anyway there is no question at the moment. Too much work. But it looks like Dakar may work out alright in April. Bill and Jeannine Klein began filming their movie yesterday. Sheila is busy becoming Parisian. Carmen de Lavallade and Geoffrey Holder are in Paris dancing. We went to a party for them night before last. Carmen is going to Dakar for the Festival. So she gave me all the low-down on the committee and all the little intrigues. Did you get the *Epoca* and the *Match* with Marc's pictures? They were sent from the office. We are going to add another room to the house—but for Marc!! He wants a studio away from David. (You can imagine David is in good shape and voice!) So we are going to build a small room on top of our bedroom with a little balcony and a stairway leading up from the bedroom. That will give me a playroom for David and a room for Maria. So, it's all work. We may spend Christmas with Françoise skiing (that is, Marc will go skiing). It would be good for David. Give my love to Bernice.

Marc sends his love always.

B

Paris, January 31, 1966

Dearest Mother,

Please forgive the long delay, but as usual things are just their normal hectic selves. Anyway, this is just a short note to let you know that all is well and that I received your last letter. I am happy the gifts arrived and I am so sorry you didn't get a chance to see Marc. He is in wonderful shape these days and will be home finally tonight. I don't promise anything, but I think we will have to come back to New York in the spring, so maybe we will see you very soon. David is wonderful these days. He is a very good baby with a wonderful character. He is very funny and is beginning to say some things. He is also getting very tall. It is amazing! His legs are getting so long and he is losing his "baby shape." We bought him a toothbrush yesterday because he likes to play brushing his teeth with mine. It is fantastic the power of observation of children. He also "shaves" with a little metallic case which holds a measuring tape and he "makes up his eyes" and

makes his chignon like me when he is in the bathroom! He is so funny. We are going to cut his hair when Marc comes back, so he should be even prettier. He loves other children (especially little girls) and is always putting his hands either up some lady's dress and down her bosom . . . and it is not Marc he takes that after! He is finally a very fresh little boy now that I think about it. I am working hard to get Marc away next week for a few days of vacation somewhere where it is warm and then he will have to start on his text for the book. As for my biography, I haven't done anything since 1960 except get married and that doesn't count on a professional biography. The only things were the two fountain competitions and the exhibit in November at the Architect's League in New York. But never fear, things will be popping again soon I hope. I got a brochure from Tyler about their school in Rome. It looks good. Why didn't they have that when I went there. Anyway I will run over sometime to see Boss. We are making two new rooms on the house this spring. At least I hope so and I am going to do the hallway and bathroom downstairs in wood paneling. I also bought a beautiful dress on sale at Nina Ricci in dark plum color. A dress and a jacket. The dresses are so short this year! I had to fight to get them to make it just above the knees! Anyway, it is very pretty. I hope Marc likes it. He hasn't seen it yet. Give Grandpop a big kiss for me. And keep well yourself. I hear you are having a terrible cold wave in the States. Here the weather is extremely mild for the time of year. One can go outside with just a heavy suit. I promise to write again very soon. I kiss you.

David sends a big kiss to his "mummy." I am getting to speak English with a French accent! It is because I think now in French rather than English so I have to translate from French to English before I say anything. It is very funny. And every now and then I can find my word in English that is the equivalent of the French . . . not that my French is all that good I still should spend about a year perfecting it, I dream of having a broken leg and staying in bed for three months so I can study French! Anyway, poor David speaks the most fantastic combination of French, Spanish, and English possible. Jeannine and I have already decided that we will have to send Peter and David to school in London for a year so that they will speak English as it should be spoken!!! Must run now. Love and love.

Barbara

February 22, 1966

Dearest Mother—

Thank you so much for the wonderful letter. Marc and I read and reread it when we got back. The obituary was very good. We hope to come back to the States in the fall and maybe I will come before depending on events. We have been trying for months to get to the country to find out what is going on and see the house. But Marc is fantastically busy and I should be even busier. David is in good shape.

He loved the Valentine I brought back. He said Oh la la! Very French. Wednesday is his birthday (as if you didn't know) and I am going to have a little party for him on Thursday (children's day off from school in France) we hope Sunday to go to the country and Marc is going Thursday or Friday to London. Marc's own father was the same age as Grandpop (or would have been) and we had a friend of his who is now 79 for lunch the other day. He told wonderful stories of his adventures with Marc's father on their trip around the world! We call him "Uncle Morris" and he is the closest thing to a father for Marc. Françoise just came back from skiing for three weeks. She sends her condolences. I've decided to do some work in the house this spring—a new room for Marc which will make more room for a separate room for Maria and one for "Josephine," the sister of David. I must tell you I don't know when I am going to have time to produce this "Josephine" as Maria calls her, but I'm all for trying! Ben Shahn should be in Paris in a few days. So we will see him. I was glad to hear that Harold is well and as "charming" as ever. Also glad to hear you have gained weight! Bravo! I got a short letter from Daddy, but before the death of Grandpop. We get a weekly report from our friend in the country that is in charge of the work on the house. One thing about staying away so long is that lots of things have changed when you come back!! It is really going to be so beautiful. I promise to send pictures because I remember you were a little bit taken back by all the wreckage around. It was a mess, I must admit. I just sent the sculptures off to New York for the festival the other day. So that is one thing off my mind. I must write a long letter to Sabatini (boss) who is retiring from Tyler at the end of the year. He will probably take over the school in Rome. Well, I must get busy for this party of David's on Thursday. Finally there will be 8 children between the ages of 2 and 4! What a ball that will be—Maria is going to make cookies and I am going to buy a raspberry cake with white icing that David loves—and me too. And tea and cakes for the grown-ups. There has to be three groups: the children in the dining room, the mothers in the living room, and the maids in the kitchen! So democratic!! I promise to write again soon.

Love and love. I am so sad about Grandpop. Thank you for his World War I medals I can save for David. I haven't stopped thinking about him since the funeral—yet I couldn't cry! I wonder why—I wonder why? Was it because I would have admitted defeat? Grandpop was old. I knew he was going to die—yet I didn't—like a little child I thought he would be Grandpop forever.

B

Tuesday, March 15th, 1966

Dearest Mother,

Got your last letter and as always was happy to hear from you. This thing from Daddy is unbelievable, but I think after all he will realize it by himself. Just go ahead with plans for your bathroom. How is Bernice and everybody? No word from Doris or Felmar. How was Doris' christening? Marc and I went to London last week and had a great time. I saw some old friends from school, lots of book publishers, saw again Han Suyin, the friend of Marc's that wrote *Many Splendored Thing*. She had just gotten back from the States. Maybe you saw her on television? She was on everybody's show, being interviewed about China. She had also attended a big meeting at the University of Michigan on China also. She even talked to Fulbright and Goldberg, so she was full of stories. London has changed a lot in the past three years. It is really swinging and very glossy. The girls there are really in the avant-garde. Without exaggeration, the skirts in London are six inches above the knee, usually worn with long, tight stockings. Marc thought it was great. Of course. I must say, from a man's point of view, it is really something to look at. We didn't get to see any theater, we just didn't have the time. And the thing I really wanted to see was in New York. A couple of days ago, both Marc and I were in Bill's movie. It was the end and there was a big fashion collection (in the film). So I played a fashionable lady and Marc a photographer. What casting! Anyway it was a lot of fun. Bill had made the most fantastic clothes out of aluminum!! And one of the models was an enormous, very beautiful American Negro girl who is having a great success in London and Paris these days. I had seen her at one of the discotheques in Paris and later in the English *Vogue* magazine and had told Bill about her. And it turned out great. She is as tall as Geoffrey Holder, the color of honey and a divine face although in person, she is really weird looking. She is so thin. Anyway, she was one of the models wearing these fantastic metal clothes. The film should be very funny. Elia Kazan, the movie director, came out for drinks at the house the other day with Barbara Logan, the actress who played in Arthur Miller's *After the Fall*. I also saw some galleries in London. They were interested, but nothing final has come out as of yet. I wore my new Nina Ricci dress which is very short (two inches above the knee) but I really couldn't go all the way with six! We have also been to the country. The house is coming along, but still very slow. The day we left, Marc sprained his back picking up David!!! No kidding. This kid is built like Cassius Clay. Anyway, it is better now. He just doesn't pick up David anymore... Vicky is still having her domestic problems and Tamara too, although I think Tamara's are better now. The brother of Marc just took over a huge company of glass in France to combine with his own. It's called a "takeover," the first in France. Only Antoine could merge with a company larger than his own and still remain president! It was in all the papers.

Françoise is well. She just got back from skiing and is coming to Paris soon. Magnum is suing Marc's brother's company Schlumberger because they allegedly lost a lot of negatives of Magnum! Never a dull moment around here. Both Marc and I are going through one of our "vague" periods so we are having a time getting anything done, let alone half the things we must get done. It doesn't seem possible that it is almost a year since I have been in China. Publishing this book is a real headache since there are co-publishers in all the countries: England, Italy, France, Germany and all those small countries and now Japan too. One thing seems to be set. The book will come out in September in the U.S. and Marc is going to make a show of his photos at Asia House (owned and run by the Rocke-fellers) soon afterwards. So we will be in the news. I am replanting the garden for spring. Will spend the next month helping Marc with his book. Then I may go to New York. Then, I have to get the house in the country ready for the summer. Nothing new for the house except we may have the hallway done in panels if the guy ever shows up. I give you a big kiss. And of course David too. He has your pic-ture by his bed and he can say Mamie which is the French word for Grandma.

Marc sends his love as always.

B

March 25, 1966

Dearest Mother,

Hope everything is well with you. I received your last letter. I am happy about the new Colored model in the store, but what is happening in Watts is much more important and certainly nothing to be ashamed about. A new model in a store is of very little importance against the violence and bloodshed of Watts. It is Watts that will change things, not a pretty and pleasing face. (See enclosed.) Changes were never brought about by being either pleasing or pleasant. People with power to do things for the people they have in their power only when they have no other way out. This is the reason people go on strike. Change is always desperate. When the people with the power have their backs up against the wall and cannot do anything else. The people in Watts are making themselves heard and visible in the only manner open to them.

Spring has not yet come to Paris. It was snowing this morning. I can hardly wait although it seems this winter was hardly here at all. I managed to see a part of the bookcase in the photo of the mantle. It looks very nice. Any word from Daddy? I will send you a picture of David with his haircut in his yellow suit when it gets a little bit warmer. I hope I can get Marc to take a week off next month to go somewhere it is warm. David is really beginning to speak now. It is very funny

he can repeat practically anything and knows the names of all the parts of the body although he can't say them. And he sends you a big, big kiss. And Marc also.

<div align="center">
Love and kisses,

B
</div>

April 16, 1966

Dearest Mother,

Finally managed to get away to the country. Marc has sat still for eight whole days!! Well not really sat still we've been working like dogs from morning to dusk, but the house is going to be beautiful and the grounds too. Marc is working on the park, me on the house. I told you I would send you photographs of my chair covers. Just try to make covers for Louis XIII armchairs!! We are going to send you pictures soon. You won't recognize the place. David Riboud is getting fatter, browner, and fresher every day. We took him to the beach yesterday where of course he was a big hit. He is really beginning to talk thanks to Jeannine's little boy whom he plays with. There is still a heavy Spanish influence—all the cows he sees around here are "toros, ole!!" But he is eating like a railroad worker—can you imagine a typical day's meals:

> Breakfast: Chocolate, cereal, hardboiled egg, toast and butter
> Lunch: Melon, rice, steak, cheese, peach milk
> Tea: Six cookies, hot chocolate
> Dinner: Ham, macaroni, cream cheese, milk, stewed prunes.

He doesn't make pee-pee in his pants at all and is perfectly dry at night. But he is so strong it's frightening. He is almost blond from the sun. I think Maria washes his hair in lemon juice to make it blonder!! Anyway I am so happy. Marc really seems to be getting a rest or at least sleeping. As for me, I am not even thinking about what awaits me in September. I have a commission from Pierre Cardin for two sculptures for the entrance to his new building on the Champs Elysées and I still have hopes of having a show in October. Next week I have to do some drawings here and go to Paris to choose the frames. Marc is going to Tunis on Wednesday for a travel magazine for six days. I am going to stay part of the time here and part in Paris. This month seems to have gone by so quickly. I haven't seen the *Ebony* you told me about. I will go to see them when I come to New York. So many people I have to look up. Well, I promise to write a long letter soon. David sends you a big kiss. He can begin to understand now who's his "mummy."

<div align="center">
XXXX

B
</div>

April 18th, 1966

Dearest Mother,

Belated Happy Easter! David received his Easter present which is adorable and a perfect fit. He is really enormous. He got a chocolate automobile for Easter, the hell with all those Easter eggs! We spent Easter with Sheila, her husband and children. Marc was frantically working on the text of the book. Thank goodness, it is finally finished and is being sent to the translator today. What a load off. The book will come out in America in September, published by Macmillan. Now all we have to do is gather together all the European publishers (France, Germany, etc.) and we will be all set. I hope I can get Marc off some place for vacation before the next two weeks. Other than that, there is no news. Your David is fine and bad and fussy just like I was. The house is coming along OK. Actually David is not bad. He is amazingly good, but he does have a hell of a lot of energy. I will have to get him a bicycle this summer, as well as a car, a tractor and a wading pool! Tell me when you leave on vacation. Are you going with Bernice? How is Bernice these days? And how is your handsome minister? Vicky sends her love. She is worried about getting old (Aren't we all) and says if she would look like you she would be happy, wouldn't we all? Well, I'm beginning to be jealous of seventeen-year-olds. You notice I call them "seventeen-year-olds"...how's that??? The dresses are so short here and in London, it is incredible. In London they are called mini-skirts and are about as long as a tennis skirt. It hasn't caught on yet in Paris, but I am sure it will. Then, what am I going to do? I'll be a member of the "older generation"! Tamara has found a new flat, so she is all excited. She is going to move in July. Vicky is still fooling around with Jean. Sheila seems happy and settled. I just wrote a long letter to Joyce who is in Washington working on the Poverty program. Maria and Madame Rosier are fine and so is all the Riboud family. Well, I must go type for Marc. I am so tired of typing and reading Mao Tse-Tung I could scream. David's godfather and cousin is coming to see him today and bringing him a boat. He loves his cars, but now it's boats too. There is also going to be a big party for the fifteenth anniversary of one of my sisters-in-law next week. Françoise will probably come up to Paris for it. Well, goodbye for now. I'll write again soon.

<div style="text-align:center">

XXX
B and David

</div>

April 30th, 1966, Dakar, Senegal

Dear Mother,

My goodness, you are very casual about announcing a proposal of marriage. I am becoming very European in my attitude about marriage proposals. This should be considered very seriously…First of all, I don't see what his being short, thin, and ugly has to do with it! After all, Daddy remarried somebody short, fat and ugly. The question to ask is, is he nice? Can he support you? Can he make love well? There are the three main qualifications for a good husband. You didn't bother to say anything about his character, how old he is, what he does for a living, if he loves you and if he treats you well. I think it would be wonderful for you to marry again. And I am surprised you are so snobbish about color! I think you must be racist!!! You are as bad as Daddy. If Marc doesn't mind having a Black father-in-law, you shouldn't mind having a Black husband. After all, your first one wasn't exactly taffy colored!!! Anyway, I am joking, but I would like to hear more and I wish you would take it seriously. You must not be influenced by people like Bernice and her ideas about glamour. It is much more important to have a good, steady, solid man. Of course I managed the glamour and the man…but that is very rare. Send me a picture, even, and I'll let you know what I think. Even better, I'll make you horoscopes!!! Marriage is, after all, also a business arrangement as well as love and companionship. If he can help you to stay at home and sew and have your grandson stay with you and you can offer your husband a home… even if it is yours, I think it is a fair bargain. No? Tell me what you think? After all, Marc told me I should speak to you like I would to my own daughter! So how does he make a living? How much money does he earn? Do you love him? How old is he? Has he ever been married before? What kind of family does he come from? Is he well brought up? Where would you live? Does he have a car? Can he drive? Is he against having a French son-in-law? And is he against having a French grandson? Does he have any children? Where does he come from, where was he born? How did you meet him? For heaven's sake don't ask Bernice what she thinks of him…ask somebody more sensible…ask your divorce lawyer!! Remember your first husband might have been handsome, but he was (and is) a fink!! Lastly, what would you like as a wedding present?

Love,
Barbara, Marc, and David

5 June 1966

Dearest Mother,

We got your last letter—thank you. You seem to be having a very exciting time. Did you get David's mother's day present? He is very well and happy. Our present is on the way. Well about your problems. I realize that ideally, Rocky should make a place for you, but couldn't you start out in your place? I realize it is a bit small, but with a little planning and alteration it could work (see plan). You have to make some concessions on your part. This way with what he would save in rent wherever he lives would be enough for you to stay home if he continued payments on the house. Or better still if you sewed at home and you continued payments on the house. We could help you a little. You are still a young woman and you look even younger! You should have a husband. You could fix the cellar to sew in. With the hallway, the bedroom and the rest of the house would be completely private and cut off. You could build a big closet to close off the living room from the bedroom. With the porch and the yard and the cellar you would have enough room—think about it. If you provide the house, I should think he would be able to manage to keep you at home with your sewing. He would save money on rent and restaurants. The bedroom would be small, but big enough after all with a window and a big closet (find out how much the work would cost). It shouldn't be much. The most difficult is to break into the wall between the bedroom and dining room (where there is the closet now) but that shouldn't be too difficult. It is not an outside wall. It is not that I am trying to push you in one direction or the other, but you have to try and make the best of things as they come and your apartment isn't impossible for two people without children.

 We are working hard as usual. Jeannine had a terrible accident in the country. She fell down a very steep flight of stairs in the middle of the night and fractured her skull. But she is recovering very quickly. She has a lot of vitality. But still it was a horrible accident. She has been in the hospital for a week and is coming out tomorrow. She is going to stay in the country for two weeks. I went to see a funny picture today. If you thought men were bad wait til you see *Alfie*, an English film starring Michael Caine. What a bastard!! I'd like to be with Bernice when she sees it!...I promise to write again soon. Let me know as soon as our present arrives.

<div align="center">

Love XX

B

</div>

P.S.—Marc sends a big kiss. Vicky is very impressed by all your exploits! Françoise too!...

[no date] 1966

Dearest Mother:

The latest "David" photograph! See how much I love you to part with it—Maria sent it from Spain, but she promised to send more copies. I must say he looks very Spanish. He will be back Friday—all brown and full of cow's milk. Did you get your Mother's Day card and hankie from David around the 5th of June? You never mentioned it and I was wondering if it ever arrived. I'm happy at least that our present arrived.

I must say your amorous adventures are fascinating. Marc and I fight each other over who gets to read your latest letter first. Well, Bernice must be purple with envy—for that matter so is Vicky! Again she has bad trouble with Jean and this time I think it is finished. He had to go back to his wife because she threatened to kill herself, etc. Anyway, that's one way to get an apartment fixed up! I told Marc I was going to try it on the plumber. As far as I can see it is the only thing that would make a French plumber "move his ass" as they say in Philadelphia. I am so desperate to get this house finished I'm tempted to try it on the painter too!! Well, I think it is very funny, all these guys fighting over who's going to fix up your apartment—anyway as long as it gets fixed!! Make Clarence buy you a big fat engagement ring. I bet Daddy never did. Also while I think of it, you'd better get some hormones from Dr. Ramsey! It is the hormones they put in the birth control pill and it is called estrogen and it keeps you from drying up!...and keeps your muscles firm. Not that you seem to have that problem at the moment. Ask Dr. Ramsey. He'll probably laugh his head off, but he'll give them to you. You might have to take the "pill" in order to get the hormones, but they can be given separately. Onward and upward!! I think I am going on the pill myself. I am tired of my contraption and I have to start thinking about my old age. If you begin early enough, they eliminate the "change of life" completely.

Well Marc's book is in its last few days. They are doing the printing this week. Am I glad that's over. 9 months of agony worse than having a baby. I am going to spend the day cleaning David's room and getting his things straight. In August we are going to build a studio for Marc in the garden so that David and Maria can have the two front rooms. Unfortunately, Maria is not going to stay. Her brother bought a café in Spain and wants her to help him. I am very sad. She was just perfect. But then it was too good to last. I hope at least she stays until November when we are supposed to come to the States. I am waiting for a letter. I know she doesn't want to leave David. She was already crying and moping around when she was leaving for Spain without him. Anyway, I'll think about that tomorrow. Just when we get Marc's book out of the way, I have to go and decide to have an exposition! More work and headache. I haven't really firmly committed myself, but tentatively it would be October 15 at a gallery here in Paris. I don't know.

I know I should and need to have a show and that it is an ideal time, just before leaving for New York, but it is a great deal of work and nervousness and money for casting, etc. And we have been spending money like it was water this year. All the investment of the book which we won't see for two years, Marc not doing any other work except the book, the new studio for Marc and the house in the country. Anyway, it is time to stop. We are getting too many things to take care of. Speaking of spending money, Marc's brother gave his daughter a dance last night at Annecy. She didn't want long dresses so everybody wore mini-skirts. I never felt so old in my life. Marc said I couldn't wear a mini-skirt, that I would embarrass my nieces and nephews—that anyway it was a dance for children. That may very well be, but nevertheless, my favorite nephew (he's 21) gave me a pair of "up" panties for Christmas with a card saying "to my dearest old Auntie." I told him he should have more respect for his "old Auntie"…Anyway, I hope the "younger generation" had a good time.

Just this minute got your birthday card. Thank you so much. I had completely forgotten! I gave Marc an old map of China for his birthday and I think he has completely forgotten mine!! But since he makes me a birthday present every day, I can't really complain…wait til you see my alligator bag!! All my love, always, and thank you again for the wonderful card.

<div align="center">

XXX

B

</div>

August 2, 1966

Dearest Mother,

Please forgive the long delay in writing, but as usual things are more than hectic. Marc's book is being finished in Holland and will be out in the U.S. in September–October, published by Macmillan. It is called *The Three Banners of China* and it is very beautiful—expensive, it sells for $12.95 and I hope it will be a success. Anyway we should have lots of reviews and publicity. The plan is to be in New York in November for the opening of his photography show (also China) at the Asia House in New York on Fifth Avenue. We are going to have announcements printed for the show. But there was a lot of difficulties with Macmillan, the contract, the printers, all the other publishers (German, French, Spanish, etc.) so it was a fantastic work for Marc and he is exhausted.

Next we are trying to move into the country house next week and that was a huge work for me—as everything is extremely slow here and trying to get even part of it finished was a mountain. Anyway we have six rooms more or less done or livable and are trying to straighten out the grounds a little. On top of it all, we have had a miserable summer—no sun. Rain, cold—just miserable—not that we have had a really good summer since I've been here. At the moment the only

thing to have working in the house is the central heating!! Anyway we will send pictures. You may be happy to know that I am finally learning how to sew on a machine! Making chair covers of all things! And they turned out very pretty. I will send you a picture, I know you won't believe me, but I made the pattern myself out of brown paper, cut the material (which was blue and white plaid!) and basted it all together and fitted it. Then I hired a sewing machine and my new maid (another Maria) sewed them on the machine. How about that! I am going to make two more chair covers (I made six) and a couch cover in the country. Anyway to get Marc to stay there is another question.

Next. I decided to have an exhibition in Paris on the 15th of October '66 to the beginning of November just before we come to the States—25 drawings, three big sculptures and about 15 small sculptures. So as you can imagine, I am in a panic. Nothing finished, nothing ready. I thought it would be a good idea to have a show before I came to New York to have a nice catalogue to show in New York. Speaking of catalogues, I finally got the one from Dakar Festival—very nice. I am writing the committee to send you one—I hope they do it—with a picture and everything—

So between the house, the book, and the show—I am hysterical. Besides Marc is very depressed (he is always after a big project) and so on top of every-thing I have to keep beautiful and cheer him up! I may have an interesting project coming up for next year. I will write you if it comes through. I saw the Cardin show (collection) day before yesterday. Very nice. Also we are very happy about your sewing plans. We are going to help you as soon as we catch our breaths. I hope everything will go well and we (all three) will be in the States in Novem-ber in good shape!

Next David!!! Well, where do I begin? He is beautiful, of course and gets prettier and prettier every day. He is very tall, blond and weighs 15 kilos about 33 pounds!! He doesn't talk much, but he is (of course) (smile) very intelligent and has a passion for cars. Your Christmas present, the green jeep is his favorite, favorite toy and I'm not joking. He plays with it all the time. He is very strong and has lots of muscles. He is just beginning to make sentences like "The auto of Papa is in the garage" or "The auto of Maman is broken" etc., etc. You can see where his interest lies. He has just learned to say his name David and to realize who "me" is. He is also at the age of contradiction where everything is "No." David eat your lunch—"No." David don't eat your lunch "No." I found a very good Spanish girl for him (another Maria) and am very happy. He finally doesn't make pee-pee in his pants—can you imagine his diaper days are over. He is grown up! He is terribly spoiled I suppose, but thank goodness he has a calm and gracious temperament so it isn't so bad. He is also at the "clinging" stage, so he hangs on to me all the time. It is so funny to see all the stages—so classical that all children go through. He still takes a nap in the afternoon thank goodness. And already next year begins the problem of nursery school! Jeannine's little boy too—We

are going to try to put them in the same school. And this August they will be together in the country. It will be very good for David as Peter speaks very well for his age and besides is 8 months older than David, so David should make big progress. Medically he is in perfect health. But he has a little umbilical hernia which if it doesn't go away by next year has to be taken care of and his circumcision which wasn't done right has to be redone (the two at the same time). When I come to the States I am going to take him for a check-up at the Children's Hospital. Of course David is the kind of baby people make such a fuss over, but I wish he had his grandmother here. He needs a lot of affection and is himself extraordinarily affectionate. He has the habit of taking your face in his hands and kissing you which really sends me!! My god, at twenty what is he going to do??!! Now I understand mothers and their sons!! You can already see what kind of a build he is going to have. These French girls will be wild. Antoine, Marc's oldest brother just pulled off a fantastic coup—a merger that I don't understand very well called a hostile takeover but which now makes him the producer of ½ of all the bottle glass and glass in France!! Besides being president of Evian, the biggest mineral water in France and Jacquemaire, a French baby food equivalent to Gerber's in the U.S. Really fantastic. The other brother, Jean, is president of Schlumberger, one of the biggest oil and electric companies. Actually I am very proud of the Riboud men. They are all extraordinary and exceptional men. One wonders how to bring up a male child in this society so he turns out to be a real man and not a half-ass excuse. David will have some fantastic examples to follow. His godfather is the oldest son of Antoine, also a charming boy, if spoiled (how could he not be?) Anyway, for the moment, I am quite happy that David is finally toilet trained!! One step at a time…

Françoise is very well. Antoine is taking her on a trip to Russia with his family the 15 of August—she will probably come to visit us sometime in September. Her daughter, Caterina adores David. They get along wonderfully together. David even looks like Caterina.

Tamara is fine. She found a great job stealing fashion designs from the big collections for some Americans! I saw her at the Cardin show sketching away. I told her if she got caught I wouldn't even admit I knew her.

Vicky has her usual troubles—men. She is supposed to go back to the States for a visit in September.

Sheila is in Spain with her family. Finally. I see her rarely. We don't move in the same circles.

The film of Bill will be out in the fall with me in it (for about two seconds).

Serge, the one that you met here has a daughter of 17 years old who is making a big splash in café society. She is the niece of Vadim the movie director and very beautiful, so she is getting more or less the starlet treatment—photos all over the place. She is modeling for Courrèges this season and Serge is out of his mind—his little daughter is turning into another Brigitte Bardot! I could just see Marc in

the same situation. Or wait until David decides to become an actor instead of an engineer. Madame Rosier is on vacation in her country house! I think I told you about the big garden party I had for Magnum while the annual meetings were going on. It was a big blast, vèry successful that completely ruined my grass!! And guess what I wore? Remember the white crepe dress with the drape on one shoulder. Well, my dear, it is still around and looking great! I wore it and the sapphire diamond brooch of Marc's mother. Oh yes, Magnum is finally integrated! I used to taunt Marc about it, but it is true that there are no Black photographers in Magnum. Actually there is only one Black photographer with the qualifications, Gordon Parks, and he is with *Life*. But there is a new guy, a Black South African who escaped from South Africa with fantastic photographs and all the photographers are in such admiration (I haven't seen the photos), they are sure to ask him to join. He is now in Copenhagen living it up! Supposedly he is doing "research" for a picture story on why Swedish girls are so crazy about Black men ha ha!!

Well, there is not a bit of sun in the miserable place and Marc doesn't improve. I'm just going to pick him and David up and go someplace. I don't know where.

Well, back to work. I am writing this during "lunch hour." David is fast asleep. I am sitting surrounded by boxes and crates of things for the country. My head full of kitchen utensils, pillowcases, towels and glasses and Johnson's wax—and Marc's book, the publicity, etc., my exhibition and Marc's exhibition. Oh yes, Eisenman, my old professor from Yale will be in Paris soon. Marc is doing some work for him since he is the designer for the Morgan Trust Company. It will be fun seeing him. We have met some very interesting people lately, but I don't have time to go into detail—mostly New Yorkers, so I am so looking forward to a visit. I hope nothing happens. Well, how is Bernice and all the gang? Your trip to Montreal sounded very nice. Did you find out anything? How is your love life? Marc gets such a big kick out of it. Françoise too!!

A big kiss from your David

XXXX

B

Sunday '66 [no date]

Dearest Mother,

At last! Please forgive the long delay, but I know you understand. It is not that we don't think of you, now that you're gone. David especially. I ask him "where is Mummy?!" And he says "In New York"… "Philadelphia" is really a little too hard! He is very well and growing like lightning. He is still very pretty and this summer he was almost black. Well, it seems sure now that we will be in the States for Christmas! Marc's show opens in New York on the 3rd or 4th of December. And

the book comes out I think the end of October. So it's all set. Why don't you ask Dr. Ramsey or Joan and Dick Watson if you can't give a reception. I don't think Marc would like the idea of a hotel. Joan's house is quite big and very pretty. I'm sure she would do it. Dr. Ramsey too. My work is going very well. I have an exhibition in Paris the beginning of November (more details later) and the sculpture commissions I did for Pierre Cardin were a big success. They are all installed with a big opening where everybody who was anybody came (see clipping). I think Marc's book will be a big success both here and in the States. He is already considered a China expert. Plan to come to the opening in New York the 3rd December. It should be very nice.

Did you get the photos and present delivered by your friend from the store? She is very nice. I'm sorry we couldn't have spent more time. Bill's film comes out the 20th of October. It is very good and should be a grand success also. How do you like the house (what you can see of it) now that it is more or less finished? I just love it and for Marc and David it is really a godsend. I can't wait till you see it in the flesh. Did you get the catalogue from the show in Dakar? It was a nice catalogue. I will send you some press releases for the exhibition this week: for the _Afro-American_, the _Pittsburgh Courier, Me Week_, Dorothy Grafly, etc. There are so many articles and things on Marc I have lost track, but I'll keep the most important for you—Do you want anything special from Paris? Let me know what I can bring you besides David!

Vicky is leaving for the States tomorrow. It is very sad, I don't think she will be coming back. But one never knows. Tamara is pregnant and so is one of my sisters-in-law, with her eighth! How is Bernice? Give her a big kiss for me and tell her we will all see her soon.

David has a little dog (for the moment) and he is so funny with him. I am very happy with my new Maria. She is even better in many ways than the old one. Sheila and her husband are settled in Paris for the winter. She is well and very happy with her new baby.

I have so many things to tell you about—the house, this summer, Italy—but now that I will see you in December I can tell all in person!

<div align="right">
Love and kisses,

Barbara and David
</div>

Dearest Grandmother,

Happy <u>French</u> Mother's Day _et très bonne fête._

<div align="right">
Love and kisses,

David
</div>

November 14, 1966

Dearest Mammy—

It is finally all set! We will arrive together or separately between the 27th and the 1st of December. Marc's show is the 6th (the opening). My show here in Paris got off to a great start, about 900 people showed up for the opening—not bad for a Philadelphia girl. *Match, Elle* did little things and also the *Nouvel Observateur.* Pierre Cardin was in Israel, but he sent <u>five</u> dozen roses! He is making me a dress for New York next week. We are up to our heads in work. You will get a catalogue from the show one of these days and I will bring others with me. The main thing is to let me know your schedule so I can arrange David. Also I need a bed for him if you could borrow or rent one. I have to find someone to take care of him, preferably someone who speaks French. Even if it means to pay them (we would pay them and you...) a little extra. I would love for you to spend the maximum time with David. He is so wonderful and so funny now. He knows very well who you are. When both Maria and I gang up on him, he yells for mummy! That's you (Grandma in French). I am letting Maria take the vacation now in Barcelona. I think the best is to install David in Philadelphia more or less. We would like to find a flat in a hotel for a month. Marc is thinking seriously about doing a film. Bill's film is a great success. You will surely see it one of these days... and me! The soundtrack is now being done in English. I have so much to tell you, but so little time at the moment. I'm saving everything until I see you. The main thing for the moment is to try to make any kind of arrangements possible to spend the maximum time with David—never mind the cost. Françoise is coming on the 15th for ten days and this may help too. The only problem is David is still very shy with people he doesn't know. Have you received Marc's book yet? If you haven't, you will. It is very beautiful and getting good reviews although it hasn't really started moving yet—He has to do some television and promotions in New York and the photo exhibition will help certainly.

Let me know as quickly as possible about 1) bed 2) what days you can arrange off (if any) 3) possible nurse-baby-sitter. I will write again soon. Kiss Bernice for me. How is your love life?

<div align="center">XXX
B</div>

1967

I was visiting my mother in Philadelphia when the U.S. Supreme Court handed down its landmark decision sublimely named *Loving v. Virginia*, which overturned the last existing laws against miscegenation as a crime in Virginia and thirteen other states that still had Black Codes on their books. Only Alabama didn't formally revise its Black Code; its one-drop laws, its miscegenation laws written into its state constitution stood until 1998. It was now eight years since my engagement to James Stirling and six years since my marriage to Marc Riboud, neither of whom had ever believed my mother when she had admonished them about their legal stature as felons fit for prison, me included if we set foot in half of the states of the United States.

If miscegenation was no longer a part of the legal vocabulary of the United States, it was still a social and political provocation. School integration had progressed by starts and stops in the South. School bussing and redistricting according to segregated housing abounded. De facto segregation dominated the North, and local courts and school districts upheld these contradictions. National Guards escorted schoolchildren to class in the South, "bussing" had a new meaning in the American vocabulary and became a noun, President Johnson pleaded for a "Great Society" and a "War on Poverty." Thurgood Marshall was named to the Supreme Court as the first Black judge on the bench. The protest against the war in Vietnam reached its apogee with the March on Washington. On October 21st, 300,000 protestors descended upon Washington, the day my second son was born in Neuilly, a suburb of Paris, and Marc shot his famous photograph *The Girl with the Flower*, an image that circled the globe. Chris Marker the filmmaker dedicated the documentary he filmed that day to our newborn baby, named Alexei Karol after the journalist K. S. Karol sentenced to death in absentia by Stalin.

February 1, 1967

Dearest Mother,

Well, we are all arrived safe and sound. We went straight from Paris to Lyon to pick up David and spent the weekend, coming back Monday. David is in wonderful shape. He is his old sweet, easy, obedient, adorable, calm self again. I am the mother of Dr. Jekyll and Mr. Hyde, to say the least. But it is really amazing the change. He is just as anti-American as De Gaulle!! Anyway, all's well that ends well. We have a pile of work and the exhibition has been postponed until the 16th of February. But we hope to be able to leave on vacation around the 17th if there is no television. David is going to go skiing in the mountains with Françoise and the boys and sunbathing. The mountains in February are wonderful. Full of snow and sunshine. Bill and Jeannine have already left for the mountains with four other friends of ours. I have been trying to get the house in some kind of shape. I spent the first two days painting the room of David and his bathroom. It looks so sweet. He was so happy to find his room and his bed and all his toys, broken and non-broken. He was absolutely dazzled with everything and delighted. Before I forget, did you get your check. Tell me how the Goodwill thing is working out? How is Clarence and Bernice? Have you seen Dr. Ramsey? Everything here is normal. Paris is just as beautiful as ever. The weather is mild. It seems almost like spring. We went to a party at the Ritz for the New York editor of *Newsweek* last night. So we caught up on a few Paris friends. Otherwise we haven't seen anybody since our three best friend couples are out of town. Vicky is fine. She is back from Germany and starting to write her book. Sheila is in Germany at the moment. Tamara is waiting for her baby. Sylvie, my sister-in-law (Marc's youngest sister), just had her eighth!!! A girl called Veronica. I hope she had those things of hers tied up...I told Françoise to tell her. I didn't really think it was my place, but really. Anyway she is too old to be having any more children. We are going down to see the house this week. We have some planting to do too before the end of the month if we want anything this spring. Well, there's always too much to do anyway. But I am quite happy to be back if we could just get a little rest. The collections are on and are they mad...I haven't seen Cardin's yet, but as usual it seems to be the best around. Everybody is going mad for pants suits, Bermuda shorts under mini-skirts and guess what...the African Look...no less. I knew it would get around to us eventually. Everything in everybody's collection is beaded, flowered, draped; the hairdos are even African. Since they can't get straight hair kinky, they lacquer it until it is completely stiff and then make these weird African hairdos. And the chokers and the bangles and the arm bands and the leg bands...well you'll see. Let's see, what else is new? I am still stunned at the fact of being able to get a taxi when I want one. I've been on a diet because I am too fat. I've been stuffing myself with French bread. Marc's book is selling

well in France and with this exhibition coming up, it will probably be sold out in a few months. Vicky has found herself a millionaire if she can just land him. The christening of Sylvie's baby is the 11th and I am going to dress David in his white suit I bought him in the States. I don't think you saw it. It is in white piquet and it is so sweet. He will look adorable. Well, write soon. Let me know about the check above and let me know about the job. Marc sends all his love . . .

XXXX
Barbara and David

February 9th, 1967

Dearest Mother,

I am very worried not hearing from you. Have you gotten my letters and have you gotten the check. How is Clarence? We are still working hard on the exhibition which is the 15th and then we hope to get away around the 16th. Françoise arrives today for the christening of Sylvie's new baby tomorrow. And Sunday, we will probably go to the country for the day to see the house and come back on Monday. Haven't seen many people since we have been back. We will see them all on Wednesday. Jeannine and Bill are in the mountains and will be back on Wednesday. I just spoke to her on the telephone before she left. Vicky is back from Germany and moving into a new apartment today. Sheila is back in Paris with a cold. David is fine and very happy. I have a new girl for him from the country. Very nice, a little serious but quite good with him and he likes her very much. But I am really worried not hearing from you. Please write at once and let me know what his happening. I am still trying to get the house straight. There are so many things to do and I must admit I am feeling a little bit lazy and disorganized. I don't know if it is the trip or not. Madame Rosier is fine.

David has really started to speak now and holds long conversations with everybody especially on the telephone. It will go much faster now that he has a French nurse for a while; he still thinks English is hilariously funny, but I am beginning to speak a little to him now. The little outfits I bought for him in New York are adorable on him. He is going to wear one of them tomorrow for the christening. It is the one thing I am sorry I didn't buy more of. I'm especially sorry I didn't buy a dress for Caterina, the daughter of Françoise. Maybe I'll send you a traveler's check later on to pick up something. Little girl's dresses are so expensive here.

Please write at once. I am sending this off fast to get an answer.

B

18 February '67

Dearest Mother,

Great to hear from you. I was so sorry to hear about Miss Bertie. I sent a letter c/o you to Janet and MacKins. It happened so suddenly and Mr. Edgar is still going strong. Well that's life, I guess. Marc and I are leaving Wednesday for Morocco for a few weeks of sunshine and a few photos for *Vogue*. David is going skiing. It is fantastic how he changed back in a few weeks from New York. The opening of Marc's show here went very well. It was jammed with people. Very well installed, so we are quite happy. He has several television appearances and part of his Vietnam story will be out in *Match* next week. You must write me more about your "adventures in wonderland." It is fascinating. Why don't you keep a journal? I will write from Morocco in a few days and let you know all the news. We had dinner with my brother-in-law last night who bought a sculpture. So that was nice. We got a letter from Asia House saying that 18,000 people saw the show in New York. Did you get the new pictures from *La Carelle*? We are going to run down to the country just before leaving to see how things are. Well, write soon. Did you get the check?

Love X X X
B

March 23, 1967

At last! We are back from a wonderful vacation. Marc really got a good rest. Did you get my letter from Morocco? We sent you something too. It should arrive in about two or three weeks. It is not very practical for the summer, but it should be wonderful for those winter nights in front of the television. David is back from his "winter sports" looking like a little toasted corn muffin. He is really adorable. He had a great time as you can imagine and is full of health and good spirits. He is not at all a child like I was. He is very gay and very funny and so good natured it is incredible. He was really not himself at all in the States. I was so disappointed. He is so full of affection and fun. Everybody at La Bergerie adores him.

I am told he will be very good with a little sister which is what he is going to have (or a little brother) in about seven months. Ah so!!!! And that's my big news for today. Marc is delighted, but he is so set on a girl, if it is another boy he'll probably call him Regina! Anyway I too would prefer a girl although another boy would be much simpler. If the Barbara luck holds ... anyway, the problem now is to make some space and stop eating. I know it wasn't funny, but I couldn't help laughing at that list of yours. I think your book would make a better television program called *Goodwill Place* or something. Anyway, I'm glad you are happy!!! I know Bernice must have something to say about it. Françoise is driving up from

La Bergerie for Easter weekend and we are all going to the country to the house. It should be a pleasant weekend. Marc is looking very handsome these days, all suntanned. The hotel in Morocco was divine, very modern with a heated swimming pool and private terrace for each room. We managed to have a thirty dollar a day room for nothing because Marc took photos of the hotel!! The owner is a photography fiend. So it turned out to be a cheap as well as pleasant holiday. We even had the "Rolling Stones" as neighbors. They were very funny and had the most fantastic outfits on you have ever seen. They arrived in a Rolls Royce with black windows (so their fans can't recognize them) very discreet...only Queen Elizabeth and the Beatles have Rolls Royces with black windows. Well, I'm still in my sleepy days and after my big news, all the rest is rather anticlimactic. So I think I'll go and take a nap...

<div style="text-align:center">

Love,

B

</div>

P.S.—Did you get the second check from Magnum?

April 10, 1967

Dearest mother,

I hope you got my last letter with my new news!!! I was expecting to hear from you. But we got your beautiful Easter Card and David got his too. His is fine and adorable. Did you like the photos of him skiing? What he liked best was to fall down. Did I write and tell you that we sent you something from Morocco? It should be arriving now. Write and let me know when it arrives as I don't have much faith in Moroccan salesmen...

Anyway, it was so surprising not to hear from you I'm afraid there's a letter lost somewhere...Everything is fine except that I am tired and can't do anything and nobody can figure out the date!! I figure January February March...that is three months, thus the arrival should be in September, but my doctor doesn't agree. Tamara is due this week or next. Could you look out for some white (cotton) maternity slacks for me—if you come across them buy two pair—I'll need them for this summer. Also if you find a kind of tunic: [DRAWING] like this zipped or invisible closing up the front in white or any solid color. The French are still 20 years behind the times for maternity clothes. If not, don't worry about it. I've just got back all the things I loaned Tamara. I think I told you, Marc's sister Sylvie had another girl....So even this one may not be the last Riboud—but it will be for me, you can be assured. David seems to like the idea, but when I told him it was in my stomach this little baby—he looked at me like I was completely out of my mind and in fact said in French the equivalent of "go on..." like you're pulling my leg!

Marc is very well and is sure he is going to have a daughter to spoil. He won the overseas Press Club Award (a big dinner in New York on the 21st of April) for

his book on China. It is second only to the Pulitzer Prize. The show here was very successful too and one in London opens on the 1st of June.

Well that's all my news. Still no visa for Marc for North Vietnam.

Love,
B

La Bergerie, April 22, 1967

Dearest mother—

All goes well. David is very well and we are all going to spend three days at Françoise's in the country May 1st. Bill Klein was in New York to film the big peace march in N.Y. Marc's prize dinner in New York was Friday evening. We are going ahead with building a new studio for Marc. We haven't done anything in the country yet, but I intend to go next week. I have started working a little. I get more energy as I go along. I certainly hope David is going to appreciate this little sister! He has decided it is somewhere very far away—not in my stomach at all. The idea is so ridiculous to him he just laughs.

I thought your newspaper was very nice, bravo! How does Clarence like being a prospective Grandfather-in-law? Very good news about Bernice. I hope it works out alright. Don't you stop looking around—anything can happen! What is happening at work? I hope they decide to keep you there. Let me know what happens. Anyway I think it was a marvelous idea and change for you. Tamara is still waiting for her baby. Her parents are here all nervous and twiddling their fingers! It is already a week overdue. We finally bought a television set one of the little portables. At least David and the maid are happy. Marc has been on several times in the past month. Also since he wants to make films for television, he should at least know what is going on.

Have you received your present yet from Morocco? Let me know when you do. Please excuse this short note, but I promise to write again soon.

Love,
Barbara and David

Paris, Sunday, May 1967 [no date]

Dearest Mother,

I was so happy to hear your voice over the telephone. Are you sure everything is alright? Marc began to worry when he realized that for you it was 3 o'clock in the morning. Everything is well I went to the doctor's yesterday and all my tests, etc., were normal. The only abnormal thing is my weight which is (for me) fantastic

although I don't look fat! Anyway the idea is to stop eating and you know how difficult that is for me!

Marc will be in New York in July. We are leaving for London for the opening of Marc's show June 1st. It should be smashing—even better than New York. I am not particularly happy since I can't wear my Cardin suit! David is very well, sunny, happy and gay. He is such an easy child it is incredible. He is spending the weekend with his seven cousins and he is absolutely carried away (6 boys and 1 girl!). Sylvie, my sister-in-law, was here for lunch yesterday and asked him if he wanted to come today (Sunday) to play with his cousins. He said "no-today" (meaning yesterday). He went upstairs, asked for his pajamas, toothbrush, and a sweater and off he went!! He did kiss me goodbye, but just. He had one little cousin, Marc's godchild with him. What independence. He is going to be worse than I was! I don't know what we are going to do when he is fifteen. Anyway I kept calling my sister-in-law until she told me to quit bothering her—"David hasn't asked where Maman, Pap, or Christian are since he got here..." So I finally quit calling her up. But he is a different child entirely from New York—like night and day. It is a shame he left the impression that he was spoiled and difficult because he is exactly the opposite although he does have too many things. Well, September and he will start school! Can you imagine. He is very happy about the baby. Insists that it is "in the country" and thinks it absolutely ridiculous that it could be in my stomach. Also his little peter is fixed—very pretty and his belly button! So he is in good running shape.

Everyone here is sick at what is going on in Vietnam. I am very happy about King's stand even if he is being criticized. I wrote to the *N.Y. Times* protesting their condescending attitude about King's opposition to the war—"You take care of Colored people's business and let us White people take care of the business of the United States!" Bill was in the U.S. trying to make a film about American attitudes toward Vietnam and the protests, etc., and got nowhere. I had the impression even in January that America was turning to the military right and now I am convinced. Not very pretty when it happens in your own country. The U.S. seems to have gone completely mad. What is worse Russia seems to have given the green light because of China. Russia is the only country strong enough to stop the U.S. and she does nothing because she hates China. It is like the beginning of World War I and World War II all over again and the human race is too stupid or blind to see it. When I think of David, I just wonder what I have gotten him into. I don't think the French are going to reinstate the draft any time soon...Well, apart from the lousy world situation, things couldn't be better. I'll write again soon. Do by all means continue with the course. I'll send you your first white lab coat—"made in Paris"—

Love XXXX

B

May 28th, 1967

Dearest Mother,

I was so happy to get your letter. And Happy Mother's Day! Here it is the 28th of May so you see I am not late... We are leaving for London day after tomorrow for the opening of Marc's show on June the first. The publishers there are very nice and are giving all kinds of parties. I am taking some drawing with me as I feel so lazy, not working. These past days I did manage to do a few. David is in great shape and he finally realizes that the "bebe" is in my stomach. He also asked, of course, how it got out. I told him... We are making a new studio for Marc as I need his office. I hope it turns out alright. I am happy you are going to see the expo. I envy you as it seems to be quite beautiful. Maybe you can go again with Marc in July if your job permits. He will certainly go while he is in New York. I think I told you about the overseas Press Club Award. Very important. It was announced in the *New York Times*. The house in the country is coming along. I hope to spend August and September if not July as well there. David is very happy there and I work well. Nothing else new. Tamara's baby is thriving and Vicky is just the same with all her troubles. Sheila is fine. Marc is writing again about your check. I am sorry it is overdue, but they are not very efficient in New York. We have a newly decorated Paris office now which is very nice and elegant. I got a letter from Daddy about the baby. He asked me if I was trying to keep up with the Kennedys... Thank you for the photos. They are so sweet. David just came and told me to look at the "big car of mammy" (that's you). He speaks often of you. It is very funny. But he doesn't want to go back to New York for the moment. The foot warmer was Marc's idea, the dear. I am glad you like it. Let me know when you start on your job. Remember I have promised you the most elegant French white lab coat I can find! That is for Mother's Day.

I am enclosing some more photos. Remember the picture you have of me doing the Suzy-Q? Well, look at David... It is fantastic. David will be a lot of fun when you see him next. He is very funny and very bright and so sweet. And the girl I have for him now is so sweet. She took care of Françoise's little girl for four years. Françoise is very well. She seems to get more full of life with each year. She is glowing with vitality now. Everyone remarks on it. But she does take very good care of herself. I really don't think I could be bothered to spend so much time on myself. I may feel different when I can't lose these 16 pounds! But I really don't look fat at all. I don't know where it is unless I have a baby with the heaviest bones in history! Well, that's all my news. How is Bernice's romance coming along? Have you seen Harold or Izzy lately? I am going to have to see Stirling while I am in London. I hear he has gotten fat and lost all his blond hair! I don't know why one always imagines ex-boyfriends and husbands as being bald!

Bill came back from New York absolutely stunned. He couldn't get backing for any kind of film on the Vietnam War. Nobody in the government would see him. His phones were tapped. It was awful. Everybody in the movement was afraid to talk. It was really like the Gestapo. So much for freedom of expression. Everybody that has gone to New York or the States lately has come back disgusted including myself. Anyway, we will talk about it some other time. Marc sends all his love and of course David too.

<div align="center">
XXX

B
</div>

June 20, 1967

Dearest Mother,

Everything is fine—we received your two letters and cards! I got the dress and the pants...wonderful, thank you so much. Of course David loves his jungle book and all the other little things you send. He remembers you very well—never fear. He is a very sweet baby and so good...He knows he is going to have a little sister soon, that it is in my stomach now and that it comes out of a little hole—so much for sex education at 3 ½. I have registered him for nursery school in the fall (it is a wonder the French don't have an entrance examination!). Anyway it is an "experimental" school supposedly very progressive (for France, that is) and was recommended by a child psychologist, a friend of Marc's (I have much more trust in a French psychologist than an American one—they are more plausible). At any rate it is around the corner which is the main thing and it is free—We are again in the midst of remodeling—trying to find room for this baby—we are putting Marc out in the garden! I hope everything goes all right. We have to ask permission from the co-owners of the building—so that's for July. I am so happy you went to the Fair. Everyone who has seen it is stunned—it must really be something. Marc will surely go in July—if you are free and up to it, you could go together. All the girls are fine except Vicky who is having her usual rotten luck. Françoise is coming to Paris next Monday for a few days to see Marc—(he had his knee operated on this morning—an occupational hazard—too much walking). It seems that it happens (a broken cartilage) to all ballet dancers, football players, tennis and ski champions, and photographers!! Anyway he is fine and the operation went alright. But he will be stuck at home for a few weeks—hobbling around—and driving me crazy...

<div align="center">
Love,

B
</div>

July 1st, 1967

Dearest Mother,

We are having a heat wave here, or at least what the French call a heat wave. It is not all that hot when I think of New York and Philadelphia. Anyway I bought David one of those wading pools for the garden and he is delighted. We are going to hang around Paris all the month of July. Marc is coming to New York around the 18th as I have mentioned. He is hobbling around now and can't sit still. Still he should take it easy all the month of August and September. I hope we will stay the whole two months in the country. I am going to send David to Françoise's around the fifteenth with Christian to get him out of the city and he will have to be back in Paris on the 15th of September for school!!! He is going to one of these experimental schools just around the corner. Nothing else new. I feel fine and David is in great shape and getting prettier and prettier every day. We are finally going to build this studio for Marc in the garden. The work is supposed to begin in July. David is very excited about the baby. He is finally convinced that it is indeed in my stomach and that eventually it is going to come out! So Marc will call you and see you in about two weeks. He is going to bring back David's car that we forgot in New York and I have a list of things he should bring back for me. This plus the house in the country plus the new sculpture I am doing is really keeping me busy. Vicky and I even decided to write a television show based on *Mademoiselle*!! We haven't DONE it yet, but we plan to make lots of money and retire. We are going to write just the idea for the first thirteen scripts and sell it and let television writers worry about writing them. Bill Klein is starting a new film and Marc, I hope, is going to finish his this summer. I just wish you could be here. Are you going to be off all summer? Write and let me know… Thank you for your birthday card. It was lovely. Do me a favor next year and just forget about it I'm finished having birthdays. I have decided to be thirty-six for the next fifteen years. That way, nobody will believe me for the first ten and after that they'll be in the habit. It is much better than going backwards. I got a card from Daddy too. Wouldn't you know he would start to remember my birthday after thirty!!! I am so happy about Bernice. She finally made it!! I hope everything goes well. Françoise is well and sends her love. She was here last week with Caterina to see Marc. All the rest of the family is well. I am sending by Marc some things for this winter I hope you can use.

<div align="center">
Love,

Barbara
</div>

P.P.S.—just got your last letter this morning. I am so happy to hear about the glasses. I am sure you will do very well and look beautiful in your white lab coat!! I am sending you two as I promised you so don't buy any. I am putting them in the packet for New York office. So, if they send them right away, you should have

them the fifth or sixth. Give my love to Dr. Ramsey the next time you see him. I am going to send him Marc's book. And give a big kiss to Bernice. I am rushing to get this posted...

Love,
Barbara

Thursday, August [no date]

Dearest Mother,

Hope you have seen Marc and the new pictures of the baby and that it wasn't too hectic. I hope Marc is leaving on Monday. I was so pleased at the way school is working out. I hope you are having a good time. I'm glad you liked the uniform. I enjoyed buying it. Our cousin Peggy Coats turned up (did I write you already?) and stayed here for four days. It was funny to see her. She is still fat. She remembered all kinds of things from Washington that I had totally forgotten. I helped her as much as I could and I think she enjoyed staying here and her stay in Paris. I put her on the plane to Venice...I'm glad you got the check. It's not that we don't think of it—but it is not regular through the office in NY so we have to be reminded. Please don't worry about it making problems. We can spare it. Marc can afford it. Marc and I have two different philosophies as far as money is concerned: for me it is to spend and for him it is to make more of (the result of his banking family background). So we live off of our income from Marc's photography, more or less which is more than enough. But we have a great deal of money to fall back on, counting our houses and not counting all the negatives of twenty years' work of Marc that are sold and resold bringing in royalties enough to live on. The other thing you mentioned in your last letter was my happiness. You should know me well enough to know that if I wasn't happy I would have been long gone as independent as I am. That is the only thing that worries me is that my happiness makes me very vulnerable. Marc couldn't be (as far as I'm concerned) a better husband. He is kind, gentle, sexy, strong, funny and intelligent and of course there is his French charm. We have never really had a fight in all the time we've been together except once—before we were married when I stormed out of the house and stayed out for hours. When I got back, Marc was in such a state—he couldn't even stand up he was so pale and sick and I promised myself I would never do that to him again. And I never have. Marc does tend to be a fuss-budget from time to time, but it is so funny I don't really mind. I just let him fuss away and do exactly what I intend to do. On top of everything else I find him handsome and faithful, (although it doesn't matter very much to me) I don't think it would really ever occur to him not to be (and if it ever did, not that he doesn't look! I am sure it would be in Africa!). He is along with you and his sister Françoise the only genuinely good and pure people I know of and that's a fact. And I don't know

really which one of you comes out on top! So I consider myself very lucky—so lucky I don't speak about my happiness to anybody. I don't trust people who go around saying how happy they are. Real happiness is too fragile and too rare to vulgarize with words—I just keep my mouth closed and my guard up—like money, it can disappear overnight. Another woman, an accident, a stupid illness, a war. For David or Marc...there are so many things...as you well know—so unless something happens to change all this with this letter you will know that I am alright. That I love my husband—my husband loves me—our real view spot is David. There is no difference against that—you just have to hope that he makes it and try to lead the way as much as you can...I kiss you—

<div align="center">

Love,

Barbara

</div>

P.S.—I don't want to keep harping on money—We will never let you down. I personally think it is important that you work. I think it is important that Marc works and that I work. It is a great part of the meaning of life. We know too many unhappy people with too much money who have never accomplished anything in life and never will, who have no confidence, no backbone and no will to live—and who don't even know how to enjoy their money because they have no personality, taste or interest in life. Marc was taught to work. I had no choice and I think that is one reason why we are happy and I think it helps you more to work than anything else: defends you against boredom, despair, sickness and hopelessness.

My David-Chou is coming back from Françoise's tomorrow with Christiane. I'll be so happy to see him. Françoise spoke to me over the telephone saying how brown and beautiful he is. We will wait for Marc Monday, and Tuesday we will drive down to the country. I've been working like a workhorse getting the place in order. Madame Rosier is on vacation and I am in my high pregnant lady phase where I clean and clean and arrange and paint and sew and scrub and fix and change away and run around like a really mad woman. I don't know where the energy comes from even...I'm glad to have all this building to do for Marc. It keeps me occupied (in my spare time). The house in the country is coming along nicely and so is Marc's studio. I am hoping to really work after the baby is born. I have really fallen behind, there are so many opportunities that are passing me by. Sheila is going great—she has just finished a huge commission for the Ford Foundation (a wall-hanging almost 400 square feet!). She set up a whole cooperation to do it. I don't think she made much money on it (she has a payroll of about 25 people) but it will surely come with the next job. So you see I have a long way to go. Marc is already one of the top photographers in the world—so he can't go very far. I have to catch up with him one of these days...Boy I bet you never thought your one little question would get such a big answer, but if you are worried I want you to know the truth and dis here's da truth! I got a letter from

Doctor Ramsey thanking me for Marc's book that I sent him and saying that he hoped to get here soon. I had a phone call also from some friend of his on their way through Paris. Daddy says he's too busy to come this fall, so has put off his trip again...Vicky is still holding on, but she is getting weaker and weaker and I can't blame her. The most hard luck person (after you) I've ever met! Well, I am going to wash my hair and go to bed. I am reading *Hurry Sundown* by Gilden. Get it and read it. It is a wonderful book about the south—black and white don't forget. Kiss Bernice for me—when is the wedding? I want to send a present.

XXXX

Your one and only—

P.P.S.—Please don't mention to Marc that I discussed his finances with you. Another one of Marc's tics. He doesn't like credit, mortgages, loans, or rent—and that's that. He got that from his banker father...who never trusted...bankers! So we pay cash period. And as far as he is concerned, he is right. My brothers-in-law are two of the most powerful industrialists in France (and now Jean in America), to them, Marc is a pauper. And that's a fact. But they're not famous...so I call it even. So there's our background. We are the poorest in a very, very rich family— that likes me and that I like—love really very much especially Antoine, my favor- ite after Françoise, who makes half the glass in France! Not such bad connections for David too when he grows up—and if this one is a boy—and Marc's relatives... what stories I'll tell you some day. He has one aunt in New York whom we had tea with who lives in the same building as Jacqueline Kennedy on Fifth Avenue and voted (of course) against her coming into the building (a celebrity!). Remember the story I told you about 1040 Fifth Avenue? I sailed through the front door and when Marc arrived the doorman sent him to the service entrance. I told him not to run around New York in those old corduroy pants of his and that jacket!!

There's another old aunt that lives in a big chateau near Lyon that I like very much too. She is as close as I'll ever get to knowing what Marc's mother must have been like. Of course to them, who live very sheltered lives, Marc (and I) are the great adventurers in the big, wide world who know all sorts of people (smile) including ourselves. They are puzzled (why didn't Marc stay in Lyon, keep at his engineering, go into a family business?) but pleased—they like to see his name in the papers, his photographs, his books and now, my exhibitions, my catalogues. They are really very sweet. It and we must be a grand mystery to them. Lyon society is to France what Boston society is to the US. Anyway it's all very amusing especially since it is about once every two years! The Riboud children are wonderful (Antoine has three boys, one girl) and Jean has one boy, but very spoiled in a way that David never will be simply because we don't have the means. On the other hand, the children of Marc's sisters' sides (two sisters besides Françoise, Sylvie who has 8 children and Michelle who has 8) are brought up in strict poverty which is more like what Marc was brought up in

which I think goes to the other extreme. I know there must be a balance somewhere between the two: children who can have anything they want and children (all rich) who have nothing. Well, at least we can always provide the nothing (smile). Well, now you know all. One day I will write you a real history of Marc's family. I realize now that I never told you much. But then I am getting as close-mouthed as Marc. Make this last!...

<div align="center">XXX</div>

August 18th, 1967

Dearest Mother,

We are more or less established in the country. The weather is beautiful and David is in great shape. We have done lots of work. Marc returned safe and sound. He told me all about your visit together. He was so impressed with your diploma and the new developments and so am I. I think it's absolutely great. Besides being a nice job, you are doing something very important. And I am sure all these college graduates aren't doing it half as well. It is amazing. I see it even in Magnum: people aren't interested in working anymore. The less they can do the better: when in the end it is much more interesting to work and be interested in what one is doing than to spend all that time and energy trying not to. But you have a golden opportunity to make yourself absolutely indispensable. You have the time and the ability—anything somebody else doesn't want to do; do it— extra hours (not too many) and in a year or so you will be worth your weight in gold and you will be getting it as well. Write and tell me more about the institute and the people. When I think Marc told me you were hesitating between this and answering the telephone at Yellow Cab!! I nearly fainted and what a revenge on Daddy and his Red Cross/mistress/directress!! Well, Madame Curie, all I can say is good luck and keep it up. Marc wants to know when they are going to name you to the board of directors! I am so proud of you—imagine—in ten years they will finally find a cure for cancer and you will have helped! Get books and brochures and read up on what you are doing: not the whole field, but just your particular little section of it—be very selective and limited, but know very well what you are doing—it's the age of experts, even if you know only about one little fingernail, but you know everything about it. All this and just three blocks from home! What does Clarence and Bernice think about it—and wait till Daddy hears! I'm not going to tell him: let Dr. Ramsey or somebody do it!

Well, I am sitting here and rocking. I feel very well and full of energy. Marc too. His leg is practically healed. Françoise will probably be coming next week. David is all registered at school. He starts the 15th of September. I hope Marc's studio will be well on its way to be finished by then.

Nothing else new. You are the one that's making the news. I am sitting here

watching the cows go by. I give you a big, big kiss. Marc will probably be back in New York in September for a few days. We are staying here until the 14th of September with a few trips back and forth to Paris for the work. Write me here.

La Chenillère
Pontlevoy
Loire et Cher 41
France

XXXX
B
La Chenillère

September 13, 1967

Dearest Mother,

Absolutely no action on this front. Spending our last few days in the country and will be packing up to return to Paris this weekend. David will start nursery school next week. Can you believe it? I enclose the latest picture in the life of master Riboud...Now the doctor says somewhere around the middle of October! I wish she would make up her mind—or that the baby would. It has been doing the cha cha cha for seven months in there. Marc is in West Berlin on an assignment and won't be back probably until Saturday. He is in good shape. His knee is finished. I got a letter from Daddy who, except for overwork seems to be fine. He is not coming this fall. How is the job going? I loved the picture. David recognized you right away. The work is still going on at the house. It is going to be a mess. I am feeling fine, but fed up with waiting. It is also a relief to know that this is the last time I am dreaming of mini-skirts, etc., and of getting my figure back forever!! No other plans for this fall except the baby. Marc is not planning any big trips (just to Russia for the 50th anniversary of the revolution). I intend to get back to work as soon as possible.

[TELEGRAM]

October 7, 1967

Everything is fine. Still waiting. Love you. Miss you. Letter follows. Will telephone event expected imminently Marc New York after birth.

Barbara

October 11, 1967

Dearest Mother,

Still nothing. I kept putting off writing you until the big news…that isn't coming. Everybody is fed up waiting including me. I spend more time on the telephone telling people "not yet" than anything else. Otherwise everything is fine. David is in good shape although he had a bad cold last week. That was from his first week at school and all those other kids' germs. But now he is fine and he adores school. Tamara's baby is a living doll. She was over yesterday with her. David was fascinated. My Christiane took them both to the park and got a big kick out of all the people who would come over to admire David, hear him call Tamara's baby "his little sister" and then look into the baby carriage and see this White blond-haired blue-eyed rosy little girl. Christiane said she would almost fall off her seat laughing because nobody dared to say a word. Marc is rushing around like a chicken with his head cut off. He is on his way to New York as soon as the baby comes (whenever that is) and after that to Russia for the celebration of the 50th anniversary of the Russian Revolution. I am so happy your job is going well. Don't be too impatient. What you are learning is much more important than anything else and once you have mastered your field, you will always be able to get a job, anywhere and anytime. It is worth waiting for although I understand the need of storm windows too!! But this is really an opportunity. Don't get blasé about it. I'm not and I'm the one who is always taking things for granted. At your age, to be able to start a whole new professional career is terrific, I think. It looks like Vicky is going back to the States. She can't find a job here and is absolutely broke. I feel very sorry about her leaving, but I can't seem to find anything and there is nothing at Magnum for her. Marc's new studio is coming along slowly, also the baby's room although it won't be finished for the birth, I don't think. Or maybe it will at the rate I'm going. Anyway, it will be quite nice since I will have three small rooms upstairs to make up a nursery separated from our bedroom and also Marc's workroom completely independent, but still "in" the house. It is finally the perfect solution although the children's rooms and the maid's room are tiny, tiny. We have to do the garden all over. It is completely ruined with all the cement and stuff. But the terrace will be very nice once it is finished.

How is Bernice? When is the wedding? It is a shame your neighborhood is turning bad. Are you afraid? Would you like to move? What does Bernice think? It is so close to where you work, it seems a shame. This situation is unknown in Paris strangely enough. One, because people hardly ever move! And neighborhoods never change character. To the French, the idea of moving because somebody else has moved doesn't sit well with their sense of independence. Well, that's all the news I can think of. I haven't heard from Daddy lately. Marc is going to be in Washington for this big peace march against the war in Vietnam. I hope

it turns out to be extraordinary for everybody's sake. Although it doesn't look like anything short of loss of office (of which I would be delighted) or a bullet will stop Mr. Johnson. We have all been very much involved in a film against the war made in Paris by movie director friends of ours including Bill Klein, which was shown at the New York film festival at Lincoln Center. It was Bill who went to New York to present the film. I hope it gets a general release in the States. If so, go to see it. It is called *Far from Vietnam*. Well, I will be talking to you on the telephone soon...

<div style="text-align: center">

Love and X X X X X X

B

</div>

October 22, 1967

Dearest Mother,

Well finally it came! A beautiful baby boy Alexei Karol (Russian after Karol). And neither of you were there! Saturday the doctor and I thought it was about time to do something. She had said between the 10 of October and 20 and I, of course, had been much sooner and totally wrong. So by the 22, he was two days or so over-due. And it is lucky we did decide to induce labor otherwise I would have had the poor little thing in the street or the movies or the bathroom or God knows where. Remember Alma? Anyway he came in exactly ten minutes and five pains! They just barely had time to get me to the delivery room. Sunday morning at tea they gave me two shots and two pills (I came in Saturday night, had dinner with Vicky) and at 11 I was having vague backache and contractions that I was finally feeling so I was reading a murder mystery. At noon the doctor came in, examined me and decided to puncture a little bit the sac to activate things a little since I was still feeling nothing. And she decided to come back in an hour. Ten minutes later I had two pains, one right after the other no interval at all in between. I called the nurse and midwife and she took one look at me and called for the stretcher. I had one pain on the stretcher (good thing I was only one floor above the operating room) and I had one pain on the table and it was over. I saw this little gray-white thing come out—a boy!!! The whole hospital was astounded. My doctor managed to get back at one o'clock and that's it. Of course I called Marc right away and I already think of him as "little Alexei" because he is so tiny—much smaller than David and more delicate and more Riboud! He has that nose. He is very good, never cries and is totally sweet. Of course I was disappointed about it, it is much better for David certainly to have someone he can really play with, ski with, sail with and do all the same things. Marc of course was disappointed, I could tell from his voice. But he won't be once he sees him. Anyway if he is so set on a girl we can adopt one. It is no sense in taking a chance on having another boy. The Riboud men seem to make only boys—of the 24 children there are 16 boys and 8 girls!!

Anyway, at the moment, he looks just like Grandma! He has her lower lip!! Believe it or not! It is really funny combination. I suppose he will be good-looking, but probably not as good-looking as his brother—but then one can't tell at this date. But is he going to be tall and long—you should see the hands and feet—miles of them.

As far as I'm concerned our family is finished (in size) once the house is in order and running smoothly I will be able to get back to work and with Françoise I will always have a great place to park them! She is coming next weekend, I hope, and Marc should be home by Monday. He said the March on Washington was really something although it seems the press underplayed it. The *NY Times* said 50 thousand people when there were more than 100 thousand, Marc said. He said also he got a little tear gas—but nothing to make him really sick. He has an appointment Thursday to photograph Johnson so he will be back in Washington. He spoke to Joyce while he was there for the march. He is also going to photograph Kennedy and Rockefeller and Galbraith and Gavin. So, he will be busy running around until he leaves. I called Daddy Sunday evening and by luck, got him on the telephone. I think he was more impressed with getting a phone call from Paris than about his second grandson!! I had forgotten that I had never called him from Paris before. Anyway, he said he had gotten calls from New York and New Jersey, but never from Paris! Anyway, he was very pleased that I called and to hear the news, I hope. People have been tramping in and out since Sunday and my room is stuffed with flowers. I'll send you pictures of baby Alexei. I love him...Love him...

October 29, 1967

Dearest Mother,

Well, little Alexei is doing well. He has gained back what he lost from birth to three days and is quite picky. He is so sweet, so small with very fine features. He really does look like he started out to be a girl! David is very sweet with him. He gives the bottle (holds it) and makes the bed (in his own manner) and everyone is bending over backwards to spoil him (in an attempt not to make him feel left out). As a result David is getting more presents than Alexei. Marc seems quite happy, now that he has seen him and I am delighted. I am surrounded by males! But I think of all the things they can do together when they are older—so much more than a girl and a boy can do. We are still in the middle of all kinds of house alterations. But one of these days, it will all be finished I hope. Alexei's room is yellow and white and I made new curtains and spreads for David's room. Also installed a desk and a library and worktable. It really looks like the room of a little boy and not a baby. I guess everybody has the news by now. We will send pictures soon. Françoise is here with her daughter for a short holiday so the house is full

up. Alexei is really so different from David. Well, we will see. David is as beautiful as ever, loves school and does beautiful drawings and constructions. Now, of course he seems enormous beside this little baby (6 ½ pounds). It is so strange; one forgets how small they are when they come out. Well, no more news since you have already talked to Marc. The weather is beginning to turn cold, but we had almost an Indian summer in October. Alexei sends a big kiss.

<div align="center">

XXX

B

</div>

P.S.—I was very impressed with your slides!

P.P.S.—Please send more packages of Evenflow plastic disposable sterilized bottles! The same as before.

November 20, 1967

Dearest Mammy,

Happy Thanksgiving Day! I was so sorry to hear about the deaths of your friends you mentioned. But it can happen at any age. The only thing to do is live each day like it's your last and it may very well be. Things change so quickly and if Johnson keeps up we may all be exterminated anyway. So much for my jolly thoughts for today. How do you like your second grandson? Sweet, isn't he? I think he is going to be even better looking than David. And tough. David is a little softie. Christiane has a terrible time keeping hold of his toys at the park because he lets the other children just come along and take them!! Even girls! He doesn't cry or anything, he just seems completely amazed. So we are trying to get him to understand he has to defend himself and his possessions. I think he will end up having to defend himself against Alexei. He may be small, but oh you kid. I am sure David is going to be this sweet, good-natured, handsome giant and Alexei is going to be this small skinny tough guy, a regular Richard Widmark! I never saw such a strong baby. At three days old he was holding up his head! I swear I never saw anything like it. The doctors either. And you know when they examine the babies they hold them up in the air and they walk on air just as if they could walk. Well you should have seen little Alexei scuffling. You would have thought he had a number 36 bus to catch!! You know that Marc did the peace march. Well, he also went to Moscow for the 50th anniversary celebrations. He says it was fabulous. He was very excited. He is now doing a story on the "Frenchman" for *Look Magazine*. After that, I hope he is going to take a vacation. He is worn out, but this time completely. The terrible thing is that he recovers so fast he thinks he's all rested and he is not. He spent two days in the country at our house last week and he looks like he has had a three-week vacation. Now there is a great

crisis at Magnum and he is back in New York for two days. There is a big interior argument which is too complicated to explain over the diary of Che Guevara, the Cuban guerilla who was killed in Bolivia three weeks ago. Marc is ready to break up Magnum over it. Give my love to Dr. Ramsey when you see him. I am sending you a picture of your Alexei. I am so happy the job is going well, even if it did keep you from Alexei! Keep it up...

<div style="text-align:center">Love,
B</div>

P.S.—Alexei and David got their presents and send you a big kiss.

1968

Sixty-eight was more than the date of a year. It was the symbol of a whole generation, a revolt that swept through the United States, France, and Japan in student revolutions that changed the society of more than those three Western countries alone. It also marked a rise in violence of peaceful protest in general—it was no longer peaceful. There were thousands injured or arrested during the student riots that began in the United States with the National Guard massacre of four students at Kent State and the deaths of three students in Mississippi. Martin Luther King was assassinated, in Memphis, then Robert Kennedy was killed in Washington, and President Johnson committed virtual hari-kari in front of the TV cameras by announcing his intention not to seek reelection because of Vietnam. It was Nixon who would withdraw the first 25,000 troops from Vietnam, as well as initiate the first official visit to China and open up U.S. diplomatic relations with a quarter of the world.

It was the pinnacle of romantic revolution: the Black Panthers in the United States, the Red Brigade in Germany, Miriam Makeba married Stokely Carmichael, LeRoi Jones, Eldridge Cleaver settled in Algiers, Julia Wright was fundraising in Paris, Angela Davis was in jail in the United States, James Baldwin was living in Turkey, at the Pan-African Festival in Algiers which I attended, revolutionaries were lecturing, dancing, singing, playing, reading poetry, listening to Abbey Lincoln, Max Roach, and Nina Simone. Parisian students took to the streets in revolt, almost toppling de Gaulle's government and electrifying the French. That month of May came to be known in Paris and around the world as May '68, as if the month and the year were inseparably turned into legend. The other legend was the one word that stood for uprisings in the States: Watts. The smoldering ruins of Watts with its burned-out cars and destroyed buildings and shops remained an ugly open wound for decades. My father cancelled his trip to France, but as suddenly as it had exploded, the student revolution in France died with the August vacation when France itself closed down for five weeks as it has every year since French workers won annual leave. The students went to the beach, and everything except the rocks they had thrown by digging up the stones in the Latin Quarter's cobblestone streets with their bare hands went back to normal. The quaint cobblestone streets of the quarter were asphalted over.

My mother turned forty-five in January and received tenure from her laboratory. She had turned into a different person. She walked differently. She talked differently with more confidence, more sophistication, and an altogether different vocabulary. She looked different when she came to see us at *La Carelle*. She even smelled different. She had changed her perfume to Miss Dior—it suited her. She had acquired a horde of men friends and had augmented considerably her flock of male suitors. At the same time, her general health seemed to have stabilized after bouts of walking and heart problems that had brought me running to the States several times. To her colleagues, she was a heart-warming miracle, respected and beloved at the medical center. To me, she became my fountain of youth.

She began to write to me about her impressive slate of suitors, each of whom she would describe to me, to which I would reply but without any judgment to which in turn she would not answer. She was picky and choosy, funny and desperate, and I could do nothing to help her. She had a mile-long list of aptitudes and attitudes, physical attributes and character traits, do's and don'ts her next husband had to adhere to. She had added to this list the role of grandfather. Whoever he turned out to be, he had to have all the attributes of a wonderful grandfather. Quite seriously she discussed these qualifications with all of them, some younger than she—and one of them, a favorite, older than Grandpop. Of course, for both of us, the measuring stick *was* Grandpop.

I remembered fondly his mania for buying me new shoes to protect my feet, convinced that every 21 days I had outgrown my present ones, the result being that by the time I was 12, my shoe size was 9 ½ AAA. I wondered if it had had anything to do with his army career and tight boots. Perhaps the "Colored troops," I mused, in World War I had had poor-quality shoes . . . Or maybe it had to do with the feared "trench foot" of the mired trenches of the Somme of World War I.

As Nixon announced the end of the gold standard and Martin Luther King was felled by a rifle bullet in Tennessee, we put a man on the moon and at Philadelphia's Independence Hall gay adolescents demonstrated for their rights. Charles Bronson stated that "of course the Founding Fathers didn't intend to protect perverts and criminals." The Stonewall Inn Riots gave birth to the Gay Pride movement joining the feminist movement of the previous year. Black gays decided it was OK for White gays to sing "We Shall Overcome." The incredible 60s were drawing to an end. When Martin Luther King was assassinated the day after his "I've Been to the Mountain" speech followed by Robert Kennedy's murder, I stopped trying to explain anything to the French or to anyone else.

La Bergerie, 1 January 1968

Dearest Mammy,

Happy happy New Year!!! We miss you and think about you so much. And just
think, it is the first New Year for Alexei. But you didn't say anything about him!
Isn't he pretty? I think he is even prettier than David. Well, to think my fam-
ily is complete. We are spending Christmas and New Year's with Françoise at
"La Bergerie." It is very beautiful. For the last three days we have had snow, so the
children are overjoyed. They have been sleighing and we made a special party for
them yesterday. Françoise's house is so lovely and gay and David loves it here. He
has his own special people that take care of him, his own bed…I was happy Marc
could get a good rest. Things are hectic as usual. But at least his new office will be
finished in a week or so. So he can move in and organize himself. I am anxious to
get back to work. There are no big trips in the planning for the moment, although
Marc may go to Cambodia. I was planning to go with him, but now there is
another possibility of a movie job in Singapore in six months and I would much
rather do that. At least I am keeping my fingers crossed. I just might take the
whole family if it works out and find a wonderful "hù shì" (Chinese nurse) for
the children. Otherwise nothing is new—Jeannine and Bill are hard at work on
another film. Vicky is back in New York, but she went to California for the holi-
days. I miss her terribly. Tamara is fine and so is her darling baby girl. It is terrible
how human beings are able to adjust their lives to changes no matter how sad or
important. I just hope that Vicky will manage alright in New York. I have the feel-
ing she will be back. I don't think after all these years, she can live in America. As
for me, I am more and more disgusted with the whole mess. Marc and I feel very
strongly about the Vietnam War and all its implications. Even more depressing (if
that is possible) is the state of American politics. When I think that all America
has to choose between is Johnson and Nixon or Johnson and Reagan or Johnson
and Rockefeller, I could throw up. Bill Klein and some other friends of ours have
made a tremendous film against the war in Vietnam called *Far from Vietnam.* It
is now showing in Paris and probably will be shown in New York, but nowhere
else in the US. When it was shown at Lincoln Center at a film festival it got an
ovation of twenty minutes. The critics, of course, were ferocious. But that doesn't
mean anything. Tell me how the work is going—you are in a different department
now? What are you doing? Is it very difficult? How is "mighty mouse" these days?
Has she calmed down a bit? And what about Bernice? Is she still getting married?
And how is Clarence? You haven't mentioned him in your last letters! He had his
women so planified. All I can say is he certainly has a lot of energy!

I hope you didn't mind that we didn't send a gift. I thought you would rather
buy something yourself when you come and with the customs being so strict.
Anyway, we haven't forgotten your birthday. Write soon and let me know how

you are. We think of you all the time and wish you were with us. It seems so wonderful that you have kept (relatively) your health this year and that you have a work that you like and that is important. Let's just hope that it will be the same in '68. Alexei sends you the biggest kiss and David too. And of course Marc. We are expecting you this summer in the country. Just think Alexei will be walking!! Imagine. The time passes so quickly. In a month David will be four years old!

For Christmas we bought an electric car for David from you so don't worry about his present.

IMPORTANT—Can you send 12 boxes of Evenflow plastic sacks (like the last time) for the baby? You know there are only 65 in a box and with five bottles a day they don't last very long…If I run out, I am really in a pickle—Thank you.

<div style="text-align:center">

XXXXX

B

</div>

P.S.—we return to Paris today.

Sunday, January 7th

Dearest Mammy:

It was in Washington, DC, and not in Russia that Marc took the photo of the girl with the flower!

We had a wonderful time at La Bergerie. There are other photos on the way but these are the only ones that would fit into the envelope. Everything's fine, if a bit unorganized. Haven't had my "depression" yet, but it's coming! As soon as I have time for it. David has the mumps! But it seems to be a rather mild case—little fever, but great big fat cheeks. I hope he will be well enough to go skiing with Françoise on the 15th. I'm trying to persuade Marc to go too. It would do him so much good.

<div style="text-align:center">

XX Love, I will write soon.

B

</div>

P.S.—Alexei weighs almost 12 pounds! David got a garage with lights and an elevator, a car that runs on batteries and airplane that runs on batteries, and lots and lots of books and puzzles. Marc bought me a kind of 1900s toy movie which was for all three of us—David, Alexei, and I with a music box. David of course was with Caterina and two other little boys also mixed: Congolese, Greek and Swedish and Danish! You have never seen such a combination—skin like David's only with gray eyes and blond hair!

We had a wonderful time. I bought Marc a new wallet, a woolen shirt and a turtle-neck sweater since he never buys himself anything. I gave Françoise one of those oversized watches.

Paris, January 23, 1968

Dear Mother,

This is your Happy Birthday letter. Marc will be in New York about the 14th of February and will bring your present. I am afraid to send it through the mail. He will be going from New York to Cambodia and I may join him there. Everything here is fine. So far I don't have the mumps, but I will have to wait until tomorrow. Alexei is getting prettier and prettier. Everyone says he is prettier than David as a baby, but I don't remember. David is in the mountains skiing with Françoise and having a ball. Marc spent a few days in the snow in Grenoble, but it was work not ski. I do wish he would get back at it. It would do him good. Of course we are hoping and expecting you in the summer. I think the boat trip would be wonderful. Except that it should be a French boat. They are the best with the best food. It would be a wonderful rest and you would gain weight. We can decide in June after you finish your course, but you should make your reservation now. Or tell me the approximate date and I can make a reservation from here, which might be the best, especially if the Americans decide to put a travel tax on tourists. It is so stupid and discriminatory if they do. It certainly won't stop any rich people from going, but it may make the difference between going or not going for a student or a poor tourist who can just scrape up enough money to come. The house in the country will have three new rooms and another bath by spring, so I will install you for as long as you like. Vicky writes me regularly and seems to be perking up a little. You can't say that she doesn't lead an interesting life. She is as bad as you are.

Well, Mammy, what does a middle-aged daughter say to her young forty-five-year-old mother on her birthday? That I am full of admiration and love for you as is your extraordinary son-in-law. We wish you many, many more birthdays and lots of great-grandchildren! We can't wish you any more grandchildren 'cause we are through. So you will have to depend on David and Alexei. I must say also I hope I look like you at forty-five! One of my many former admirers just told me last week I hadn't changed one microscopic inch in seven years. Which isn't exactly correct since I have gained permanently two or three pounds and as of now have two or three extra on top of that! Anyway, he predicted that I would stay exactly the same until I was fifty-seven and then crack into little pieces! I told him he should see my mother and he would recalculate that by about ten years! So that gives us sixteen more good years. I think really it is the new job, and new house (although it is not so new anymore) and the knowledge that you can stand on your own two feet and do a job well. Vicky is complaining about starting over again at thirty-one. But you did it at forty-five! It seems so young now to me and it seems such a short time ago. Well so much for the arithmetic which really isn't important, I guess. The important thing is that you are working and well and

coming to see us this summer. So again, Happy, happy birthday and many many more. I wish I could be with you to celebrate … but I frankly, aside from the fare, I have so little desire to return to America. I know I shall have to for my work and of course to see you, but I really have little or no feeling about America, except at the moment a great disgust and a great fear of what is going to happen to it and what it is going to do to other people.

Did I tell you that David has won his first Art prize? A coloring contest in Paris run by an art gallery. He won a "prix d'honneur" in his age group (three-six year olds). Isn't that something? He was so excited when he went to pick up his prize (books, an automobile poster, a huge box of crayons and a deck of playing cards). So between his artistic life and his social life and his athletic life, I will really be kept stepping. I just hope Alexei doesn't decide to be a musician on top of everything else. David is still crazy about cars and building houses. He really builds the most extraordinary complex buildings and things. He has two different kinds of building sets that you can add to. Thank goodness now he has enough room to spread out a bit.

We have had friends staying in our house in the country all winter. We will probably go down next weekend. Also we are planting some new trees and we will plant one in honor of your birthday. It will be a big spruce tree already twelve feet high. How about that? And we'll call it "Vivian Mae" or better still, "mammy." And we'll plant one for Alexei at the same time, a baby pine. We planted one for David in the garden in Paris.

I just got in the mail two of Martin Luther King's posters "Black Is Beautiful" and "It Is Beautiful to Be Black" made for his SCLC Foundation. I think Marc ordered them while he was in New York last time.

Well, no other news. I am taking the pill. I started a little over two weeks ago. I will see how it goes and if I don't gain any weight. I must say, it is very convenient so far. One wonders how one ever could have put up with that diaphragm. But if I am going to look like Aunt Jemima, then forget it. They are a German make and don't have estrogen in them (which is what you take, no?) and I think it is that that makes one put on weight. But also one has slight pre-menstrual tension, but permanently which I can see would make women eat more. For me, it has the opposite effect, I eat less.

For the hundredth time, Happy Birthday and Long Life as the Chinese say.

XXXX

B, David, Alexei, Marc

P.S.—Alexei was born the day I called you! October 22nd!! Did you get the letter with all the stamps in it??

Happy Valentine's Day, '68

Dear Mammy,

How are you? Marc will be arriving Monday or Tuesday in New York and will call you. I am still waiting to hear your plans about this summer. Also hoping to hear from you period. Everything here is fine. The boys are growing and very sweet. Did you get all the pictures? Next week is David's birthday and I am taking him and Peter (the little boy of Jeannine) to the circus. Other than Marc's trip and the fact that the studio is finally finished, I have no news. I expect to be working while Marc is away. There is a possibility of coming to the States in June–July by a special chartered trip, but I think it would be much more interesting for you to come here the beginning of June for the whole summer. I might be able to arrange the same deal in September–October, which would be better all around. Haven't heard from Daddy at all. We sent him a Christmas present, but didn't know if he received it or not. We have been giving lots of dinner parties and going to lots of dinner parties. It is always like that when Marc decides to go off for a trip. Julia is here trying to organize a meeting and a fundraising demonstration in Paris. The daughter of Richard Wright contacted me to try and get in touch with James Baldwin who is in London at the moment. This I did do and Bill gave his film on Cassius Clay, but so far there is still a problem of speakers. Nobody here (who is French) is really an expert on the subject and very few people would be able to fill a huge hall. Anyway, I think they have decided to combine it with the Vietnam question, which is very relevant and also very "hot" with the French public. Emotions here are very high about it and with good reason. Last night we spoke to a French friend of ours who had just returned from a tour of the U.S. and was very pessimistic, not just about the war, but about just everything except the students who seem to be at last waking up. He gave a dinner party for the editor of *Newsweek* when he arrived in Paris (they are good friends of ours from the last trip in New York) and of course all the discussion was about Vietnam. It was very difficult to keep the conversation on a civilized level. Although he is even considered very left and very liberal. Anyway, it is all very frightening and very sad. His idea of being an American let alone living in America gives me a chill.

Françoise just spent four days with us before going to ski with her daughter at Antoine's place in the mountains. She is marvelous as ever. She has broken off finally after years and years with the Italian father of Caterina. I hope it leads to more freedom for Françoise to find another lover. I really don't think she wants a husband. She has seen too many bad ones. Certainly to be badly married is worse than not being married at all. What about Bernice? What is she up to? Please write and tell me what the situation is for this summer. I intend not to move until next September. It is very doubtful that I will join Marc since it would be

the beginning of the hot season and not very comfortable. Of course, this could change. But anyway, we will see.

28 February 1968

Dearest Mother,

I am afraid you have ANOTHER fur hat. Is it true? Because you can give it back and I will buy you something else. Anyway, I am enclosing the label. Marc was delighted to see you. He thought you looked great. He mentioned that Clarence was there. Did he buy you a mink hat too? Give him a big kiss for me. Why oh why don't you two live together? What's this thing about not wanting to? You know it doesn't make any difference to anybody except you two and this is the twentieth century. Mother, NOBODY CARES what you do with your life. We just want you to be happy and comfortable and not lonely. What do we care if you are married or not? There are so many badly married people in the world, I should think one less would be quite alright. What is this sense of sin? Surely you can't believe all that nonsense from your convent days? If you believe in God, fine! But surely you must realize that organized religion was and is a social, political and economic structure usually destined to support the status quo and keep people in the places that the ruling classes have decided they must stay. This is the entire history of the Catholic Church. War? They put "Holy" in front of it and it became alright. Slavery? They found a way of condoning it and had the Bible to back them up. Sin? They didn't have enough of it so they invented "original" to put in front of that. Just live your life the way you want. You are one of the best people I know. And if there is a God, he knows it as well. So much for my sermon. Were you happy to see Marc? He is formidable. I just love him. It is terrific. Harold hasn't changed a bit except I keep forgetting how big he is. Try to get in touch with him. Will he be working in the same building as you? *The Heat of the Night* is opening Friday here. David went to the circus for his birthday and tomorrow goes to a costume party for Peter, the little boy of Jeannine and Bill. He has the sweetest costume. I will send you pictures. Alexei is the sweetest baby ever. He is really a doll. And I certainly intend for them to grow up to be "Frenchmen." Mother dear you must not believe everything you read in *LOOK Magazine*. Especially if you knew what a stupid and boring fool the man who wrote the article is. I know only too well. Anyway, there are certainly a lot of things that could be improved in France, but Frenchmen aren't one of them. There is an enormous and silly campaign against the French in the US these days mostly because the French insist on doing exactly what they like when they like whether the Americans like it or not. They also are against the Vietnam War and say so in no uncertain terms. Nobody is against the Americans as such, they don't want Americans telling them what to do and how to do it and they don't want American money

to dominate their economy or their politics. Somebody has to tell the Americans that they are wrong except the communists and at least France has enough influence to upset them. England now is too weak. It is just a yes-man to Johnson. And Johnson has far too many yes-men around for the world's good. The United States has become a very unhappy place.

Well, nothing else is interesting. Françoise and I are going to the theater Saturday to see a friend of ours. I am working a little. Françoise's whole school is sick with the flu. Can you imagine twenty boys sick in bed? There has been a real epidemic, but so far nobody in the family has caught it. I am keeping my fingers crossed. Well, that's all the news I can think of. Marc told me you had decided to wait until Christmas to come. Is it true? Then I will come to the States now with Alexei!…love and kisses from all the family. We miss you.

<p style="text-align:center">XXXXXXXXXXX</p>

March 7, 1968

Dearest Mother,

I was so happy that you liked the hat. And I was so happy you looked so well. I was delighted to see you and Clarence. Nothing new here except it is very cold. I am going to write her. Well, ready or not, here comes old age. What a depressing thought. Just when I got back my 18-year-old shape. Anyway, Marc is now in Hong Kong and the children are well and happy. Françoise spent the weekend with me and we went to see a friend of ours in a play or did I mention it to you? Very pleasant. I am sorry you are not coming over sooner, but I think you are right. I will come in September, but not with the babies. Daddy may come this summer, but it is not sure. Things are looking so bad in the States, I wonder if you won't be coming as refugees!!! This new report by the government commission to investigate the summer riots certainly spelled it out. And if they don't do something then it is their own fault if the whole place blows sky high. I saw *In the Heat of the Night*. Very good. *Guess Who* is coming, it starts in a few weeks in Paris. I am working a little and getting myself in shape a lot. Haven't gotten any new clothes, just a few blouses and sweaters, but I had some things re-cut by a Spanish lady…Very well done. Did I leave by any chance a purple pleated skirt? I can't find it and I wonder if I left it with you by any chance? Also I haven't gotten the plastic fillers yet, but I hope they are on their way. Alexei is eating us out of the house and home. Not to mention David.

I am so proud and happy over the progress you are making at your job, I can't tell you. I think you are the seventh wonder of the world. And I thought you looked great. How do you do it Maman? I look at you and I still have faith! David talks all the time about Daddy and Mummy (you) and whenever there are grandparents in his storybooks I always color them brown! They aren't authentic

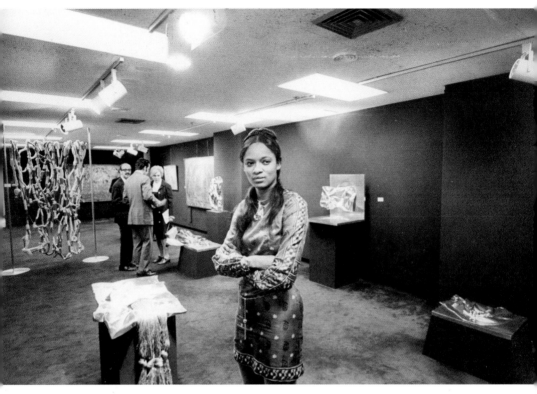

43. Author with sculptures (left to right): *Sheila*, *Malcolm X #1*, *White Emperor City*, and *Black Light* at the exhibition "7 Américains de Paris" at Galerie Air France in New York City, April–May 1969.

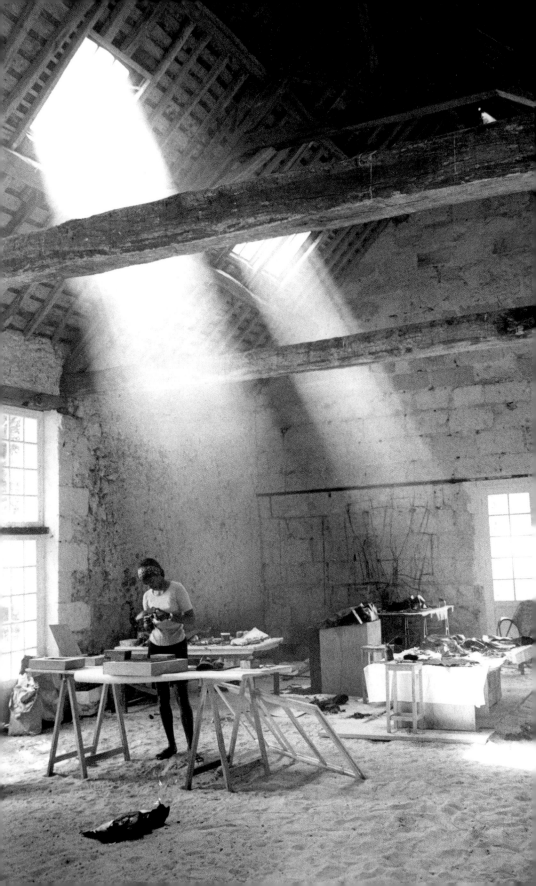

(facing) 44. Author at her atelier in La Chenillère, 1969.

45. Max Ernst and André Breton, 1962.

46. Author and *Bathers*, La Chenillère, 1969.

47. Author and sculpture *Malcolm X #3*, 1969.

48. Eldridge Cleaver and wife, Kathleen, 1969.

49. Author with English sculptor Kenneth Armitage at her exhibition "Four Monuments to Malcolm X," 1970.

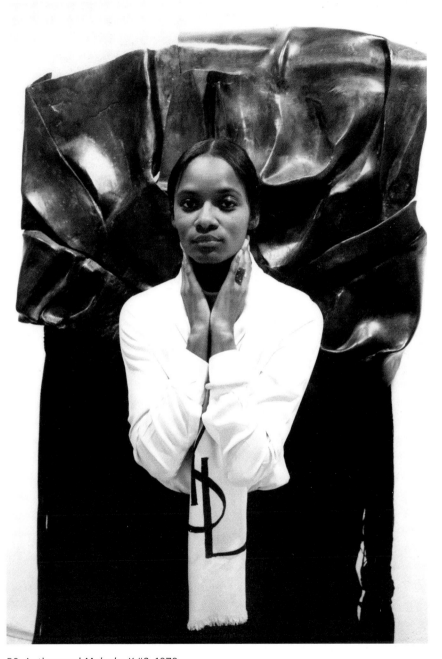

50. Author and *Malcolm X #2*, 1970.

51. Françoise and Caterina Riboud, 1970s.

52. Sergio Tosi, Julie Man Ray, and Man Ray, 1970s.

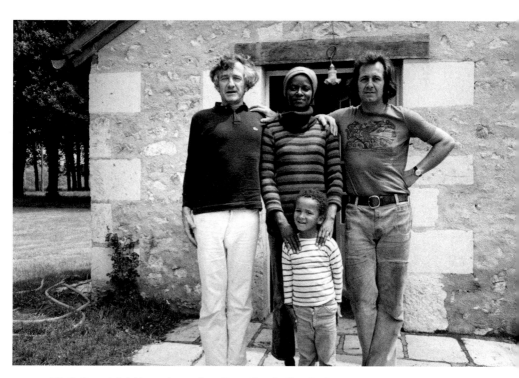

53. (left to right) Marc, the author, Rene Burri, Alexei, 1971.

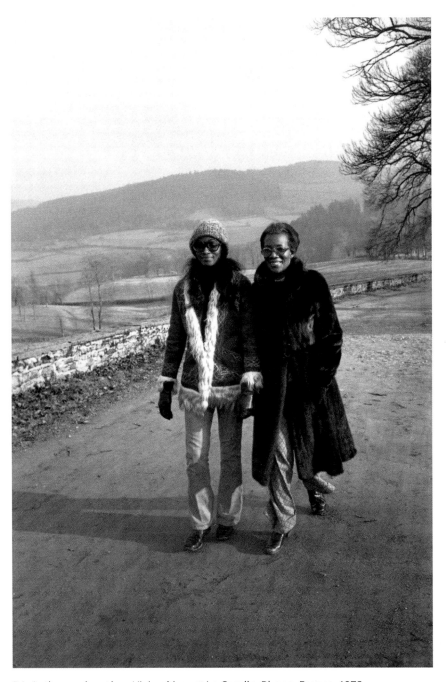

54. Author and mother, Vivian Mae, at La Carelle, Rhone, France, 1972.

55. Author working on *Confessions for Myself*, 1972.

56 (right) and 57 (below).
Author in her atelier
at Rue Dutot, 1973.

58. Portrait of Betty Parsons, 1962.

59. Author with Nicole Salinger, 1973.

60. Author with Alexander Calder at Calder's residence in Saché, France, 1973.

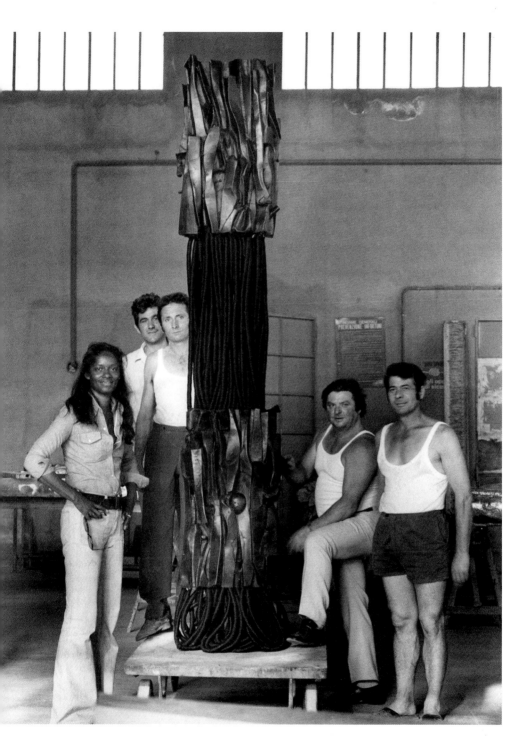

61. *Black Tower*, the author with the Bonvicini brothers in Verona, Italy, 1973.

62. Author's portrait, 1972.

63. Author with Jacqueline Kennedy
Onassis, *Women's Wear Daily*, April 7, 1978.

64. Giovanni Tosi, author's father-in-
law, Ethiopia, 1936.

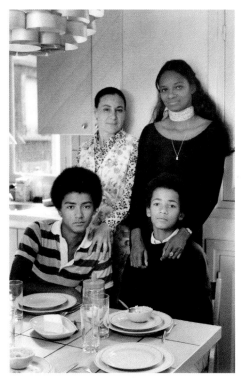

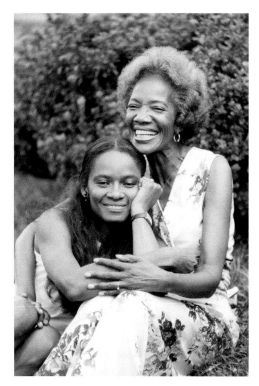

65. Author and sons with nanny Maurie, 1979.

66. Author and mother, Vivian Mae, 1979.

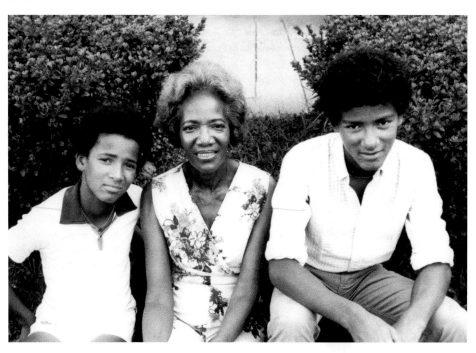

67. Vivian Mae and grandsons, David and Alexei, 1979.

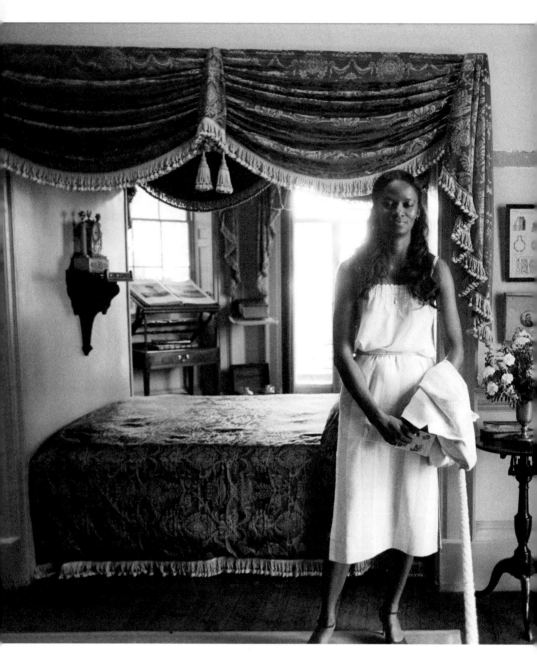
68. Author at Jefferson's bedroom, Monticello, 1979.

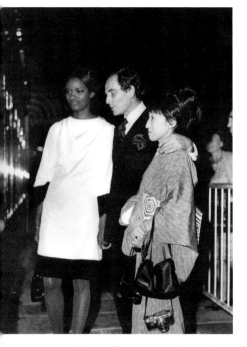

69. Author with Pierre Cardin and Yoshi Takata, 1981.

70. Author's sons David and Alexei in Rue Auguste Comte, Paris residence, 1984.

71. Author's atelier in Rue des Plantes, Paris, 1981.

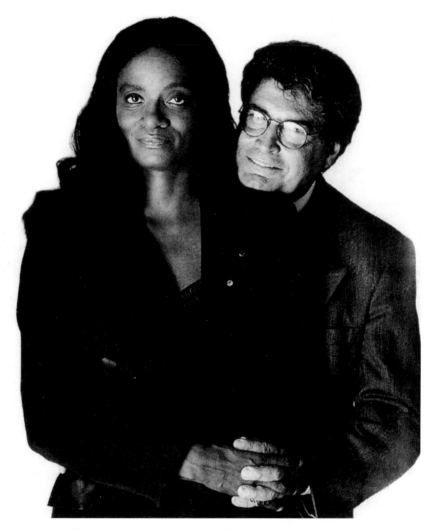

72. Author and husband Sergio Tosi, portrait for French *Vogue*, February 1996.

if they are not brown and if Daddy isn't sitting in a car!! I never saw anybody so extraordinarily happy to be Black as David. He thinks it is the greatest thing. His only regret is the "poor papa is White." So much for race relations. David adores Alexei and it looks like it is going to be very vice versa. Alexei is fascinated with David and lets him do anything he likes with him, although David is very gentle with him. He especially likes when David sings to him or anybody sings to him for that matter. And he likes the red cooking pots in the kitchen and he likes his food... He also (like his father and his grandfather) loves to go in the street. Now he looks very much like David did as a baby. I looked at old baby pictures of David and it could be Alexei. You can't say we are not consistent. And they are exactly the same color too. Which is a very good thing, I think. I have a friend who has two boys by a Danish national and one is the color of David with gray eyes and blond hair... fantastic and the other is perfectly White with very fair skin, blue eyes and blond hair. So one can't understand why he is "Black" and his brother is "White" and no amount of explaining can satisfy what he can SEE with his own eyes... They are hellcats, the two of them but David adores them especially the older one. They went skiing together this winter with Françoise and will probably go together every winter from now on. Next year David will really be able to make progress. He is still a little too young this year. Marc is talking about going skiing for a week or two when he comes back.

March [no date] 1968

Dear Mother,

URGENT: You must order some boxes of plastic bottles for Alexei. I got the two you sent but you realize that each box contains only 65 bottles enough for about two weeks... then I am stuck again. The Playtex ones are no good because they are too small. Also got your last letter. I am so happy to know that everything is going well. You have some very sweet pictures of Alexei and David on the way. They are being printed now and I will send them to you as soon as they come back. Everyone here is fine and Alexei is just adorable. He is going to be a little hellcat. He is so strong, he should be sitting up any moment now. He turns over by himself and does all sorts of gymnastics that are so funny. On his stomach he crosses his legs behind him and advances by rocking from side to side on his tummy. Now he has the habit of grabbing the spoon with which you are feeding him and shoving it into his mouth!! He loves his little chair that we have for him to carry him around in. That way he can be with David in his room while David is playing or he can come down in the kitchen. He weighs SEVENTEEN AND A HALF POUNDS stripped as they say and is thirty-three inches long. The size of an eight-month-old baby... at four months. I do hope he stops at six feet three... The latest news from Marc is that he is in Hong Kong and very happy

with his trip to Tokyo. I will write him to send you some cards and some stamps. He says Tokyo is fabulous and if everything goes well, including an exhibition of his China photos we will go there together in September. He had the funniest stories to tell about Japan. He said he was met at the airport by three bowing Japanese, one of whom he had met ten years ago, but had completely forgotten, who greeted him with "Please forgive me for this long absence"…He said he stayed with a Japanese friend photographer and lived Japanese style while he was there which means among other things sleeping on the floor. He was very stiff, but then those communal hot baths help, not to mention nice massage from a geisha. I am working hard and back to my pre-twenty-year-old shape. Marc will be very happy. It is still very cold here and absolutely no signs of spring what-soever. If you get a chance, send me the pocketbook edition of the report of the commission on last year's race riots: it is called exactly *The President's Commission Report on Civil Disorders* and is published by Bantam Books. You should be able to get it around Temple or the Lab. There is a special mailing rate airmail for books. Well, that's all the news. Give Clarence a kiss for me. I am very pessimistic about the political situation in the States and of course the war. People seem to be paralyzed and unable to do anything. Let's hope that McCarthy shakes up the administration. It would be too much to ask for Johnson to be kicked out and God help us if he was kicked out and Nixon was kicked in. I think it is too late for either Robert Kennedy or Rockefeller to do much. The terrible thing is if Nixon promises to negotiate the war's end, after the good showing of McCarthy in New Hampshire, he could just win and Civil Rights would be set back for twenty years. His reaction to the Riot Report was to blame everything on Stokely…It is very sad. Bill's film is a satire on America with the race riots and all kinds of things going on. There is a Mr. Freedom (that is the name of the film) who is a little like Mr. Clean or what is the other white knight that comes charging on in a soap commercial? The white tornado or something? Well this Mr. Freedom is just about the same. The film is in color and is very "pop."

Love and kisses from all of us.…

The First Day of Spring, 1968

Dearest Mother,

Happy, happy springtime. Here is a little springtime present…

Everything here is fine and as you can see the children are just one big bundle of joy or should I say joys. I hope everything is going well at work and that Alexei's bottles are on the way. He is a very hungry baby. At least he has "soul." When I put on an Otis Redding record, Alexei wails!!! Much crossing of feet and waving of hands and he laughs too!! Or else he gets this "stoned" expression on his face that he could only have found in some South Philadelphia wino dive at

three o'clock on a Sunday morning!! God knows I've never been in a dive like that and David's sense of rhythm comes from Lyon...So I am beginning to believe in Black Power.

Other than that, nothing new. I am working, am very slim and am going back to dance class. I am also busy getting the two gardens in shape. I think I have found somebody to come once a week to do the one in Paris. I have a commission to do a sculpture for a New York townhouse for a woman who saw the two sculptures at Cardin's. She turned out to be very sympathetic and I like her very much. She is more or less along the Jacqueline Kennedy line (her name is Jacqueline) and as intelligent. We'll see how it works out.

Say hello to Clarence and Bernice and Doris. I wrote her a little note. And take care of yourself. I will probably see you in the States before you see me here if Marc's show works out in Tokyo. Also I have all kinds of special rates now to get to New York. It is fantastic. So I will definitely see you in September. I might even bring Alexei if I can find a way.

<div align="center">

Love,

B

</div>

Easter Monday, '68

Dearest mother,

Nothing new. Everything is fine here. Alexei is almost sitting up! And he laughs. One of those horse-laughs like David. I wonder where they ever got it from. Did you go to Baltimore for Easter? I hope so. How is everybody? I hope you sent my love and regards. Haven't heard a word from Daddy. I suppose he is still coming over this fall, but I have no idea when. France took the death of Martin Luther King very hard. There were memorial services, etc. The whole thing is just too disgusting. The most disgusting of all is everyone falling over one another to go to the funeral. Scared shitless and with good reason. It is going to be a horrible summer. Did much happen in Phila? Did you get the Easter Cards? It has been beautiful weather here. The weekend has been marvelous. I am going down to the country Thursday or Wednesday to see how things are.

Marc is in Laos and from there he is going to Cambodia. He should be home in about two or three weeks, I hope! Meanwhile I am working. We may take another trip East in the fall to Tokyo. If so, we will pass through New York. I hope so anyway. Give my love to everybody and kiss yourself for me.

<div align="center">

Love,

B

</div>

Saturday, April 11th, '68

Dearest Mother,

I hope everything is well. Here are the pictures of Alexei. He is even fatter now. And very pretty. Can you send me again the names and addresses of your two supervisors at the hospital? I will be sure and send them cards. Marc should be home in a few days. After staying a few days in Paris, we will go down South on vacation to St. Tropez and the Cannes Film Festival. It will be very warm, and since I have never been to the coast, it should be a nice trip. Besides the Vietnam negotiations, there are huge student riots in Paris. Last night there were 30,000 students demonstrating in the streets around the university. Makes the demonstrations at Columbia look like a picnic. So, there is lots of excitement here. Marc is going to be sorry he missed it.

As for your stamps, do you remember all the big French ones I sent you? Well, they are all in the "portrait series" you mentioned. They are not all really portraits, but paintings, and I think I sent you just about the whole series. I enclose a new one which has just come out. Look through your stamps and see how many big ones you have and let me know. I put them on the envelope, because they are more valuable when they have the postmark on them. If I have missed any, I will send them to you.

Nothing else new. I am fine. I hope to get down to the country this week to plant a few things for the summer. I just spoke to Françoise over the telephone. She sends her love. Did you ever get our Easter Cards? And remember, you will get a card for French Mother's Day. You are no longer an American mother!! Also, did Dr. Ramsey ever get my letter? Thank you so much, I got the Riot Commission book. Also David and Alexei got their Easter things, very late. I don't know what happened. Anyway, everything arrived finally.

You should really be honored, you are getting a special drawing from David just made especially for you. He has all your cards and letters in a little box and the letters from his father in a little copy book. Marc wrote him a wonderful letter from Cambodia with drawings. All about how the Easter egg David sent him for Easter made the long trip and finally arrived at his hotel in Phnom Penh.

Well, love and kisses,
B, David and Alexei

Thursday, April 25, 1968

Dearest Mother,

I got all your letters. Of course I sent Easter Cards, and a card to Clarence. I hope you finally got them. I suppose you did if you got Françoise's. I mailed mine the

day before! Also I wrote a long letter to Dr. Ramsey the same time I wrote you with the pictures of the babies and I sent him a picture. Didn't he get it? This morning I got your Easter package. David was out of his mind with joy. And I was very happy to have the book and the bottles. I really do wish you could see the babies. I am trying to figure out something. There is a charter plane that I might be able to get you on, but you would have to stay so long. Also I will surely be in the States in September–October but without the babies. You have no idea, Françoise is like a second mother to David. Her house is, for him, like going to our house in the country, it's all home, he makes no distinctions. So don't start getting complexes about my leaving him. When I go, he still has two Mamans: Françoise and Christiane. Alexei is going to sit up any day now. He is fine and beautiful. I am determined you will see him soon. Marc is well, but a little tired by now. He is in Cambodia for about two weeks and then he will be coming home. He wrote an article, very beautiful on Hue, the Vietnamese city, which made a sensation in the French press. I hope it will be published in America, I will let you know if it is. Or in London. Got a letter from Daddy with still no dates. He hasn't even made his reservations yet! So I don't know what he is up to. At any rate, we will be here all summer, so it doesn't matter. I am so glad Doris is better. I got a card from Aunt Gertrude.

Please, Maman, don't believe everything you read in the newspapers! The US is not going to break off diplomatic relations with France. Where do you hear these things? France has taken a very just position against the war in Vietnam and against the monetary policies of the US. That is the reason everyone is so mad. France happens to be right on both counts and the Americans don't like to be told that they are wrong. Everybody that says the US is wrong is an "extrem-ist" or an "anti-American." France is neither. America likes to think of themselves as having a "free press," but in effect, the press in America is very slanted and very manipulated. You simply don't get all the story on many things. So don't worry. Neither am I living in a "communist country," nor am I going to be shut up behind an "iron curtain" neither is the US going to severe relations with France, nor is De Gaulle some kind of monster, nor do the French dislike America, nor are the French trying to ruin America. On the contrary we are trying to SAVE it. It is all nonsense.

The Supreme Court has decided that all travel bans are illegal. Even my trip to China is no longer illegal. So there. You will always be able to see me and Marc and the children. You really shouldn't waste time worrying about such things. I don't really need much for this spring. I do need a couple of silk jersey dresses for travel. I could send you the material and you could make them up. Just straight with long sleeves. I wear my dresses very short. Sort of demi-micro length. It is fun and Marc likes it. So does every other man. My legs seem to have improved with age! So has my figure, for that matter. I am a very sexy girl. But the very short dresses I like with long sleeves. I have several like that. Vicky is still

in New York. Tamara also for the moment. Her father was ill, but is better now, so she went to see him. He is very old, 80, or something like that. I told her to try to call you, but she may not have time. Vicky has found an apartment and seems to be into the routine of work, men and more work and more men. She thinks they are pretty hopeless, but she certainly has enough of them.

<div style="text-align:center">

Love, love,

B

</div>

You have to sign the check on the back under your name before you put it in the bank.

P.S.—Hope you stayed home on Tuesday the day of the strike.

Tuesday, 30th April

Dearest Mother,

Congratulations! It is wonderful news about your acceptance on the staff. I am so proud of you. I wrote Marc today, telling him the good news. I hope you got my last letter. I will send you a present as soon as Marc gets back. I have spent all my allowance on flowers for the garden! I will also send cards to your two friends at the hospital. I thought I would have heard from Daddy by now, he is supposed to be coming this summer and he hasn't made any reservations or anything. I found through Tamara a kind of international club which has charter flights which are half the price of even the 21-day trip and I wrote him that I had to have an answer by cable at once as the seats aren't going to last forever. No answer. They are going to end up paying the full price at the height of the season. If I don't get an answer tomorrow, I am going to cable.

Don't know my measurements in English anymore and I don't have birthdays anymore either, but I would be delighted if you would make me something. I will send the material and you can make it. Or maybe the material is cheaper there. The thing I need, as I told you in my last letter are silk jersey dresses that don't wrinkle for traveling and are washable. A black, a white, and a beige.

Nothing at all new. The babies are fine. I will send some new pictures soon. I think I have found an English-speaking school not far from here where I can send David. I hope it works out. Alexei is almost sitting up, is getting teeth, weighs a ton, talks a lot and is the image of David except that he doesn't have dimples. Yes, he does, but they are tiny, tiny ones just at each corner of the mouth... funny. This is about the time I sent you pictures of David in those yellow shoes. Do you remember? I will do the same with Alexei. This affluent baby has three pairs: yellow, blue and white. I went to a Black Power rally in Paris last night with James Farmer. Great. He was very well received here by at least a thousand people mostly students and young people. Did you call Dr. Ramsey to see if he got

my letter and pictures? My love to all. Especially Clarence and Bernice. We will be in the country for the summer. We are doing two new rooms for the babies and my studio. I hope to go down in June and stay until September. In October–November we will probably be through the States on our way to the Far East. And when Marc gets back this time, we will probably take a short vacation in the South near St. Tropez, stopping in the country and at Françoise's for a weekend. Marc wrote the funniest letter to David, all about the Easter egg David sent him (paper) to Laos. David was out of his mind with joy. Well I must run to mail my letter to Marc, so I close so I can mail yours at the same time.

Love, love, I miss you.

P.S.—I haven't forgotten about stamps. But the series seems to be sold out—I'll check.

May 68 [no date]

Dearest Mother,

Happy, happy Mother's Day, French style. I hope everything is well since we saw you. Did you get the other pictures of Alexei? There is great excitement here because of the student strikes. Like at Berkeley and Columbia the students are revolting against the university and against the government, since the Sorbonne is state owned and run. It is true, they have a lot to revolt against, the Sorbonne is hopelessly overcrowded and outdated, understaffed, and rigid. Its examinations are a terror, but it is the only route open to power in France and although the quality of education is fantastically high, the percentage of students and the percentage of working-class students is disgracefully low. Actually, the strikes didn't begin in Paris, but in Nantes, a suburb of Paris and spread to the Paris University. Now the workers are going on sympathy strikes all over the place and if you don't get this letter quickly, it is because the postal workers are on strike as well. It is going to be as long and hot a season of strikes and revolts as the U.S. "Our" US ambassador, Shriver, the brother-in-law of Kennedy invited us to the residence. He is of course, very Kennedy with that Boston accent, but he is very charming, funny and very good-looking. Afterwards we had dinner with a woman who is in the cultural section of the embassy, Mrs. Butcher, who is a Negro, but very light like grandmother. She reminded me of grandmother as a matter of fact. I am going to introduce Daddy to her when he comes. She has taken a great liking to me and is leaving for the States soon, to retire. She made some great Creole dishes and everybody was happy and stuffed.

We have been following the student marches for the past two days with Marc photographing the clashes with the police that goes with the same tear gas they use everywhere in the world. Get *Newsweek* this weekend and read all about it. We know all of the photographers . . .

Alexei is a little terror and so funny. He is going to be much less calm than David, I am afraid. He is already getting into all kinds of trouble and he can't even crawl yet!

<div style="text-align:center">Love,</div>
<div style="text-align:center">B</div>

Tuesday, May 30, 1968

Dearest Mother,

I hope you haven't been too "affolée" as they say in French, that is, you haven't been going out of your mind, worrying about us. Everything is OK. Life went on just as before in Paris except that it was like living in a small provincial town in the Middle West. Nobody went anywhere and nobody came.... There was no mail, you couldn't telephone outside of Paris, there was no metro, or buses, or taxis, or gas for the cars. Some people hoarded a little, but nothing to write home about and the stores were full. Everybody walked and there was a feeling of holiday since nobody was working. The schools were closed. You could have wired or telephoned me, but I couldn't write, wire or telephone. I suppose you got the letter I sent in the package that went to the New York Office via Switzerland. It was just before everything broke, so of course nobody had the least idea that anything at all was going to happen. I imagine that the American press had a ball with De Gaulle. I was worried that all the exaggeration would get you worried, but there was a time where we did think a real revolution was going to take place: the first modern revolution. Neither the workers nor the students were "starving masses" as they say, they are not on the barricades because they were hungry. They were revolting against a technological society where there is no room for the human being, a vast impersonal world even in the universities where the individual feels swallowed up in a big machine. Just like the young people don't want to be fed into a war machine to kill and fight people in a war they never made and don't want, but was made by an aging, stupid war machine. The workers don't want to be fed into the machine of vast technology of the factory machine like so many cattle. Everywhere people are protesting against bigness, impersonality, bureaucracy, technology that are the overwhelming characteristics of the modern age. And nobody can protest like the French. Also here, the situation is much more clear because the society is much more rigid and the lines more clearly drawn. Also police brutality and the silence of De Gaulle made the situation much worse than it would have been. But the same thing is happening in the States, in England, in Germany, in all the eastern European countries, in China, all over the place and for the same reasons. The Sorbonne has one big hangover, as does all of France. I think the students are relieved not to have taken power. It was mostly the communists that prevented the whole thing from turning De Gaulle

out, much as protest forced Johnson to bow out. The communists are more conservative than anybody else and so split the left and put such brakes on the workers that a real revolution became impossible. What will happen now, is that everything will go up, wages and prices and it will be much the same as before. Certainly the universities which are all state run, will be reformed and I hope the professions like architecture, law, and medicine which are very rigidly structured, will be liberalized also. Certainly France will never be the same again and it is a very good thing. For people like us, who don't really belong to any society or country, it was all very interesting and exciting, but for Marc's brothers and brothers-in-law, factories were on strike with occupation of the factory and red flags flying. One, the stockbroker, had his office in the stock exchange slightly burned. Marc's uncle's banks were all closed, etc., etc. Anyway, Marc was busy as a beaver. He made a miraculous recovery and was out on the streets for three weeks, photographing until three in the morning or sometimes all night. Most of the riots took place in the student area where we used to have our old flat. The streets got torn up and repaved so many times it was amazing. Bill and Jeannine did some filming as well, also they live in the thick of everything. I guess it was like living through Watts or Detroit. Where we are, it was very quiet, like the country.

One thing people all over the world have learned is how to make barricades. It is going to be something this summer if they start that in the States. David and Alexei are fine and beautiful and growing. Alexei is sitting up and fresh as dishwater. David is quite a young man. We just took some pictures of Alexei last night, so you will have new pictures soon. Also I may come over with Marc for a few days in July. There is a special half fare for wives, so I may pop over with Alexei to see you. Let's keep our fingers crossed. But I do want you to see more of him while he is little. How is the job going? Well, I hope. I really hope you weren't too worried. How is Clarence and all the gang? And how is Doris? I hope she is on her feet. Tamara's father died a few days ago. She will be back in Paris from New York in a week. Sheila is going to the States in a few days too. I will tell her to give you a ring. Christiane, Alexei's nurse has a new boyfriend, an African student from the Sorbonne, so she is in Seventh Heaven. I think it is all psychological. She has such a passion for Alexei; she is always saying she wants a baby just like him!! Madame Rosier is fine. Alexei has six months' supply of milk because every time she went to do the shopping she would bring back a few more cans, "just in case" so her baby wouldn't run out.

We will be going south on a short and well needed vacation in a few days (as soon as the planes start running again!). So I will write to you from Saint Tropez. Marc really needs a rest. Between his trip and the riots, he looks like death warmed over. I must say, it has been a fantastic time. It was like living in suspended motion. Nobody DID anything but listen to the radio, try and find newspapers, wander in the street and have endless discussions. It has all

passed as quickly as it came with this weekend, which is a holiday weekend with beautiful weather and the first weekend in three weeks where there was gas... So everybody fled Paris for someplace else and relaxed. Only the French could have a revolution and then go off on a long weekend to rest up.

Well, I guess that is all the news. If there are any revolution stamps out (which I doubt there will be) I'll buy them for you (as soon as the post offices open up!). Françoise is fine as well. She could call us, but we couldn't call her. There were riots as well in Lyon, but she felt very cut off in the country. She is even more militant than we are and was involved with all kinds of political meetings and protests. She even took part in a protest march of 50,000 people. Her brothers must have loved that! Anyway, for three weeks, really not able to budge, has given me the wanderlust too and I am dying to take off not just on vacation, but on a long trip to the East. We might even stay there for a while. It would be wonderful to work and Marc is very fond of that part of the world. He has done beautiful stories on Laos and Cambodia and Thailand this trip, and we have already decided to make a trip in the fall to see the Angkor temples in Cambodia. The more I think about it, the more I like the idea. At any rate, we have our hands full for this summer and fall with work, the country house, Daddy's visit, Magnum meetings, and planning the fall trip.

If you can manage, get a hold of the May 26th issue of the English *Sunday Times* newspaper (you should be able to order it anywhere). There is a very good explanation and history and description of the 1968 French Revolution. Also this week's *TIME* magazine has photos of Marc's on the riots although I haven't read what they have said about the whole thing. But the English *Sunday Times* newspaper of May 26th is very, very good and very clear. Oh yes, Happy Mother's Day. They couldn't decide when to have it in France because of the riots, but the florists had their way since they insisted that their roses were at the peak of condition, so it was last Sunday. I couldn't send anything because there was no mail, no telegrams, and no telephone...

<div align="center">

Love,
B, David, Alexei, Marc

</div>

P.S.—Do you think you could take off a few days around July 12th or so if I do manage to come with Marc?

Saint Tropez, June 21, 1968

Dearest Mother,

At last! No more revolution—just beach and sun. They haven't even heard of the revolution here in the south. I expected your letters to pile up because of the postal strike, but I got the last three-in-one sent to Magnum, so I guess there

aren't any more. I hope you have since gotten all the pictures of Alexei. Isn't he the 8th wonder of the world? We just adore him. Your letters progressed from worry to demi-worry so I guess the news there got better and better. Actually it is so different when you are in it. And when you think that all that "revolution" and there were only three dead—and all those accidental and when you think that one riot in Chicago can kill 48 people, you wonder really where the revolution is. I know the press in America exaggerates to a fantastic degree, but even in France the movement was built up to incredible hopes. Everyone was sure that De Gaulle was going to step down. But he didn't and with the first returns of the elections in, the Gaullists are stronger than ever. So much for the revolution. But there certainly will be profound changes in France with or without De Gaulle, so it was a very good thing, all in all. For the moment, the left is weakened instead of stronger. As for all the rest, the Franc and so on, prices will probably go up and the cost of living also because of the strike, but the Franc is still one of the strongest currencies in the world. The dollar is in much more of a crisis than the Franc, but even this doesn't mean anything *inside* the country, it is only outside, internationally that there is any effect. So don't worry about our money, houses or anything. I can't tell you how calm it is. Also people like us hardly depend on one country or one system to live. We could work as well in London or Hong Kong or Rome or Mexico.

Daddy has cancelled his whole trip which I think is pretty silly. If we say it is all right to come, would we really lead them into a dangerous situation? Anyway, Marc will try to convince them when he gets to New York. If not, too bad. They'll come another time. But I told Daddy it is like saying we won't visit the States in December because there were riots in Chicago and Watts and Washington in August! How is Doris? I hope she is better. How is Bernice? Tamara is still in New York, but should be back soon. I have Marc chained down to the beach with stakes and every time he says something about Magnum I fill his mouth with sand.

David is with Françoise at *another* beach with his cousins and Alexei is in Paris with me. How did you like the latest pictures? It is still up in the air whether I will come to New York or not. Even if I did come, it would be for a very short time. Marc wants to spend the least time possible, so I don't know. Forget about my birthday, I have. I have decided not to have any more like Helen. I must say, though, for an old lady, I am holding up not too badly amongst all these Lolitas— I have a dazzling bathing suit of nothing in dark brown held together by three strategic white rings. So it looks as if I have on nothing but three white rings. "Did you see that girl with nothing on but three white rings?" And not a pip out of Marc either! Also I am wearing my hair long with a switch in the back, very pretty. I'll get Marc to take a picture. Otherwise our lives go on happily as before. I must say, though, the revolution does have a rejuvenating effect except that everybody was exhausted at the same time. Everything is quiet here. The season

doesn't begin until July. At the moment I am writing beside the hotel pool and Marc is swimming. We will go to the beach this afternoon. The only thing I wish is that it would last! Marc has all kinds of work to do and now all the dates have been changed so that I don't know where we are at anymore. We miss Alexei. He is so funny now. He is going to walk much earlier than David. He is already standing up, his legs as stiff as a board. And when we walk him, he is afraid to bend his knees so he walks on his tip toes. It is so funny. He is sitting up by himself and sings all the time. He is an even happier baby than David was. He is going to do everything much earlier than David of course because of having an older brother. David absolutely adores him and is so sweet and tender with him. My favorite picture is the one with David and Alexei, each one looking into each other's eyes. You know the one with David's hands on Alexei's shoulders. It is so sweet, I think they are going to be very close. Alexei, at least, seems to adore David. I have the feeling it is going to be Alexei who is going to be the leader and raise hell and get David into all kinds of trouble or get himself in all kinds of trouble that David is going to have to get him *out* of or is going to take the blame for—

We are doing two rooms for them in the country: a red and white for David and blue and white for Alexei, both with pine furniture. I got David bunk beds, because he has been dreaming about them ever since he slept with Peter (Jeannine's little boy) who has them. We also made a room for Daddy (which won't be used it seems) very nice all in white. I am going to ask Tamara to come with the baby and stay for a few weeks when she comes back from New York. We are also making a huge studio out of the barn with big skylights in the roof. It is going to be beautiful, but at the moment, as usual, the whole house is torn up. But Marc's studio in Paris (in the garden) is all finished and is very nice. He is so happy with it. There is lots of storage space and big light tables and a projection screen. We haven't done anything else inside the house except make Alexei's room and Christine's room from Marc's old studio. Alexei's room is all yellow—very pretty. Well, back to the revolution. The police finally evacuated the Odeon, the theater taken over by the students and the students themselves evacuated the Sorbonne. So that's why I guess the Americans finally had the pretext to evacuate "Resurrection City." I just read today that they had done it and had arrested about 60 people including Pastor Abernathy. Here after the elections, we will have a government that is more Gaullist than ever, which means more conservative than ever and more anti-American. It will be the same in America. Nixon will probably win and even if Humphrey does, it won't make much difference. I think everyone has been so depressed since Kennedy's death (Bob Kennedy) because now it really is hopeless unless a miracle happens and Rockefeller or McCarthy manages to score an upset at the conventions. But that is farfetched to say the least, but then everything else has been farfetched: Johnson's retirement, McCarthy, Kennedy's death—the whole awful thing. I am just waiting for the barricades to go up in Watts and Harlem—that will really be something because it won't be

paving stones and tear gas like it was in Paris, but guns and tanks. I just hope it doesn't happen. I didn't tell you even David was on strike. All the primary schools and kindergartens went on strike as well. So he hasn't been to school in months, what upset him most was that there were no taxis or buses so he couldn't go to the Luxembourg gardens. At least he knows what a strike is. Now every time something doesn't work or is closed, it's "on strike" as far as he is concerned. Well, I will write soon. I want to drive down to the post and mail this—

<div align="center">Love love love—miss you so much—

B</div>

P.S.—I got your telegram of the 13 May a few days ago!

July 2, Paris 1968

Dearest Mother,

Your letter was waiting for me when we got back from St. Tropez. I was quite worried about your pain. Is it better now? What did the tests show? I have finally decided not to come along with Marc this trip. I think the change and the heat would be too much for Alexei and instead of having the perfectly happy baby I know, you might have a cranky, difficult one on your hands. He doesn't take much to hot weather and of course what we call hot here in Paris is nothing compared to Philadelphia. And all the trouble of renting an air conditioner, the water, the crib and all that for just two weeks seems difficult. Marc is determined to stay the least time possible. I wanted so much to see and talk to you but since you have seen Alexei, I will come in the Fall and bring Alexei back. I must say, when we make them, we really make them.

I too am very sorry about Daddy. I have written him to change his mind, but knowing Lucinda, I doubt if that is going to happen. I told Marc to try and talk to them. It is so silly, the whole thing. You know they are half afraid to come anyway, and this was, I admit a very good excuse. I also told him it was silly to spend that much money to come for two weeks. I invited them for a month. I am glad your pay is finally coming. 75 dollars a week from 35 is really something, although of course, it should be more and will be. Aren't you proud of yourself?

As for my birthday, just forget it. I am not having them anymore so you might as well stop too. Or start going backwards like Helen. Yes, I got your beautiful card. Vicky sent me a telegram that fink. I hope you still plan on coming Christmas if you can. We are counting on it. As I mentioned before, I have just finished remodeling the barn in the country into a studio for me so I am going really to try to get back to work. It is so difficult with the kind of life we lead, always something new and interesting coming up like this trip. But the trip at least will be educational. Cambodia has without a doubt, at least in my mind, the greatest

existing stone sculptures in the world. Meanwhile I will try to work this summer. Sheila is going to Chile with her family. Tamara is going to spend some time with me in the country and paint. Jeannine of course will be in the country too. So no more news now that we are back. The vacation was wonderful but too short and Marc looks great!!!

<div align="right">

Love,

XXXX B and David and Alexei

</div>

La Chenillère, August 1, 1968

Dearest Mother,

Got your last letter this morning and was so happy to hear you so cheerful. I was so worried over this electrocardiogram thing and although Marc said you looked fine, I feel better that you think you feel much better. And you think you never looked better then you must look great. Anyway I hope Marc made you understand that whatever happens you are not to worry about anything ever. We are more than capable of taking care of you, so just relax. I think, of course it is much better for you to work even if it tires you because it gives you an interest in life. Especially the kind of work you are doing now which is fascinating and important. This is the important thing in life: to have something to do which means something and that you do well.

I laughed about the Cadillac and Marc. Who is the guy?

The house looks great, but is a madhouse. At the moment, I have FIVE babies here, two nurses, Tamara and her husband, and an English butler named David!!! Well, the butler is really a houseman who fell into my lap (excuse the expression) two weeks ago and turns out to be a gem. As a matter of fact, I don't know how I ever got along without him. He cooks, cleans, washes and irons better than Madame Rosier plus he serves dinner and lunch in a white jacket!! He is very funny, very English and very cheap...he even costs less than Madame Rosier...Tamara and I have decided that he is really one of the bank robbers of that tremendous train robbery in London last year and that he is hiding out. That's why he asks so little money. Marc is dead set against him for Paris, although he has become less so since he saw how well his shirts were ironed. I am determined to try and keep him for Paris if I can figure out a way to lodge him. That is the problem.

Anyway, we are very well taken care of and lots of work has been done on the house and it is very comfortable and pretty. Marc is so happy here and David is out of his mind with joy. I have two of his little playmates here for the month, the children of another Magnum photographer, a little boy of five and a little girl of four with their nurse. Then I have Tamara's daughter of fifteen months, plus little Alexei who gets more adorable by the day. He is one of those love-love babies. He

can't get enough squeezing, hugging, kissing...David gets more beautiful by the day as well. People really stare at him in the street!! And he is as sweet natured as ever. But he needs playmates. Since Alexander has arrived, he has really been in seventh heaven. All and all it is a very happy house. I only wish you were here! But we will make a special trip during the Christmas holiday so you can see it. I can't wait. My new studio is very beautiful except with this madhouse I am not doing any work. I spend all my time doing the shopping. It is amazing how much thirteen people consume. That seems to be all that I do from one end of the day to the other. The only drawback with David (the big one) is that he can't drive, so he can't do the shopping alone. Jeannine is arriving tomorrow to install herself, so David will have Petou as well.

Why don't you get a kinky wig? Vicky promised to send me one!! *Vogue* did a whole issue on the "jungle look" that's us...including a "new" hairstyle which used to be called "corn-rows" remember? All those little rows of braids all over your head. I think the whole thing is a scam. Us poor Colored people can't have anything...love, love, love. I am racing to the post office to mail this before it closes.

<div align="center">

XXXX

B and David and Alexei

</div>

August 7, 1968
La Chenillère

My Darling Mother,

Got your letter this morning. I only wish that I were with you. It seems so crazy and silly that we are so far apart. If you like, I will come over. What I would really like is if you could come here. The house is so beautiful and so are your two grandchildren. But if the doctor doesn't want you to take a plane...what about a boat? I know it is not the ride, it is all the preparation before. If only you would promise not to run around making a lot of preparation, I am sure she would let you come. For example, Bernice could do your packing and I am sure that Dr. Ramsey would come to the house to give you your vaccination. I am sure your passport is still valid. Ask your doctor about it. If you went now, to the Father Divine retreat for two weeks solid rest even in bed, maybe she would let you come if you promised to do it very calmly, the end of August. Anyway, that is my dream. Of course we may just HAVE to wait until Christmas, but I hope not. Anyway, don't worry about anything, just try to take a good rest and not puttering around. My thoughts and love are so much with you and Marc's too. Even though it wasn't a serious attack, it is much better to be extra, extra careful. I would absolutely go to the Father Divine retreat for two weeks. If you stay around the house, you are not going to rest like you should and even making

three meals a day and doing the shopping is too much for now. Much better to have someone else do it. So this is settled. You do go to the retreat that is if you can get in, if not to the mountains somewhere you won't have to worry about the house and cooking.

We are having a good summer. The house is full of kids, mine and other people's. At the moment I have three children of a photographer friend of Marc's: Ernst Haas, ages four, five and eleven. Next week, Françoise is coming with her daughter. So with us, that makes thirteen including the nurses (two) and my English butler. So I can begin to work a little, but I realize that with all these people coming and going, I have too many interruptions. I didn't realize how just the presence of so many people is disrupting and distracting even without all the cooking, cleaning and minding babies. Well, I've learned my lesson for next year. Anyway, I am very happy with the studio. I had fixed a wonderful room for Daddy if he had come, which will be for Françoise next week. I am giving the little house to Gerard since he has to work on a new role, memorizing and reciting. So I've stuffed the three other children and their nurse into David's room and put David in with Alexei.

There are all kinds of exciting prospects for the fall. Marc's work seems to be going well. He just finished several things for American *Vogue* that will probably appear in the Christmas issue and his Laos story will probably come out in *Look* soon. Also, he may go to North Korea and North Vietnam this winter and there is a possibility of covering a film of Han Suyin's in Singapore which would be easy and fun and lots of money. This would be in January–February and I would take the children with me. Find a Chinese nanny and set up housekeeping and do bronze casting. It would last for at least three or four months. So this is the big project if it comes through. I am just wondering if the movie company is going to pay for all of us.

Is there anything I can send you from this far side of the sea? I feel so far away. Promise me that you will go away to a complete rest for at least three weeks and afterwards we will talk to the doctor. For goodness sake, don't worry about money. Everything will be taken care of. Just get rested. If I know you, you look great. So I don't have to worry about that. At least I'll never have to worry about losing my looks thanks to you...

I love you and we all send you many thousands of kisses. Write. Write.

What else is new. Tamara's baby is adorable, but she is not getting along too well with her husband. Well, she is not getting along at all with her husband. Vicky is back in New York and it looks like she is going to marry a drugstore tycoon. Françoise has broken up with the father of Caterina and is with this Gerard that I mentioned. It was a great drama for her and for her daughter. Jeannine and Bill have just finished their movie which is opening at a festival in the south of France next Tuesday. They are both exhausted with the film and the revolution. Bill worked day and night filming for almost five months counting the

two things. So Jeannine is looking forward to a rest here. We are both going to try and stay until the end of September. Her son and mine are the best of buddies. It is wonderful they get along so well together and complement each other so well. There was a time when David was smaller than Petou and David was more or less the victim of Petou, but now it has equaled out even though Petou is older. David doesn't let him get away with anything. And Petou is such an exuberant child. He has a good effect on David who is very calm. Like a tonic and David has a calming effect on Petou for which everybody is very happy. I have never seen a child with so much energy. He has an answer for everything and most of the time has the last word to boot. Of course all of them are bursting with good health, which helps. Petou and David are the same color. And Alexei! Is something else again. He is one of those baby-contest babies. He is so pretty and good-natured, it is unbelievable. He is going to walk very early and he is so strong we can hardly sit him down. And since all he wants in life is to stand up all the time, it is a real battle. It takes all my strength to bend his legs!! Isn't that ridiculous? He eats just about the same amount as David... Let's see, Tamara and I couldn't figure out how long to boil the cow's milk that we get at the farm and then we found out you weren't supposed to boil it at all... so much for us as country ladies. You would be amazed at how well I've learned how to make curtains and things, necessity is the mother of invention. But haven't gone yet to see Cardin. I'll send you all the fashion magazines when they come out. Again, love, love, and write soon. And let me know what the Dr. thinks if you really promise to rest for two weeks or even three.

XXXXXXXXXXXX
B

September 9, La Chenillère, 1968

Dearest mother,

Everything went very well while I was away. Marc and Christiane were very proud of themselves. Everything is very quiet now with all the children, except mine gone. Marc has his visa for North Vietnam so he is busy preparing his trip. I finally flew back in first class as they didn't have any room in coach and I had a reservation confirmed. So I was very comfortable and drank champagne all the way to Paris. When I got off the plane, Marc didn't recognize me in my new hair. He was really stunned. Françoise was with him and she was stunned too. I don't think he really likes it too much. I must say, it doesn't have the same effect in Paris where everybody's hair is like that. Françoise kept telephoning Marc to tell me not to cut off my hair. Not that I have any intentions of doing it. Alexei is crawling around on all fours. I have to get him a playpen today. The weather

is beautiful. I hope it stays through the month. I intend to stay until the end of September if it doesn't turn too cold. I am getting prints made of the photos I showed you. I hope Mary got my thank-you note. Did Clarence like his files? Are you alright?

How is work going this first week back? And how did the last electrocardiogram turn out? I saw the doctor briefly while I was in Paris. He seems to think that I don't have my maladie anymore. So I'd like to know what I do have!

I am planning the things to plant for next year in the garden. The friends of Daddy who were supposed to show up on the first finally sent a telegram saying because of illness, they couldn't make it. They had already sent one cable saying that they were coming. So it must have been something sudden that came up.

I finally got word that I am on welfare! They will pay me all the allowance for David for '67 and for David and Alexei for '68—so I am going to buy a new couch. But there is so much red tape and paperwork; it may be '69 before I get anything. Jeannine and Bill are fine. We saw their new film which neither of us liked. I think this one, he can just write it off. There is still a lot of trouble with the censors and it can't be shown publicly in France yet. So everyone is just waiting to see what will happen. There will probably be a big scandal which will give lots of publicity to the film anyway. Our film in Singapore is still up in the air. I don't know if it is going to go through or not. We just have to wait and see. For the moment, North Vietnam is the most important project.

How did your weekend turn out? Did Bernice too? How is her little drop-out from head start? I must write Daddy too. Meanwhile I hope everything is going well at work and that you feel well which is the most important thing. I thought all the girls at the lab were charming. And the doctors too. Well, we were supposed to be having a picnic on the beach today, but it is beginning to rain. So I will mail this while I am in town. Marc left last night for Paris for a few days. He will probably be back on Thursday. Françoise is coming next weekend. Caterina was absolutely overjoyed with her bra! She wouldn't tell her mother what I brought her, but she wrote to the girl I have taking care of the children while Christiane is on vacation, who works at La Bergerie. She was so pleased and so excited—And besides, even at 11, she needs them!

Love and kisses,
B

And a million kisses from Alexei who runs his mouth from morning til dusk without stopping. I think he inherited something from Grandma. I never saw a baby talk so much. He talks so much, he gets exhausted and goes to sleep in the middle of a sentence—just like her . . .

October 1, 1968, Paris

Dearest Mother,

Well, all's well. Marc left yesterday for Vietnam in a flurry of preparations as usual. He will be gone about a month. I am going back down to the country for a couple of weeks to work once the children are well settled and Christiane gets back (tomorrow). David started a new school too. A private bilingual school that I think will do him a lot of good and you too since he will begin to speak English. It is very small and very near the house. It just opened this September. The other two in Paris were much too far for him. But the difference in price between David's school and Doris' little girl's school.... mine cost $24.60 a month! He has a very sweet uniform of gray trousers, a white turtleneck pull and a dark blue English cardigan. He looks so sweet. Today was the first day he went, and he seems to like it. He said they sang in English today. Alexei continues to be something else. I hope you like the latest pictures. You can't leave him alone for one minute and since I've had him since Saturday without anybody except Madame Rosier, he is driving me raggedy. Be careful of the new stamps on the envelope, they are the newest in the painting series and a new thirty-centime stamp. Tell Mary, I am sending some of Marc's reject pictures very soon.

As for work, I think the best might be to have another full day off once a week. That way, you have one morning less to get up and out which is what the doctor said was so tiring.

I got the pictures for the boys. I think I told you in my last letter. They are installed in their respective rooms. Please, please send me one of your photos in MY bathing suit. That I would really like to see. Didn't you have anything better to do you two? Well, give my best to Bernice and tell her to take care of her crazy self. And say hello to everybody at the lab. I am having my fur coat redone. I took off the collar or rather modified the collar to a Chinese collar, shortened it, trimmed it in a tiny, tiny band of panther and put a belt on it. I think it should look great. It is amazing how soon fur coats go out of style. I may buy myself also a (very cheap but pretty) ankle-length fur coat. God only knows WHAT kind of fur probably cat, but it is really stunning and great fun. The one I really want is a Russian-cut great coat trimmed in fox from Hermes. Fat chance of that!! Anyway, I am saving up all my welfare payments, then I'll see how much ahead the government has made me! (by Christmas). Well, Alexei is getting up and walking carrying his playpen, so I guess it is time to stop writing and go catch him before he breaks something.

<div align="center">Love, love, love,

B</div>

November 2, 1968, Paris

Dearest Mother,

Thanks so much for the letter and the clippings. Nothing new here, not even any new photos now that Marc's not around. Tell Daddy that I do send him <u>every</u> (well not quite, but practically) photo I send you. Marc has had fantastic luck with his story. Can you imagine being the only Western photographer in N. Vietnam at the cessation of bombing? It is fantastic—for the moment there is literally nobody else there! I am so happy for him. He is sure another book will come out of it. Especially now. I suppose he will try to stay as long as possible. I am going back to the country house to work for a week or so. I have so many things there that I have to finish. So now that the house is in order and running, I can do a little work. I changed around the living room! Sold the two English armchairs and along with my welfare check bought myself a beautiful white Italian couch! It looks great. So it really looks quite nice, I am putting in some more shelves for books—! We are swimming in them! David loves his new school and is finally beginning to say a few words in English. And he has a girlfriend named Caroline whom I haven't seen yet. Alexei is almost walking. It is a matter of days now. I think I am going to give a big Thanksgiving dinner if Marc is back. It is the 28th? Everyone can come and see my new salon, my new weaving and my new sculptures! At least one new thing should be finished by then. Everyone sends you big kisses.

P.S.—I just discovered that Marc threw out all the slides I wanted to give to Clarence! I am so sorry—but he will have more very soon. Tell Clarence to be patient.

La Chenillère, Nov. 11, 1968

Dearest mother:

Just a short note to let you know that everything is fine. Still working. Today's a holiday. At the moment I am listening to all the disgusting Armistice Day ceremonies. No wonder the younger generations are disgusted. Can you imagine celebrating two million dead men in probably one of the most stupid, useless and horrible wars ever??? Anyway, the children are fine. David loves school. He is doing a lot of painting and sculpture. Alexei is still struggling with his two upper teeth: Marc should be out of Hanoi on the fifteenth and home in about ten days. It is finally getting cold here. I think I will have a Thanksgiving dinner if Marc gets home in time. I'm also planting a few trees in the country and that's about it. I have five or six dinner parties I have to give when Marc gets back and we will probably go to Françoise's for Christmas and New Year's. How time flies... I haven't gotten my horoscope yet, but I think this is going to be a good year. Marc is

surely going to do another book on North Vietnam and I will surely have another exhibition. One I hope much more important and in several cities. Well, first I better shut up and do the work…

Love,

B

P.S.—Thanks for all the clippings. The Plaza sounds nice. Is it open yet? How are you? Are you taking care of yourself in this cold weather? Do like I said, don't bother to try and cook for yourself. Stop at Horn and Hardart or find a nice small restaurant, get the papers, and eat out. That way you will get balanced meals without all the mess of trying to fix them yourself. I love you.

B

30 December 1968
La Bergerie

Dearest Maman,

Happy, happy New Year—Expect us around the 13th or 14th. Marc's story on Hanoi and North Vietnam comes out in *Look* on the 7th or 8th and Marc will be in New York for his book on Vietnam and to do interviews with the news magazines. It is quite a scoop, his story—he saw all the leaders of North Vietnam: Ho Chi Minh for the first time in years and his photos are beautiful. We are spending Christmas with Françoise like every year, in the country and we have a foot and a half of snow! It has been snowing for two days. But we drove down to the Midi—the south for two days to do a story for *Vogue Magazine on Julia Child*—you know the American chef on Channel 13. Anyway, can you imagine, we had lunch outside on the terrace, it was so warm and sunny—We were very close to Nice and St. Tropez. Now I know why people love California so much. Remember—my friends the Phillips from Cairo? Well, they stopped through Paris a few weeks ago and we had dinner together. Can you imagine I hadn't seen them in ten years? They hadn't changed a bit except that they have three instead of two beautiful bad little girls. He will be in Libya, next as consul. But can you imagine too—my 7th wedding anniversary! The same husband for seven years! The same one! Anyway, we both forgot more or less and decided just to ignore it until the 10th. Alexei is really walking now. He is so funny. He still has only two teeth! But he is very sweet. As sweet as David and David got his first report card just before the vacations—an "excellent student" in everything—manual work, beginnings of scholastic exercises, singing, dancing, painting, sculpture, construction—everything…!!! The children love their presents. David especially the AB book which folded out—you will get a thank-you drawing when we get back to Paris. David has done marvelous ones in school. I hope work is ok. And

the X-ray—what was the final analysis? How do you feel? I know the weather must be awful. How is Bernice making out? Marc and I have so much work to do, we are out of our minds. We have the whole dummy for the new book to do before we leave for NY. I have a new studio which has to be all settled and work started. I have three sculptures to be cast in London before I leave. Of course our Christmas cards are late—not to mention all the other things we have put off. At last—I got the new car—dark green with beige and black inside—a little station wagon, very cute and it drives very well. Also I have trees to plant and painting to do in the country house. All this and trying to work at the same time. Anyway, we both seem to be flourishing at the moment—and full of new plans, Caterina, Françoise's daughter is growing into a stunning teenager (she is 11½ but looks 15). She is going to be very beautiful. Well, I just barely mentioned the fact that finally after a lot of maneuvering around and good luck, I got the new atelier I have been after since September. It is beautiful. Very near the house on a garden, a little like our house, but of course much smaller. It belonged to a little old maid who manu-factured Christmas cards and she had promised to sell it to someone else—a nasty old man. I found it the day after Marc left for Vietnam!

> Your loving daughter,
> And David and Alexei

1969

Besides the studio at *La Chenillère*, I had a new bigger studio, Rue Dutot. I left Rue Blomet and its folklore of Josephine's songs and dances behind me. I wrapped myself in a cocoon of motherhood, sculpture, and restoring the farmhouse in the fervent and green landscape of the Loire Valley. Marc's photography began to attain the international fame of his two brothers and the three of them comprised, for the media at least, the so-called Riboud brothers—*Les Frères Riboud* colossus of Food, Oil, and Glass. In the wake of 1968, a wave of terrorism swept France and a series of bomb and kidnapping threats led to bodyguards for all the Riboud children. It was a strange and eerie time that everybody tried to take in stride. I never told my mother about it. But the terror was real. This was not a movie. Alexei was too small to realize but David was both subdued and curious about being taken to school by men with guns. The world had changed forever. Kennedy was gone. King was gone. Malcolm was gone. Bobby was gone. All at once, I became the eye that wrote. I had found a way suddenly to express my feelings other than by abstract sculptural forms. I began to write poetry, sending it to a friend of mine in New York so as not to destroy it. I wrote in another language, French, as if that somehow made me a different person, not a sculptor. I would separate my writing from my sculpture for several decades.

I exhibited at the Air France Gallery in New York, at the Réattu Museum in Arles, at the Centre Pompidou in Paris in "The Eye That Listens," and at the First Art Festival of Dakar in Senegal. A certain calm reigned in France and a new conservative government under Giscard d'Estaing took over the Elysée.

I worried about my mother. She never complained, she was always cheerful, always busy, always adored by all the people around her. But I missed her. I knew she had a hard row to hoe. She made her life look serene but the divorce despite her youth was the tragedy of her life. She was still in love with my father. There was loneliness without Queen Lizzie without Grandpop and without me. We had always been close, more like sisters since we were so close in age and now what could have been a time of freedom and dating she seemed not to be able to make up her mind between the few eligible men she found. I wondered if this was the key to my father's enigma. His betrayal had cost my teenage mother her health.

She had taken to her bed when I was a little girl, unable or unwilling to walk for more than three years. I remembered her illness vaguely, at about the time I discovered my father's paintings stacked up to the ceiling in the basement of Grandpop's house and had wandered among them as if I had been transplanted to a strange, new, foreign country. But I never dared ask him about them even when they all suddenly disappeared. I knew only that he made the blueprint drawings for the houses my Grandpop built and that they were signed by somebody else. I once asked him to build me a doll house, but he never did, cruelly replying that I ought to build it myself. The incident remained with me through childhood and young adulthood and led possibly to my sojourn at Yale. I never discussed my acceptance into Yale with my father and he never set foot on campus while I was there. I finally did build myself a magnificent Monticello doll house for my granddaughter Mathilde in 2011 when he had been dead for twenty-five years. But these were not the only unspoken words between us.

15th January 1969

Dearest Mother,

I was so happy to get your last two letters. Thanks for the new address of Joyce. It looks like we won't be coming until the 25th of 26th … too much work here. But everything is going very, very well and Marc is quite happy with the results of his trip. I hope you have seen last week's *LOOK*. I am sending you the article in the *New York Times*. I will also send *Paris Match* and the *Sunday Times*. No sense in sending stuff in French, but his article in *Le Monde* (the *Times* of France) had a very big impact. Day before yesterday we had lunch with the North Vietnamese ambassador and next week we will probably see Shriver. Marc has also spoken to Harriman. I think he thinks he is going to wrap up this war single-handedly. But Ho Chi Minh and especially the prime minister of North Vietnam told him some very important things. On top of all this, Marc's brother is the talk of France … for two weeks the newspapers have been full of nothing but him and his fight to gain control of Saint Goblin, which is the competitive glass manufacturer (twice as big) to Antoine and would make Antoine, if he won, head of the largest glass manufacturing complex in France and Europe and second or third in the world. It is too complicated to explain to you the financial complications, but it is the first time that this kind of financial operation has been attempted in France and it has made a sensation. Anyway, the Riboud brothers are all over the place in name and deed. Françoise is well and sends her love. We spent a lovely Christmas and the children are going with Christiane back to La Bergerie to go with the school on their skiing vacation beginning the 26th of January and lasting two weeks. I would love to see Alexei in the snow now that he really walks well. He is something else. Laughs all day long. A real sweetie-pie. I guess the worst

of the flu is over. I am so happy you didn't come down with it. I am fighting off a cold myself at the moment, but I think it will be alright. Marc is of course very tired. I think maybe we may take a few days in the sun somewhere although HE is going to Israel for three days next week! I have just got some castings back from the foundry and am having them polished. So expensive. And we will sign for the new studio next week. It is really now or never. I am determined to be rich and famous...My trip to London and the Royal College of Art went very well. I have done three big sculptures there. With all this, I should have a show ready by spring. While I was in London, Stirling gave a dinner party for me. He looks like Sydney Greenstreet!!! But he has a very beautiful house, although I prefer mine! And he has a very nice soft English wife and two new babies. It was just awful. I'll never let the two of them meet...after all my talk and all that drama about my tall thin and handsome English architect Marc stole me from! And what else... oh saw a lot of my old English friends who didn't know I was married to THE Marc Riboud. But mostly, I worked and worked. Have to go now; we are going to a reception at the Cuban embassy....I promise to write tomorrow.

> Your loving daughter
> B

Friday 21st, Feb. 1969

Dearest Mummy,

Finally—some place and quiet. We are in the mountains near Lyon—in the Alps really at a ski resort to rest for about ten days. Marc is already recovered and David is divine. The weather is splendid—lots of sunshine and the snow is perfect. We are in the hotel of the father of Jean-Claude Killy the Olympic ski champion and David is out of his mind. He really skis quite well and the ski instructor says he is very gifted. Marc is little by little getting into shape. The mountain air and exercise will do wonders I am sure. London was exhausting and as soon as I got back from London, I went directly to the country for three days to see about the house and the plants for the spring. So this is the first moment's peace I've had too. For me once you've seen one mountain, you've seen them all, especially if you don't ski, but I'm happy for Marc and David and brought lots of books. It is incredible how suntanned one gets immediately. It is the combination of sun and snow that does it. I hope you got the clippings I sent you and you weren't confused that there was no letter with them. Anyway I found David and Alexei in great shape. All caramel color from the mountains and so healthy-looking. Françoise is also in very good shape and she sends her love. She is coming up here for the weekend and Antoine and his wife and children will be here next week so it should turn into a real bash. Anyway, all is well. I was interviewed by the *NY*

Times. I guess it will come out soon. I'll send it to you. Marc will be working on his Vietnam book and me in my new studio all spring. As soon as you have your dates, let me know.

Daddy *says* he is coming in August. Say hello to all the girls at the lab and to the doctors. I hope not too many people were mad by the time they found out I was there and gone. The same thing happens in New York and London. Oh well. That's life. David is so sweet looking in his ski outfit—bright green (chartreuse) wind breaker and dark blue knickers and red socks and yellow racing sunglasses—very chic. And a chartreuse turtleneck sweater underneath. Alexei is with Françoise and his nurse—happy as a lark as ever. I never saw such a happy baby. Tamara is expecting a second baby in October and doesn't know whether to laugh or cry—me neither. Vicky is here for the week. I have the feeling she is a little upset she saw so little of me both in New York and in Paris, but it just couldn't be helped. It was a bad time for everybody. New York was a madhouse and of course we left Paris three days ago for here and she'll be gone by the time we get back. But she looks good. She bought all kinds of clothes while she was here and had her hair lightened, her skin peeled—the whole works. I must say she was a wreck when she arrived. Nothing else new. I am still amazed we really got here and are still staying a week. I will write you when we get back to Paris Wednesday—I am writing Magnum about a check for the television.

> Love, love,
> I miss you.
> B

Paris, March 25, 1969

Dearest Mother,

So happy to hear about your plans. Everything is fine here and we are all waiting for you. The babies are fine. Did you like the pictures of David at his birthday party? It was so wonderful to hear your voice. You sounded in good shape. Marc is busy as usual as am I. We spent Friday and Saturday in the country where it was very beautiful. Still work going on at the house. I suppose it will never be finished. There is always something else to do. Otherwise, everything is quiet. David will be out on Easter vacation at the end of the week. French children have more vacations…he just got back from Mardi Gras vacation. The new studio is shaping up fine. You will have your own little apartment over my studio. It will be great. At least you can consider you have your own flat in Paris now!!! We are both in the clouds these days, but I hope we will settle down soon. We go through these cycles, us Cancers. I am so looking forward to our time together. There is a possibility of a trip to the South, the Midi as it is called for an

exhibition of Marc's. Also, we will surely go to London. Did you go to London the last time? I forget. You went to Rome and Amsterdam I remember.

Last night I went to a party at the Max Ernst's. But now that things are coming back from the foundry, I feel a little better. I have a new Madame Rosier whose name is Madame Marcello and who seems to be very good. She just started today. Also her old boss says she is a very good cook, so maybe I'm lucky. Anyway, David took to her immediately which is always a good sign. Plus the Spanish all love children and have a very good relation (they tend to spoil them) with them. Anyway, keep your fingers crossed. I thought I would lose Christiane too this summer, but I think she is going to stay until next November. So much for the home front. Let me hear from you. If my letters are few and far between these days, it is not from lack of thinking of you. How is old Clarence? And did Mary and Clarence get their slides yet? I sent them with Chris and they promised either to deliver them or send them by mail the soonest possible. Let me know when they get them and when they project them. I sent lots so they should be very happy. I will send you a list of things to bring for Alexei. Actually, it will be a very short list but there is a special kind of underpants which is plastic lined which you can't get here which I would like you to bring and maybe some gum-drops!!! No I am not pregnant again...

> Love,
> Barbara

P.S. Missed a Pierre Cardin party because of our vacation.

March 30th, 1969

Dearest Mother,

Happy Easter! Hope you got David's Easter photo. It was taken at school. I thought it was going to be a school photograph with all his classmates. That would have been funny. Nothing else new here. The weather is terrible. I hope it warms up soon. It is like December. I am busy with the new atelier and my various projects. The atelier should be finished by next week. The flat is going to be adorable, I think. I may have to rent it for a year to pay for the repairs. At any rate, I am going to try to rent the whole place during the summer while I am in the country. If I don't write this week coming, it is because I really won't have time even to go to the toilet. I am trying to finish a whole new sculpture for an exhibition in New York the 30th of April! Anyway, there will be an exhibition (group) in New York at the Air France gallery in their new building with the title of "Six Americans in Paris"? Sheila is in the show too which is fun. You will get an announcement about it. I think Air France should fly everyone to New York for

the opening. After all it wouldn't cost them anything. But I don't think they quite see it that way. Anyway, I am going to suggest it.

There is another project of an exhibition this summer at the festival of Avignon where both Marc and I could exhibit. It would be fun together. And since it opens in June, you would be here for the opening. Avignon in the south, the Midi and is extraordinarily beautiful, warm sunny. Fantastic landscape. So this is something to look forward to. I will know in a few days one way or the other. It would be an enormous show with 150 painters, 50 sculptors and ten photographers showing 50 photos each . . .

Love, love, love,

B

La Chenillère, June '69

Dearest Mother,

Please forgive this long delay, but as usual we are up to our ears. At least the children are settled in the country. It is very hot here. I hope you are not suffering too much from the heat. Maybe you should get an air conditioner. Remember we talked about it last year. Also I got all moved into the atelier and am more or less cleaned up. Lots of people started showing up, of course: the Lansners, friends of mine from New York named Noma Copley who came down to the country for a week, also Bertha Schaefer showed up and we got our business straight. She finally agreed to buy a sculpture as I am going to have a lot of expense in transportation for New York. The date is set for the 7th of February to the 29th. So both Marc and I will be in New York. A week ago, Marc and I spent the weekend with David in Jan's house in Brussels. We were on the beach and that is where the photos are from. [IN SEPARATE LETTER] We had a very good time and David was delighted by the sea. Also Jan has a very sweet little boy a little bit older than David and they play very well together. We drove back to Paris, picked up Alexei and Christiane and came immediately down here. The house looked good and they have started construction on the dam for the lake. And the weather has been magnificent: very hot with a little wind: Alexei doesn't like the hot weather too much. He is much happier when it is cool. I think also he is getting in his last teeth. Marc is in good shape. He had been in Paris for the 14th of July to do photographs and arrived last night at four in the morning. We are going to this Pan African Festival in Algiers next Sunday for a week. It should be very interesting . . . I'll send you lots of letters, postcards and stamps.

Then on the way back, I'll stop at Avignon to see my sculpture and photograph it and see some friends nearby. After that I'll be in the country all of August and September working. I have practically finished the wax for the sculpture for Jacqueline Simon and am working on the last *Malcolm X* (number

4). How did the girls like all your adventures…on the boat and off. Finally we did a lot of things. I'm glad you met all the family. Françoise will be stopping by the beginning of August on her way to Spain and one of Michel's boys is here at the moment. I got the drawing for David's costume for Christine's wedding including pink white and pale green striped Bermuda shorts! Is David ever going to be jazzy. I have to send back the measurements this afternoon. Speaking of measurements I found in Pontlevoy, our village, a dressmaker who is 85, has eyes like a cat and is going to make me a 1900s dress (her favorite style) in mauve velvet with a high lace collar for the show in New York. I think it will be great fun (if she doesn't knock off in the meanwhile). She had me and Noma dying laughing with her stories of how the first time she went on a train, her skirt was so tight she couldn't lift up her leg and she couldn't pull up her skirt because her knee would show, so her husband had to pick her up and carry her on the train. Anyway she is very sweet and there can't be more than three or four people on earth that could sit down and make that style dress…I am getting my sari ready to take with me to Algiers, plus an Indian top and Indian pants, plus my Indian dress. I might as well be in style. There'll be a lot of Black Panthers around. It seems that it will be better than Dakar as far as the exhibitions of African art are concerned. Anyway, I am looking forward to it even though I can hardly afford the time. But it will be the only break in my timetable. Marc is invited, of course, but I am just going along for the ride. Bill and Jeannine will be there making a film on the festival for the Algerian government. David misses Petou who is in Brussels with his grandmother. But he will be here in August and September. I am making some designs for jewels as well and you are on my list. Noma said she would have some of them done in the States (she is a jeweler) and the others I will do here. I think I told you that Cartier may be interested, once I get a collection together. This time I intend to be better organized than the last time. There is all kinds of advance publicity to be done and photographs and announcements, etc., etc.

But getting to Philadelphia, what do the girls have to say? How is Bernice? What did the doctor say about the clot in your ankle? And what about the dentist? I realize that getting back to work must have been difficult in all that heat. Did you find the blouse you wanted? I will send you one from Paris: a lightweight one. I'll try to get it Saturday before leaving. Is there anything you need from here? Anything I can do? I'll try and find something pretty for you in Algiers. You know it is there that those pretty robes are made that everybody is wearing I'll see if I can't find you one for the winter. How is old Clarence? Does he feel better? Have you two gotten yourselves together yet? You were supposed to go on a big weekend to the mountains? Did you go? How was it? How is the "long hot summer" shaping up? Anything going on so far in Philadelphia? What a fink Nixon. He is going to get himself a head full of trouble before it is all over. He is even worse than everybody thought. He hasn't done one thing except put his name on the plaque that goes on the moon as if HE had anything to do with

it. And this double-cross about the school desegregation guidelines...he is really asking for trouble just to please a couple of shits like Thurman and Dirksen. Oh well, enough of US politics, it is too hot. I am going to write to Daddy and send him some pictures and let him know about the show.

Marc sends his love and kisses as usual. Françoise also. I promise to write soon and not let so much time go, but you know how it is. You have seen it with your own eyes! Lots and lots of kisses. I told David you got the pictures. He was very pleased. He asks about you often.

<div align="center">

Love,

B

</div>

Algiers, 23 June 1969
1st Pan African Festival

Dearest Mother,

We have just come from a fantastic rehearsal of Mauritanian singers and danc-ers. I bet you didn't even know that Mauritania existed! Anyway we are more or less installed—seeing lots of things. There was an enormous opening ceremony and a big parade—all very beautiful. Last night we ate at a wonderful restaurant in the Port of Algiers. I spoke several times with Eldridge Cleaver who is here with his wife and the Black Panthers have opened an Afro-American Center. I think we will stay until Saturday and then go to Avignon for a few days before going back to the country. There is an enormous political conference going on at the same time of all the African States with of course the final objective of liberating the rest of the African continent. We have managed to do and see so many things: films, dances, openings. Stokely Carmichael and Miriam Makeba are here also she is going to sing tomorrow. Algiers is a very, very beautiful city—built by the French, of course. Tonight there was dancing in the streets and outdoor performances. The whole city is lit up and very colorful. Nina Simone is supposed to show up here too. This morning we had an interview with Stokely Carmichael and yesterday afternoon, there was a great poetry reading by Black Poets (American) sponsored by the Festival. I found several long-lost friends—a painter from Philadelphia, a playwright from New Jersey!!! Also a couple living in Paris named Barbara (Black) and Marc (French) who are always getting mixed up with us since he is a journalist. She is very pretty! Last night the big gala took place and tonight along with traditional dancers from Senegal and Guinea, there is Abbey Lincoln and her husband Max Roach. I have found an underlying theme for a new series of sculptures which is quite tremendous and is going to make, I think, a lot of controversy, combining what I know of architecture with what I know of design with what I think I know about North Africa and Africa itself.

I suppose the revolutionaries have gotten to me but this is truly a "non-political experiment…" More later, when I've figure out a few more things…

La Chenillère
Pontlevoy, Loire et Cher (41)

July 29, 1969

Dearest Mother,

We are all back safe and sound. The trip was very exciting but tiring. Besides being very hot. Anyway, everything here is calm and under control. I have a very sweet girl for the children while Christiane is on vacation. I also have Petou for a few days. Jeannine and Bill are still in Algiers, but they should return this weekend. On our way back from Algiers, we stopped in Avignon to see the things in the art exhibition and the photo exhibit. I hope you got the card and the catalogue. It was all very strange after Africa. I also sent Marc's book on China to Eldridge Cleaver who was still in Algiers. (His wife has since had her baby there—which makes him Algerian instead of American.) She had it the day after we left. Marc may have a few of the Algerian photos in the *Sunday Times Supplement*. If so, I will send it to you. We had a very funny thing in the *London Sunday Times*. All kinds of posters, old postcards, and prints having to do with the moon and imagined travel to. It is mostly 19th century stuff which is really funny and some early twentieth century fantasies. All in color, they made a big spread out of it.

Jan just spent a few days here with the children on her way down south to the Midi. She just left this morning.

The work on the dam is finished for the lake and they have cut some trees bordering it in the forest, so everything is set for the fall. Marc has a "participation" in the fishing rights (six men in all), so if you ever want to go fishing…I am going to have to go to Paris probably on Tuesday to finish up some odds and ends and to find a dress for this wedding. I should be able to find something on sale, I hope. I hope I can get everything done during the day and come back the same evening, maybe go to see a show in the late afternoon. I was going to wear a sari to make things easier (and cheaper) on myself, but Marc thinks people would think I'm copying Krishna (heaven forbid), so here goes an expensive dress… Anyway, I'll send you another picture of me in my sari the next time I wear it. At least I have a dress (long, Nina Ricci) for the ball. I will try to get something from her (on sale) for the wedding as well.

Well, how was your trip to Peg Leg Bates? Did Bernice get back in time to go? How is Mary and Clarence? And what is wrong with Clarence? I hope he is better now? It has been very, very hot here as well. And you know it never gets very hot

in Paris. But we have been having heat like in New York. The children have been to the beach every single day. David still doesn't know how to swim, but Alexei is something else. Jan went with them yesterday and she said she had never seen anything like it. He just marched into the water like a little tank and the water just kept getting higher and higher and he just kept going. They would pull him out when it got up to his nose, but, he would have kept right on going right over his head—"the indestructible"—that's him. And he is almost swimming. He can float on his stomach and he kicks his legs. He doesn't have the arm movement yet.

I have to get all David's books for school. He goes into the first grade in September and has six books to buy! He'll miss Jan's little boy (although they don't go to the same school) who will be in school in Rome next year. Surely David will spend at least one school year in London for his English later on (ten or eleven) and if I could, I would send him for a year in the States, but it just isn't possible in the public schools and if he was in private school, he would have to live in anyway and so it wouldn't be much point and it would be a hell of a lot of money.

I haven't heard anything from Daddy these days. I wrote him from Algeria. I also sent him some pictures. We saw Françoise in Avignon. She stopped off to see us at the hotel since she was starting on her vacation and driving south toward Spain. She has rented a house there for two weeks near Malaga, on the sea. It sounds very nice. One of those package deals: cottage in a sort of compound which has maid service, swimming pool and dining rooms so you don't have to cook if you don't want to. Caterina loves the sea. They left the three of them: Gerard, Françoise and Caterina, the last day of July. Gerard is so funny. I can't think of a better person to spend a vacation with. I have rented him the little flat on top of the studio for the winter while he is rehearsing and acting in a play in Paris. It is very good like this because he is never there. I just got a long letter from Françoise who is very happy with the arrangements in Spain and the house and all. She will probably stop here on her way back.

We have been reading all about the Kennedy case—and Europeans being naturally suspicious, you can imagine the reaction here. Even the Americans were very cynical. But it really does seem like the Gods are out to destroy the Kennedy's—what's left. I wouldn't be surprised if he thought he could have gotten away with the whole thing. It is certainly the actions of his friends and all the people who live off the Kennedy legend who come off worse: as well as those who hope to cash in like the district attorney who decided three weeks late to make an inquest. Really! It is all too disgusting.

Well, Henri Cartier-Bresson and his bride-to-be are not doing the thing!! Another runaway bride…Remember? She got cold feet or something at the last moment and the whole thing was cancelled. We saw him in Avignon where he was working and he was in quite a state. It is probably all her psychologist's fault. I must write Vicky. I owe her a long letter from way back. She wrote me that she had gotten a job as editor of an underground literary digest. I am writing

for more details. At least I hope she is not as bored as she was. I expect she will be over this way sooner or later. She said in September, but with this new job, I doubt if she will be able to make it. Tamara is expecting any month now. I forget which exactly. Judy Kipper is off on vacation in Saint Tropez. Well, write soon with your news. The children miss you. They send lots of love as does Marc. I can't wait for Alexei to start talking. That is going to be something else!

<div style="text-align:center">

XXXX
Miss you—
B

</div>

1970

The beginning of my signature sculptures emerged after the Pan-African Festival in Algiers, where I determined to resolve the contradictions inherent in the idea that there was a fundamental separation between art produced by mainstream artists (White) and art produced by artists labeled "Black" and the ensuing argument about what if anything was so-called Black art. There was no such thing, I believed—and could prove it—and the idea that there was was as stupid as listing rhythm and blues and pop music separately, one for Blacks and one for Whites. I had other concerns—how to release what were basically abstract configurations in bronze from the tyranny of the base or the "legs" that transformed the sculptures into the surrealistic figures of the 1960s. I had developed a casting process that was almost unique of sculpting in direct wax, and now the final hurdle was this. I had to hide the armatures that held up the sculpture. I invented a skirt of wool which when combined with the bronze assumed a surprising transference that metamorphosed the wool into the weight-carrying material and the bronze into the ascending or floating material. The philosophical ramifications and structural bravado were perfect. When I added the light playing and luminosity of skeins of silk thread, I had found my signature sculptures.

It was fashionable to insist that sculpture and painting produced by professional artists of color should have some naturalistic, stylistic, or indefinable and recognizable "Black" element, realistic, folkloric, or political. This left abstraction and abstract expressionism in limbo as the province of White artists, the owners of "intellectualism." Not even the appreciable influence of ancient traditional African art was allowed. American abstraction was considered too cerebral for Black artists.

I was exploring the dynamics of opposing relationships, the imperceptible movement of raw silk and light, the transformation of weight from one material to the other, from passive to active, the metamorphosis of power from one to the other, the transformation of one material into another, the "literate" and literary transformation of dynamics into a new form.

I was excited and pleased. I had been devastated by Malcolm X's assassination and impressed by pan-Africanism. In honor of these two things, I titled the first bronzes with silk (I used both real and synthetic silk) sculptures as *Monuments*

to Malcolm X. That is how I exhibited them first at the Bertha Schaefer Gallery in New York and then the Hayden Museum at MIT in Cambridge. What I had done was simply to have integrated a vision of a highly unique, original, world-class technique with a title taken from the international headlines in the context of the worldwide Black Movement, even if it was only symbolic. But the sculptures created a firestorm of controversy fueled by a reactionary art critic of the *Times*, Hilton Kramer, who pronounced them "Too beautiful and too sophisticated with too much 'French sensibility' to ever have anything to do with Malcolm X." As usual, my innocent, artistic quest had became a cause célèbre. It would not be the last time.

The gauntlet was thrown down. Editorial letters were exchanged in the *New York Times* and *Art in America*. Discussions, arguments, and counter-arguments erupted on the "role" of visual artists of color and what they could and could not do. Or should and should not do. My position was that I was free to do what I pleased and that no political agenda especially a racist one was going to stop me. This was the first time the word "expatriate" was applied to me. There were dozens of American artists living in France, England, and Italy. No one referred to them as expatriates. Why me? Why not Cy Twombly, Andy Warhol, Man Ray, Stuart Davis? They were all labeled international. I believed I too should be considered without borders—an American internationalist.

No one mentioned the fact that without being able to use my technique, which could only be produced by Italian master bronze founders like the Bonvicinis in Verona and in Milan, there wouldn't be any sculptures at all, since their exorbitant price in the United States would have been prohibitive and there were not the craftspeople or bronze foundries to cast them. There was no way either through craft or money, time or technique that I could produce these unique sculptures that belonged everywhere in the world in the United States.

MIT's poster for the Malcolm X exhibit won the annual Art Director's Prize for best poster design. I would continue to fabricate my bronzes in Italy for the next four decades. Not because I was a so-called expatriate but because I had outsourced to Italy for cost and craft... which included my own persona.

Thursday, March 1970 [no date]

Dearest Mother,

I am sending your jewel in a separate package. You should get it soonest.

And here is the family portrait. Pretty funny. I hope to see you in four weeks!! Keep your fingers crossed.

I miss you already.

<div align="center">

XXX

B

</div>

P.S.—You must stop in a jewelry shop and get him to put an eyelet on the chain for safety—the little thing that fastens at the back. It just slips on the chain. I didn't have a chance to get one before I left.

Paris, March 11, 1970

Dearest Mummy,

Home at last! I was so tired from talking I had to stay in bed for two days! Just like Grandma. The children came back on Sat—round toasted and beautiful. David passed his first star from the National Ski Institute first in a field of 53! With 48 ½ points out of a possible score of 50!! Marc was so proud. I hope Marc manages to take him skiing for a few days during the Easter vacation. We are going to the country quietly to see our lake (which has filled up and is very beautiful) and our dog (Sian which means peace in Chinese!) so the kids will be happy although I would have liked some sun. I'm too tired to go look for it. Maybe the weather will change. As of now, it's cold as hell.

Did I tell you the exhibition at MIT is the 10th of April in Boston. Also don't forget the television the 28th (or 29th for you). The *Tuesday* article I will let you know when I know. Also any other interesting things—

April 5th, Paris 1970

Dearest Mother,

Happy belated and cold Easter. I heard from Noma that the weather is cold in the States as well. Here is an Easter message from David. And thank you so much for the card. Alexei is bad and beautiful. Both children have very good complexions from the country air and so on. I am taking Alexei to see the director of David's school to see if he can start kindergarten next September. We had a very quiet holiday, cold and sunny. Marc and I both in a kind of stupor. But we both have to snap out of it. I have to be in Boston on Friday for the MIT opening, and he has the cover of his book to finish. Did the television program come off? I will call you from Boston or New York when I arrive. There is no need for you to come up what with all the cold weather and plane strikes etc. I don't know how long I will be able to stay, it depends really on events and I might as well enjoy the last months of Christiane. I will probably arrive Thursday afternoon in Boston and come down to New York on Monday or Tuesday. You could meet me in New York the end of the week, or I could come to Philadelphia. This will be my last trip to the States for quite a while. We may go to Cambodia in the fall and I have to work for this museum show in Geneva next May. It sounds a long way off, but it is not. I am so happy you liked the jewel. Wear it in good health. Also look out for the

article in *Tuesday* magazine. It should be coming out one of these days. No other news. A great tragedy in the family. One of Marc's closest family friends and distant cousins lost one of their sons in a canoe accident—drowning. I remember him well from the wedding of Antoine's daughter: the most beautiful and brightest of their children. Twenty years old. Very sad, and very stupid, but one cannot prevent twenty-year-olds from taking risks and this particular sport is very, very dangerous, you know it's riding the rapids in a little canoe that you are attached to. Françoise was beside herself. She, along with Jean's son Christophe and Antoine's son, Patrice, had just spent several days together at La Carelle riding and she was the first one to arrive at the scene of the accident. One really has to live from day to day, life is so full of disasters and surprises.

No really new projects on at the moment. I am going to try to redo the kitchen this summer while we are in the country. Our new lake is beautiful and the house is in good shape as we have had friends living in it this winter. Kiss Bernice for me. See you next week.

<div style="text-align:center">

Love, love,

Barbara

</div>

1971

Traveling in celebrity circles in the 1960s and 1970s, I was amazed at how different my reactions could be, ranging from indifference to Salvador Dalí to exasperated affection for Henri Cartier-Bresson, who woke us up every morning by calling on the phone to see if we were up. He reciprocated with "I love her but sometimes I would like to wring her neck."

Why was there such a maternal reaction to Giacometti, who slept with the lights on because he was afraid of the dark? I remember every second of my first and second meeting with him and have completely forgotten the afternoon I spent with Le Corbusier.

I first met Alberto Giacometti in 1962, as a very young woman newly married to Marc, who had asked his mentor Henri Cartier-Bresson to look after me while he was away on a photographic trip to Cambodia as I didn't speak a word of French. Cartier-Bresson took me to see Giacometti at his studio at 46 Rue Hippolyte-Maindron in the 14th arrondissement in Paris.

It was the most rundown, decrepit habitation I had ever seen—made of wood planks and an iron roof, crumbling stairs and no windows except a skylight. It was tiny, no more than five meters by five meters. Everything was covered in plaster—the walls, the floors, the ceiling—and the first time I saw him, he himself was a walking Egyptian mummy, entirely white, covered in white plaster from his shoes to the Afro curly hair on his head: his clothes, his hands, his feet, and his cigarette, which dangled from his lips and from which a long curl of white smoke escaped. The last time we saw him alive was in late 1963 or early 1964 wandering through the great dome of Milan as if he was lost. We raced up to him and asked him what was wrong? What was he doing there all alone?

"Maestro, can we help you?" we said.

"I've lost my train ticket for Gaubunden," he said.

We bought him another ticket, fed him high tea at the Biffi Scala in the galleria, and put him on the train to his mother's house in Borgonovo.

Why do I remember the gentle sweetness of Pierre Cardin, who became a collector, and can't think of one thing François Mitterrand said to me?—or be moved by the ravished beauty (not a trace left) of Lee Miller but not of Julie Man Ray's splendor?—by the jaw-dropping, heart-thumping surprise of Jose-

phine Baker singing "I Have Two Loves, My Country and Paris" while forgetting I met Bertrand Russell in London—twice? There were celebrities like Ben Shahn who became collectors and Man Ray who lived down the street from us and who was family. I swooned over Alan Bates' looks and took the archangel beauty of Robert Redford with a grain of salt—stunned by Stephen Boyd but indifferent to Charlton Heston's watercolors he drew on the set. Physical beauty in any and all shapes—female, male, or genderless, always moved me. Intellectual genius I also considered a kind of Beauty. But I fell hopelessly in love with Sandy Calder, my neighbor in Saché. What made me stand transfixed before the white-suited, white-haired presence, abjectness of Ezra Pound and only giggle with James Baldwin, my heart's hero? I stood in jaw-dropping adoration before the old Henry Miller and not the young Alain Delon. Dizzy at meeting Zhou Enlai and not the king of Greece, weeping over Simone Signoret's faded looks but not Jeanne Moreau's.

Sitting at a feast table, I was not celebrity-hungry. For a little American girl from Philadelphia, I was almost oblivious, as if I thought this can't be happening so I might as well ignore everything around me. I spent a lot of the time dreaming, instead, of taking notes or photos. Cartier-Bresson scolded me for being late to my own opening. He was emphatic on celebrity politeness—you showed up, you smiled, you answered questions if you had an interview, you were on time, you wrote thank-you notes, you ate whatever was on your plate. But then he never accepted interviews nor people's invitations to dinner in the first place.

I could never acknowledge the passing of time, which I believed I never had enough of so perhaps this was the reason I passed so much of it in oblivion. Beauty became a narcotic; landscape was wine, architecture was whiskey, painting was cocaine, and sculpture was heroin. Churches, palaces, chateaux, gardens, fountains, frescos, statues, reliefs became my religion and my fix.

The one thing all these celebrities had in common was a kind of homelessness; they were nonspecific entities unto themselves. They "belonged" nowhere, in no time, place, or race. As Man Ray pointed out many times, he loved being an alien. What made them unique, self-contained, enclosed, and barricaded in a universe of their own—what was celebrity? Being perpetually alone in your own world with fame-hungry people milling around you? Finally living with the debris of your own beauty? Was this also the fate of works of art? Of beauty both physical and intellectual and subject to the lens of a camera like Marc's? For a long time, I wasn't disciplined enough to ask myself that. But I began to notice that Marc didn't *see* people except through the lens of his camera and he didn't listen to people except over the telephone…

The Museum of Modern Art in New York premiered the Seagram documentary film called *Five* presenting five American artists: Bearden, White, me, Hunt, and Blayton. In an amazing and ironic closing of the circle, there was Rene Burri of the 1958 Valley of the Kings fame and Marc's best friend to whom we had both

written "Dear John" letters on the same day, announcing our marriage plans, who filmed the artists in their studios. Closely following the Schaefer show was the Whitney Annual, the first time a Black American woman had been included, which led to an invitation by Peter Selz, the former director of MoMA, to do a one-person exhibit at the Berkeley Museum in California.

At the same time, I was exhibiting in Europe— France, Belgium, Italy, and Germany—and Canada. There was an explosion of activity at the Bonvicini Foundry and much coming and going between Paris and Verona. Even my letters to my mother increased as did my visits to the States besides her coming every year to Europe. I even exhibited in my mother's Canadian hometown, Toronto. I retrieved my London friends from my Stirling days and even cast sculptures at the Royal College of Art. James' reputation had ballooned internationally along with his fame, and he had married a colleague architect Mary Shand. Marc's activity didn't wane either, so we kept to schedules that, as my housekeeper put it, "the defense minister of France would keep." Once, we crossed paths in Charles de Gaulle Airport totally by chance. I was coming from Germany and he from India. We decided the kids could wait and booked ourselves into the Hotel Raphael near the Étoile—the best and most luxurious hotel in Paris for the night—with no luggage. Imagine the director's surprise when our passports revealed that we were married—to each other...I was determined to have it all: perfect wife, perfect mother, perfect sculptor, perfect poet, perfect Frenchwoman. And always Queen Lizzie smiling in the background as I danced as wildly and frantically as Josephine ever had, *making things look easy...*

1971 January [no date]

Dearest Mother,

Here is David's letter. He got a wonderful report card this trimester! We are so proud.

It was great speaking to you on the phone. You sounded so well. I'm happy Clarence is back. Give him a big kiss for me—nothing new. I'm working on some jewels. We are going to London on the 5th of February for a few days. I've been dragging around with a cold, but hope to be better soon. Marc is finishing up a new book on Bangkok. He just called me: there is a big fire next door to the place where he is doing the layout of the book. A guy just ran out with his dummy under his arm. It seems it is a huge fire with ten fire engines and traffic blocked for miles. He says he is coming home since he can't work. Did you get the clipping about Reverend Sullivan? I know you don't take *Time Magazine*, so I thought you might not have seen it. Marc just got back with all his tales of fire, etc. The weather here is just beginning to feel a little bit like spring. I'm planning to go to the country next week as they are supposed to put in the telephone at last! Rene

just cabled me from New York that the rushes of the film look great and that I look splendid! So I'm looking forward to seeing it—saw the new Marlon Brando film *Queimada* where he is absolutely beautiful. The film is gory—I don't think it is for you or Bernice! All about a slave uprising in the Antilles with lots of blood torture shooting, etc. Sunday I was interviewed for an African Magazine here called *Africa Scope*. I'll send it to you when it comes out. It will be in French however. Marc and David went to La Bergerie in Jean's private jet on Sunday to help Françoise celebrate her 50th birthday! You can imagine how thrilled David was. He stayed in the cockpit with the pilots—his eyes all shiny like they get. So it was quite a day for him. He will have his birthday soon. Can you believe it seven years old! Alexei is back in nursery school—on probation...no word from Daddy since Christmas. Work is going okay, but slow. We are going to London on Friday and maybe Morocco for another opening on the 18th of February. I would love to get some sun...And David and Alexei will be going skiing with Françoise on the 1st of March—He may even get his first pair of skis! Write and tell me more about work and school. Also when you plan to come—

Love from everybody.

B

24 February

Dearest Mother,

We are leaving Morocco today Thursday for Paris. I will stay in Paris, the children go skiing and Marc is returning to Algeria to photograph Eldridge Cleaver. But love and will write soon from Paris. Looking forward to a few weeks quiet work.

Love, Love,
B

Paris cold and rainy, 1971 [no date]

Dearest Mother,

So happy to speak to you over the phone you sounded very well. If you can, go to the Whitney Opening with someone (Mary) it might amuse you. You could take the train in the late afternoon and then go to dinner or a show [...] or Faith [...]. I am leaving for the country in a few hours to install the telephone.

Have a hectic time coming up this week with receptions, dinners, and openings every night. Saturday I'm going to a party to show Marc's slides on Morocco—with Moroccan food. The children are well and beautiful. They send you big kisses. Tell Mary's Clarence that I have some more slides for him from Marc. I will write soonest. I want to get this off to you. All my love always,

Paris, 6th May

Dearest Mother,

Your letter crossed mine. Anyway I was happy to hear from you. Can't you really manage more than ten days? Do you have any sick leave you can take now? It seems such a shame that it will be so short. I am calling about reservations and so on—and will let you know.

Marc is back and in fine shape. He had a good trip in Milan—saw and met and photographed lots of people and did a lot of work for me as I am trying to have a show there.

Weather has been wonderful. Tomorrow afternoon we hope to get down to the country.

Haven't heard half of Marc's funny stories yet so I am looking forward to the weekend. René Burri just left here to catch his plane for NY and Sheila should be heading back via Chicago. Her husband Enrique is coming tonight for dinner—having Indian curry.

And happy mother's day. I hope you got everything on time. And I hope it is this weekend...

Give Janet all my love.

I'll write again as soon as I have some news about tickets, etc.

<div align="center">Love and kisses to everybody, B</div>

The year 1972 was monumental for me. Bertha Schaefer, my first dealer, had
died the year before. Schaefer was born in Mississippi, the daughter of a Jew-
ish refugee; I had exhibited with her and the likes of Kenneth Armitage. I had
had my first personal show with her as well as my first museum exposition at the
Hayden Gallery at MIT. The only great female dealer left was Betty Parsons, who
specialized in abstract expressionists, with Rothko, Calder, and Noland on her
walls. She took me on, traveling to Paris and visiting me at La Chenillère because
she was visiting Calder who lived only a few miles away from me in Saché. I could
hardly believe that Betty Parsons, Calder's dealer was tripping across my lawn in
high-heeled red shoes and a Calder red-and-white polka dot dress.

The same year I had walked into Peter Selz's office at Berkeley, and he had
said he had seen the MIT show of Malcolms and offered me an exhibition in his
museum, where I showed for the first time *The Albino*, 1972, now at MoMA. I
also signed a book contract with Random House for a poetry collection, my first.
And finally, Betty Parsons bought *She*, now at the Birmingham Museum, and I
signed with her gallery. At the same time, there was a surge of interest in Europe.
The Dusseldorf Museum mounted a drawing show, there were exhibits in Essen,
Freiburg, Cologne, and the Merian Gallery in Krefeld with Antonio Calderara, an
Italian painter, as well as Documenta and a European drawing show. The Berke-
ley show seemed to spur a rush to display my work with solicitations from every-
where in Europe.

January 18th, 1972

Dearest Mother,

Thanks—all the pills finally arrived. Also got your two letters. There were only
three months' supply. Is that what you sent?

Expect a call from Marc. He left yesterday for New York via London to install
his exhibition at the Metropolitan Museum. It opens the 15th of February, but I
don't think we'll be there. I am checking on the flowers. Am so disappointed you
didn't get them. Anyway it was marvelous to hear your voice and speak to you on

the phone. I gave a great party (about 100 people) for <u>Kynaston McShine</u>, one of the <u>curators of the Museum of Modern Art in New York</u>. Everybody came—gave them submarine sandwiches and potato salad!! And apple pie—they loved it. The most exotic meal they had ever had...All the museum people in Paris and lots of artists, etc. Kynaston was very pleased. Faith is here in Paris still. She'll be leaving soon, still working finishing up the show. It will be a rest for me not having Marc for a week or so! I can get so much work done. I'm doing more jewels, which will be in the show. And the curator of the Museum of Modern Art in Paris is writing an article for *Art News*.

I'm still trying to finish this letter. Got your latest this morning—I did go to see about flowers and I will write Daddy to tell him what happened as I had sent a letter along with the flowers. If I don't write soon—Please remember this is the worst time for the show. Things are piling up and have to be dealt with long before the show opens. Right now I am swamped and Marc too—with his show that opens before mine—

Had dinner last night again with Kynaston and went to the opening of a new "American" restaurant in Paris—hamburgers! And pecan pie, which they tried to make with walnuts—but it didn't work. Am looking forward to NY and seeing you.

Kiss Helen for me and give her my thanks. I'll write in a week or so, things should be a little better. I'll have the article and photos out of the way—

<div align="center">

Love you,

B

</div>

April 2, 1972

Chère Maman,

Please, please forgive the long delay in writing. I can't figure out exactly what's been going on—anyway, here I am—safe and sound. Everyone here is in good shape and leaving for destinations unknown...Marc is going to Israel, David is going to the Alps near Italy to ski, Alexei is going to Françoise and I'm going to Verona to work! Maurie is going to Spain and the *au pair* girl is going to London!!! I sent Forrest another book—signed—and I enclose an invitation to an opening at the Metropolitan Museum called "Gold"—I am supposed to be in it, but the jewels just left today—so I may be out of it! Anyway I'll let you know as soon as I know. Get Forrest to take you—get all dressed up and go anyway—Noma will be there. On the 14th of April (Sat) there is an opening of my jewelry at the Leslie Rankow Gallery. You will get an invitation (108 East 78th Street). I am very happy with the jewels. They look nice. The latest one is silk pearls and gold. I also did two jewels for Velma—that I like a lot. It is a shame I can't afford them. And tomorrow April 3 the Berkeley show opens in Detroit at the Detroit

Art Institute. They also have the film you saw at the Museum of Modern Art in New York. And today I signed the contract with Random House for the book of poetry! It should be out next fall some time. You, Agnes, and Anna are going to be famous. I am very happy about it. I have a very good literary agent, Lynn Nesbit—one of the most famous in New York and her agency is called "Famous International"!! Thought you'd like that. I got a letter from California State University asking me for an autobiography—which I am going to do—I turned up some old letters and my movie contract with MGM for *Ben-Hur*—what a book that's going to be one day… The boys couldn't be more adorable—bad!! Both of them. Alexei had three weeks of ski with Françoise. He is incredible anything that goes straight down, he'll take it. He got his first star from the French Federation of ski! I'm going to get him a crash helmet or otherwise I'll be a nervous wreck.

There was a big story in the *London Sunday Times* on violence in New York that made a big scandal here and was really hair-raising. I don't know what is going to happen in the States. The New York City Park Commission wrote to me to do a project for the subway at 125th Street and St. Nicolas Avenue. That's really what they need: a sculpture they can tear up and beat someone to death with… I'm doing the project because they are paying, but I doubt if it is ever going to be built.

Please go to Las Vegas. It sounds like a nice trip. You'll tell me all about it. I'll write you a long letter from all of my favorite cities: Verona—I want to get this into the post—You know the children have 20 days of vacation for Easter here. So it becomes a really big deal. Longer than Christmas vacation. French kids work harder and play harder than anyone else. Today the high school students were out on strike to protest a new draft law. But I don't think it will turn into anything like May '68—people are too tired and too rich.

I saw *Superfly* the other day—a rip-off of *Shaft*, but the music was good. Haven't really seen any good films lately—not even any good Westerns. Well, I'll have two weeks of seeing Italian films. I will be working on a new show for Germany which is going to be very important. It opens the 6th of October and runs for two months. As the Berkeley show will still be touring in principle, I have to do all new things for October a lot, lot of work. The Berkeley show that was to have come to Philadelphia in May is postponed until the fall. So I may come back for it especially if the book is anywhere near finished. All my friends who don't know anything about publishing, all take it for granted that I got my book published—but all my writer friends are absolutely stunned because they know how difficult it is to get poetry published. Most publishing houses do one book a year. And to do an unknown is practically unheard of. And that I got Lynn Nesbitt as my agent… Vicky is absolutely fed up with me. But even Marc takes it for granted that "of course" I got my book printed. Anyway it is going to be quite an adventure. Who knows what is going to happen. Tune in next to the

June "American Woman" issue of *Vogue* for my next chapter—I love you and miss you—the children kiss you and so does Marc. I'll try to send some money in my next letter. The devaluation really hit me. I don't even want to think about how much money I lost. I can't spend it all in the States. Has Forrest gotten his new car yet? Maurie (Madame Marcello) and her husband have been battling for two months now over a new car. Last weekend they weren't even speaking to each other. I haven't done anything in the house. I'm getting some flood lights for the garden to light up the trees. It's very pretty. And I'm selling my dining room set and getting new chairs and a glass table—that is if I ever get around to doing it. Maurie made me a patch-quilt cotton skirt, long which is very pretty and goes with a patch-work shirt I got from an Indian boutique here and that's about it. I'm not getting anything for spring. Well, I have to get this to the post. Take care of yourself. I'll write soonest—

Your loving daughter—

April 24, '72

Dearest Mother,

Got back home OK. Everybody was very glad to see me. Marc looked wonderful. Just spent a glorious weekend with Françoise in her country house: lots of strawberries and cream and chocolates and cheese and fresh bread and hot baths and long walks and music and good wine and strong tea and flowers and huge beds and dogs and asparagus: the first of the season and new potatoes...I was happy to talk to Françoise. She is in good shape. I gave her the fur jacket and she loved it. Marc stayed on to do reportage and I came back this morning with the children in Antoine's plane. So, we had the whole works. I am now trying to get organized for the coming month. The show at Berkeley is on. There is even a vague chance it will come to Philadelphia. Keep your fingers crossed. Meanwhile, I have a big sculpture to get done for them by this summer. Also a few side trips to do. Otherwise, I will be in the country all summer. I think Forrest is cute too and he will get his picture and pronto. Anything else he wants? He can have it! What does Bernice think? I was really very tired by the time I got home, but I'm feeling fine now. I'm still taking it easy, seeing the children who are adorable. We are going to the country this weekend which is a long weekend: May 1st. I have things I have to plant and we have to get the house ready for the summer. I hope it is in good shape. It seemed to be the last time we were there. Spoke to Tamara on the phone and to Sheila, but haven't seen them since I got back. Also haven't seen Jan or Jeannine. I've just been lazy. Also I had a lot of letter writing to do and since I'm broke, I didn't get my secretary to come in and do it and it took forever. My friend Velma just told me that *Essence* wants to do an article on me here. There should be a couple of interesting things coming out. My friend

from *Harper's Bazaar* said she was going to try and do something for the Christmas issue. Marc is going to go to Afghanistan and Israel and I am going to be going to Verona in Italy to work in July and August. David may go to England to school for a month. It all depends on his new school. But the babies are really in good shape, very cheerful and relaxed and sweet. I have a lot of preparation for the Berkeley show: the catalogue and the photos and text, the jewels and I have quite a few new drawings I want to do.

At the moment, I feel very free as I am not working at all and seem to have whole days to myself although I still seem to run around a lot. Fay was here, you know, doing a tapestry. I saw her when I got back. I am going to a cocktail party at Mary McCarthy's next Tuesday. She has my manuscript. I'll let you know what she thinks. I haven't written Daddy, I must this week. I'm glad he did manage to get up to the show. So, you decide what you want to do for Christmas...I will definitely be through Philadelphia in October: the show is from the 4th of October to the 5th of November. I still haven't made a decision about teaching and staying the eight weeks. I have to let them know in May. I haven't really spoken to Marc about it yet. It would be an adventure. I haven't lived that long in the States since Yale...I'll write again next week. The boys send their love and kisses.

Your loving daughter—

Paris, May 15th, '72

Marc is off to Israel. I am tempted to go with him it is so miserable here—as cold as in January. Two weekends straight we didn't go to the country because of the cold. This weekend is a long weekend and I have absolutely to go. The boys are fine and send their love. Whatever you decide about this summer is fine with me. I think you should go on that cruise. Invite Forrest to go with you. At any rate I will be in the States in late September and will see you then. A nice cover story in *Crafts Horizon*—that I will have sent from New York for you. Still have lots of work to do for the exhibition at Berkeley plus a few other projects that may be interesting.

Write to me as much as you like about Forrest. I think the whole thing is very nice. I may be the mother of the bride yet!

Marc has been going to the swimming pool with David every Saturday. He swims quite well. David and Alexei both swim fairly well. Last Sunday we went to a horse show in Paris. They loved it. David will probably start riding lessons this summer. He would look so sweet—lots of things to do in the house for the country—the garden, etc. I am feeling very overwhelmed at the moment—but I am looking forward to working in Verona at the end of the month and going to Venice for a few days the beginning of June. The children are writing you for mother's day (French mother's day). There was a school visit the other day

and Marc and I went with David to see his classes and his notebooks. Then we went to see Alexei's teacher and to our great surprise, he is first in the class—the brightest and the sweetest! This is the one the teacher used to call me about and say "Would you please keep him for a few days—I can't take anymore!" From the devil, he has become—not an angel but so alive and sweet and intelligent. School is going to be very easy for him—unless he becomes bored. That's the only risk I can see.

Listen, I also wanted to ask you to write me about—or whatever you remember about your father. If you can remember any of the names of his jazz friends. Also where he played and when—and finally what happened to him. But mostly who his jazz friends were and where (in what cities) they played and the most important years... This is for something I've written, but I have to check on the epoch and above all the names.

Also thanks for the clipping about the Philadelphia Centennial in '76. I love your clippings anyway. That's how I know what is going on in your head.

Anyway, write and tell me all about how it goes with Forrest. Don't worry. We'll take care of the dowry and the wedding. Take care and work hard and don't let anything upset you, independent lady—

Love,
B XXXXXX

July 2, 1972

Darling,

I guess this will be waiting for you when you get back home. I am looking forward, finally to a quiet summer in the country. Marc may be working close to Paris as a set photographer on a movie for a month. Anyway, I have plenty of work to do. I just got back from Italy and Germany and the Berkeley show seems finally settled: January 1973. By that time I expect you to have Forrest wrapped up... (smile) or I'll have to do it for you. I thought his card was very sweet. I'll send him one from the country. The babies are fine. David is in London and Alexei is at the seaside with Sylvie and his little cousin Veronique... It is terrible weather here: cold and rainy, so I am happy he is where it is warm and sunny (the south of France). So things are going to be very quiet on the home front for a few weeks. Alexei was very lonely without his brother. They are both staying in the same school next year. David didn't pass his exam although it didn't seem to bother him much, I am sure he would have been proud to have passed. We will try again next year and if it doesn't work, I will change Alexei at any rate and leave David in his same school until the 7th form. You know I saw Venice for the first time last month. It is really an incredible place. I really want to go back as soon as I can. I will probably stop for a day when I go to Verona to see the

sculptures. It is only an hour away by train to Verona anyway. Marc showed up the last day of the Venice Biennale and made a sensation as usual. Then to top it all off after having spent two weeks in Israel, he got an assignment to photograph the pope! Which he did. I really felt it was something out of the dark ages… Michelangelo being summoned to do the Sistine Chapel… Anyway, it was a lot of fun to be able to tell people about it. But nobody invited me along!

I know there are a couple of things you asked me to do which I haven't done including the present for Forrest's godchild, but I lost the letter, couldn't remember the size (you better give me the weight as well) and I will do it as soon as you let me know. Also I am enclosing the poem I wanted the information for. It is part of a book which will probably be published in the next six months or so. What I didn't know, which was practically everything, I imagined and we'll just leave it like that if you have no objections… Let me know what you think. As soon as I have more copies of the entire book, I will send it on to you. So far, it has been very well received and I have hopes it may do well. The whole thing was a big surprise to me especially this particular poem. I did the final editing with Vicky in April and decided to keep the real names as far as I could. Just got David and Alexei's report cards. David is quite satisfactory and Alexei's is excellent, really fantastic. So they will both be in the same school next year again. David seems to be speaking English well in London, so with another year of English at the school, he should be over the hump. I don't think there will be any problem with Alexei at all. Thing is I have to find a new girl for them for next year and for the month of August. I'll try to get someone who speaks English. I do hope you had a good holiday. And Bernice as well. It sounds very nice. How is everything at the lab? All the doctors and everything? As I said, the weather here is just awful. I'm glad the kids are not around. No other news. Some interesting exhibitions coming up next year and I hope, of course, my book.

I'll write from the country. I am up to my ears as usual even without the children. The house is fine. We were down there weekend before last and had a big Sunday lunch with the mayor… The lake is full and now that the farmers are raising horses, it is very pretty to see them grazing in the surrounding fields. We are thinking of getting a pony for David next year as the farmer can now keep it for him in the winter. I will talk to them about it. I think Daddy is ready to contribute. It would be so sweet. You wouldn't recognize Alexei, he has grown so much this past year. Really incredible. And so pretty and strong and brilliant. Not that he outshines David, who has gained a lot of confidence to go along with his great store of charm. He wraps his teachers around his little finger, although I must say, Alexei does too. This weekend we were at Françoise's for another family wedding. Alexei got completely drunk along with his little cousin Veronique… They were talking about how many whiskies they had had and how many glasses of wine and to my horror, they weren't kidding. Françoise said (we had already left as Alexei was going to the seashore with Marc's sister Sylvie) Alexei got a

"sentimental" drunk on and went around kissing everybody and being very tender and irresistible. Boy, is he really going to be something. I remember David got drunk at about the same age in New York one night at Noma's on vodka and tonic.

<div align="right">
Love,

Your daughter
</div>

[TELEGRAM]

July 15, '72

Welcome home your letter and postcard received you travel more than we do have never been to Venezuela how is it letter follows much love,

<div align="right">
Barbara, Marc, David, Alexei
</div>

Paris, August '72 [no date]

Dearest Mother,

I'm writing you another long letter from the country. I am in Paris today to see Marc off to Hanoi. Yesterday we had lunch with the ambassador and his wife. It was fascinating. We spoke a lot about how Vietnam and the resulting war had profoundly changed America and its evolution as a nation. He had some very interesting ideas. Also had a friend here from Berkeley who has a deserter-brother (24 years old) in Sweden where she spent two weeks with him. Everyone here thinks Nixon is going to let South Vietnam down in order to assure his re-election. If he can make peace before November, he will be re-elected and he will do anything for that. Everyone is holding his breath.

Other than that, no news. Did you read the article on acupuncture in last week's *Newsweek*? I will send it to you. I think you should talk to Dr. Johnson about it—for certain diseases especially organ-linked and nervous diseases (like ulcers) it works amazingly well—and since nobody seems to know even what you have. Speak to your doctor about it maybe she has some ideas. Han Suyin just came back from Peking where she had an operation on her gall bladder and various other things and some acupuncture. Since she is a doctor herself, I could ask her about it, but I would have to have a very clear medical description if not diagnosis of what you've got. Dr. Ramsey didn't seem to know and from what I can gather, nobody else does either. If you feel that it is getting worse, then we should do something. But there are a lot of things doctors just don't know and won't know for a long time. Acupuncture works where other treatments don't and sometimes instead of surgery—quite amazing like with ulcers—then there are some things it doesn't work on at all…very mysterious. There are many

quite good acupuncturists in Paris, some of them French and some oriental—They usually combine both Western and Eastern techniques. Think about it.

The boys are fine, enjoying their summer. They are staying with Petou for two days. Alexei is such a clown—you cannot imagine. And so bright. You should read his report card. David gets more charming and beautiful and interesting every day. It is really like talking to a real person now. I have quite fallen in love with him. Both Alexei and David have very, very strong personalities which they certainly are going to keep!! Alexei is enormous and growing every day—both are slim. He has lost all his baby fat. It went much quicker than with David. The house is fine. No new repairs this year, but we hope to buy the lake.

I'll have to get jumping—and working on drawings in the country. It is going very well. The weather is not very good, however. I expect September will be better as usual. I have to go to States at the end of the month for a couple of days. There at least, it should be hot. Walked today down Rue de Rivoli (remember the arcades?) and looked at all the funny-looking tourists! And had an English lunch. I had just put Marc on the plane and was slowly recovering. This time he really nearly drove me up the wall and I was absolutely exhausted along with his secretary, his assistant, Magnum, the Vietnamese, my friend from Berkeley, the concierge, the taxi driver, the travel agent, American Express, the telephone company, the telegraph company, his solicitor, my foundry, and other odd people.

Kiss that elusive boyfriend of yours and give him my love. Will finish this tomorrow.—

Monday, August 1972 [no date]

Dearest Mother,

At last in the country. It is absolutely miserable. We never had such a bad August and August is not the best month anyway. It has been raining like hell and cold. But from what's been happening in the States, it doesn't seem to be any better with all the floods. I wish you would call Vicky in Lebanon (Pa.). I wonder if she had any floods? She is near Fredericksburg and Hershey. I haven't heard from her since June. Anyway, Marc left Thursday for Hanoi and l got a message from him during the stopover in Moscow, but don't expect to hear much as there is only one plane a week and it is very hard to get mail through. One of his hysterical departures as usual. This time we were a quarter of the way to the airport, the one which is far from us, not the other one, and he realized he had forgotten his passport and his money. Back to the house then a race course to the airport. Fortunately the taxi driver was very nice and very good. We arrived in time for him to buy his newspapers, but not perfume. Then I collapsed as usual and went to a movie! David is in the living room with his tutor having a lesson and

Alexei is outside playing with Chantal. I have another little girl, an American, the daughter of the editor of *Craft Horizons*, who is here while her mother is in Istanbul. But it has been a very quiet summer. I expect my friend Gwen from *Harper's Bazaar* around the middle of September. They want to do an article for the Christmas issue, so she is coming. Françoise is in Corsica and Sylvie in the mountains. We have been having a lot of dealings with Jane Fonda since she came back from Vietnam and Magnum has been distributing the photos of her. She is a very nice girl. I'm glad Congress didn't decide to impeach...I guess prosecute is more exact...her although they didn't have a leg to stand on as the US is not officially at war...A fantastic situation. Marc is hoping to pass through Peking on his way back from Hanoi. As I said in my last letter, Han Suyin just got back. She is doing a biography of Mao Tse Tung. I am still working on the exhibition for January. I hope everything goes all right. Am going the 31st to Verona to finish some sculpture including the sculpture for Berkeley. I may go to Düsseldorf for a day or so and perhaps to the south of France. I'll have to go back to Verona the end of September to ship the sculptures and Marc and I will probably take a week's vacation somewhere in Italy, I don't know where. Marc may also pass through New York from Peking, so don't be surprised if he calls you up around the 15th of September...It would be fantastic if Marc had another great scoop. If peace or a cease fire were declared. Not that it wouldn't be a good thing whether he was there or not! I think Nixon would do anything to get re-elected, but the Vietnamese are not going to give him anything on a silver platter. We had dinner or rather lunch at the Vietnamese embassy with the ambassador just before Marc left as I told you and they are so intelligent and so lucid on what's happening in the States. The economic situation doesn't seem to be getting any better as well. The whole place seems to be falling apart. Remember Kermit and Fay Lansner? Well, Kermit, who was the editor-in-chief of *Newsweek*, one of the highest paying jobs in the US, just got fired. Just like that. Fay was here in Paris as a matter of fact, I was just next to her when Kermit called. Of course he gets a year's salary and all that and of course they are not exactly in the poor-house, but neverthe-less...One thing about working for yourself is that you can't get fired!!! Last night I spoke to Fay on the telephone. She is going home by boat on Thursday, so I may go into town Thursday to see her. I have a few things to do. I am doing a lot of drawings for an exhibition in Brussels next spring and I am thinking about having a drawing show in New York maybe. If I have enough drawings. So far, it has been going pretty well.

Tell me how Bernice is and all the girls at the clinic. How is the work going? I thought I had that *Newsweek* article here in the country, but I can't seem to find it. Try to get hold of it and read it. Here, I found part of it. At least there is the date: August 14th. Madame Pillaut must have put the rest of it in the fire...Not much excitement over the collections either. Everything is very classic and wear-whatever-you-want-as-long-as-you're-happy. Pretty dull. The ready-to-wear

collections are much more exciting. I had a raw silk suit made up in a sari by a friend of mine. I had had the material ever since Marc got back from Bangkok three years ago. I also had some silk he bought me made up in a shirt that was that. There is nothing even that I see that I want. Everybody here is wearing platform boots, blue jeans rolled up and baby-doll 1945 sweaters with short sleeves over long sleeve shirts and turbans! Or a scarf tied around their heads 1945-style...and THAT goes everywhere. So much for fashion. All the fashion designers are busy making towels and furniture and wallpaper...I did buy a pair of platform sole boots which make me about four centimeters taller than Marc...I'm still hoping to arrange an exhibition in Philadelphia sometime this year. I have someone working on it at the moment. Betty Parsons, my dealer was here for a few days. She loved the house and the country. I hope things will start moving after Labor Day.

I'll write again as soon as I can, probably from Paris. It goes much faster. Please forgive the long delay in letters. Things just got caught up in July and I really THOUGHT I had written. Normally I have the secretary every week which reminds me to get all my letters done for the week, but she has been on vacation and I just let things pile up.

Your darlings Alexei and David send big kisses and lots of love and so do I. I have new photos which I will send you from Paris on Thursday...

B

19 September 1972

Dearest Mother,

Just a note to let you know everything here is fine. Marc may be in New York in a few days and will call you. The children are back in school and in very good shape. Alexei is turning into quite a character. From what we have seen so far, he is going to be extraordinarily gifted.

Work piles up as usual. There may be a couple of Philadelphia shows coming up this winter and still the Berkeley show which opens on your birthday...

The reason I am so rushed is that I haven't found a girl for the children and I am going out of my mind. I left it to the last moment as usual, thinking my luck would turn up someone, and now I'm stuck. I must say they are very easy to take care of except I am not used to it, especially lunch, so I am a little slow, but they don't seem to mind! They think it's very funny, my peanut butter sandwiches...

The editor from *Harper's Bazaar* showed up last Saturday, and we started working on the story for the December issue. Marc was supposed to take most of the pictures, but he was so caught up in his Vietnam story and all kinds of emergencies that I don't know how many of the pictures are going to be his. Plus, of course, he had to be in some of them.... Next Saturday, I am going to

Belgium with my friend from the Louvre for an opening of Pol Bury (my friend Velma's husband) and the weekend after that I have to go to Verona to ship off the sculpture for Berkeley and then to Düsseldorf for a day.

There will be a big story of Marc's in *LIFE* in a few weeks, so keep your eye open for it and next week's cover will be his (*Life*) as well. Lots of other bitty news, but there is just no time to write. I'll write the end of the week when Marc has left and things are a little more quiet.

Love, love, love,

B

1 Dec. 1972

Dearest Mother,

I'm sending this via New York as there is a mail strike. I got your last letter. David is writing you. I'm so glad the television is an enjoyment for you. I am sending clippings and things soon as I get a minute. Things are certainly hectic with this show, but friends tell me I better get used to it and look on it as normal from now on. In case you're interested I'm in *Who's Who in American Art* and *Who's Who of American Women!* We are all going to Morocco for Christmas finally: Françoise, the children, Marc and I. Caterina and a friend are going skiing in Austria. There is a big drama with Caterina and Gerard. I'll tell you about it when I see you. All I can say is I'm sure glad I have sons and not daughters. I will let you know exactly when I will be in NY. If I have time I will pass by to pick up my coat before going to San Francisco. If not, I'll do it on the way back. Also I hope you'll come back with me. I'll write more about this. Love, love I'll write soon.

B

1973

M y mother was in seventh heaven. One of her doctors at the center connected with the University of Pennsylvania won the Nobel Prize. Dr. Gerald Edelman shared the Nobel in medicine with Dr. Rodney Porter of Oxford for their work in antibodies and immunological science. Religiously, she hunted down every article she could find on their work and pasted these in a scrapbook that resembled the scrapbook she kept on me. I was her daughter but he was her doctor. The Supreme Court legalized abortion with a seven-to-two vote in *Roe v. Wade.* The Watergate break-in and cover-up was all anybody was talking about on both sides of the Atlantic. The French especially remained very fond of Nixon and couldn't understand what all the big fuss was about. Nixon for them was the instigator of the U.S. resumption of diplomatic ties with China, which made him a global hero. The rest was only gossip: no more or less than a three-day notice in the satirical newspaper *Le Canard enchaîné*, certainly not enough to bring down a government and certainly not the U.S. government. The bewildering events that ended with Nixon's resignation or why I was for impeachment were impossible for me to explain to any rational Frenchman.

I completed *Confessions for Myself,* the monumental black bronze and wool sculpture commissioned for the permanent collection of the Berkeley Museum in California, which made me the second American female to have a one-person show in a major American museum, Georgia O'Keefe in 1945 being the first. It was curated by Peter Selz, former director of MoMA, with essays by Geneviève Monnier of the Louvre, Friedrich Heckmann of the Düsseldorf Kunstmuseum, and Françoise Cachin, director of the French National Museums.

That July, several Parisian friends and I sublet the summer house of the *New York Times* chairman Arthur Sulzberger and discovered the island of Speccia in Greece. It was a vacation island for Greek nationals that had no hotels, no public beaches, no cars, no tourists, and one open-air movie house. I rediscovered the astounding Aegean Sea and the pure light I had found on my first trip to Delphi in 1958.

The summer ended with the visit of my editor Toni Morrison and her two boys to *La Chenillère* in August to finish work on the poetry book now called *From Memphis to Peking*. A year earlier, Ken Noland, who was also represented

by Betty Parsons, and I had sat next to Lynn Nesbit, and Noland had proclaimed, "Guess what Barbara's done…A book of poems!" She asked to see them, and that night at 3 a.m., called to say she would take me on. She proposed it to Random House's Toni Morrison, who accepted it. Chloe spent three weeks with me at *La Chenillère* for the editing. Our four boys played together, Alexei and David trying to speak English and Harold and Slade trying to speak French to everybody's mutual amusement. In the sunshine and lyrical light of the Loire Valley, we found a common language for the poetry book but we never found a common language for our tastes in men.

That next summer, we returned to our Greek island of Speccia, where this time we stayed with the Philadelphia couple who lived in Paris and with whom we had become close friends the year before. Between them they had eight children—four of his, four of hers, and none together. The wife, Jessie Vilmorin Wood, was an old schoolmate of Jacqueline Onassis, and every summer she would decline an invitation from her college roommate friend to spend some time on Skorpios, Onassis' island, a ten-minute helicopter ride away, using the heat, a sick child, a previous engagement as excuses, but this year I convinced her to accept Jacqueline's invitation, which included a visit to the *Christina*. "I don't know about you guys," I said, "but I'm accepting…" I had never met the former first lady and I had been pondering a new novel that involved an American president. So despite the heat and the absence of Marc who had flown off on assignment to Cambodia, the helicopter picked us up and landed us on the island Jacqueline laughingly called "The Island of Dr. No."

From Memphis and Peking was to be published by Random House, but they had refused my idea to write an epic narrative poem about the secret slave wife of Thomas Jefferson, Sally Hemings. This was my chance to begin to form an idea of how she would have lived in such a situation from someone who had actually been the enslaved wife of a sitting American president and had occupied the White House. The weekend turned into long discussions on the beach about Hemings, American presidents, love, history, power, enslavement, and above all, historical invisibility. Finally, in her breathless voice, the former first lady proclaimed that I should, *had* to write this story. Toni had predicted it would take me three months. It would be more than four years before all my writing and research would culminate in the novel *Sally Hemings*. It would be another sea change in my life. For me at the time, it was a one-time passion: walk Sally Hemings through the front door of history. As it turned out, it meant a new career for me, a best-selling book, literary recognition, and a twenty-year controversy that shook American academia and how American history was written and interpreted. Neither of us at the time had the slightest idea that we would one day end up author and editor in New York.

January 1st, 1973
Berkeley, California

Urgent:

Darling,

Happy New Year! Did you get our cable?

This is very important so I put it on a separate page:

The box that came from Jacques Kaplan. You must open it, make sure there is a lynx coat with a suede belt inside which I exchanged a large sculpture for, and send me this coat to California by parcel post, insured for 500 dollars. You must find out how much time it will take to get there and if it will NOT arrive by the 20th of January, send me a cable to Paris so I can take a coat with me. I am not going to take a warm coat with me to California!!!!

You should send it:

> Miss Barbara Chase-Riboud
> c/o Mr. Peter Selz
> Office of the Director
> University Museum
> The University of California at Berkeley
> Berkeley, CA 94720

I leave for San Francisco the 15th of January.

Now, for a real letter...

Please forgive me for not writing, but things have been usual here only more so... enough said. The children got their cards and we got ours. Thank you so much. We've had no Christmas in Paris as I worked up until the very last minute. I didn't even leave with Marc and the children, but two days later when I joined them here in Morocco for ten days rest with Françoise. I really dropped everything in Paris, so I am anxious to get back and get things settled to leave. The boys are back and having a great time even though they both had the flu for a while. Today Marc took pictures of them for you, riding on a camel... actually they just look like little Arabs anyway. People are always stopping them and talking to them in Arabic. Alexei finds this very funny... the hotel is very pretty although the service is very Arab which means that it is two hours later than Colored people's time... But what do we care? Last night was the grand gala for New Year's Eve. There were a lot of dancing Moroccan ladies who were having a ball doing belly dances for their husbands. I was very tempted myself. I love Arab music anyhow. The hotel is right on the sea. We can walk out of our rooms onto one of the most beautiful beaches in the world. Vast, with absolutely no one

except a few people riding horses. The sea is very cold and I haven't bathed at all in it. I went down and put my foot in and thought it was going to fall off with the cold. But there is a heated swimming pool that gives onto the beach...Marc bought David a camera and then decided not to give it to him. I promised both of them guitars and guitar lessons this year. I also have inscribed them in the French Racing Club where they can swim and get coaching in swimming. The doctor says they both have the physiques of athlete's bodies, so they might as well be really trained in something and at any rate, they needed the exercise now that school is getting so difficult. So, that's their program for next year.

I will be leaving for San Francisco on the 15th which is a Monday, and the following Friday, which is the 20th I will be in Minneapolis and from Minneapolis I will fly to Philadelphia if I can for your birthday on the 23rd. At any rate, I will call you from San Francisco on Monday. I'll let you know where I'll be staying in Berkeley. How did you happen to see the *Harper's Bazaar* article? Glad you liked it although I haven't showed it to Marc yet! He hates those kinds of things... "Best photographer in the world, etc., etc." She really got carried away. I think she fell madly in love with him anyway.

Tell all the girls at the lab I said hello. Maybe Monday, I can stop by. I heard you have a Nobel Prize winner this year. And then we can go to a show or a movie and have dinner. Just like I've never left Philadelphia...Or would you rather go to New York? I have a very good friend, Alan Bates (remember *Nothing but the Best*, the *Go-between* and *Women in Love*)—who is in a very funny play on Broadway. I could try to get him to get tickets for the 23rd. When I see you, we can talk about you coming back with me. February is such a bad month weather-wise in Paris. It is cold and gloomy. I'll try to see when Easter is, if it is late or early when the children have holidays. There is also Mardi Gras holiday. I'll have to find out when it falls, but that is some time in February. I'll have to get to lots of things in the house when I get back, it has really fallen to pieces since October. But Maurie is fine. I have to do the boys' rooms over and work on the garden. I want to redo the living room at least by this summer. I certainly won't be budging anymore after this trip at least over the Atlantic. I have three shows coming up, one in Belgium in March and two in Germany, two I said? It is three, all very important shows. I may do a drawing show at Betty Parsons' next September. I have to see her and speak about it. As for the projects of Marc, I don't know what he plans for the next few months. He is thinking about making a film on Vietnam with his still photos. He is so incensed with the latest bombing raids. Never can Americans ask "Where were the good Germans?" during the extermination of the Jews. And at least the Germans lived under a dictatorship that had the power of life and death over all its citizens, not a so-called democracy with a so-called free press and a television screen in every living room. For Americans who have never been under bombs, who have never had their own

country destroyed, the only way to make them understand is to drop just one B-52 plane load of bombs on New York City. Maybe then they would understand what they are doing...there is total repulsion in Europe. America has become the most dangerous country in the world.

Tell me how you feel. Have you had any more examinations for your eyes? Have the spots gotten better? What would you like for your birthday? How is Mr. Forrest? Still playing hard to get? Anything I can do? I don't have any love potions handy unfortunately, but I'd be willing to try anything once. Why don't you try a little cigarette of marijuana? It really does wonders, believe me. Nothing like a little pot for your sex life. I'll bring you some from New York and show you how to smoke it. It is also very good for the nerves. Much better than alcohol and you don't have a hangover the next morning...Everything is crystal clear and you've solved all the problems of the world. Hey, no kidding, I think I will turn you on...Forrest too if he's around. For your birthday. It will be a good surprise! Speaking of pot, how is Helen? And Bernice? Give her my love. I hope Whitney isn't coming around the house anymore. And I hope the neighborhood hasn't gotten any worse. I worry so much about that. Would you consider moving again if I could find you something? You would have to move both of you, you and Bernice...

Well, the beach here is very beautiful and we have just taken our last walk. I am getting ready to do the suitcases for the trip home tonight. And tomorrow instead of a bright blue sky, I'll see the dirty gray sunless sky of Paris in winter. Not that I'll have the time to contemplate the sky when I get back. Marc is sitting here soaking a blister on his foot, the children are having a fight over their toy soldiers and I'm trying to finish this letter that I won't have time to finish in Paris and I'm going to order mint tea for everybody in just one minute...

We send you wishes for peace and a healthy new year and all our love and thoughts and hugs and kisses.

Barbara XXXXXX

P.S.—don't forget coat! Or else I'll freeze my ass off!!

Wednesday, February 14th, 1973
Paris

Dearest Mother,

Sorry about the delay in writing. But anyway, got back safe and sound. Everyone here is fine. The boys are perfect. We are leaving for the country on Friday for ten days of vacation (school's out), called Mardi Gras. Have been getting house straight both here and in the country. If the show in Philadelphia develops I may be back the middle of May. Marc is thinking of going to Chile for the elections

there. Now that the dollar isn't worth anything anymore we are buying yen...I can't tell you how wonderful it was to see you. You look so well. The boys loved the books and have promised to write (David). Alexei thank-you note is inside. Did I leave anything in Philadelphia?

When I got back here, I changed everything around (Maurie says I always do that) and have to get to work on the garden. Françoise is in Paris for the day on her way to London for a few days. I had some friends over for her last night. We had a great dinner. Bought a new car yesterday. The old one was really falling apart. Marc called me from Belgium to tell me to buy something quick before it really fell apart. So now we have a metallic blue station wagon (a small one), one more problem solved. Once I get the garden straightened up, the house will look nice. I should do some painting, but I don't have the energy to tear everything up. I haven't really spoken to Marc about your bedroom on the back. I will try to do it next week. Still have lots of follow-up letters and things to do for the States. I will probably go to Italy the beginning of March to start working on the German show. David has started swimming lessons at the racing club of France which later he can really train for the Olympics! I am also going to start him taking guitar lessons. He would probably be very good. I want to get this in the post—We all kiss you and love you!

Barbara—Happy Valentine's Day!

May 11th, 14th, 15th, 1973

Dearest Mother,

Happy Happy Mother's Day! Again, please forgive the long delay. Today I got your mother's day card. Time seems to be going so fast it is incredible. It must be old age. It seems the year just started and it's vacation-time. Already I have to start planning for July August and after that, the year is over. The show which is traveling now, after Berkeley should be in Philadelphia in the fall and if so, I will come over. I just might come for two or three days the beginning of July to Indianapolis for the opening—if they invite me. Meanwhile I haven't heard anything from Betty Parsons so I don't know what exactly is going on. I have a group show of drawings opening the 15th at Betty Parsons. I don't remember if I sent you a card from Verona, but I was there working for three weeks on the German show and after that I went to the country to finish up the drawings for New York which I just sent. Meanwhile Marc was in Israel and then spent a week in the mountains skiing with David. He and David came back looking fabulous! All brown and healthy. David is a whiz on skis. He was the youngest to pass his third star in the National French Ski School. He really is as good as Marc and he loves it. Marc was there when he passed (you know they have to

do this obstacle race with all the flags like at the Olympics) and he said it was the first time he knew what "paternal pride" was... It won't be the last time. And Alexei is fine. A tough little cookie though. He drives Monique crazy. The only one he is really scared of is Maurie... We spent a beautiful weekend in the country last weekend and the week before. The house looks good and Madame Pillault is in fine shape as well. Françoise was here for a conference that lasted a week. She brought back Alexei as she had kept him while I was in Verona. She is as beautiful as ever and fine except that Caterina really gives her hell. I'm glad I don't have any daughters! All the other Riboud's are fine, big and small. Antoine was here yesterday for a film projection looking very handsome and snazzy. He is still buying up everything in sight. He was #13 in size of company in France and now he is #8. He is going to be #1 in a very short time. Next weekend we are going to visit him in Annecy for the weekend. His son Patrice is back in France from Minneapolis and he has invited some friends from Detroit where my show first closed. So I'll have to think of what to wear. Everything here is washed out blue jeans if you can believe it! At incredible prices. I just bought David and Alexei both a pair with the windbreaker to go with it. They look so adorable and it cost me a fortune... David is getting prettier by the day. It really takes your breath away. Jeannine and I were talking about it this afternoon. He is going with another friend of his (Pierre the son of my friend Jan) to Prague for the weekend. It seems there are marvelous things for children (films, theater, etc.) and they will go to school for a day as well. They will be with one of the directors of the Museum of Decorative Arts in Prague. A very good friend of Marc's. So a new epoch is beginning. David traveling... he will do a report for school. It will be wonderful for him. This summer in August I am inviting a whole band of boys to La Chenillère including the two boys of my editor in New York who is Black. It should be a lot of fun....

Later—This is after I spoke to you on the phone. It was so good to hear your voice. I'm glad Forrest was there as well. I just spoke to Marc and it looks like he may be in New York for a few days. We saw Lindsay the mayor of New York the other day here in Paris for a drink. Boy, is he ever beautiful. He was on his way back from Moscow. We had a long conversation about abortion in New York because here in Paris there is a big campaign going on. Marc is definitely going to New York next Sunday from Geneva. I was tempted to go with him but there are no more family fares to New York and as the opening at Betty Parsons is today. There is not much point.

So anyway he will be calling you for sure. He will be running around like crazy as usual. I don't think he plans to stay very long at any rate. The photos are from David's last skiing trip with Marc. He is really very, very good. Fantastic and absolutely unafraid. Skiing gives him a lot of confidence. At last some spring weather. I hope it stays for a while. We are beginning to use the terrace a bit. Had

lunch on it the other day. As soon as I have my definite plans for the summer I will let you know. I know I'll be in Italy some of the time: July—I'll have to see with Marc in a few days.

I'll write soonest—

All our love always—

B

June 19th, 1973

Dearest Mother,

You must think your only child is lost…Just work keeping me from writing. I was happy to hear that everything is OK on the job. Things are getting tighter and tighter in the States and Watergate is not helping things. Marc is in Washington and is trying to call you. He says he never gets any answer…Your grandchildren are in great shape. It is the end of the school year so everybody is a bit restless. Alexei is going with his aunt to the South to the sea for the month of July and David is going to another aunt (Lucette) on the lake at Annecy with Petou for July. I will be in Italy for the first three weeks of July and the last week hope to go to Greece to visit friends with David and Marc. Then in August, we will all be at La Chenillère. My book editor Morrison is coming with her two boys the last two weeks in August, so we will put the last touches on the book. Everybody here is fine and it is hot and beautiful in Paris. How I wish I could see you this summer. But next summer, I am decided to spend the whole summer in the States so that the problem of English gets solved. I think I will have enough work to keep me there, and our friends the Lansner's have bought a house in Southampton where practically everybody that we know in New York goes for the summer. So, as she is always descending on me, this time I intend to move in on her. So, you should have them around next summer. Thank you for the Mother's Day card. You can forget about my birthday this year and forevermore. I'm not having any more until I'm seventy-five. Then I'll pretend I'm eighty-two.

What is happening in Philadelphia. I read about the epidemic of gang wars in Phila. It really sounds bad. And hopeless…what to do? When I think how innocent the children are over here. The other day, Alexei had extra homework to do because he made a face at his professor…can you imagine that happening in Phila?

I heard indirectly from, of all people, Charles Hammock, Doris' brother. It must be the same one. Ask Doris. I got a letter of invitation for a competition for a sculpture (i.e., the new State building of New York in Harlem) and there he was on the letterhead…

It is hot and beautiful in Paris now and we spend a lot of time on the terrace. There are a couple of good openings coming up and a friend of mine (the people

we are going to see in Greece) gave a fabulous dinner party the other night.
I found a very pretty Afghanistan dress with an embroidered front. Very rare
because it is in light colors, almost white. Very pretty. Other than that, I haven't
bought anything. The rage here is blue-jeans of all things, but you have never seen
such well-cut blue jeans in your entire life. Also your friends came. I saw them
twice. Very nice. They seemed to have a good time. The *Vogue* story didn't come
out in June. They decided they wanted more material to make a better story, so
Marc shot more in the country. But *Vogue* is so chancy; I'll believe it when I see
it. At any rate, I don't care. I have very mixed feelings about that kind of publicity.
There is already entirely too much gossip going around New York…Not really
gossip, but the feeling is that I "have made it" etc. There is no point in advertising
the point. It just makes people more nosy and more small-minded. I'm beginning
to get like the French in my old age. I like to be left alone and keep people out of
my business. If the article comes out later, it is better for the book.

Right now, I am working on the German show. I have three big ones coming
up which may make my reputation in Europe. I also signed a contract (exclusive)
with them for a year in exchange for financing thirty new sculptures. As a matter
of fact, I am waiting for a payment to arrive. As usual I am up to my neck in debt.
I think they are going to throw me in jail very soon. I have a letter from my bank
I haven't dared to open! What are you doing for your vacation? I hope Forrest is
going to be with you. I heard from Vicky who is fine and writing. Her husband
is somewhere off in N.Y. State and comes home on the weekend. She says it is an
ideal situation…You know Vicky. She didn't say anything about coming over
here this summer, but the last time she was here, I hardly saw her. Marc thinks
she is a bad influence on me. If he only knew…

We got a mini-tractor in the country to cut the grass. Of course the children
love it. David can drive it. It is just his size! We had a lot of fun with it last
weekend. We had a big lunch to celebrate Petou's birthday and my winning a
competition for the monumental sculpture in Harlem. I think I told you about it
or maybe not. But now the troubles begin. Already there have been two letters
and two hour-long phone calls and we haven't even started! Anyway, you have to
expect that kind of thing with a committee situation. They change their minds or
one person changes his mind every two seconds and there are endless discussions
etc., and endless letters. I suppose it will be sorted out in the end. We'll see.
Meanwhile, the phone calls continue…

Haven't heard from Daddy, but then I haven't written him either. Just no time.
The photo is of me with the wife of Pierre Salinger in the country. They have a
chateau very near us and we went there for lunch not too long ago. Salinger is still
living off his Kennedy past…But his new wife Nicole is very nice (French).

Just talked to Fay on the phone. She's here for the summer. I'm going to have
dinner with her on Thursday night. I have to go…Will write soonest.

All my love,

July 8th, 1973
Speccia

Darling Mother,

We are here, David, Marc, and I, for a week and it is fantastic—so beautiful with
perfect weather and beautiful light a wonderful house and friends we like very
much—Marc was so tired from Watergate and I was tired from Italy. Only David
was in good shape, having spent 3 glorious weeks at Antoine's in Annecy with
Petou. He now swims so well and he is so beautiful it scares me. Strangers turn
around to look at him—stare at him really. I got all your letters and cards darling,
thank you so much and thank Forrest for his card. It was so sweet of him. I did
send you a card from Italy, but I was really in a panic with deadlines staring me
in the face and all kinds of work problems. But everything is straightened out
now and calm and I'm enjoying to no end this week. My friends have insisted on
teaching me how to swim!! I don't know if I will make it by Wednesday when we
leave, but I have made progress. I can swim on my back! On top of that they swim
off the boat so I am immediately in deep water. Yesterday we sailed right by the
Christina, the Onassis' boat or rather battleship! I've never seen such an enor-
mous pleasure-boat in my life. Their in-laws are in town as well with their boats—
each one trying to outdo the other. It seems that Niarchos, Onassis's shipping
rival, has the best one...everything being relative. David is in 7th heaven here
and has learned to do underwater swimming with fins and a mask and a tube and
he is enchanted. He has two friends his own age in this house and lots of older
boys in the other house. The second house (this house belongs to the Sulzberger
family the owner of the *NY Times*) belongs to Jessie and Clem Wood who are
Philadelphia main-line socialites. He still has a brother in Philadelphia who is,
among other things, one of the trustees of the Museum of Modern Art. Very nice
people, I like them a lot. Jessie is an old school chum of Jacqueline. The Woods
decided to get married 9 years ago when they both had already been married and
each had four children—so together they made eight and it was their children
who begged them to marry. Their house here (they live in Paris) is fantastic,
very modern and beautiful. I must take you to Greece one of these days. Noma
Copley has a house on one of the islands as well. Lots of Americans and English
have houses here. No wonder—the weather is near perfect for six months out of
the year.

Would you like to come over for a few weeks in September? Your vacation
sounded so short. I wish you had gone on that cruise with Bernice. How is she,
anyway? How are all the girls at the lab? Tell them I asked about them—I sent
the final manuscript for the book in last Monday just before I left with a big sigh.
My editor will be here on August 15th (in Paris, I mean) and we will discuss the
last details. She has two little boys who are coming as well—as we have been

away so much this summer, I am not expecting anyone else in the country except children. Time here seems to be standing still, but time in Paris goes so quickly, there is never enough. Angela Davis will be in Paris in August and my editor has to see her, so I will meet her. I'm looking forward to it. No other news, everyone is still talking about Watergate & Co. It must be hilarious—and appalling at the same time. Marc may go back again. I wouldn't put it past him. I think I told you he wanted to do some work on the house in Paris. I am fighting it like mad. That's all I need this fall is a torn-up house. Then he will go off to Hanoi or something and leave the mess for me to cope with. Anyway, this spring we did put lights in the garden (in the trees and bushes) and it changed completely the garden, made it much bigger and it's beautiful at night. I only wonder why we didn't think about doing it sooner. And in the country, we put in a new toilet downstairs under the stairway and a new bathroom upstairs in the children's wing for them. I also built myself a new entrance gate: a small stone wall on either side and a criss-cross oak low fence-gate. It should be finished by the time we get down there. It should look very English. I'm going to plant a lot of black pines on either side of the gate this winter and at last we'll have a pretty entrance. Besides this, we haven't done anything. We are really desperate because we think we have Elm blight and it is going to kill some of the most beautiful trees. Marc spent last weekend running around seeing tree surgeons to no avail. It seems one can't do anything about it…It is very bad in the States as well and has been for some time and no one seems to know why. Madame Pillault is still there running everything. I have a great flower garden now, thanks to her. She often asks about you—when you are coming. So, now I must change into my bathing suit and let my friends bully me into getting into the water. They are determined that I shall learn how to swim and one can't really argue with a whole boat-full of people. Every day the boat goes out to a different place and yesterday, happily, it was somewhere I could touch bottom!! Sitting here on a white terrace filled with plants and flowers, overlooking the sea, thinking of you with all my love.

Barbara

August 15, 1973

La Chenillère

Little brown boys playing in the sun,
Playing in the wide green lawn sprinkled
With corn flowers, the pond swollen
Under droplets of light, the deep green
Line of Montrichard forest forming blue haze.

French and English tickle each other,
In phrases and cries, gibberish and shouts,
As strong thin legs rush by hedges,
Circle around oak trees and into rushes and pines
Oblivious of needles, nettles and poison ivy.

No longer four separate supple bodies
But one interlaced mass of young flesh,
And perhaps a football, I don't recall,
I remember the red rowboat inscribed *Beetle*
Lying wet and shiny on a bed of moss.

The swans who think they have the run
Of the pond, sing and whistle love songs
Chirp about their right of way in traffic,
But the children pay no head until
The Black Swan glides along

Regal and male calling in loud shrieks
For quiet and sex from his females
The children not understanding,
Go on playing and screaming oblivious
To the swan songs of rutting

Above their romping and shouting
Lies the vault of a perfect summer day
In chateau, country, the Loire, a chorus
Of white limestone in architectural musicality
Chaumont, Ambroise, Chambord, Blois

Bloody stone songs stabbing the
Centuries when peasants and kings
Romped like those four beyond us
And still believed in Divine Right
We have work to do but we linger

Our drowsy eyes hardly open after lunch
Yearning for a *Negre* to do the work
And write our verses in milk and honey
Drawn from the lazy unending afternoon
Except for strings of hoots and hollers

Rebounding from oak to oak
Bees from flower to flower
How will they remember this taste of La Loire

These American brothers nurtured on
A billion hamburgers—hold the ketchup

They are so different yet so alike, these
Same multi-toned cousins their mothers
Sitting in the shade with mint and lemonade
Who pick a rose and cry "A Rose!"
Is a rose is a rose, damn it!

Don't say that just because you know
The words and can tear off the petals
to count the hanging participles
We are prisoners of Zenda dressed in fancy
Armor ready to do battle with syntax

No more than a sword point away from landing
In the attic of our dreams, Chloe and me
Ready to do battle with sons and lovers
In rustling fields and sand and gravel
Paths leading to the magic of poets.

September 4, 1973
Paris

Dearest Mother,

Just a quick note to let you know everything here is fine, children are still in the country—will be back next week. I think the two of them really had a wonderful summer. We are up to our necks in work—the first show of the year is coming up in about three weeks in Germany. I just spent ten days with my editor from NY working on the book. She also saw James Baldwin and she is the editor for Angela Davis—Marc is supposed to photograph Angela Davis this Sunday. She was supposed to come to the country, but she hasn't showed up in Paris from a tour in Africa yet. Anyway, you'll meet my editor Toni Morrison next year. I think you'll like her. Forrest's flat sounds very nice. Well…you can always move in with him!—Maybe in a few years I can offer him a dowry for you! It used to work!

Françoise went on a cruise for her vacation and is just back—says she could write a book…Thanks for the multi-multi-dress. Can I give half of it to Françoise??!! You crazy lady—Maurie got a kick out of it. If nobody else did. The house is a mess since the summer. We are little by little getting it back into working conditions. Have to paint David's room. Put a new rug in Alexei's room—Things are going up here too!! Especially food and Paris always was more expensive than New York. We are cutting down and so is everybody else. I would

say that your food prices are just about approaching ours! But here clothing is very expensive as well as housing which is incredible. So it goes—Maybe the whole thing will just blow up one of these days—Toni Morrison was telling me all kinds of horror stories about NY as usual. She is divorced and has two boys to raise. She finally gave up on NY and moved to the suburbs so she has a 1½ hour drive to and from work! The boys go to the UN school which costs $5,000 a year (no lunch)!!! It really made my hair stand on end.

I promise a real letter soonest.

Love XXXXX (from David and Alexei)

P.S.—Sunday we made a film with Jeannine and Bill Klein on the kids. We dressed Alexei up like a lady—he was so funny you can't imagine. Then we put David in a bikini with his hair in a 1945 up-swap—he was the prettiest thing you want to see...

October 13, 1973

Darling—

If you pass your driving license I'll buy you a little car. How about one of those Hondas!!?? I am well but terribly busy—that is why I haven't written. I have been in Germany twice—the last time for an opening the 28th and 29th. I have to go back for a day or so, the end of next week—for the 16th of November—After that another show (the same and the USA show now in Indianapolis) at the most famous and important museum for sculpture in Germany. Then...in the spring this same show will be in the States for the book—sure—you can come back with me...Then...the Lehmbruck Museum wants to plan a European tour for their show—plus I am still supposed to do a drawing show at the Kunstmuseum in Düsseldorf—That's it. The boys are fine, fine, fine. Alexei has become long and narrow like David and David is a real person. And what a person. Alexei has a lot of temperament he is not easy at all. The only one in the whole house he pays any attention to is Marc!!! Yet, he is not tough, he is as tender as a peach. So we can't treat him toughly or with violence. Yet he is so intelligent and so sensitive he knows everything and he can decide when to exasperate us and when not to...Alexei's birthday is coming up: October 22 send him money (a dollar) he is fascinated with money. He is obsessed with money. I don't know where he got hold of the idea but it is a rather profound one: that money can buy anything—I try to explain to him that money can't buy happiness, but he looks at me as if I'm crazy—maybe he knows more than me...! The church looks beautiful. I am so glad. My editor Toni Morrison had a very funny lunch with your Reverend Sullivan...I'll tell you about it when I see you—

Hold on to the coat. I'll get it when I come...

Kiss Bernice for me—For the Toussaint Holiday we are all going to Françoise's. It's a long time since she's seen the children or us, for that matter. Don't know what to do for Christmas. Am really working my ass off—Marc is not taking it too well, so I hope he leaves soon...He is supposed to go to the Middle East (of course—any place where there's a war) the 5th of November. And before that to Hamburg. Magnum is changing offices so there is a lot of work, worries, architects, decorations, etc., etc. going on. I put new carpet (red) in the boys' room and white in our room and the hall—but everything needs to be repainted and the salon needs to be redone. They are building a new building next door to us. I went the other day to ask the price of a studio (one room 18' × 15') plus kitchen and bath. It is the same price we paid for our house ten years ago!! I thought maybe for you—or for David and Alexei later on...I haven't broken the news to Marc yet. Still I have the little flat over the studio which will do quite well for the boys later (if they don't tear it down) the whole neighborhood is torn up—luxury flats right and left. Montparnasse is going to look like Park Avenue so we've moved up without moving—Even Galeries Lafayette is right around the corner and the new movie houses—there must be 15 within walking distance... Kisses kisses and love. I mean it about the car.

November 10, 1973, Düsseldorf, Germany

Dearest Mother!

Got your last letter just before I left. I'm sorry I didn't answer your questions. I was waiting to get here to find out if the opening of the show could be postponed until November 24th. I was going to ask you to meet me here! But unfortunately it cannot. The opening is the 16th—And I don't think you can leave that soon. Now—did you pass your test? If you did, I can begin to order you a car here in Germany—a Volkswagen! It is the cheapest way—I buy it here and they ship it to you in the States...what color would you like? Red? White? Silver? Yellow? Let me know.

Now for Thanksgiving. It is not a holiday here you know and the children are out of the house all day at school—David doesn't come home for lunch anymore (he has changed schools) and Alexei still does—and he has Wednesday afternoon and Saturday and Sunday free. David has all day Wednesday free but goes to school on Saturday morning. I think the best would be Christmas...I am trying to plan something with Françoise at her house in the country along with Jan Amoor and her children, maybe Jeannine and Bill and Petou and one or two other friends. We can be 8–10 adults—so it would be good, no? Why don't you ask Forrest if he doesn't want to take the time off and come? There is the apartment of Caterina at Françoise's you could have...! I will write more as soon as I see Jan and see if we can arrange it. We want to borrow from her brother 15 or 20 films!

And spend the Christmas holidays—looking at movies at home (Françoise's). She has built a small theater for the children, which is marvelous. We will turn it into a movie house, rent a projector and invite someone who can run it—No art films—only goodies like *Bullet* and *Shaft* and Westerns...But until I get back to Paris I won't know for sure—but at any rate—count on Christmas with or without Forrest. It would be so good for Alexei. It is true he adores his brother, but is very jealous of him also he is jealous of my time—he never had me all to himself like David. But he seems to like his new au pair girl and of course at Françoise's everybody makes such a fuss over him. But he is very bad sometimes, but you can't really get angry he is so tender and so funny and it is so obvious why he does it. But sometimes he gets on David's nerves...No, in Greece, Alexei was not there. He was in the south at the seaside with Sylvie and his cousin Veronique whom he adores. David spends July with his Aunt Lucette (Antoine's wife) at Annecy (remember you were there) with Petou.

This spring I will definitely be in the States for the book. The publication date is May. There is an exhibition I am participating in April 27th to the end of May and for the book Random House wants to do a big "book party" (New York), but they may do something also in Philadelphia as there is a festival of Women in the Arts the whole month of May in Philadelphia. They want me to do a "reading" of the poems. I told them only with another person—an actress—They also wanted to know if I would be comfortable on the TV circuit. I said yes, that should be fun. I said NO to radio (boring) and as for reading in public that is a big question mark...Anyway it seems my editor got an exceptional "run" (number of books printed) which depends on the salespeople...and now she's very nervous about how to sell them all...Will write soon.

Also Marc will be gone until Xmas in the Persian Gulf. So you wouldn't see him either and the house is a mess. I have to get to it when I get back.

Sunday Night, 1973 [no date]

Dearest Mother,

I hope you understood that long letter from Germany. We are expecting you for Christmas! The children get out of school the 22nd of December to the 5th of January. I am looking into a special tour where you have to leave on a Monday and come back on a Sunday, but is cheaper than the 14–21 day fare...Will let you know. Meanwhile, Christmas will be at Françoise's but if Forrest wants to come you could spend a few days at the house in Paris, no?

Also the publication date of the book is May. Can you take an early vacation? If you can, I am thinking about bringing Alexei with me when I come...it all depends—on his new school, when he is accepted. Also you must bring that coat with you. Also some American corn seed (ask Mary) to plant in the country. We

are draining the lake for a year because the fish are sick or something. I'll ask the farmer who will probably plant corn to plant me some white Virginia corn—they don't have the seeds here. They use corn only for animal feed.

Very pleased with the show and busy with the house—I just wanted to be sure you understood about Christmas. Write me by return mail so I know where we are at...Marc won't be back until Christmas Eve as usual so I'm making my own Christmas present: I'm painting the living room and putting new carpet. As usual I found a packet of little rubies I'm going to trade—incredible I don't know how much they are worth. Anyway I never wear my ring as our lifestyle has changed so much so I want an antique one. Christmas '73—12 years! Can you imagine that—I never thought I'd stay married to anybody for 12 years, but then if I count all the time off I reason it comes to about four years and a half!!!

<div align="center">Love, Love,

B</div>

Write!

Darling—I'm sorry it couldn't be now if you are down, but I got back exhausted from Germany with a new au pair girl, the house in a mess, Maurie hysterical and ready to quit and a bad cold and Marc gone...so let me get myself together here as they say—also and most important—the children are in school all day (David eats lunch in school now) and they have no vacations so you wouldn't have really seen them.

Monday night, 1973 [no date]

Mother—

If you can, bring a Virginia smoked ham! I'll make it for Christmas Eve with cloves and honey. You can get sweet potatoes here and—one of my friends gave a fantastic Thanksgiving dinner yesterday Sunday for about 30 people. It was superb—There is nothing really I need that I can't get here—or borrow—I'm going to have you sewing up cushions. If you can find some face cleaner astringent that I love, but can't remember the name—either 1000 or 2000 or 8 o'clock cleaner or something like that I'll try and remember the name in a minute. Maybe it's 7000 or 8000 I know it has a lot of zeros. Anyway, don't worry about it. I'll find the name. Meanwhile I can't tell you how happy we are that you are coming and we look forward to it with joy.

<div align="center">Love,

B</div>

1974

PART I

My new dealer, Betty Parsons, who replaced Bertha Schaefer after Schaefer's sudden death, leaving me an orphan artist, was a glamorous icon on the New York Art scene. She became godmother, aunt, nanny, nurse, and muse to those who represented the crème of New York abstraction. The poetry book was published with impressive credentials from friends in Paris and elsewhere—Mary McCarthy, Kenneth Galbraith, James Jones, and Arthur Miller—and wide acclaim. Perhaps I had reconciled two opposing worlds: the word and the eye. But I was going to keep very quiet about it. And keep the worlds separated. I exhibited widely in Germany at the Kunstmuseum in Düsseldorf, museums in Baden, Freiburg, Munster, and the Cologne Art Fair. And when I finally exhibited in a one-person show at the Museum of Modern Art de la Ville de Paris, I finally felt Paris was my home. No female American artist up to that time had ever exhibited in a one-person show at MoMA Paris. I included the first *Cleopatra* sculpture based on the Han Shroud poem I wrote on my China trip.

Gerald Ford announced that "Our long national nightmare is over," and Tom Wolfe named the 1970s the "Me" decade. Apple computer, founded by two college boys named Jobs and Wozniak, changed the world as much as Nixon's embrace of Mao. Almost ten years after my trip, Americans were finally allowed to cross the Chinese frontier. Betty Parsons had great plans for our collaboration and my first exhibit with her was a commercial and critical success. After so many absent exhibits in Europe, I could finally share one with my mother. My mother insisted that my father attend the opening, relinquishing that night to him. He accepted and wandered around the gallery in a daze, discovering sculptures he had never seen even in photographs since they had all been shipped directly from Paris or from Verona. He had never seen the *Bathers* in aluminum until then. I finally asked him what had happened to all his paintings I had seen as a child.

"I burned them," he said. "There was no point in allowing them to exist..."

"Bronze doesn't burn," I said. "It melts at 555 degrees..."

January 19th, 1974

Dearest Mother,

Please forgive the long delay...it seems longer than it really is! I can't believe you were here only ten days ago! Everything is as hectic as usual: Marc is leaving for Saudi Arabia on Wednesday. He finally got his visa. The boys have a school holiday beginning the 8th of February and I am trying to organize that. I have Antoine's flat in the ski resort of Val d'Isère, but I have to get them there, have someone to take them skiing and get them back. Jan's little boy will come too and I am sending Maurie, so it becomes an expedition: Maid, nurse, chauffeur (Emilio), four children. God...

If everything goes well, I have the two exhibitions coming up in March, April, and May before leaving for the States the end of May. I will let you know. I saw the Alvin Ailey dancers a few nights ago. They were fantastic. Had the French on their feet stamping, which, as you know, is a very difficult thing to do...I will see them again on Wednesday. The boys miss you and David keeps his hair combed...They are in good shape. No colds or anything.

Just spoke to Françoise about the whole expedition staying the night at her place before going to the mountains. In principle, Emilio drives everybody up there on the 9th. (For ten days.) I got your cable. Did you have any trouble getting back? Was everything OK at work. Did you catch up on the latest Nixon-isms? What an incredible mess that is. And Kissinger just keeps on tap dancing.

I have started taking dance class again and so my back feels much better. David starts his guitar lessons the beginning of the next month and he started his actor's studio last week. Got up on the stage and they couldn't get him off again. Did a whole damned scene in English that faker...Françoise has the wool for my sweater so I shall have it soon I just spoke to her on the telephone. She sends her love. So, I will write again soonest. This weekend for sure. Haven't written Daddy yet, but I will. I have got to get David's guitar first. How did everybody like your sheik?

<p style="text-align:center">B</p>

Monday, 1974 [no date]

Dearest Mother,

Please forgive the long delay: the usual is the reason. Am leaving tonight for London to take the last prints for Marc's exhibition there which opens on Wednesday...Next Sunday, he has a big issue of *The Sunday Times* color section coming out with the photos you saw at La Bergerie...We will send you a copy.

Here, at last are the photos Marc took of you and the boys. I hope you like

them. They are fine. Alexei is skiing with Françoise until the 15th of March. David is delighted to be by himself! I am too! I got your last letter, I'm always glad to hear from you. As soon as I know when I'll be in the States, I'll let you know. You can tell Chris, if you see her, that if she wants to do something at the bookstore, that I will show up if at all possible. I should be there around the end of May. I was so sorry to hear about Lottie. I know how upset Helen must have been. Glad you are still seeing old stick in the mud. Give him a big kiss for me. Ask him why he doesn't come over this year before all that money he's saved up turns completely yellow instead of green! Yes, David got his guitar and is taking lessons. He is even showing a bit of interest in the piano! It has only been standing there for all his ten years.

It looks, from this side of the sea that Nixon is really on his way out. I think the Americans are really fed up with his "Who me?" game. It is really disgusting the whole thing and that worthless Congress standing around wringing its hands trying to decide what to impeach him for when he is guilty of fraud, tax evasion, crimes against humanity with the secret bombing of Cambodia, obstruction of justice, bribery, harboring criminals, conspiracy against the American people, price fixing in the milk scandal: trying to bribe federal and state employees, illegal campaign contributions, extortion, concealment of evidence and just plain theft... Now what more can he do except beat his wife which he probably does... (not to mention setting up a secret police and corrupting the CIA, the FBI, the Internal Revenue, the Navy and the army). It seems we still have our lake. They didn't drain it at all this year. I was really dragging my feet to go down because I was so depressed by the idea. Madame Pillault says the lake is more beautiful than ever. The weather is turning fine. I hope we don't have another cold spell before then. I am sending also the catalogue from the German exhibition.

Lots of problems with the exhibition at the Museum of Modern Art in Paris, but I guess it will all turn out OK in the end. Some of the sculpture has arrived from the States. Maurie and Sandra are fine. Sylvie has had a lot of trouble with her youngest son who was not normal at birth and now at puberty has a tumor, they don't know quite where. He is supposed to be operated on this weekend. He was already in the hospital last week for tests. We all made a great fuss over him.

Antoine has a new toy: a telephone in his car. Now all he has to do is get it hooked up to his private jet! Anyway, it makes him happy. He's called everybody in the family at various times announcing the traffic conditions wherever he happens to be and then signing off as he approaches a tunnel. Then his son borrows the car and makes all HIS telephone calls... I just hope Marc doesn't get any ideas. The telephone is tyranny enough without having it in the car. Where I AM going to put one is in the fucking bathroom, so he can have some peace and me too.

I have given up looking at spring clothes, everything is so expensive. I'll stick to my jeans. Everything is 1945 as if that was such a hot year. But then we are going to have 1930 and the Great Gatsby along with the Great Depression. Well, it

does go together...Never have so few people been making so much money. Class is IN again. Except that how they expect anyone to wear those clothes when there is no one to wash and iron and clean them is beyond me...You have to dry clean them every time you put them on and as no one knows how to iron anymore, I really don't see the point in all those pleated skirts. And all that white... and crepe, and silk and white linen...They must be out of their heads...

Tell Bernice hello for me and give my best to all the girls. I will write again soon. I will soon have the cover (the dust jacket) of the book. It is black and silver. That's all I know...I hope we can sell it to Japan. I'd like that...

Love and kisses...and from your two babies as well.

<div align="center">B</div>

P.S.—The size of the blue-jeans you sent was good.

July 14th, 1974

Dearest Mother,

You must think we are absolutely crazy and insane (did you get the package?) but I am just now getting out of the domestic hinterlands of end-of-school-children's-vacations, new-school-for-Alexei, Marc-in-hospital, no-nurse, new-drawing-show-in-Germany-possible-house-moving (finally no), bills, repairs, vacations for us, David's camp in London, his outfits, packing and unpacking, etc., etc. I really know there is no excuse, but just disconglomeration period. I just hope to get through the next two weeks (David comes back tomorrow), and then leave for a month in Greece and not do anything. Marc is taking David to the Vercors where he was in the resistance and fought the Germans for the 20th anniversary of World War II. All very romantic. Then they will go to Annecy for a few days, I think. I must stay in Paris to finish the drawings so I can leave the 7th. Alexei is still with Sylvie in the South, and Marc will bring him back as well. I have so many letters to write to the States that I haven't done yet. In your last letter, you mentioned that there were things to do in the house. Please let me know what they are, so we can help you. Also let me know if you have any ideas about selling the book in Philadelphia. There might be something to organize with the church or is it too racy-radical. After what is now passing on the screens and on the newsstands, I doubt if anything could shock anybody. I must write to Daddy as well and send him Alexei's class photo. Now that he has changed schools, he won't have any classes in English which was a waste of time. I plan to speak it at home from now on. He is so much sweeter than he was. All of a sudden, he calmed down. I think the new school will be great for him. Poor thing, we always forgot there is almost four years difference between David and Alexei and he is at this moment only six! I can hardly believe it. Anyway, he is

very good, and sweet and adorable. David as well. He was so happy in school last year and did so well (3rd in his class). He still has his spelling problem, without which he would certainly be first. We are trying to help him again this year so that it doesn't hold him back as the psychologists said he is a brilliant boy. I am trying to get enough time to finish the second book (also poetry) before the end of the year at least, but the accumulation of things to do is just overwhelming. Then a friend of mine and I had the crazy idea to swap houses! Her kids are much older and are leaving home and she has an enormous house (really, in the end a white elephant) and I was seduced by the idea of all that space and she wanted something much smaller that she could run herself, but when it came right down to it, the house was impossible, Maurie wasn't happy even though she would have had a flat in the house for herself, Marc thought we were crazy as did her husband, the children were unimpressed and HER children always thought the house too large and imposing. And there was no garden and I felt closed in. It also meant a loss of independence for me as I had planned to have my atelier in the house, a plan that Maurie pointed out would never work! Anyway, at the last, last minute it fell through much to everybody's relief. It would have been easier to swap husbands than houses. Then you realize how difficult it is to change lives with even your most privileged friends (her husband is a research scientist very famous in his field which nobody knows exactly what it is because the whole thing is secret). She is about to have a nervous breakdown and I really wanted to help her out, but looking at that house, I figure I would have the nervous breakdown and better her than me. I told her to tear down a few walls, redecorate or just leave it. Her husband is very happy there. At least she did fire the maid who was, I think at the root of the trouble. The maid gave her an inferiority complex plus nothing to do either for her husband or her children. A dream situation if you have a job and are not neurotic which was not the case. So I guess I'll struggle along with bossy Maurie in the space that we have and escape to my atelier when the ceiling falls in around here. Marc never said yes or no, he just let the whole thing collapse of its own weight. But it was a house that had really impressed me seven or eight years ago as the only other house in Paris I really wanted. Yet looking at it now, it struck me as cold and dead and it would have taken a hell of a lot of energy to change it, if it had been possible to change it all (and I'm too tired). What I really liked was that I would have had a bathroom all to myself... my dream. The house had seven!!! And the boys' rooms were divine and there was an extra bedroom. But finally there were no more rooms than here and not enough space for my atelier which would have been in the garage with very low ceilings and in the middle of the house. Then there was a big Magnum party and Marc's hernia. Well, I think everybody in Paris now knows about it and he has the LBJ habit of going around showing his scar. He does have fantastic recuperative powers, as he is back on his feet bouncy as ever. Those nervous kinds always do, it must be their metabolism. He

did stay 8 days in the hospital which was very good. It gave him a good rest. He looks much better coming out then going in!

Getting back to *From Memphis and Peking*. The Black press in Philadelphia hasn't done anything, if you know anybody involved. At least it would sell some books. I don't expect any great literary reviews, but I should try to sell at least a thousand copies in Philadelphia area and poetry books are the most difficult to get published, the big publishing houses like Random House publish only one or two poetry books a year while they have thousands of titles, and the most difficult to get reviewed in papers, and the most difficult to sell. If I had written a novel, I wouldn't have any problems... or at least not such big problems. But then THAT would have been too easy. Anyway, '73 has really been a hectic year (I count from June to June) and I am exhausted. I can hardly wait to get to Greece where I can collapse. We won't be spending hardly any time in the country, but that's that. I am always working in the country anyway, trying to keep up with Madame Pillault. Rene is there living, as his house is not finished so the house is not empty, at least. But Madame Pillault is disappointed. We are her movies.

Give my love to all the girls and tell them to get their friends to buy the book. I will let you know if I come back to the States in the fall, but I doubt it unless I am invited. We really should do a book party one of these days.

The weather here has been terrible, raining and cold. Last night we went to see *Soylent Green* with Charlton Heston. What a terrifying film. We came out and Marc said quick to Greece! It is about the year 2022 when New York had a population of 40 million people with half of them out of work and people sleeping in the streets like Calcutta and there is no sun only a kind of perpetual haze and a temperature that's always around 90 degrees. Go to see it if you can. It will make you think about blue skies... and vegetables and beef and flowers! I am sending the catalogue from the Paris show under separate cover and some of the reviews of the show and the reviews of the book. But the German catalogue will be even nicer with just drawings and poems. I will write again soonest and please forgive me for the past weeks.

September 14, 1974

Dearest Mother,

Don't be surprised by the New York postmark... there is a post office strike on in France since three weeks... Telephone as well, so this is being mailed by Magnum New York after having received it in an Air Freight package from Paris. People are mailing their letters from Belgium, etc., etc. You will get one from Düsseldorf too. Everything is O.K. but getting tight for this winter. Everyone here is pessimistic, fuel is scarce, we are getting only 80% of last year's oil delivery and very expensive. The French and the Italians are spending their money like it is going out of

style (and it is). And of course, the English are muddling through as usual. I have a proposal from the State Department to do one or two (or three) tours in Africa with drawings and poems, etc. I'll let you know if anything happens...Love to go somewhere warm in February. Marc is at the moment in Algeria, will be back next week. I have a new show (proposal) in Tehran, at least that's where all the money goes...We may be in New York the 14th of November for the opening of a photography museum in New York. I won't know until Marc gets back, but at the ratc of things, I'd just as soon go now and spend the money rather than wait for the air fares to go up again! At any rate, the children are magnificent. Alexei is getting prettier and prettier every day. He has caught up with David and maybe will surpass him. His features now are very delicate now that he has lost all his baby fat, and his face is oval instead of square like it was. I keep his hair rather short... and those eyes...devastating. The Riboud clan is all OK. The husband of Sylvie, who is a stockbroker, got robbed the other day...very unusual for Paris, but they got away with 60,000 dollars...enough to have a nice Christmas. It seems from the police that they were amateurs, but George, her husband, got a nasty knock on the head, he and her son-in-law both got tied up, locked in, and scared shitless. Because you never know with amateurs, they were very nervous and had a lot of guns, all shaking. But after they got the money, they calmed down a bit (nobody could find the key to the safe, and then when they did, nobody know how to open it), so much for security precautions. George didn't even know the combination to the safe! Anyway, as the telephone company is on strike, it was the only reason we could get through to Françoise...life and death...She will have a good time with that story as nobody in the end got hurt.

The boys are doing wonderfully well in school, Alexei as well as David. Fantastic report cards and Alexei is very happy at this new school. It has worked wonders for him. I am enclosing the blue jean size of Alexei and David. Blue jeans are so expensive here, they are out of the question. I thought you might get them a couple of pairs (Wranglers or Levi's with flared bottoms, not the straight ones I got last time they are too tight around the ankles). You would make Alexei the happiest boy in Paris. I would pay you back. Of course if I come on the 14th, I can get them myself. But just in case...I should come for the book, which is not selling very well, after a good start. But as we have had no mail for three weeks, I don't know what is going on. But I guess the world is going on. It took me five hours to get back to Paris from the country on the new auto route and I was two hours late for Mary McCarthy's birthday party (surprise) for her husband. She practically had a heart attack, she is so New England punctual. I told her I was on C.P. time...She thought it meant Canadian Pacific, but I straightened her out on THAT. So, that's all the news. It is cold and rainy here. It has been a horrible, cold fall. I want to plant some pine trees in the country before it is too late. We have one tree to cut in the middle of the lake. Madame Pillault is fine: as fresh as ever. She always asks about you, Maurie too. Finally

Marc is leaving for NY tomorrow and I am not. I may follow in a few days, but meanwhile I am sending this with him just in case xoxoxoxoxoxoxoxoxoxo. The post strike has been on for 21 days now!

<div align="center">Love,
B</div>

17 September 1974

Dearest Mother,

As promised... It was so good to hear your voice on the telephone. I told the boys you had called and we had a long conversation. I will get them to write this evening. Why don't you send me again the address of Maurice Simpson. I have lost his address and I will forward it to the publicity department of Random House. Try to remember. If I come back to the States this winter, I will try to arrange a few things. I found that two weeks is not enough to get things really moving. One must stay a month at least, and with the children, that is not too easy. Anyway, I just got back from Germany from the opening of the drawing show which was a big success. Everybody very happy. Lots of people at the opening. I told you over the phone, I saw James Baldwin there as well briefly. I will see him in the south of France next time I get down there. But there were a lot of people at his lecture. Practically all of his books have been translated into German including his latest one.

The boys were so happy in Greece, I can't tell you. It was really a dream vacation, to be on the sea, only to have to walk down a flight of stairs. Both of them swim very well now and David did some skin diving. They will continue to take lessons at the Racing Club this year at least. Then we'll see. It is hard training for them, not like going to the pool to play around, but it builds up stamina and keeps them from having colds in the winter. Alexei is delighted with his new school. He is always so happy to be able to do what David does. I am trying to get them settled down for the winter, but for a short trip. I am supposed to go to Spain the end of the month as well. So, it depends on how things go. Maurie is fine. She sends her love and says to tell you she is still taking care of this crazy household... that is if she doesn't go crazy herself. Her husband and baby are fine as well. I haven't really seen Françoise this summer. I spoke to her over the telephone about Caterina who took a trip to India this summer and is just back. I had lunch with Jan, who sends her love too. She was in Arizona this summer in July. David really rides very well and he LOOKS terrific! Of course! He is learning to do all these fancy show formations and he looks so elegant, it is a crime. If we go down to the country this weekend, he goes back to the local riding club if it is not too much of a come-down. In Greece he was with some other children who wanted to play musical chairs; his reply was that he only plays musical chairs on horseback!

I am pleased to hear you are going back to the mini-university this fall. But LEARN HOW TO SPELL PHILOSOPHY please. I saw Alvin Ailey while I was in New York and we spoke again about the ballet. He has the whole ballet, costumes and all and would love to do it. The only problem is the 100,000 dollars to produce it! The costs of theater are so high it is incredible. When you think of the rehearsal time: for thirty people and the musicians, then the sets and costumes and the stage movers and the electricity and lighting, the rent for the rehearsal hall and then the theater, the publicity, etc. We would be lucky if we could put it on for that and probably, it would take three times that, 300,000 dollars...So you see the problem. He says he gets it out every once and a while and looks at it. I have put it in the back of my head until we can do something about it.

Of course I decided not to change houses, it was just too much trouble and I didn't have the physical energy even to contemplate it. Besides, I had everyone against me and it didn't work for studio room anyway. But we all had fun. It is very difficult to decide to live in someone else's house. Either you make it into your own and that takes enormous work and energy and money, or it doesn't work. It is like trying to wear someone else's clothes. I would like to try it one of these days, but now is not the time.

Now really is not the time to make any move. Prices are rising here before your eyes. It is terrible. From one day to the next. And nobody seems to know how to stop it. I've stopped going into the department stores all together. Not that I have the time to do it anyway, but I get reports from Maurie who threatens to quit shopping for reasons of health. Between her nerves and high blood pressure...

The kids just came home from school and are having their tea. I had coffee with Sheila this morning after I dropped off the boys. Hers went to Minnesota for a part of the summer and to Mexico where we got married. She brought back a picture of the church, it is still there to say the least. The little town is booming. Her daughter has what I would like David to have—both an American and an English accent in English which she switches back and forth. She also speaks German and Spanish as well as French.

Had a wonderful lunch with Antoine last week who is in good shape—at a very elegant restaurant near the Madeleine Church, remember where the Trois Quartiers is? With his son Patrice and Marc in a private dining room. And speaking of private dining rooms, I promised to tell you about the trip to Skorpios and Jacqueline and "Ari." Anyway, my friend Jessie where we stayed in Speccia is an old school friend of hers and Jacqueline calls every summer to invite her to the island and she never goes. But this year they had been together with them in Egypt for Christmas and I said I would like to go, so I finally talked her into it. They sent a private plane for us to Athens, then we changed into a private helicopter to the island (meanwhile, Marc had gone to Cyprus) where Jacqueline met us at the helicopter pad in a white jeep and a bathing suit. Jessie and I were being

very cool about the whole thing until at the last minute, then we panicked about what to bring! Anyway, we decided no jewels and the minimum. So that's what we did. The lady at the Athens Airport couldn't believe her eyes when she saw we only had two suitcases for three people! Actually everything was, as they say, "simple" luxury. That means a bamboo hut with a butler hiding behind it in case we need anything. When we arrived, we took a swim and saw the guest house (pink on the outside and white on the inside) where we were to stay and the staff (five) to serve us. I had a beautiful room (all white and off white with a huge canopied bed and white voile netting over it). Then we took a tour of the island which Jacqueline calls the "Island of Dr. No." The next day she took us on a tour of the boat, the *Christina*, which should, by all normal calculations, sink under the weight of the marble bathrooms alone . . . It has a crew of thirty, two dining rooms, four suites, a doctor and an operating room. It also has two enormous fireplaces, two living rooms, a nursery and a circular stairway that is four stories high, as well as the usual swimming pools (one for the staff and one of the boss), etc., etc. The island itself is very beautiful and peaceful, but it was really bought so that the boat would have a home. It is only lately that Jacqueline has managed to make a home on shore. And even so, the French chef refuses to set foot on the island and cooks all the food on the boat. The butlers then have to drive down to the port to get it, bring it back, heat it up again and serve it. Ari is very gentile and very nice especially with the ladies. He has a weakness for champagne, other than that, he is as simple as the Godfather. So . . . I took to her very much and we liked each other. She liked very much the poems and so did Ari. There was only one other couple so it was very quiet and peaceful. Quite nice. Jacqueline and I talked a lot on the beach about the Sally Hemings project of mine.

She looks good. She is very slim and still has those eyes. He had been ill, but he was much better when we saw him. Nureyev had just left, soured off by the war. So, my dear, this is all my news at the moment. I want to write to you more about Speccia next time and Winston Churchill II.—

> Love, love from us all,
> Your crazy family.

September 19, 1974

Dear Mother,

Everything fine. Children are settled down in school. Marc leaving for a week in Africa tomorrow for independence celebration. I think I will take the children to the country tomorrow if it stays nice, bring them back on Sunday night. I may leave myself the end of next week for Italy and Spain to see several foundries for work. I have an offer from the State Department to make a tour in Africa (East) maybe, including South Africa. Should be interesting. Also a project for

an exhibition in Tehran in Iran. That interests me. Went to a big party for the Belgian cultural attaché in Paris as he is leaving for Belgrade. It was the first party of the season. I just felt like getting dressed up and showing my beautiful face! Went with Françoise Nora, my friend who was with us at La Bergerie last Christmas. She had been in Colorado this summer at Aspen and I hadn't seen her since she got back. The weather is still good. I hope it lasts a little while longer. They are building a new apartment house next door to us, so we have to get up early, there is so much noise. This is the last one, as there is simply no more room. Noma was in Europe this summer, but I didn't see her. There were less people that came through town, or maybe we were just away. I think I told you the German exhibition travels in Germany. On the 18th, it opens in Baden Baden, then I expect it will go to Münster. I am hoping it may travel in the Scandinavian countries as well especially Stockholm. I would add more drawings as it goes along. I am trying to finish the second book of poems, so I can start on my Sally Hemings project which should take me to the States soon. But I haven't really gotten down to work yet. Maybe now that the children are back to school. I also have some work to do in the studio to get it organized and so on. It will take a few days. Try to remember to send me the address of the public relations man you mentioned, Simpson...I will try to contact him for this winter. I hope Helen is feeling better. Give my love to Bernice and all the girls at the lab. Also say hello to Doris for me and the children. Do you have any plans for Christmas? I don't know what we'll be doing. Maybe skiing or maybe in the country. Alexei, I can't tell you how much he has changed. He is adorable. His face is much slimmer and he looks more and more like David. He has definitely gotten better looking and as he says, he has reached "the age of reason" (seven years). Thank God! Anyway, he is delighted with school and I think he is going to do very well. I will get Marc to take you a picture of him in his little red gym outfit with the name of his school on the t-shirt. Also, I don't know how tall he is going to be, but he has the biggest feet for a six-year-old I've ever seen! He is going to be at least six feet if not more. Petou, Jeannine's little boy, got thrown out of his school, so David and he are not together after all. After all that trouble. Jeannine finally told Petou he was adopted. I don't know if she said it just so as not to be taken by surprise or if it was really true (which I think it is) but anyway he said he already knew. It hasn't made him less nervous at any rate, but I think they waited much too long to tell him and if he didn't know, he sensed something. Children are much smarter than you think. Finally they know everything that goes on. After all they have nothing else to do except to look and listen. We always forget that. How is Bernice's grandson? And all your little godchildren? I am happy you will be going back to the mini-university. Can you get another degree for your work? Maybe you should take some more courses in that. Also I would love to know your official title. My friends ask me what you are and I don't even know...Everyone here sends love and kisses. I am going to call Françoise tonight and see how she's doing, I haven't

seen her all summer. I just talked to *Vogue Magazine*. I hope the article they did finally comes out. I'll let you know when they let me know.

Love, love, love,
B

[TELEGRAM]

23 December 1974

Darling Mother,

Happy New Year. Will see you the end of January. All our love and all our thoughts.

Your adoring family—Marc, David, Alexei and Barbara

28 December 1974

Mother,

Did you get the plant for New Year's? Happy Happy New Year and a new beau. Marc told me to tell you try and write down all the details of the legal problem with Daddy and he will take care of it when he comes in February. The least you should be able to do is SEE the will! He may and probably does, owe you the whole thing. Your grandsons are terrific and send you lots of kisses. I am in Paris at the moment and it is very warm. Trying desperately to work while Marc and the boys are not here. They are all in the mountains skiing. Françoise too. There is a big family wedding... the second generation. My sister-in-law now only has seven more weddings to go. Anyway there was a big wedding feast and the children stayed up until three in the morning eating foie gras (didn't like it) and caviar (nasty stuff) and drinking champagne (that they liked). I dressed them all alike: Marc, David and Alexei: blue blazers, beige trousers, pale blue shirts and school ties and black loafers. It is the first time David and Alexei ever had a tie on... It is so strange to be writing again. After the two-month postal strike, one gets out of the habit. I must say, it was wonderful not to receive any mail including bills. I have some really nasty ones... You got Alexei a "computer" for Xmas and David a radio repair and experiment set. They were delighted. I plan to be in the States at the beginning of February and will call as soon as I arrive. I don't know where I'll be staying maybe with Noma. I'll let you know. Anyway, try to come to Marc's opening sometime between the 12th and the 18th of Feb. I'll let you know. I will be there before as I have a lot of things to do. I hope you have been going out and ordering *From Memphis and Peking* like mad. You don't have to pick it up, just order it... Jacqueline gave it to all her friends for Xmas... Marc had dinner with

her at Maxim's when she was in Paris, while I was in Italy and he saw her again in New York where he escorted her to the opening of this new museum, the International Center of Photography, run by Robert Capa's brother, Cornell. Last time I saw her was at the Rose Ballroom at the Gala for the American Ballet Company. She got John Ashbery to escort me. Otherwise, Marc is still running, running, running, he got into a big "verbal" fight with Henri Cartier-Bresson, which was in all the papers and now they aren't speaking to each other. Everybody in Paris has taken sides and it has become a cause célèbre as they say and the whole thing has gotten out of hand. Anyway, a lot of letters to the editor, etc.

The boys are fine, they love school and are doing very well. Alexei is as skinny as David. They both ski very well. Better than their father. I am supposed to leave for Africa the end of February for a tour for the State Department. Did I tell you? To French-speaking Black Africa. Smart-ass Marc says I won't like the natives… But it is true that a lot of American Blacks run into trouble with Africans, both think the other is stuck up. Well, I have an invitation to South Africa as well. Marc is hoping to go back to China in the spring for a new book for *Life*. I promise pictures soonest (ones that you can show…). Both boys are taking judo lessons and they love it. At least it tires them out twice a week. Both are just as skinny as I was. Alexei has lost all his baby fat. He is getting much better looking and probably will be as good looking as David in a different way. His face has lengthened and gotten more oval or heart-shaped. He will also be much bigger than David. They both wear the same shoe size as it is! Alexei just won't be as angelic-looking as David. Probably not as photogenic either. I'm thinking about getting David in the movies…support his old mother. Both are doing very well in school and love it. There's no reason why they shouldn't, it is the best school in Paris, but very strict especially with the parents. The school was founded 100 years ago for French Protestants coming from the Alsace Region of France which was more German than French. It is a private school, but compared to private schools in the States, the fees are nothing. There are no uniforms, but they do stay for lunch at school instead of coming home. They go alone on the subway or bus. It is three stops, but in good weather, they can still walk. Jeannine's son Petou got thrown out last year, so he isn't there anymore and David sees much less of him. But he still sees a lot of my Jan's son, Pierre, who is eleven and in the same school.

The tour I'm making after New York beginning March is for the State Department and ole Henry.* They haven't decided the countries yet, but one will certainly be Senegal and the Ivory Coast. I am looking forward to it. I've started to get all my shots starting with yellow fever. I'm taking everything they've got just to be on the safe side. The only one that makes you ill is the cholera one? Happily I am just next door to the Institute Pasteur where they do all the tropical ones. So, let me see what else. The children haven't been sick all winter, Alexei had a slight cold, but neither of them had the grippe. Marc thought he had caught a bug coming back from Nigeria, but it turned out to be nothing. The mail is

beginning to come in droves, which is a pain. It was so great when there were no letters. And strangely enough, there seemed to be less phone calls too. People just relaxed and gave up. You couldn't call long distance anyway. But now, I am buried in mail mostly bills I could do without, anyway, I am trying now to wade through mine while the children are not here. I did get a card from your friend Minnie and wrote back. I didn't have their address. I explained it to them. The children loved their blue jeans. Alexei could even have been a size smaller. He likes them tight across that nothing fanny of his and the more patches the better. Keep up the good work in school and let me see some of your papers when I come to Philly. Save them for me. Finally all my love for 1975 with that of Marc and the children added. One never knows... it might even be a good year, except for money. At least people will be doing a lot of thinking.

Kisses and love, B

*Kissinger.

PART II

My first encounter with Jacqueline Bouvier Kennedy Onassis took place in 1974 in probably the most privileged, secluded, protected place on earth, the Greek island Skorpios belonging to her second husband, Aristotle Onassis, with a backdrop of arguably the most beautiful private vessel in the world, the treasure-laden *Christina*. That summer, we were visiting our best friends from Paris, Clem Wood, an American writer, and his wife, Jessie de Vilmorin, and their eight children, on the island of Speccia, only a helicopter ride from Skorpios. And every summer thereafter, Jacqueline would call us up and invite us to her island, which she laughingly called the Island of Dr. No, and with eight children plus my two, plus cousins and assorted child friends, brought the total in three summer houses to fifteen. There was never a summer when a child emergency prevented us from accepting the invitation. But to my surprise, this year was different, and this year I would sit on the deserted beach at Skorpios guarded by the thirty heavily armed sailors of the *Christina* and explain to one of the most privileged and protected woman on earth what I thought it had been like to be an enslaved American woman of color, the absolute property of one of the most powerful white men in existence—the third president of the United States, Thomas Jefferson.

The Onassises had greeted us at the helicopter pad, this mythic couple both dressed in white pants and black t-shirts, framed by the *Christina*, and beginning after lunch I was drawn into a conversation with the woman who would eventually be the impetus and instigator of my escorting the then-invisible Sally Hemings through the front door of history and controversial fame.

Why it should have been this particular woman remains even today a mystery to me and a subject of amazement at the unfolding of this story.

But after lunch, sitting on the beach while boats filled with paparazzi circled the island with telephoto camera lenses that resembled bazookas, I told Jacqueline the story of Sally Hemings, my desire that the world know who she was, and my own frustration at perhaps not having the skills or the stamina. "I'm a poet, a sprinter—not a long-distance runner," I said, "and no one seems to be interested in the life of an American Revolution–era enslaved Black woman." Random House, my publisher, had turned down the idea. Toni Morrison, my editor, had washed her hands of getting me an advance. I had begged every writer I knew to take on the story, including Morrison—everyone was involved in their own projects. Finally, it was Morrison who said, "You've been talking about this woman for years. Why don't you just sit down and write it yourself? How long would it take? Three months?"

It took three years from the time a concerned Jacqueline Onassis had turned to me and said, "You must write this story," to the time it was published at Viking Press with her as my acquiring editor—the second job of her life, the first having been as first lady of the United States. I realized that sitting beside me in a black one-piece swimsuit was one of the few women in the world who could explain political power and ambition, American sex and American autocracy, the back stairs at the White House and the intolerable glare and flame of living history. Who else? And she listened all weekend, and she asked questions and took notes, and we forged a friendship that lasted twenty years, through more than one book, and that spanned the rest of her life.

By the time I had finished the manuscript, Onassis was dead, and Jacqueline was back in New York with a job as an acquiring editor at her friend Harold Guinzburg's publishing house Viking as a balm for her second widowhood.

She had been calling my agent Lynn Nesbit for months, asking if I had turned in my manuscript. The day I did, Nesbit sent it to her, and Viking bought the rights. This, more than anything, protected its fate. No one except Jacqueline and the editorial and production staff at Viking had seen the manuscript nor knew its subject matter. It was safe from controversy and censure until the day the first proofs were sent out. So no one had or could or did destroy it. Pandora's Box and the question of human property and Thomas Jefferson was opened forever.

The Jeffersonians made the mistake of attacking the book instead of ignoring it and sealed its fate as a bestseller, with a million and a half copies in print, and a Literary Guild Selection. By this time, Jacqueline had left Viking over their publication about a fictional failed assassination plot against Ted Kennedy. She could not stay, she said, as Viking chose the thriller over her. Jacqueline was not allowed to take me with her. So I remained at Viking.

And if we hadn't sat on that beach on that weekend and she hadn't nudged me to keep going and not to give up, I might have given in to victimhood and never

finished what I had accidentally started, which of course resulted in the famous DNA testing by Dr. Eugene Foster that proved me right. And Sally Hemings took on a life her own, a historical life for which I am eternally grateful.

We used to laugh a lot about the fact that I could never get my mouth around "Jackie O." "You and my mother," she would say, "are the only people in the world who call me Jacqueline."

I pronounced her name "Jack-line" with an accent on the last syllable using the French pronunciation. We would sometimes lapse into French with each other, and she would pronounce Barbara as "Barr-ba-rra" in her soft and deliberately inauthentic Swiss finishing school whisper.

We found that we had mothers who resembled each other and who had instilled in us both the golden rule of survival: never accept the role of victim. Or as my grandmother had put it, never letting people know you are carrying a heavy burden, "Making things look easy is a matter of politeness, letting people know you are carrying a heavy burden is a third-world attitude toward life."

In other words, great tragedy you accept with bravery, victimization—never!

Little did I know that day I met her sitting on the beach together on the island of Skorpios, gazing at the purity of the Ionic Sea, watching the paparazzi circle the island again and again like sharks that my life would be changed more than once and forever by her and the eighteenth-century enslaved Virginian Sally Hemings. "You simply have to write this book. You must tell the story of this woman!" she said.

And if Jacqueline were exploring her DNA today, her North African ancestry would probably draw one of her enigmatic mischievous smiles. Even though she insisted in the 1960s that this side of her family was Jewish. She had thick, unruly, curly hair that she managed by straightening and heavy lacquering to tame it into her 1950s signature coiffure. But the curly roots were always lurking at the temples in what Black women called "the roots going back." Insanely beautiful in real life, cool and passionate at the same time, able and willing to make a strategic marriage, intelligent, fatalistic, and brave, she switched from one of the most elegant, refined, and beautiful men in the world to one of the most vulgar and physically ugly yet fascinating ones, and then back again at the end of her life. One of the last things I wrote about her was in a long poem *Helicopter*, my elegy to violent, life-changing, non-negotiable events and tragedies of human existence—my *Wasteland*.

The enigmatic and mysterious Aristotle Onassis remained in the foreground and clarified for me many things about Jacqueline and her relationship with such a man. A man who was dead less than a year later, Jacqueline a widow again and a new editor at Viking Press in New York, thousands of miles away from this haunting paradise, having acquired and published the story of another survivor of an earthly paradise for the privileged few in Monticello. Jacqueline had acquired my book for Viking. She and I had begun a long and surprising literary partnership.

America, especially now, owes her the fact of politeness, of bravery, of civility, of physical and mental beauty. She changed my life, she enriched my life, she gave me courage. She helped resurrect the Virginians—both of them, Black and White, male and female—and who knows but that she may still have words for us. Perhaps not on her 100th birthday, but perhaps on her 150th birthday or her 200th birthday, another eternal Virginian, to help us through difficult times and warring epochs and racial dissonances.

So this is the story of our twenty-year friendship until her death on May 19, 1994, and well beyond, with the uncanny involvement with three of my most important books: *Sally Hemings, Amistad: Echo of Lions, Helicopter* and finally this book. It consists of letters written on her blue-and-white Tiffany stationery.

Jacqueline's ancestors Anthony and Abraham van Salee were among the first settlers of New Amsterdam, later to be renamed New York. Abraham was the son of Jan Janszoon, a Dutch pirate who converted to Islam and had a North African concubine of mixed race who conceived Anthony. Anthony arrived in New York in 1664, perhaps the first Muslim in the colonies, and found success. He was described at the time as tawny, half Moroccan, a former Black slave, and "mulatto." One of the Van Salee descendants, John van Salee de Grane, received a formal education as a doctor and joined the Medical Society of Massachusetts, serving as a surgeon for the 54th Massachusetts Volunteer Infantry Regiment during the Civil War.

It is thought that Jacqueline was not the first White House inhabitant with African blood. President Warren G. Harding shared her Van Salee ancestry, as did the Vanderbilts, the Whitneys, and Humphrey Bogart.

A strangely American ancestry, as strange as any Virginian American, full of adventures and boldness, perseverance and ambition, somehow weaving the most exceptional threads of fortune into the uniqueness of the typically American character—the bold and the cruel as well as the free and the brave. An exceptional destiny in an exceptional world that only we could have invented. Our lives ebbed and flowed into three literary adventures, many quiet lunches at home or at the Stanford, a happenstance meeting in the Charles De Gaulle Airport when Onassis was dying at the American Hospital in Paris, a blind date at Roseland with the poet John Ashbery, a date she found for me to cheer me up during my divorce, a photomat picture with my husband Marc when they were in Peking. But mostly letters and words. She, fastidious enough to have her pantyhose and her sheets iron-pressed after her siesta, was always afraid of becoming a bag lady—we both were, but my chances were a lot better than hers. We both adored our mothers and often quoted them, and we both adored our children and felt guilty about being working mothers. Although she was not happy with my divorce, at the end, we both turned to rock-solid men of great stability, balance, and intelligence. Her sense of humor and of irony, her great intellect and funny accent, made her beloved. And her courage made others around her brave.

A note to the Reader:

At this point in my narrative, I had planned to introduce a selection of a dozen or so letters to me from Jacqueline as a substitute for the silent voice of Vivian Mae, but copyright law prevents this.

An astounding thing happened in the aftermath. I recognized that an extraordinary empathy had occurred between these two historical women—one in the public eye forever and the other, never—creating a kind of armor of invincibility around this subject. Nobody knew. Nobody cared. Nobody questioned Jacqueline's little insignificant self-help book project.

Sally Hemings and Jacqueline Onassis had taken on a new and bizarre convergence: I am convinced that Sally Hemings might never have emerged as a historical figure at all without the benign protection of Jacqueline Bouvier Kennedy Onassis. Quite simply, my novel might never have been published at all considering the intense suppression that the story had endured for two hundred years before and thirty-eight years after its publication.

In a sense, Jacqueline had played the role of guardian angel of Hemings. ?

By the time *Sally Hemings: A Novel* was published, Jacqueline had quit Viking, unable to take me along with her, and the brouhaha around Jefferson and Hemings erupted. The Jeffersonians threatened CBS, Viking cut the print run, cancelled the book tour, and declared that the book was "one Black woman's opinion."

Eighteen years later, in 1997, when the celebrated DNA study proved me right, the Jeffersonians continued their attempts to erase both me and Sally Hemings from the American history that they still controlled. We never discussed this. I never had a chance to thank her for firstly championing Sally Hemings, pursuing the project unceasingly, and succeeding as my acquiring editor against all odds.

She believed that this was "normal." I believed that it was right, providential, and brave and that her devotion to me was neither naïve nor triumphant—it was like Vivian Mae herself: steadfast, intelligent, honest, loyal, and Divine.

Thank you, Jacqueline, for having existed, for having made and endured history, the best and the most deplorable—you got the victory.

Skorpios
FOR JACQUELINE ONASSIS

How many pebbles on how many beaches have got wind of us?
How many penny whistles and brass trumpets have made their announcements?
I suffocate under the airless dome of so much knowledge
For after the moon has raced through here
After the asteroids and comets have ricocheted
Back and forth across the arc of the century
What is left for me?
Where is the sailor to navigate my stars?

Where is my felucca and my crew?
Bring me my captain and my children
Bring me that crystal veil of Greek light:
Where my eyes become mouths to savor the spilling sky
Filtering through flesh in spells
Diving under my sweet unanchored Skorpios
My face surfacing through star clover and pale flax
I enter my butterfly-shaped harbor, turning to myrtle like Daphne,
Weighted in lapis lazuli sea lavender and larkspur
Leaving wet tracks on Agamemnon's purple carpet
To lie between lighted lamps for like all islanders
I am afraid of the dark.

Undated Letter, 1976

Thank you for your letter—

We were all so moved by the first half of your book—then, when Sally comes here, those long, long years—how do you keep them from dragging?

Of course I'll stay involved in your book—because you are my friend—but too many editors spoil the book—

Just promise me this: on the most discouraging days—bent over your typewriter—sweating in Greece or Paris—don't you dare ever give up hope—you have something so special there—so deeply and timelessly moving—as are the great novels, operas, ballets—what are all their themes?—all the same—love, hope, jealousy, despair, death—Gian Carlos Menotti said that to me once and I have never forgotten it. So don't you either—and though you have done the research of 100 scholars—in the end your story must be timeless—hit the great themes.

Historical documentation is less important—though I understand so well the reasons why you felt you should underline it.

I have said too much—you will have a blockbuster one day—don't be too impatient—to make a Christmas list—to come on the heels of Roots*—You will give us one of the great romances (—and I am sorry but I believe so profoundly that the great romantic themes are the ones which have the power eternally to move) of American or any history—and if you are 9 months instead of 10 months behind Alex Haley—how unimportant that is—in fact I think it diminishes your impact to come too closely on his heels—*

I have written too much—I send you all my love—I have such a conviction that a book that will change us all and move us forever will come out of your travail—

I wish it didn't have to be so hard. That is what Tom Guinzburg told me to tell you: that perhaps our enthusiasm for your book had been, in a way, <u>unhelpful</u> to you. It might have made you think that writing a good novel is easier than it is—that it could work the first time around. He feels badly—as he loves the book—but feels that great enthusiastic reaction on Viking's part misled you—a first novelist—it takes doing and re-doing + that is demoralising—but it will be worth it dear Barbara—all love

<div align="right">

—Jackie

</div>

WIDOW

Helicopters approached through mist, in a season of Valkyrie,
Military style as befits the passing of a sovereign,
Penetrating the air space of Central Park's oriental carpet of green
Yellow and brown laid upon the hard grid of New York City,

The platoon hovered over the rooftop of 1040 Fifth Avenue
Lifting peaks of vapor from the reservoir's serene depths
Startling a lone cyclist circling the circumference who
Glanced up at the commotion in the sky.

Inside the famous building filled with treasure and angst
And non-entities, History awaits to claim one of its own,
The salons filled with courtiers and in-laws, loyalists
And children, the ghosts of husbands, fathers and lovers.

As each waited to reclaim a sliver of the ebbing life
Of the queen enclosed in the home hospital sanctuary
Far from the carnivorous press which waited vampire-like in
The cordoned off street below, their telephoto lenses lifted like spears

Pointed towards the windows of the empress once exiled,
Banished but never forgotten nor forgiven, the eternal
Widow for the ages, our Lady of Camelot now
Reclaimed, redeemed, reconciled, redoubtable

Her courtiers hold silent vigil suppressing the weight of
A justified wail for the legend about to depart
Her purple sails already filled and ready to sail,
The predatory press primed for one last cruel photograph

Gliding softly by, the Helicopter necks
Stretch like plunging herons unfurling in serpentine
Splendor lifting her frayed soul upwards towards
The shimmering city of light she loved.

The widow flung her arm across my chest
And closed her Modigliani eyes,
Below, Paris spread like a Maelstrom left and right
In the Frankensteinian light: The Invalides, the Grand Palais—

I'm dying she said, her infantine voice more of
A whisper than in life, the secret held like a cactus holds water,
"Look, my widow's peak is gone I'm bald"
She said, "I'm bald and I'm gray, no one will believe it."

She adjusted her headscarf tightly knotting the ends
Now there was nothing left but a royal purple hajib
The rich thick black hair had fallen like peony petals
Having first turned Stone White.

The Helicopter's insistent whine hummed overhead
As it descended upon the rooftop unnoticed by the crowd
Distracted by the CBS and ABC trucks and the strange
The herons perched on the roof's cornice; their necks entwined

Like Golgotha mourning the mighty harvested like mere mortals,
She is real, she is flesh, she is gone
No magic can save her, no miracle drug or potent guru
No Parthenon of gods, no religion or lack of such,

The erasure of a trillion words of truth and lies,
The beginning of posthumously, a different kind of fame
The mortal beauty she was notorious for dissolving
Into the purple shroud marking the end of life,

She plucks the sheets as she patiently waits
For her last breath so she can repeat for the last time,
His name: "Jack Jack Jack, I love you Jack."
Arlington's eternal flame reflecting in her eyes wide shut,

Leaving it for the ages, her pale hand settles into mine
Softly curved around the secret of the century,
Carrying with her like the cancer,
The knowledge of who killed J.F.K.

L ife's transformations come in all sizes and shapes. Sometimes one perceives those changes little by little and sometimes they fall like thunderbolts from the sky. It was only years later that the effects of an Italian summer storm over Lake Orta would have a life-changing effect on me. But this was far in the future on that day I walked across the Luxembourg Gardens toward the south entrance flanked with its gold-and-black grill and found my dream house at number 3 Rue Auguste Comte, an Art Deco building overlooking the gardens.

"If I have to spend the rest of my life in France," I thought, "this is the street and this is the building I would live in, high enough to see the gardens." When the next day in *Le Monde* I saw an advertisement for an apartment that turned out to be on Auguste Comte, it seemed the miracle to my quandary of how to change my life without changing my life. But change usually produces more change and unexpected collateral damage and consequences, and from that moment, everything seemed to accelerate in incredible convergence and upheaval.

We sold our house on Rue Vaugirard to a young couple returning from Rhodesia who wanted trees. I sold my atelier on Rue Dutot. My mother arrived to tell me she was seriously contemplating marriage with someone at Temple University Hospital. I was leaving on an exhausting five-country U.S. State Department lecture and exhibition tour. On my return, she had sent a newspaper article about an old high-school sweetheart who had been murdered by his wife over his affair with another woman. She had then taken her own life. There was no comment from my mother, as if to say events like this don't happen to people we know.

I encountered Jacqueline by chance on an Air France Paris–New York flight only to learn that Onassis was in the American Hospital dying. I moved into first class, we sat together on our way back to Paris almost in silence. Was there anything more to say then?

Suddenly and biblically, the trees at La Chenillère were struck with Dutch Elm disease and began to die. Trees both oak and elm fell around me, then family and friends, then my own private life. I realized our triumphant marriage, our romantic gamble, our extraordinary adventure was ended as winter followed fall without either of us being able to explain exactly why. For the boys' sake, there

was no question of separation. We had a new, beautiful home, discontent would pass. Work would solve everything.

The "double life" my marriage was taking, or rather consuming, continued to take its toll: long separations, frantic travel, less and less time with the boys, less and less reason to communicate as a couple. Marc's initial interest in my work (as long as it was considered a "hobby") no longer converged with his ambitions and demands. Isolation set in and became permanent. A bond unraveled like an endless bolt of silk from a sumptuous Fred Astaire and Ginger Rogers movie to Bessie Smith's blues to *The Girl of the West* tragic opera, in three acts with more and more farewells and departing arias. Yet Marc didn't seem to notice, or care.

The trees of La Chenillère continued to sicken and die. They had to be felled one by one in leafless genocide until the beautiful stone house stood naked and forlorn. Only the artificial lake remained, placid on the surface but teeming with growth beneath. Everything was denatured—the farmhouse seemed a mockery. The children began their own independent lives; absence became the rule, emptiness the measure, incomprehension the vine that grew like the wisteria covering the walls. I decided I didn't want to live there anymore nor work in my atelier. More than one friend advised against making a principle out of an impulse. But what else, I asked, could one base one's actions on except principle. "Reason," everybody answered. "Be reasonable" was the plea. Think of Marc, think of David, think of Alexei, think of your mother, think of your sanity, my family on both sides of the Atlantic insisted. My husband thought I was crazy. But I knew I wasn't crazy. Right or wrong, life would go on. The sun rose and set. Queen Lizzie's words came back to me and became cant. "Making things look easy is a matter of politeness. Letting people know you are carrying a heavy burden is a third-world attitude toward life." Waiting, I wandered among the severed tree trunks and watched the farmers tear them out by the roots.

February 23, 1975

Dearest Mother,

This is after I spoke to you on the telephone…Found the flat of my life! As a joke, I took the map of Paris, I chose the street in Paris I would most like to live on, the YEAR of the building, the exposition and layout of the flat and like in a dream, I found it the next day! And Marc is talking about not being superstitious! The only problem is the incredible price…not only will I have to sell our house, but the studio and take a mortgage on the country house in order to do the repairs. You can imagine what state this puts Marc in, but he STILL doesn't seem to realize that we are in a desperate situation and that I have no choice but to stay in Paris at the moment for the children. Antoine knows the situation, so I am counting on

his help. He always comes through when I have a real estate problem. I am seeing him tonight and will talk to him about it and I hope he will find time to look at it with me. He is leaving for the West Indies on Saturday… Tonight we are celebrating Françoise's election as mayor of Mâcon, her village, over her brother Jean who has been de facto mayor now for twenty-five years. Well the election is over and Françoise won over Jean by 1 vote—the master of La Carelle lost the election to his little sister—sounds like the *Dallas* television series. Here's to woman's liberation! It has become a family drama, which has split the family, sister and brother against sister and brother. You would have thought she was running for president the way everybody carried on. And she won by ONE vote! It is so fantastic! Will tell all when I see you.

<div align="center">B.</div>

March 24, 1975

Dearest Mother,

I will be in New York from March 27th to Sunday, April 10th. I have a charter. Viking has asked me to spend only six days working with them on the book, so it doesn't seem as if they plan many changes in the manuscript. This being the case, they just might get it out by November. Let's hope. I heard from them a few days ago. So that being out of the way for the moment, I am concentrating on my next problem, changing houses. I just stopped because the real estate agent just came in. I saw a flat on the street where the children's school is, very big, and not bad inside, but on the second floor which is low. But it is a corner building, one of those ole 1926 Art Deco buildings, so it is very light and only a hundred yards from the Luxembourg Gardens, and Bartholdi's model of the Statue of Liberty which stands on one of the paths. It is the only park in the center of Paris, but since no one really takes care of it and the whole thing is getting more and more run down and I think emotionally I've had it with this house no matter what happens, between Marc and I, so we'll see what we can get for it. See if you can get off that week before Easter, the 3rd to the 10th. I have my plane the 10th in the afternoon. I hope we will finish the 2nd as we hope. That gives us a little time. But it will be hard work. Don't let me forget the ultra sheen again. I am all out. I promise to write Pat Gates as well before I leave.

Just talked to you on the phone, so I'll close. Will call you Sunday night as soon as I get in.

Love to Ray,

<div align="center">Love,
Barbara</div>

April 15, 1975

Dearest Mother,

It is now the 15th of April! It is almost three weeks since I wrote the main letter. I am typing up the pages I wrote in the country with my friend Caroline from UNESCO. We have about two hundred and I am not too unhappy about them. I have fallen madly in love with her little girl, her real one, although the adopted daughter (half Black, half Vietnamese) is beautiful. Alexandra came in nine months after the final adoption of Rebecca and is a dream. You will see her. Anyway, she has been at home since the girls, and on a hunch I stopped in to see her. She had called me on behalf of someone who wanted to meet me after several years. So we are working on the text and manuscript. Wish me luck.

Last night had a dinner for a friend of mine, an art critic in New York who gave a lecture here on Tuesday. The boys are fine. They have just come back from spring vacation all tan from the mountains and skiing. We have a long weekend for Easter and so we are going to the country tomorrow. Maurie is fine and sends her love. Still holding on with this crazy family. She gets more like that cleaning lady, Mildred, on television, every day…I am well. I got the New York State Office Building sculpture commission. It is only the model and it is in the lobby of the building, if you get to New York. I don't know what is going to happen now, with New York and New York State so broke. Probably nothing. Nevertheless it is the only model finished.

Nathan's death was a shock to me. I was laughing with Maurie, saying you were getting senile sending me "crimes de passion" as they are called in France. Then I read it again and realized who it was. Shot and killed by his own wife over another woman. Nat! I had read the whole article without realizing it. Also got the card you sent from Pat. I will write to her this weekend. Also wrote to Julian King, who wanted a jewel for his wife's birthday. I didn't have anything available in the States. My affairs there are in a mess. If I can, I am coming in May or June, before you come here. If the book works, I will have to come for that anyway. Next week a friend of mine from Dakar is arriving, so I'll have another dinner. She is in government and I stayed with her when I made my trip last year. I can hardly believe that it is already a year since Africa!

Did you get the catalogue from the German show in Freiburg? I think I sent it to you.

I hope you are well and your little house is OK. I know I promised you a car when you passed your driving license and I hope to be able to buy something for you this summer.

I have lists of schools for David and Alexei, all available. I just have to go to London to visit. They are all quite small with no classes over 15 students and all in the country. In most of them, the school goes up only until 13 years old which is

perfect as they can be together, David and Alexei. The trouble is they both might lose a year here when they come back, if they come back, but we really haven't discussed anything so far. Marc is always too busy. You won't believe I haven't really spoken to him since September! I promise. Françoise sends her love. Marc talked to her on the telephone not me. I, as I said, haven't spoken or written to her since I last wrote to you. I am taking time and getting through a long list of things, the next on the list is to send this manuscript off. Then choose a school for the boys and decide if I am going to move out or not.

I hope you had a good and sunny Easter. We will all think about you in the country. The children already got their Easter eggs from Germany last week. I have two painted ones I'm going to fill with chocolate for Sunday. We are all invited out to lunch on Easter Monday and the children have to be in school on Tuesday.

<div align="center">B</div>

P.S. Your letters:

I am taking care of the insurance for you from New York. I or rather we will carry a policy for you as much as we can, not less than $150,000. Also I am making my will so you are taken care of. Strange that Nat and Elenora both died so young. I will never forget the time you? or somebody, grandma? caught them making love on the bed in my room amidst all the coats… Truly the boys are very well. David went skiing for Christmas and Alexei went to Saint Tropez in the South very pleasantly. Marc was in Vietnam. So much for the holidays. I came back right after New Year's to work and Alexei stayed a few days in Annecy with his aunt before coming back. David passed his third star for skiing. He is really very good. If he lived closer to the mountains, he could probably become a professional or at least make a run for the Olympics. But he is simply too far away. He can only manage to ski three or at most four times a year. For Easter he is going with his school for two weeks near Avoriaz which is very high. He hopes to pass the next degree, but I think it is a little too difficult for him. Alexis is coming along too. He passed his second star during the last vacations. I never saw the children with so many vacations in my life. They just had two weeks, four weeks ago and here is another two-week vacation.

Very strange, I got a long, long letter from Doris Albritton, telling me her whole life since Girl's high school! All these voices from the past. I did a poetry reading in Paris last week (now two weeks ago) with the same poet I read with in Dakar. It was a big success, standing room only. It was fun. David came and Marc took some pictures which I will send. I was at the American Cultural Center. The sculpture for the New York State Office Building in Harlem is installed as of two or three weeks, so if you are in New York, you can go see it. It is in the lobby. It seems the place is guarded like Fort Knox… and no wonder.

My friend Velma is coming to New York next week and plans to spend a day in Paris. She will certainly call you. She's had her own troubles with Pol, her

husband, sort of the opposite of mine, but has things under control now. She knows nothing about mine. Nothing. But I love her dearly. She always cheers me up and prods me on like seeing the advantages in a new pair of boots...May 8th, there is an opening in Montreal of my jewels along with those of Pol's and another sculptor. They are opening a new wing of the museum. I wish I could go. If I do get to the States this spring, I will. I might get a charter Paris–Montreal and then take the bus down if I have a reason for coming which means that something would be happening on the book and I would need to do some research in Washington and Virginia before the summer. Anyway, I'll know more by the end of April if I get anything finished.

Got another letter from you this morning the 22nd. David went off skiing with his school last night, so the house is empty (Alexis left Friday morning with his uncle). We are working on a school in England for the boys, I have several good contacts. It is very important to find the right school. Will keep you informed. It is wonderful about Ray going back to school. I hope he makes it. I would love if you two could get together. I am sure Marc and I could scrape together a little dowry...say a down payment on a new house. Also, I haven't forgotten about the little car, but times are hard at the moment. I hope by fall, I may be able to get it for you. I haven't heard from Daddy either, but I suppose he is alright. I will send pictures as soon as I can. Have some good ones of Alexei skiing. It was very warm here, but has now turned cold. I guess spring isn't here yet.

April 25, 1975

Dearest Mother,

Got your wonderful letter. I am so glad you had a good time at the reception, it was quite a surprise that Daddy invited you to go, but I am very happy, I didn't want you to miss it, yet I felt I should let Daddy get the award for me as it would please him so much. So...dancing until midnight! I was also surprised there were so many people there about 600? Next time, it will be you and Ray (for the Nobel Peace Prize!!!). I'll just let Daddy keep the plaque or whatever it is. If he wants to start investing in plaques, he can have one from *Who's Who International of Art* as well. Anyway, your little soiree was a touching short story. Very nice.

Now, as to the second part of your letter...Mother dearest, this IS the 20th century, second half, as a matter of fact, it is practically 1980. Now NOBODY marries anybody these days without living with them first, so I say, go ahead and find out! You have nothing to lose but a cold bed! It is absolutely Victorian to feel you are compromised by ANYthing you do let alone something so important. You are an independent, self-sufficient, solvent, intelligent, educated, beautiful and sexy lady. You have nothing to fear but fear itself! What can happen? He

comes, stays, and either you get married or you don't get married and eventually he (or you) leaves? So...? Meanwhile, you both have a lot of fun, I have a handsome and sexy stepfather and you get the best of both worlds...You have a house that belongs to you. You can always put him out or go back home to your own... It is simply not the same situation it was twenty years ago. Try it, you'll like it....

Also I am glad you got the check from Daddy. I spoke to him on the telephone before I left for New York. A rather heated discussion that is one of the reasons I thought I should ask him to take the award. I was a bit rough on the phone. I however did not move him to give you any more money, but at least he sent you what you signed for. If I can possibly, I'll send you some more for the rugs and things. Get cream or white or brown or navy blue rugs...not red, at least not with white furniture. What about yellow? What color is the kitchen unit? I like the idea of the black ceiling. A black and white bedroom with green plants would be terrific too...or a black and red bedroom. Then you could have your red carpet, but black furniture and black ceiling. Black lacquered furniture and I'll send you something Chinese for in back of the bed...The idea of recuperating the white kitchen table was a good one, it should look nice like that. I just regret you couldn't have had a whole new bathroom with a dressing table and everything. The more I think about the black and red bedroom, the more I like it. Red drapes too. Then it is like the inside of a Chinese box...very sexy. Might come in handy. Here is really panic time. I am still trying to decide what to do about this competition I won. And waiting for some word on the book and trying to get the children through the last few weeks of school. And keep body and soul together. The children are fine, David especially is in very fine form, doing excellently at school, happy, charming and very self-composed like you-remember-who. Alexei is getting more and more handsome. He is going to catch up with David. He too, is doing very well in school. We spent the Easter holidays with Antoine's wife in Annecy, David went skiing with another aunt and got his "skiing arrow" which is the fourth degree in skiing, where you have to do a very difficult "slalom" (you know, go between all the little sticks with flags in a certain amount of time). He did it in one minute and thirty seconds, the youngest successful candidate. He was thrilled! So that was the holiday vacation. Now about Africa...I'm sorry it has taken so long to write to you, but I was so snowed under and in a daze when I arrived back that it has taken two weeks just to start to get the wheels turning. I haven't seen anyone since I got back except Antoine and Patrice. None of my girlfriends except Velma and then only for an opening. And my desk is still piled up with stuff. Anyway. I had a fabulous time in Africa. Met all kinds of interesting people. I was such a hit that I am invited back immediately. I can leave for Nairobi in May if I like...the cultural officer here said she had never seen such glowing reports. I must say, I worked my ass off too. Traveling, speaking and twenty-five dozen dinners, receptions, lunches, cocktail parties and then off to another country with a whole new batch of people. And switching back and forth from

French to English and French again. I began in Tunisia which is lovely, French speaking, very sophisticated and where I met some adorable people. I got off the plane (after having spent one day in Paris between New York and Tunis, and you remember what New York was like) and was taken from the plane to a reception at the ambassador's house for sixty people. Someone asked me about my name, why it was so strange. So I said it was CHASE like Chase Manhattan Bank and RIBOUD...and the person said "Like the industrialist!" So I said yes, either one is my brother-in-law...This particular ambassador (I met quite a few of them in three weeks) was tall and distinguished and the perfect picture of what an ambassador is supposed to look like. And a fantastic new embassy and house. Very beautiful. I did television, and radio, and there were a lot of write-ups in the papers, both French and Arabic, which gave me a kick as they were so beautiful to look at, the Arabic writing. I sent some blow-ups home, but they haven't arrived yet. Then, I went to Mali (Bamako), which was the most African town I went to. Very far down on the West coast. I had a good time. I met a poet-friend of mine from Timbuktu and we had a ball. Also, the people there are very beauti-ful: tall and very statuesque, thin. Then I went to Sierra Leone, which is "English speaking," but not really. Everyone speaks Creole which I couldn't understand at all...Very ugly town on a harbor a lot like Hong Kong. The ambassador there gave his first dinner party for me. He turned out to have been in the class ahead of me at Yale. He was very young, one of Kissinger's protégés...Very charming. He had just arrived about three weeks before from Rome. I usually met everybody who was anybody in the first few days, the writers, poets, painters, cultural ministers, etc. In TOGOLAND, the ambassador was a woman, fantastic. She gave a tea for all the ministers' wives, then gave a dinner dance which was really scrumptious...The only ambassador I didn't meet was...Shirley Temple Black who was on a trip. I didn't stay in Accra, which is the capital of Ghana, but in Kumasi, which is the old imperial capital of the ancient Ashanti Empire, an old beat-up city, but with some nice people and a very good university. I gave a lecture there and also a poetry reading. There the consul was very nice too. Very young married couple. There I got to see some of the country and some villages. Then Dakar, which is really a cosmopolitan city that was incredible. It is French speaking, of course, and there was a state visit on while I was there...It was there also I heard about Onassis' death. The cultural officer there had worked for the Kennedys and the Shrivers and knew the family and Jacqueline. The weather, especially in Dakar was fantastic, balmy, and sunny, cool at night. I am definitely going back there. It seems I can do this sort of thing on and off forever, so it makes a nice little winter vacation every year, now that I know how to organize it. I did a lot of poetry readings while in Dakar and some of the Senegalese poets translated some of the poems into French very well. I also met up again with my poet friend from Timbuktu and he took me around to do some shopping and get a few objects. We didn't do too badly considering I bought three statues, a mask

and some old jewelry. Also some cloth. I wish I had gotten some lizard shoes and a bag. I almost did, at the airport. Almost missed my plane a la Vivian Chase... Most of the time I stayed with the cultural officer with whom I didn't get along at all. I found out later (I thought she was a little old lady in tennis shoes, a little White old lady in tennis shoes and she turned out to be—I got this from the next embassy I went to—a little BLACK lady in tennis shoes...). Anyway, she sent a glowing report back, so it really didn't matter that she didn't do her job.

So, all in all, everyone was delighted. And it was quite an experience for me to say the least. I got to see Black Africa at last and meet the cream of the crop. There is something melancholy about it as well. None of the big powers are really interested in Africa anymore, now that they cannot control it and the only countries that get any attention are those who have oil like Nigeria and Algeria... for the rest, they have to struggle on their own. Ghana seems to be doing alright and Senegal, but the drought has hit northern Mali and the whole central plain of Africa. East Africa is going to make war on South Africa, and within the countries, they are so divided in tribes and language groups that it seems hopeless. In less than twenty years practically all the governments have had coups, and there is not one existing real democracy left... all military men or dictators more or less. Which is not necessarily bad except that the governments tend to become tribalized: that is all the high posts go to the members of the same tribe as the chief of state which leads to discrimination, revolt, and war or coup after coup. Then there's the poverty... nothing, of course like in India, but still so much to do and so far to go. The Chinese are doing a lot in Tanzania, but they haven't made much progress on the rest of the continent. I didn't have any of the gut feeling I had when I saw Egypt for the first time. I was strangely detached. The vibrations were good, but it really was another world for me and for most American Blacks. Rarely a Black makes real contact like my friend in Timbuktu (he has a house there) but this is rare and it is because he has made a great effort over fifteen years. And still, he doesn't speak any of the African languages of Mali. And the ironic thing is the Africans themselves have to speak a foreign language, either English or French to be understood by their own countrymen, there are so many native languages. You can go thirty kilometers and change completely the language. I mean one person from that region or tribe will not understand a WORD of the other person from a different tribe fifty miles away. So, they have to speak the colonial language to make themselves understood!! The two best exhibitions were in Tunisia and Dakar as they have the nicest cultural centers. I am supposed to make an exhibition in Tehran in October next plus a group exhibition of jewels in the Shah's Palace at the same time. Interesting... I wish all this was making me some money cause I sure could use some. Anyway... maybe I was never meant to have FORTUNE as well as fame... But I'm going to give it a whirl anyway. Let me know all about your love life immediately. And how Bernice is and the work; how it goes. Don't worry about the mess, it will all come together as soon as the

big work is done. How is the lab and all the crazy girls? And Dr. Johnson and HIS love life. Did his old girlfriend come back? I seem to have survived Africa in very good shape. No trouble at all, not once, except for overeating...I didn't gain any weight though: too much moving around for that. I would like to go back to East Africa next time: Kenya, Tanzania, Zanzibar, Ethiopia, and Central Africa: Gabon and Cameroon...I have always been more attracted to East Africa than to West because of its physical beauty. At least I would like to see it. Meanwhile I did get some new poems out of the trip. Not many so far, but I haven't really gotten down to writing yet. This book project has not gotten off the ground yet and everything is hanging on that. Antoine has offered me his house in the South of France to get it started, but I need an advance from my publishers which has not arrived yet. Even though I don't write I think about you all the time and am so proud of you. I will try to write you a long letter again next week. Once I am in a writing mood and sitting down in front of the typewriter, it is easier to dash something off. I'll tell you how the Sally Hemings story is coming. There is also a project with Alvin Ailey that I told you about that may come to something for the bicentennial either here or in the States. I have been in contact with him and his lawyers and the State Department. We are hoping also for a film.

So, remember what I said: you are independent with your own job, your own money, your own friends, your own family, your own bed and your own shoes to put under it as well as anybody else's you may fancy. No one, least of all your dear daughter and son-in-law will think the least about it, as a matter of fact I think it is a super idea. You are a babe in arms, and a lot of years ahead. Enjoy, enjoy.

<div align="center">

Love and Kisses,
B

</div>

June 23, 1975

Dearest Mother,

Please forgive this long delay. I have no excuse. First, when I got back from Africa, I was absolutely submerged, then I got the blues and had to cope with all kinds of psychological problems. I am still in a bad mood, but I promise to write again as soon as I feel better.

The boys did get their sheets. They were delighted. But I have to tell you they are NOT on the bed, but hung up on the wall. They both are fine and send lots of kisses. They will definitely be in the States next summer. It is an absolute necessity for David.

I am so excited about the flat. I bet it really is going to look nice. And even the best workers are slow, slow. There are always problems. I know of nobody who has ever redone a flat who hasn't complained about the slowness and practically

had a nervous breakdown. Remember when I was doing this house? And in France, believe me, it's worse than in Philadelphia. But nobody thinks it goes fast enough and the mistakes people make are incredible. Anyway, I expect by now, everything is practically finished. Think of all the fights you wouldn't have had otherwise.

Marc is leaving for New York tomorrow, so I will give him this to carry. He will surely telephone you, but will only be there for about five days, then to Scotland and back here.

Well, Marc left without the letter which I am mailing, but I am going to call you anyway Saturday or Sunday... If you do speak to him before he leaves, make sure he has got me a box of Fashion Fair face powder in Amber Tint. I couldn't get it the last time I was in New York. We will be leaving next weekend for the country until the 14th of July, then the children are going to Annecy for three weeks and then we all go to Greece if all goes well, weather cools a bit. We will probably stay in Greece until the 9th of September. School starts the 15th. David in the equivalent of Jr. High School!

Went to a big birthday party (65 seated for dinner) for Marc's aunt who is 80 and who looks 50. It was quite a dinner (no grandchildren allowed... there are too many). It was amusing and touching. We'll give you one! With considerably more adopted children... Other than that, nothing new. As I said I have been down and out. Tomorrow there is a surprise birthday party for Mary McCarthy at the house of our friends from Greece. She is 63. Having brunch with Françoise Nora on Sunday and am keeping the children in town this weekend because of the party. They are going to Sylvie's on Saturday night. This last week will drag out. Next summer they will definitely be in camp in the States or England. And I prefer the States. David will have had one year of English which he starts in September and that with what he already knows should finish up the English problem. Alexei will just have to cope. I must try to speak English to them this winter. Meanwhile, Françoise is in the South on vacation with Caterina. Also saw a private preview of a film Susan Sontag did on Israel. Did a poetry reading not too long ago for some writing students at the American Center. I don't know what to tell you about the book, the embassy here ordered sixty copies in January for my trips and got them in May! With all kinds of excuses about the mailing address etc., but nevertheless... My friends from the embassy in Dakar and in Paris are both going back to Washington this summer. I saw Alvin Ailey dancers here, but missed him, he went back to New York. His new season is coming up in August. The new ballets he showed here are very good, but neither of them have been choreographed by him. I am looking forward to seeing some of his new things. Have a new book of poetry finished and still thinking about the idea I had for a novel. Maybe I'll do it and maybe I won't. I'll see if I can't get David and Alexei to put their two cents in here when they come home from school. Alexei is in a dance program this afternoon and I'm going to see it. David got his yellow

belt in judo (second degree) the other day. He was so happy and thrilled. He will definitely be going to the sailing school at Annecy this summer. Not Alexei. And Christine, Antoine's girl, is expecting her second baby any minute, since the 18th of June. A lot of Cancers around. She wants to name it either David or Alexei. Alexei will be delighted, he loves babies. You can imagine how happy Lucette is! She has both the babies all summer.

How are things going at the lab? Are you still so busy and all? How is Dr. Johnson? I got a nice letter from Julian King with the Marcia Rose clipping in it. Ben Johnson is always calling him up with newspaper clippings…

Françoise should be back this week. Caterina has finished high school and will probably come to live in Paris next year. She wants to work in the movies… like every other young girl in Paris. Nevertheless, we can probably get her an apprenticeship somewhere with a little pull.

We had a few days of beautiful weather, but now it is back raining again and cold. Last night, there was supposed to be a tremendous public ball on the Place de la Concorde, free for the first day of summer. Although it didn't quite rain, it was pretty wet. The day before there had been a free concert on the Place de la Concorde, but most of it was rained out. At least in Greece, we will have perfect weather. It never rains. I hope to work on a new book and turn in the new book of poetry in the fall to my editor.

I will write as soon as I get to the country next week. And please forgive the silence. I expect things will fall into place in a few weeks of work. Certainly, I can't stay in the dumps forever and usually something turns up to surprise me and give me a jolt.

Say hello and love to Bernice. And write to me even though I am long in answering.

XXX
Barbara

June 24th, 1975

Dearest Mother,

I have gotten all your letters. Did you get the mother's day cards (our mother's day), Marc will surely call you, he has left for New York this morning. As you can imagine, I have been completely tied up with the book and trying to do the flat with my left foot. But, of course, you can't do everything at once. We are finishing up the typing on another draft of the book and are sending it off the end of the month. We are making Xerox's and hope to begin selling the subsidiary rights. This whole business of publishing is very complicated and very slow. I am sending you an article on Blacks in publishing which was in a review that published a review of my poetry book this spring! It is still going to be a long hard pull for

the book: the money invested is enormous, the publicity machine, the reviews, the various rights, all have to be handled and constructed in a certain manner to achieve the result we all want which is a bestselling book. Once the book leaves my hands, there is really very little to do with what is in the book, but how it has to be produced, packaged and marketed, reviewed, distributed and sold and then how the foreign rights, the second serial rights, the magazine rights, the theater rights, the television rights, the movie rights are sold. I really didn't know what I was getting into at the beginning. And this is not merely a "literary" venture like the poems, but a commercial book in a big commercial house which makes a great deal of difference. So, if the book is in the bookstores by NEXT SPRING, we will be lucky. If I have bound galley copies by Christmas that will be fast. There is nothing to be done, on top of which I lost six weeks with the first editor at Viking and will never recuperate them. But, at any rate, the book is finished. I have started an outline for another and am hoping the manuscript will be more or less accepted as it is. The whole project took enormous concentration and reserves and I am worn out. I also have to get back to my art, if I am ever going to get back to it, books are coming out, fellowships being offered, exhibitions, reference books, etc. Dealers and missing sculptures or sculptures returning from this place and that, new exhibitions (did you get to see the one at the Smithsonian in Washington, "The Object as Poet?"). It has a very nice catalogue. I hope you got it. It is the one you sent the poetry books to. It is coming to New York at the Crafts Museum next to the Museum of Modern Art. Also Yale is organizing an exhibition of graduates' work next year, so it might go there or another piece, or the jewels. I have to buy up the rest of the stock of jewels as my jeweler is going out of business. I really needed that: two kilos (five pounds) of gold! I sent Daddy a magnificent Baccarat vase from Tiffany's for his birthday and he didn't even write to say thank you. I hope at least he got it. Marc sent it, the last time he was in New York, and I sent cards from the children from here and not a word…
Everything here is falling apart. We haven't sold the house and IT is falling apart as houses will do when they know they're being sold…nothing works! I am glad it is vacation time at least. I think we will all remain very quiet this summer. David is spending three weeks with a little friend at the seashore and then he will go to Annecy. And Alexei is going to Françoise's for three weeks and then to Annecy. I am staying in Paris in July and probably the first week of August. Then I am going to Formentor in Spain for two weeks to attend the Formentor Literary Prize. After that, I don't know. I will certainly be back in Paris by the first of September. I don't think any of us will be in the States, although I did think about it for this year. But I just don't have the energy to arrange it. Are you going to be on strike all July? If only we had known in advance…you could have had the boys for a month. David speaks OK and Alexei would scramble along somehow. I am enclosing your razor blades and your will. Get Ben Johnson to rewrite it for you. He is Julian King's partner. It is much better that it be someone in Philadelphia

that is responsible and Magnum's lawyers in New York are so expensive, even a telephone call is beyond my means at the moment. So, let him do it.

Oh I know what I wanted to ask you: you remember those snoods you wore in the forties? I'll never forget a photo of you in one (see drawing), do you think Helen could crochet one or two for me? I am going to launch them with my men's suits this winter and also with my bathing suits this summer...I want a gray one, a black one, a natural color one, and a white one. I have seen one or two here, but small ones, I want large ones that come all the way to the shoulder.

Caroline is typing up a blue streak to finish before she leaves for the States next weekend with her two little ones. And you wonder why women never accomplish anything.

Anyway, I have enthusiastic letters from my agent and from my new editor. They promise the world...let's see what they produce. As for me, I am only supposed to produce a masterpiece...that sells! Nevertheless, despite all the troubles, Sally Hemings will appear one day on the horizon in the not too distant future I hope and stun everybody out of their $8.95 or $9.95 or $10.95... I just hope this last push does it because I am exhausted, my house literally and figuratively is in shambles, and I am living from day to day (as if there were any other way to live). But then it is the end of the year and everybody is tired. We have been having terrible weather all spring, rain, floods, cold, sleet and not a big of sun. Last year this time, Paris was roasting and there was a drought on!

I was terribly sorry to hear about your friend's death. It must have upset you very much. Let's just hope, the time she did live, she lived to the utmost. It is the only thing one can do.

How's my sweetie-pie Ray? Did you take him out to dinner for father's day? AND to a movie, I hope, at least! Tell him you have a dowry from your daughter maybe that will put some steam under him...I'll FIND the dowry if necessary.

Two new books out in which I am included and the *1975 Who's Who of the World's Women* is out as well, but it is so expensive, I didn't bother ordering a copy.

<div style="text-align: center">

More Later,

XXXXX

B

</div>

14 July 1975
La Chenillère

Dearest Mother,

Another letter—we sold the house yesterday and will sign on Tuesday coming— and we start negotiating for the new one on Monday. I'm having lunch with Antoine. The 14th of July is like the 4th for France. Lots of parades and dancing

in the streets and fireworks tonight. I am having dinner with the parents of Alexei's "love" Cecilia Bloum—a blond! They are in the same class. Little girls are so different from little boys—she is pursuing him with a vengeance and poor little Alexei is scared to death. She called him at "La Bergerie" this afternoon from Paris because he had a slight riding accident—nothing serious but I went down there anyway as Marc was in Arles—and met Cecilia's father on the train who asked me if I wasn't the mother of Alexei, Cecilia's boyfriend! The first time I ever heard anything about it. What a mother-in-law I'm going to be! The house is sold to a young doctor who is working in Mali (Africa) for four years and still has two more years to go. His parents are buying it for him and he is married to another young doctor also working in Mali. In Bamako—where I lectured last year, remember? Isn't the world small? Happily I didn't get sick in Bamako! Anyway, they decided almost immediately the same day. It was the first house they saw and he fell in love with it. I am quite pleased it is going to someone I really like and I like what he is doing and I like his parents. Now, if only I can get mine bought...I will call you as soon as I do—if I do. So you can imagine what a state I'm in at the moment. And then I'll have all the work to do on it. I hope we can close the deal by the 30th of July at which time I am going to Annecy for a week and then to Spain for two weeks' vacation which I really need. I am still waiting for the final word on the book (second version). Vicky and I did a lot of work on it and I did a tremendous amount with Caroline here. We sent it last Wednesday but with the 4th and everything, I haven't heard a sound yet. I expect this weekend they will call. Both boys had very good report cards—excellent—and David's piano lessons are coming along. You know the school took them on a field trip to Rome last month with 5 other high schools of the same grade and David won a medal for the 100-yard dash! Quite good. His school won a lot. He was in seventh heaven. Now he is by the sea. Françoise is coming to the States on the 29th of July and I'm sure she will call you. Are you still out on strike? If only we had known ahead of time. Write. I will be in Paris until the 30th of July and then for a week in Annecy

c/o Madame Antoine Riboud
La Sabaudia
Sévrier 74 (par Annecy)
France

Love and kisses,
B

August 21, 1975

Dearest Mother,

Please don't be cross. I really have no excuse and it is NOT your fault…I just couldn't bring myself to write and was in such a state of mind that it would not have been a very cheerful letter.

I feel much better now…here. The children are in great shape as is Marc. Noma is here. We met by accident on the boat from Athens. I had no idea she would be here. She is leaving tomorrow for another island where she has a piece of land, then Athens, then London and the States. Our friends here are marvelous and as ever, the house is beautiful, cheerful and full of beautiful people. J. Onassis was here for about a week before we came and poor Clem (Jessie's husband) got the newspaper treatment of the mysterious "third man." Were they ever disappointed when he turned out to have 8 children! The wife didn't count. Yesterday for lunch we went on an enormous yacht which has put into the port for a few days…another Greek armature married into an English diplomatic family. The boys came later to visit the yacht since they missed the visit of the *Christina*, Onassis' huge ship. We are twenty-two in the house at the moment. That means breakfast for twenty-two, lunch for twenty-two and dinner for about twenty-eight by the time a few friends drop by. The two ladies Jessie has for the house are really wonders. Would you like to write to me here (I know I don't deserve a letter, but anyway).

> c/o Mr. & Mrs. Clem Wood
> Oikia Wood
> Palio Limani
> Speccia
> Greece

I will be here until the 6th of September I think. Marc will certainly be in New York in September and probably again in October, so you will see him to reassure yourself. He is due to go to Hanoi and Alaska amongst other places and to do a book on Istanbul for Time-Life Books. I may come for the problem of this monumental sculpture for New York. I haven't made up my mind yet or rather circumstances haven't made up my mind for me, but I am thinking about it. Also about next summer as well. Maurie and everybody in Paris are fine. I had lunch with Françoise just before I left and spent a weekend with Antoine the end of July. The children stayed three weeks with Lucette in Annecy and were very, very happy. David is taking tennis lessons and seems to be very good. We saw the Arthur Ashe Wimbledon match. I thought about your friend. She was probably there. It was so exciting, we saw him win the deciding match. He has been trying to win Wimbledon for a long time. Now he has. I hope they were there to see

it. I can't believe school is in a few weeks. This year has gone so quickly. David is in 6th and Alexei in 9th. They both did very well and *Vogue Magazine* sent a photographer to finish the story they started last year on the house. I must say, Marc wasn't very cooperative, but anyway, I was so put out they didn't publish it when they promised to. For the publication of the book that I really don't care when or if it comes out. I must put this in the post and stop typing as everyone is taking their siesta. Marc got bit by a jellyfish...not serious, but way, way out in the ocean...I am still walking on the bottom...

<div style="text-align:center">

Love, love, and please forgive.

B

</div>

September 1, 1975
Speccia

Dear Mother,

The last days of vacation. I think the boys had a wonderful vacation between the country, Annecy and Greece. We will be back in Paris on Saturday the 6th and I will call you on the weekend. I am taking them directly to the country until school starts the 16th. Meanwhile, I will probably go to Milan for a few days before school starts. I think we have definitely decided to send David at least one year to the States for school probably Saint Paul in Mass. where there are friends here on the board of directors who can get him a scholarship. He will start English in school this year again and I have stopped speaking to him in French. We will probably do it year after next when Alexei can go to boarding school here. Anyway, there is enough time to think about it.

Meanwhile, I must take my own plans for the next year. I do hope Marc called you to say that everything was all right. I just didn't have the courage to write. Everything was not all right, but I guess I am working things out. At any rate, things keep happening regardless of whether you work them out or not, especially in a life like mine or Marc's. Anyway, I may be in New York this fall for various reasons. I will let you know as soon as I know. Or perhaps we can come for Christmas. The air passages are so expensive now, we just can't fly over at every drop of a hat. Happily, the children can still go half fare until Feb. There is also the problem of Tehran where I should go in December. I might get the kids to join me there for Christmas. It is warm. I am beginning to get addicted to warm climates. I especially like Senegal, but all of North Africa appeals to me as well as Greece and Italy. I still haven't learned how to swim properly. But I am beginning to love the sea. The kids in the house here are down to twelve. At the "height" a week or so ago, we were twenty-two for breakfast, lunch and dinner...I told you that Noma was here for about a week. We didn't plan it that way. If we had, it surely would not have worked out. Anyway, I was happy to see her and get all the gossip

from New York, etc. She has been working hard on her jewelry and has had a lot of exhibitions and success. She was in car accident in Italy, which is why she was so late in getting to Greece, in which she broke her foot, but she is OK now.

Jessie and Clem are fine. You remember, we had dinner at their house together, the last time, I think, you were here. You remember the couple with eight children and he is from Philadelphia? A very famous Philadelphia family, the Woods from Conshohocken (steel mills), so, we are trying to stretch out our last days here. Marc went to London, but is now back in Paris I guess. Said the house was still standing. August is the month of burglaries in all those empty flats.

I must run. I have to go to the village to take Alexei to the dentist. He has a hole which is bothering him. We have to take the bicycles back and buy the papers and fool around. I'll write from Paris.

> All my love always,
> Your loving daughter...

Been to some good parties here, it is a very chic island especially for the rich Greeks. A few nights ago I found myself giving my best curtsy to Michael of Greece, the Greek prince. I didn't snub him like I did his father!

September 20, 1975

Dear Mother,

Yes, the children got their cards and your picture! How do you do it??!! You looked fantastic. Alexei asked me if you were older than me or vice versa! Also got your letter today. I guess you have mine by now.

I'm sending you the clipping from *Sepia* since you didn't get it. I have no energy to attack this new flat. I hope it will come. I'm glad you got your parking place and everything for the winter. I'm sorry the hospital is in such a mess. From the article, it is really frightening. The motto is never go to Temple University Hospital. But the Skin and Cancer Hospital is very good isn't it? I didn't know that Tina was already gone. You must miss her. Who else is still there that I know? Sorry about Ray's back, I hope it's better now. And his hay fever. No real news. The weather has been good for a change and we spent two nice weeks in the country. Caroline was with me with her two little girls and I took Maurie and Sandra as well. Of course you should come this summer or spring. Goodness knows how things will be. I don't know when exactly I'll have to come to the States, but maybe we can go back together.

Keep your fingers crossed that the meetings I will have weekend after next will go well and that the book will be in production soon, with Jacqueline gone.

It is going to be a hard year. I am just grateful the book is finished for I would

never be able to do it again. The next one will be harder in a way, but simpler with much less research. But from the looks of things, under great duress. We will see.

Love you. Keep well. I will write soonest.

Barbara

⸺

[no date] 1975
Annecy

Dearest Mother:

Got your letter this morning—so am putting this in the post today. The new apartment is not altogether settled. I am hoping it will be by the end of the week. I am leaving Saturday for Spain for 15 days. Marc is in Istanbul and the children stay here. If all goes well we will have sold the house and studio to cover the new apartment but not the repairs which are considerable—but first things first—We have until April 15th to get out of the house at any rate. I also got the beautiful snoods—the only trouble is the gold threads. You know how Marc is about things like that! Tomorrow an American couple I met with Patrice Riboud in Minneapolis is coming for the weekend. I saw them briefly in Paris. She has a gold jewel of mine—They are the head of Corning Glass Company.

I have good news from the book—Things seem to be settling down and the last revisions are at hand. You will have your book party at the Faculty Club, etc. I am glad you are back at work. You seemed worried. Still no word from my father. When and if we get this damn apartment I will send you the plans. If all goes well with the book it should go into production in November–December and be published February–March. There's a huge machine to be put in motion if we want a commercial success. But it is much easier in U.S. than in France. In the U.S. 40,000 copies is a bestseller. In France you have to reach 150,000 copies! We should be able to sell 40,000 copies in Philadelphia alone! The art director of Viking is an old friend of mine and Black and he was in Paris two weeks ago and we had lunch together. He has a terrific cover if we ever get the book printed! Things will be slow for the next three weeks then everything should (or should not) fall into place.

We have had lousy weather for the whole summer. Today it is beautiful but in Paris it was raining and cold two days ago. My address in Spain:

> c/o Horst + OTE Hirschbiegel
> Casas Helga No I
> Posto Salè
> San Francisco/Javier
> Formentera/Baleares
> Spain

The new garden sounds nice—give my love to Bernice. If I have to come to the States it will be probably in Sept. There are new low airfares beginning the 27th.

Love,

B

P.S.—The next to latest *New York Magazine* has a reproduction of, I guess the *Cape*. I haven't seen that.

Love,

September 23, 1975

Dearest Mother,

Just this minute got your last letter. I've been meaning to send these photos for weeks. The portraits of me are not by Marc (not his style) but I thought you might like them...for the record. School is in and everything has started up again. Last night I went out to the ballet with the King of France! (pretender of course) but he is charming: Prince Henri d'Orléans. I was with a couple who were in Greece with us this summer and we went to see a very funny American Ballet company at Pierre Cardin's theatre. The ballet was marvelous. I am going back again on Saturday. Then we had dinner at La Coupole. Marc is in Mexico as you should know. I hope he called you. He passed through New York on his way down. He will be back on the 4th or 5th of October, then he goes to Hanoi.

I did hear from Jacqueline about becoming an editor at Doubleday. She was not allowed to take *Sally Hemings* with her when she left Viking over that stupid Ted Kennedy assassination book. She may end up publishing my next book of poetry which is finished and being typed. I am going to send it off next week. Two projects I am working on: one the exhibition in Tehran and the other this monument in New York. I don't know if either of them are going to come off at the moment. The New York project has dragged on for so long. There is also another very big project I have in mind, but which I can't talk about now. We'll see what happens. But it will be fantastic if I can pull it off.

I got the photo of you in the African dress: very pretty. I gave it to David. The boys are wonderful. As I said they had an especially good summer. Are delighted to be back in school. Where they are both very happy. I know how lucky I am and they are not to have to cope with American schools. Either they would be in danger of their lives or we would be bankrupt sending them to private school which is, at any rate, no guarantee. But I do think David may be coming to the States for a year of school perhaps next year depending on if we can get him in to Saint Paul in Mass. He must as soon as possible be completely bilingual and although most of his English schooling will be in England, I wouldn't mind at all a year in the U.S.A. just to remind him he's not totally French. I don't think

it would make too much difference with his accent if it were reinforced later in London. Saint Paul is one of the best private schools in the East and it is our friends in Speccia who are on the board and who want him absolutely to go. We'll see. Better now than later I think. Anyway, David's English has improved and he now has five hours a week in school as a second language and the girl I have for the moment speaks only English to him as do I. So, I think we are over the hump. Of course Alexei wants to copy David, so he is picking up a few words. He is furious if I speak to David in English and he can't understand what's going on. Both, as you can see are in terrific shape, David is very blond and Alexei's feet are enormous, bigger than David's. The weather here has been off and on. Very hot days and rain. This week has been really Indian summer. I am still slow in getting myself together. I have been back from Italy since Monday and have yet to get all my letters out, clothes sorted and atelier in some kind of order. I think I am going to try to work a bit in the country this fall to catch up if this girl works out for the children. They, in one way are so independent and grown-up, but still one needs to have someone with them all the time. Last year, you could barely get them to give you a kiss, this year they are both the most lovey-dovey that I've ever seen especially David. Such hand-kissing and hugging and carryings-on, you've never seen. Alexei was always a little like that, but David was always the cool one. I have to start teaching David the proper way to treat a lady, not that he is going to need much coaching. We haven't done anything to either house this year. Work is so expensive. Any little thing, even in the country. The house needs painting in Paris, but we just can't afford it, neither the money, the time, nor the bother. More important at the moment is a project to buy the entire lake in front of the country house. The lease is coming up in November and I think we should try and get it immediately if we can. It is only going to get more expensive later and it should belong to the house. It completes the property. Now that the old man is gone and the old lady (she died about a month ago) we have to deal with the son and his wife and the quicker the better. I want to make a bird preserve out of the whole thing which is about twenty acres. In even a few years, it would be beautiful and full of birds if no one hunted them and some exotic ones as well. One year we had two swan couples, one black and one white and we've also had cranes and of course all kinds of wild ducks and so on. The boys did some fishing at Annecy this summer, so they will probably begin to fish in the lake and we would still use it for fish raising. The last haul was over three tons of fish!

Harold did call up long distance for about an hour to ask me about some kind of exhibition for next year. I told him to write me and haven't heard from him since. Which doesn't surprise me. I hope he gets elected to something... soon. Someone met me the other day and said they didn't make the connection between my name and me because they figured I was about twenty years older than I am so I just said I had lived a lot... and I'm afraid the end is not in sight. As long as YOU keep YOUR looks, I figure I can go on burning the candle at

both ends. How is Bernice? Who is her new, has to be new boyfriend. I would love to see him next time I'm in the States. Maybe we can have another Chinese dinner together. Antoine and his women are fine. His daughter had another baby (boy) and it looks like Patrice, the son is going to get hooked up soon to someone practically my age. The girls are going for young flesh these days. Françoise dropped her scientist who was fifty, married and couldn't make up his mind, for someone who is thirty-two, seven years younger. She is leaving today for Boston with him for a week. He is producing a French television program on the political personalities in and around Boston. I told her to have a ball, she seems quite happy and since she wanted to have a baby before it is too late, this guy wants nothing better than to give her one, and she better hurry up, I think something (a baby anyway) will come out of it. More women are simply having the baby and dispensing with the husband which saves a lot of time and energy to say the least. Men are going to start accusing us of using them as sexual objects, poor things. That's nothing, Genevieve's boyfriend is twenty-six, Jan's is thirty-seven. I'm just wondering what Jacqueline is going to come up with...

Love, love from all of us especially your loving daughter.

Barbara

October 1, 1975

Dearest Mother,

I am sending you under separate cover the *Sepia* magazine. I'm sorry I've been so bad about writing, but things have been very confused and are just now beginning to sort themselves out, not completely to my satisfaction, or rather to my surprise, things that I expected to remain stable, have not. At any rate, the real estate problems are settled more or less. We sold our house and bought the new flat which is, if I must say so myself, one of the most beautiful flats in Paris and thus, in the world! But it is in terrible chaos and needs a lot of expensive work done on it. I really need the success of SALLY HEMINGS! That too, has sorted itself out. My editor is due here in about another week or so for the final revisions and it will go into production I assume in November. Little will be realized for the moment until it is in galley proofs. Then we can hope for some dramatic sales... with luck. The book itself won't be out I would think until March of next year. I think the children had a good summer. They are spending the last few weeks quietly in the country, getting ready for the new term. I think they are happy about the new flat. I enclose a plan of the flat. It has two entrances plus a service entrance, a garage and three maids' rooms on the top floor. It overlooks the Luxembourg Gardens and is not only the street I chose, but the year of the building and the layout of the flat! One day I just opened up a map of Paris and pointed. The children's school is literally down the street: two minutes away. The

street separating the apartment house from the gardens is very small and has only three buildings on it. At the end of the street is the most beautiful avenue in Paris, L'Avenue de l'Observatoire, which runs into the gates of the Luxembourg Gardens. Magnum's office is only a walk across the park. I'm taking Maurie to see it on Wednesday. She is really upset about our old house, but what I've done is done and I hardly regret it although this flat is much heavier in upkeep, it is insurance for me and also that the boys will have flats in Paris no matter what. It is really big enough to make four different flats if necessary and its placement is as good as gold. Antoine was very pleased. He thinks we made a good deal. We sold our house well and got 30% off the price of the flat, thanks to Antoine! But what negotiations...they had been going on since April! Caroline, her husband and two children are coming down for the weekend tomorrow, but the weather is not too good. It has been a lousy summer in every way including the weather. Did you get your parking place for this winter in Temple's parking lot? Do you want me to write to Dr. Johnson about it? How are all the girls? Give them my love and tell them all to go out and get Sally Hemings T-shirts! She's really coming!

Françoise was in Maine for a few weeks with her daughter who went up to Canada. Caterina was going to go to Philadelphia with her friends, but at the last minute changed her plans. They are both well. How is your sweet Ray? Give him a big kiss for me. Also tell Mary to tell Chris that if she wants to plan something around the publication of the book, I am willing to show up and sign books! I am writing several articles on the book or rather the subject matter of the book, any of which might be turned into a lecture, which I also may do if I get desperate enough. If I can do it in Africa, I can do it in Des Moines...I guess. I'll have to talk to my writer friends about that.

> Love and kisses,
> Barbara

October 29, 1975

Dear Mother,

This is just to let you know that everything is OK. The children have so many holidays these months that I am going crazy. They just got back from four days' vacation and they have four days of armistice...Marc's trip to Hanoi has been postponed (hopefully) and his trip to Alaska fell through, so he should be home this month. I have to go to Verona next week for this Harlem Office Building sculpture in New York and then at the end of the month to Berlin. Never been. I am making an exhibition in Freiburg on your birthday, January the 23rd. That's in Germany. I laughed and laughed over the letter you sent me with the description of Marc's "ride" to the airport. It was so typical, I laughed until I cried. Françoise is coming this weekend to the country with Caterina and her

boyfriend...the sitting room couch is definitely passé. Makes you feel your age! Anyway, when they are here I will just put them in the same bed, if I have one and forget about it. She's not mine, thank goodness. Both David and Alexei doing very well in school. David is in the big Lycée now, until the end of secondary studies. Marc found you in good shape he said. I hope you are OK. I have a friend's little boy who just turned 14 who has been sent to school near Françoise for the holidays. Sweet, fat little boy with that no muscle American fat and a big fat behind. But the prettiest face you've ever seen. He was in the Lycée Française in New York, so he speaks perfect French. He is here for the year, came all the way by himself. I think they are coming over for Christmas. Otherwise, I'll take him, he is so nice. No news from New York. I've been holed up the past few weeks with Sally Hemings. I've finished the second poetry book as well, very erotic, to say the least. I'll send you a copy soon as I get one off to Vicky and my agent. I have some corrections to do on them. But I think it is a better book than the first. More powerful because it is more concentrated. No word from Daddy. I guess he is alright.

I am going to Verona on the 9th for a little over 10 days to do that sculpture for New York, then back to work on the catalogue for Germany. This weekend I am writing an article on Josephine Baker for *Essence Mag.* I'll let you know when it comes out. It should take me about three days. Gwen is in Haiti writing a book on Katherine Dunham. She was talking about living there. But that is really crazy. Who wants to live in Haiti...Also was supposed to go south with Antoine for a few days last week, but didn't go finally. He was taking his plane down full of Brazilians. I didn't tell you his daughter had another baby. She called him Alexei so now there are two Alexeis in the family. The first baby boy is fantastic: funny and intelligent. David and Alexei are uncles seven times over already. I don't know where that will end. Well, write soon. The boys love to hear from you. Even if I don't write you know I think about you every day and love you.

<div style="text-align:center">

Best love,
Barbara

</div>

December 10th, 1975

Dearest Mother,

Love to all and have a happy Christmas! And buy yourself something you really want. We got your last letters and the children have sent off their Christmas drawings to you. Also heard from Daddy who is OK except for his high blood pressure. I always think of him as a young man (like I do of you) but he is getting up there. He spoke about the banquet and ball for the Temple Award, so he was as impressed as you were with the evening! Marc flew off to Hanoi Sunday

morning. He got a call from the Vietnamese on Thursday just before I left for Berlin asking him to leave as soon as possible if he wanted to go to the South, so he left the Sunday after the Tuesday he got back in town. So everything that was planned for Christmas is up in the air. I expected him to take both boys skiing, but now David can go with Sylvie and Alexei is going to Antoine in Annecy for the holidays. I will go down with him for a few days, but I have to stay in Paris to work. We got David a new racing bicycle that he wanted very badly, so he is quite happy. I haven't gotten Alexei a big gift yet. There is nothing really he wants especially and David's bicycle is now his although I don't approve of always giving the second one the hand-me-downs of the other. I just may buy him a new bicycle anyway or one of those television tennis games that I love to play. I have to get him some surprises because we had a little celebration before Marc left and we ate in a Chinese restaurant and the children ate so much, they both had stomach aches the next day! Happily it was Sunday! I wrote the article on Josephine Baker for *Essence*, did I tell you? It is in the February issue. I rather like it. I may do some more things for them and am thinking of taking a pen-name because things are getting just too complicated what with the poetry, the sculpture, the drawings, etc. I am thinking seriously of West: Vivian or Virginia West. Or Dewayne, one or the other. Lots of writers, especially poets, who do other things, have two names. I just sent off the model for the sculpture for the New York State Office Building in New York. It is leaving Verona in a few days. Just got back from seeing it this morning. Met the craziest lady who works for Salvador Dalí. We took the night train back together. Crazy lady! I don't know which to do first at the moment, finish the drawings I need for the exhibition in Germany the end of January, or write the names my agent is waiting for for the Sally Hemings book. It takes such a fantastic concentration for the book, there is no question of doing it while the children are around at any rate. I work best in the country by myself, something I can surely do, but I hope to be able to go for a while in January. It depends on the girl I get for the children as usual. They are both doing very well in school. David is still doing judo, but Alexei (the tough one) dropped out. He is now taking fencing in school and seems to like it. I have some new photos from Greece this summer that I'll send you. I can't remember if I've already sent you some or not. It is suddenly very cold. Sometimes we have temperature drops like that. Our friends got back from Greece, tanned and radiant. They stayed until now. They thought they were going to have a quiet Christmas but instead all their children except one are coming home...all seven! We went to the movies the other night to see *Nashville*...*Shaft* is now on French television and the children love it. Even Marc can't get them away for that program! I must say, I enjoyed it the first few times I saw it. Marc hates for them to watch television. Yes, I did get a call from Mackins. He was in London and tried to come over just for the weekend, but he couldn't make the plane connections. We should be back, pass this way around the 15th, he said, so I am expecting him then...He had called and

gotten Marc and when he called back I had no idea of WHO it was until the next day, I got your letter, thank god, in the post, so when he re-telephoned I knew who it was. He sounded fine, a little homesick maybe, but I'm sure he's having a good time. I can't wait to hear about his adventures... you know our saint's day is just a couple of days apart? Yours is the 2nd of December: St. Vivian and mine is the 4th of December: Saint Barbara. European women usually celebrate their Saint's rather than their birthday: makes life more cheerful... So, happy saint's day and the same to me! Alexei is knitting you a scarf. I tell you this because God knows when you are going to get it. He has undone it twice because it didn't suit him. He made a lovely one this summer in red white and blue which was well done. I decided he should do one for you. He was thrilled and proceeded to pick out the colors which he insisted should be red, yellow, orange and brown. Well, then we decided to mix the colors to get a thicker yarn for him to knit with, but which is much more difficult to do. Anyway, he is on his third try poor dear. I hope he makes it this time, but don't hold your breath for Christmas! Maybe New Year's after all... one thing is sure, it'll be the most beautiful scarf ever! I'll write again when I have more time.

 Love,
 Barbara

1976

The previous year had been marked by two shocks. One the delayed impact of Africa on my work once again and the other, the death of Aristotle Onassis. With the death of Onassis, Jacqueline's insistence had become a reality and the circle had closed, full stop. I had no idea what we and Viking were about to do and no inclination of the tempest it would cause. We now had a movie option, the first of eleven.

I exhibited *Cleopatra's Cape* in Europe in a personal exhibit at the Musée Réattu in Arles along with *Malcolm X #2*. I exhibited at the Kunstverein in Freiburg in Germany, and *Zanzibar/Gold* was purchased by the French Ministry of Culture and went into their national collection.

I was invited to participate in an international seminar on the role of the artist in society at the Aspen Institute in Berlin. I saw the Berlin Wall up close—visiting East Germany made me reflect on what the historic responsibilities as well as the political responsibilities were for an artist on the international scene. Did one plead indifference, deference, or defeatism? Should our Civil Rights Movement in America move onto the international scene? And more specifically, could I write a novel about real facts? Take on one of the most iconic figures in American history just because it was the right thing that nobody dared to believe in? Who was I to contradict the very history that was written? And to what end? Did I really think I could change history? Did right thinking made you right? The Sally Hemings project kept whispering in my ear to finish it. I thought about the Albers dictum stating that right thinking, straight thinking, was the key to everything; art, politics, war, and love.

July 22, 1976

Dearest Mother,

I got your last letter. Just a quick note. I am at Annecy with the boys—Marc is in Paris. Everything went very well with the exhibition. I have just heard that I am included in an exhibition in Washington D.C. at the Smithsonian Institute called "The Object as Poet" which will open in December. If the book is finished

by then I will come over. David would like to come. So maybe something can be worked out for the Christmas vacation. Now, I got a letter from Minnie but I didn't realize it was her daughter who sent the resume. I thought it was just a student she was helping out—I asked her if she wanted to be my au pair girl for the next year or at least until January!! I need someone who can tutor the boys in English, drive a car, and take more responsibility than my normal girl. I can always get out of it, but as it fell very well, she got a very nice letter from me! I explained that it was not in her age or professional bracket, but if she wanted to learn French and have pocket money and room board, I would consider it. Tell me what you want me to do. I haven't contacted my agency or asked around for someone, but it is going to be critical in the next months with the book. She could also do some research and typing for me although I have my typist. I don't care one way or the other, the letter just fell at a good time. I wrote to her from Annecy. David and Alexis got their letters too and were very happy. They sent thank you notes to Minnie who left skateboards and books and stamps for them when she was in Paris! Got a long, long letter from Alice Freeman about her last trip to Paris (she missed me) I am forwarding it to you. We were leaving a week later to Greece because of a friend's sudden death (the friend of our friend in Greece who needs our room for the funeral) so we will be in France until the 9th of August. Spent a few days in Italy. Will write again this afternoon—Lucette is going to town now, I'll give this to her—your loving daughter.

XXX

August 9, 1976

Dearest Mother,

Back in Paris for the night! Tomorrow we leave for Greece. I am working hard and will work right through the summer. We are just back from Annecy where the boys had a wonderful time. Both of them did some water skiing and David tried the new fad which is something called "wind-surfing" which is like wave surfing with a sail! And if you think that isn't difficult...you'll see, Marc took pictures...Also Antoine just built a tennis court, a very beautiful one and I must say it really is a luxury, so David was able to get in some practice in tennis as well. He is very good, or will be. He seems to be very gifted in all the sports. He lived in front of the television for the Olympics like everyone did. It was quite a show, the children loved it. Christine, Antoine's daughter, now has two little boys, the second one she called Alexei, so there are two Alexeis in the family, "Le Grand" (as in Mohammed Ali) and "Le Petit"! He is so sweet. It was a big help to have all the kids around for David and Alexei. I could get some work done. I'm happy about the car...let me know as soon as you get one. My address:

c/o Wood
Olivia Wood
Palio Limani
Speccia
Greece

I will be here until September 2nd. Jacqueline sent me an advance copy of
Roots. I just got it today on my return. I am delighted. It will be the first thing
I read in Greece. But even reading, I write every day. It is very dangerous to
stop and break the rhythm. I asked Random House to send most of the books
to you if it is not too late. So don't be surprised if two hundred books show up.
I have to pay the freight and since I may need them in the States in December,
I didn't see any point in having them sent here and then possibly having to take
them back to Washington. I am in a show in Washington at the Smithsonian
Institute in December. As it is also a kind of poetry festival, I may try to come,
depending on the state of the book and also how much if any work I have to do
on it in the States. David wants desperately to go to America! Now that he thinks
his English is so good! Anyway, I will keep you informed of developments. If I
don't write often it is only because of work, not lack of thinking of you. I read
about the mysterious disease that killed so many people in Philadelphia and that
they thought might be the swine flu. Did you get any echoes of it at the hospital?
They said in the articles that there was a skin rash involved. It made headlines
over here along with the poison cloud in Italy. If I do get over in December,
maybe we can give that cocktail party you are worrying about. It is never too
early to start publicizing the book! It is that kind of book. Either it is just going
to take off into a big success, partly a success "de scandal" as they say. Anyway,
we can start thinking about that later, now all I want to do is keep up at a steady
pace with the writing. It is very difficult with the children, even when there are
people around to amuse them. Arles was fine and a lot of fun. The exhibition
looked very nice and got a lot of attention. Some lady arrived from Chicago
while I was in Annecy and bought a thousand dollars' worth of sculpture from
Marc! He was so proud of himself. I told him if he expected a commission from
me, he was sadly mistaken. But I am going to buy him something. I don't know
what. He doesn't even see his family that much. I see them much more than he
does. He does like his children, but he doesn't really spend that much time or
money on them... more than he spends on anything else. He used to like to give
parties and dinners until it started costing so much. He doesn't go to the movies
for pleasure. He doesn't drive a car, or a boat or a plane for pleasure, he doesn't
gamble... He just works. Period. Well, he does like to talk on the telephone...
his one vice, his telephone bills are astronomical! I never thought of that. He's a
telephone freak!

I've got to stop typing it is 4 in the morning and I have the rest of the baggage

to do, my hair to wash and I have to be at the bank at 8:30 and the library at 9 and at the plane at 10!

<div align="center">Love XXOOO</div>

<div align="center">B</div>

P.S.—Alex Haley's *Roots* is a terrific book. It is going to be a big bestseller, especially with the television specials.

August 13, 1976
Speccia, Greece

Dearest Mother,

I am calling you tonight, but at the moment, I am sitting in my little borrowed study at Jessie's house on Speccia, working. We left Annecy on the 9th and arrived in Athens on the 10th. We spent several days in Athens before we came here…everything is the same here, we found our friends and a full house of children, etc. I am leaving on the 1st for Paris and Marc may be leaving before to Italy. I thought I would hear from you here, but the mail is so slow, it is no wonder. I must quickly get myself organized for the winter as this book is far more difficult and longer than I expected and I have to work on it without interruption right up to the deadline which is February 1977. If it goes well, I will come back to the States either in October or in December. If it goes well, I will come in December at any rate, to finish up details and for the exhibition there, the 26th of September and may stay a few days in the south installing a sculpture bought by the museum of Marseilles and having long talks with Antoine. There is really nothing new, and I haven't made any decisions about anything nor do I intend to as long as this book is hanging over my head and I don't know what, if any kind of financial success it will have when it comes out. I will have an indication long before publication in the Book Club sales (or non-sales) and in the serial magazine rights and the movie rights, as well as the foreign rights. All this will occur next spring, or at least some of it, but as the book is far from being finished, I refuse to think about things that may or may not happen.

How is Bernice? And Mary? And how is ole sexy crazy Ray? I hope everything is going well between you two. If he hangs around long enough, I may be able to get him a job in television! But he's got to stick around until I become famous. Can you imagine in Speccia, I had lunch yesterday with four Philadelphians not including of course my host Clem! Who all hate Philly. We had a lot of laughs about Mayor Rizzo whom, we all decided, could neither read nor write which we finally agreed might just be a blessing for Philadelphia. One of the funniest stories was that he was at a banquet for the ambassador of Nigeria and he introduced him as the ambassador from Nigeria! I can believe it…One couple was half

Greek; the husband is an architectural student at the University of Pennsylvania and the wife is, well when I asked Clem, my Bailey, Banks and Biddle friend what kind of background she came from, he said RICH. Anyway, her family lives in New Jersey, as Jessie says, sitting on their money bags in an old converted farmhouse and swimming in the altogether. Jessie sends her love and kisses. I have a new article to send you from the *Chicago Daily News*...not bad. Did you ever get to go to Alvin's opening or did he forget? I saw a picture of Judith doing a soft-shoe with Betty Ford in *Time Magazine*. I hope you did get to go...I am going to install myself in the country when I get back to Paris and not budge until the book is practically finished, then if I have to come back for research, I will. And what about the car? Do you have it yet? Are you happy? Are you nervous driving? Does it have air conditioning? Send me a picture. We are going to have to get a new car when we get back to Paris, ours has just really died, we mistreat it so. I don't even know what make to get. I think we should get a Volvo which is built like a tank which is exactly what we need. At any rate, we still need a station wagon, so knowing Marc we will probably get another of the same that we have now. The children kiss you. They are speaking better and better English. Did you get their letters from Annecy? They're sending postcards.

Love,
B

September 1976 [no date]
Paris

Here are your beautiful children! They had a good summer, I think. My editor has finally arrived and we will start to work on Monday. Marc is still in Istanbul and I am working on the flat. Don't have too much time as I may have to leave for Berlin on the 10th of October. I hope we sign for the house on the 17th, the Monday afterwards. The division has not been made yet and has to be worked out with the notary. I spent the weekend with Antoine in the south. I really needed the rest and the change...had a very upsetting two weeks...nothing to do with Marc. Anyway, Antoine took me fishing...some fishing! Just about the most expensive tuna fish ever! But I did catch one. All by myself, if you can call being on a big motorboat going full speed (tuna have to be fished moving) with four lines out and a sailor there to knock the devices, of course—AND with a sonar searching system to find the damn fish. But we caught nine. There were four boats out (with intercom and intertelephone to tell the others where the fish were, or were headed...real James Bond), one boat caught twenty-five, but then they had seven lines out, and the other two about a dozen...The children were very impressed. And we've been eating tuna fish ever since...mine weighed in at twelve, no

thirteen pounds. Speaking of pounds, we are waiting this weekend for Antoine's oldest son, Patrice, to have his baby. His girl Evelyn, I love. She is Swedish, so now we have the whole gambit of color. The baby is going to be just beautiful. The only thing everyone is wondering is when is the marriage…We thought it might be nice to wait for the baby's christening and have a double ceremony!!! Poor Lucette retaliated by proclaiming that nobody sleeps in the same bed unless they are officially engaged…That way she is at least doing the marathon from one end of the house to the other…So now, there is only the last son, Frank, to go. Antoine has really been wonderful to me and whatever happens, I will never forget it. He is the one who got the apartment for us and he was the one holding me together. He is really adorable. He finally got his act together, but it took a hell of a long time…

Kiss Ray-Baby for me. Write to me about the land in New Jersey. Did you read about Jacqueline? She finally got her act together too…She didn't do too badly in the end. Those who have, get…

I guess you miss Tina. Give her a big kiss for me. I am happy about the parking space for this winter. It will be much easier for you.

Write.

B

September 11, 1976

Dear Mother:

I intend to spend the whole month of October in the country writing. By then I'll know how the book is going or going to go. If emergencies come up, I may have some luck if I am to keep my place in the international intelligentsia crowd, I can't slur the historical parts. It has to be accurate. As Jacqueline sent me an advance copy of *Roots* which my agent sent as well, I have two copies. I will give you one.

I can't tell you how happy I am about the car. I know the girls at work are pleased that you have "wheels" and "air." I tried to explain THAT to David without success. He sounded just like Marc…But he is very proud of the car and wants a picture of it soonest. I decided not to try to explain to David what Deidre did before she came here. She tried to explain it to him in English and when I found out she was teaching pregnant schoolgirls so that they would not have to drop out of school, I decided that that was too mind boggling for David to cope with for the moment…it was a bit mind boggling even for me…I've been in France for too long. But whole classes of them? Even with the pill? Tell all the girls in the office to go out and get their Sally Hemings t-shirts. That's what they are all going to get for Christmas, but they might as well have two, so they

can wear one while the other is drying in the lab oven...I wrote to Jacqueline to get herself a Hermès/Sally Hemings T-shirt. That's even better...The politics of love...since she's decided she wants to be ambassador to Paris...let her work for it. Saw the write-up of Rev. Sullivan in *Time Magazine*, or was it *Newsweek*? I kiss you and the boys too. Kiss Ray for me.

Your loving daughter—
xxxxxxxxxxxxxxxxxxxxxxxxxxxxx

1977

ooking back, Jacqueline's widowhood and her subsequent decision to seriously follow an editorial career and my decision to explore the story of an unknown historical figure's undefined and unacceptable role in America's history was an unexpected, undeliberate, and independent correlation like a pebble thrown into the sea around Skorpios, where it made waves neither of us planned. Her "You've got to do this, Barbara," had been uttered in a void with no thought of her future or mine.

No one sat me down and said a couple of million people are going to read a novel in a dozen or so languages, which is going to make you (and Sally Hemings) a public persona despite anything else you do. Be careful because your primary goals and your personality as an artist will be eclipsed for a while and your life will be changed forever. Nobody did this because no one expected the reaction of the Jeffersonians to a configuration of Thomas Jefferson and the enslaved Sally Hemings that would end in a quarrel that would last 20 years and be solved by a scientific method that had not even been invented the day I stepped onto the *Flandre*.

But that's what happened. Unknowingly it pitted me against a powerful myth and an entrenched hierarchy. To which I was not only an "alien" but an interloper. But I had seen the mountain and I wasn't letting go. Hemings' life in Paris, her return to Virginia re-enslaving herself fascinated me. The story humanized Jefferson, and she vibrated as the subterranean presence of the eternal Black existence at the bottom of our history, or, as I call it, the invisible in American history or the 1619 enigma. I also discovered a passion for historical research and a gift for the kind of analytical faithfulness that could connect the dots of an enigma. I had great empathy for Fawn Brodie, a brilliant historian who suffered an early death because of this persecution, who had introduced Sally Hemings in a single chapter of her book, not as an affirmative but as a legitimate question in her biography of Jefferson and been vilified and petrified for it. It never occurred to me that the same fate was in store for me.

I plunged into the secret life of America's past, an accidental historian. It was the beginning of a strange new life. I discovered what I had long suspected, that the presence of Blackness in American history was fundamental and subversive and, to the best of everyone's efforts, removed. "Black" studies, like "Black" lit-

erature had yet to be born. James Baldwin was under B in American literature because of his name not because of "Black Studies," the mania to label everything segregating art into smaller and smaller slices and vocations, into minuscule "genres"—if you did one thing, you were forbidden to do another. This was especially true of Blacks, who were supposed only to do "Black" things, and abstract art was not one of them. If one stepped out of one's label, one had the distinction of having no biography at all. The media had the habit of presenting one as a "discovery" no matter how long and how many times you had done whatever it was you were doing. You had your presenter who had just discovered you. I began to realize that you had to start every time at the end of someone's discovery of your biography and the reporter or critic's "discovery" of you.

Indeed, it was like having a double life—mine and the one people labeled me with. I decided that one day I would write a book called *The Woman Who Began at the End*.

Even before the publication of *Sally Hemings*, Warner Brothers bought the movie rights. The Jeffersonians got wind of the subject matter and immediately got on their warhorses and started a campaign against the book without reading it which eventually put it on the *New York Times* bestseller list. They realized they had to stop the movie. They terrified Viking and CBS, who was planning the miniseries, by threatening a letter-writing campaign by Virginia schoolchildren, calling the book a lie invented by a drunkard journalist in 1801 and an angry Black woman with a grudge 178 years later. They were adamant and unanimous— it never happened and they know because they possessed the suppressed Holy Grail themselves. Viking was terrified. Their publicity department issued a statement saying that *Sally Hemings* was not a historical treatise but the conception of one Black woman. I was no longer a writer or an author but a "Colored" girl without a name or a biography or even a profession since they never mentioned my credentials or fame as an artist. This was not the first time I had noticed that the media in reporting anything about Black professionals especially in the arts always wrote about them as if they had been born yesterday and that their very existence depended on their being "discovered" by whoever was writing the article, however ignorant. And it always began with an "Oh" and an "I" after which your entire life before then would be dismissed.

Why the hysteria? Because I had written a book about the 38-year liaison between Jefferson and his slave and half-sister-in-law Sally Hemings, with whom he produced seven children. I based it upon Madison Hemings' memoirs, historical record, the affirmatives of people like John Adams and the impossibility of any alternative explanation including Jefferson's famous sojourn in Paris, France, where I had now resided for some eighteen years. The book was not only a bestseller but a Literary Guild selection and won the 1979 Janet Heidinger Kafka Prize as the best novel by an American woman. It went on to sell over a million and a half copies in the United States and another million or so as a bestseller in

nine different countries including France where it stayed on the bestseller list for sixteen weeks.

Exactly twenty years later, DNA tests proved the veracity of the story and Monticello published a white paper verifying the results and circumstantial evidence in the positive. The Jeffersonian Establishment then had to invent another scenario as to how the story had been told why, when, and by whom, in order to whitewash the whitewash. I had to be totally obliterated and turned into an invisible woman like my characters.

February 17, 1977

Dearest Mother,

Oof! *Sally Hemings* is finished and here is your long-lost daughter at last.

I will be in New York at least by the third week in March to work with the editors. As you can imagine, after *ROOTS* they are practically snatching the manuscript out of my hands. I won't know their reaction for several weeks maybe even three, although I am at least hoping for an initial reaction soonest. Only Caroline, her mother (who was here from Chicago), and her husband have read the manuscript, so the reaction at Viking will be my first indication of what I have. *ROOTS* it is not, but it is something. More complex, more dense, certainly not as "Black" and "White" as *ROOTS*, certainly not with the same immediate pull of folk history, but whatever it is that I have, and of course, this is not fiction not non-fiction, it is six hundred pages long and has ninety-nine characters, I would say about half and half!

I want to get this into the mail at once. I know you will never forgive me for the silence (did you get your Christmas plant we sent?), but believe me it was a struggle this book. I simply didn't know what I was getting into. Fools rush in, etc. But now I do and things will never be the same again.

I am going to Germany for a week. Will be back only on Monday the 21st for a dinner with Antoine and Françoise because he needs me there. This is the first time (after fifteen years) that Françoise will meet his mistress of twenty years and it is one of the few things I can do for him, is to show up. But I will be back in Paris by the 26th and should have by then a reaction from my publishers. As soon as I know, I will let you know,

You know that I love you, that we all love you and think about you all the time. I am sending David to the post with this. They are on holiday, AGAIN for a week and are going skiing with Antoine's wife at Val d'Este, being picked up by his chauffeur, being put on his private plane and being flown to his house in the Alps. So the least I can do is show up for this dinner when he needs me!

My love always,
Barbara

73. Carrie Mae Weems, Mary Lovelace O'Neal, Barbara Chase-Riboud, and Toni Morrison, U.S. Embassy in Paris, 1993.

74. Author's residence, Palazzo Ricci, Rome, 2021.

75. Chateau de La Carelle, Riboud family seat in Mâcon, France, 1961.

76. *Reba*, ca. 1954.

77. *Untitled*, drawing, 1966.

78. *Untitled*, drawing (Women and Abstraction), 1967.

79. *Malcolm X #3*, 1969 Philadelphia Museum of Art installation, 2021.

80. *Bathers*, aluminum sculpture, 1969–72.

(facing) 81. *The Albino*, 1972 (reinstalled in 1994 by the artist
as *All That Rises Must Converge/Black*).

82. *Le Manteau (The Cape)* or *Cleopatra's Cape*, 1973.

83. *Mao's Organ*, 2007.

(facing) 84. *Malcolm X #11*, 2008.

85. Author's portrait as a child painted by her father, 1940s.

86. *Last Supper* painting by Vivian Mae, 1980s.

87. Author's Monticello dollhouse, façade, 2011.

88. Author's Monticello dollhouse, full view, 2011.

89. 1535 portrait of Alessandro de' Medici, from the atelier of Jacopo Pontormo (1494–1557).

90. Detail of Francesco Buonavita, *Francesco de' Medici (1614–1634)*, ca. 1625. Francesco de' Medici's dog resembles the author's dog, Beauty.

91. Jules Riboud, author's grandson, 2021.

92. Author and Mathilde Rose, both four years old.

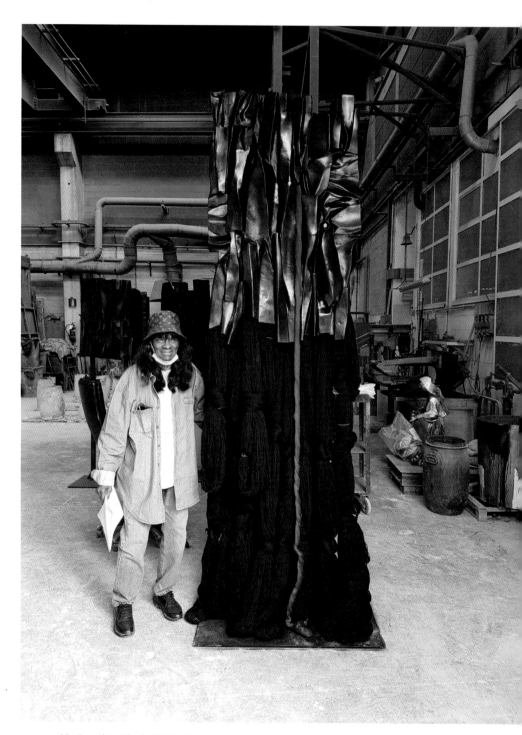

93. *Zanzibar Black*, 1974–75, restored.

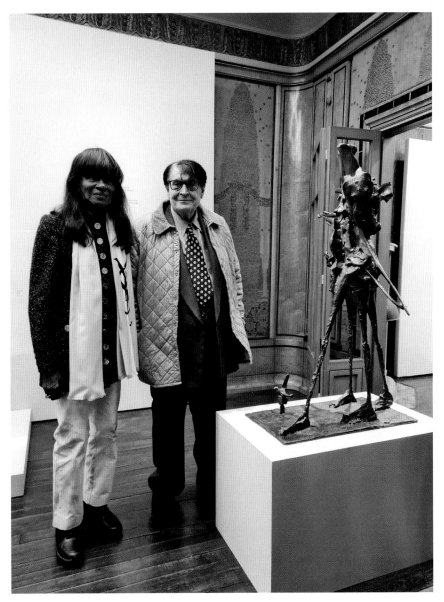

94. Author and Sergio Tosi, with *Le Couple*, during the exhibition at the Giacometti Institute in Paris, 2021.

(overleaf) 95. *Zanzibar Gold*, 1970, and *Grande Femme*, 1960, Giacometti Institute, Paris exhibition installation, 2021.

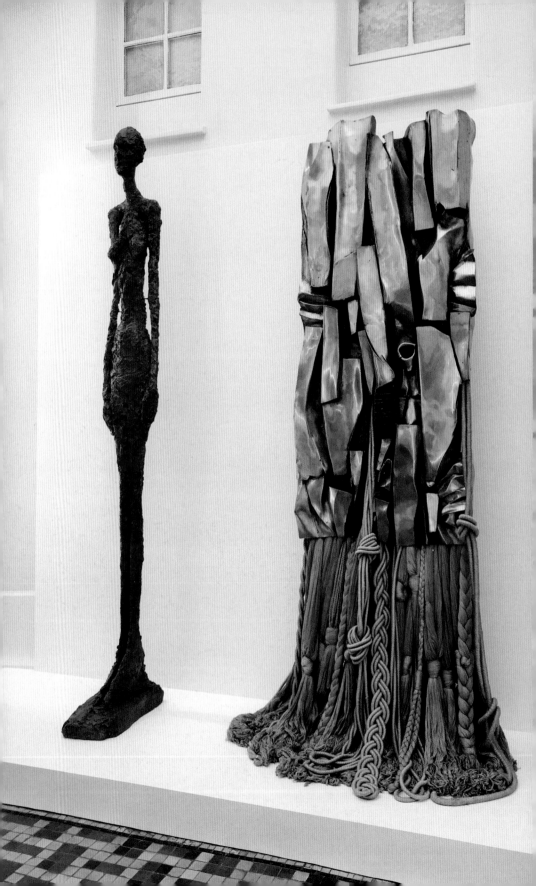

July 1, 1977

Dearest Mother,

Marc was trying desperately to phone you before he left New York, but had the wrong telephone number. Did you change numbers? I hope he got you. He is on his way to Canada to see the Prime Minister and various others for his new project. Now diplomacy! Anyway, this project is an enormous photo exhibition on the cities of the world and needs the support of several governments...probably the French and the Canadian. It is all about ecology and population and pollution, etc. He is very excited about it. How did your Father's Day dinner go? I sent off the second draft of the book yesterday and am waiting for the reactions. Once I know where I stand with that, I can concentrate on problem number 482: the house. I am staying in Paris all of July in the hopes of selling it and will be there until about the 10th of August. If only you had known about the strike sooner, you could have come here or the boys there! But now I don't have the courage to make those kinds of plans for this summer. We would get new charters and I should stay here I think and try to sort out the house problem and the studio. Lots of letters and requests for this and that and exhibits to catch up on as well. The weather has been awful. It has gotten a little better in the last few days, but all of May and June was rainy, cold, windy, etc. My secretary, Caroline, is leaving for Chicago tomorrow with her two little ones. Her husband is already there. And Françoise is coming to the States the end of July. I am sure she will call you. She is going up to Maine. The boys are fine. Yesterday they went out all by themselves and bought skateboard helmets, which their father insisted they wear and which are a good idea. The Germans have prohibited skateboarding without a helmet because of the accidents. It is a sport and not a game, especially the way they do everything so intensively here. So they have the whole outfit: board, knee pads, gloves, helmet, etc. Alexei does it in his green sweatsuit you got him.

I celebrated my birthday with Françoise with friends who have a swimming pool and a sauna: the first time I had ever been in one. I liked it. Your hair doesn't get messed up if you wrap it in a towel. You would like it I think. The heat is good for the muscles and then you plunge into the pool and then do the same thing again. It is rather easy to construct a sauna, it's the indoor swimming pool that's difficult. Afterwards we drank champagne and I went to sleep. It really tires you out and I was tired to begin with. But I had a nice cake. If I do go away this summer, it will be to their place in Formentor, Spain, on the sea. I haven't decided yet. The wife is trying to get me a cheap air ticket and it is difficult in the high season, but I think I'll go, if I work well in July. Marc was supposed to go to Russia among other places and I don't know where he will be in August. Antoine has decided to move into another flat as well. He may move and we will still be here...I hope not. If this operation doesn't work out, I don't know what I am

going to do. Well, I still have another whole month before I have to think about it again...How is Bernice? What is she doing these days? Are you alright as far as money is concerned? How long do you think the strike will last? How are the doctors taking it? Did you get your car repainted? We still haven't bought any-thing except Marc bought a little second-hand Fiat for the city. Ray would laugh if he saw it. It is about the size of his trunk! Very strange, but Formentor is where I met my present editor at Viking for the first time. Do you remember I went for a literary prize ceremony and James Baldwin was there and Henry Miller and Philip Roth and all those guys, and I haven't been back since. It has since turned into a German enclave, I think. I remember the beaches were beautiful and I had my monkey from Senegal. I wish I could remember all the people that were there, but one I do remember is Jeannette Seaver and her husband who is now the head of Penguin Books, who last year bought Viking. So, the circle comes full around. I liked her very much then. I was shocked—a cookbook editor! He is fine but what an insult. I haven't had a lot of time to talk, but we probably will before this is over. I wonder what Jacqueline's reaction is going to be?

Well, I'll write again in a few days. I'll let you know if anything happens with the house. Keep faith and go out and buy yourself a Sally Hemings T-Shirt and tell Tina to do the same. S A L L Y H E M I N G S right across your chest!

B

November 28, 1977

Dearest Mother,

Happy Thanksgiving! Here is the letter I promised. I hope all is well and it is not too cold or bad weather. How is Ray? Is his back OK? Getting ready for Christmas without much enthusiasm. We will be up to our necks in the work for the flat, which begins this week. Everything is signed and official. We must be out of 199 by the 15th of April next at the latest, but I hope to move by the 1st of April 1978. One-third: two-thirds in Marc's favor. I am going to go to the mountains for a few days and think about it, some friends* who own a ski resort have invited a lot of people from Paris for a weekend before Christmas. No, Jacqueline's resignation doesn't affect my book. They won't let her take it to Doubleday. But she was in a no-win situation: if she had begun screaming about Viking publishing the fiction book about Ted's assassination the press would have accused her of censoring the "free press" etc. and by keeping her mouth shut, she is accused of complicity which is certainly the last thing she wanted. Anyway, it has all blown over. It was one man's making at the *New York Times*, a bastard. The book turned out to be a bomb at any rate, which must have given her some satisfaction. I wrote to her and so did Marc. She is fine. Françoise and

her daughter are fine also and everybody in the whole family is moving. I don't know if I started it or not, but Sylvie is moving out of Paris to Aix-en-Provence, near Marseilles, and Antoine has found a new flat in Paris and wants to move, but he hasn't found a buyer for his flat, which is, as you can imagine, very expensive. Nothing is moving now. We got in just under the wire. From now until the elections, it will be very static. But Sylvie is certain. They have already bought a new house on 18 acres. I guess it is all the uncertainty, people want to nest and are turning inwards. But I think it would be a very good idea for David and Alexei to spend some time in the States, especially for the language. There is a Lycée Français in Boston where they could go as not to miss a year of their schooling but they would more than make up for it in perfecting their English. David speaks fairly well now, but for him, it is still a second language, and Alexei is so bright that I think in three months, he would be fluent. Anyway there is still the house in the country. I think we will spend Christmas there but really, we use it so seldom, that I wonder if we shouldn't sell that as well. Of course I can't force Marc to sell it if he wants to keep it, but between the upkeep and the fact that we use it about four weeks a year except when I go down to work alone, I think we should get rid of it. I hate it ever since the trees died...I am more and more attracted to the South and a warmer climate anyway and unless I was going to continue my studio there, I don't see any reason to keep it. We'll see what happens this summer. Marc is his usual. He is in Istanbul at the moment. He has really not come to terms with the situation and perhaps he never will. It will be for me to decide what moves to make, right or wrong. I am amazed I even got him out of that house and just in time...it needs a tremendous amount of repairs. At least the flats are very solidly made (1929) and once renovated will be little bit like Fort Knox, which is exactly what I was looking for. You get in there and the world can be falling down and you won't feel a thing...But I have discovered that writing and sculpting are two different ways of life, one compatible with my present situation and the other, I am afraid not. Writing is just too emotionally draining and demanding not to have something or someone very solid in your life and too lonely as well, just you and the typewriter and a blank sheet of paper, in other words, no shit and no bullshit either. So I have to take that into account as well depending on what happens with the book and if I am really changing professions or not. I don't think I can keep a foot in both camps forever unless I make some kind of arrangement with the academic world and this is a possibility as well except that I am a late-comer to the scene and there will be a lot of battling to be done to enter at a certain level and still retain a certain amount of freedom of movement and freedom in general.

I know Marc is talking to you and I know what you are saying to him. Not what I want to hear from you. Well, I'll continue this later, or in another letter, the children will be arriving in a moment. I have to be careful. Tomorrow there

is a general strike: no electricity or gas or transportation. Alexei doesn't have school, but David has to go from ten to twelve! I am going up to hear all about Antoine's trip to Japan (he just came back) he took my last corrections to New York with him when he left.

*Some family friends, the Boissonas who own a ski resort and built the Marc Rothko chapel.

[no date] 1977

My darling mother,

Not only do your friends think you are rich, your grandson thinks so too! I'll discuss this in my letter. For now, I am rushing to the post and want to put this into Alexis' letter. I wish we could spend Christmas together, I am tempted to come at least for your birthday. But it is so expensive now unless you reserve 60 days in advance. But there is the sky train—so maybe…Just came from the flat, the work begins this week. This too I will tell you about in my next letter. Marc did say you called while I was away and I wanted to write you a long letter, but anyway, next time. I will begin it tonight. David is huge and growing. He is doing a lot of wind surf. He is getting a surfboard for Christmas in which we are all supposed to participate. So you see what simple taste they have—But David is terrific and it toughens him up.

<div style="text-align:center">

Love I will write,

Your daughter

</div>

December 28, 1977

Dearest Mother,

Merry Christmas! As you can see, I thought I had mailed the other letter and I hadn't. We are at Annecy and I am looking out over the lake and it is snowing in the mountains. A very quiet Christmas. Antoine's son Patrice had the sweetest baby boy, Douglas. And now his second son's girl is pregnant. Nobody is married…so I begin to think what is the big deal? Evelyn, Patrice's girl who is 35 or 36, two or three years older than Patrice, but a splendid, Swedish blond creature, told me a horrendous story about her first marriage and she is determined not to get married to Patrice…poor Patrice, he wants it so badly. They were supposed to in January after the baby came, but I think in retelling the story of her first marriage that lasted nine years and ended with her husband's suicide and of the nine years, they slept together six months, she has changed her mind again. Boy! And Gilles' girl just graduated from law school and got her first job and bang—she's pregnant. I think she is really very foolish, but then it is none of my

business. Now that the precedent has been set by Evelyn, THEY'RE not going to get married either. Lucette is resigned…Antoine is happy. Christine's wedding for 600 practically ruined him…Caterina has broken up with the boy she had been living with for about four or five years, I guess. He had a nervous breakdown. Françoise R. can't marry because, one: he already had an Italian wife and two children plus a Swedish mistress…Antoine spent all the Christmas holidays with his mistress in the south except for Christmas Eve, two of my other sister-in-law's daughters are living in sin and their mother isn't speaking to them. Nobody has brought home a spade yet, so they can't blame any of it on me…David and Alexei are fine I do hope I can get them to the States this June. That is what I plan. The book is going ahead slowly. I hope everything is alright. I think I told you Françoise C. my curator friend also joined the ranks of the unwed mothers. Her father says he doesn't even know the last name of the father (the first name is George) but her stepmother says he does, he just isn't sure how to spell it! Anyway she is very happy and talks about it as if it were really the immaculate conception, but George is still there, well installed in her flat and married or not (since on the birth certificate one had to put "mother unknown" because, I forgot to tell you Françoise is still married and her husband doesn't want a divorce and it would be his otherwise!) and as she doesn't want to get married…well. As for the older people I think they find the whole situation hilarious…people are dropping bastards like in the 18th century. What counts is from what class they come. And what about Jeanette's divorce? Isn't anybody on that side of the ocean getting married? Tina? Anybody? Well the Virgin Mary had Christ out of wedlock, so why not? And a Merry Christmas to you! Marc has been editing pictures for seven days now, ever since we got here. I collapsed because I was really tired and there is still a lot to do on the house and it is going very slowly and I don't know if I'll ever live in it anyway, which makes things like deciding what color tiles to put in the bathroom very difficult: my taste or intercontinental hotel taste for the people who will rent it? It is really driving me straight up the wall. And so it goes. I just hope I get it finished in time and that there are really no bad mistakes.

January 2 (same letter): Just got back from the flat and there are at least four things to change. The children fought all Christmas holidays about who got the biggest room. So we are knocking down a wall and making the two rooms exactly the same size! Also Marc has decided that the bathrooms are too small and that means knocking down two more walls…and we really can't decide or rather agree on anything. He wants the flat one way and I want it another and our purposes are at cross ends, so it is difficult to get any kind of agreement. I am sorry I started the whole thing now. We should have just split the proceeds of the sale and let each one get the kind of flat they wanted except Marc would never have sold the flat under those conditions and he will never go out and find another flat if it was his flat. Anyway, it is done now and I have to get it finished some kind of way but my own sense of order won't let me do it any old kind of

way nor in a way which will not enhance the value of the flats that would be silly. But I am really feeling the lack of energy and tomorrow I have to face the contractor and tell him all these changes, plus all the other things that have to be decided. I had wanted to get away next week and I have to go to Brussels on business, but I don't know if I'll make it or not. Maurie is not back yet, but I think she will be in tomorrow. I'll let you know how it goes by the end of the week.

How was *Timbuktu*? I got your last letter. I hope you had a nice New Year with Ray and I hope the show was good. I don't see how it can miss. The original music from *Kismet* is wonderful. Must go now. I don't know what I'm going to give the children to eat tonight.

<div align="center">

Love,

B

</div>

P.S.—I got your little package with the lovely hats in it. Thank you—I am trying to catch up on my letter writing before going to the flat this afternoon—

<div align="center">

XXX

</div>

How many times have rich, socially prominent White women changed my life—Betty Blackwell, Betty Parsons, Jane Doggett, Jacqueline Onassis, and many more. They all had one thing in common—extraordinary intelligence that was underestimated as merely social power and a burning ambition to rise beyond their class in inverse, almost like a mirror image of my own ambitions.

I remember staying in Jane's Upper East Side brownstone flat when the window washer came to the door to ask if I wanted my windows washed and I told him no. "How would you know?" he said, and I said, "I live here." Not more than an hour passed before I received a phone call from the landlord admonishing me for letting my "bohemian" Negro friends stay in my apartment not realizing of course that she was speaking to "a Negress" over the phone simply because I didn't speak like one. In my situation of down looking up as well as up looking down, I saw the absolutely obscenity of racism and racial profiling just as in the halls of Conde Nast when the editor of *Mademoiselle Magazine*, Betty Blackwell, had to figure out in a flurry of memos what to do with their first Black college guest editor when they weren't even sure if I could stay at the Barbizon Hotel…

Now that I think of it, I could expand my list of women mentors and friends to another long list of brilliant, exceptional women in my life who were themselves married to powerful exceptional men. Martine Franck, the photographer who married Henri Cartier-Bresson, twice, having left him at the altar the first time. Inge Morath, another photographer who married Arthur Miller after Marilyn and to top that off is the mother-in-law of Daniel Day-Lewis. The third photographer Eve Arnold who never married a second time. There was Noma Copley who married billionaire artist-collector William Copley. My sister-in-law Krishna Roy, grandniece of Nobel Prize Poet Rabindranath Tagore, who married Jean Riboud. Then there was the irresistible Juliet Man Ray, who had in a double wedding with their friends Max Ernst and Dorothea Tanning, got married to Man Ray, the mentor and father figure of my second husband, Sergey Tosi.

In London there was Lee Miller, who married Sir Roland Penrose, or Candace, Lady Rattle, wife of Simon Rattle, the conductor who was the first Black female to be inducted into the Director's Guild of Hollywood for whom I made the first gold *La Musica* titled *Simon*. My friends also included Jackie Goldman, for-

mer Alvin Ailey dancer, who married the youngest son of Nahum Goldmann, and Jacqueline Matisse, the first Black top model, who married the grandson of Pierre Matisse. Françoise Cachin, the granddaughter and heir of the French impression-ist Paul Signac, who never remarried. Then there was Françoise Riboud, heiress who chose never to marry after losing her fiancé in World War II. Another heir-ess, Denise Dennis, a member of the Daughters of the American Revolution and the CEO of the Dennis Farm Trust, the oldest continuous Black-owned farm in America dating from Colonial times, who also chose not to marry. Finally, there was Dominique de Menil, a looming figure in art philanthropy, who decided she couldn't help me because I was family and that was nepotism!

Contemplating this list, I must add to it Jacqueline Onassis, not only for her role in the Sally Hemings saga as editor, which was decisive, but because her let-ters were the closest thing to my mother's voice—the tone, the timbre, the turns of phrases and choice of words were like listening to Vivian Mae. So I included one of them in this book, as there are none from my mother, because they seemed to fit so well and somehow rang so true, so apt and appropriate.

February 27, 1978

Dear Mother,

I have a ticket to New York for Wednesday the 7th of March: TWA, arriving in the afternoon at 2PM. I will take the shuttle to Philadelphia from Kennedy, hopefully the EASTERN AIRLINES one at 4:25. If I miss that one there is an ALLEGHENY AIRLINES one at 4:50 which means that I should be at the Philadelphia airport around 5pm if I get the Eastern. I am coming more or less incognito (ha ha) but I have to let my agent know I'm here and three or four other people as well. So I have little hopes of it not getting out. But I plan to stay with you in Philadelphia until Wednesday the 21st and enjoy the house and your hap-piness, also see my lawyer (divorce and tax), my banker, Jacqueline, a layout man for a project of a book on me, and an architect in Washington. But you know how these things snowball, I'll have to see. I also want to look around Bucks Country for a house at least for the summer or maybe I can work something out with the Lomax's. I will have to come back to New York the end of April for this exhibition at the Bronx Museum and then again in June for the publication of the book the 21st of June. I'm sending the latest clippings to you! I'm also bringing your house-warming present! I'm trying to think of something very French besides your doorbell! I really want to take this chance to relax because the two trips after this are going to be real working trips, so, I promise not to go ANYWHERE, although you may have quite a phone bill (I'll pay it) for the duration... This was just to let you know, I'm on my way. Don't get married without me! I wish I could

have given you more notice, but I just made up my mind yesterday. This is NOT
the latest development in my private life: the others I don't want to talk about at
the moment. It is too fragile I'll just have to think it out once and for all.

<div align="center">

In haste,

B

</div>

Kiss Ray for me. Do I really have a new PAPA!! Don't tell him that! He'll have a
fit! Everyone here sends their love and best wishes for your happiness and loads
of affection and admiration.

Friday, May 19, 1978

Mother Dear,

Got your last letter. Of course it is OK. I thought it was decided on the phone.
I am still struggling with the flat which is why I haven't written. Many prob-
lems. Lousy contractor who has really messed up the painting which here costs
a fortune and a lot of mistakes which are annoying and nerve wracking. The
whole job is a month and a half behind without the end in sight. I have stopped
all payments and there we are. A real mess. But I am looking forward to seeing
you and I just hope I can get the flat in shape in time. Maurie is very worried,
knowing how neat and meticulous you are, she is having a fit that nothing is fin-
ished and your room is not ready. I will do my best. Everybody is waiting for you
including the boys and everyone is looking forward to seeing you. I will try to
go back with you on the 28th. It is not sure I can get on the same plane. I will let
you know. Try and get Ray to come with you. It would be so nice and he would
have so much fun. Everybody would love him. I bet Antoine would like him a lot
and he would get a kick out of the way Antoine speaks English. Maybe at the last
moment you can let him get carried away. Just think: free room and board, tell
him and French cuisine. Marc promises to tell him all about Cuba too! It would
be so nice.

 Anyway...David and Alexei got their letter. Patrice and his girlfriend finally
got married. The baby's christening was Thursday, the marriage was Friday
and the celebration was Saturday and Sunday...so now the rich are imitating
the poor or something. I read in _Newsweek_ a special article on the family and
especially the Black family where 56 percent of the families are headed by women
and 52 percent of the births are illegitimate and 70 percent of Black children are
on welfare. _Newsweek_ wouldn't dare make up figures like that. I was stunned.
Your reverend Sullivan is probably furious they published the figure, which says a
lot about the atmosphere in the U.S. Nobody cares anymore.

October 1, 1978

Dear Mother: Got your three letters at once. Remember you have a space on one side of the envelope to write as well! You never use it (smile). I will be in the States from the 26th of October to the 9th of November to visit you. We have to talk. Talk. Talk. Already have my ticket and it is a midweek I can't change it. Do with me what you will!! I have to spend some time in New York, but in principle it is a vacation. I would like to see a show or two and some friends and think quite a bit. Actually I wish I had taken three weeks instead of two, but now it is too late to change. I will go back via Paris–Düsseldorf. I am writing Ray in the same letter. I hope the house you wanted on North Broad came through. We can speak about financial arrangements when I come, but if that is the one you want, I am sure we can swing it. Marc said he spoke to you and your only two subjects of conversation were your marriage and your funeral... well they are important I guess, but you did shock him! He thinks he's going to live forever. All men do. I would say try for 1979 January instead of 1980!! Time flies... I feel like the father of the bride. Find a place for Ray to stay? Why can't he stay with you?

The boys are fine and back in school. I read about the teacher's strike. Poor Philadelphia school children. But all my Black American friends say that they cannot send their kids to public school. Impossible. I'm looking forward to seeing Doris. How is Janet making out? Nobody thinks I have a prayer of living in the States again... they don't even think I have a prayer of living in reality! Still negotiating with Warner's.* It is not as easy as it seems. They will screw you if they can. And they can. Talked to my lawyer friend in Paris, an international theatrical lawyer who knows how to read contracts, until two this morning, then tried to get through to California, but couldn't. I hope to get them today. I got some rest, but not much. Spent a few weekends with Antoine in the south because I was completely hysterical and then went to the country with the boys for the two weeks before school. Everybody is back from vacation, but I haven't even started making phone calls yet. Have started a new book to my surprise, but, of course as soon as I got back from the country, there was no time to work. I hope to be able to get back down again this weekend if I can get my letters done and get my telephones to the States. I am keeping my fingers crossed for the house on Broad. Try to take off a week or two when I come as you have the time: fourteen days from forty-two still leaves you quite a lot of sick leave. I tried to explain it to Marc, but as here, there is total sick leave compensation, he couldn't understand. You get paid for as long as you are sick. Period. Not your full salary, however. I'll try to get some ballet tickets if I can. The boys saw *Saturday Night Fever* and loved it: twice and now *Grease* is playing. Nostalgia time. David will be going to Oxford with his school this year and Alexei is beginning English as a subject. I think by the end of next summer, their problems in English will be

on their way to being over. I hope so. I still have to go through all my papers, a job that will take weeks, but I don't want to stop the rhythm on the new writing, so I guess the papers will wait. I also have the poetry book to revise and give to Caroline to type. That one I am bringing with me.

*Warner Brothers movie option for *Sally Hemings*.

November 29, 1978

Dearest Mother,

I was happy to have your good news about the house the other night. Tell Ray how PROUD I am of him. The little house sounds divine. I can hardly wait to see it. Send me a picture. As I told you on the phone, if there is a difference between what he wants to pay, I will make it up. I so want you to have what you want. The check can be sent on demand either from Magnum New York or my New York bank. Also if you need any legal advice, you can call my lawyer in New York: either Howard Squadron or Stanley I tel: 661-6500. Am working on the ring problem as well...never fear. And on the king-size bed as well. But you need a flat one for Ray's back like I have. I have written to Julian and the Beverly and Walter Lomax. I really want David to get in contact with Charles David. I hope he can arrange something for this summer with Charles David coming here before. We will see. I still have no plans for Christmas except that I won't be going to the country or to Annecy or to Françoise's. There are so many parties for the Ribouds first, the next to last son is getting married on the 16th of December (they have a three-month-old daughter) and there is the marriage (on skis practically) at Val-d'Isère. Then Antoine has his 60th birthday party and Lucette is giving him a party on the 25th.

Françoise's daughter Caterina is starring in a play in Lyon and I should go down and see it as a gesture to Françoise who called me to ask me to ask Antoine if Jean was invited to the dinner which in that case, she wouldn't come...politics! So much for large happy families...Jean is invited to one and not the other... And let's see, what else? Oh yes, Alexei is now playing tennis twice a week at a covered tennis court very near the house and is being trained for the junior National French team by an ex-champion of France. He is doing quite well. Of course, now David is jealous because Alexei is soon going to be on his level in tennis and he couldn't find anywhere for him to play this winter because they are not in the age division and it is much more difficult for David. They want to catch them very young, between nine and eleven.

Of course I did tell you the news about *Sally Hemings*: Literary Book Club selection, so let's keep our fingers crossed that nothing else happens although anything that happens would not surprise me at this point. I will be more content

once we set up English/Canadian sale and I can finally have the version I want completely. Then I will hand in the poetry book which is called *Portrait of a Nude Woman as Cleopatra* and THAT will be done with. I am still making last-minute corrections on the book. Once you are not pressed for time, everything becomes so much more simple. Went to Vita club last night with my friend Jan, stayed for a long time. I told her all about my adventures in New York and the editor calling me a "Black Jewish Princess" and Jan said "Well, Barbara, if you walk in there with your ten-inch heels and your mink coat down to your ankles..." and I said "But, I didn't have a mink coat on..." and she said "Well you look like you're wearing a full length mink coat all the time...you even look like you're wearing one now!" And we were both stark naked in the Turkish bath!! I died laughing... Give my best to Tina. Talk about somebody going to marry a crazy man!!! And tell her to tell her friend who trod all over my toes trying to get in the last dance with the escort I had monopolized all evening that I forgive her. I just had on my dancing shoes. No offense meant or taken! Keep me posted on the developments for the house. Let's try and get the car paid off too. Oh yes, Jan also said nobody was going to believe I had any troubles so just forget about sympathy. She makes the same impression on people as I do, who figure she can take care of herself. And she said, "If that's how they see me, you can imagine how they see you!" So, as they say in French I will have to de-shit myself all by my lonely...

> Your loving daughter,
> B

December 3, 1978

Dearest Mother—Got your last letter and the real estate settlement—I will send some money via Magnum as soon as possible I am so nervous. I hope everything goes OK.

Do you think you could find for me an electronic "SIMON" for the children? I know they are supposed to be sold out everywhere but I figured maybe Ray could find one somewhere for them. They cost between $20 and $40 but if you locate one, I can get money sent from Magnum—I asked Marc for a divorce just before he left for Italy (then Jordan) and he told me to go to "Vitaclub," my health club, which is like telling someone to take a cold shower—I am going to have to sue if I want it—so much for undomesticated bliss—am working on your wedding band so you better get a date set—I will be in Paris all the holidays—Write—love

> Barbara

December 27, 1978

Dear Mother,

Got your card this morning. I hope the check has arrived by now. Spent a quiet Christmas with Caroline and David and friends. David left for the mountains Christmas Day and I plan to leave for two days for Germany to visit friends tomorrow, but will be back Sunday night. Got a small check from Daddy for the children and they have written him. I can't tell you how happy I am that you are having such a wonderful Christmas with the wedding to look forward to. I am sure the house will come through. Now, it is just a matter of setting the date. The last weeks have turned out to be unexpected. Guess my stars are at it again, I'm game, but tired. The book and the flat really drained me, but now with this new situation, I can't relax, at least until I know a little more about the real situation. I hope the German and Italian (not to mention Spanish and Japanese) editions will follow. It is warm and rainy here. Not Christmas weather and I will find the same in Germany, sure. Meanwhile trying to do odds and ends in the flat. Still finishing up and hope to get some furniture on my side soon with the January sales. If I leave it to friends for six months, it will have to be furnished, more or less. They are a gay couple, so I know it will be well taken care of. Also the Berlin Museum called about an exhibition in Australia of all places in April! So I am going to have to do new drawings very soon. I may even go, if they invite me. Otherwise just waiting to see what the next six weeks bring…pray for me. You are very good at it. It happened so suddenly…out of the clouds…Anyway, now I have to go and hold the hand of a friend of mine who had a liaison with Tyrone Power back in the sixties and it is all going to come out in a new biography on him and her husband doesn't know and is in the diplomatic service about to be named ambassador to India and she doesn't know what to do: write another book herself? So much for the past catching up with you…However, she assured me it was worth it!

Now, what else: oh yes, Antoine's next to the last son got married and Antoine had his sixtieth birthday which was quite a bash. But strictly his friends and family. It is true he is like a father to me. I gave him a pair of gold cuff links and Michèle a wool sculpture by Sheila entitled *Antoine's Incubator* because he was born prematurely and they had him in an incubator and he is always making jokes about them giving him a bicycle and making him pedal for electricity to keep the damn incubator going…He's not the only one…I told him about my iron lung. Have to take this to the post on my bicycle…Keep well. I'll write soonest. If you have any of that voodoo, send it over I need it.

Love,
Your daughter
B

1979

The year 1979 was the year I came out of closet as a writer. With Jacqueline Onassis as editor and Viking Press as publisher, I walked *Sally Hemings* through the front door of history forever to my great surprise and that of all my artist friends. And to the chagrin of most if not all of my writer friends, one of whom scolded me by saying, "Supposed I painted ONE painting, the first in my life and the Museum of Modern Art bought it off the wall for a million dollars and gave me a solo show! You would be pissed off, too, my dear..."

What nerve! It was true. I had started a sandstorm of reaction and controversy and attacks by the Jeffersonians that made the book a global bestseller, by simply paying attention to the record and to the voices of her presumed children, who should have known after all who their father was, and followed them through history defying a thirty-eight-year denial, solved only then by the DNA tests of 1997 that proved me right. Then started another cover-up to cover up the cover-up by denying the denial, which goes on even today with such idiocies as the so-called Sally Hemings "room" at Monticello in the middle of the Monticello kitchens, when anyone with a brain would know that a windowless brick "room" in the middle of a kitchen was no more than a bread oven for the 200 or so people that ate at Monticello every day—180 of them Black.

And then patting themselves on the back in an orgy of self-congratulations about how "liberated" everyone had suddenly become. They continued to ignore me—the invisible non-historian to this day. Truth in American history had begun. Truth in American history began in 1619 just to set the record straight.

April 20, 1979

Dearest Mother,

I hope you had a wonderful Easter. I got your lovely card—spent the week in the country and now planning my next trip to New York. No more vacations! This is a working trip. Viking is publishing a press release, so we will probably be back in the papers. Remember the articles so far have been based only on the name of Sally Hemings—Nobody's *read* the book yet. Then they'll really be mad! The

boys went skiing for Easter and came back black as aces of spades with white rings around their eyes where their glasses were—look like two little raccoons! But the skiing this year was magnificent. And David did a special championship course. Marc may have called you on Saturday the 21st. He spent five days taking pictures on the *Queen Elizabeth II*, but it wasn't very interesting. Now he is off for two weeks to China. He has three hours to get from the docks to Kennedy airport and a plane to Tokyo. But I sent a large sculpture with him as luggage since first-class passengers have unlimited baggage. I just hope he doesn't have too much trouble with it. It really might not have been a very good idea…but it does round out the show and I hope to sell it. It is a piece that has never been shown in the U.S. What's new with the house? Can hardly wait to see the two of you again and we'll have to plan out the summer this time. The boys will be arriving the 18th of July. I had thought to keep them a few days in New York to wind surf. Then near the end of the month to install them for August somewhere. I'll have to see with the Lomaxes and the Johnsons and also what kind of schedule I'll have before they arrive. I should be free of all obligations as far as the book is concerned, by then. Will write soonest. Again thank you for the lovely card.

> Your loving and admiring daughter,
> Barbara

XXX to Ray.

November 8, 1979

Dear Mother,

Sorry I didn't write to let you know I got the pills. Also the books arrived. I am asking Viking to send some directly here. Yesterday morning had a long conference with a French editor who is proposing…yes that I write my memoirs! Or at least a kind of long essay. I told him I would think about it. Did you keep by any chance—the clipping you sent me about Nathan being shot? Suddenly while I was making notes for the conference and for an outline, it came to mind and I don't remember the details exactly. Do you think you could find another clipping or description? I know you kept a lot of letters and perhaps I might do it after the next book. I already told them I couldn't do it before. As for my health I feel better. But I am still very depressed. Marc and I are going ahead with the separation but the problem of the children remains the same. Also the problem of the apartment. I intend to make a lot of money on the next book including a movie—so that with a little luck (mine seems to be running out) I will be financially independent. This however will not solve my problem since my heart has to be attached somewhere solidly for me to feel really at peace. I was really ready to make all kinds of sacrifices for the sake of the boys…my boys.

They are very unhappy. I finally told them. David has gone to Florence with his class for a week. He will be back on Sunday. Alexei is here, playing tennis. Spoke to Françoise over the phone but haven't seen her. I don't know what I'll do tomorrow for that matter—got a call from Warner Brothers about extending this option. I think my agent is going to California to discuss—she promised to cable me about it.

How is Ray-baby. Give him my love. Tell him not to work so hard—to live a bit. I am enclosing the photos you asked for—plus some others that were taken for that article. Seeing a friend of mine on Monday about finishing the flat—the drapes and more furniture and my dressing room. Will write soon. Don't forget clipping.

<div style="text-align:center">

Love,
Barbara

</div>

Dear Mummy and Ray,

Happy Christmas!! I'm thinking a lot of you. I remember my beautiful stay at your house in Philadelphia.

In Paris everybody is going well. My first three months in school were not very good but now it is going much better (it was not catastrophic!). I will come to the States with my school on April. I will probably use this occasion to stay for the Easter vacation. So I will maybe see you then. I presume there is a lot of snow in Philadelphia, in Paris morning it was raining. We must go to Annecy for Christmas. And after we're going skiing at "La Clusaz." We're going with Tante Françoise and Dad. I will write to you soon. Happy New Year too. I kiss you both. Say a lot of things to Ray.

<div style="text-align:center">

David Riboud

</div>

Can you send some more soap if you can. It's not very important.

December 11, 1979

Dear Mother,

Got your last letter. I am so happy for you for the 28th! It means you won't go back to work after X-mas—what a good idea! Otherwise nothing changed—no news on Sally Hemings' film option—as always with those projects, there are ups and downs and no one is ever certain of anything until the film is "in the can" as they say—and even then there is just no guarantee. I have to call New York tonight. Hope Ray is well!! I will certainly call you before Christmas. Just got your package—it arrived safely. I may be back in the States in January sometime, depending on work, etc. I am trying to start a new book. The French version is going forward. I will see the translator later on this month. He hopes to have the

translation by February and my editors hope to have it out in French in May. David and Alexei are fine. David will probably go to a ski competition training camp at Avoriaz for Christmas. Marc is not too happy about it, but I think he needs to go especially with Alexei having his tennis training. Maurie is fine except for her knee which bothers her now and again. I am going to my health club a lot. Finally we are all going to Annecy for Christmas. I will then come back to Paris and the children will go skiing for six days with Marc. I don't think much of the idea but since it is a very delicate time I made a fuss, but will not continue to make an issue out of it. It's a man's world and I'd rather get even than get mad. I'll give David the money instead. I still haven't completely made up my mind. Anyway, I'm not getting much work done—I will definitely call you for Christmas. Marc says he wants to stop on his way back from Washington on Thursday. News from Warner Brothers is that they have picked up the option on S.H. for another 120 days—non-applicable against the final sale price.

Write soon.

Sadly,
Barbara

1980–81

The gulf between my two worlds and my double life was enormous and not likely to change in my lifetime except that it did one day. Coming out of my agent's office on 57th Street, having for the second time in my life become a runaway bride except that this time I was divorcing a husband of nineteen years, the literary and the art world collided as I looked up at the building next to International Creative Management (ICM) and saw a tall dark and handsome man staring down at me as if he knew me. Then I read the name in gold letters on the plateglass window of the art gallery. It read Sergio Tosi Stampatori. He smiled and waved. It took me a moment to recognize him. The Sergey Tosi I knew had been a Milanese art publisher, friend of Man Ray, Lucio Fontana, and Cy Twombly, whom I had first met in Venice at the Biennial sixteen years previous when we had both been married to other spouses. Our second encounter had been eight years ago in a much more dramatic and flamboyant way. I had been invited to dinner at his seventeenth-century villa on the Lago d'Orta in Italy where I had gone for the weekend from my foundry work in Milan. Because of plumbing troubles at my hotel, I had asked to use one of his bathrooms to take a bath before dinner, which everyone including him had forgotten about. At the same time, an electrical storm, for which Orta is famous, blew out all the lights just as I was descending the grand staircase decked out in the long white Renaissance cum Mexican dress I had changed into. Suddenly, a bolt of lightning illuminated the empty black stairs as I slowly descended, invisible except for my white dress floating disembodied with no head, hands, or feet, down the steps toward my host. Needless to say, my apparition, which he was sure was a seventeenth-century ghost haunting his villa, was both terrifying and indelible as Dracula, at least according to the yelp of terror he had let out.

Our third encounter was taking place now on the sidewalk at Fifth and 57th. Here was the golden boy of the Italian art world, a publisher of numerous art and artists' books in Europe and one of the last and sweetest playboys of the Western world. He had produced editions of Man Ray, Max Ernst, Duchamp, and de Chirico and published the famous Paris–New York 800-page catalogue of the 1977 landmark exhibit curated by the legendary museum director Pontus Hultén.

He had moved to New York only a year before from Venezuela to open a gallery located just between Betty Parsons, my art dealer, and I.C.M. my literary agent. He was divorced he said, and when he had left for South America, he had burned all his papers and photos and taken only his pictures and an address book with only five names in it—one had been mine.

I invited him out that night to see *Evita* which he pretended he hadn't seen and then we wandered around, ending up in an all-night movie house watching *Fame*. We never recovered. I thought of that long-ago bolt of lightning. He had wondered why he had kept my name in his tiny address book all these years. Now we both knew.

Before leaving for Paris, I took the train to Philadelphia to tell my mother what had happened. She had been appalled at my impending divorce and had stopped speaking to me. She had also thrown away all my letters that had spoken about it. At the airport, I asked this perfect brown-eyed stranger if his life was complicated. He said no. I asked him if he would escort me to the New York Public Library's Janet Heidinger Kafka prize ceremony for *Sally Hemings*. He said yes. It was a declaration of love.

When I returned to New York for the prize, I introduced him to my mother, who knew at once. She also figured out that this new love had nothing to do with my divorce. In the end, she fell for Sergey as hard as she had fallen for Marc.

We remained in New York for almost a year, living on Central Park and 82nd until Sergey could wind up his affairs and close the gallery. We moved back to Europe. Sergey opened an Italian-backed cultural center Kiron, near the Bastille, and I installed a new atelier at 26 Rue des Plantes in the Montparnasse District. This was my last Parisian atelier, which I occupied for the next four years after which I moved my atelier to Rome. It was an Art Deco building of artists' lofts coincidentally only a few hundred meters from Giacometti's studio at Rue Hippolyte-Maindron. It was famous for having housed the Resistance fighter Jean Moulin and had a huge plaque on the façade in memoriam to him. The likes of Max Ernst and Édouard Pignon had lived there, as well as Loulou de la Falaise and her husband, Balthus's son and Yves Saint Laurent. Art and literature had finally met.

Whoever or whatever was at work had given me someone amazing with a brilliant knowledge of the art world who could finish the sentences I had begun, could read my mind, and looked like Marcello Mastroianni. Then like magic, my mother finally made up her mind between her numerous suitors and married a handsome Latino, Raymundo Sol, a retired U.S. Marine officer, a fitness apostle, a year younger than Marc; they married in the house they had bought with our help in Mount Airy just outside Philadelphia.

26 February 1980

Dearest Mother,

A big kiss for Ray. I hope you both are well. Is it over yet? I got 1) the vitamins
and 2) the books thank you! And forgive me for not writing sooner. I just thought
it better not to write any complaining letters especially since I have nothing to
complain about. I have only to leave that's all—And I can't bring myself to do it. It
is so complicated. Where, first of all, to go? And with whom? And why, after all.
I guess it's my romantic nature coming to bear, but co-habitation should be better
than this. Although when I look around there don't seem to be many people
(yours truly excepted) doing much better—and no couple I really admire to the
point of changing places, If I could. On the other hand I am not meant or fit for
living alone so it is really a matter of luck and my luck seems to be failing me at
the moment.

 The book did really well in hardback and literary guild, selling in various
book clubs like Doubleday so I'm hoping with a 500,000 first printing we can
reach one million three in all before the Avon paperback comes out in June.
People are still writing articles—and Avon, the paperback editors, plan a big
campaign (if they get the advance orders) including television spots—which
should be fun. The French edition comes out in June also. Called *The Virginian*
(*La Virginienne*) instead of *Sally Hemings* because the French can't pronounce
the "H" in Hemings and the marketing people (they really don't have a very
high opinion of their readers) don't think they'll recognize the book in the
bookstores!! Oh well, I've learned never to listen to marketing people. Nobody
knows *why* one book is successful and another not, everything is a horse-race.
Anyway, let's hope my luck holds for one more. It seems the book is getting
more and more famous in feminist circles and ladies clubs. Caroline's sister
wrote her from Chicago that she had been invited to a "discussion group" on
Sally Hemings and of course when she announced she *knew* the author...So
maybe you can organize a discussion on the author of *Sally Hemings*—how she
never learned to clean up her room or after herself....Maurie sends her love,
by the way! Marc is more and more nervous and it is really dangerous for the
children and I really don't know what to do. I don't want to deprive them of
the only family (and only father) they have. David has made an application to
Andover Academy near Boston for the summer session. He has a friend who
went last year and loved it. It is really beautiful and they have a special English
course for foreigners who want to continue their studies in the States. It seems
hard, but worth it. There are about 1,000 students in the summer—about fifty
or so foreigners. So, I'm hoping he gets in. He will not be going to the States
with his school in Easter as I had mentioned. They want to take children who
wouldn't have a chance to go otherwise. I am writing to friends of mine also

about St. Paul's. If David really likes St. Andrew and he says he wouldn't mind boarding school, he could finish in America. After all he is 16 and I left home when I was 17! Alexei is another matter. He is so French I can't imagine him not finishing here and going to a "Grande Ecole" as they call the important colleges here. But we'll see. Also it's a matter of money. School here is free or relatively inexpensive. The boys' private school only costs $2,400 a year. I could never find anything in the States for even double that. The summer school for David alone is $1,125 but then that's everything and room and board. Anyway at Easter, David will be racing with his skiing team and Alexei will either be skiing with his cousins or doing a tennis camp with his team. He hasn't made up his mind which at the moment, but it looks like skiing with a friend of his David Meyer. But I will probably be in the States for Easter. For one thing that is when Avon will decide how many paperbacks they are going to print for the first run—I'm hoping a million which is a possibility according to hardback sales and which is not unusual for a paperback which sold well in hardback. But, we'll see—there's always something that goes wrong. Give my best to the "girls" and of course, to Joan and thanks for looking at the house. If you felt like looking some Sundays do so. From your description that one was not at all what I wanted. The one they had proposed and I lost was near the Johnsons, on a national park which had a lake, it had two acres, a separate (in-law) apartment, a studio, a swimming pool and the usual number of rooms and it was $72,000. So this one was out of the question for that price. Of course that is why the other one went so quickly even before I could see it. Sometimes you might see something interesting in the Bucks County advertisements, but of course I wouldn't buy anything without seeing it and the good things go so quickly, it would have to be while I'm there and just by luck or connections like the last house. Also I don't want any repairs in addition to painting if possible. Of course the price of painting in the States is ten times less than here, but when I even *hear* the word "painting" it gives me heart failure. I guess it wouldn't be too bad—my father might even give me a price... The prices here are science-fiction and show no signs of coming down: maids' rooms are selling in new buildings for $36,000!! I looked at one down the street from me. So my maid's room (one of them) would be enough for a big down payment on any kind of house I would want. It's the upkeep and the taxes that make these houses impossible. Anyway, it's like buying *Vogue Magazine*. It's nice to look if you have nothing better to do. It's like Joan's auction sales where she never buys anything... Has she bought anything since I left? A chair? A clock? Anything? Tell Ray I won't love him anymore if he gets a beer belly—stop cooking for him for heaven's sake! Of course there is nothing you can do at work about the popcorn and the jelly beans... better fat and happy, although as the Duchess of Windsor said you can never be too thin or too rich—but she proved herself wrong poor thing on both counts!

Jacqueline's mother got married a few months ago to a very seductive man.

I wrote her. I don't know, you girls all must be doing something right! She didn't answer me so maybe she's miffed. Her other daughter Lee got cold feet at the altar and called the whole thing off. Another runaway bride! My nephews are waiting until their babies are old enough to carry the bridal train. I'm beginning to think I'm a real 19th century romantic. No ticket, no laundry! Well, no more news. I hope I answered all your letters. Everybody here likes the book. I wonder how it is going to do in French. I may go to Israel just before the Easter vacations—Practically the only nation I haven't tried at least once—after all, some of my best friends...I'm sure Ray would have something to say about that! I did write to Charles Brockton—a short note.

<div align="center">

Kisses,

Your daughter (loving and otherwise)
</div>

Happy (belated) Valentine's day—Hope you got your box of candy!

--

June 12, 1980

Dear Mother and Ray,

Now, for the prize:* unless I call you otherwise, please block the 30th of June evening and tell Frances and Ben and Joan and her husband to do the same. If all goes as planned, the presentation will be at the Metropolitan Museum at a private party in the 20th century galleries in honor of their new American wing which just opened the 11th of June. It is a terrific coup for me and the curators are doing it as a favor to me. It will be catered and optional black tie...all you guys in black tie please. All us provincials from Philadelphia, Rochester, Milan, Düsseldorf, Paris and London in black tie. The New Yorkers can do as they like. I can't think of a more fitting end to the Sally Hemings saga. Have you seen any of the T.V. commercials? I guess they will still be on when I arrive which should be before or on the 20th. I will call and I'll be staying at Burt's (last chance, he's getting married...I told Helena it was bad enough trying to live with him without him trying to live with me). Anyway, please count on that date. Won't Ray be on vacation? I don't know what will happen after the reception, but I'll think of something. As you can imagine, there is a lot to do and as Velma told me coming back from New York, you can't count anymore on American efficiency to get anything done right. She spent the five days before Pol's opening correcting the mistakes of other people. I'm glad I'll be out of it for a while after this. But I think this is important to do and do well. Oh yes, tell your doctor friend, I've forgotten her name! That she is invited and that her piano player (the one she had at Jefferson Hall that played all the soft ragtime and I never even got a chance to thank) is invited to play at the Met! I think it made a very nice background atmosphere. The Met is a rather daunting place and this would considerably lighten it,

I think. Then Velma (this whole thing was her idea to start with) started laughing and saying not to invite too many Colored people cause they see a piano and a piano player and they gonna start singing them spirituals for them White people or some White liberal is going to start singing "We Shall Overcome" for the Blacks. I told Velma if one Black person opens his mouth in ANY kind of singing except the Star Spangled Banner, he is going to be thrown out. I mean out! So you tell Joan don't come in there humming, or I'll kill her and if Ben opens his mouth with "Swing Low Sweet Chariot," "Wings over Jordan," "Nobody Knows the Trouble I've Seen" or "Old Man River" he can count himself as disowned.... I'll call you as soon as I arrive. You remember Lowery Sims, you met her in New York the last time, and Bill Lieberman who bought my first drawing for the Museum of Modern Art is now the head of the Contemporary Art Department at Metropolitan Museum. That is how we got the place.

<div style="text-align:center">

Love, XXX
Your daughter

</div>

*Janet Heidinger Kafka Prize for *Sally Hemings*.

September 21, 1980

Dear Mummy,

Glad the driver got you back to Phila. safely. I was so nervous. Now that you've met him at last, you understand. You say it is too early—too early for what? For whom? Lightning doesn't strike twice—and life isn't going to keep this brown-eyed handsome man, as Nina Simone would say, under wraps just for me. I love him. It feels like we've always known and loved each other. For 16 years our paths have crossed each other without a clue that this would happen.

Please don't be frightened—this is a man who does not equivocate. We've had three chances over the years and this is the last. I watched you two descend the steps of the Metropolitan Museum together and it sent chills up my spine. It seemed to me that I belonged to both of you and you two to each other. You were my little island of peace and calm in all those people swirling around you. And he is the love of my life.

Sergey or Tosi as I often call him has had an extraordinarily eventful life and when a ladies' man falls, he falls like a ton of bricks. You are not the only one who is frightened—most of his friends and mine are too when he announced who he was in love with. Too late—There it is. He is an exceptional man mother, who can finish my sentences. An incredible mind. The only question is where? Would I give up France for the New York rat race? Would he give up his free-wheeling nomad life in South America for the Europe he left with all its restrictions and class system? We will work it out however the cards play. We are grown up

people with pasts. I have children. Neither of us believe in fairy tales. Happiness is getting another chance.

<div align="right">

Your Loving daughter,
Bobby

</div>

[IN SERGEY'S HANDWRITING]

Gentile Signora,

I am taking up Barbara's pen to tell you I was so moved to meet you and be able to tell you how much I admire and love your daughter and how I am prepared to care and look after her. Our paths have crossed three times in sixteen years and this time, luck was on my side. My mother died when I was twenty-three. My father and I still miss her. You and she would have liked each other and I hope you will come to like me in time. I understand your shock, but it is even more so for us! We didn't plan this but I know there is no other choice.

Please accept Gen. Vivian Mae, my most ardent salutations. I will take very good care of Barbara. I cherish you as she does.

<div align="right">

With affection,
Sergio

</div>

October 29, 1980

Dearest Mother,

It was so good to speak to you in person. Your voice is always the voice of reason. I know everything will be O.K. Take care. I think doing a little sewing is a good idea. Retirement doesn't really agree with some people. The boys are fine and send their love (included). They are on vacation this week but they have decided to stay home, the two of them. I think they just want to stay close to their mother.

<div align="right">

Your daughter

</div>

December [no date], 1980

Mummy,

The divorce papers are almost signed. It will only be a matter of a few more months. I will be back in the States in December. Sergey is waiting for me. From the looks of things, we will probably stay together. As I told you, nobody is more surprised than we are, believe me. His family is in Venice and his company in New York. And in such a beautiful package. 42 (just turned on the 12th of

October), no children, one ex-wife, no brothers or sisters, Milan Polytechnic, art expert and publisher. I hadn't seen or heard from him in seven years.

—Your loving daughter

Paris, November [no date] 1981

Dear Mother—

We may go to Rome for Christmas but we are waiting to see what David wants to do—he has a month (from 18 December to the 15th January) vacation. Maurie sends her love, Alexei too—We went shopping for David's things for school yesterday and of course Alexei ended up with more than poor David—as usual. No other news—looking for a house in Rome. Having Thanksgiving dinner with Mary McCarthy—doing a conference with her on Friday at the American Embassy. Having lunch Saturday with the Mayor of Paris. My friend Jackie Goldman sold her flat to Mitterrand (he objected to her parties—she lives next door to him and the secret service would knock on her door at 10:30 every night and of course she had a party every night at 10:30—curfew. The rich are changing flats— the poor people can't find any).

Imagine little old *Sally Hemings* has 14 different editions so far, 34 printings and one million two hundred and seventy-two copies sold—who would have thought! Sergey sends his best.

—Barbara

Paris, December 13, 1981

Dear old unwed Mom,

Here is (I hope) your dress, the flowers for the chapel and the invitations. We can discuss the food, etc. when we see you. Hope you are having a good time running around. We would like to offer you a honeymoon trip to the Islands— the only condition is that your new husband goes with you. I can make all the arrangements here. Just tell me where and when you can go. There are wonderful package deals of even weekends in Bermuda, Jamaica, St. Martin's, Martinique, St. Croix, etc. Think about it and let me know. Do it if only for the pictures! And the reception can be your birthday party! I told the boys not to forget that you were giving a fête on the 23rd of January, your birthday. I spoke to them on the phone last night. They are fine—have good report cards, going skiing as usual. Marc just got back yesterday from Cambodia. Maurie is fine and sends her best. Daddy called last night to find out where to send his check for the boys—if we were going back to Paris for Christmas or not. I told him we weren't, that the

boys would be there until the 23rd when they go to the mountains until after New Year's. The time will go so quickly you will be married before you know it. We'll see you around Christmas—I'll call you. I wanted to make an appointment with the dentist across the way—but at this moment, I don't know when I'll come. So dear about-to-be-married Mom, have a good day. See you at the wedding! Long life and happiness forever...So glad you finally made up your mind between all those fellows...

<div style="text-align: center;">XXX Barbara</div>

I n April 1979, *Sally Hemings* the novel was published to great critical acclaim and a front-page daily book review by John Russell. It went on to be published on four continents in sixteen different languages, and sold more than three million copies worldwide in twenty-three different editions including book clubs. Hemings was finally world historic. The book started publication in translation and exploded across Europe as *La Virginienne* (feminine), becoming a global bestseller translated into French, Italian, German, Spanish, Portuguese, Dutch, Flemish, Slovene, Canadian French, Swedish, Norwegian, Danish, Japanese. I was a European celebrity. I appeared on the famous French television program *Apostrophes*, hosted by Bernard Pivot, which everybody in France watched faithfully every Friday night from Mitterrand to nanny Maurie.

As the book came out in foreign editions in Europe, I began working once more and storing my sculptures, convinced I would never write another book. Why should I? I had accomplished with a single book the dreams of most of my writer friends. "Well," I said, "the first part actually happened when I was fifteen," I laughed, "And maybe Sergey is the second part...."

Sally Hemings, published in Italy as *La Virginiana* (*The Virginian*), was an Oscar Mondadori bestseller, as my double life pursued me into the Tuscan hills, where I found a new father-and-two-son bronze foundry just outside Milan and where I began my *Tantra* series, setting up a studio in the foundry itself.

I followed the wisdom of keeping the two professions as separate in my life as they were with the public, and people who knew me as a writer knew nothing of my art and vice versa. An art critic would stare blankly if I started talking about the *New York Review of Books*. A literary critic was unimpressed with a solo exhibition at MoMA, Paris. There had been a time when poets wrote on painting in their friend's catalogues and sculptors wrote poetry and potentates appropriated both, but those times were a hundred years old. Now, there was no communication at all—in fact, artists and writers didn't even talk to one another. Literary critics hardly knew there was a magazine called *Art in America*.

That summer of 1982, the children were in Annecy with their uncle, Marc was in Cambodia, Sergey was leaving for Viareggio in Italy where he had a sum-

mer house, and it looked like every Jacqueline I knew was in the Hamptons—Sag Harbor: Jacqueline Simon, Jacqueline Matisse, Jacqueline Goldman, Jacqueline Rothschild—everyone holding their breath. Would she change her mind? Come to her senses? Call it all off as she had done before? Everyone kept their distance, even my mother. The stillness was terrifying and deafening. I was all alone in the Hamptons crowds as well as the Sag Harbor crowds both White Sag Harbor and Black Sag Harbor. I introduced Sergey as a distant cousin of my endless in-law relatives and when he left for Viareggio alone, Toby the wife of Alexander Calder's lawyer Stanley Cohen offered me her empty villa in Majorca to get away. I was in Majorca, another island, when the final papers came through. I began my third novel, *Validé*, and when Sergey returned to New York, we took the penthouse apartment at the Alden 225 Central Park West and 82nd incredibly only one block away from the location of the mansion that would be the centerpiece for my seventh novel, *The Great Mrs. Elias*, still far, far in the future. It was about this same time that Betty Parsons my dealer died, leaving me an orphan in more ways than I had imagined. All of her male stable immediately found new dealers, but her four female artists—Hedda Sterne, Agnes Martin, Jeanne Reynal, and myself— never found subsequent representations for decades. Her other artists scattered to the four winds of different galleries—Alex Lieberman, Jack Youngerman, Mark Rothko, Ellsworth Kelly, Jasper Johns, Kenneth Noland, and David Smith. But I never received an offer from another gallery. I would never have a permanent dealer in New York until the 2000s. Betty had been my beacon, my godmother, my security blanket. In Europe, I had buried my New York ties.

Alexei and David were growing up fast and were through and through Frenchmen, although I believed their Americanization would come with college in America and was just a matter of time. David had applied to Brown University rather than Yale. When I protested, he proclaimed that Brown was the top school in the United States. It seems that I was out of touch with what was really "cool" in the United States. Besides, that was where John Kennedy Jr. was going. David would start at Brown with a full year's advance as a sophomore because of his diploma from a French Lycée. Alexei seemed headed toward a French Grande Ecole and following in his uncle's and cousin's footprints with perhaps a sojourn in New York.

By hook or by crook, we worked out a schedule that included Milan, Paris, and New York. Two extraordinary events happened: my stepfather turned out to be a Reagan Republican, and my mother began to paint, having installed an atelier for herself in the basement. The AIDS epidemic began, and Doris' brother Julian fell ill. Mumia Abu-Jamal, a Black journalist, was arrested, he claimed falsely, for the murder of a Philadelphia policeman. Michael Jackson's album *Thriller* would go on to sell 232 million copies. And in Central Park on June 12, a million people protested against nuclear weapons.

By the middle of the 1980s, I had exhibited all over Europe, in Australia, Canada, Iran, Tunisia, Algeria, Morocco, Mali, Dakar, Sub-Saharan Africa, Sene-

gal, Nigeria, Japan, and the United States. I had had unique or landmark exhibits at the Museum of Modern Art in Paris, the Kunstmuseum in Düsseldorf, the Kunsthalle Freiburg, the Sydney Biennial, Documenta, the Newark Museum, the Seattle Art Museum, the Berkeley Museum in California, the Metropolitan Museum's "Gold" exhibit, Brussels, Switzerland, and Italy. The literary world would learn little of this double life nor would the art world learn much about my novels. My disappearance from one world or the other would be noted and then forgotten.

November 12, 1982

Dear Mother,

Got both your letters—I didn't send you a card from Germany where we had to go for the Frankfurt Book Fair because it was too ugly! Anyway, I have to go to Istanbul for some research sometime in the next month—so don't give up on postcards. I spoke to David on the telephone last night. He is very happy, working hard, he has been given a year's credit so that instead of being a freshman, he is already a sophomore or second year—very convenient since he has so many years of study ahead of him. Anyway he has made a lot of friends, like his roommate—will be coming home for X'mas—We will probably be here unless we decide to spend a few days in Rome—the weather has been terrible, but today the sun is shining for a change. We are so used to good weather all the time in Italy— Maurie is still the same—sends her love—she comes 3 hours a day—so Tosi is at least well taken care of—The book is going very well in Germany, it is at 60,000 in Italy and a Danish edition will be out next September—As soon as I get my new Belgium checkbooks, I will reimburse you for this summer. I know David ran up a telephone bill at least and there were his driving lessons as well—How is Ray? Give him my love—Nothing new on the film. Everything else is quiet—we haven't really gotten back from Germany yet and as we are doing some more work on the flat, we haven't been going out all that much for the past two weeks, there was the big International Art Fair at the Grand Palais—a busy time for Tosi—so he had that to cope with just upon arriving back in Paris—lots of New York friends and art dealers in town—Alexei is particularly pretty these days—he has a natural elegance which is incredible—he has cut his hair very short (like in the photos) and it suits him well—He sends you a big kiss—

Barbara

1983 January [no date]
Paris

Dearest Maman,

Got your letter this morning—Happy Birthday! I hope David has not forgotten to mail all this and it arrives in time. Sorry about the confusion for your and Ray's Christmas present. I had it sent directly as we were in Milan through my banker. Had a nice quiet Christmas with the boys in Paris then they went off to ski and we went to Milan for New Year's. We stayed in Milan for New Year and Tosi had some business to conduct for his father. We spent the New Year's Eve with friends (the traditional dinner in Milan for New Year's Eve is pig's feet and black-eyed peas! Believe me). The tradition is naturally German since Milan was a German principality (Austro-Hungarian or if you like the Holy Roman Empire) before Italy was united. I laughed thinking about it! But of course, being Italian, they add to the menu, ravioli, three kinds of quiche, cheese, salad, and enormous cake they call panatoni and champagne...You can imagine how everybody feels after all that. We then went to Viareggio to take care of the house and see Tosi's lawyers there. Tosi finally got his father to agree to sell the house in Viareggio by buying him a new flat in Milan. Smaller than his old one, since he lost his wife and was rattling around a huge apartment. So we are selling Viareggio and buying in Rome. After Viareggio we went to Rome where we stayed in a beautiful palace belonging (one floor) to Princess Pontacali, Tosi's old gallery partner, for ten days looking for a house in Rome. The day I took the plane back to Paris (Tosi is still in Rome looking), he found what we were looking for and by the time I walked into the door in Paris, he was on the telephone. I told him to sign without me and I would take the plane back to Rome that Saturday. But the deal was complicated, Tosi's notary hesitated and in the 24 hours that lapsed, the guy sold it (he wanted cash on the line). That's how the housing situation is in Rome: about equal to New York in price and in rarity. The two things we saw that we liked and could afford (sort of) were gone in 24 hours. But I'll walk up those palace stairways yet...It means Tosi has to sell Viareggio first and go back to Rome, cash in hand. Deals are closed in a matter of hours. On top of that we are looking in a very restricted area the "historic center" of Rome which is completely restricted to "historical landmark" buildings which means there are very few things available, very expensive and one has to have the permission of the minister of culture even to change a window—and the frescos forget it. Every house, every palace is considered a "national treasure" and the fine arts commission has suddenly gotten very tough. Anyway I was very disappointed we lost that one: it was in the center of Rome (in back of the Pantheon), it had a beautiful stairway of about 14 feet across, it was the first floor with ceilings that were 15 feet high with vaults. There were two salons very big with windows so high there were stone steps to

reach them. The apartment had been cut up into 8 rooms but it was really 6, the two salons should have been twice as big. It was a real palace of the 1800s so more comfortable than a 16th or 17th century one. It had Venetian marble floors and marble door frames. But there was a lot of work to do. But what was nice, it gave an impression of being in the country in the middle of the city. I don't think we'll ever find anything like it again for the money, but there are other things around except we are not likely to be satisfied with less!! Anyway that's what we've been doing in the past month. I am back in Paris where I am desperately trying to finish the book before Caroline goes off to Washington. As you know, the US walked out of UNESCO and Caroline's husband, David, took a new post (still with UNESCO) in Washington. They are leaving the end of March. Caroline had just gotten the naturalization papers for Rebecca (her little Vietnamese girl) in Chicago! So it is a race against time and all the distraction of money for her and for me. As for the Hessmayling Corporation which is headquartered in Brussels, everything is fine but not yet operable—in a month or so it should be functioning. I will explain it all to you in another letter since there is always something new happening also lots of news of David on his way to college. Love and kisses to everybody—new letter to come—

<div align="center">XXXX</div>

February 10, 1983

Dear Mother,

Just a quick note before I go to the post office. Love from everyone. Alexei just got back from skiing holiday. I hope David called you for your birthday! Am working day and night on the new book. Tosi just sold a fantastic Renaissance sculpture he had bought with his partner in Milan a few weeks ago. Some new action on S.H.! She is now in 25 different editions in 8 different languages with over a million and a half copies sold...I just signed for Denmark, Sweden, Finland. It is going to be very funny to see the books out. The film is optioned again...let's keep our fingers crossed. There was a big fight between several producers including Motown with frantic telephone transatlantic calls from Beverly Hills—very Hollywood. But let's see the green and the cameras rolling. So far it's all American this time and for cable television. I am rather optimistic if fatalistic about the outcome. I think it will be easier to produce Sally Hemings under a right-wing conservative government like Reagan than under say Carter—or any liberal. It is a political law that the right can do things the left could never get away with and Sally Hemings on state television is one. Anyway, never a dull moment. My New York agent has gone away to a boot camp (the latest in health clubs) for a week! Anyway, another dream realized: your daughter president of a multinational corporation! Hessmayling Corporation, headquarters in

Brussels—all nine: 3 Belgian, 2 French, David Riboud (who is of age in Europe), 1 American, 1 South American. Capital, million Belgian Francs—sounds like a lot anyway. We are a production company and a publishing house and agents for the exploitation of BCR's artistic endeavors—sculpture, literature, movies, television, poetry, etc., etc. It will give David something to think about in a few years and Alexei to start a bank (private) with. So you can imagine we are both nervous wrecks. We thought last week we had found a house in Rome, but at the last moment it was bought by the city of Rome for a museum! We were going to share it with two other couples. The big news here is a big Nazi trail about to open in Lyon. It is going to be quite a spectacle with a lot of dirty linen and wartime collaborators washed in public. He was extradited from Bolivia and here they called him the "butcher of Lyon." Too bad my "German" book is not finished; it would be a good time to publish it. Too bad I'm running out of paper—my friend Barbara LaMonte from New York just passed through Paris on her way back to the States after a year working for the television in Nigeria. The events there are really too terrifying.

Next letter. Kiss Ray for me. Tosi sends love, Alexei too.

B

Easter, 1983

Dear Mother,

Happy Easter—I was so happy to hear your voice on the telephone. This is not a letter—just a short note to let you know I owe you a long letter. Did you get the German edition of S.H.? And the Italian? I signed for the Swedish, Danish, and Finnish editions. So much for S.H. As for the movie it looks like another round of options and deals coming up. An option is money, quite a lot paid to an author for the right to think about making the movie—it is a non-returnable against the final sale price. Remember the only Black company capable of producing S.H. is Motown and Motown just missed the chance to option S.H. who is optioned as of the moment to another company. Remember also that the cost of producing S.H. is the astronomical area of 30 million dollars. Not an easy deal to put together, although politically it may be easier to get it produced under Reagan than under Carter. Anyway we will see what happens.

My friend Frances Cook, who was named ambassador to Burundi three years ago, was back in town on her way to another post in Egypt. Sure that we will visit her there. We never did get to Burundi (Burundi is near Kenya). She was in very good form back to the States for four months of R + R and lessons in Arabic.

Ruth Ann, my New York public library director friend will be here on the 14th for the weekend from London. It is the season when people start coming

through. We will be in the States either the end of April or about the 5th of May depending on whether I decide to go see David before his examinations, or afterwards. Somewhere between May and the end of June, we have to get in the trip to Istanbul and as I said we want to go to Egypt in October/November at which point the book that I am working on now had better be finished.

Our address in Italy is: 5 Via Bertini, Viareggio par Lucca Italy. But we won't be there until June! Our address in Paris is still 3 Rue Auguste Comte.

<div align="center">

Love you,

XXX BCR, Sergio, Alexei

</div>

P.S.—Alexei's Italian (he is taking it at school) is coming along splendidly except that according to Sergio, he has a Russian accent...he got straight As—He now wants his name spelled the Russian way.

[no date] 1983

Dearest Maman,

Everything is fine. Got your letter. Yes, we were at Roland Garros—one of the board of directors of my company is a man called Jarobin Gilbert, a vice president at NBC (Black from Barbados) and this was one of his responsibilities. He is in charge of all international productions and programming. A fabulous guy— 33 years old. Anyway he got us tickets and seats and Alexei was so wide-eyed I thought he was going to faint. Everyone was in tears at the end. Noah really played his heart out (so did Alexei) so it was an experience. We were on the camera (NBC) side so that's why you didn't see us.

Sergio sends his love. He is in Milan—Rome—and back on the 18th. On the 21st I have a television program in Brussels. On the 4th of July we leave for Italy (our anniversary) and on the 22 of July we spend a week in Venice at the Palazzo Spinelli. At the end of August I am taking the boys to Venice—same palace. I am so excited. Also the apartment here is finally getting finished and it is superb. We are going to get it published. We have a dish which belonged to Prince Gonzalo of Palermo plus I just found six dining room chairs—Russian 1830—fantastic. As a surprise birthday present, Sergio exchanged some Calderara watercolors with his cousin Sergio d'Ashnash for a 16th century portrait of Alessandro de Medici from the atelier of Pontormo hanging in his hallway! He agrees Alexei does resemble the first Duke of Florence—he was quite annoyed he hadn't known he was biracial when I told him, then he remembered the portrait. Was I surprised . . . beautiful—portraits of this size were used as diplomatic presents—there are only 13 known to exist. Work is going well. You are going to love the new book. Am opening an exhibition in Paris on the 21 (yes I know I'll be in Brussels, but it can't be helped) a great exhibition. I'll send you the invitation.

David and Alexei send love. I'll send photos soonest. We bought a Polaroid!
For work—

<div style="text-align:right">

In haste,
Love,
Barbara

</div>

20 July 1983

Dearest Mother—

We are just leaving for Italy, so write to me at the Italian address. Lots of work
on the book. Still waiting to hear about the film option. Saw while I was in New
York a film called *Flashdance*—go to see it if you get a chance—the music's pretty
good and the girl is gorgeous. How is Ray? Give him my love. David is here
talking to Tosi and it is 3 A.M. in the morning. I am busy trying to get all the
letters off I must do before we leave. Anyway we are not driving. We are putting
the car on the train for Milan instead of driving—especially since we have to be
in Viareggio by the 24th and it takes two days to drive. Alexei is off to Monte
Carlo for three weeks—living in the same building as Borg with the tennis club
opposite. His idea of heaven. David broke up with his girl in Paris (I guess for
the Russian at Brown). He is working this month for an economic magazine.
They have both taken the curl out of their hair—very pretty—just a mass of curls.
No, Tosi will not straighten his hair!! Maurie is fine. Michèle and Antoine's new
house is finished. Evelyn has a new baby. We have a new flat (for the corporation)
in Brussels overlooking the lake—very chic. Our desk arrived (by the balcony
window). There's a new Afro-American museum in California who have asked for
a sculpture—very pretty building from the drawings and plans. It opens in June
1984. No other news. It's been quite hot here for the past few days with storms.
I'll be glad to get to Italy. I hope we find our flat in Rome this summer. We should
sell Viareggio before the end of the year.

<div style="text-align:right">

Lots of love,
Barbara
Alexei, David, Tosi

</div>

[no date] 1983

Dear Maman—

Just a note to let you know how everything is fine. Got your letter. So did the
boys. Don't worry if you don't hear from David. Marc has had exactly one
telephone call, me, one telephone call (collect) to Italy and a letter (asking for

money). So no news is no check! But he is fine and happy, I think, to be back in school. Alexei has the most difficult courses the French mind can conceive of—all science and mathematics called "S-C" and he is submerged with work. His fling with his 18 (no 19) year old lady is over and he is back to being a baby again.

My husband Tosi sent me one hundred white roses while we were in Italy—So I must be doing something right! His father who moved into a smaller flat gave us a 16th century (1580) Flemish tapestry 9 ft. long by 10 ft. high. Now in the second salon—extraordinarily beautiful. Every time I walk in there I catch my breath. I will send you a photo. We are trying to get the original slide so that we can have it published.

Also bought an empire mirror (small—1820) and an Italian empire sideboard (1810) and of course we have the desk...otherwise nothing new. Opening tonight, big art fair opening tomorrow night, friends arriving from Milan tomorrow and day after tomorrow. Brussels for another opening and to settle a flat Tosi has taken in Brussels. Looks like we sleep on the floor on Saturday and Sunday!

The French were not very excited about our Black "Miss America"—"She doesn't look Black to me," said the television commentator...But the Italians loved her. She looked Black to *them*! Caroline called me from Chicago to tell me as she is there with Rebecca, her adopted daughter for 6 months in order to get her American citizenship. David, her husband, is back here with the small one coping.

Didn't do anything special this summer. Did one sculpture in onyx—worked on the new book which is fascinating, long and hopefully a blockbuster. It is not yet finished and I don't see it being less than 800 to 900 pages...too long. But, it has led to another book I am determined to do this time for the Pulitzer Prize! On the Russian poet Pushkin, who was Black, the grandson of a slave captured in Abyssinia and sold in Constantinople a little before the new book (NAKSHI-I-DIL) begins—but which touches all my themes: slavery, miscegenation, power, women, and historical destinies.

The postcard from the Cathedral in Sienna not far from the house—still on the schedule before winter: Istanbul, Berlin, and Leningrad (plus Brussels and probably Nice). For Christmas we would love to go to Alexandria (Egypt) to visit my friend Frances Cook who is the new consul, but I don't know if we'll make it with the manuscript to finish.

Tosi's birthday is coming up the 12th of October and I don't know what to get him. Alexei's is the 22nd and so maybe we'll try to do something together. Last year I gave him a party and year before last as well. Kiss Ray for me—glad he had a vacation! What exactly does he do again??!!...

As ever,
Barbara

October 6, 1983

Dearest mother,

You sound as if you didn't receive my last letter! Did you? I have given up hope like Ray that you will stop cutting things out of the newspapers (local) and sending me. It has become like an inside joke between Ray and me—Go on—keep on cutting and pasting mother! But what I'd really like you to send me is a dozen yellow legal pads of 50 sheets 8½" × 14" that you find in the 5 + 10 or the supermarket or the stationery store. They usually come in packages of three and cost about a dollar or so. I write on them and I can't get them here. I get very hysterical when I run out of them since I can't write on anything normal like white paper...So if ever you get an uncontrollable urge to send me a pile of clippings just substitute a few legal yellow pads and you will make me as happy as Tosi's hundred roses... I think we will be here until we leave for Istanbul and or Alexandria. I hope to finish the book. I just finished a review of *Brown Girl Brown Stones* remember? It came out about 20 years ago and is just being published in French here. Alexei is fine and sends his love. David is his usual tormented self: should I buy a hot dog or a hamburger? I just wrote him <u>three</u> letters. One is not enough to face all his "problems." Like he two-timed his Martinique girl, got back to New York too late to catch up with his Russian girl—who dropped out I think and now he is in the soup. I told him to get himself another girl, preferably rich and beautiful and forget it. I wrote to my father so he knows I'm alive and well and living in Paris. Not that it ever bothered him before—Otherwise nothing new.

Keep warm this winter. We are enjoying a few days of Indian summer. The park is beautiful.

<div align="right">Best love,
Love from Tosi and Barbara</div>

7 November 1983

Dearest Mother,

Got your latest letter and the yellow legal pads...thank you. Got the news about Martin Luther King Day as a national holiday. Tell Ray now we too can have a Martin Luther King White sale! Just think now Ray will have to choose between Ronald Reagan and Jesse Jackson! But seriously I understand the anguish of the Black politicians. Jesse Jackson is still playing the "folklore" bit when the whole world has moved on. It is much more important to have a Black governor of California than a Black candidate for president or even—or even a Black vice-president—an impossibility at any rate. And then to associate himself with the women's movement (over) and the Gays. Really. What does he think to have a

White woman vice-president or what? The only way he could get away with that is that she proves she is also a lesbian—no hanky panky! He is upsetting rational national goals: the control of the big cities: Chicago, Philadelphia, Atlanta, Detroit, Houston, etc. As many judges, governors, senators, representatives as possible. This is how vice-presidential and presidential candidates are made—not singing hymns on French television. The French love him—he is just what they think a Black politician should be. Tosi and I had a good time laughing at the commentary. Everyone here was very upset about Beirut—to see on television again those black plastic bags with Marines in them was very traumatic. The French made a big to-do about the 58 paratroopers killed in the same terrorist bombing. They had a national ceremony. I had to explain to the French that the Americans send their dead back to their hometowns so that there was no enormous ceremony for everyone. But it was perhaps the first time the French ever died for anyone besides themselves. "Only Americans" as one of my Swiss friends said "die for other people"!!!! And it is true. Otherwise, no news. Grenada was very funny. Was Castro ever surprised! According to Tosi, who knows the island (it is right off Venezuela) there were so many marines, they keep slipping off the edge of the island with one foot on land and the other in the water. Got word from my friend Frances that she is well installed in Egypt and awaiting our visit. She called at 7:30 in the morning (her usual time to start work) and read us a schedule that would make Schultz faint with fatigue. But we are looking forward to a grand tour of Egypt. I expect at Christmas, but not really sure—if not in April. Kiss Ray for me, love, children send love and Tosi.

—Barbara

October 20, 1984

Dear Ray—

We were so sad to hear of the terrible news of your daughter. I wish we could have been with you, but our lives seem to always put a lot of distance (physical, not affectionate, moral, or spiritual) between us.

It is the hardest thing in the world for a parent to outlive a child and there is nothing really to say except that we consider ourselves as part of your family even though we cannot replace what you have lost. We hope that you consider David and Alexei your children too (even though they are at that difficult age which is hard to understand but which changes day to day). I know that they too live very far away in distance from you but I hope you know that they are there as well.

If there is anything I can do on this side, please let me know. We hope to see you soonest hopefully sometime in November. We send all our love and all our sympathies even though we never had the chance to meet.

Take care of yourself and Mom. I won't say be good because you are good.

Most affectionately,
Barbara and Tosi

[TELEGRAM]

[no date] 1984

Hi Mom,

Happy Valentine's Day. All's well. See you in April. Letter on way. Tosi and Alexei send love. Alexei is really gorgeous these days... Take care. Kiss Ray. David's graduation—May 26th.

I decided that a trip to Egypt was the easiest way of explaining to my husband, who had never been, the impact of my Egyptian trip decades ago on my life. I was working on a new poetry book called *Portrait of a Nude Woman as Cleopatra*. We left for Egypt and Syria. We started out in Alexandria, on the same quay, only this time we were met by an old American friend of mine, Frances Cook, who is now the former American ambassador to Burundi and who was then U.S. consul to Egypt. We got put up in the presidential suite of the Hilton, which came with rooms for the bodyguards. The atmosphere was so different now, I wondered if we had landed in the same country. But the pyramids took care of that, as well as the Valley of the Kings, and the Cairo Museum, which was now a marvel of modern museology, its musty unguarded uncatalogued treasures now electronically protected. The new library of Alexandria was truly pharaonic. Luxor and Karnak as soul-stirring as ever. We even experienced rain on the top of the great pyramid, standing drenched after a sudden sandstorm that turned into rainstorm, which our taxi driver proclaimed a blessing and a miracle. I wanted Sergey to feel and love North Africa as much as I did and be willing to renounce the so-called efficiency of the West for the mystery and fatalism of the East, its power and energy. From Egypt and the Sudan, we passed into Syria, arriving at Petra to admire that masterpiece of rose marble and filigree before returning to Cairo and flying to Istanbul leaving with old and new visions of the *bazaar,* the Mosques, the ghosts of Greeks and Nubians, the Sahara of Bedouins, and the royal blue blood of Nefertiti. I had started a new novel *Valide* set in Constantinople in the eighteenth century, and my research had evoked the need to see Hagia Sophia and Topkapi once again. It was a book that was twenty years before its time, considered "arcane" and exotic since no one in America was interested in the Middle East, Turkey, or the Ottoman Empire, the *Charpor,* the veil, Muslims or their religion, either Sunni or Shiite.

We began by celebrating great moments in our life with a ritual that would become a custom, acquiring a piece of architecture, and returning to Rome, we found a house that satisfied our insatiable instincts for buildings after Luxor, Petra, and Topkapi—it was the sixteenth-century, 2-meter thick walls of Palazzo Ricci on via Giulia with its 6-meter-high ceilings. One of us, I reasoned, should

have a house in the country he was born in. Legend had it that Cellini had had his studio on the ground floor, and the fact was that the palace itself had been a storeroom for Cardinal Ricci's 16,000 paintings. Sergey's painter friend Cy Twombly lived next door one palazzo down, which gave onto the same Piazza Ricci.

In the family, another dramatic tragedy followed, when Jean Riboud died of respiratory embolism just like Grandpop, as a result of the tuberculosis he had contracted as a young prisoner of war in Buchenwald. The former Resistance fighter had barely been buried in the family cemetery at La Carelle for two years when his only son, my favorite nephew, smashed his car into a tree driving from Paris to La Carelle on a mountain road he knew by heart and was killed on the spot, in the prime of life, leaving a wife, three young children, and his devastated mother, Krishna. Our Dauphin was no more.

On Easter morning of 1986, my father died at his house in Pleasantville just outside Atlantic City. He had died peacefully in his sleep, a victim of hypertension and heart disease aggravated by diabetes. He was only 64 and had seemed even younger. His reaction to my divorce and remarriage had been the same as my mother; pained silence, except more absent-minded, since he had not paid much attention to Marc. He seemed to acquiesce in anything that had to do with decision or opinion, leaving it first to my grandmother and then to his second wife and later to my own judgment.

My mother requested that I attend his funeral with both his grandsons, which I had always intended to do. My stepfather escorted us, but my mother didn't attend. It was at that moment I realized that she still loved my father and would never love anyone else as she had him. I had not seen my father in a long time, but I was grateful to her for having begged me to reconcile with him, pointing out how terrible I would feel if he disappeared without my saying goodbye. And so, several years before, Sergey and I had visited him in New Jersey and I had made my peace with him one evening on the screened porch of the Pleasantville house after we had spent a hilarious and wildly profitable evening in the casinos of Atlantic City, a wondrous place for Sergey who had barely been outside of Manhattan in the United States except for the Hamptons, what with his cooking his way through a bevy of New York women before he found me on 57th Street. Famous for his home-cooked meals for single female New Yorkers, he had gone through a sizable Manhattan telephone book. This was middle America, I explained to him, a Disneyland for grown-ups, and one day we would go to the other one, Las Vegas. As we left my father sitting on the porch to go to bed, Tosi leaned over and said, "You should kiss him goodnight when you leave and hello when you arrive because you never know when it will be the last time. I always kiss my father hello and I never leave him without kissing him goodbye as if it were the last time." I bent down and kissed my father. It was for the last time.

It was only then that I realized how deeply I had felt his betrayal of my mother and me and how profound had been life's betrayal of him. I had stood on the steps

of the Metropolitan Museum at the ceremony for the Kafka Prize for *Sally Hemings* beside Tosi and watched my mother mounting the steps, cane in hand, and my father a few steps behind, and thought how egotistical my choices had been. Even before the age of adulthood, my father had betrayed my mother by falling in love with his lifelong mistress, so *litera scripta* it was almost Shakespearean. It was as if Romeo and Juliet had survived and Romeo had married a third woman, obliged by his mother. And my mother had been Juliet, in teenage love but not the chosen one. Just as my father had not been accepted by a skewed society to practice his desired profession in life: architecture. And I had been the consequence, surviving in the arms of my Grandpop despite everything. I heard Alison's voice, the lawyer who finally joined me in my Philadelphia plagiarism trial, beside me say, "Barbara you are the most egotistical person I have ever met." And she meant it.

The family that now remained was my mother, her "daughters," the boys, my Tosi, his father, Françoise, Antoine, and the Riboud clan. I had divorced Marc but not my in-laws, and Antoine who was now its nominal head was an attentive uncle to David and Alexei.

America had changed. Jesse Jackson was running for president. Vanessa Williams had been elected Miss America only to lose the crown over a *Penthouse* photo. Apple had introduced the Macintosh. Ronald Reagan was beginning his second term of office, and for the first time the United States had become a debtor nation.

Rome, Thursday, 1985 [no date]

Mother—

We found a house in Rome...a historical landmark 16th century palace in the center of Rome—Palazzo Ricci, Piazza Ricci, Rome. We were staying with Jeanine who lives just in front of the Piazza—we had already decided on another flat in Trastevere across the river also the ground floor and his man comes out and nails a "for sale" notice on the mammoth door as I am standing on the balcony of our friend's apartment facing the Ricci Piazza. Next thing you know we are knocking on the door—but the owner made us come back the next day because of the light...In the end, he took down the sale sign, said we could pay when we wanted and gave us an Etruscan sculpture as a housewarming present!

Both David and Alexei are back in Paris. Alexei was in Biarritz for two weeks. School begins for him on the 10th of September. We are hoping David will go back to Brown in January, so we are saying exactly the opposite since his sense of contradiction is the most highly developed of all the Ribouds.

He has taken it to the level of a fine art...Anyway, this summer he worked for a French publisher (and now he knows all about the publishing business) and I don't know if he can stay over there or not.

We went briefly to Viareggio to order the floors and the columns for the apartment. I told you I went back to Paris to have my photo taken by Horst for *Vogue*. After 20 years maybe I'll have a decent portrait! We'll see. I haven't seen it yet.

Just got a check for a Danish language audio-book! I wonder what *that* sounds like.

Working on the new book which I hope has already been sold. I haven't called New York. Will do it from Paris next week.

Got a letter from the new "producers" of Sally Hemings (they have the option until December) saying they had the financing and were working on a script and co-stars. At this point I'll believe it when I see it on the silver screen. They wanted to know if I had any ideas—as I don't give out *free* ideas, I told them to change the name from Sally Hemings to *The Woman from Virginia* or *The Virginian* or *The Virginian Woman*, to star Donald Sutherland as Jefferson and Lena Horne as Elizabeth Hemings and use an unknown face as Sally Hemings. This is all they get for free. The rest will cost them 500 dollars an hour...Anyway S.H. is still in there—even if in intensive care. Lynn, my agent, thinks that eventually the movie will even get made. Meanwhile, the name of the new book has been changed to *VALIDÉ* (queen mother) at least in the American version and the next book (besides the poetry book which is called *Portrait of a Nude Woman as Cleopatra*) is called *Amistad* (which means "friendship" in Spanish and is the name of the boat on which the only successful slave revolt took place). The book is a trial and sea story—sort of a combination of *Mutiny on the Bounty* and *The Confessions of Nat Turner*. Very interesting. And very interesting film. Will write soon. Kiss Ray. In haste.

> BCR
> Most affectionately,
> Barbara and Tosi

P.S.—If you would like, send me Ray's daughter's name and I will dedicate my plaque to her memory and send it on to you as we had no notice to send flowers... would you like that?

March 2, 1985
Paris

Dearest Mother and Ray,

Leaving today for Milan Rome Egypt! Will be gone for 6 weeks I guess. Then back to Paris around the 10–12 of April and to Montreal the 19th–23rd for a conference. And then to New York the 24th where we will stay until the 21st of May when we have to come back for a board of directors meeting in Brussels. But we will come back to Boston for David's graduation until the end of May! Other

than that, nothing new. We hope to have a good rest. We will stay a while with my friend Frances who is now First Consul in Alexandria. And in New York, always with our friend Rachel Adler. Alexei is well and filling out. Last night he swept in here like gang busters with his ("little") friend who looks like his twin Fabrice. They were off to a party at the Greek Embassy but the friend didn't have either jacket shirt or tie to go with the pants he had just bought. So Tosi had to completely dress him up in his clothes. Alexei didn't have a tie and didn't know how to make the knot. And he didn't have a white shirt. They were worse, the two of them, than any girls I can imagine. Alexei had bought a new jacket—"very expensive"—even his father says so. Anyway I hope they had a good time, haven't seen them this morning.

<div style="text-align:center">

Love,

XXX

</div>

September 15, 1985

Dearest Mother,

Just a note to say that everything is well. Spent a wonderful weekend at the Savoy Hotel in London with Alexei—It's been his dream ever since he slept there for the first time at age 7! We had a good time. Tosi still in Rome. The house is going slowly, but surely. He thinks he can move in by next week (in a little room next to the kitchen), the salon is far from being finished. The bath works but all the marble has to be put in. I will go down in a few months. I expect my friend Rachel from NY on Wednesday and Frances Cook from Egypt the same day! I am going to move into my office upstairs! It is warm and beautiful here. Finishing up details and spent the day clearing out my office. I sent you the *Vogue* but by surface mail, so goodness knows when you'll get it. But you'll get it. Some beautiful new collections in town—very oriental, especially Givenchy, Sherrer and Armani. I'll go see one with Rachel when she comes. Planning Tosi's birthday party the 12th. Nothing else new. Jean Riboud resigned from Schlumberger for health reasons. An American has taken his place. Just two years ago he had a rule voted that the president (him) could stay in power over the mandatory retirement age of 65—and he is just 65—so it goes.

Kiss Ray for me. Tell him I'm praying for snow any day now. Tosi sends his love. Alexei and David too. Tell you all about our adventures with the house (palace) in Rome when I see you. But we have a doorman who has more gold epaulets than a Marine Brass band. And at the last co-owners meeting, "La Countess" wanted to know why he was walking around in his shirt sleeves (it was 110 degrees). Wait until "La Marquisa" puts in her two cents...

<div style="text-align:center">

XXX BCRT

</div>

October 11, 1985

Dear Mother,

Back in Rome. Sergey's birthday tomorrow, Columbus Day. As for our last conversation about Daddy. You are right. I would be very unhappy if he disappeared and we were still at odds. You have such a beautiful house now; it really doesn't seem worth the grief of keeping up the vendetta. It's been since Grandpop's death. I called him last time in New York and went down to see him in Pleasantville with Sergey. We took one of those special Casino buses for little old ladies in sneakers and retirees instead of driving and it was a hoot. Sergey couldn't believe his eyes. They gave us 25 dollars in casino chips and a coupon for lunch and dinner. There were slot machines in the bus station! What is this world coming to! Anyway you were supposed to play the machines immediately on getting off the bus—but Tosi refused—you know the European intellectuals. He was going to keep his for the moment. Thank you very much. The bus driver was furious. He thought he was a tourist who didn't understand English. Was he ever surprised when Daddy showed up and dragged Tosi into the car by his pants? It's a big black car and the guy probably now swears Tosi's the incognito Mafia from Palermo come to check the books! We went to the Casino later—Venice and Monaco it's not—but our little Atlantic City where I used to get sick off the saltwater taffy! My God, it's Gomorra! Before we went, Daddy and I went out on the deck and I told him everything I felt outright and what I told you. He seemed shocked as if he were being accused unjustly and everything had been out of his hands and that he was not responsible—(It was after all, Grandpop's will) that it was all his fault but that he now had a new responsibility towards his wife. I listened to him hemming and hawing and didn't believe a word then I put on my best Grandma face and scared the hell out of him telling him exactly what I was going to do and what he was going to do. He was as white as a puppy. He said he was going to sell the house anyway and make arrangements with you—it was too expensive to keep up and so on. But that he would do the right thing. We kissed and made up.

We left for Trump Casino. We both won—and didn't stick around. I never saw Tosi laugh so much. I didn't know if he was laughing at his winnings or that I had kissed Daddy goodbye. We fled with the loot which covers our whole trip! The Casino invited us back. So did Dad. He has done a lot to the property and now the whole deck is screened and there are lights in all the trees and a new road and a boat deck out back on the estuary. He let Tosi cut the lawn with the new mini tractor. I called Alison before I left to make sure he follows through. Can you imagine he sat me on his lap! But he was alarmed when Sergey tried to kiss him goodbye...I told him Sergey kisses his father every time he leaves or enters his flat. He was amazed at the quaint customs of the Old World. Sergey kissed my stepmother's hand European style—she nearly fainted. Then all her

sisters insisted on the same treatment, Tosi said, "But you only kiss the hand of a married woman these days—her sisters are all maidens…"

Your daughter who loves you,
Bobby

19 December 1985
Paris

Dearest Parents,

Happy Xmas!
Our Accounts:

$150—Mother's Azaleas
$150—David's phone calls
$200—your trip to Cuba! (account)

Total $500—see enclosed!

Nothing new. Working hard. David is in New York at his cousin's during the school holidays so he will probably call—"Hamlet-David" we're calling him now. He can't make up his mind if he wants to go to graduate school or not. I keep telling him as far as the French are concerned it is *that* or the army. Anyway, besides never being able to make up his mind about anything, David's O.K. Now Alexei is the one in love: Albertine who loves her horse more than she loves Alexei and who takes riding lessons at the Military Academy of Paris! Poor Alexei! On top of that she is seventeen—too old for him. She is probably in love with her riding professor. Nevertheless Tosi tramped around with him all last Saturday looking for an "appropriate" Christmas present…worse than David! Also he only wanted to spend twenty-five dollars…and the only thing he found that he liked was a miniature Austrian wooden horse at $800. If he had *had* the 800 dollars (or if Tosi had had it on him) he would have spent it all on Albertine (he finally bought her a book on horses that cost Tosi forty bucks)…Anyway he left for two weeks of skiing last night so maybe he'll feel better when he comes back (in Lucette's apartment in Val d'Isère—seven boys). We are still planning to go to Egypt as soon as I turn in the revised manuscript, the deadline being January 1st—So we won't even go to Italy for Christmas or New Year's. I told you, my friend Frances Cook who was US Ambassador in Burundi is now in Alexandria and waiting for us to show up. I am so looking forward to showing Tosi Egypt. He has never been. Of course he knows more about it than I do, or will by the time we leave.

I'm really very nervous about the new book *Validé*. We sold the American hard-back edition rights only (this does not include the paperback or book club sales) for $90,000.00 (minus commissions, agents, etc.!) and I have to

deliver—with the remaining American sales, the foreign sales (in advance), we should go over a million dollars, not including television or movie sales. Oh yes Sally Hemings is under (movie) option again until the 31st of December—But as of now, world-wide Sally Hemings has sold over 1 million and a half copies in 9 different languages and 19 different editions including 6 separate French language editions. The Avon paperback sold 500,000 copies alone and it is still going. The French paperback is at 300,000 copies. So everybody's greedy eyes are upon *Validé*, a kind of female *Shogun* (hopefully). Meanwhile I have a new American book I am dying to begin—but I have to deal with this one first. So I am really working day and night. Tosi is very understanding and is a brilliant editor. He was in Brussels yesterday and Milan the day before, but he is back in Paris for the moment. His affairs are going well. He gave me a four-strand 28" pearl necklace that practically covers what little bosom I have, held with an 18th century Indian clasp of uncut emeralds, diamonds, pearls, opals, ruby and emerald dust and enamel in the form of flowers and leaves, the whole thing put together for me in Rome by our friend Jeanine (remember I found our house while standing on her balcony?) who designs jewelry for Bulgari. It is sensational. I guess it's my Christmas present...Oh yes, tell Ray we still have the same car: a ten-year-old Austin Morris Mini...goes great with my pearls...It isn't that we're tight fisted, it's just that we really don't care for cars except to get from one place to the other and then we'd rather take the train or a plane. But never fear, when we come to pick you up at the airport we'll come in style. I wouldn't dream of humiliating Ray by anything less than the only car we really like: a 20-year-old Mercedes Benz Spider convertible for two (with ivory leather interior and wood strip)! We saw one in Viareggio this summer but they really wanted too much money. The place to buy a vintage car is Switzerland and then somebody tried to steal our Mini last week! Three kids caught by the doorman of our building. They ran off after having ripped out the front of the car trying to start it! Well, have a happy New Year. We are thinking of you.

<div style="text-align:center">

Love,
BCR, Tosi, Alexei XXXX

</div>

1988-90

published the melologue *Portrait of a Nude Woman as Cleopatra*, and in it I quoted Pasternak: "From my early years I have been wounded by a woman's lot, and the trace of a poet is no more than the trace of her movements...."

I wrote that this theme had none of the myth of Cleopatra's theatricality or its heroic obligation. That this was an ordinary life, a complex and continuous narrative in which the two protagonists (one invisible) put into motion and existence "a whole world of feelings." The life of my mother. These feelings that I had so blithely ignored most of my life came to the surface as part of my biography and hers embellished both in banality and extraordinariness like a perfect orchid in a mayonnaise jar—awkwardness and coolness, passion and apathy.

I'd been taught by Queen Lizzie early in life never to play the victim (perhaps in reaction to my father's disappointment), never to play the "female" nor the feminist, never to play the race card, and never to play the "poet." To talk about my own artistic "creativity" or "sensitivity" always seemed to me *gauche* and somewhat embarrassing. It always seemed to me that those who flaunt it, don't have it. There was always that apathy that prevented me from aggrandizing what was for me my most natural and ordinary attribute. I continued my "double" life as always, always determined to choose between the two professions and never doing so. Each time I took a step in one direction, something would happen to pull me back to the other axis.

In August 1988, I was awarded the Carl Sandburg Poetry Prize as Best American Poet. I found the letter unopened in a box of books shipped to me by the editor of my latest book *Validé*, a novel of the harem. It was for my poetry book *Portrait of a Nude Woman as Cleopatra*. No one had entered it, it seemed, so when the letter addressed to me from the Platform Committee arrived at their office, they forwarded it to me without opening it. It was a month late arriving, and no one had bothered to reply to them. The ceremony was in Washington, DC, in August. Once more, I had been left at the starting gate without a jockey—once more, I made it to the finish line, barely making it on my own. My grandmother's mantra came back to me, "Making things look easy is a matter of politeness, letting people know you are carrying a heavy burden is a third-world attitude toward life."

Moreover, I had to give a speech in front of the literati of the world. And do it as if I had been doing it all my life—as if...I had been born to do it.

I also discovered I had been plagiarized by a North Carolinian writer living in Philadelphia who had written a play called *Dusky Sally*, which copiously extrapolated from *Sally Hemings* and my copyrighted material. After a year of protest, the playwright sued me for libel, defamation, and commercial interference. I found myself embroiled in a court trial in the United States, representing myself, while in Paris, and facing more than a dozen New York and Philadelphia lawyers including the appellant's brother-in-law.

My mother had grown used to controversies over the years in my life, and she took them in her stride with no more than "That's nice" or "That's interesting." Her unearthly calm had come to match her eerily youthful looks that never seemed to change through the decades. Even when she allowed her hair to go gray, she merely looked like a young woman with gray hair. Her body helped, as it was lithe and strong, but it was her lineless face that fooled people into believing I was her younger sister. Not wanting to upset her, I kept most of the details to myself, something I could never do now with the Internet, but that was still possible in the late 1980s. How provincial we all were in those days. Vivian Mae grew in charisma and charm, in persuasion and presentation. She was often mistaken for a doctor with her white coat, dignified demeanor, and grand smile. People would turn instinctively to her authority, talking, touching—her goddess-like presence a calming influence on everyone—tears or screams would stop, curses would evaporate, even clashes over procedures or car parks were solved with that smile. Then to my surprise, she began to paint; she had started with quilting, then embroidery, and finally mixed-media constructions that finally became flat gouaches and then oil paintings. This was her secret garden, and I wondered how much she had absorbed from my father. His paintings had been straight, solid, academic painting, whereas my mother's paintings were completely the opposite, fresh, unpretentious, colorful, with a primary, Frida Kahlo palette of warm browns and burnt siennas. They could have been called primitive, but primary would have been a better description. Simple still lifes evolved into last supper motifs using a rare concept of half of their apostles with their backs to the viewer. I marveled at this composition, ingenuity, and originality. There existed only one painting in Renaissance with a composition like that. How had she imagined that? There was nothing banal about her works, just as there was nothing banal about her person. She finally went back to dying her hair back to its original brown color. And like the *Validé* I had just published, she ruled friends and foes, got along with everyone without exception: the good, the bad, and the ugly, the angry and the calm, the choleric and the sweet tempered, the intelligent and the stupid—she always had something to do, as is the habit of intrinsically good people. But she also had her ideas about goodness. She was more apt to attempt to change herself rather than risk the confrontation of trying to change another person, since she knew through

me how difficult that was. But change she did, her look was more modern with her gold-wire spectacles and the expensive brooch watch she had been given a few Christmases ago by her lab. Moreover, her heartbreaking smile remained as fresh and white and poignant as ever. It lit up a room, 10,000 watts, before she had even entered it. She walked into it straight-backed and luminous, with that Anglican forthrightness that still thrilled to lighted candles and incense. She kept most of her paintings, selling or giving them away rarely. She kept them in the cellar like my father had and never hung one in her house. She began to reign over soirées and parties much like Queen Lizzie had, enlisting the help of her "daughters" and young colleagues who adored her. Her parties were card parties, book parties, or theatrical parties. And so it was that she wrote me how excited she was that "my play" was being produced at the Walnut Street Theatre in Philadelphia. Indeed, *Sally Hemings* was being plagiarized at the Walnut Street Theatre as *Dusky Sally*.

I had been eleven years old when my mother had withdrawn me from middle school over an accusation of plagiarism because my middle-school teacher had not believed I had written a poem called *Autumn*, all about death and dying leaves. She never returned me to that school but had me tutored at home. My mother somehow got me into the elite Girl's High School by lying about how old I was.

This time she was adamant, no North Carolinian was going to victimize me with impunity. I called one of her "daughters," Alison, a Philadelphia lawyer from Oxford and with a brief that would have done justice to *Brown v. The Board of Education* (as it was noted), we won not only the suit, but a landmark decision that became jurisprudence: that fictive elements in historical narratives were copyrightable. The decision was published in the *New York Times* and by Cornell Law School's *Review*.

Sergey and I celebrated with another piece of real estate: a two-acre plot of land on Capri with the oldest trees and most spectacular view on the island. Perched high on a cliff, next to the Certosa, overlooking the sea, where on a clear day one could see Africa.

January 1, 1988

Dearest Mother,

Sergey, the boys and I wish you a very happy New Year and the same to grandpa Ray! May it snow all winter long and may his television never go on strike.

Sergey just left for Milan to see some of his clients and his father. I started a new book. My deadline is November, which is very short. The contract is signed and the money paid! But it is a fantastic story, the second volume of my "American Trilogy" which began with *Sally Hemings*. It is called the *Amistad: Echo of Lions* and is the story of the only successful slave revolt in the U.S. (unknown)

tried in the U.S. Supreme Court, the rebels were defended by John Quincy Adams and freed. They returned to Sierra Leone. This insurrection which took place on a ship on the high seas is not recognized as an American slave revolt but as piracy by non-Americans (i.e., the Africans). But it will be by the time I get finished! The third book in the trilogy is already decided. It is called *Butler's Book* and concerns a kind of *Alamo* incident in the Civil War where the only time the only regiment of the Black Union soldiers fought White Southern soldiers to the death and to the last man was in Virginia in a place called Marketville. The Virginians (here I go again) do not recognize this battle, nor its site, although the commanding general, William Butler, had a special medal designed and executed by Tiffany's in New York as an homage to the soldiers who fought in the battle. The U.S. Congress never recognized this decoration—(but they will when I get finished!).

The new book is on its way—Mother, I'm warning you it's very cultural but quite erotic. I can send you an expunged copy and Ray the other version! Morrow, my publishers, are very, very happy. The cover is beautiful, the book probably will be too. I don't know where exactly it will be out now but by April you should have an advanced copy. The book after this one is the novel in verse (already bought by Morrow) called *A Nude Woman as Cleopatra*. I have no publication date on that one yet.

I never told you, but before he died, I had a very surreal conversation with my father, who wanted to know if Marc still spoke to me and if Tosi still lived in Venezuela! He had still not gotten it through his head that Tosi is not Zorro... Anyway, I have a hilarious story to tell you but I'll wait until I see you. Alexei is back in school. David starts back the end of the month. I still don't know if he is going back to school in the States next year or not.

Otherwise no news. The French elections are in 70 days and it looks like the socialists are out and possibly Mitterrand himself (I hope). He has ruined France, made everybody move and now won't leave although he no longer has the majority. It is going to be a mess. Had drinks last night with the minister of the interior who is scuffing around trying to keep his seat in the senate. Mitterrand is simply letting everyone sink, trying to keep his own head. But I really think it is too late. The French want him out. Everybody except Alexei Riboud who is such a fanatical socialist, he considers Tosi and I "upper class reactionary liberal honkies" which needless to say sends us into hysterical peals of laughter which he considers an insult. But we just can't help it. Alexei with his Canon skis, his cashmere sweaters, his Japanese restaurants, and his horseback riding girlfriend—not to mention the street where he lives and the school to which he goes... Anyway, you can be sure that he will grow out of it. I will make sure of that. I want him to know whose shoulders he is standing on. Tosi too... No more news. I'll call soon.

XXOOOXX Happy New Year!
BCR + Tosi, David, Alexei

May 1988 [no date]

Mom,

Here's my acceptance speech for the prize...see you there...

<div style="text-align:center">

Carl Sandburg Poetry Prize 1988
The International Platform Association
The Mayflower Hotel, Washington D.C.
August 4, 1988

</div>

Mr. President, Ladies and Gentlemen:

I cannot tell you how surprised and happy I am to be standing here to accept the Carl Sandburg Poetry Prize for Portrait of a Nude Woman as Cleopatra—nor how terrified I am to be making my debut as a public speaker, by the grace of Daniel Webster, before such a distinguished audience. I could even say that I am accepting this award from a character in my new novel since, by sheer coincidence, John Quincy Adams says in it that Daniel Webster wants to be president and that he would make a great president. I never dreamed that the good Mister Webster was eavesdropping on my manuscript and was, in turn, so happy with what I had written that he arranged all this—and with such dispatch!

Thank you, Mr. Webster. Thank you, President Anderson, and thank you, Carl Sandburg.

And so, standing before you today, between the two great political conventions and in the midst of all those presidential dreams and ambitions swirling around us in Washington, both past and present, novelistic and real, thwarted and consummated, I would like you to remember that one of Daniel Webster's most passionate beliefs was that our political life depends upon an informed and literate public, that liberty and the perpetuation of a free constitution "rest on the virtue and intelligence of the community which enjoy it." It is an idea to which I would like to add that an informed public depends upon literacy and language: its good use, conception, comprehension and incorruptibility.

It seems to me that in a democratic society, we must all believe in the sovereignty of words, that a democratic society is impossible without literacy and a unifying language. A literate society depends on three things: culture, communication, and choice. One could add that culture is also faith and morality, that communication is also social interaction and equality, and that choice is both individualism and political action.

All three form our body politic. And of these, perhaps the most important is culture. For culture is true progress in the sense that it is the absolute heritage of one generation to another.

The shoulder of a nation is its language: its mastery, the highest defense of the legitimacy of that nation. If a nation's songs and ballads are spoken, its laws and history are written. And so the basis of the culture we transfer from one generation to another its literacy. This legacy is every citizen's birthright: access to his own culture.

Though part of this feeling may come from the fact of being a writer, I feel very strongly about this birthright. It always intrigues me that in my own country I am a hyphenated American, consigned to waiting in the wings, whereas abroad, I am simply the quintessential American expected to explain, interpret, and defend American ideas and society. The irony of this is not lost on me since what my interlocutors are asking of me is to define a society in which my own legitimacy is questioned.

People ask me, for example, how I manage to live in one country and write about another. But as Nathaniel Hawthorne said, "An individual country is by no means essential to one's comfort."

Distance lends perspective. And this perspective is one of the most precious gifts any artist can hope for. It is this bird's eye view of one's own country that permits a true appreciation of its strengths and weaknesses, of what we have and what we lack.

For Americans, the idea of living in another country has not only exotic, but let us be frank, vaguely unpatriotic connotations. But having to explain what is after all one's own self over and over again makes the American abroad more ferociously patriotic than he would ever dare to be at home. And while the perspective of an American abroad is not necessarily better, it is different. For me it is underlined by things like coming back home and hearing dark hyphenated Americans speak about their own country as if they were living in a foreign one. They speak of the "man," the "power structure," "downtown," "Mr. Charlie." It is underlined perhaps by the quiet drama of one of our most important writers and one of the most eloquent defenders of our language, James Baldwin, dying abroad in self-imposed exile.

By exile, I do not mean a change of address. Exile for a writer means silence. It means one no longer has the means, the energy, or the safety to communicate what one knows about one's language and one's society.

We cannot say this of James Baldwin, whose manipulations of the language and understanding of his own society were masterly. Yet, in the end he thought himself to be a cultural icon, a fossil unable to communicate with his fellow Americans, knowing that communication after all is the way we dispense our culture and history, not only through the media, but also through the whole interaction of a nation, both as groups and individuals who share the same language. Communication is the basis of a people's association one with the other and, more important, their civic relationship has to be par, equal to equal. When one segment of the population, for one reason or another, is excluded

from this culture and history, it breeds alienation and civil strife, unless, of course, you have a minority so weak that it engenders only oppression.

Communication is the key to our cultural identity. And it is literacy that permits participation in this process. It is the very passport into this nation made up, as it is, of many nations. Lastly, choice brings us to the actions inherent in culture and communication. They are the ability, the will, and the possibility to participate in a democracy as a partner in the transfer of culture and history through choice. As one chooses one's leaders, one also chooses one's words.

Literacy, then, is every American citizen's right. When we speak of "education," what we really mean is the mastering of the tools and codes of behavior necessary to function in a society based on language, accommodation, work, and action.

Shut out of this process for any reason—racism, sexism, poverty—one becomes an alien in one's own country, one's own birthplace. We speak of a war on poverty, but the equally important war on impoverished language and understanding and the inability to master one's native language is often forgotten.

How much joblessness and poverty are linked to illiteracy? One thing is certain, these days one no longer asks for a job, one has to read and write for one—to deny any citizen or the children of any citizen the right to literacy is to leave them behind permanently in the ghetto of impoverished language—a cultural ghetto as destructive as a social or economic one, from which they may never escape. Literacy is not only poetry, it is blueprints, electrical diagrams, manuals, computer printouts, and voting ballots.

Another of my novel's characters has something to say about Daniel Webster. Martin Van Buren, being President in 1839, is worried not only about a slave revolt on the ship, Amistad, which threatens his re-election, but also about the emergence of national party conventions as a new phenomenon. "Think," he says, "what a Daniel Webster or a John Calhoun could do with five or six thousand voters all in the same place at the same time listening to the same thing!" I wonder what he would have thought two weeks ago listening to Jesse Jackson! At any rate, we have only to look back to Atlanta two weeks ago to appreciate the power of the word upon a literate gathering.

We, then, as men and women of the word, if we consider ourselves democrats in the Athenian, not the Jacksonian sense of the word, must surely recognize literacy as the cornerstone of our national life, of the life of any nation that considers itself free. It is the heartbeat of a civilized society. It is the veins and arteries by which every value we cherish is both transmitted and inherited, just like our genes. Language is the genetic depository of the entity we have created and which we call the United States of America, and this genetic pool in its infinite diversity, produces a person, a national, if you like, called an American.

And as men and women of the word, we must defend this genetic heritage—with language, yes, but at times with action, with sacrifice, and even perhaps with, as they say, all God's dangers. However hard it is for us here, pampered and safe with a powerful free press and an indomitable constitution to imagine the dangers our own words might impose upon us, of being forced to face the real moral, physical, or psychic consequences of words, written or spoken, it is something to contemplate.

Having lived abroad, traveled in China, Russia and Africa and having seen first-hand what the machinery of society can do to a man or a woman who is out of step with that machinery, who is in fact a dissident—and all that means in terms of torture, exile, imprisonment, and silence—I have a keener appreciation of our own constitution. For just as words are passports into a free society, words are also our exit visas from demagoguery, censorship, and official lies.

As Daniel Webster pointed out almost 150 years ago, there are "two principles, strictly and purely American, which are likely to prevail throughout the civilized world—that are indeed necessary to progress and knowledge, and these are: First, popular governments restrained by written constitutions, and second, universal education. Popular government and general education, acting and reacting, mutually producing and reproducing each other are the mighty agencies which today, appear to be exciting, stimulating and changing civilized societies." When he says that man everywhere is now demanding a participation in government and that he will not be refused, and that he demands knowledge as necessary to that participation, I can only argue a century and a half later that liberty and knowledge are still the basis on which our own American system rests in safety. But that safety can only be ensured by breaking down forever the ghetto of cultural impoverishment.

As I said earlier, an individual country is by no means essential to one's comfort. From my vantage point, which may be a little different from yours, I see the United States in a period of transition. This transition is not only technological, a new information age which demands more and more knowledge and education, but it is also a political transition to another era, dominated by an almost universal demand by the people who inhabit this planet for the culture, communication and choice that guarantee free government. Even the Russians and the Chinese seem to have recognized this necessity. In other words, everyone in the world wants his passport to his or her culture. But before that happens, or we begin to help other passports happen, we have to be sure that everyone here, in American, already has his.

And so, I stand before you today to plead with you, the famous, the powerful, the secure, to ensure that no American is left behind, illiterate, and without knowledge. Already one in every six adult Americans cannot read a newspaper. One in every three convicts is illiterate. High school graduates ask the meaning of "address" on a job application form. We are told they cannot find their own

country on an unmarked map. This is unacceptable for the richest and freest nation on this planet. This is a disgrace. It is also very, very dangerous. But perhaps I should invite you to draw your own conclusions.

All of us, educators, publishers, journalists, novelists, and poets, must ensure that these figures characterize only the past, not the future. But most of all, it is up to our political leaders to mobilize the national will, and provide the money to support decent education. But, it is we who are here today, men and women of the word, who must provide the stimulus, the insistence, the pressure, and the respectability the politicians need to act. If we retreat into our specialized roles as communicators, we run the serious risk in 50 years or so of addressing a nation of illiterates, or worse, talking to ourselves.

The question at that point, of who writes history will become moot. For the answer will be: only those who can write. And then there will remain the question of whose history and which history. For as Voltaire so wisely pointed out, "There is no history, only fictions of various degrees of plausibility."

To be able to recognize these degrees of plausibility is the difference between propaganda and history, between being led and leading oneself, between lies and truth.

We, men and women of the word, must know that if we are true to our country in our day and generation, then those who come after us will surely be true to it as well. We can argue that education is an expensive proposition. We can argue race or gender or parentage. But we cannot argue justice or logic or safety for our own system and our own constitution.

As my guardian angel, Daniel Webster, said, "America has proved that it is practicable to elevate the mass of mankind—to raise them to self-respect, to make them competent to act a part in the great duty of self-government and she has proved that this may be done by education and the diffusion of knowledge."

Ladies and gentlemen, women and men of the word, that is our job. Thank You.

<div align="center">Love, Bobby</div>

Rome, October 2, 1989
Palazzo Ricci, Via Giulia 146

Dear Mother,

I am still in Rome. Glad everything is O.K. I do wish you would reconsider a vacation—perhaps this winter when it gets cold, snowy and freezing—Jamaica! I should be in the States to see Alexei soon and we could go together for a few days, somewhere.

As for your request for church programs for your new pastor, I'll do what I

can—a big job considering that in Rome, there are 1,200 churches over a hundred years old and 400 "new" churches. On my street, Via Giulia, which is approximately three city blocks long, there are sixteen churches and twelve palaces (one of them mine). There is an Armenian Church, a Neapolitan Church, a Florentine Church, a Spanish Church, a Swedish Church, an English Seminary, etc. (see attached). It is a street with some of the most expensive real estate in Rome (and in the world); no palace on this street is less than 200 years old and ours is 500 years old—(1499). So much for church programs. I'll do my best. Do you want stuff from Vatican as well? Or doesn't that count?

I just got a call from Yung Mei—remember her? The daughter of Han Suyin, the writer (*Love Is a Many Splendored Thing*), we stayed in her flat in New York (on Central Park West) one Christmas when David was about 3. She was in Lausanne visiting her mother and wanted to stay in the flat in Paris. Her little girl is probably married by now—or almost. But Suyin is still going strong. She must be 70 because she is older than Marc.

Got a call from Susan Du Passé of Motown. I told you she had optioned the rights to both *Sally Hemings* and *Echo of Lions: Amistad* that she is working actively to try to get them both into production and wanted to talk to me since I am also consultant on the films—the deal is quite a good one if it goes through— It seems she is quite terrific I have never met her. And yes, I do know indirectly, the girl who directed *A Dry White Season*, Suzanne de Passe. The film opens in Paris on November 9th and I hope to go to the premier, if we are in Paris.

I know I owe you a big package of books: all the translations of *Validé*—I'll do it as soon as I get back to Paris. Love you—write or call when you can—

Barbara

In the condominium there is—one English Lord (Duke of Bedford), one countess, one Neapolitan shipping magnet, one marquis (Ricci), one princess (Colonna) who is the wife of Ricci, one faith healer (who may or who may not be the lover of the princess), one ex-ambassador, one newspaper publisher, two architects, two little old ladies in rent-controlled apartments and one Swiss lute maker—with a vault full of Stradivarius violins. That's Rome—It seems that the circle has come full around...there is even a white marble staircase just like the one I ran up at the American Academy, so long ago...

1991

In July 1991, I was on my way to the Charles de Gaulle Airport to catch a plane to Cyprus and from there to an isolated island off its shore where there was no electricity, telephones, or Internet connections. I would have been out of touch with civilization for weeks. The telephone rang as I was walking out the door. It was my stepfather calling to say he had taken my mother to the hospital. I caught the next plane to Philadelphia and sent David by plane and helicopter to the island to alert Sergey, who was waiting for me there. When I arrived at the hospital in Marion County, Pennsylvania, straight from the airport the next day, I could only greet my mother in her groggy state already strapped to a hospital gurney and clutch her hand as I walked beside her toward the operation room.

I grasped it tightly, removed her rings and wedding band and slipped them on my own fingers. I whispered tender phrases mostly from childhood, kissing her hand over and over again and over again.

"I am so afraid," she murmured. My heart stopped. She had never in my whole memory ever admitted to being afraid of anything. My panic grew.

I had to let go of her hand as the doors swung open and the spotlights of the operating theater leaped out, blinding me. I remained outside pleading with the surgeon when I heard the diagnosis not to take into consideration her age, but to perform the most radical operation possible as if she were a young woman in the hope of saving her life.

"She's a strong woman and amazingly young," I said, "she should have the chance to survive regardless of the risk...." "Don't take into consideration her years...."

"I just lost my mother," the surgeon said, "I don't intend to lose yours...."

And he didn't. My mother came out alive, and twenty-four hours later when she returned to her room, we were all waiting: my husband, her husband, and several of her surrogate daughters I could always count on for help when I needed it.

She had written a living will that mandated no artificial resuscitation, no assisted respiration or intravenous feedings, thus allowing herself to starve to death, as her doctors patiently pointed out to her. She was adamant. As this slowly happened, my mother got more and more beautiful as one day faded into the next. The doctors and nurses visited her room just to contemplate her beauty. One day

near the end, she asked for a shower and the nurses carried her outside on the terrace in a wheelchair and gently hosed her down, letting the gentle watering last as long as she wanted, free from the sterile sick room and the drawn shades. There she sat under the glorious August sky enveloped in sheer light and sunshine, her wet lace gown clinging to her body as the nurses and she laughed and played. She left this world as silently and discreetly as she had lived, in my arms, surrounded by her colleagues in the medical corps she had served to the end, and as well her two grandsons, both son-in-laws, plus all her surrogate daughters, who had all arrived—at least eight of them.

"I ask only one thing," she said to us, "don't implore me to stay...."

When she slipped into a morphine coma, Doris and I watched over her the last night as we debated whether to remove the morphine drip keeping her alive but already gone. Before we could act, she, forever discreet and polite, silently removed the decision from our shoulders by leaving quietly. She died on August 15th, 1991, Assumption Day, of metastatic carcinoma of the stomach in six weeks.

Her funeral was a tremendous affair of hundreds of people and the longest of corteges, stretching miles....Many people were strangers I didn't know but who knew me, young and old, all colors and nationalities, people from work, from church, from her art classes, from my past. She had survived my father by less than three years.

It was an ugly death for such a beautiful woman, but she never faltered. She sustained her own courage as much as those who loved her and those who cared for her. While she lay dying, I was still embroiled in my *Sally Hemings* lawsuit. When I asked the opposing lawyers involved for a jury postponement because my mother was dying, they refused with the cynical reply: "Everybody's mother dies," which is true. Everybody's mother does die.

It was months after the funeral—I had just finished packing up the last things: her jewels, her paintings, her photo books, when I noticed a bright blue strongbox in the corner of her closet. There was a key already in the lock. Instinctively, my heart leapt. I knew I was about to trespass on secrets only the dead leave. The box was the size for letters. I thought of a secret love, love letters to my father or his to her that she had kept in vain hope, still loving him.

I imagined a new lover—late in life—too late to change the course of her existence. I wondered if I should open the box at all. The naked light bulb overhead gave it an ominous iridescent glow....I turned the key and pulled open the lid, removing the first two airmail letters of a huge stack of hundreds. They *were* love letters, I discovered. They were love letters to her I had written from abroad...as I glanced through them, they dated from the time she had put me on that boat for France as a teenager to a copy of my Carl Sandburg Prize speech in Washington, and a street plan of the Via Giulia showing where Palazzo Ricci was located—an arc of thirty years of laughter and tears, drama and courage, happiness and unhappiness. Slowly, I closed the lid and turned the key, locking it. Not now, I thought.

Not today. Not tomorrow. Perhaps someday. *Maman.* I remembered something I had written in *Sally Hemings* about revealing one's secrets not to your children but to your grandchildren, I knew these were my secrets as well as hers—my growing up from a blank page to a written book, printed and bound. My coming of age would read, I thought, like a novel. Children in their self-absorbed and blind love hardly ever unseal their parents' secrets whether they loved them or detested them. But these letters were a monument not only to love, but to fearlessness.

The secrets would live on between us as she would not. If you are lucky enough to still have your mother on this earth, kiss her hello when you arrive and kiss her goodbye when you leave and rejoice and cherish each day you share, for once she is gone, your life will never be the same. What you once thought was important, will prove to be the opposite and what you once ignored or forgot all about will suddenly emerge as primordial. Mothers have a way of doing that. They keep you safe. They keep you honest. They keep you sane. Unconditional love is the most dangerous kind, but it is also the most precious.

Thou was perfect in thy ways, I thought, *from the day that thou wast created.**

When I had finished rereading the transcript of all these letters on that dawn of November 8th, 2008, at a time when change was all around me she was still there, silently listening to me, *the thing I am.*

<div align="right">—Paris, September 27th, 2017</div>

*Ezekiel 28:15.

ACKNOWLEDGMENTS

✓

The author would like to thank and to compliment her collaborators and faithful staff. First, Anna, Agnes, Queen Lizzie, and Vivian Mae—the matriarchs who made me what I am. Also, my devoted editorial assistant, Marilyn Paed-Rayray, and my chief of staff for exhibitions, Erin Gilbert.

My admiration and thanks to Ali Bothwell Mancini, who in a heroic editorial marathon took a box of six hundred letters and sculpted out of these a chronological masterpiece of three hundred. I am also grateful to Peter Behrman-de Sinety and Melanie Langer for their help in typing up the letters.

Thanks to Stephanie Weissberg, curator at the Pulitzer Arts Foundation in Saint Louis, who had the forethought to recommend *I Always Knew* to Michelle Komie, publisher at Princeton University Press, as a literary acquisition.

My gratitude as always to Sergey Tosi, David and Alexei Riboud, and Mathilde and Jules Riboud, and to the multitude of long-lost and missing friends, mentors, relatives, and heroes recovered in the pages of these letters—my mother and I thank you all.

GLOSSARY OF NAMES

Where a nationality is not specified, that person is American.

Abbey Lincoln: singer

Agamemnon: pet monkey

Agnes Moorehead: actor

Alain Delon: French actor

Alan: architect from American Academy

Alan Bates: English actor; and his wife, Vicki

Alan Sheppard: astronaut

Alberto Giacometti: Swiss artist

"Alex" Alexander Lieberman: Russian-American artist

Alexandra Wilson: daughter of Caroline and David Wilson

"Alexis" Alexei Karol Riboud: younger son of author and husband, Marc Riboud

Alice: cousin

Alison Douglas Knox: Philadelphia lawyer

Alvin Ailey, Jr.: dance director and choreographer

Alvin Eisenman: dean of Yale School of Design and Architecture

Andy Warhol: artist

Angela Davis: activist and author

Anna Akhmatova: Russian poet

Antoine Riboud: older brother of Marc Riboud, and CEO of Danone S.A.

Antony Armstrong-Jones: Earl of Snowdon, English photographer and husband of Princess Margaret

Art Blakey: jazz musician

Arthur Miller: playwright, husband of Inge Morath

Arthur Sulzberger: *New York Times* publisher

"Ari" Aristotle Onassis: Greek shipping magnate, husband of Jacqueline Kennedy Onassis

Audrey Hepburn: Belgian-born actor

Barbara Bell: surrogate daughter to author's mother

Barbara Hutton: Woolworth heiress

Barbara Logan: actor

Ben Graham: husband of Francis Graham

Ben Johnson: high school friend

Ben Shahn: artist, husband of Bernarda Shahn

Bernarda Bryson Shahn: artist and illustrator, wife of Ben Shahn

Bernice Wilson: mother's friend and housemate

Bert and Katya Alpert Gilden: married authors under single pen name, "K. B. Gilden"

Bertha Schaefer: designer and art dealer

Bertrand Russell: British philosopher

Beryl Hastie: Harvard scholar, wife of William Hastie

Betty Blayton: artist

Betty Parsons: artist and art dealer

"Bill" William Klein: photographer, husband of Jeanne Klein

"Bill" William Lieberman: art curator

Billy Wilder: film director

Black Panthers: activist organization

Bob Buchanan: architect from American Academy

Bob Fabian: painter

Bobby Timmons: Philadelphia jazz musician

Boison family: French industrialists

Bonvicini Foundry: bronze foundry in Verona

Burt Glinn: photographer for Magnum Photos

Carmen de Lavallade: dancer, wife of Geoffrey Holder

Caroline Wilson: UNESCO Secretary and researcher friend in Paris, wife of David Wilson

Cassius Clay: boxer known as Muhammad Ali

Caterina Riboud: daughter of Françoise Riboud

Cedric Dover: British art historian

Chantal: daughter of family at La Chenillère farm

Charles Blockson: bibliophile and book collector

Charles Bronson: actor

Charles Edward Chase: father

Charles White: artist

Charlton Heston: actor

Che Guevara: Argentine Marxist revolutionary

Chris Marker: French filmmaker

Christiane Pilleut: David and Alexei's au pair

Christophe Riboud: son of Krishna Roy and Jean Riboud

Claude and Jacqueline Eberhardt: French architect and designer, respectively

Claude Nabokov: wife of Ivan Nabokov

Clem and Jessie Wood: Parisian friends

Cornell Capa: founder of International Center of Photography, brother of Robert Capa

Cy Twombly: artist

David Riboud: older son of author and Marc Riboud

David Wilson: husband of Caroline Wilson

Denise Dennis: writer and president/CEO of Dennis Farm Charitable Trust

Diana Stewart: wife of American Academy painter

Diana Vreeland: editor of *Vogue Magazine*

Dick and Joan Watson: college friends

"Dick" Richard Seaver: publisher, husband of Jeannette Seaver

Dionne Warwick: singer

Dominique de Menil: French-American art collector

"Dominique" Domenico Gnoli: Italian painter and set designer

Doris Albritton: high school friend

Doris Matthews: high school friend and surrogate daughter to author's mother

Doris Wilson: childhood friend

Eduardo Paolozzi: Scottish artist and sculptor

Eero Saarinen: Finnish-American architect

Eldridge Cleaver: activist

Eleanor Coleman: high school friend

Elia Kazan: film director

Elizabeth Taylor: British-American actor

Ellsworth Kelly: artist

Elsa Martinelli: Italian actor

Elsa Maxwell: society columnist

Enrique Zanartu: Chilean artist

Erik Svenson: architect from American Academy

Ernst Haas: photographer for Magnum Photos

Eva: wife of Italian American Academy painter

Eve Arnold: photographer for Magnum Photos

Evelyn Riboud: wife of Patrice Riboud

Ezra Pound: writer

Faith Stern: artist

Fay Lansner: artist

Felix Houphouet-Boigny: president of the Ivory Coast, husband of Marie-Thérèse Houphouet-Boigny

Felmar and Marie Morse: friends of mother

Floyd Patterson: boxer

Forrest Ackerman: mother's beau

Frachon family: maternal family of first husband, Marc Riboud

Frances Cook: U.S. ambassador to the Republic of Burundi

Frances Graham: cousin on grandmother's side, wife of Ben Graham

Frances Jimenez: Philadelphia ballet dancer

François Mitterrand: president of France

Françoise Nora Cachin: director of the National Museums of France

Françoise Riboud: sister of Marc Riboud

Françoise Sagan: French writer

Friedrich Heckmann: art historian, curator of drawings, Kunstmuseum, Düsseldorf

Gaumont family: French motion picture people

Geneviève Monnier: French art curator

Geoffrey Holder: dancer

George Conley: architect; and his wife, Pat

"George" Georges-Emile Julien: husband of Sylvie Riboud

George Romney: governor of Michigan

Georges Mathieu: French painter

Gerald Edelman: biologist and Nobel Prize winner

Gian Carlo Menotti: Italian composer

Goldie Haskins: mother of Harold Haskins

Gordon Parks: *Life* photographer

Gustaf VI: king of Sweden

Gwen Mazer: journalist

Han Suyin: writer

Harold Haskins: high school sweetheart

Harold Morrison: son of Toni Morrison

Hedda Hopper: gossip columnist

Helen Hay Whitney: Whitney Foundation

Helen Zimmerman: mother's friend

Helena Rubinstein: cosmetic entrepreneur and art collector

Henri Cartier-Bresson: French photographer

Henry Kissinger: U.S. Secretary of State

Henry Miller: writer

Henry White: college sweetheart

Herbert Matter: professor at Yale and graphic designer

Ho Chi Minh: president of North Vietnam

Howard Squadron: Magnum lawyer

Igor Stravinsky: Russian composer

Inge Morath: photographer for Magnum Photos, wife of Arthur Miller

Irvin Taubkin: director of the *New York Times* in Paris

Irving Stone: author

"Italian photographer" for *Ebony Magazine*: courtesy of Johnson Publishing Company, LLC

Ivan Nabokov: editor, nephew of Vladimir Nabokov, husband of Claude Nabokov

Izzy Swartz: college friend

Jack Youngerman: artist

Jack Zajac: sculptor from American Academy

Jackie Goldman: Alvin Ailey dancer, wife of Michael Goldman, daughter-in-law of Nahum Goldmann

Jacqueline Kennedy Onassis: writer and editor, widow of President John F. Kennedy and Aristotle Onassis

Jacques Kaplan: furrier, designer, and collector

James Baldwin: writer

James Edward Saunders: grandfather, and contractor and builder

James Farmer: civil rights activist

James Jones: writer

James Ramsey: family doctor

Jan Amoor: art restorer and dealer

Jane Doggett: architectural graphic designer

Jane Fonda: actor

Janet Mackins: childhood friend and surrogate daughter to author's mother

Jarobin Gilbert, Jr.: CBS executive

Jasper Johns: artist

Jean Riboud: older brother of Marc Riboud, and CEO of Schlumberger

Jean Rosenthal: French translator and journalist

Jeanne Moreau: French actor

Jeannette Seaver: editor

"Jeannine" Jeanne Klein: model, wife of photographer William Klein

Jeff Chandler: actor

Jennifer Beals: actor

"Jerry" Geraldine Fitzgerald: mother's friend

Jim Gerret: architect from American Academy

Joan Burkley: mother's colleague

Joanne Woodward: actor

John Ashbery: poet

John Butler: choreographer

John F. Kennedy: president of the United States, husband of Jacqueline Kennedy Onassis

John Kenneth Galbraith: writer

John Rodin: sculptor

John Updike: writer

John Wilson: college friend

Jordan: architect from American Academy

Josef Albers: artist and professor at Yale University

Josephine Baker: cabaret singer and philanthropist

Joyce Mitchell Cook: philosopher and editor

Judith Jamison: Alvin Ailey American Dance Theater's star dancer and choreographer

"Judy" Judith Kipper: Sargent Shriver's assistant

Julia Child: cookbook author

Julia Wright: activist, daughter of Richard Wright

"Julie" Juliet Man Ray: muse, model, and wife of Man Ray

Julien King: childhood friend

K. S. Karol: French-Polish journalist

Katherine Dunham: dancer and choreographer

Ken Follett: British author

Ken Noland: artist

Kermit Lansner: journalist, husband of painter Fay Lansner

Krishna Roy Riboud: wife of Jean Riboud

Ku Kai-chih: Chinese painter

Kynaston McShine: Trinidadian-born art curator at MoMA, New York

La Carelle: Riboud family country seat

Lady Diana Cooper: English aristocrat

Lee Harvey Oswald: accused assassin of President John F. Kennedy

Lee Miller: photographer, wife of Sir Roland Penrose

Leo Lionni: *Fortune* art director, and mentor

Leontyne Price: opera singer

LeRoi Jones: writer

Leslie Rankow: gallery owner

Little Gallery: art gallery in Philadelphia

Lowery Sims: art historian, curator, and museum director

Lucette Riboud: wife of Antoine Riboud

Lucrezia Borgia: Italian Renaissance aristocrat

Lynn Chadwick: English sculptor

Lynn Nesbit: literary agent

Madame Rosier: housekeeper at house on Rue de Vaugirard

Magnum Photos: international photographic agency based in Paris and New York

Malcolm X: activist

Man Ray: artist, husband of Juliet Man Ray

Mao Tse-tung: chairman and founder of People's Republic of China

Marc Eugene Riboud: first husband, and French photographer for Magnum Photos

Marcello Mastroianni: Italian actor

Marie-Anne Poniatowska: Polish artist and aristocrat

Marie-Thérèse Houphouet-Boigny: wife of Felix Houphouet-Boigny

Marjorie Morningstar: heroine in book of same name by Herman Wouk

Marion Cuyjet: Philadelphia ballet
teacher
Marlene Dietrich: German-American
actor and singer
Mary: friend of author's mother
Mary McCarthy: writer
Maurie Marcello: housekeeper at Rue de
Vaugirard and Rue de Auguste Comte
Max Roach: jazz drummer
Mei Lou Klein: friend from Yale
University
Michael Caine: English actor
Michel Marot: French architect
Mimmo Rotella: Italian artist
Miriam Makeba: singer and activist
Miss Bertie: grandmother's friend
Miss Ella: friend of grandfather
Monnier family: French industrialists
Mr. Edgar: grandmother's friend
Natalie Arnold: college friend and
painter, niece of Eve Arnold
Nathan: high school friend
Nathaniel Hawthorne: author
"Negro actor that won the prize as the
'Best Actor' at the Cannes festival
last year for a Yugoslavian film": John
Kitzmiller
Nelson Rockefeller: governor of New
York
Neuflize family: French bankers
Nikita Khrushchev: premier of the Soviet
Union
Nina Simone: singer and activist
Noma Ratner Copley: fine arts jeweler
and arts collector, wife of William
Nelson Copley
"Paris" Weaton Paris: college
sweetheart
Pat Gates: high school friend and
surrogate daughter to author's mother
Pat Golbitz: book editor
Pat Moore and husband: high school
friends
Patrice Riboud: son of Antoine and
Lucette Riboud
Paul Keene: Philadelphia painter
Paul Newman: actor

Paul Rand: graphic designer and
professor at Yale University
Paul Signac: French painter
Paula Saransky: college friend
Peggy Coats: maternal cousin
Peggy Guggenheim: art collector
Peter Lorre: actor
Peter Matisse: art dealer, son of Pierre
Matisse, grandson of painter Henri
Matisse and Jacqueline Matisse
Peter Selz: art historian and museum
director
Peter Townsend: Royal Air Force officer
and suitor of Princess Margaret
"Petou" Pierre Klein: son of Bill and
Jeanne Klein
Philip Douglas: Douglas Aircraft
Company
Philip Roth: writer
Pierre Boulat: French photographer
Pierre Cardin: Italian-French fashion
designer
Pierre Salinger: press secretary for John
F. Kennedy; and his wife, Nicole
Pol and Velma Bury: friends in Paris,
Belgian sculptor and wife
Porfirio Rubirosa: Dominican playboy
"president-director of Coca-Cola": Sam
Ayoub, manager of Coca-Cola and
son-in-law of the Greek president, in
Alexandria
Prince Henri d'Orléans: French royalty
Prince Michael: Greek royalty
Princess Margaret: younger sister of
Queen Elizabeth II
"Queen Lizzie" Elizabeth Chase
Saunders: grandmother
Rabindranath Tagore: Indian poet, who
won Nobel Prize in Literature in 1913
Rachel Adler: art dealer
Ralph Ellison: author
Ralph Phillips: U.S.I.S. and service
officer, Cairo; and his wife, Jean
"Ray" Raymundo Sol: mother's beau and
eventual second husband
Rebecca Wilson: daughter of Caroline
and David Wilson

Reg Butler: English sculptor

Rene Burri: Swiss photographer for Magnum Photos

Reverend Leon Sullivan: pastor and activist

Riboud family: French industrialists and paternal family of first husband, Marc Riboud

Richard Burton: Welsh actor

Richard Hunt: sculptor

Richard Nixon: president of the United States

Richard Wright: author, father of Julia Wright

Robert Capa: photographer and founder of Magnum Photos, brother of Cornell Capa

Robert Redford: actor

Rod Steiger: actor

Rodney Porter: British biochemist and Nobel Prize winner

Roland Petit: French ballet dancer and choreographer

Romare Bearden: artist

Rose Braithwaite: maternal aunt

Rothschild family: bankers

Rudolf Nureyev: Soviet-born ballet dancer and dance director

Rue de Vaugirard: street of first Paris house

Russ Edmondson: consulate officer at American Embassy in Egypt

Sally Hemings: enslaved wife of Thomas Jefferson

Salvador Dalí: painter

"Sandy" Alexander Calder: sculptor

Sarah Griffins: friend of grandfather

Sargent Shriver: politician

Schlumberger family: industrialists

Serge Lafaurie: French journalist

"Sergey" Sergio Giovanni Tosi: second husband, and Italian art expert and publisher of artists' books and editions

Seydoux family: French Pathé cinema and textile dynasty

Sheila Hicks: textile artist

Shirley Abbott: magazine editor and writer

Shirley Temple: actor and U.S. ambassador

Sian: family collie dog

Sidney Poitier: actor

Simone Signoret: French actor

Sir James Frazer Stirling: British architect

Skorpios: private Greek Island of Aristotle Onassis

Slade Morrison: son of Toni Morrison

Sonny Liston: boxer

Stanley Plesent: lawyer

Steve Allen: actor

Stephen Boyd: Irish actor

Stokely Carmichael: activist

Stuart Davis: artist

Suzanne de Passe: movie producer

Sylvie Riboud Julien: sister of first husband, Marc Riboud

"Tante Inez" Inez Frachon: aunt of first husband, Marc Riboud

Thelonious Monk: musician

Tina: Vivian Mae's colleague, laboratory cataloguer at Temple University Skin and Cancer Hospital

Toni Morrison: writer and Nobel Prize winner, mother of Harold Morrison and Slade Morrison

Tony Smith: artist

Tyrone Power: actor

"Uncle Maurice" Maurice Schlumberger: paternal grandfather of first husband, Marc Riboud

Valéry Giscard d'Estaing: president of France

"Vicky" Victoria Reiter: writer

Vicomtesse Jacqueline de Ribes: French socialite

Vincent Scully: Yale University art and architecture historian

Vivian Mae Chase: mother

Walter and Beverly Lomax: collectors and friends

William Gardner Smith: writer

William Hastie: judge, husband of Beryl
 Hastie
William Nelson Copley: artist and
 collector, husband of Noma Ratner
 Copley
William Scranton: governor of
 Pennsylvania

Yannick Noah: French tennis
 professional
Yung Mei: daughter of Han Suyin
Yuri Gagarin: Russian astronaut
Yves Klein: French artist
Zhou Enlai: premier of People's Republic
 of China

INDEX OF PEOPLE AND PLACES

Ben (Shahn), 27–28, 45, 47, 51, 249
Bernarda (Shahn), 27–28
Bernice (Wilson), 5, 9, 13, 15, 22, 26, 29, 38, 44, 77, 79, 81, 113, 128, 173, 183, 187, 189, 191, 204, 237, 259, 291, 324
Blackwell, Betty, 345
Bloum, Cecilia, 317
Boison family, 84
Bonvicini Foundry, 245, 250
Boulat, Pierre, 8
Boyd, Stephen, 249
Bronson, Charles, 203
Buchanan, Bob, 27
Burri, René, 31, 36–37, 68, 70, 164, 249, 252, 287
Burt (Glinn), 360
Burton, Richard, 110
Bury, Pol, 264, 307–8
Bury, Velma. *See* Velma (Bury)
Butler, John, 40
Butler, Reg, 58

Cachin, Françoise Nora. *See* Françoise Nora (Cachin)
Calder, "Sandy" Alexander, 42, 45, 249, 253
Capa, Cornell, 294
Capa, Robert, 294
Cardin, Pierre, 138–39, 180, 181, 248
Carmichael, Stokely, 240
Caroline (Wilson), 306, 316, 317, 320, 339, 349, 369
Cartier-Bresson, Henri, 75, 76, 84, 242, 248, 249, 345
Castro, Fidel, 124
Caterina (Riboud), 116, 178, 228, 232, 242, 264, 313, 314, 325–26, 343, 349
Chadwick, Lynn, 58
Chantal, 262
Chase, Charles Edward. *See* "Daddy" Father (Charles Edward Chase)
Chase, Elizabeth. *See* "Queen Lizzie" Grandmother (Elizabeth Chase Saunders)
Chase, Lucinda, 85, 223
Chase, Vivian Mae. *See* Mother (Vivian Mae Chase)

Chase-Riboud, Barbara, *Sally Hemings: A Novel*: completion of, 338; film option, 355, 357, 369, 380, 384, 394; and Jacqueline Onassis, 291, 295–96, 296–300, 322; Literary Book Club selection, 349–50; plagiarism trial, 386, 387, 396; success of, 358, 363, 365; and Vicky Reiter, 317. *See also* Hemings, Sally
Child, Julia, 231
China: invitation to, 143–44; itinerary, 152; Lung Men and Sian, 159–60; overview of trip, 145–46; Peking (now Beijing), 155–59, 160–61; *The Three Banners of China* (Marc Riboud), 170, 175–76, 180, 183–84, 186–87
Christiane (Pilleut), 188, 191, 193, 197, 200, 215, 219, 227, 237, 239
Christine (Riboud), 314, 324, 330
Christophe (Riboud), 127, 129, 246, 378
Clarence, 183, 184, 187, 195, 204, 209, 212, 237, 239, 241, 250
Claude and Jacqueline (Eberhardt), 92, 97
Cleaver, Eldridge, 240, 241, 251
Coats, Peggy, 192
Coca-Cola manager (Sam Ayoub), 30–32, 33, 36
Coleman, Eleanor, 10
Conley, George, 27
Conley, Pat, 27
Cook, Frances, 370, 375, 377, 381, 383
Cook, Joyce. *See* Joyce (Cook)
Copley, Noma Ratner, 238, 239, 246, 254, 274, 318, 319–20, 345
Cuyjet, Marion, 12

"Daddy" Father (Charles Edward Chase): attitude toward skin color, 114, 117, 173; author's reconciliation with, 378–89, 382; on becoming a grandfather, 114, 117; as building contractor, 95; circumstances of marriage(s), 2, 85, 379; communications with, 13, 17, 19, 21, 43, 67, 89, 90, 129–30, 199, 351, 374; death of, 378; divorce from Vivian Mae, 1, 379; doll house incident, 234; as enigma, 85, 233–34; health of, 326;

Fonda, Jane, 262

Forrest (Ackerman), 254, 256, 258, 269, 271, 273, 277, 279

Frachon, Inez. *See* "Tante" Inez (Frachon)

Frachon family, 84

Frances (Graham), 13, 63, 360

Franck, Martine, 345

Françoise (Riboud): as activist, 220; birthday celebration, 339; car accident, 120, 121, 122–23, 126, 127; as caregiver, 144, 151, 155, 181, 199; character of, 192–93; children's school, 99, 180, 210; Christmas with, 204, 205, 231, 234; election as mayor, 85, 305; mentioned, 77, 80, 100, 235, 256, 278, 279, 313, 317, 318, 325–26, 340; political differences with brother Jean, 349; relationship with Marc, 71, 338; romantic relationships, 208, 226, 324, 346; as second mother to David, 131, 204, 215, 236, 259; vitality of, 189

Françoise Nora (Cachin), 265, 292, 313, 343, 346

Galbraith, John Kenneth, 282

Gates, Pat. *See* Pat (Gates)

Gaumont family, 84

Gerard, 226, 242, 264

Gerret, Jim, 28

Giacometti, Alberto, 248, 357

Gilbert, Jarobin, Jr., 371

Glinn, Burt, 360

Gnoli, "Dominique" Domenico. *See* "Dominique" Domenico (Gnoli)

Goldman, Jackie, 345–46, 363

Graham, Ben, 360

Graham, Frances. *See* Frances (Graham)

"Grandpop" Grandfather (James Edward Saunders): affectionate mention of, 5, 7, 15, 17, 19, 22, 25, 27, 36, 37, 46, 49, 52, 61, 65, 69, 73, 77, 82, 167; as author's lifesaver, 1; as building contractor, 1; death of, 163–64, 168; health of, 90, 91, 97, 99, 133; house as issue, 81, 98, 164; letters to, 23–24, 82; Marc's similarity to, 87; marriage, 164; as puzzle lover,

44; as standard, 203; stepson as heir, 164; and television watching, 101; Vivian Mae as caregiver of, 77; as World War I veteran, 163–64, 168, 203

Griffins, Sarah, 23, 73

Guevara, Che, 201

Guggenheim, Peggy, 40, 41

Guinzburg, Harold, 296

Guinzburg, "Tom" Thomas, 301

Gustav VI, 22, 23–24

Gwen (Mazer), 262, 326

Haas, Ernst, 224, 226

Hammock, Charles, 272

Han Suyin, 156–57, 169, 260, 262

Harold (Haskins), 5, 7, 10, 15, 19, 21, 26, 29, 38, 43, 43–44, 52, 53, 68, 74, 95, 323

Haskins, Goldie, 29, 38, 44, 114

Haskins, Harold. *See* Harold (Haskins)

Hastie, Beryl, 135–36

Heckmann, Friedrich, 265

Helen (Zimmerman), 9, 13, 15, 19, 22, 26, 29, 38, 45, 79, 113, 221, 254, 291, 316

Hemings, Madison, 337

Hemings, Sally, 266, 295, 337, 352. *See also* Chase-Riboud, Barbara, *Sally Hemings: A Novel*

Henri, Prince d'Orléans, 345

Heston, Charlton, 46, 249

Hicks, Sheila. *See* Sheila (Hicks)

Ho Chi Minh, 231, 234

Holder, Geoffrey, 40, 132–33, 140, 147, 166

Hopper, Hedda, 46

Hunt, Richard, 63

Indian wife (of Jean Riboud). *See* Krishna Roy (Riboud)

Izzy (Swartz), 10, 19, 26, 50, 52

Jackson, Jesse, 374–75

Jacquemaire (baby food company), 178

"Jan" Janet (Mackins), 79, 185, 252, 348

Jean (Riboud): death of, 378; as de facto mayor, 305; on Kennedy assassination, 124; and La Carelle, 76, 99, 116; and library controversy, 76, 88; marriage, and brother Marc's support, 76;

Malcolm X, 146, 150, 245

Man Ray, 245, 249

Man Ray, "Julie" Juliet, 248

Mao Tse Tung, 143, 262

⊚Marc (Riboud): absorption in work, 331; approach to people, 249; author's relationship with, 75–76, 86–87, 192–93, 279, 304, 307, 341, 343; biographical details, 74–76; described by author's mother, 84; disregard of appearance, 149, 166, 194; divorce from, 298, 303–4, 350, 353, 353–54, 358, 362, 366; and finances, 97–98, 192, 194, 331; health of, 190, 195–96, 286–87; as Jacqueline Onassis's escort, 294; and Magnum Photos, 74, 75, 77, 98, 148, 179, 201, 221, 261, 286; meeting with, courtship, and marriage to author, 70–71, 82–83; as photojournalist, 91–92, 103, 104, 106, 107, 110, 113, 115, 124, 133, 137, 143, 152, 164, 171–72, 175–76, 182, 183–84, 186–87, 197–98, 199, 200, 211–12, 213, 215, 226, 230, 231, 238, 250, 253, 257, 259, 260, 279, 283, 318, 339, 353, 366; pride in David's skiing, 271; as resistance fighter, 285; *The Girl with the Flower*, 182; *The Three Banners of China*, 170, 175–76, 180, 183–84, 186–87; tyrannized by the telephone, 284, 331; and U.S. miscegenation laws, 182. *See also* Magnum Photos

Marcello, Maurie (Madame Marcello). *See* Maurie (Marcello)

Marie (Morse), 62, 79, 82, 95, 96, 109, 118, 119

Marion (Cujet), 12

Marker, Chris, 182

Marot, Michel. *See* Michel (Marot)

Martinelli, Elsa, 138

Mary (friend of Vivian Mae Chase), 237, 241

Mathieu, Georges, 66

Matisse, Jacqueline, 345–46, 366

Matter, Herbert, 55

Matthews, Doris. *See* Doris (Matthews)

Maurie (Marcello), 237, 254, 256, 281, 283, 286, 290, 306, 320, 347, 363, 367

Mazer, Gwen, 262, 326

McCarthy, Mary, 257, 282, 288, 313, 363

McShine, Kynaston, 254

Mei Lou (Klein), 66, 74

Menotti, Gian Carlo, 40

Michael, 320

Michel (Marot), 42, 47, 50, 80

Michèle (Riboud Lacoin), 85, 351, 372

Miller, Arthur, 282, 345

Miller, Henry, 340

Miller, Lee, 248, 345

Mimmo (Rotella), 28, 29, 52

Miss Bertie, 185

Miss Ella, 98

Mitterand, François, 248, 363

Monnier, Geneviève, 265

Monnier family, 84

Moore, Pat and husband, 10

Moorehead, Agnes, 45

Morath, Inge, 345

Moreau, Jeanne, 136, 249

Morocco, 267–68

Morrison, Harold, 266, 272, 274

Morrison, Slade, 266, 272, 274

Morrison, Toni, 265–66, 272, 274, 275, 277, 278, 280, 296

Morse, Felmar. *See* Felmar (Morse)

Morse, Marie. *See* Marie (Morse)

Moscow, 87–88, 101, 103–4, 118–19

Mother (Vivian Mae Chase): as an "independent," 125; attendance at wedding, 82–83; author's various requests of, 8–9, 16, 21, 49, 63, 69, 108, 115, 153, 186, 205, 211, 267, 281, 288, 316, 350, 374; and birth of David, 125, 132; as calming influence, 386–87; car purchase, 334, 350; citizenship issue, 2, 21; death of, 395–96; divorce from Charles Edward Chase, 85, 233–34; and dressmaking, 16, 35–36, 96, 119, 130, 135; family genealogy, 150, 256; and finances, 192, 193, 307, 309; as Grandpop's caregiver, 59, 77, 90, 94, 95, 98, 114–15, 163; Grandpop's house as issue, 98, 164; health of, 79, 82, 85, 96, 121, 128, 163, 191–92, 203, 205, 224, 225–26, 233–34, 239;

CREDITS

All images are from the collection of the author, except 4, 6, 15, 17, 18, 26, 58, 63, 66, 68, 73, 74, 75, 76, 81, 82, 89, 90, 91, 94, 95

Photographer: Western Newspaper Union: 4

Photographer: Weslie Khoo: 6

Photographer unknown: 12, 14, 16, 21, 40, 64, 71, 72

Photograph © Ettore A. Naldoni: 13

Photograph © Sandra Lousada/Mary Evans Picture Library: 17

Courtesy of Jane Davis Doggett: 18

Photograph © Rene Burri / Magnum Photos: 19, 20

Photographs Marc Riboud / Collection of Barbara Chase-Riboud & Marc Riboud. © Marc Riboud / Fonds Marc Riboud au MNAAG: 24, 25, 27, 28, 29, 31, 32, 33, 34, 35, 36, 37, 38, 41, 42, 44, 45, 46, 51, 54, 56, 57, 59, 60, 65, 70, 77, 78

National Portrait Gallery, London: 26

Photograph © Man Ray 2015 Trust / Artists Rights Society (ARS), NY / ADAGP, Paris 2022: 52

Photograph © Massimo Vitali: 55, 61

Courtesy Alexander Gray Associates, New York, and the Betty Parsons and William P. Rayner Foundation: 58

Photograph © Estate of Jeanloup Sieff: 62

Copyright © 1978 by Fairchild Publishing, LLC. All rights reserved. Used by permission: 63

Photograph © Susan Wood: 66, 67, 68

Photograph © Studio G. Delorme, Paris: 69

Photograph © Vogue: 72

Courtesy of Carrie Mae Weems: 73

Photo: Wikimedia, Daderot: 74

Photo: Wikimedia, Phildic: 75

Museum of Modern Art, New York, given anonymously, SC209.1955. © Barbara Chase-Riboud. Digital Image © The Museum of Modern Art / Licensed by SCALA / Art Resource, NY: 76

Museum of Modern Art, New York, Gift of The Grace M. Mayer Collection, 13.1999: 78

ABOUT THE AUTHOR

Barbara Chase-Riboud's first collection of poetry, *From Memphis and Peking* (1974), was edited by Toni Morrison and released to wide critical acclaim. For her second collection, *Portrait of a Nude Woman as Cleopatra* (1988), she was awarded the Carl Sandburg Poetry Prize for Best American Poet. She is the author of seven celebrated and widely translated historical novels: the bestselling *Sally Hemings* (1979), *Valide: A Novel of the Harem* (1986), *Echo of Lions* (1989), *Roman Égyptien* (1994, in French), *The President's Daughter* (1994), *Hottentot Venus* (2004), and *The Great Mrs. Elias* (2022). She was awarded the Janet Heidinger Kafka Prize for Best Novel by an American Woman for *Sally Hemings*. In 1996, she received a Knighthood in Arts and Letters from the French government in joint recognition of her literary and artistic achievements.

Chase-Riboud is an internationally renowned sculptor whose works belong to major museum collections around the world. She is the recipient of many awards and prizes, including the French Légion d'Honneur awarded by President Emmanuel Macron in 2022. She was awarded the Simone et Cino del Duca International Sculpture Prize by the Institute of France and Académie des Beaux-Arts in 2021. She was honored with a rare living-artist personal exhibition at the Metropolitan Museum of Art in 1999. She is an MFA graduate of Yale University School of Design and Architecture, and the recipient of numerous fellowships, prizes, and honorary degrees. She divides her time between Paris, Rome, and New York.

George Washington
Elementary Schl.
Baltimore
(Tonya on her niece)

Saturday March 8,
Athens

Darling Mother,

I'm now in Athens on my way to Istanbul Monday night. I'm at the American School of Classical Studies here which is a sort of an American Academy. I arrived here last Saturday, the 1st from Alexandria. I had a wonderful, wonderful time in Egypt plus the usual adventures, everything from having tea with the manager of Coca-Cola and the son-in-law of the Greek President in Alexandria to riding across the desert sands with an Egyptian archaeologist to living for a week in a borrowed penthouse apartment complete with terrace, view of the pyramids and house boy! Here their life is so monotonous. Anyway, as far as our plans are concerned I'm still expecting you in June. I'll be back in Rome about March 15th where I'll stay at least until June. As far as coming home is concerned I might be able to come home the end of June. It depends on whether I get an extension from the Whiting Foundation, if the job with Hofmann in Switzerland works out and if I get admitted to Yale in the Fall. My other dates rule out if I go to Yale in the middle of September or else; the beginning of August the end of November. I still don't have a camera, but I received a letter from Izzy who will be in Europe in April and I'm going to get him to get me a fairly good one, through the P.X. as it is now I can't even afford a cheap camera, let alone the film for it because I'm using all my money for traveling.

As I mentioned, I met some wonderful people in Egypt and had a real ball. Most of them were from the American Embassy and one colored couple, Ralph & Jean Phillips in U.S.I.S. really serviced me with kindness. Another friend of theirs Russ Edmundson, who is a consulate officer and Amer. Embassy is the one who let me use his fabulous apartment while he was in Port Said. Also on hand was one Egyptian archaeologist who really showed me all over Cairo and will be at Brown University this September and one darling Swiss photographer, René Burri whom I saw in Luxor, but is in Cairo between his assignments flying back and forth to Damascus to cover the elections. He has a doll he looks for a New York Press syndicate of photographers called magnum, is very successful and a friend of Picasso's. He also reminded me of Arnold. I met him in Luxor which is in Upper Egypt near the Sudan and he + I and another Swiss boy went across the Nile to the Valley of the Kings together. He was on assignment, but I think he took more pictures of me than anything else. Anyway we came back to Cairo